TheBritish
NickDanzig

Inspired by a sense of adventure and by the fictional world of Tintin, I left home alone for the first time in 1971 at the age of thirteen, bound for Paris. My travels subsequently took me further afield – to South and Central America, to the Middle and Far East, and to Africa. As I travelled, I became more and more interested in documenting people's lives. I have often lived rough and visited people on the margins of society in Afghanistan, Mexico and Mongolia; I have focused on people in war zones, areas of great social conflict and extreme traumatic circumstances. Writing, photography and documentary film-making are equal ways for me of capturing and recording what I see. In 1992, I decided to focus on Britain, the country of my birth, and one I barely knew. To use the words of T.S. Eliot, the American poet who chose to make his home in Europe, and who expressed his sense of wonder in his Four Quartets: 'And the end of all our exploring will be to arrive where we started and know the place for the first time.'

In 1994, I began my journey around Britain with the support of my publishers HarperCollins and a Fellowship from the National Museum of Photography, Film and Television, in conjunction with the Bradford and Ilkley Community College. I travelled to inner cities, towns, villages and remote farming communities. Initially, I took over five thousand photographs. Subsequently, John Willis, then Director of Programmes at Channel 4, commissioned me to make a television documentary series revisiting some of the same communities, and visiting others. The series, Postcards from the Edge, used a completely new set of my black-and-white stills. A second television series was commissioned, The Fight for Hearts and Minds, focusing on the work of junior doctors in two hospitals – Harefield in Hertfordshire, where they perform heart and lung transplants, and the Maudsley in South London, which is a hospital with an emergency clinic for people suffering from mental health problems. Most of the photographs of the people and places I have visited during the research for these projects have never been published before.

For The Establishment, the third television series based on my photographs, I set out to discover where and how power is exerted in Britain. I chose to look at the arts, the military, the judiciary, the Church, the media, landowners and the aristocracy. I walked the corridors of power in search of Britain's executive, rather than the homeless, unemployed shipbuilders in Barrow-in-Furness, ex-miners in Wales, heroin abusers, and runaways from care whom I had photographed in Postcards From the Edge. I decided to turn my lens on those in authority: army generals, dukes and duchesses, bishops, judges, politicians.

Growing up on the Continent in a half-American, half-British family, I was brought up to believe that the British gave notions of justice and fairness to the world. Maybe so, but on these journeys through Britain I have never been more struck by the class divisions in society. Accent is the first giveaway; regional accents are superseded by class accents, and as soon as someone speaks you can tell their background. All too often, I was reminded of what a bursar from an Oxbridge college told me, 'Change is good, but no change is better.' When change has taken place it has sometimes been superficial. I was allowed unprecedented access to the House of Lords to photograph behind the hallowed portals during the partial transition from hereditary peers to appointed peers, but it seems one unelected system has been replaced by another.

Sometimes, as in trying to photograph areas of the working life of Trinity College, Cambridge, I found myself up against an iron wall as difficult to penetrate as the KGB (no doubt that is why some alumni did well in both spheres). Everything I wanted to record had to be put before the college council. However, unlike the East End of Glasgow, my hosts didn't insist on a chaperone for protection, and only twice during these journeys was I asked to refrain from taking photographs: on the Queen's flight (en route to one of NATO's largest military exercises with the Army's Commander in Chief) I was informed that 'Her Majesty would be offended', and at a private lunch I was asked not to take a photograph of the Prime Minister while he was eating. I have already forgotten what I was not meant to hear during the Army's Strategic Defence Review when I was told, 'Danziger, close your ears.'

Having made several journeys through Britain, and having focused on both the marginalized and the people in power, I have become aware that the old definitions of class no longer hold true. Britain has a working class which no longer works and a ruling class which no longer rules. However, I did discover many similarities: these Brits, in adversity or comfort, are a brave people who can face anything with stoicism. As for their notion of equality, each and every one I met knew themselves to be as good as the next person, but also that the next person was not half as good as they were.

Britain has never been my 'home', but six years and some hundred thousand photographs later, at the end of this particular journey through the Nineties, I feel both at home and abroad in Britain, poised between cultures: both insider and outsider – a local stranger.

When setting out on this journey I never imagined that I would experience so much happiness and laughter, such pain and anguish, or that I would be confronted so often with matters of life and death. I owe the following photographs to those who allowed me into some of the most intimate moments of their lives, when they were either at their most vulnerable or at their most joyful.

Britain, I felt, is still a country of unfulfilled promise, caught between beauty and decay. Being among the friends and acquaintances encountered on my photographic journey made my world a much richer and more exciting place. **Nick Danziger** London, 2001

In the West End of Newcastle the streets of terraced houses tumble down the hill towards the armaments factories and shipyards that once followed the river's course. Violence and crime mean there are no cars on the streets – few people, and most of these are children. Whole blocks of terraced houses are boarded up, many having had their roof tiles removed. Walls crumble, letter boxes are encased in steel cages and padlocked, in order to prevent firebombs. Many streets are littered with the debris of vandalized houses, and bitumen and graffiti are daubed everywhere.

The old folk who haven't been driven out of their homes are safely back by one or two o'clock in the afternoon behind locked doors, while the children are out prowling for new victims to rob, new buildings to cover with graffiti and burn. Tommy, ex-wrestler and war hero, was one of the few who hadn't been terrorized: 'Well it's all wrong, innit? I mean, I'm seventy-three now, and if you can't get a bit o' peace now, well, you're never gonna get any peace, are you? There's no way they're gonna chase me out of it. Why should I move?'

'If they come near that door and threaten me, I just say to them, "Right, smile, boys!" Once you dae that they're away. They'll drop their pants, show their bottom, and away they go.'

In this part of New-castle the children's games are with the police and firemen – setting fire to houses, stealing cars, the children are taking charge of their lives, directing the street theatre. There is nothing to keep the children out of mischief. As June explained, 'I had a few problems with me oldest son. He stole things out of the house; he stole video-tapes, anything what he could sell to get money for solvents; he fell through the roof while up trying to pinch the roof slates; he was in a car crash – he crashed it at the bottom of the street. I nailed the windows down to stop him trying to get out. And I used to keep the keys on me all the time, so nobody could get in or out unless I opened the door.'

This woman is too frightened to show her face. Her friend has been driven out of the area for reporting vandals to the police, and she, too, has suffered at their hands. 'They're running wild all night. I had a Doberman pinscher and they managed to bash him; hit him with bricks and stones and pieces of wood. After that I had to have the dog put down 'cos he was lame. When I go to bed at night, I have a cudgel next to my bed. I'm sixty-six, but I think I can still handle something like that.'

Amanda and Mick and their two young children are living under siege. 'I've got a knife. I put the knife where I sit. And it's there all the time when Mick goes out. We've got a pickaxe handle at the front door. We've got a hammer in the kitchen. One of us always has to be in. I've made Mick a prisoner of this place. I think I've cracked. I've been told by the doctor it's stress, I need to rest, but you can't rest around here.'

The fires the nine- and ten-year-old gang members frequently start, using aerosols, have been coined 'malicious ignition' by the police. 'They firebombed us out: first through the window above the front door then, when we boarded it up, they pushed firecrackers through the letter box. I was terrified – there was only one way out which was full of smoke. We got locked out: they had smashed the door so hard the lock jammed inside. It didn't matter if one of us stayed in to deter them because even when we were inside they tried breaking in.'

His friends call him a 'creeper': he breaks into people's homes at night while they are sleeping. He's not alone. Like many others, this eleven-year-old does it to get enough money for a 'pour' – a fifty-pence bag of glue, which they sniff in empty houses. After this particular buzz, the boy's eyes glazed over, he was in another world – temporarily.

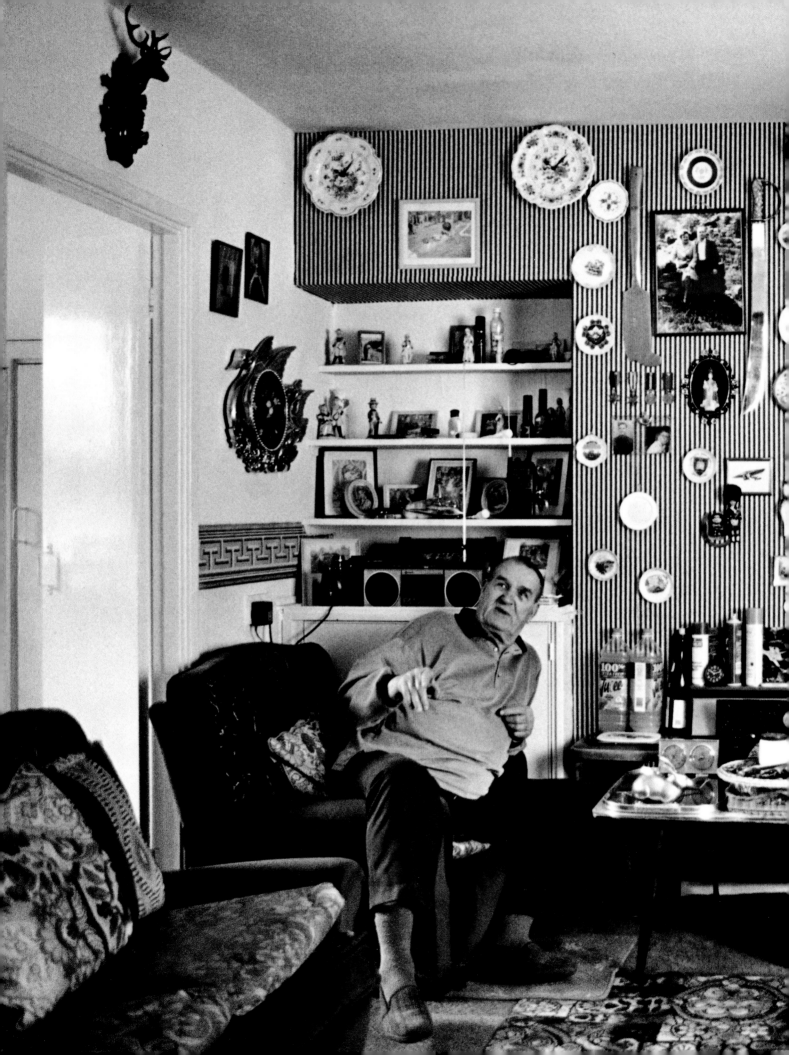

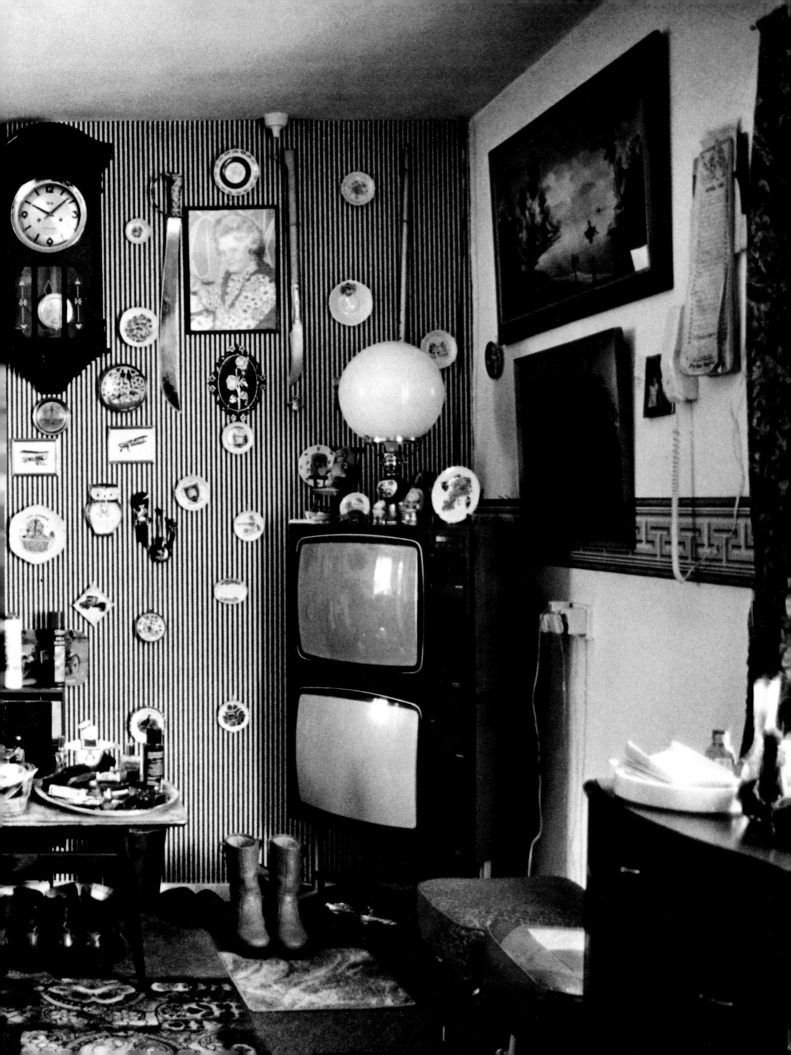

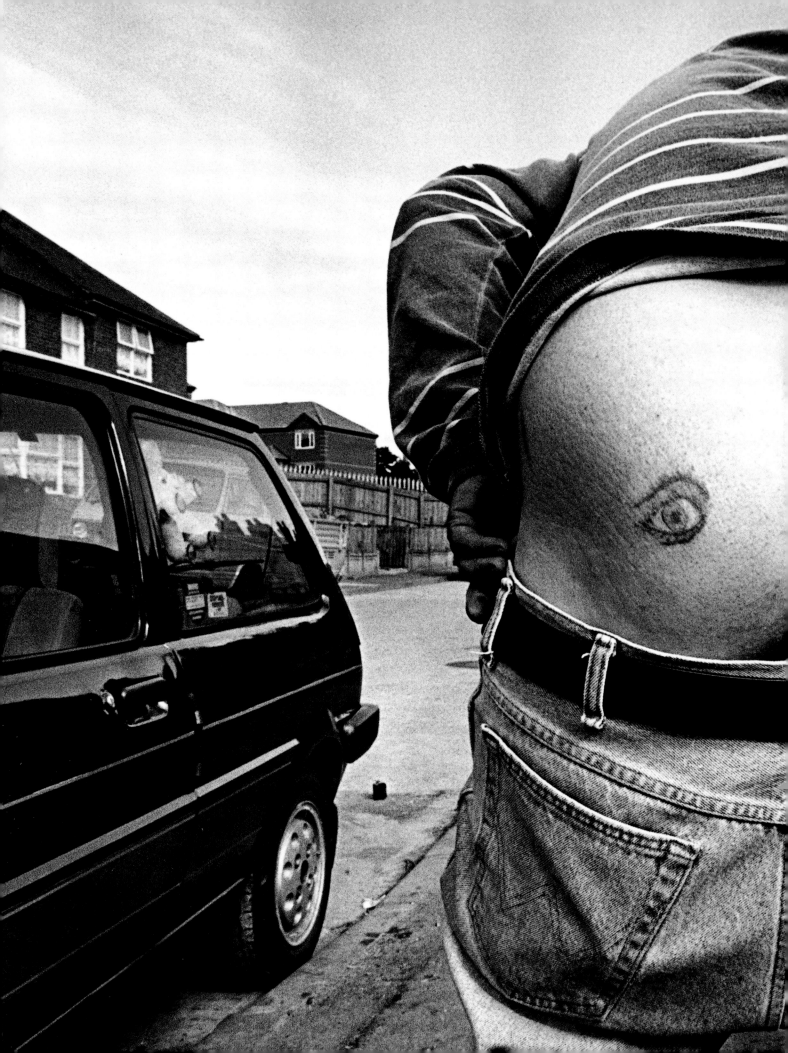

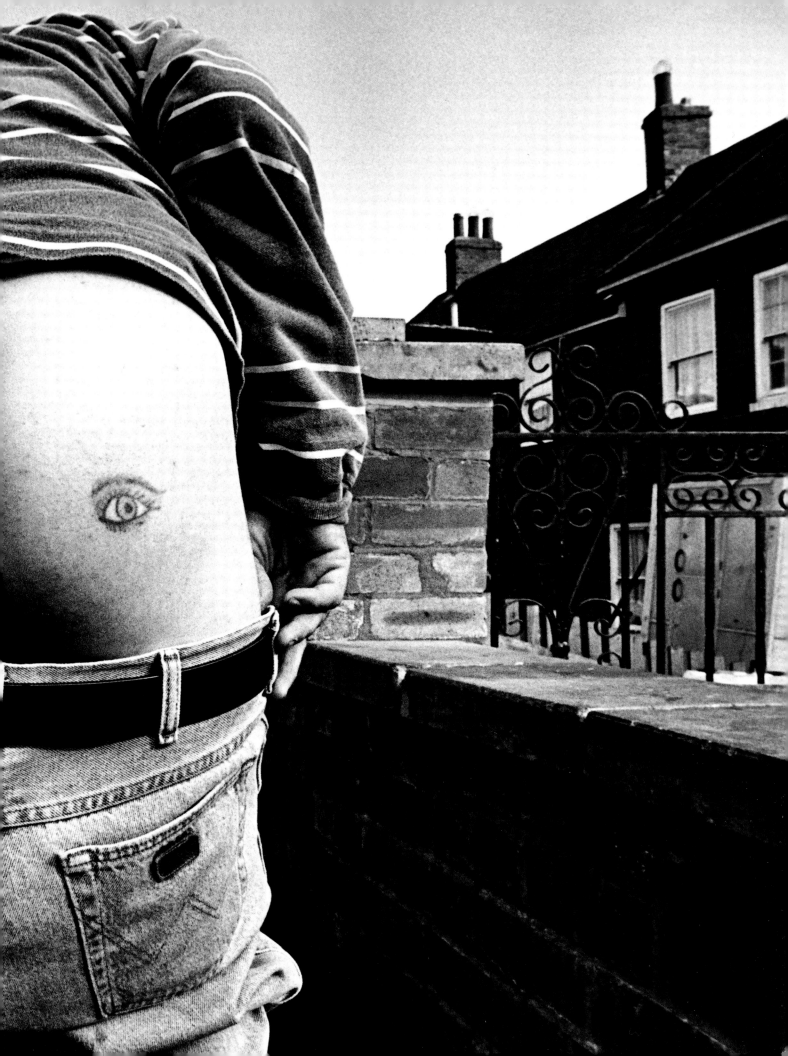

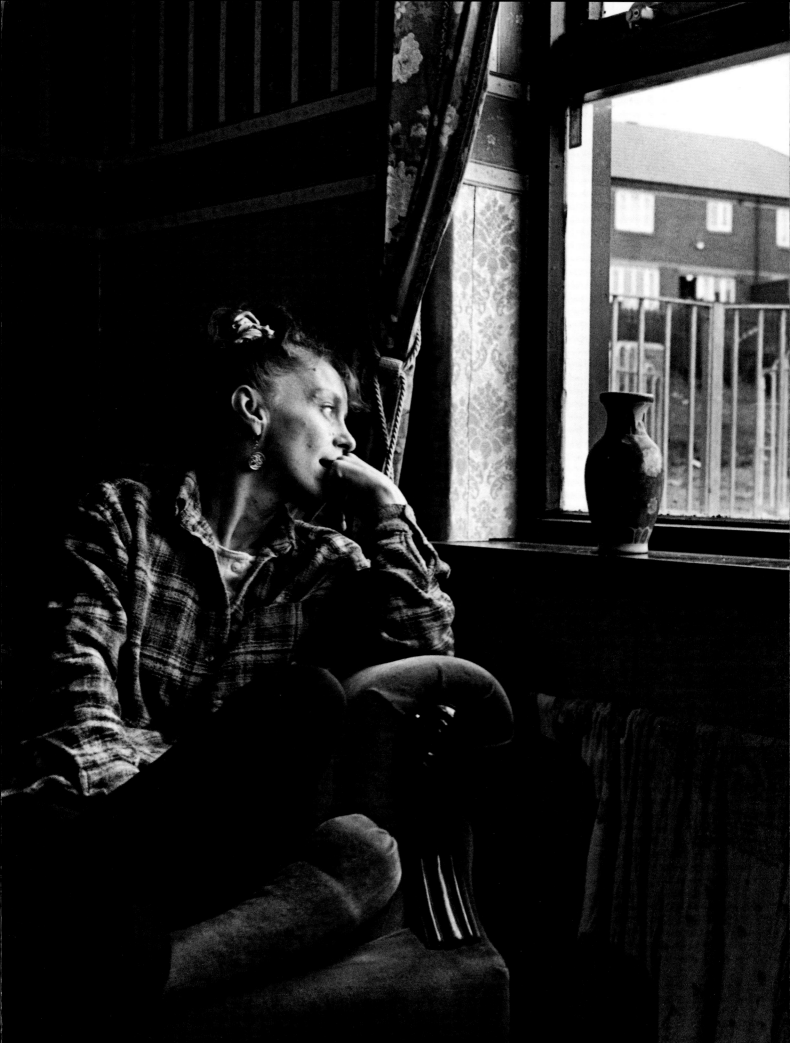

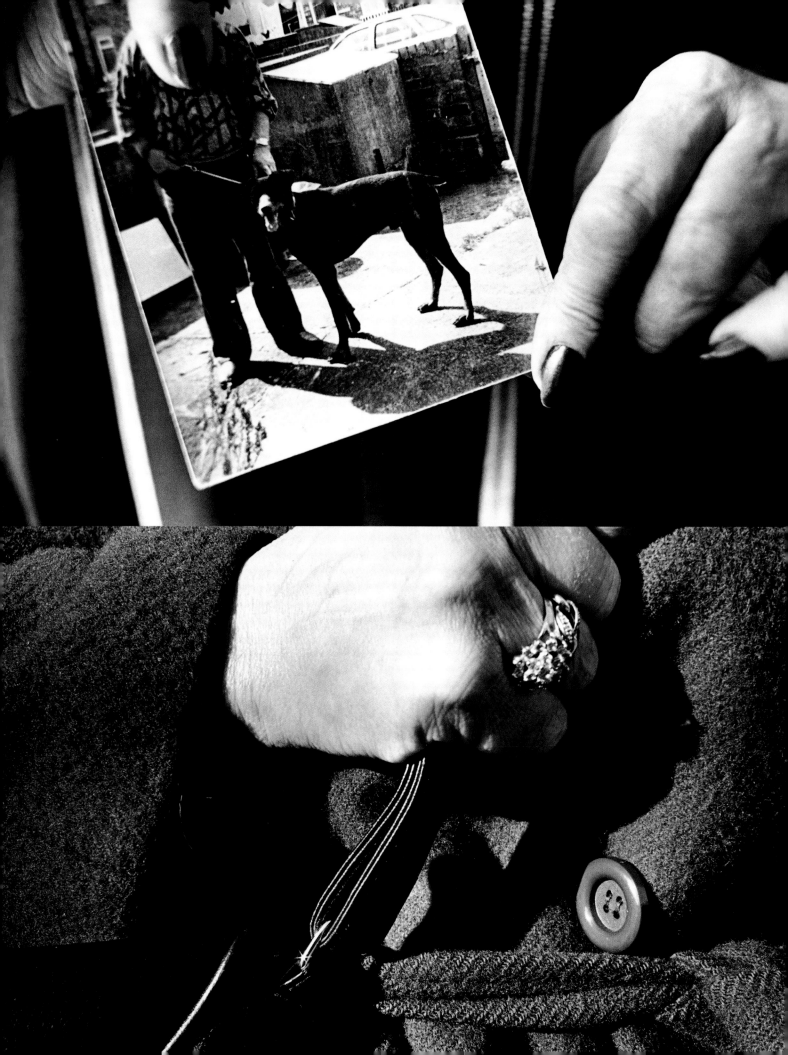

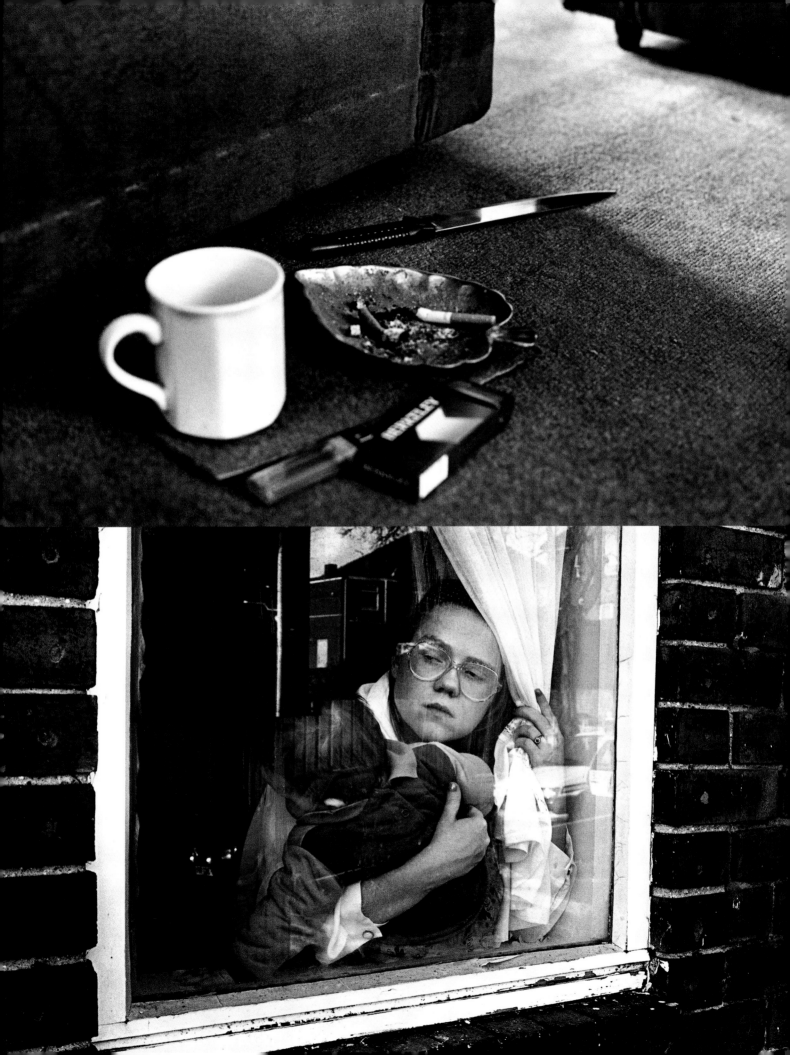

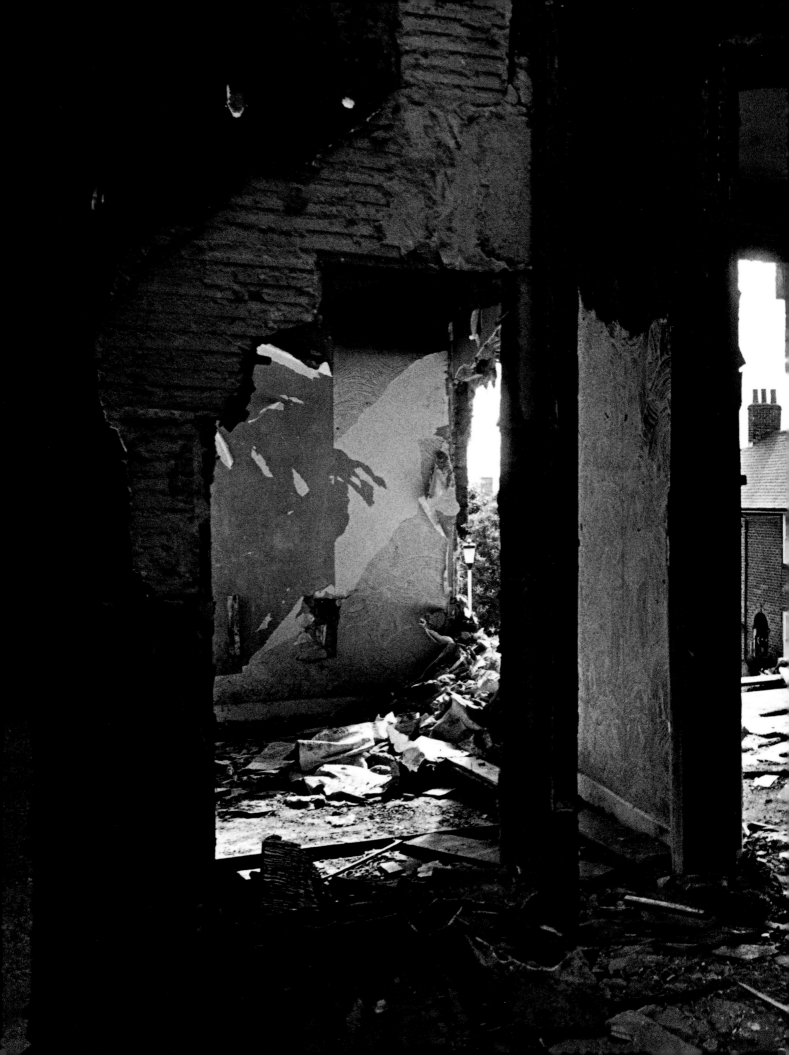

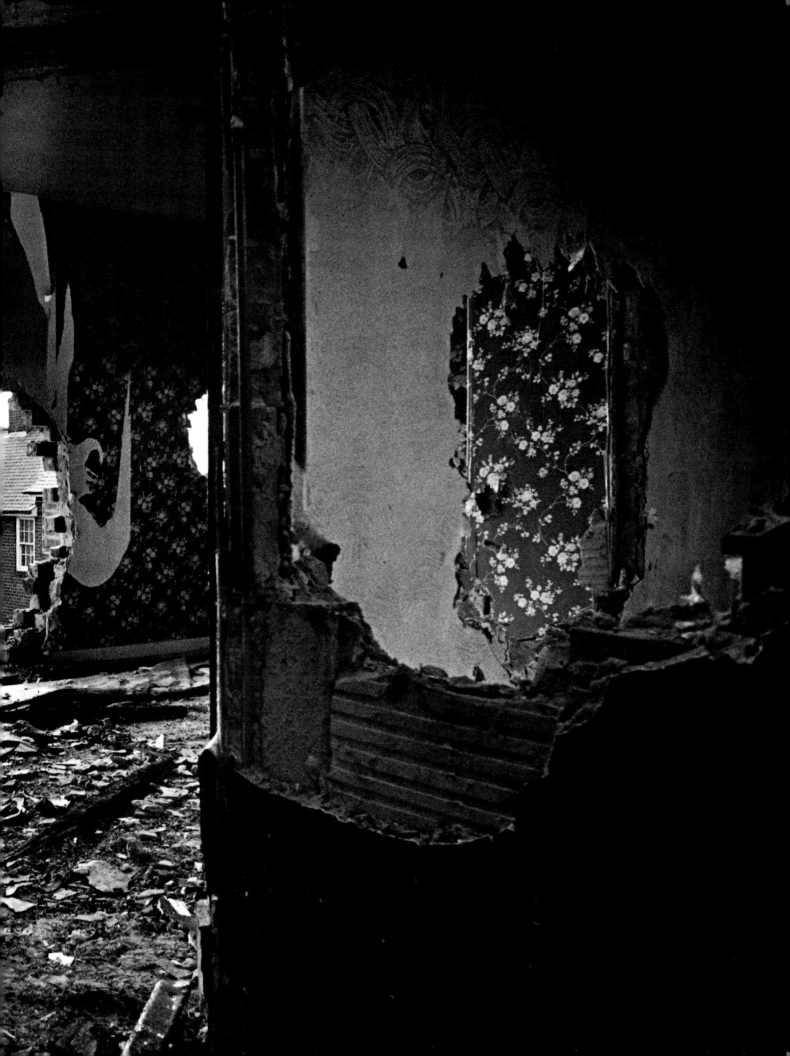

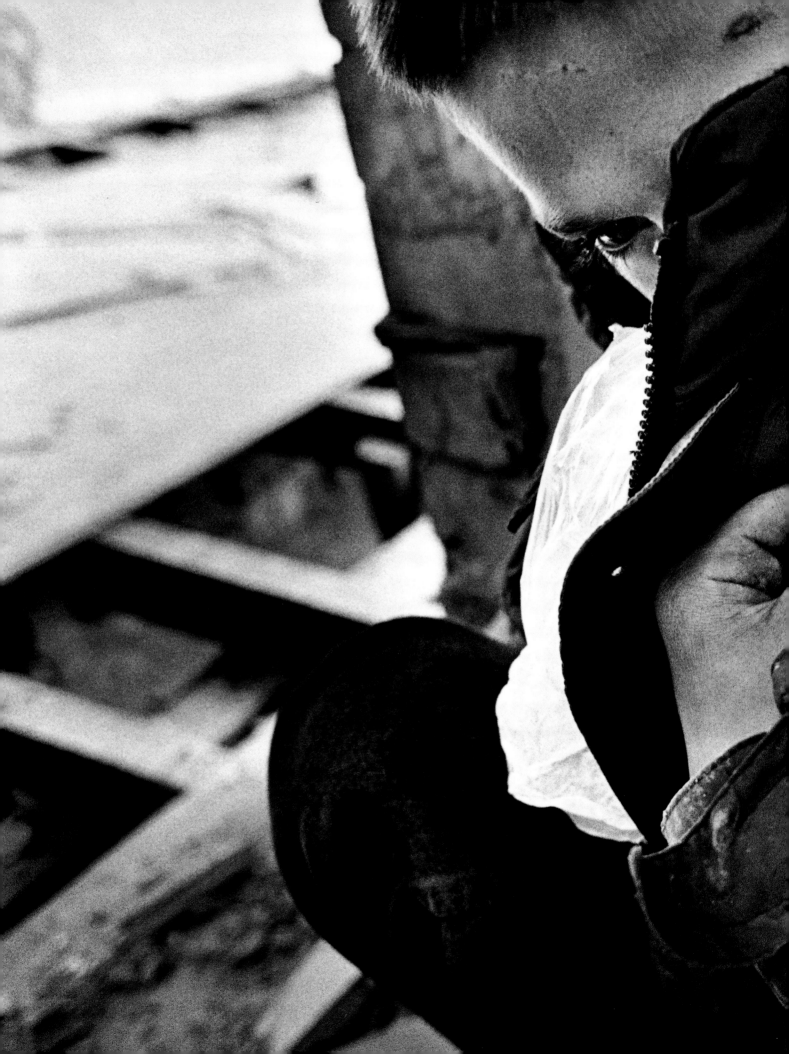

I spent several months following two junior doctors, Charlotte Wilson-Jones and Adam Winstock, trainee psychiatrists at the Maudsley, London – the oldest psychiatric hospital in the world, and the original Bedlam asylum, where Hogarth's rake ends his dismal progress. It was once Britain's only 24-hour emergency psychiatric casualty department. The week before I began work a man had shot himself to death in front of a nurse standing behind the reception desk.

Charlotte consults a patient. 'People have very strange ideas about psychiatry. When you tell people at a party what you do, they often move away, terrified that you are reading their mind or convinced you're working out their deepest secrets.'

Charlotte receives an alert on her bleeper and sprints to the emergency clinic, to receive a patient in a police van who has been picked up for creating a disturbance.

I first set eyes on 89-year-old Maud after she had emerged from the police van. She was frail and terrified. Charlotte tries to calm her, but Maud wails over and over again, 'Look what they are doing to me, George!' Maud is deaf and, it turns out, has been so ever since she was a child. The doctors communicate with her by writing messages in large, clear letters. Maud hears thirty-nine voices, all with names: Skirting Board and Edge were two of them. 'One is sitting on your shoulder,' she told me.

For nearly thirty years Maud had been living on her own, alone and forgotten in a condemned flat which had no running water, electricity or heating. She used a pot for a toilet. There were pigeons in the bath. 'What no one understands is that it was meant to be untidy,' Maud explained.

Sheldon was referred to the Child & Family Psychiatric Clinic because he was finding it difficult to concentrate, always fidgeting and not paying attention. Sheldon's mother was told he was the naughtiest boy in school. 'They said I got to pick him up one night, and the letter said don't bring him back, because as of three-thirty this afternoon, he's permanently excluded.' Adam told me, 'When I trained to be a medic I thanked God for my health. When I started in psychiatry, I thought, "Thank God I'm not mad." Now that I'm a shrink at the Maudsley I thank God I have my family.'

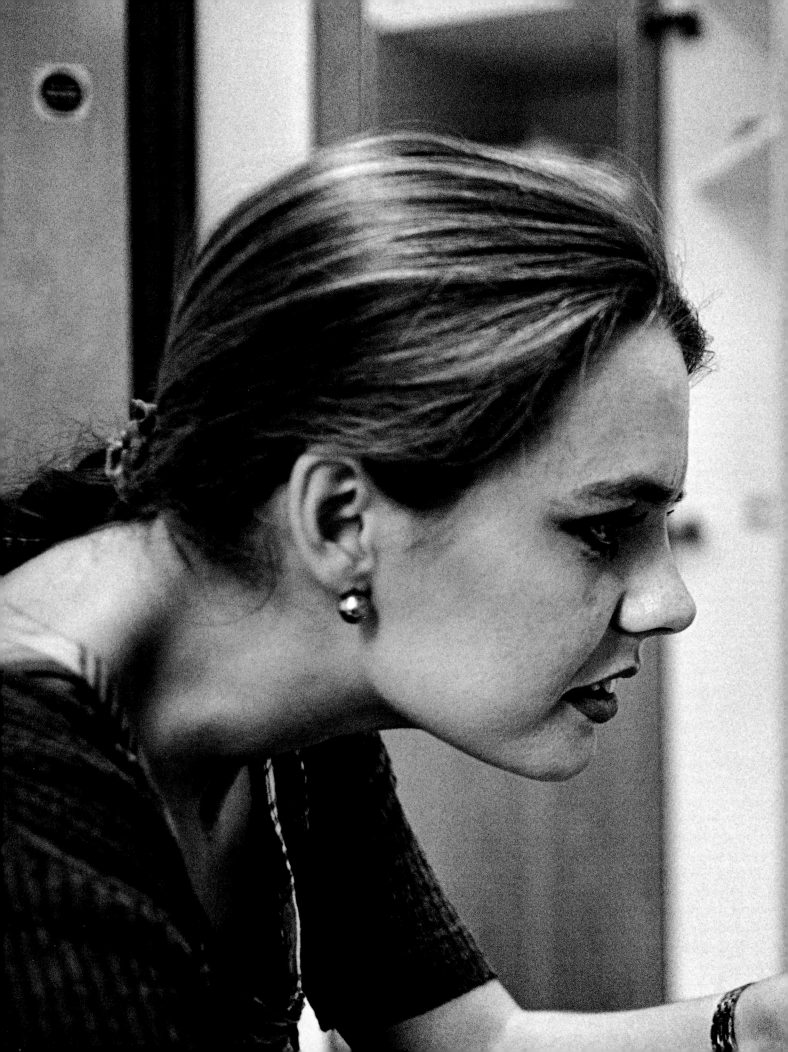

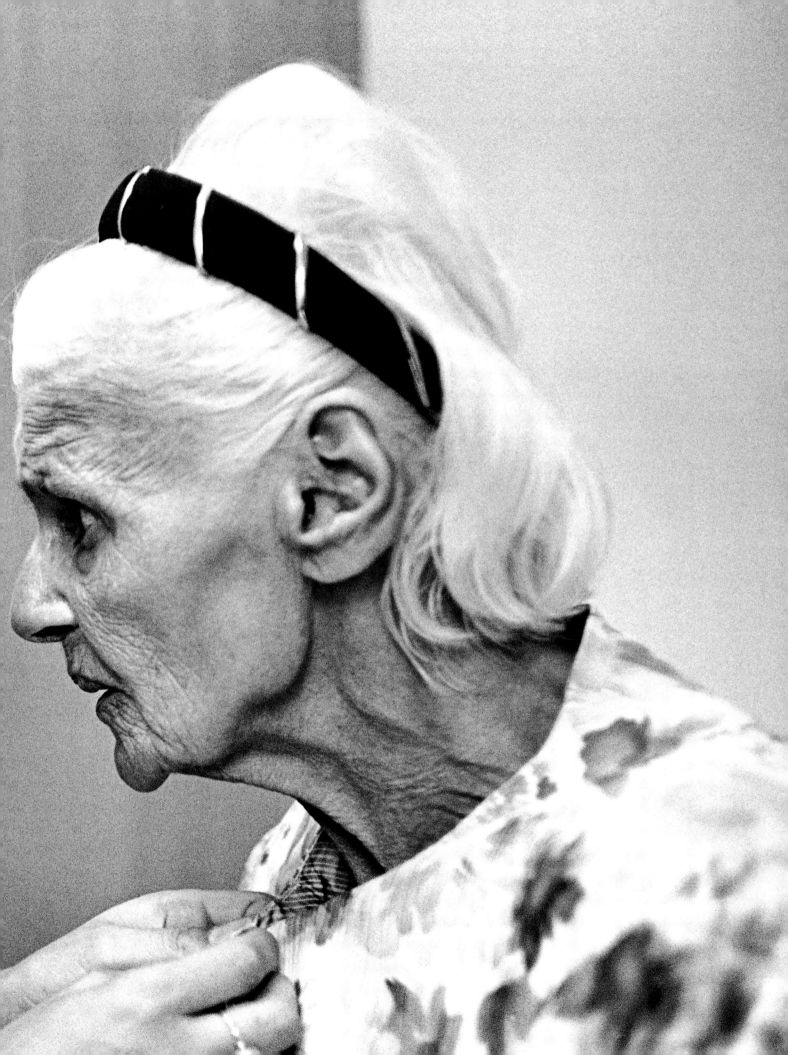

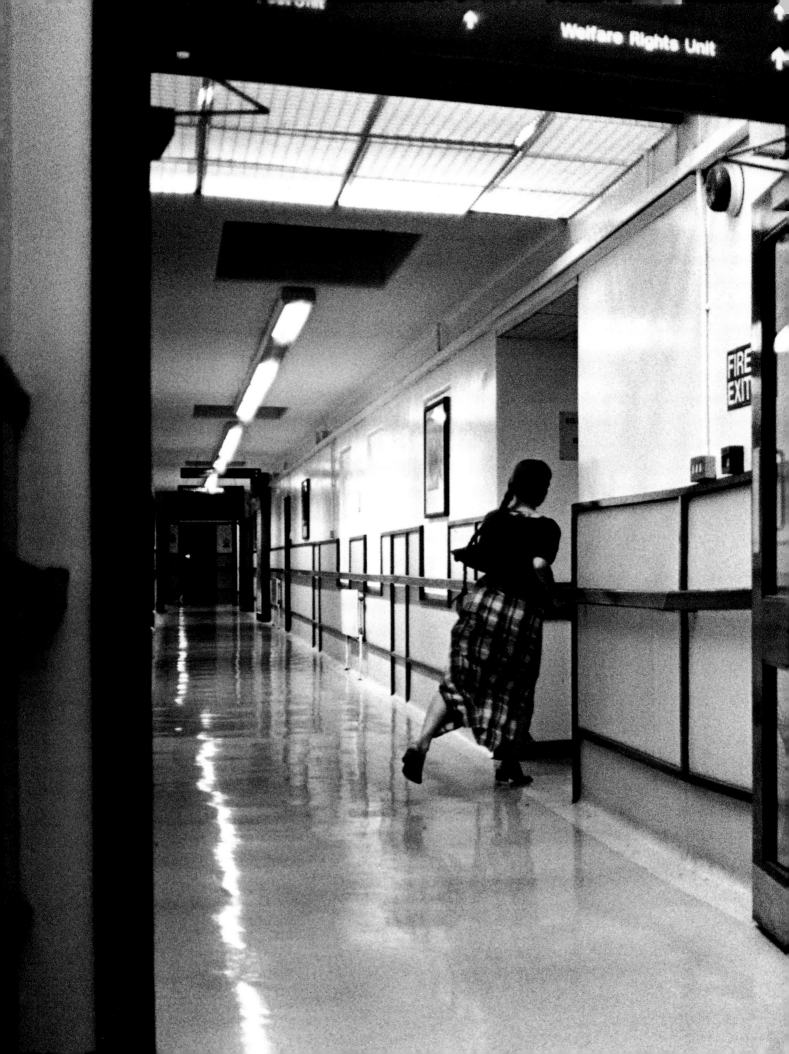

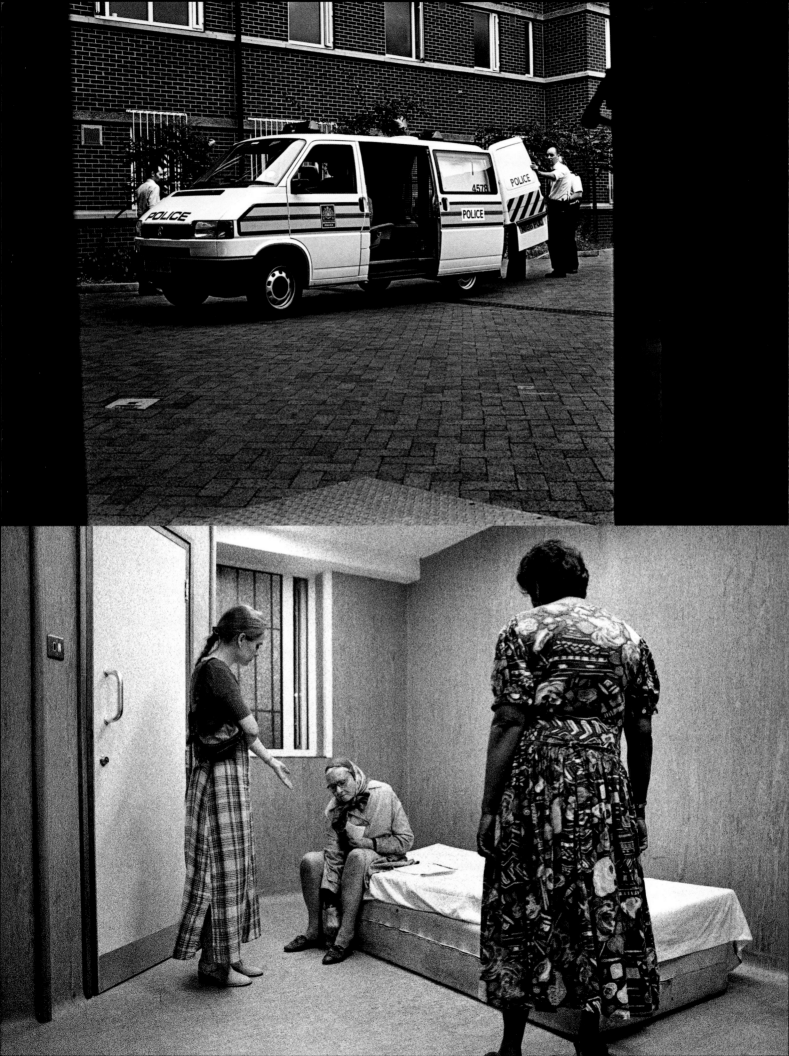

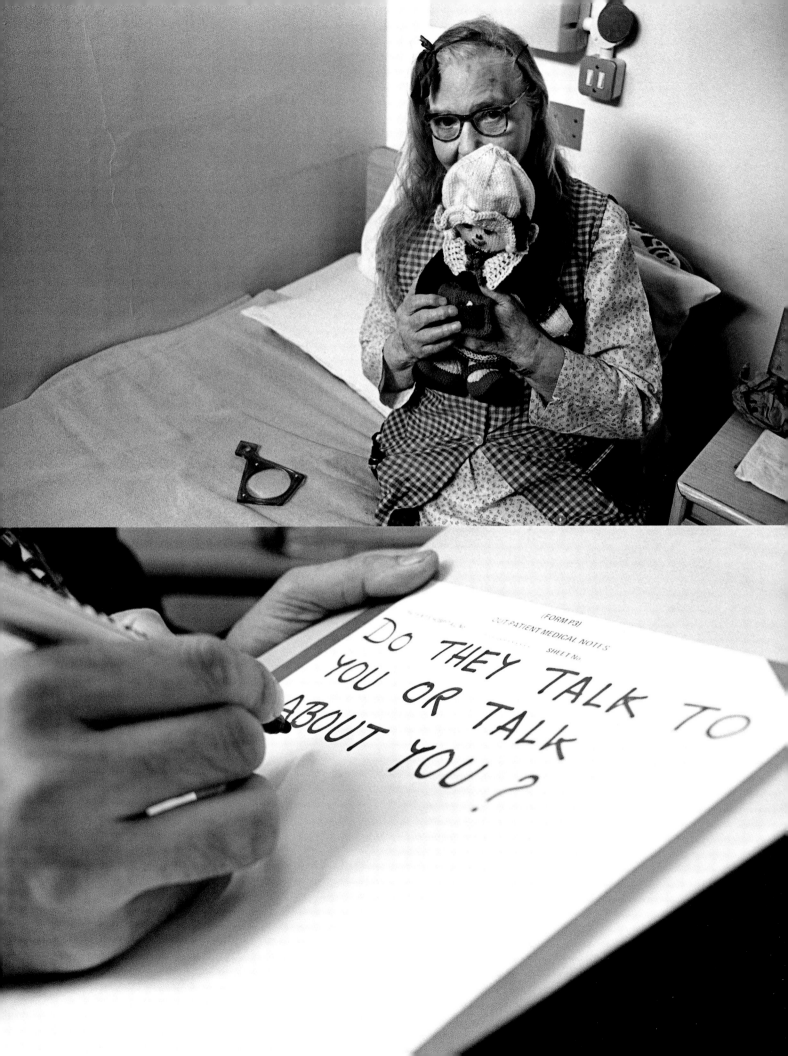

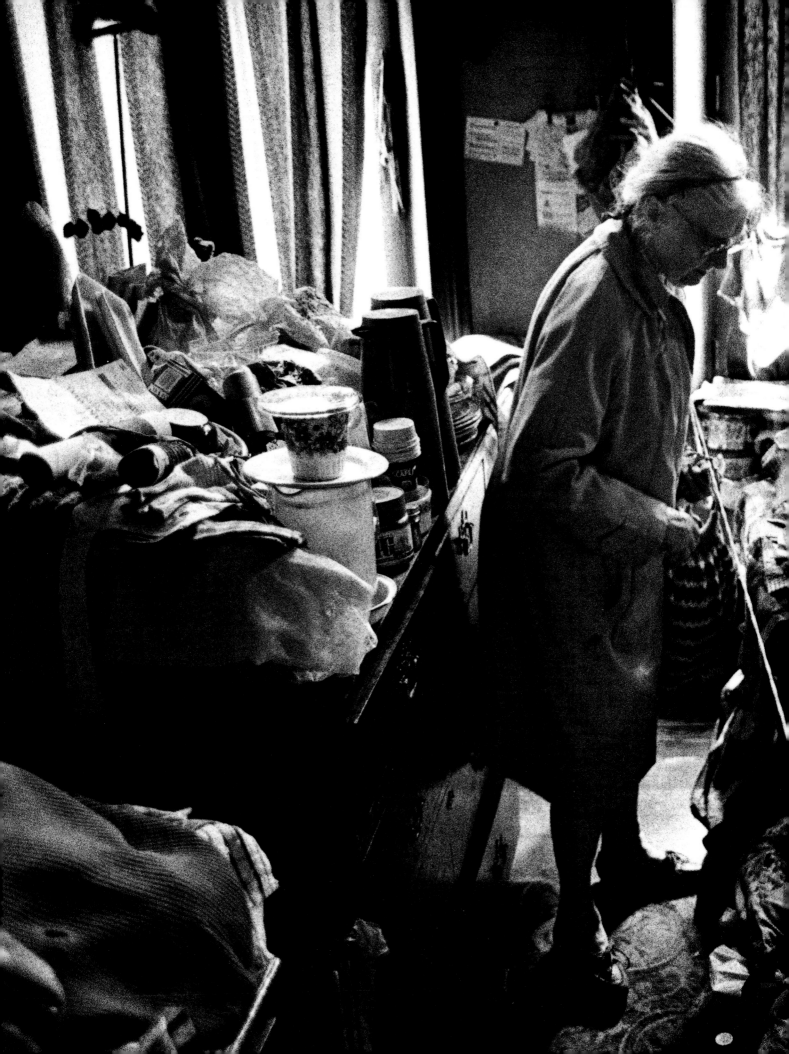

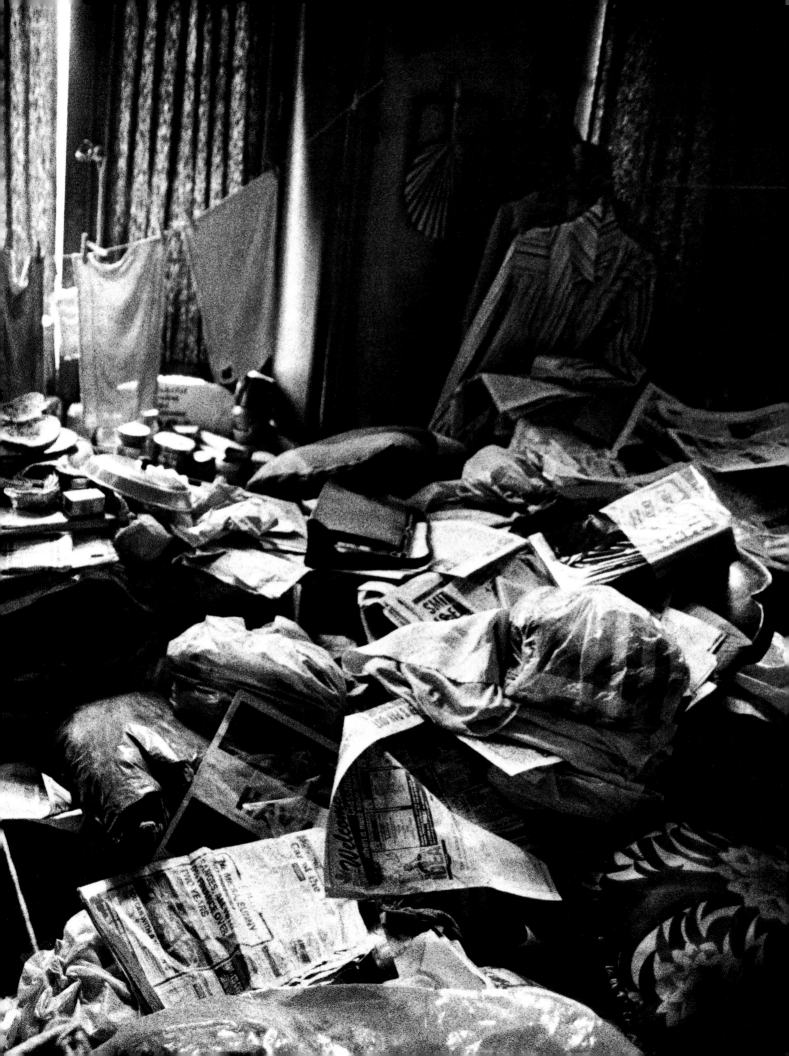

No one is ever top of a heart transplant list. When an organ becomes available it is offered first to a hospital within its own zone (there are nine cardiac zones in Britain), and if they cannot use it, it is offered to the other zones on a rotational basis. The recipient will then be chosen on the grounds that he or she is the best match in terms of size, weight, blood group and tissue type.

Peter O'Keefe is a cardio-thoracic surgeon at Harefield hospital in Hertford-shire. He had wanted to wield the knife ever since he was nine. Now he has reached the top of his profession. Like many surgeons, he sees his work as an art as much as a science. 'Heart surgery is particularly pleasing because you get to make really big holes in people! And you create your own environment to work in. It's not a sombre environment at all. We usually have the music playing. I have been known to perform heart surgery to Guns N' Roses.'

Lucy's young life has been punctuated by hospital appointments, emergency admissions and operations. When she was seventeen months old, she had her first open-heart surgery. At five-years-old, Lucy had a heart transplant – the most complicated heart transplant Professor Sir Magdi Yacoub ever had to perform. As Lucy was recovering, her mum Carol said, 'I don't look far ahead now. I know that Lucy isn't going to grow up to have a normal life expectancy, her life will be a short one. But when you have a child like this you focus on the quality of life that they will have, then the length of time that they will be with you. As long as Lucy's time is quality time, then it's a success in itself.'

Fourteen months before Rosemary was operated on, she had been given a year to live. 'Every time the phone rings I say, "Oh God, is this it?" – but all I can do is wait. I love to do the garden, love my children and grandchildren, and I love my horses – which I can't ride any more. But I keep going. I won't be defeated by it, it's not going to get me! If I gave in I would feel depressed.' Rosemary did not survive the operation. Her children, twins Rachel and Justin, were told by a nurse that she had died.

Surgery

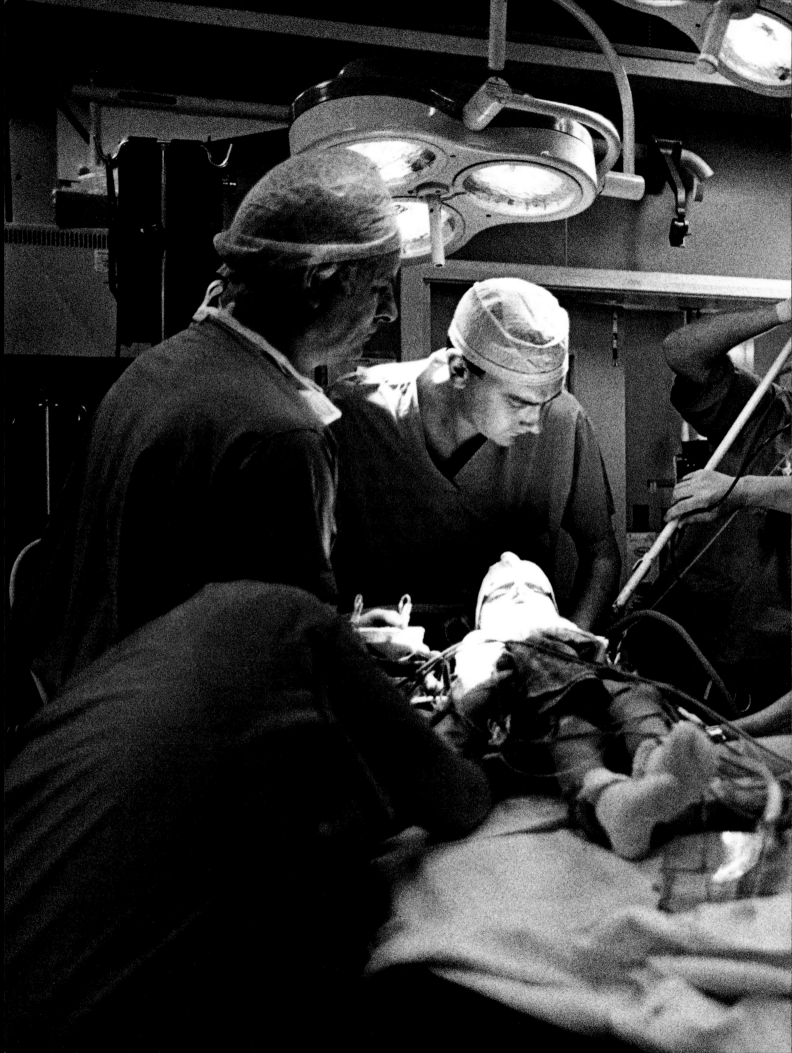

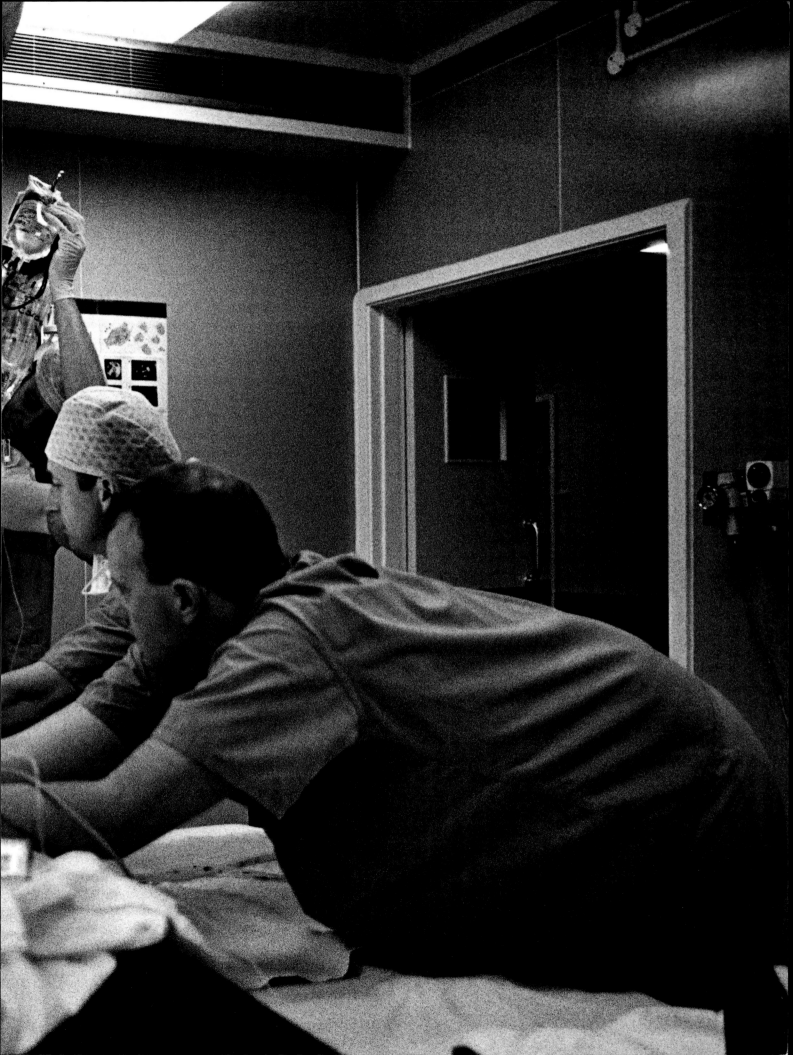

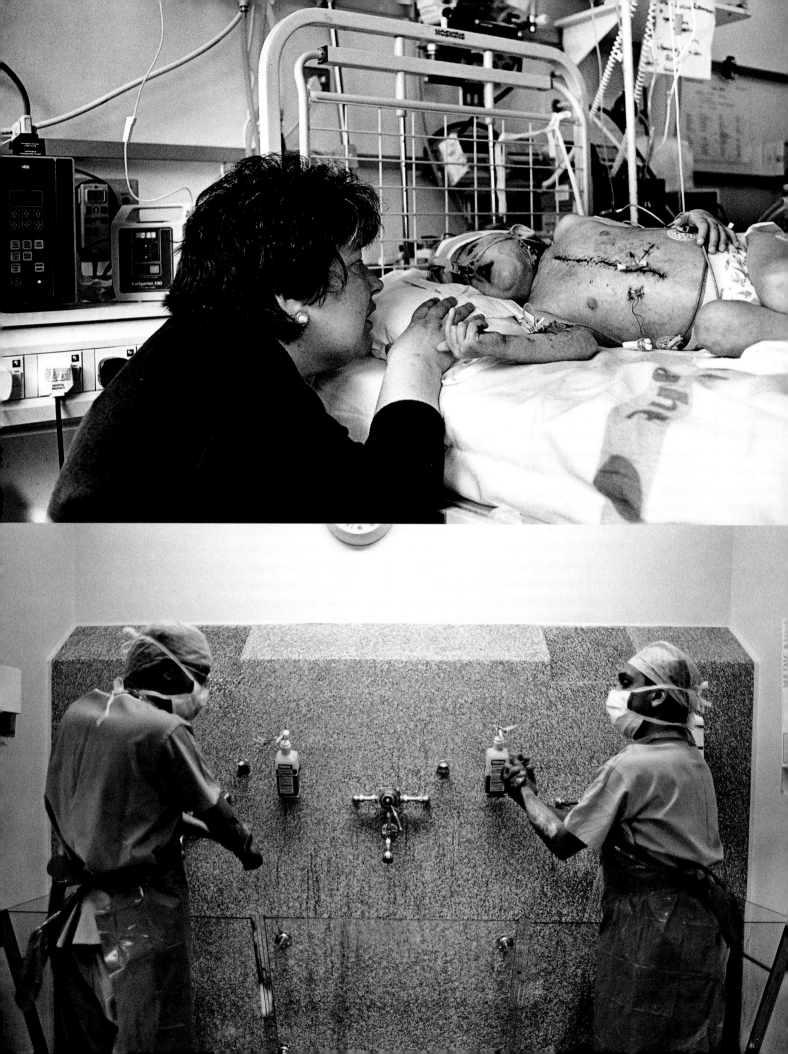

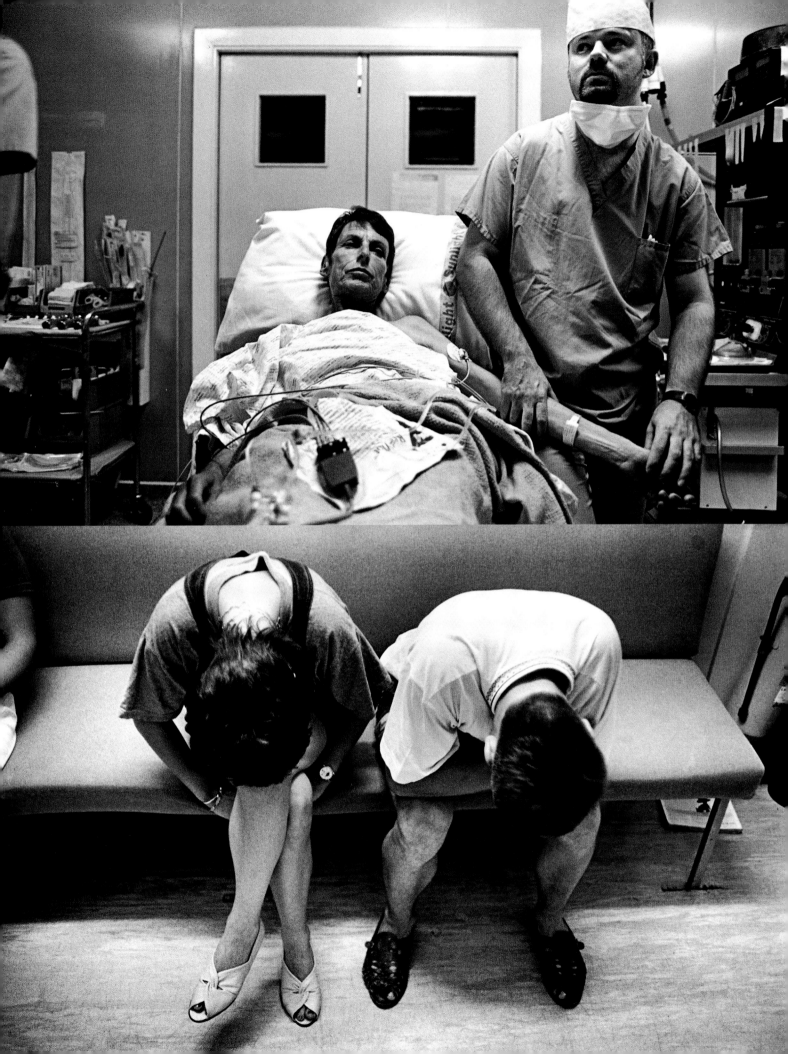

If you have to be pregnant in a deprived corner of London, Deptford is definitely the place to be. 'The Deptford Wives' are a group of community midwives – five of them in a practice – who don't think twice about taking a birthing pool into the lift of a tower block, or sharing a glass of champagne with a jubilant mother in hospital. They have a remit to work primarily with the disadvantaged, with ethnic minorities, and women at risk.

Maxine has just given birth to her third baby in a temporary bathing pool in her living room. Maxine is blind and living on benefits.

Mother and child.

Birth

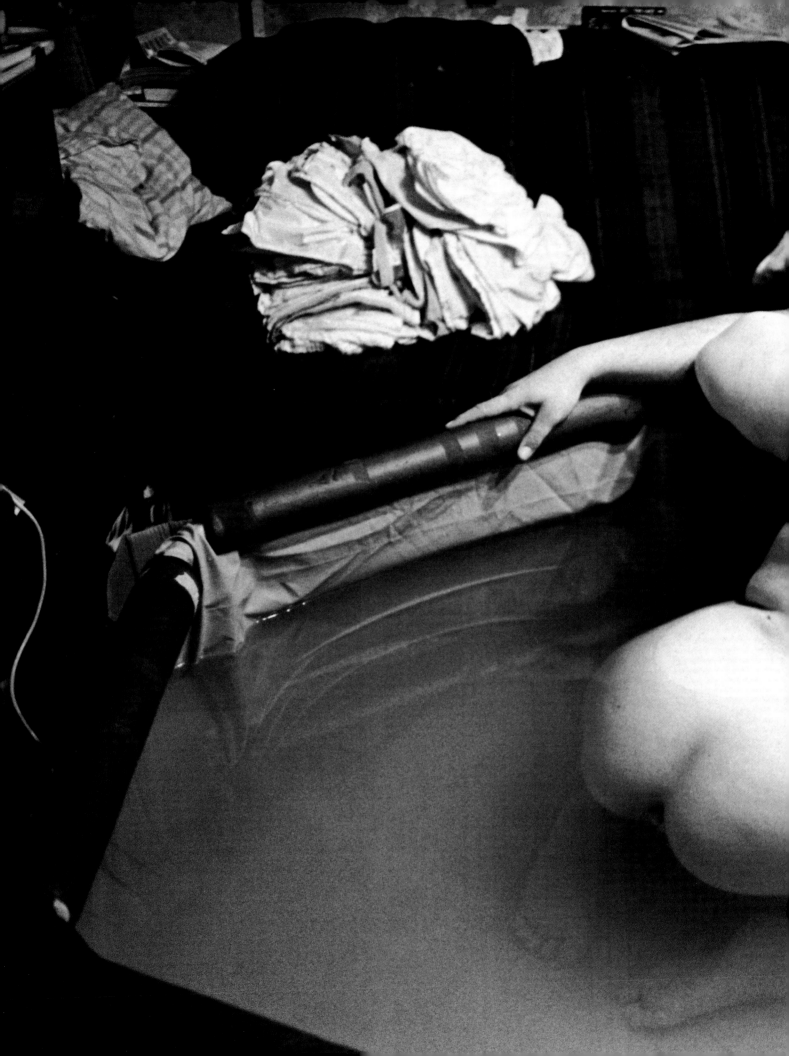

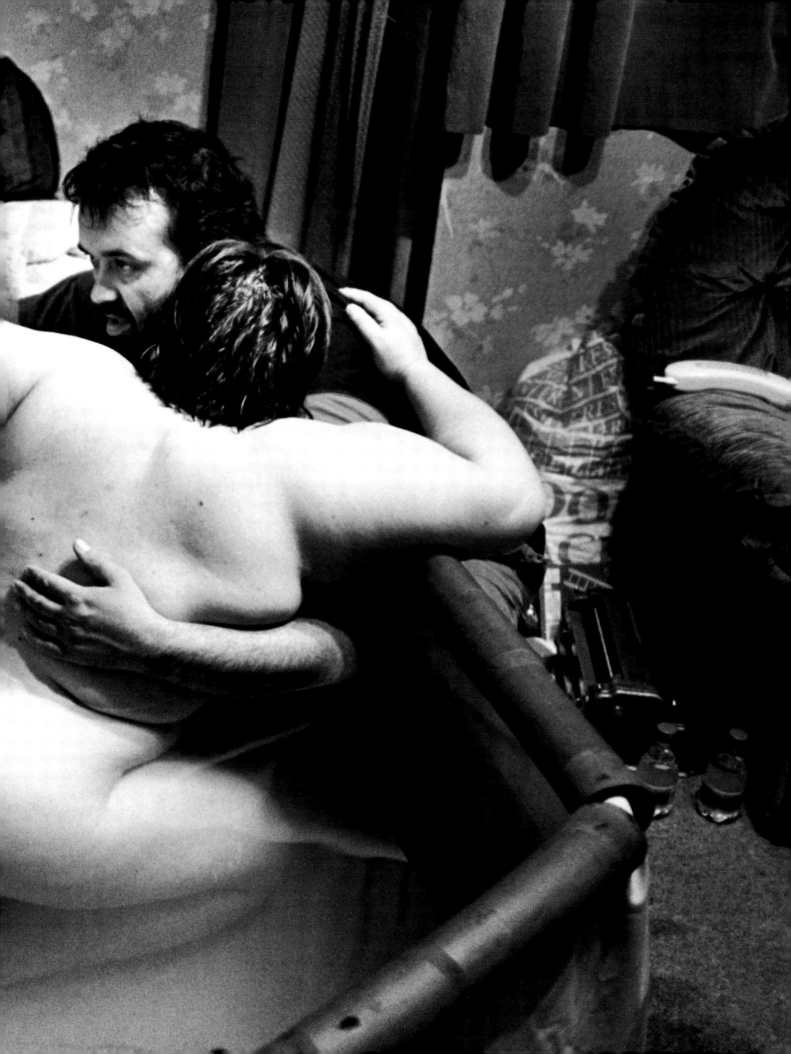

Car boot sale, Penrhys,
South Wales.

.

Bus stop, Victoria
Station, London.

.

Tag artists, Leicester.

.

Mother and child,
Knowsley.

.

Neighbours – the
television as the
modern babysitter,
South Wales.

.

Keith, Pennywell,
Sunderland.

Sarah, Tiger Bay,
Cardiff.

.

Salford.

.

Dog chasing a Frisbee,
Leiston, Suffolk.

.

Women's Institute,
Launceston, Cornwall.

Liverpudlians on a bus
taking them to the
annual Orange March,
in Stockport.

Quranic school,
Glodwick, Oldham.

Pub, Tiger Bay, Cardiff.

.

Pleasure Beach,
Blackpool.

.

Bradford Police
Station, nicknamed
'Fort Apache' by the
local youth.

.

Bigg Market,
Newcastle.

.

Queuing at a social
club, Blackpool.

Britain

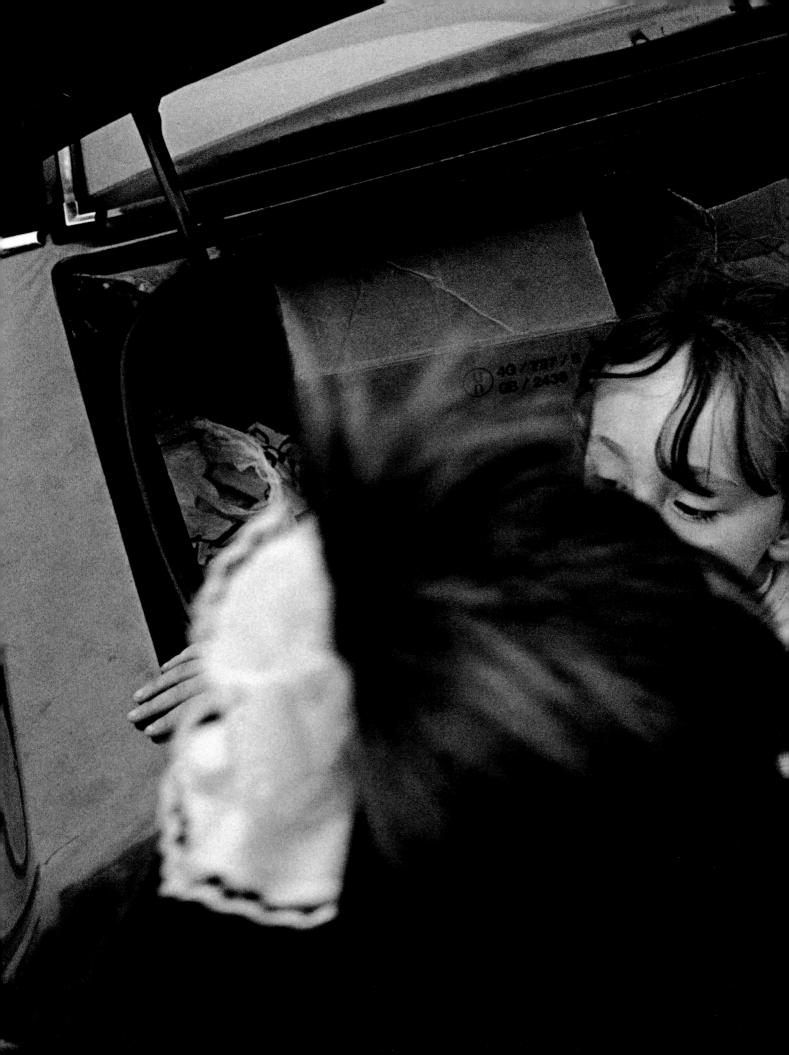

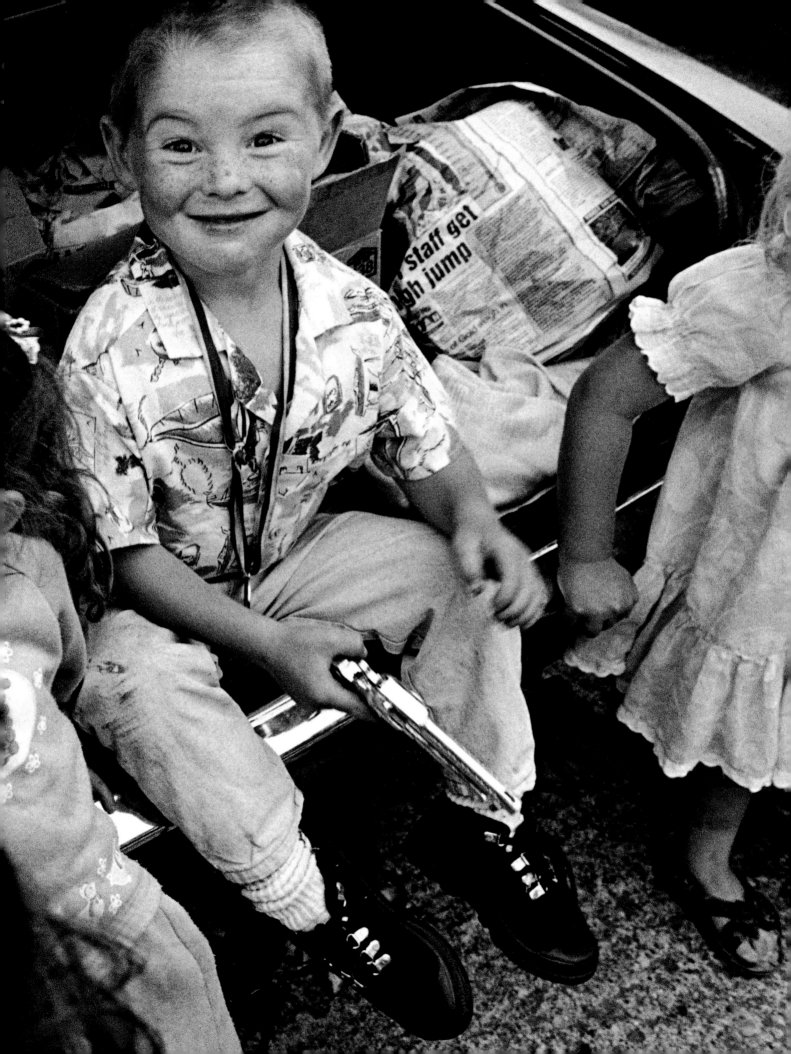

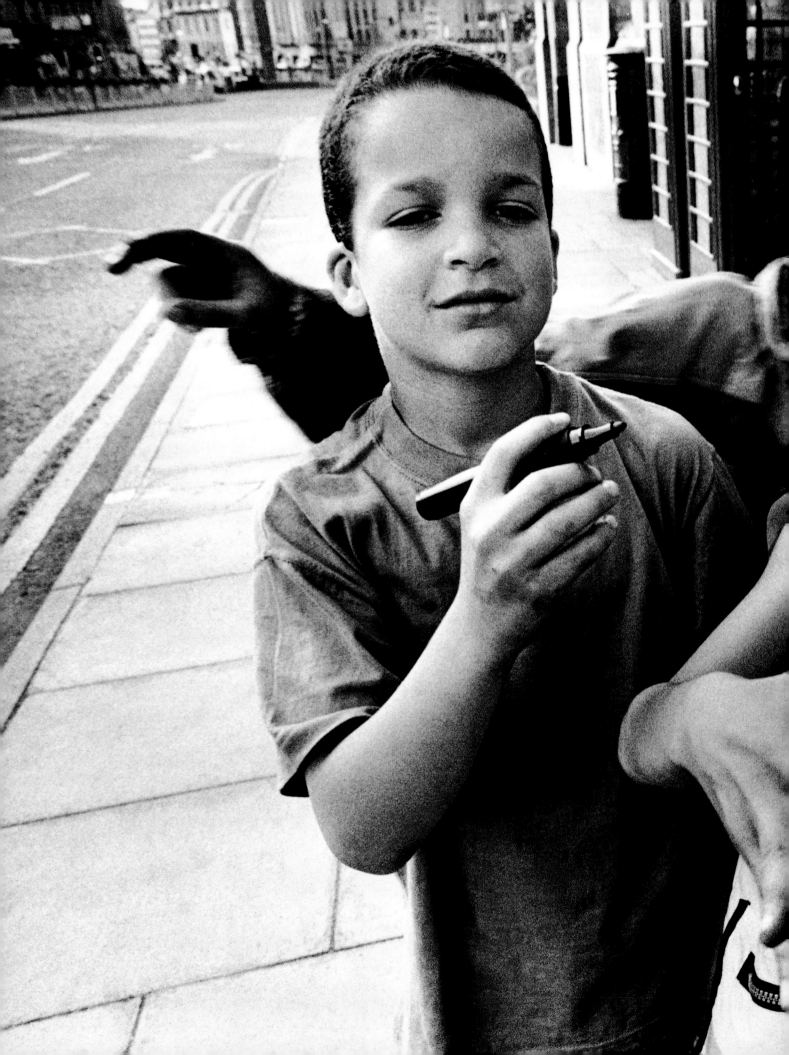

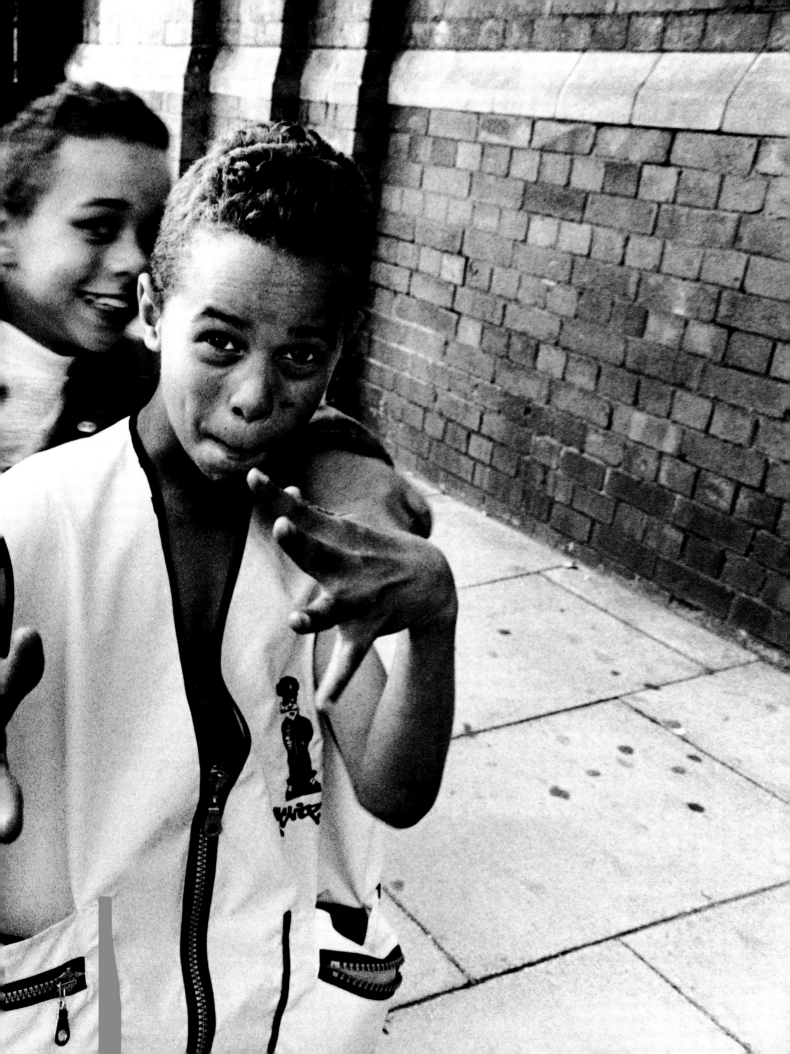

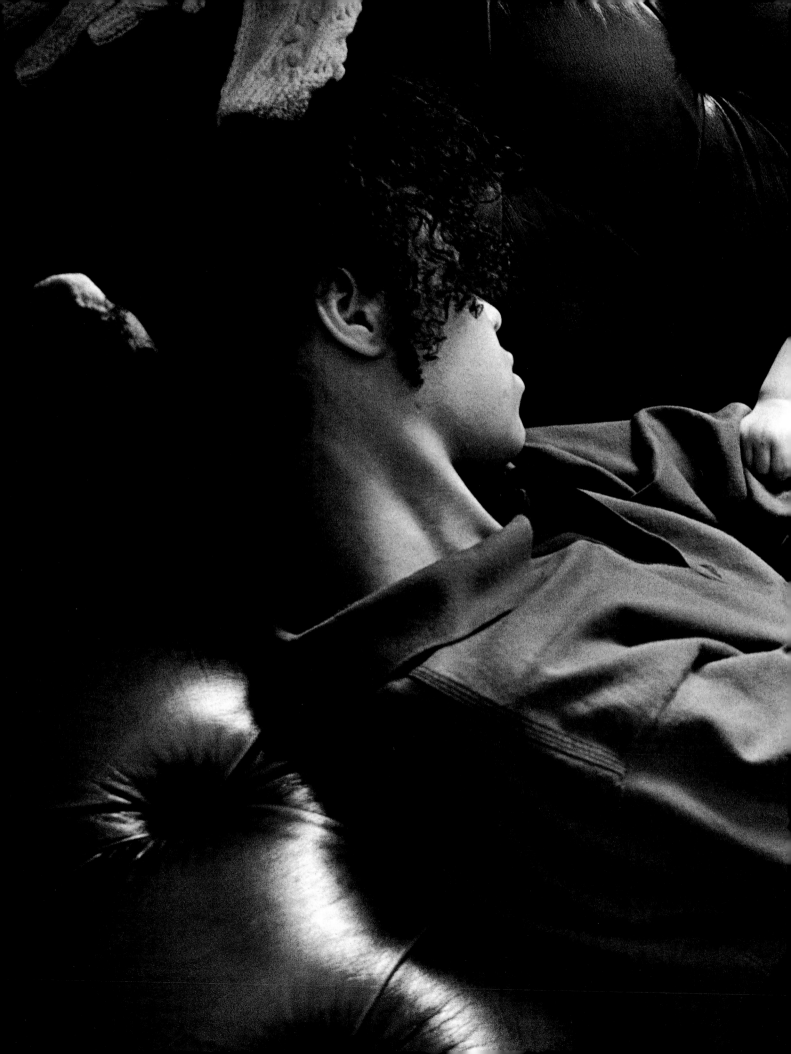

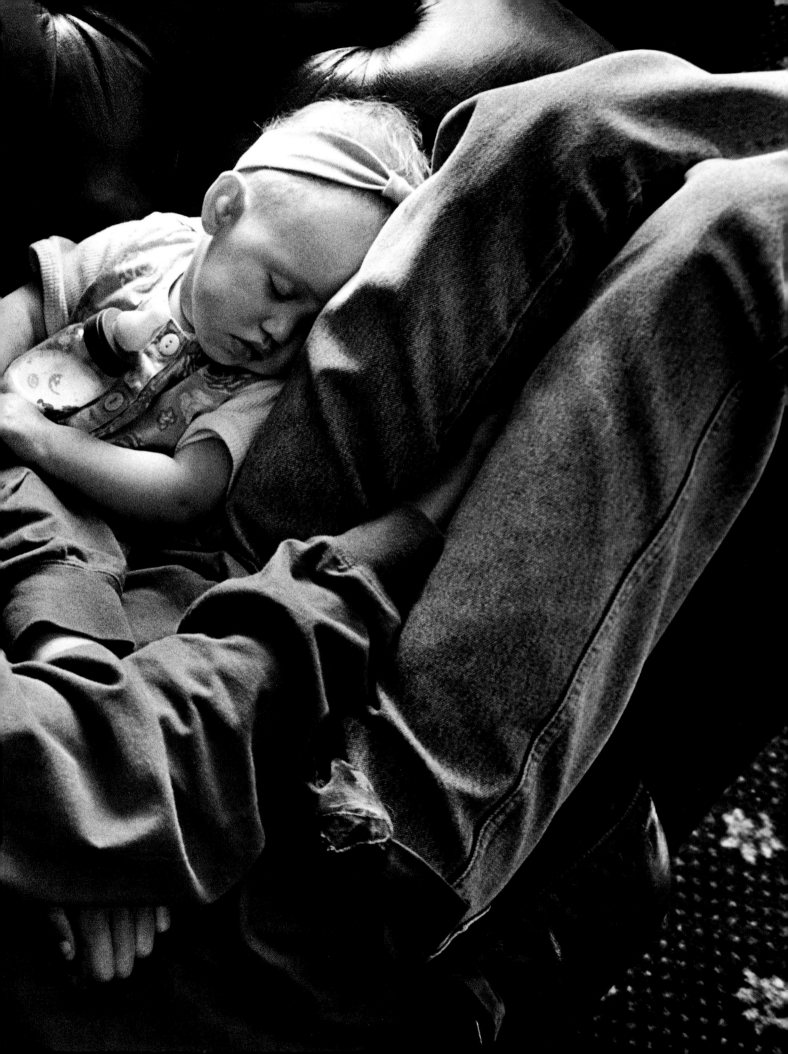

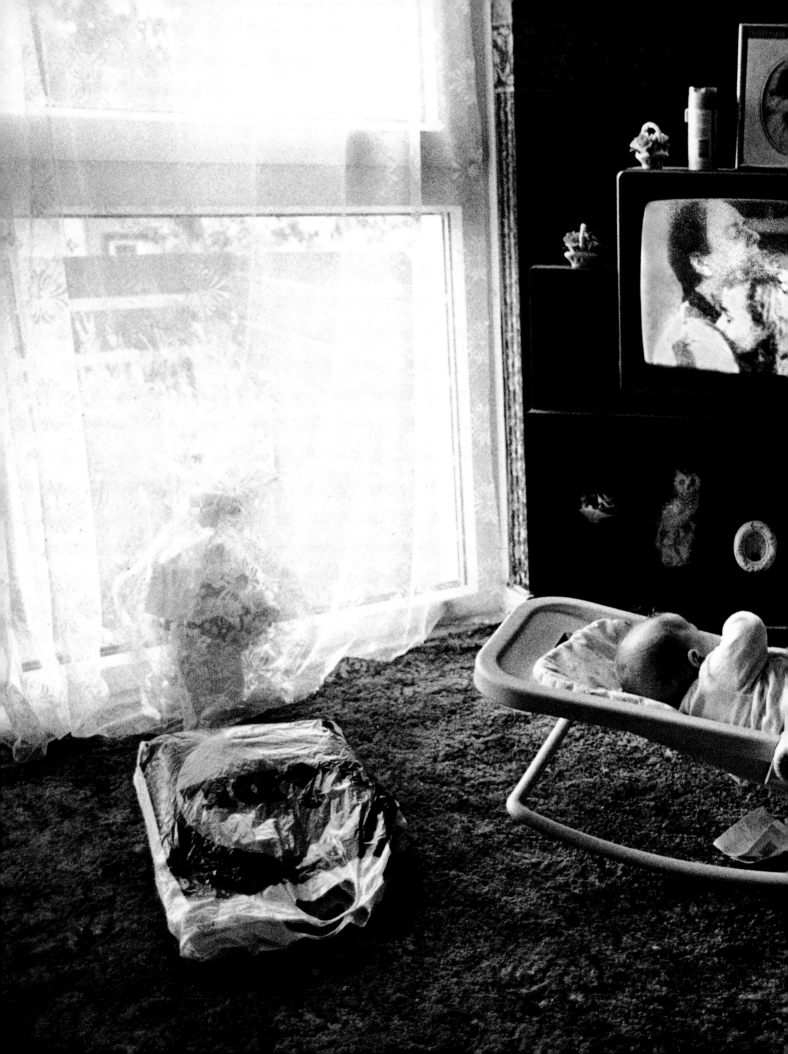

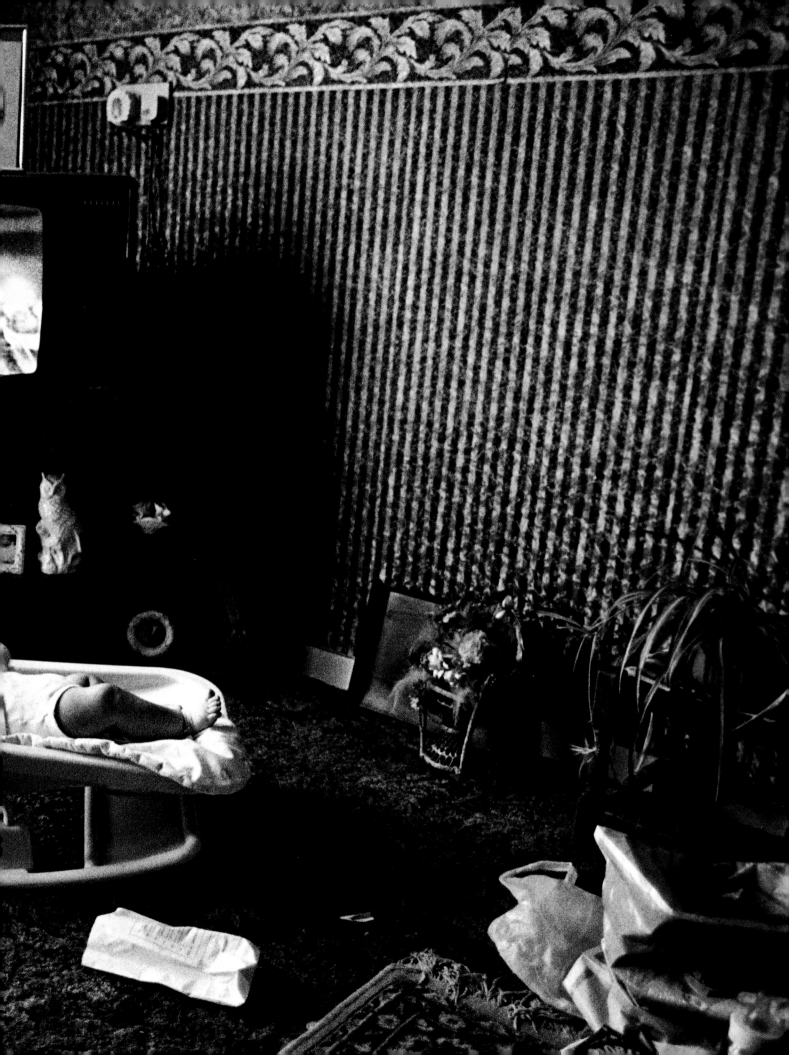

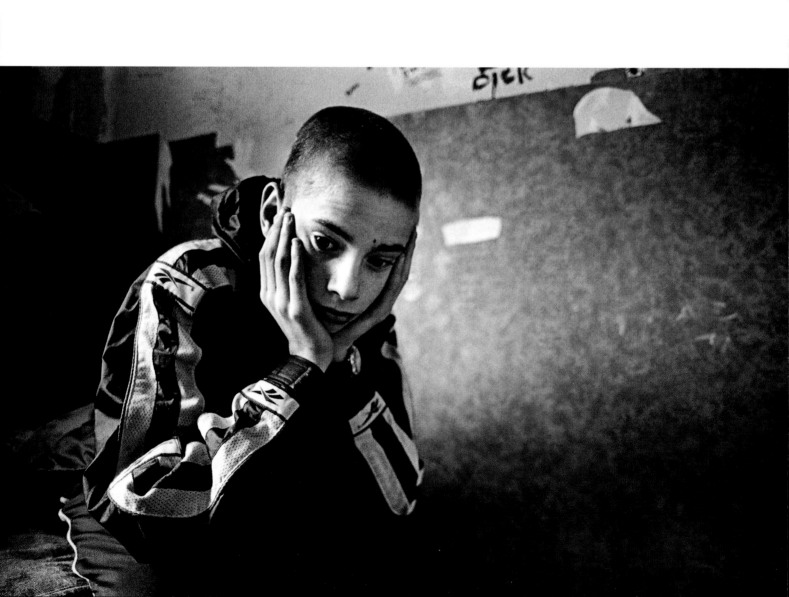

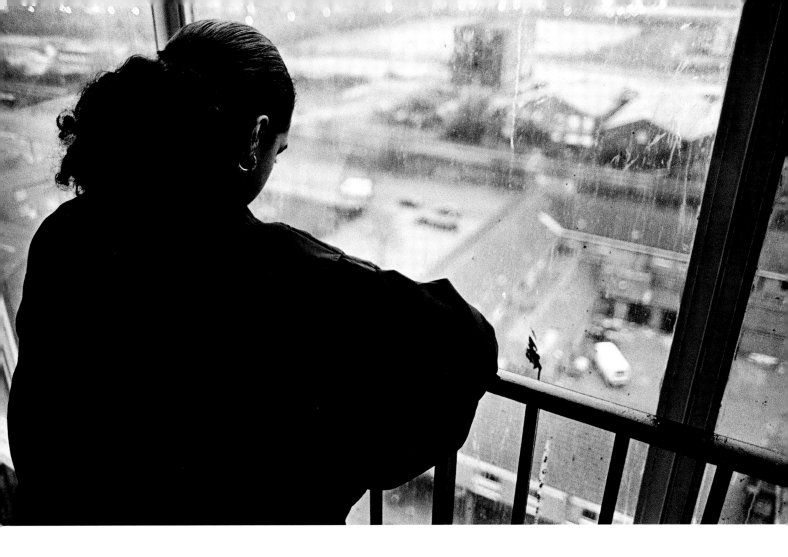

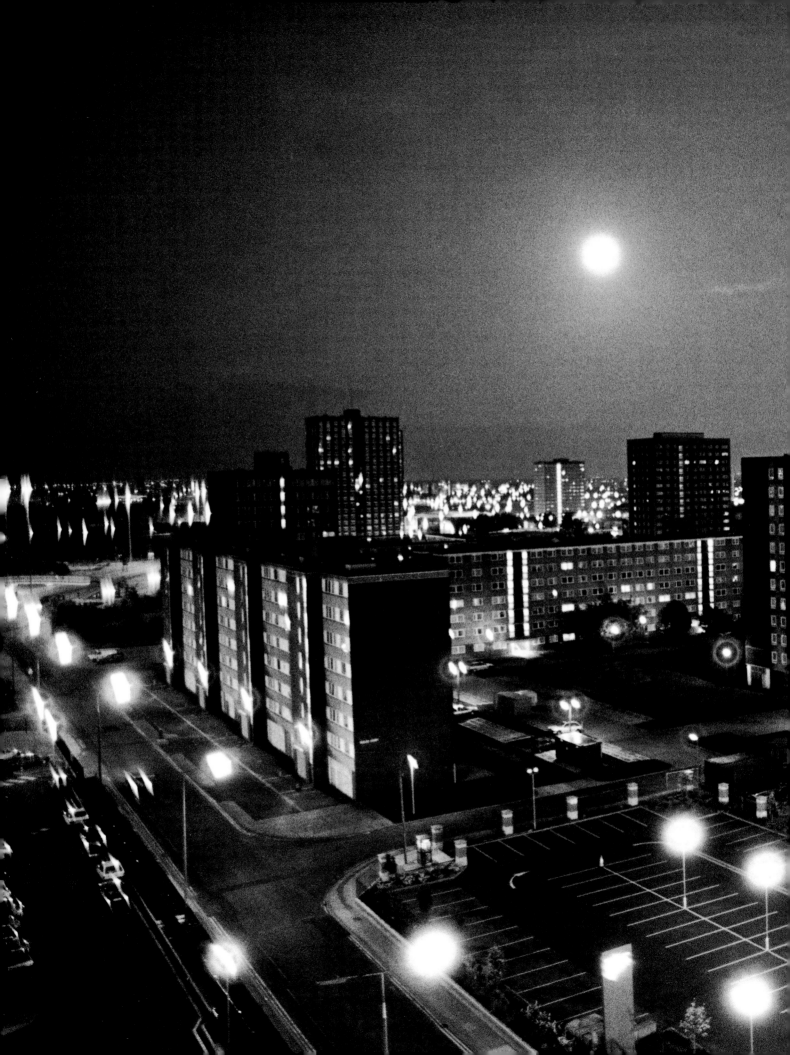

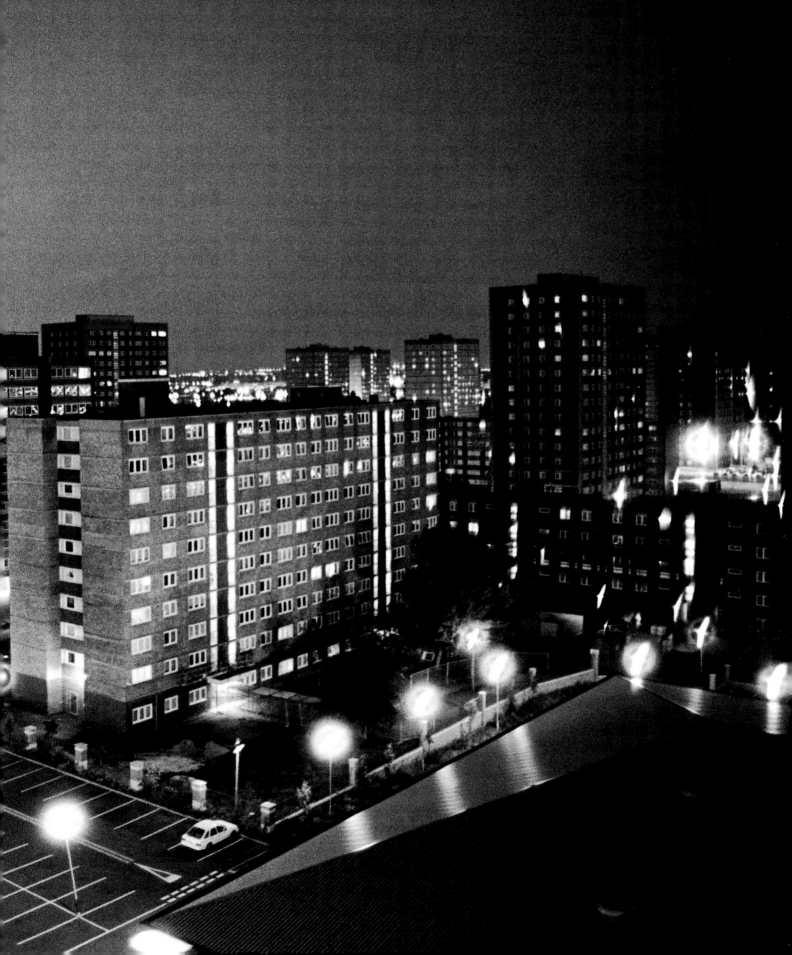

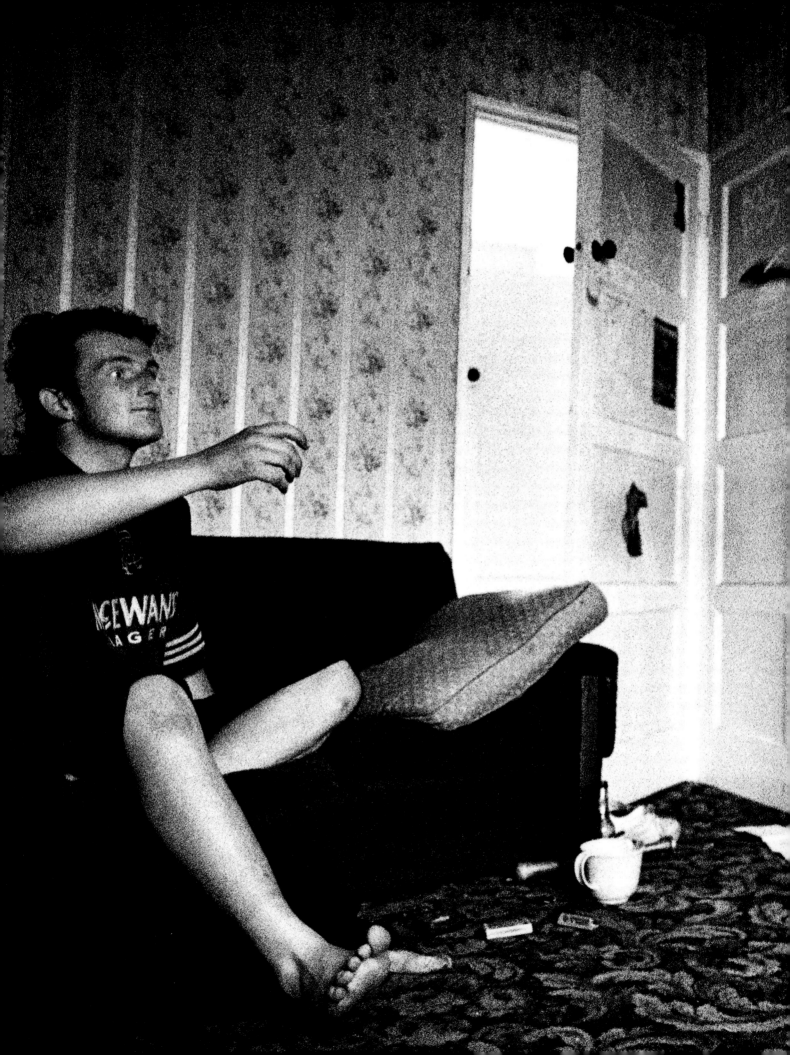

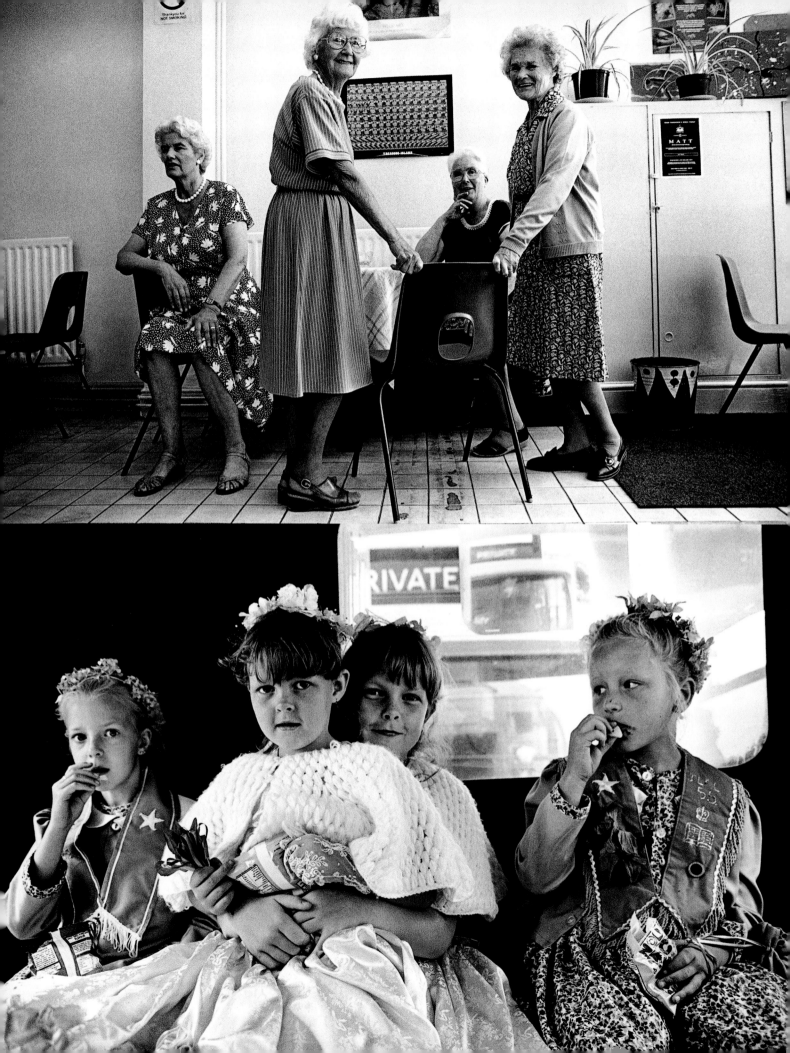

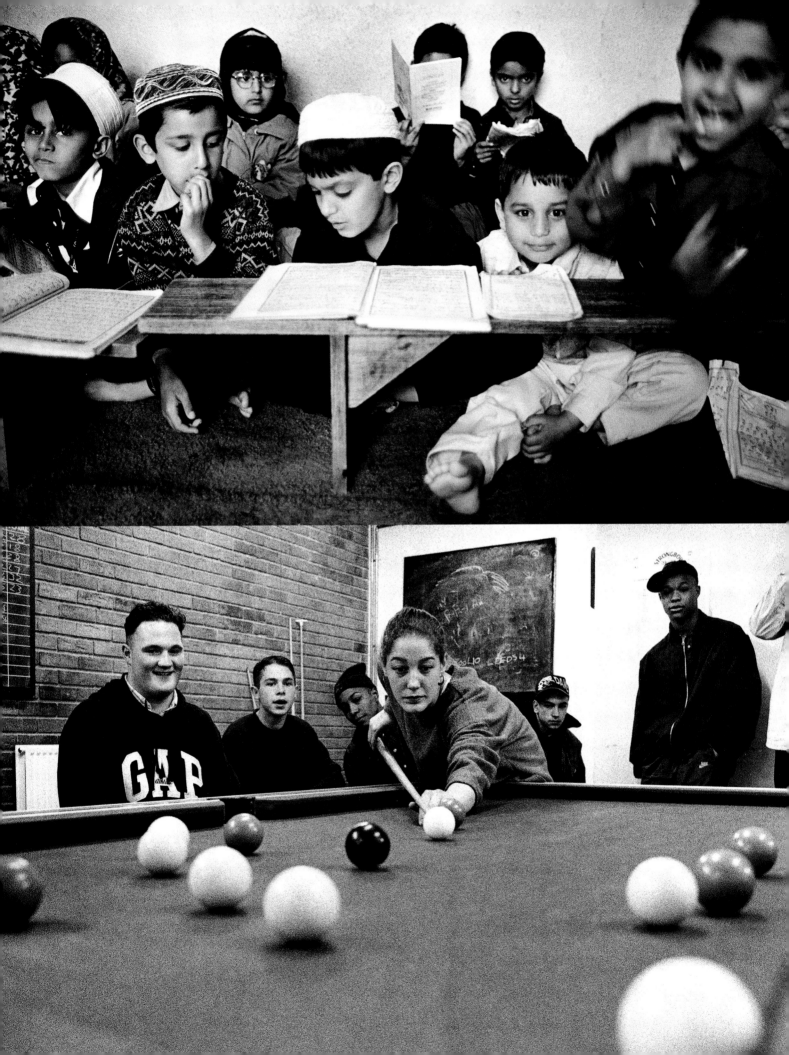

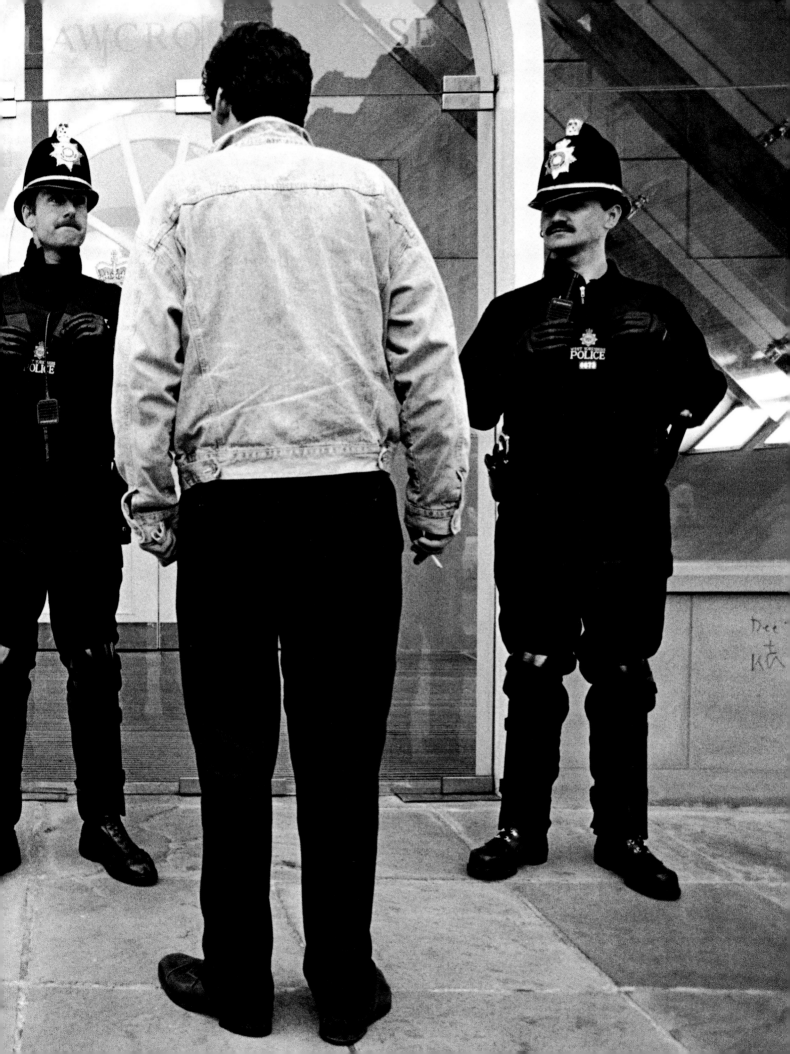

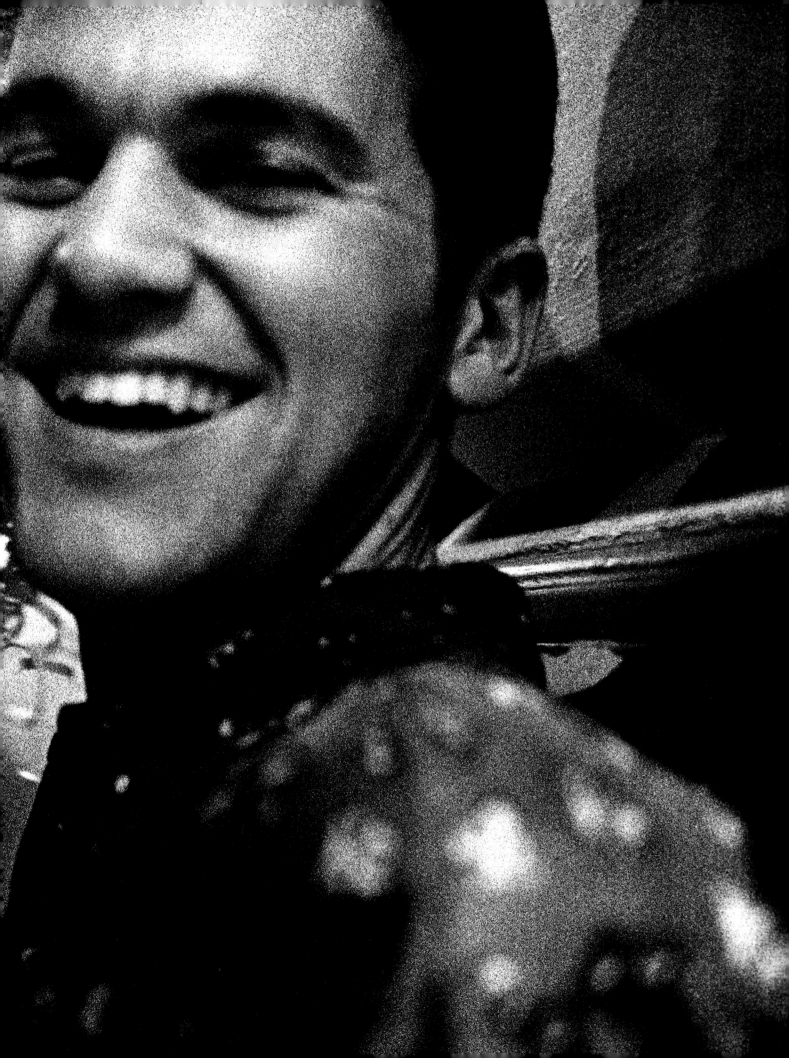

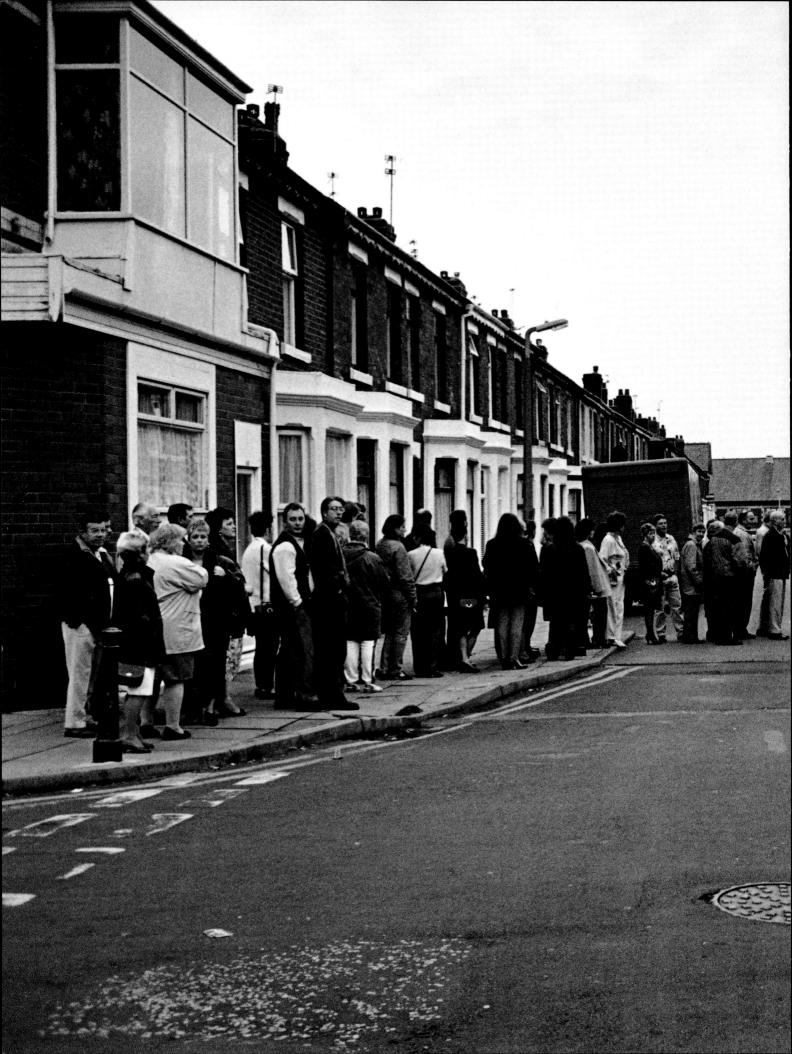

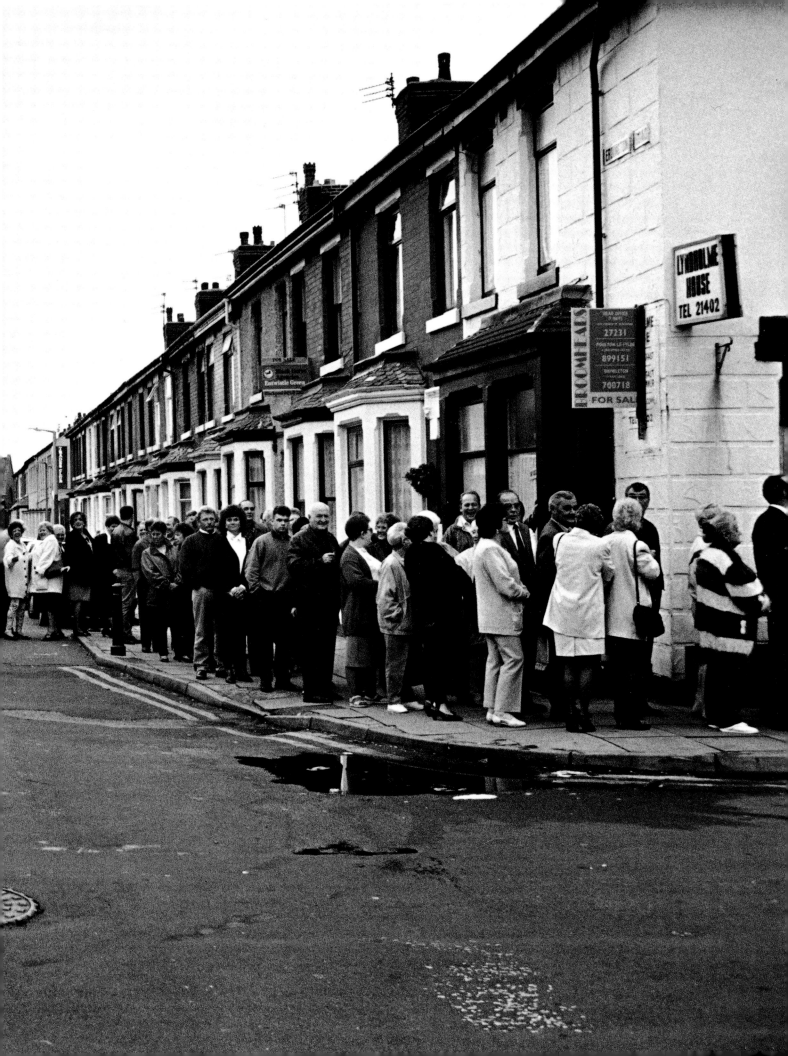

When I arrived in the county of Sutherland on Scotland's most northerly ledge, I was told, 'We're Europe's Third World country.' The Highlanders still talk of the forceable clearances that took place two centuries ago, when tenants of small farms impeded the landowners' conversion from crofting to sheep farming and deer raising. Some families had their houses burned, or were chased out of the glen and moved to infertile land on the coast.

Skerray's village elders have vivid recollections of how it used to be. 'The straths [glens] were hoachin [busy with people]. Cries echoed all around the hills as the shepherds called to their dogs. We used to carry the hay on our backs or on our heads and then climb up home. It was so tiring. You could hear the garron [small, sturdy horses used to bring back the peat] running free at night. They kept us awake. It was so bonnie before. Just existing here was a real undertaking.'

Most of Skerray's inhabitants once belonged to the Free Presbyterians, whose ministers in the past denounced Cliff Richard, among many others, for leading the young astray. It was said the village chickens had once not dared to cluck on a Sunday – song and dance were banned, and you had to travel just over two hours by foot to Tongue, the nearest town, to find moderates.

Skerray. The village has changed dramatically over the years. There were once over six hundred people living here, together with schools, bus service, shops and a ferry that delivered supplies, but all that has long since gone. The community now numbers sixty, and only twelve are descendants of the original families.

Skerray

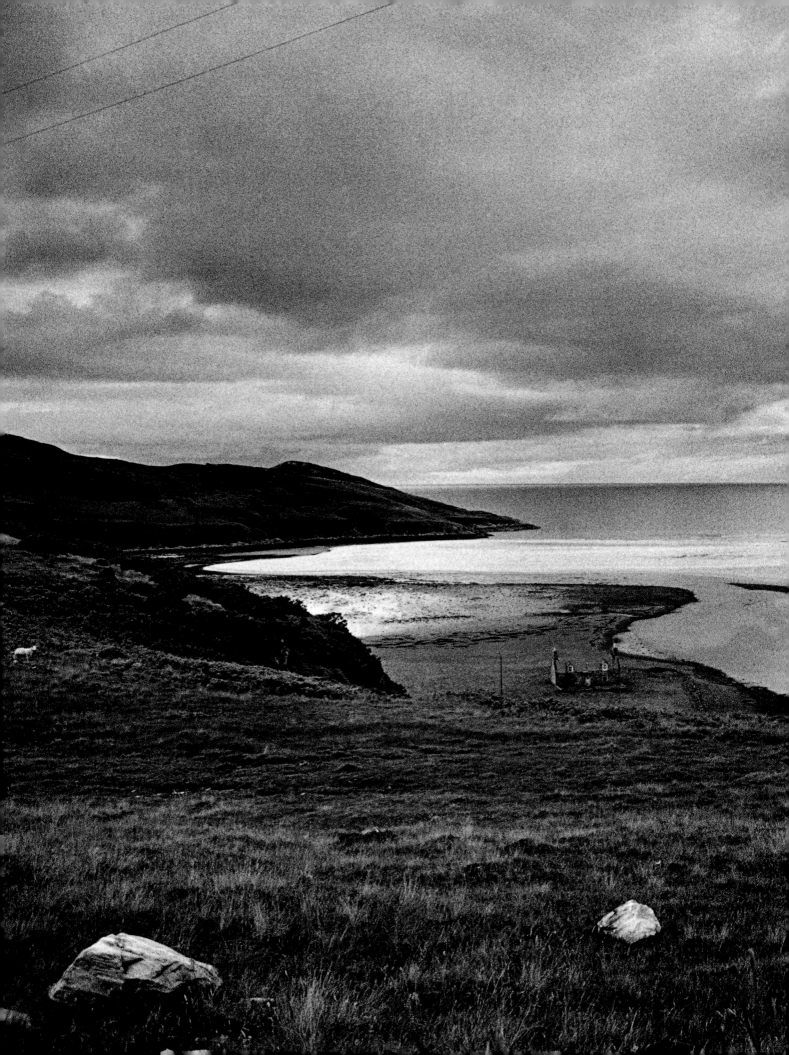

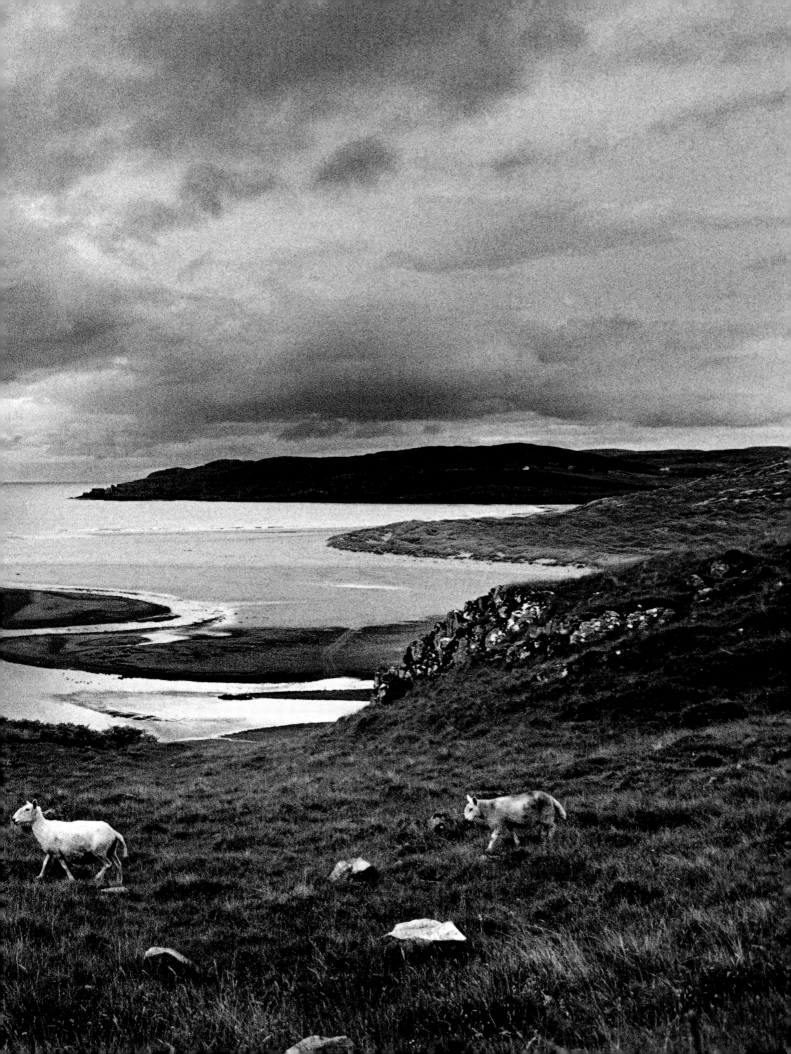

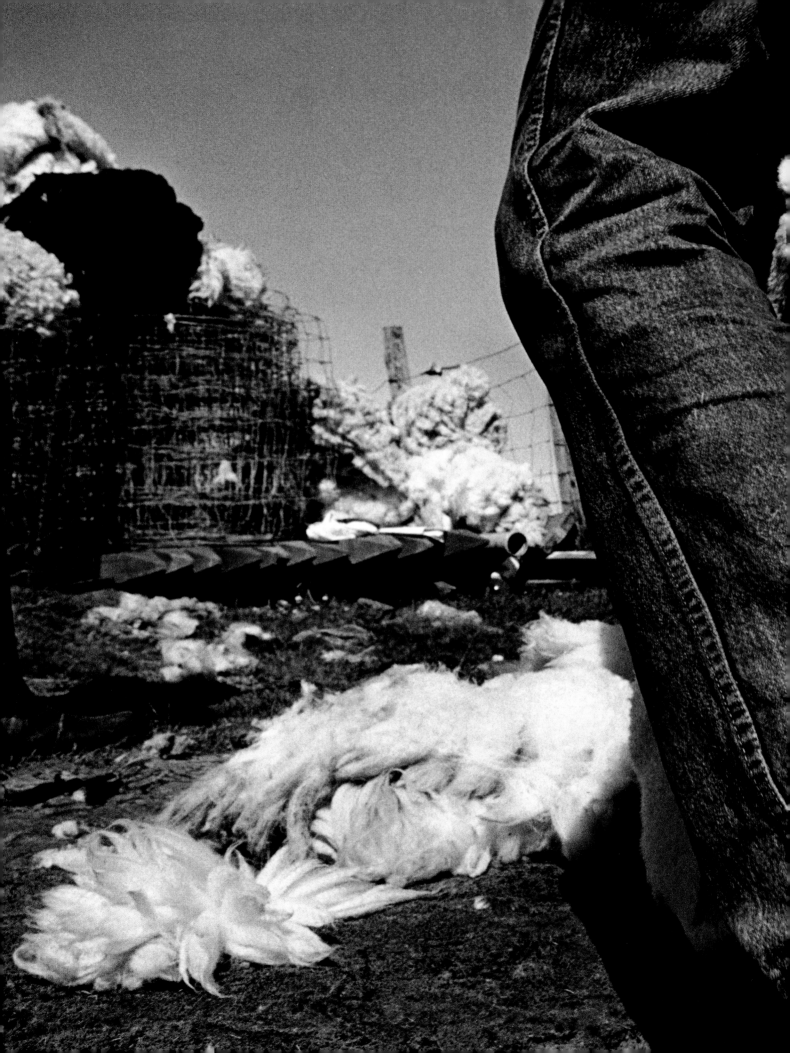

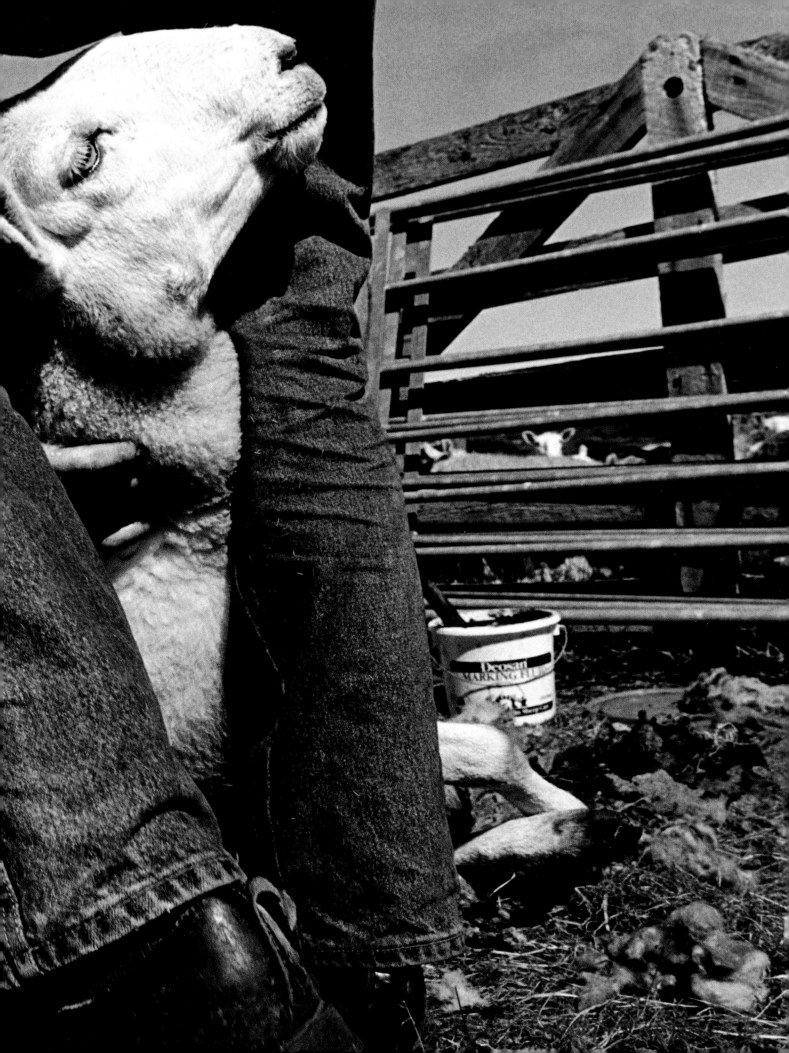

The first time I was in Belfast was during the 'Troubles' in 1987. Many of these same streets were blocked by road barriers, some of them checkpoints manned by the RUC, backed by the army in full battle gear. However, since the Provisional IRA announced a 'complete cessation of military operations' in August 1994 and the Loyalist paramilitaries did the same six weeks later, much has changed. The streets are now busy and vibrant after dark, no longer deserted but for amnesiac drunkards and the hopelessly forlorn and vulnerable. Not everything has changed for the better. For some, the ceasefire has brought with it new problems, problems that had been held at bay while there'd been warfare.

The Peace Wall cuts across roads and through housing estates, dissecting the almost 100 per cent Protestant Spring-martin area from the predominantly Catholic area of Springfield: not tall enough for some Catholics, too tall for the Protestants.

With nothing else to do, these children spend their holidays jumping off the roof of a derelict house. One of the older boys asked me, 'What religion are you?', his expression at once questioning and threatening. 'Atheist,' I answered. 'Is that Catholic atheist or Protestant atheist?'

Foot patrols are just part of the Army presence in west Belfast. They are backed up by armoured Land Rovers and surveillance helicopters. In these communities, as elsewhere in the world, the enemy is no longer on the other side of a battle line – he is right behind you.

Some of the more fortunate children from the Catholic and Protestant communities have been on holidays together to Austria, Germany and the United States. The parents didn't set much store by them: 'What's the point when they have got to be sent back to this shite?' What they didn't know was that their children had remained in contact with kids from the other religious community by letter and telephone after their return. When they could meet they would do so in the centre of Belfast, which was considered neutral ground.

British soldiers during their tour of duty in Belfast are confined to their barracks unless they are on patrol.

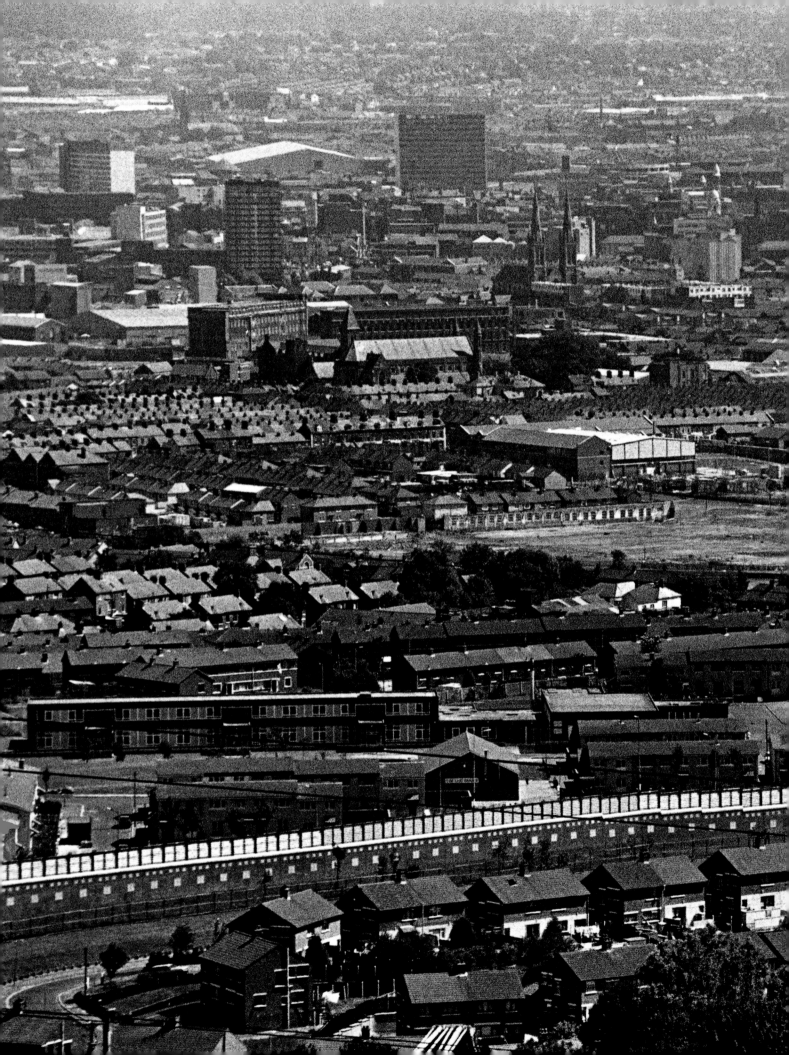

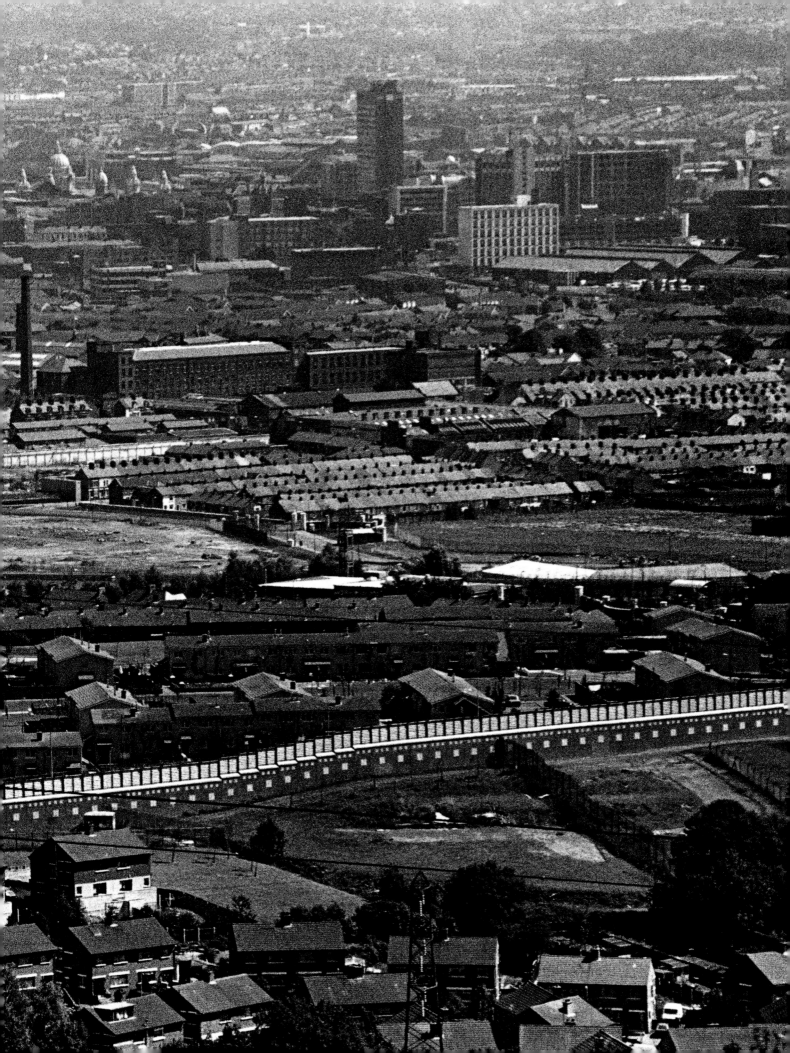

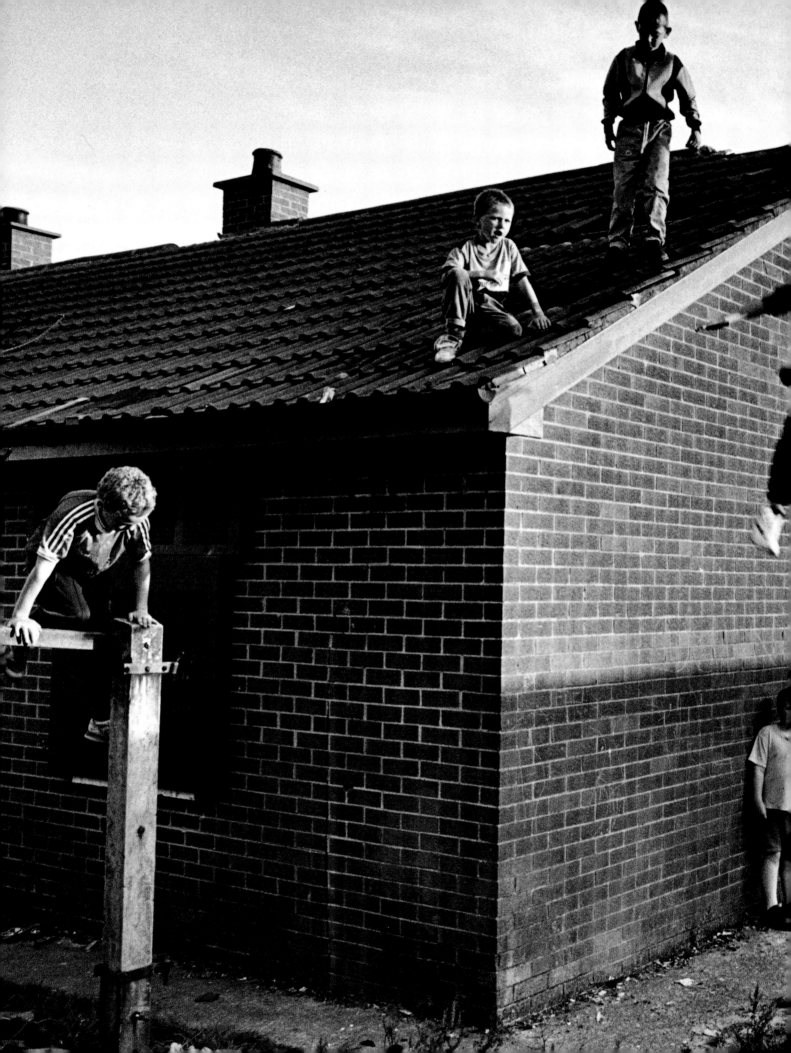

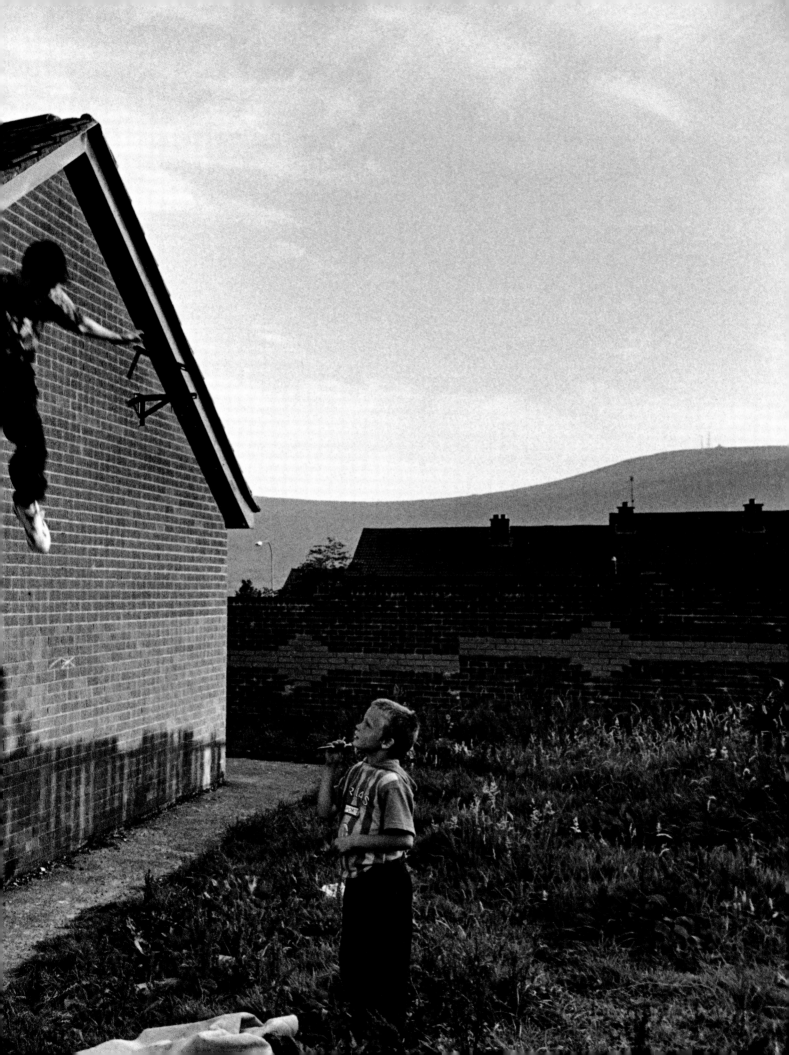

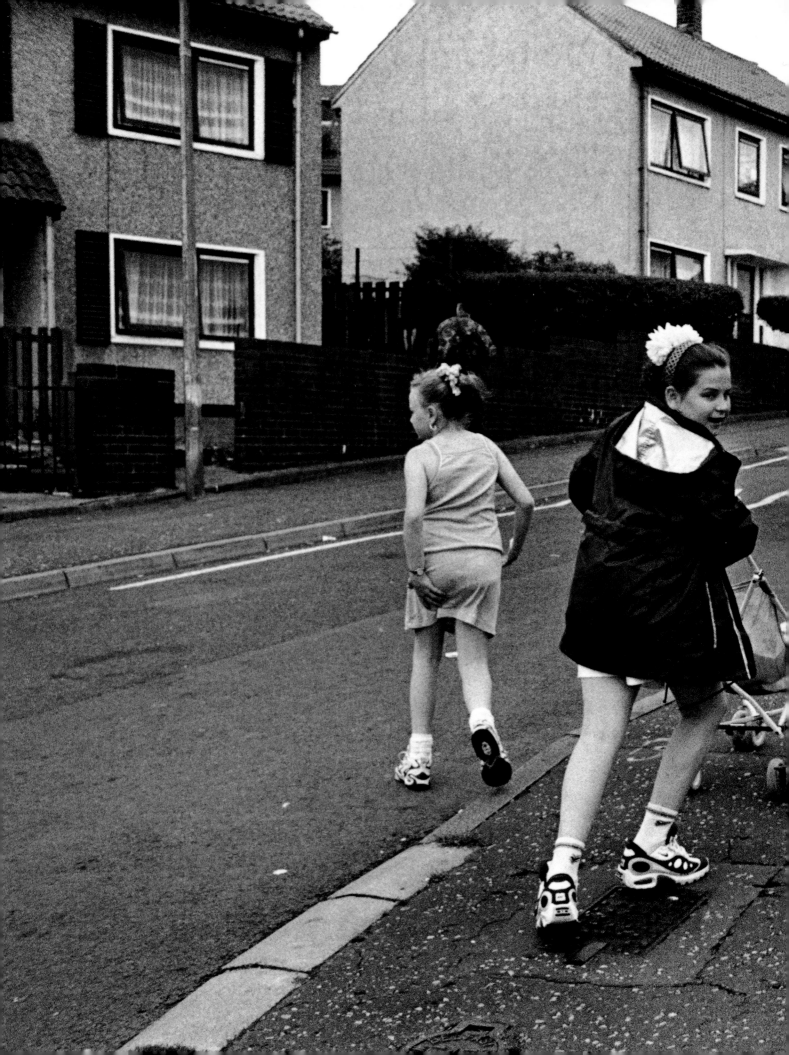

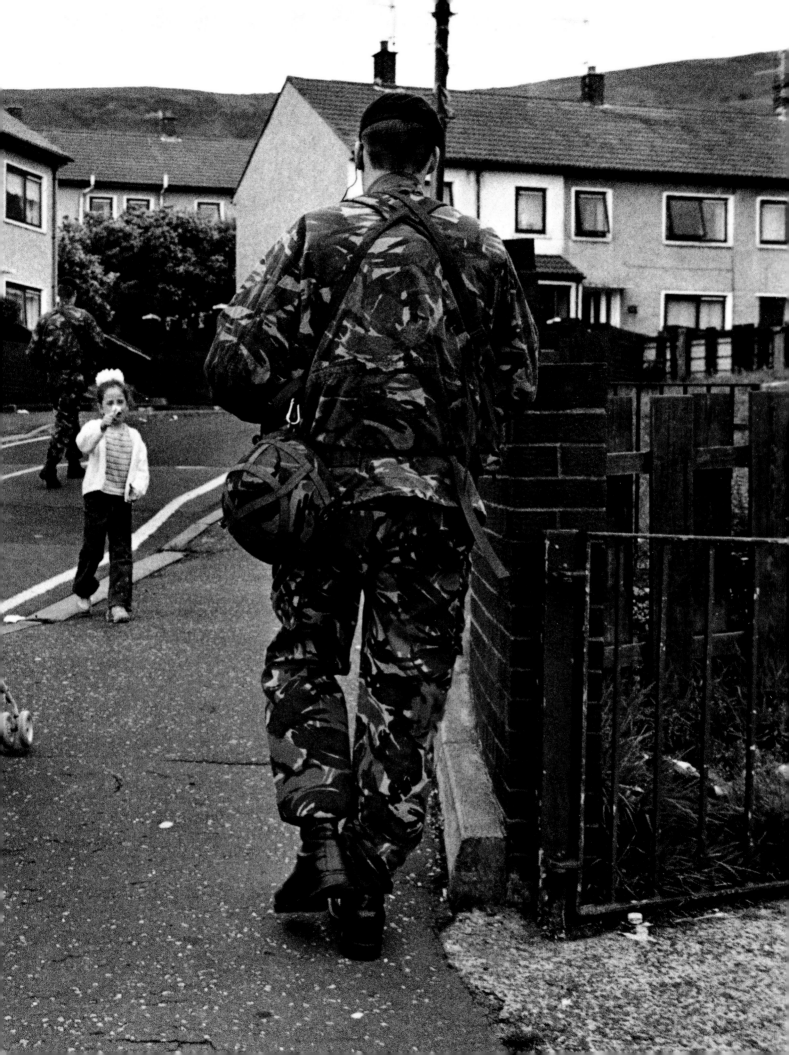

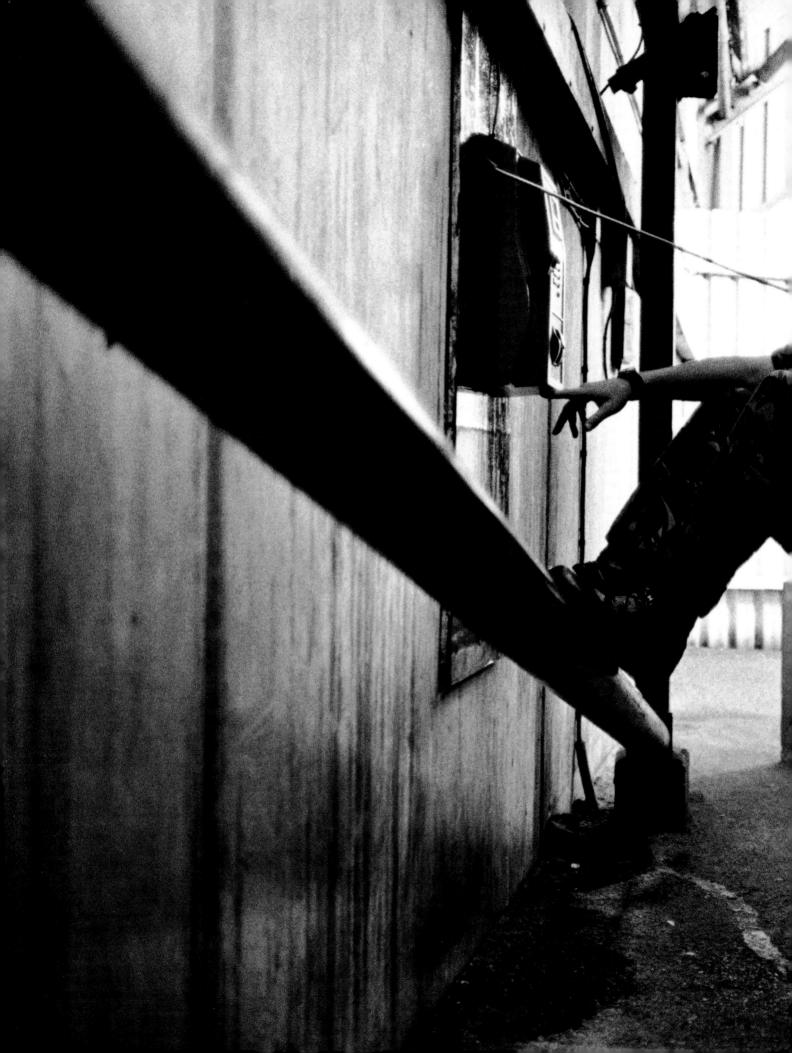

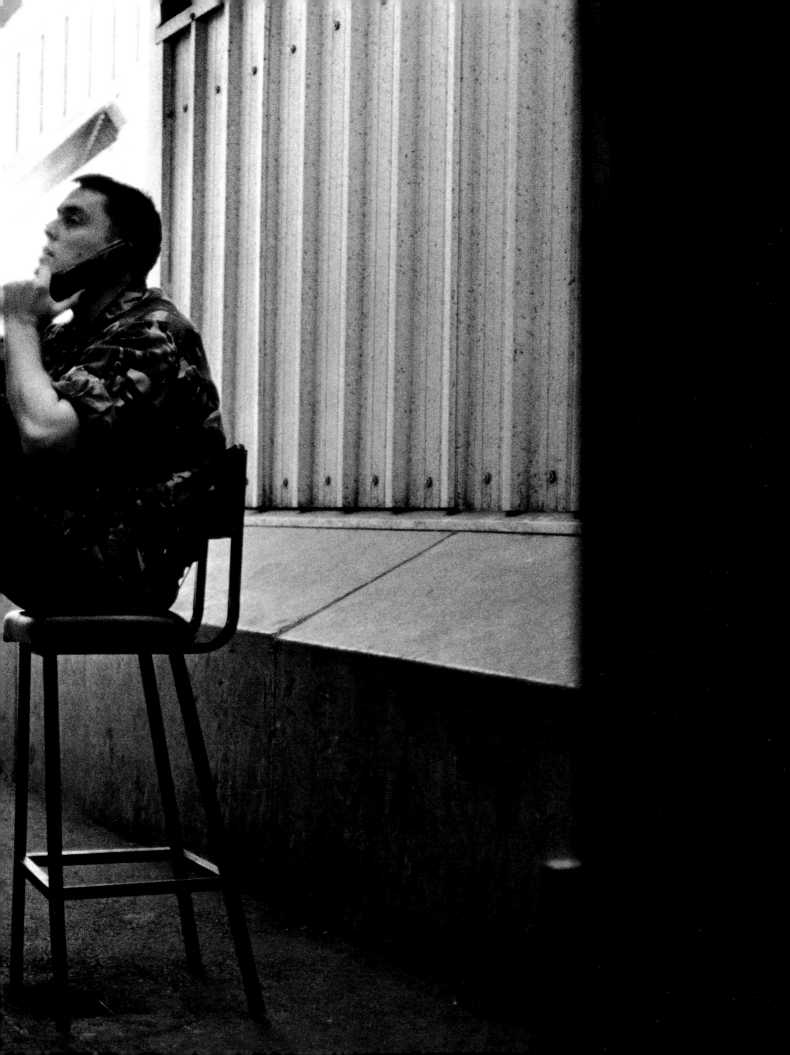

This is the story of the consequences of a lifetime in care, a lifetime without parental love and guidance – a young man without anyone in the world.

Anthony has difficulty reading and writing, but treasures anything that relates to his family and which may eventually help him understand why he was abandoned. 'I suppose it's the loneliness what gets to you really. You know, no one there – no friends, no family, no nothing, you know. Why am I here sort of thing.'

'It's been hard, Anthony. I've a photo of you three together, and it's not being disrespectful of you, you're on t'end, and I bent it over because it upset me that much I couldn't look at that photo. And it's the only photo I've got of you. Even now the photograph does upset me because it brings back awful memories of what your dad did to us. I mean I'm not ashamed of the photo.'

'I'm seriously really, really lonely, and it's not nice at all. I think me and the TV are the best company in the world, 'cos it's like it's the only knowledgeist thing I can understand because, you know, I can talk to it but it never argues back, you know what I mean.'

On the run – teenage runaways from care. These children had run away countless times from children's homes: they were refugees on the run from their parents, from school, from care, from bore- dom, from monotony, poverty and reality. The last I heard from them was a message that one of the boys had tried to commit suicide – he tried to hang himself.

Boothtown.

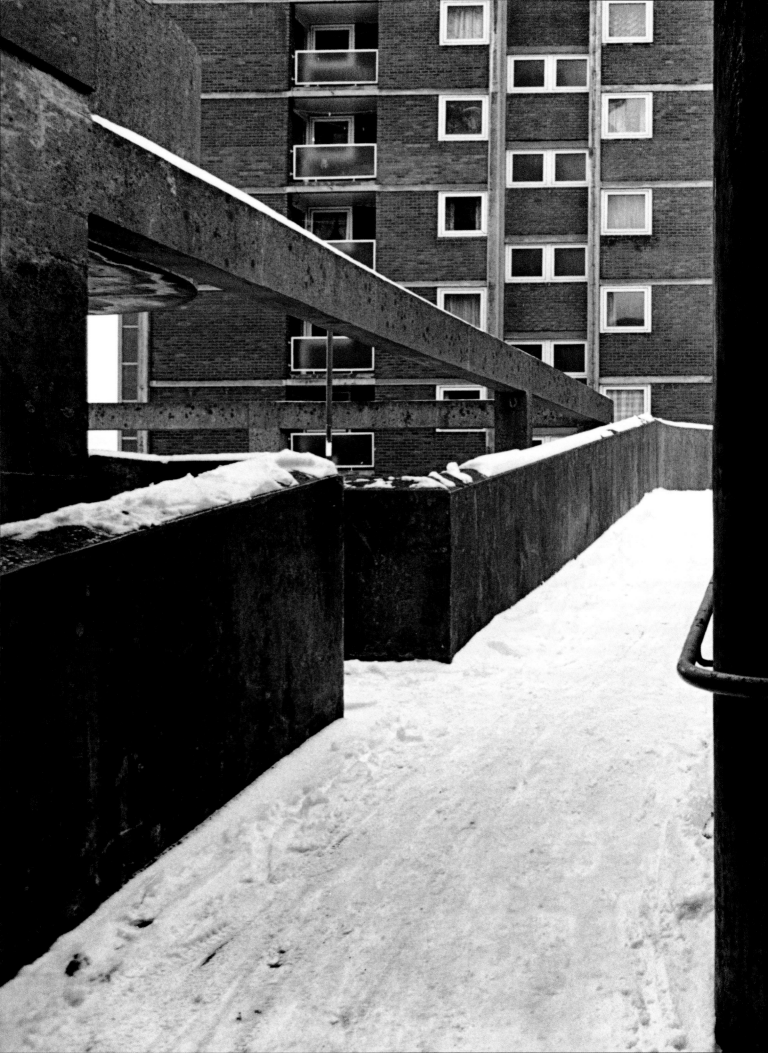

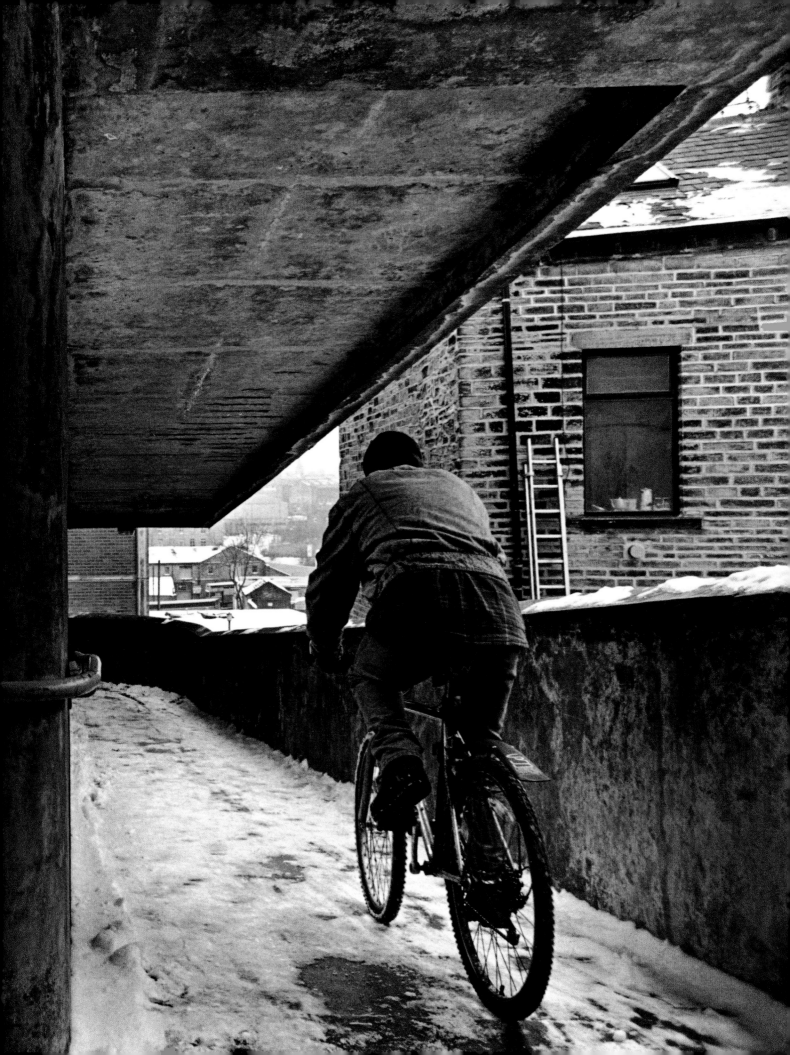

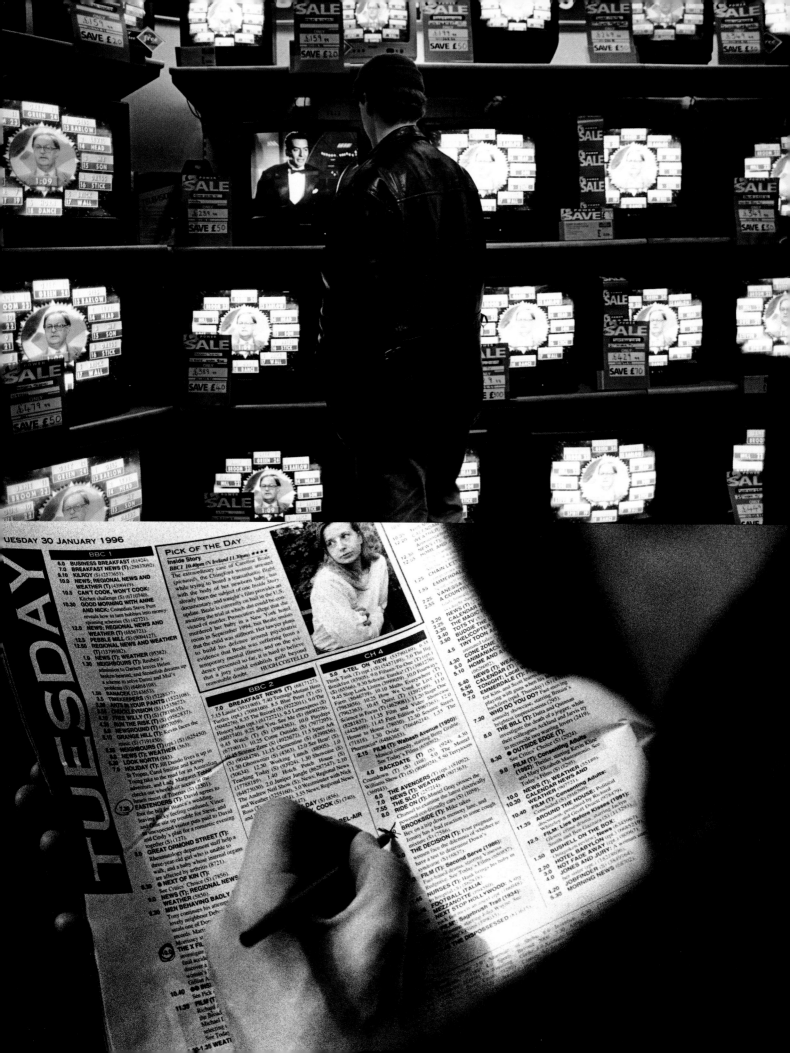

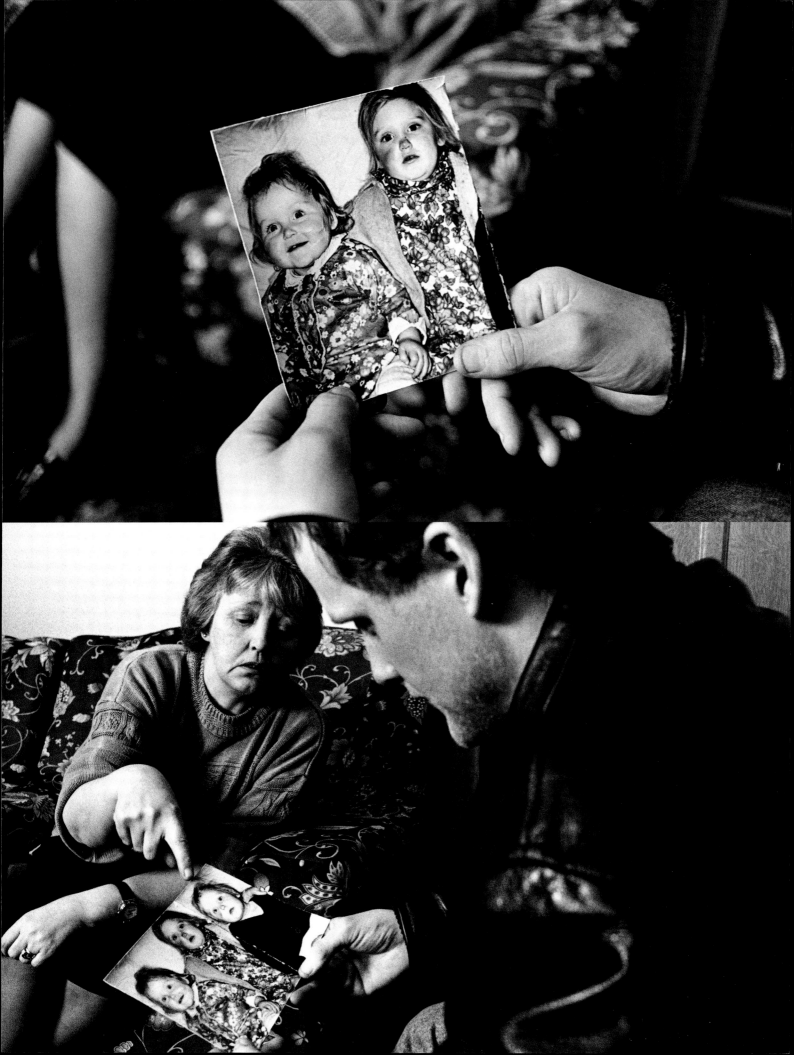

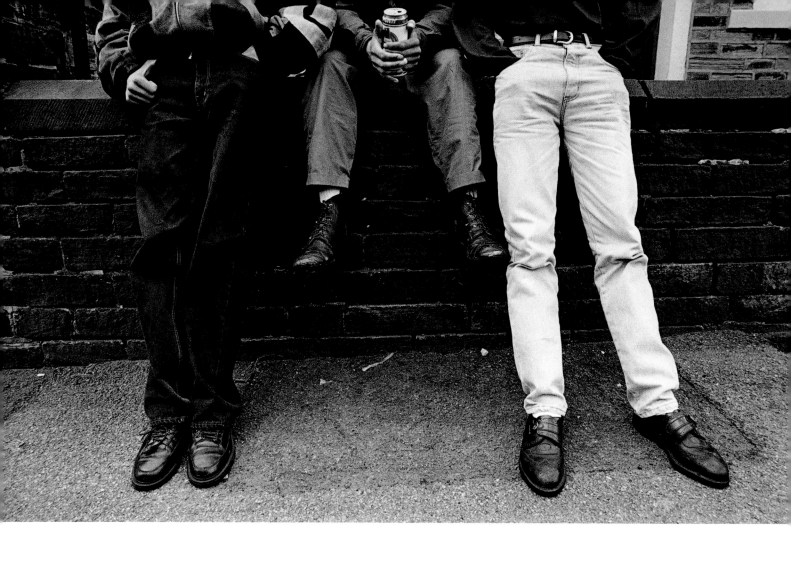

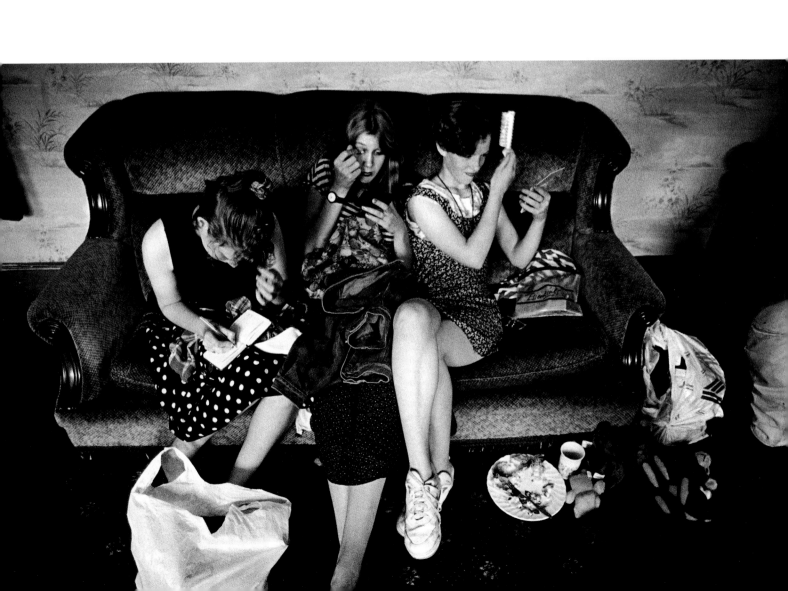

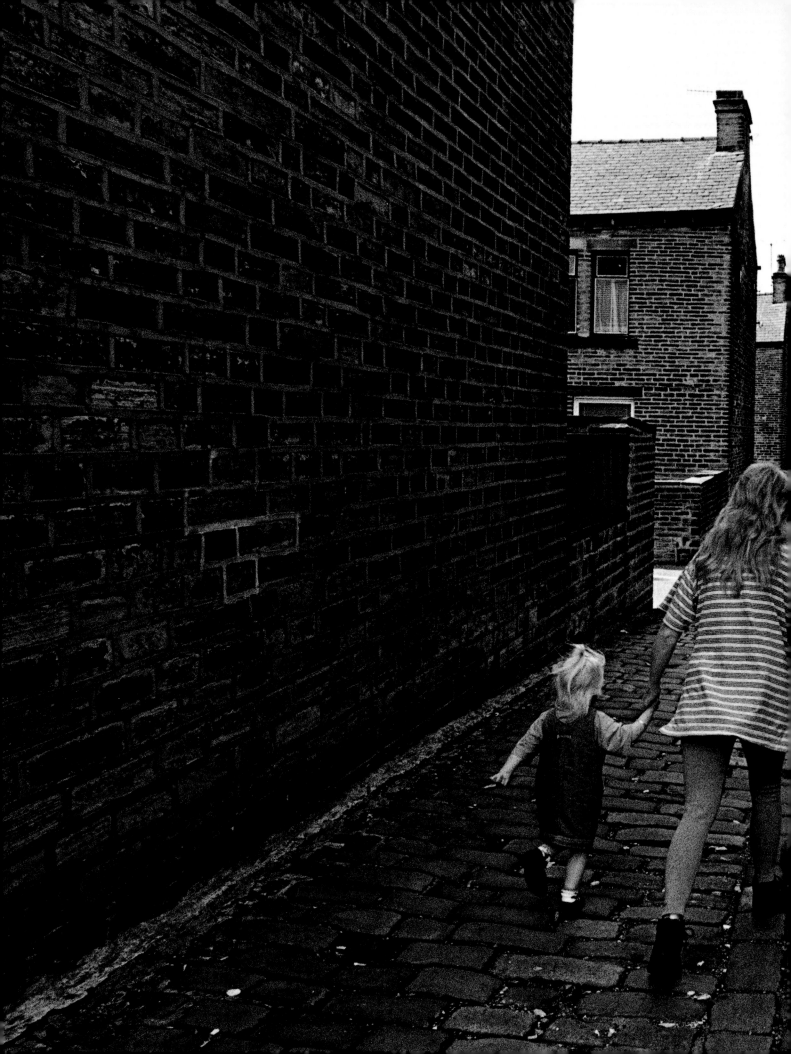

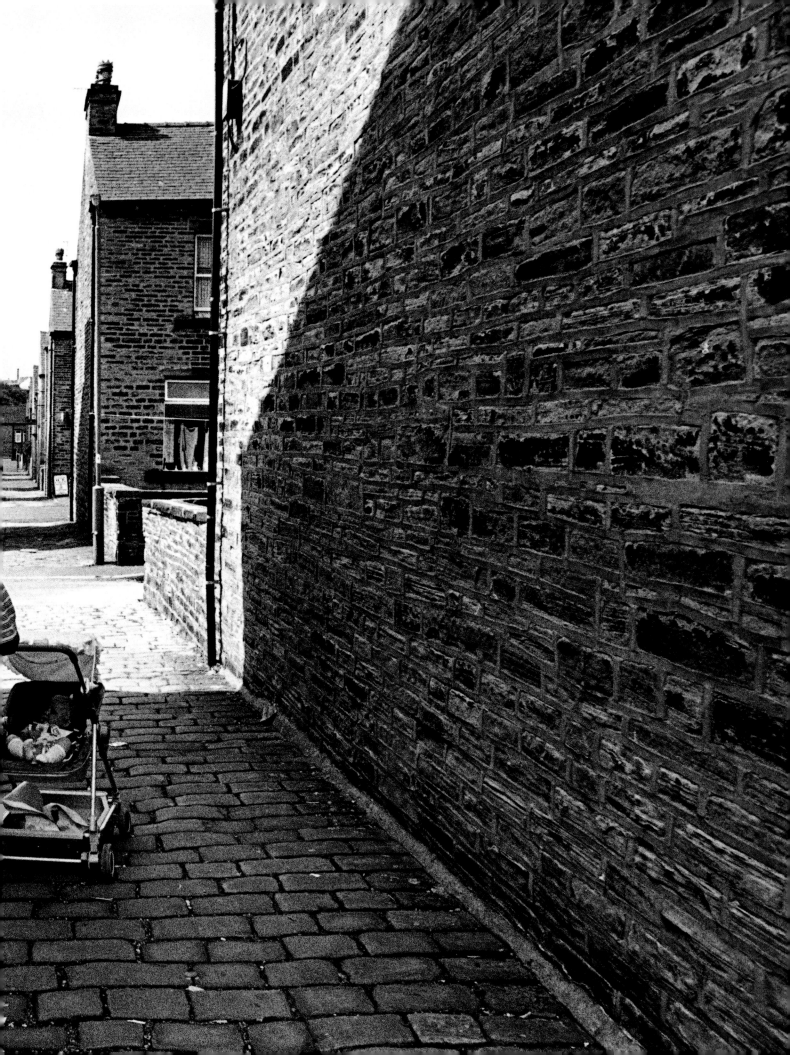

The men reminisced about the great naval boats that had been built in the local yards: the aircraft carriers, the first 100,000-ton tanker, the methane carrier and a cruise ship. These brief bursts of interest gave temporary relief from the mundane routine of sitting around sipping tea, reading the papers, and playing board games. They were filled with the toxin of chronic boredom. The wasted hours and days poisoned their lives and relationships, depression coursed through their veins and sapped their self-esteem.

Washing line, Barrow Island.

Ivy is a publican who is going out of business: 'They'd just come straight across the road and into the pub. The queue used to be miles long for the pie 'n' peas. Yes, it was absolutely brilliant. You're talking about, well, at lunch-times, nine deep, and you were having to pass pints over the heads and you had one girl going mad with the pie 'n' peas. Proper mince gravy as well, you know. And they loved it.'

Out for a walk. Barrovians feel cut off from the rest of Britain: with only one road out, they jokingly say that Barrow is at the end of Britain's longest cul-de-sac.

Councillor Les Burns, 54-year-old father of three and also a grandfather, had spent all his working life in the local ship and submarine yard as a shipyard steelworker. Remembering the day he had been given 'the tap on the shoulder', he said, 'I had to be out of the yard within three quarters of an hour, after thirty-five years. I get very, very depressed now. All the things I used to do, I don't do any more. It's gone, I've lost it. I'd love to go back and build ships like I used to. The wife will come home and ask me what I have done today, and I am ashamed to tell her I've done nothing.'

Eight months later, the day after the wedding of his youngest daughter, Les left a note for his wife, saying he was going for a walk from Walney to Peel Island, but he didn't come back. Twelve days later his body was washed up on Foulney Island.

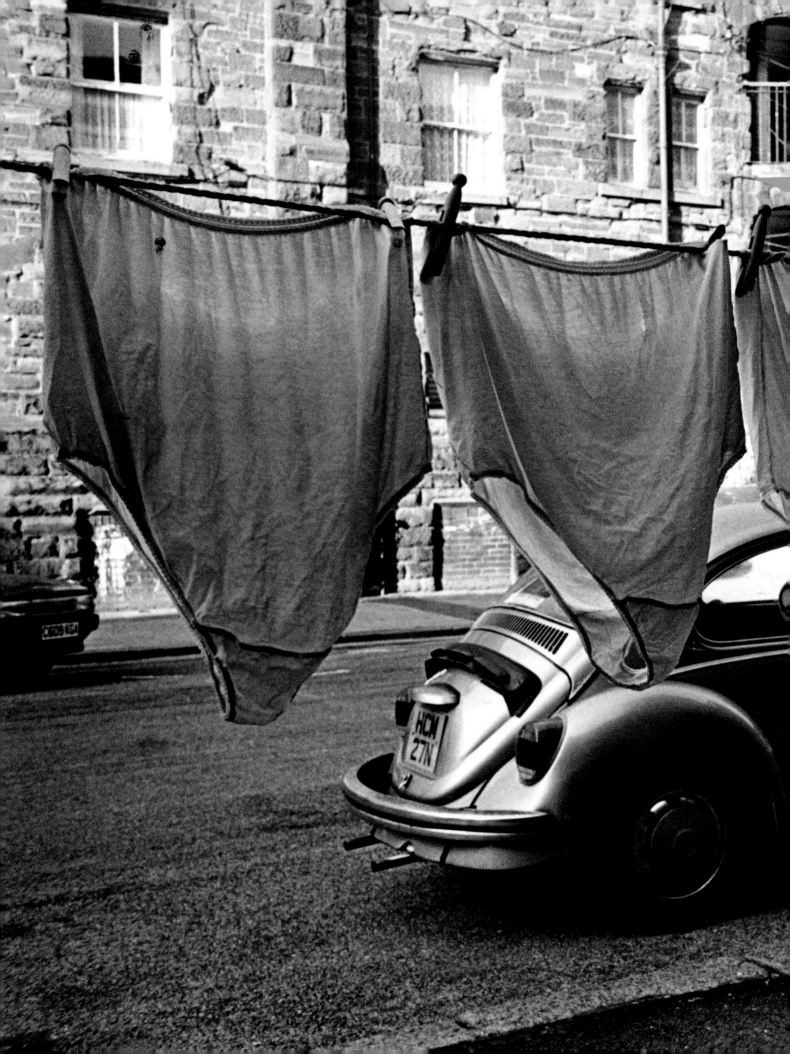

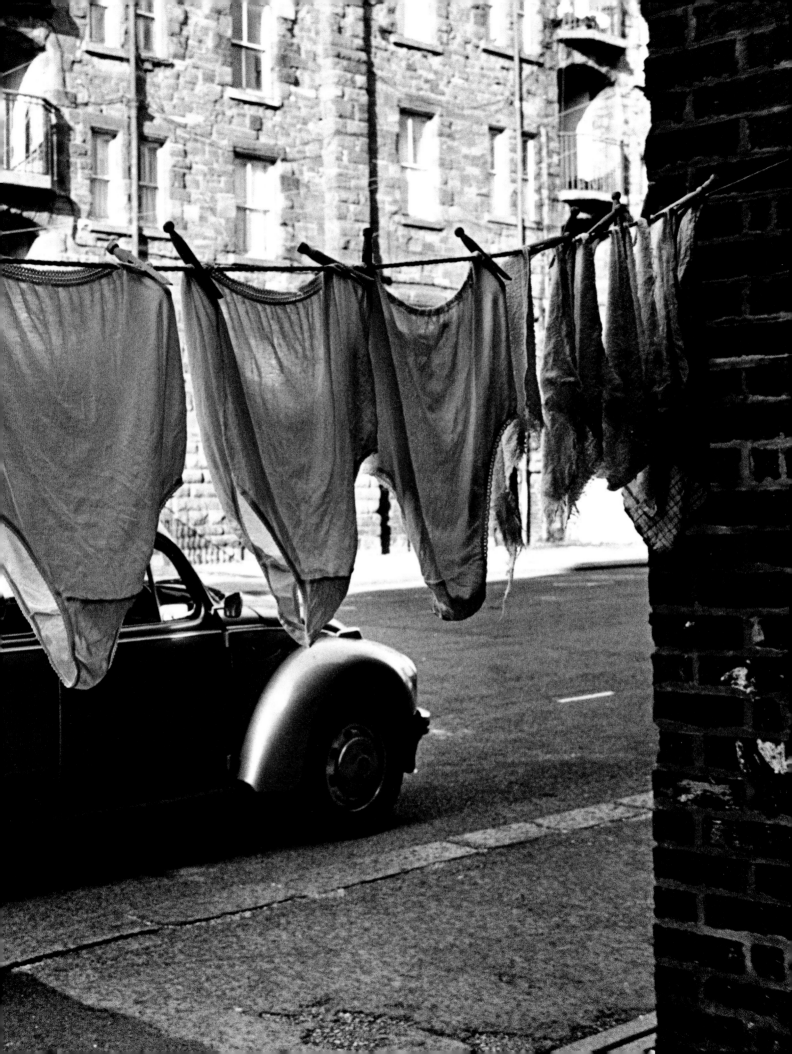

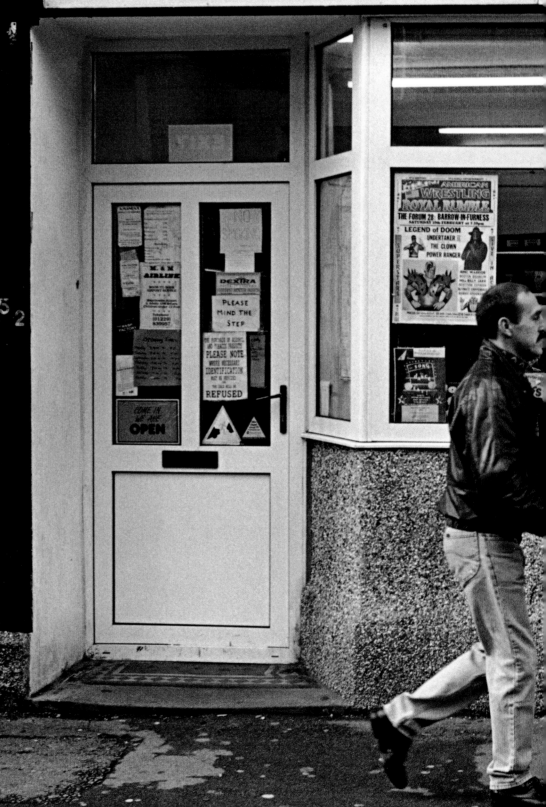

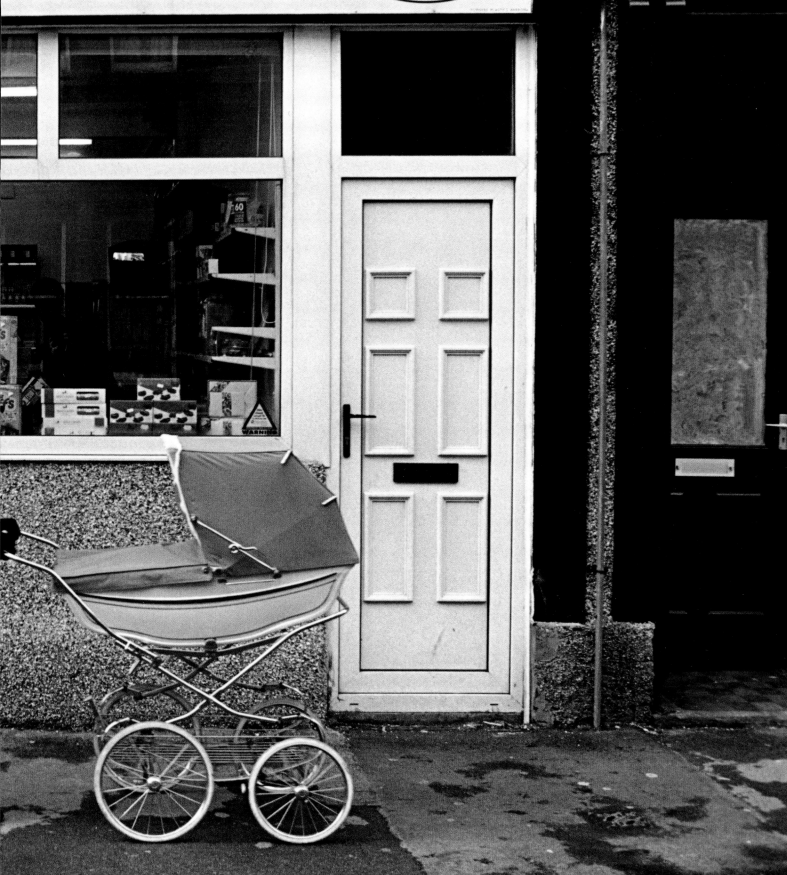

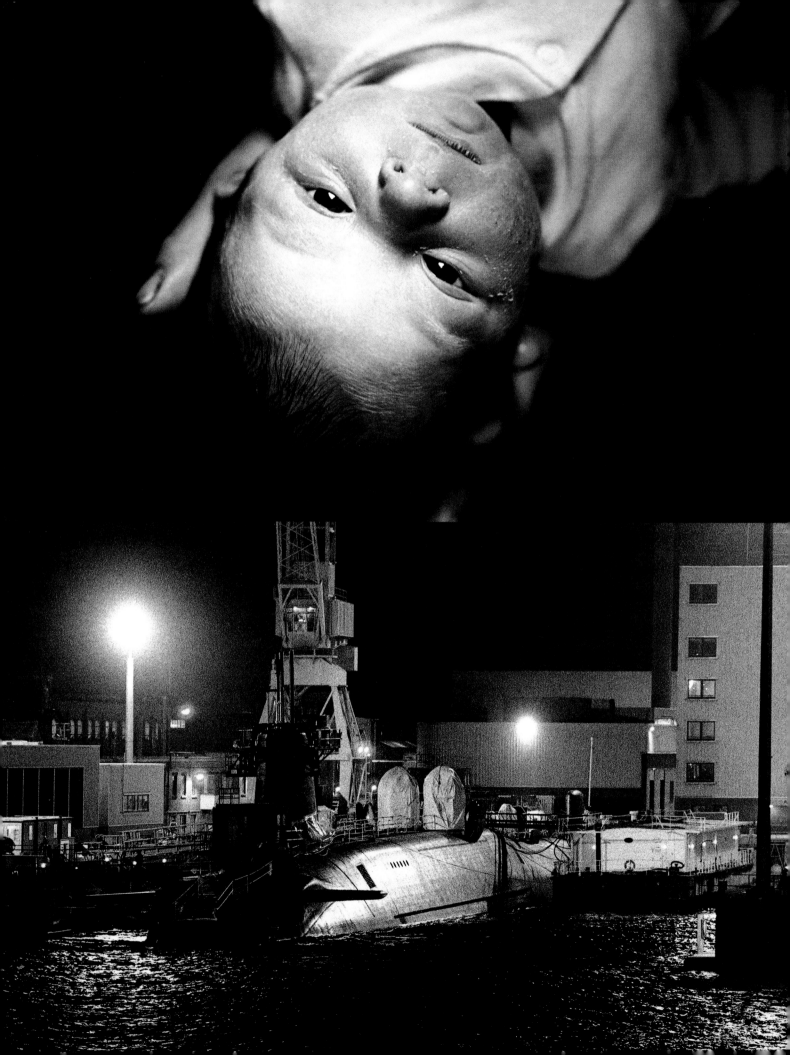

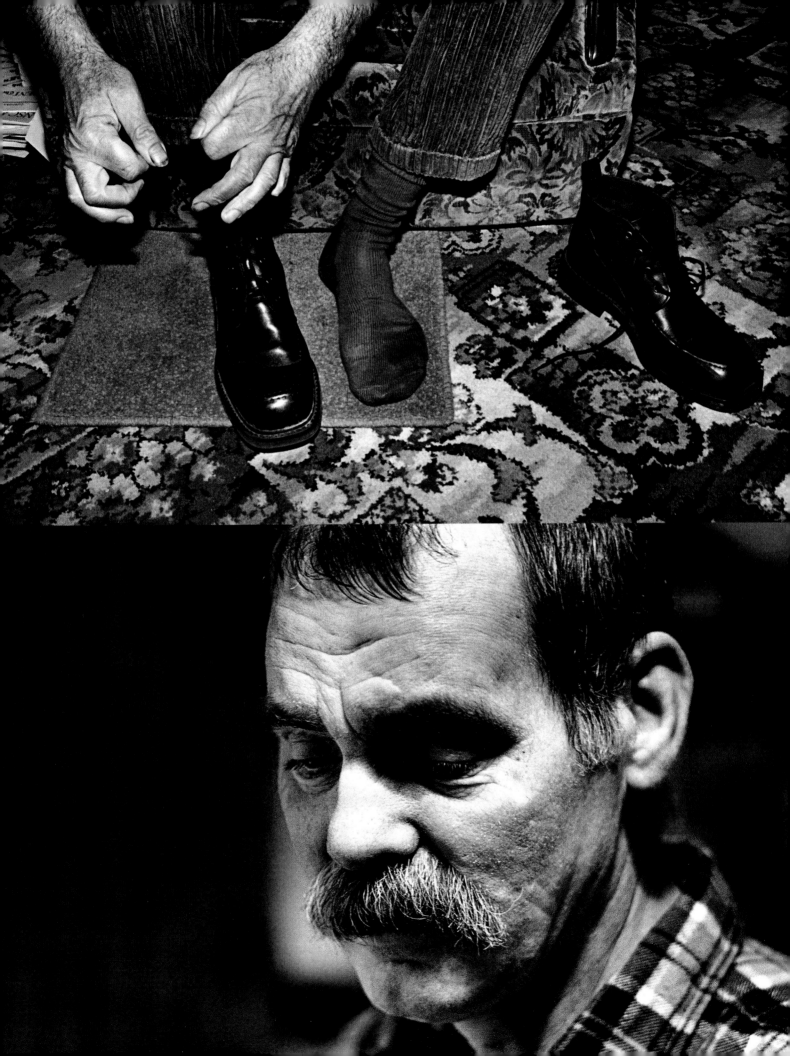

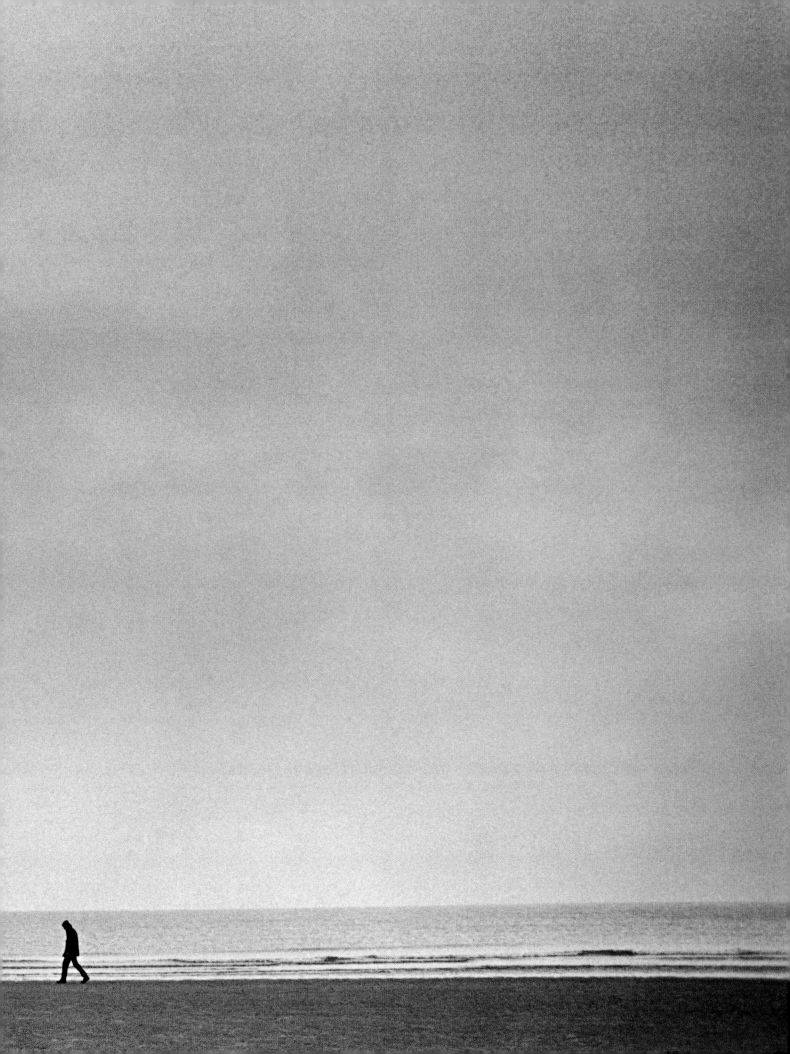

In 1990, Glasgow found new prestige as the cultural centre of Europe, but at first sight it is a forbidding, sprawling metropolis with its grim twenty- and thirty-storey tenements and claustrophobic closes. Many Glaswegians find it neither cheerful nor easy, nor safe. It is, however, a passionate place, where both young and old, the hopeful and the disillusioned, live a life constantly on the edge. The city breathes a vitality like no other city in Britain.

Broken fire hydrant, Parkhead. Three times the fire brigade capped the hydrant, three times the children broke it open.

Aggie looks after some of her grandchildren. To make ends meet, she leaves home at five in the morning. 'I would like to sit back and retire, but you need the money for to gae them the things that they need.' Aggie and her best friend Mary consider themselves fortunate compared to the poor people of Somalia and Ethiopia.

Vandalism is so great that the windows of this crèche for children affected by the prevailing drug culture have been replaced by Perspex and can't be opened because of the steel rabbit mesh that is welded to the windows to prevent burglaries. The only air comes from a single circular hole the size of a small child's face.

These women explained to me that when they were kids you could change jobs like changing your socks. 'The lottery is our only hope. The working classes need hope. Surviving is not enough! The only industry we've got left here is football. And I'm not spending me money on lottery when they're giving £58 million to opera, to the fuckin' toffs. I'll pay for half a ticket, and I begrudge even that.'

Celtic club. The man lifting his two-litre tankard, a souvenir from his trip to Basel in Switzerland for a European Cup quarter-final, still wears a hospital name tag on his wrist.

The area, with its rundown tenements, has few amenities and is notorious for drug-dealing. The stairwells function as places for addicts to shoot up. It's done openly by the young – and the sometimes not-so-young. People hang around in miserable-looking gangs. 'You know if someone is running he's just done something, or he's being chased. I wonder what it would be like to live in a place where thoughts like this never came into your head,' said my guide.

Where there had once been a steelworks there's now a bingo hall. 'It's a great feeling, you know, talking to someone sensible, and you're sitting there having a wee drink and a laugh.'

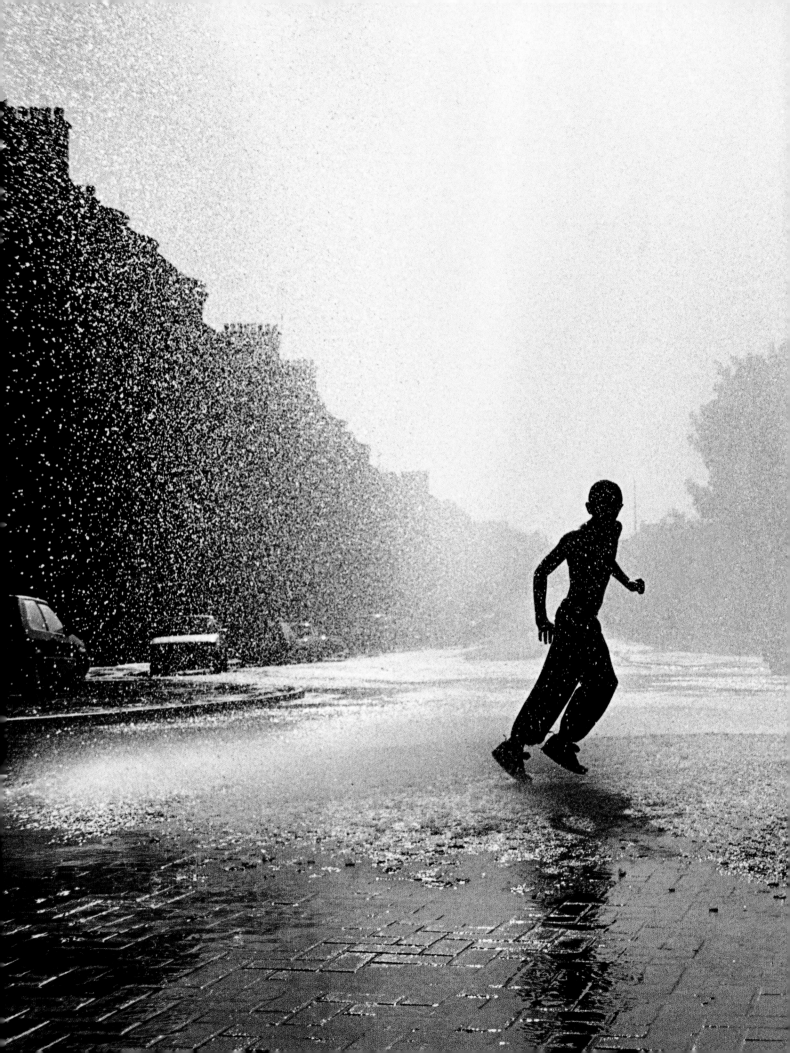

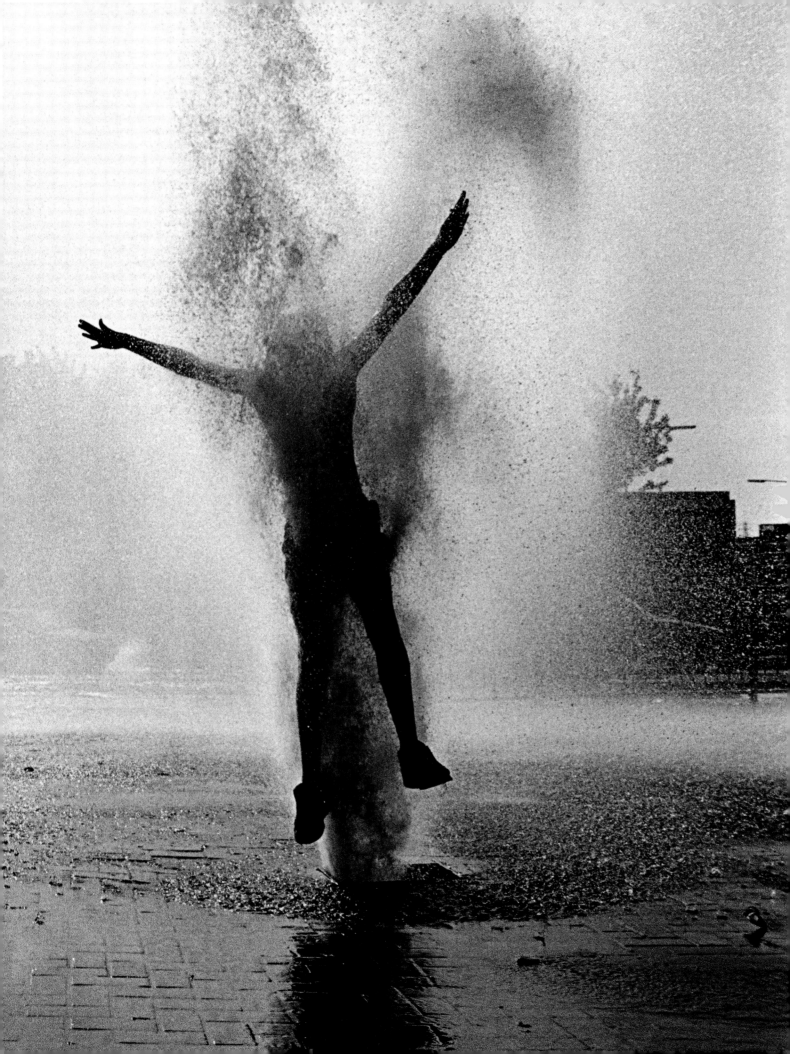

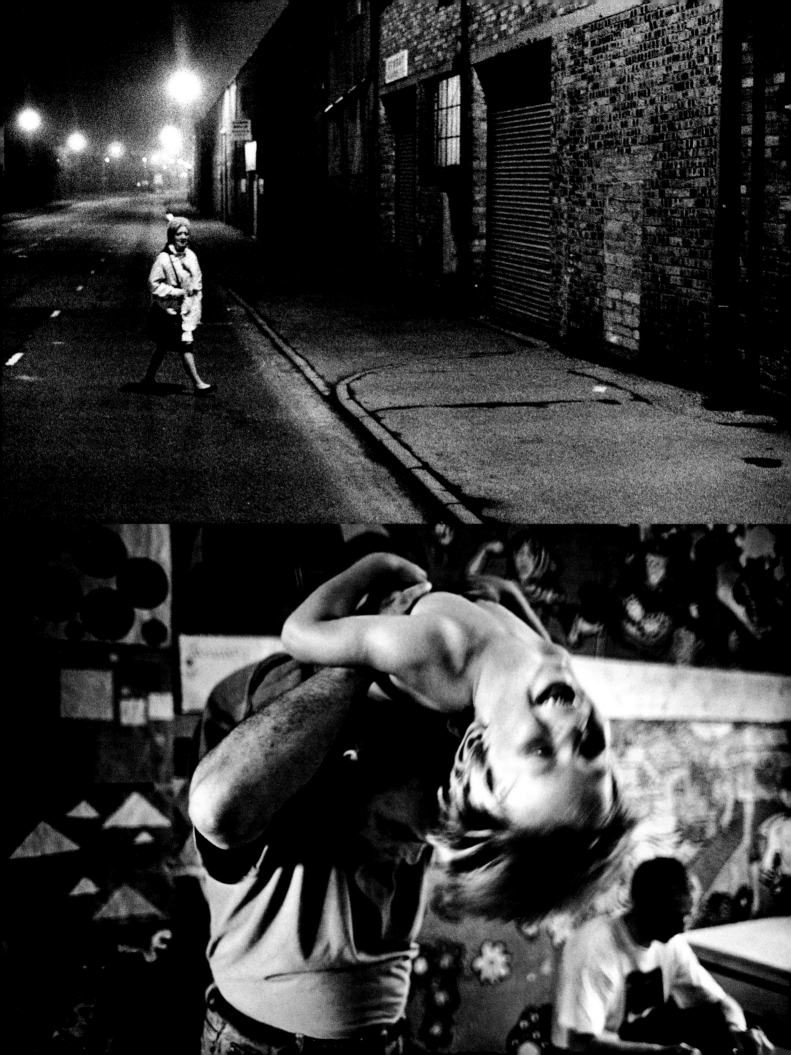

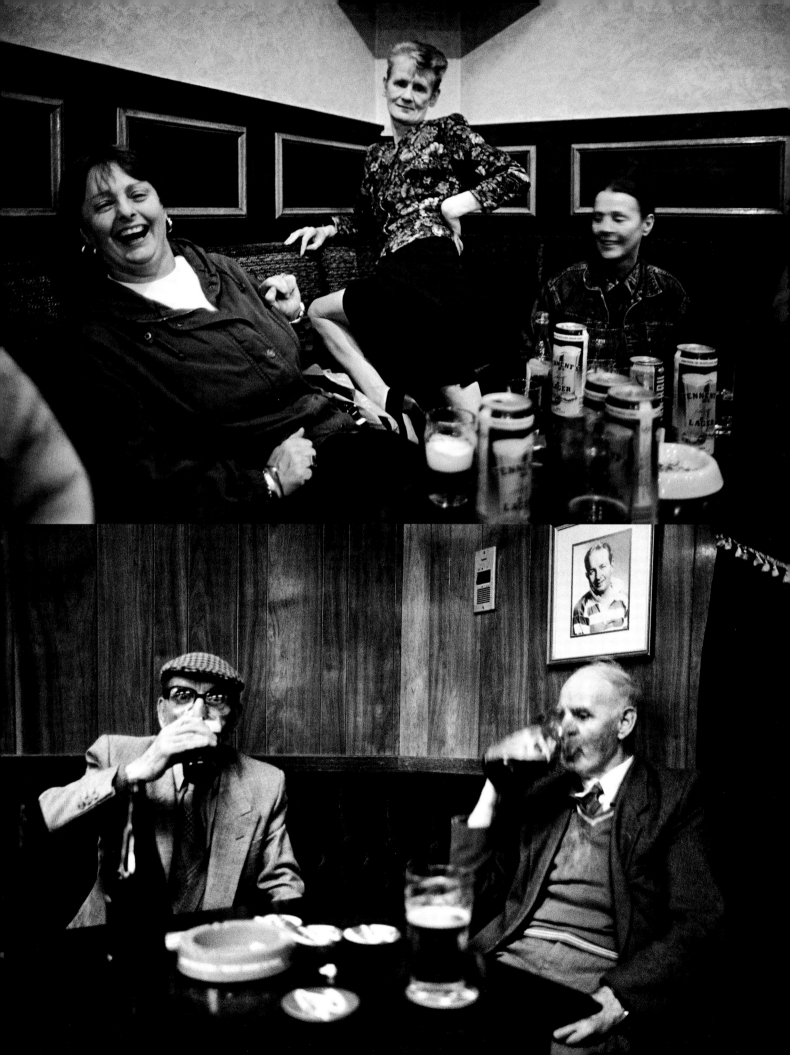

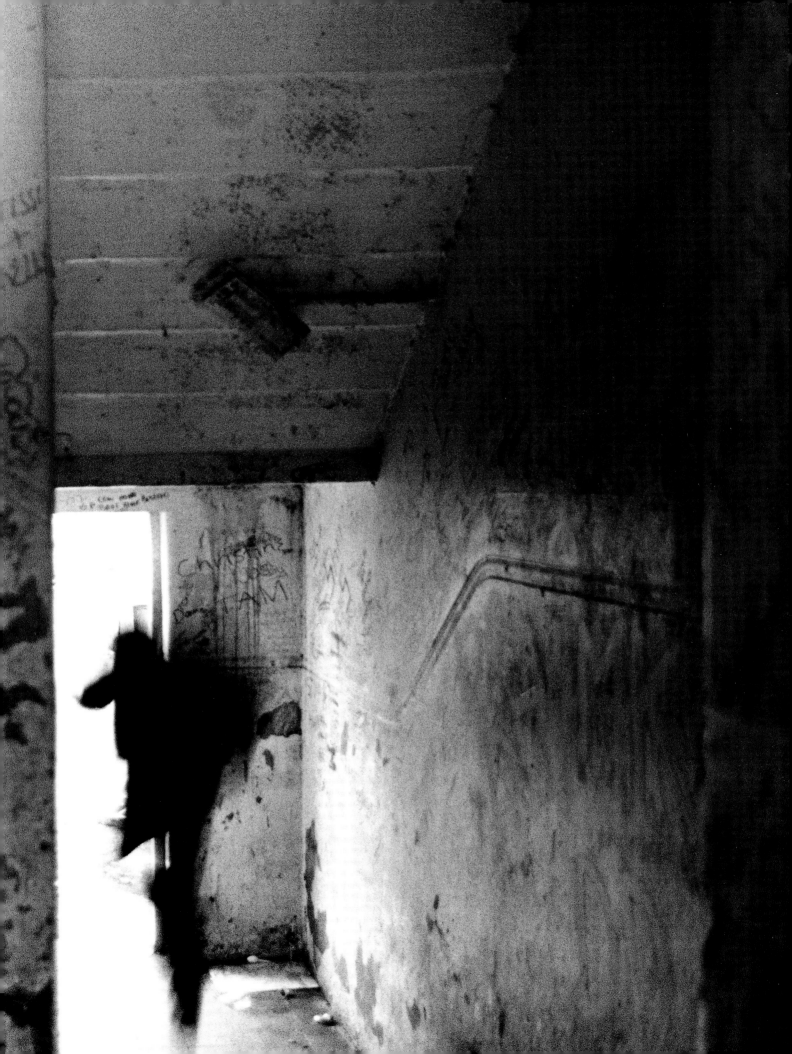

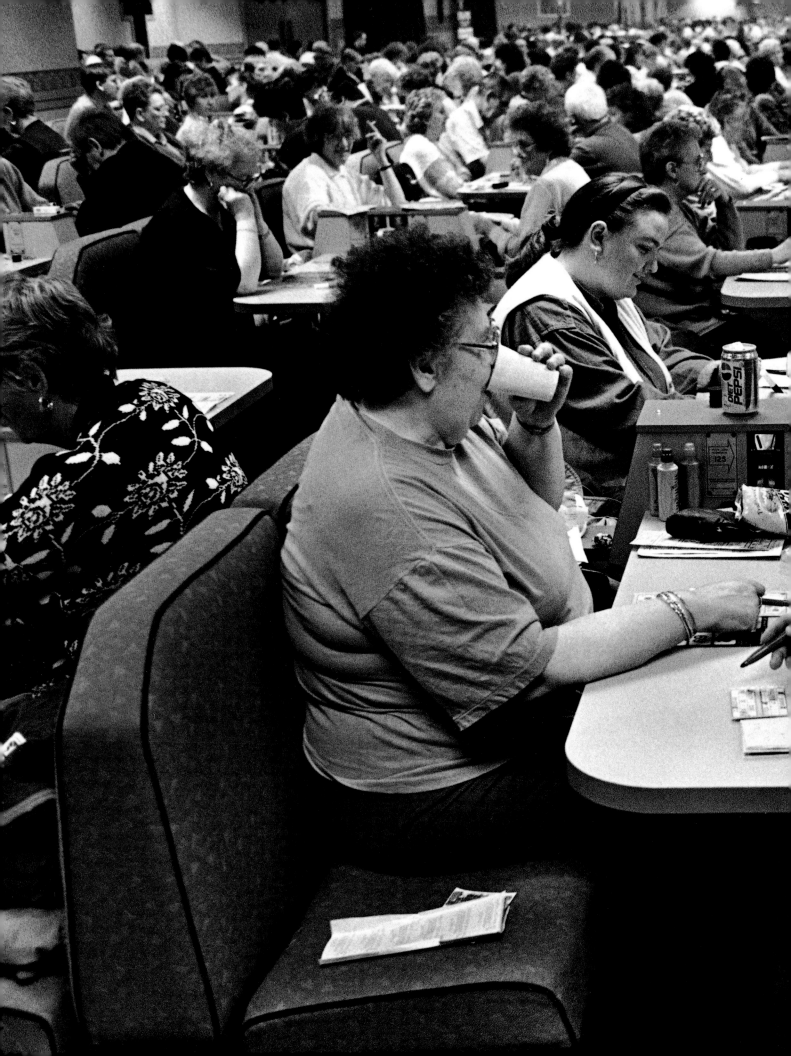

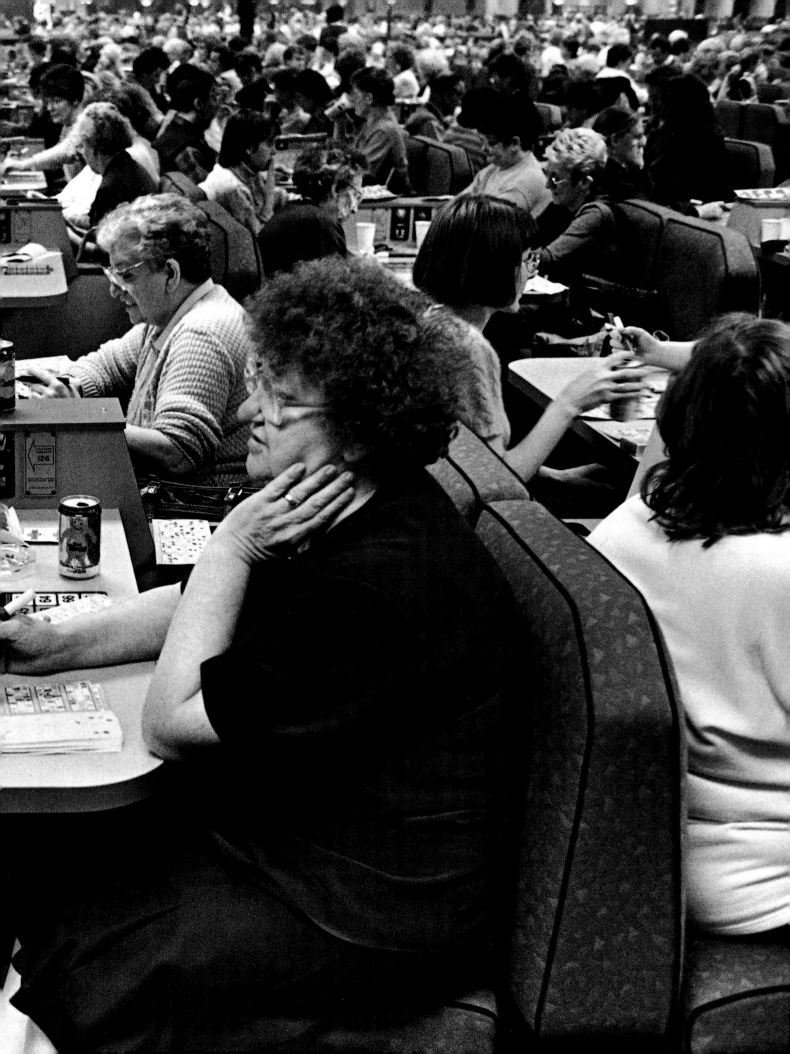

Antony Gormley's **Angel of The North** in Gateshead is destined to become Britain's most viewed public work of art.

The Angel, just before being moved from Hartlepool to Gateshead.

While visitors arrive from all over Great Britain and beyond to admire the *Angel*, some local residents are not happy having it in their back yard.

Angel

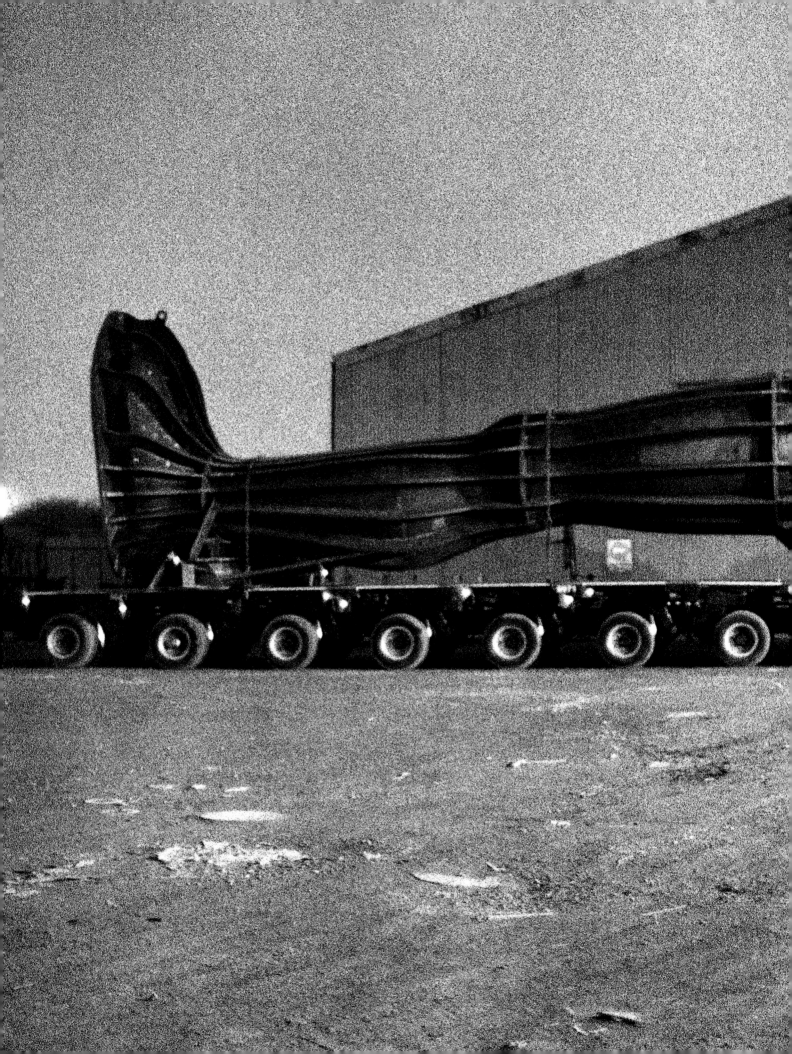

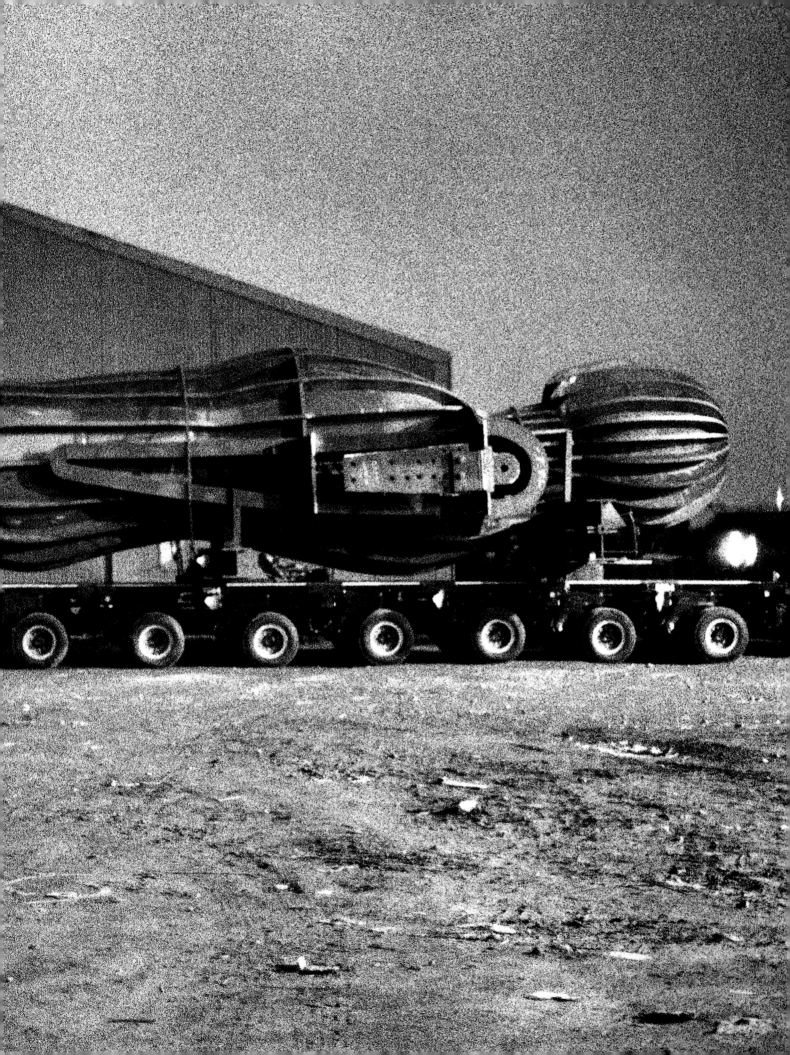

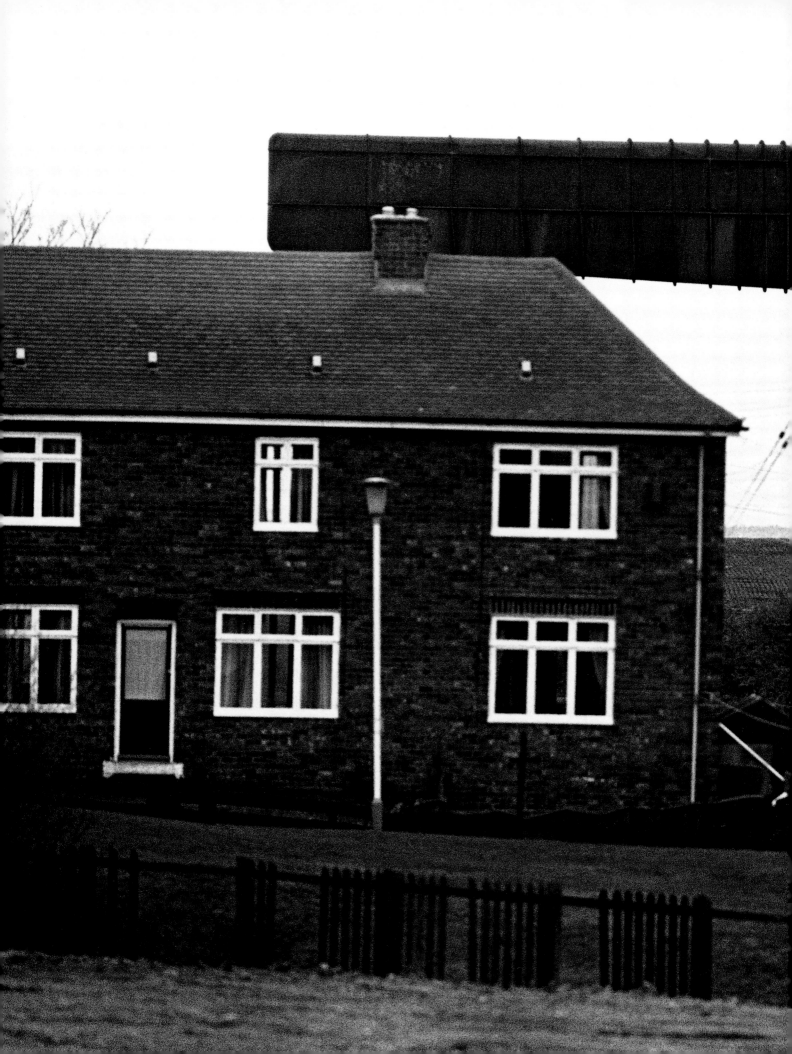

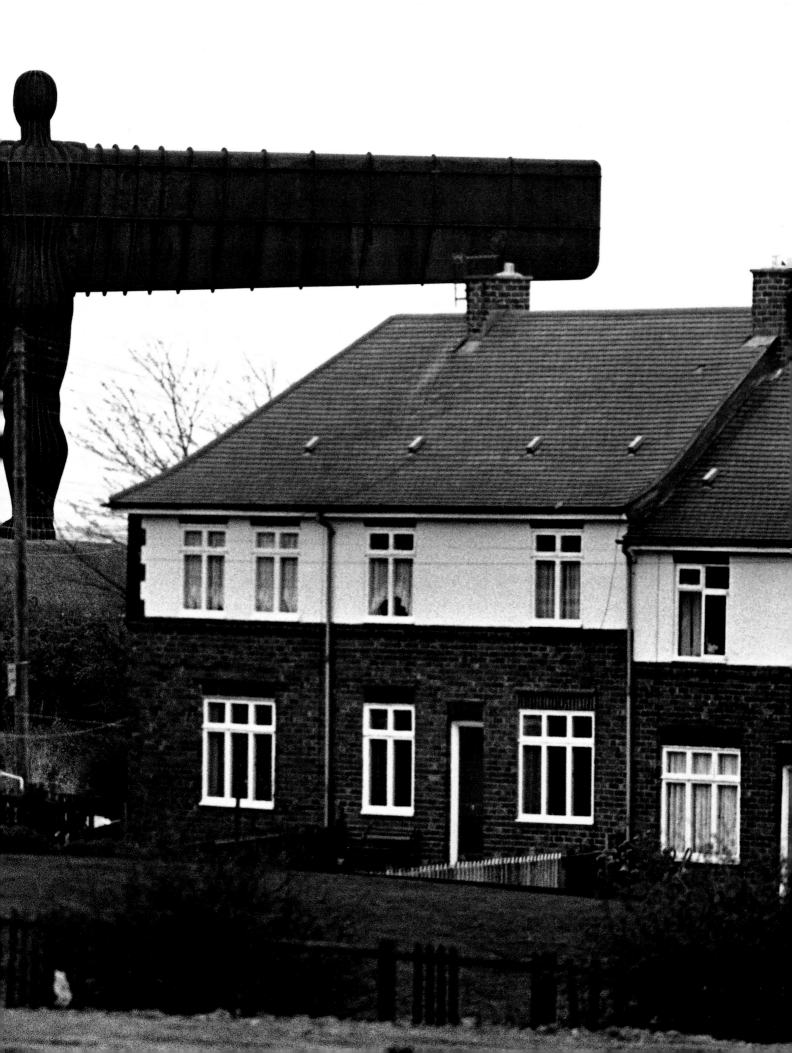

Acknowledgements

For my father Harry Lee, who showed me one world, and my stepfather Terry, who showed me another.

Thanks to Robert Pledge, whose inspiration and dedication has helped me put the two halves together; my mum and my children Satar, Khadija and Farishta; Richard Johnson, my editor; Mark Lucas, my agent; Peter Morgan, my assistant and office manager.

Dominique Deschavanne and Franck Seguin at Contact Press Images, Paris for their hard work and long hours on the book; Julius Domoney at Colorific; Sara Cubitt, Ian Dickens, Robin Hinton, Christine Horowitz and Barry Taylor at Olympus Cameras; Printers Jean-Pierre Leduc, laboratoire Central Color, Paris and Jean-Christophe Domenech, laboratoire Cyclope, Paris.

Mark Thomson for the originality of his design.

Arjen Jansen and Marian Reid at HarperCollins; Rob Dawson-Moore and Andy Vaines, who provided the work prints; the National Museum of Film, Photography and Television and the Bradford and Ilkley Community College; Kodak Professional Films, who provided some of my film.

This book is dedicated to all the people who allowed me into their lives during my journeys through Britain and to those whose research, arrangements, commitment, hard work and dedication to these projects made the photography possible – if some of their names have been omitted it is either out of respect for their privacy or through an oversight on my behalf, for this I apologise – and it is also dedicated to those who kept me going through their generous hospitality and encouragement – thank you.

Jane Amos Jo Armitage Claire Armstrong Laura Ashton Sir Michael Atiyah Behnam Attar Denise Awooner-Renner Ilona Benjamin Vicky Bolton Lieutenant-Colonel Jonathan Bourne-May Tom Broadbent The Rt Hon Justice Butterfield Rose Ann Coutts Julie Daniels Guy Davies Norman Davies Barry, Theresa, Jenny Dawson John Dowling Ruth Easterbrook Phil Foster Brigadier

Lady Gowrie Jill Griffths Simon Hall David Hart Mara Helen-Wood Glennis Henderson Anthony Holdsworth Dave Illingworth Shona Illingworth Professor Gareth Jones Lynn Keane Derek, Barbara, Garry & Peter Kirby Brian and Irene MacLeod Agnes McCrimmon Mary Morgan Rachel Quick Rukhsana Mosam William Murray Peter O'Keefe Jane Pasternak Leane and Sarah Pearce Keith Peters Joan Reynolds Lucy, Carol and Joe Robinson Alison Root Sue Rose Rosemary Scoular Natasha Seaton Professor Amartya Sen Harry Shaw A.P. Simm Bill Stalley Peter Stothard Mary Toal Brenda Turnbull Rt Revd Michael Turnbull, Bishop of Durham Chris Turner General Sir Michael and Lady Walker Revd Paul Walker Duke of Westminster John Willis Dr Charlotte Wilson-Jones Dr Adam Winstock

And also: Amanda & Mick June Maud Maxine Sheldon Tommy

In memory of Les Burns and Rosemary Vaughan.

HarperCollins*Illustrated*/Flamingo

The British
Nick Danziger

Picture editing and concept:
Robert Pledge
Designed by
Mark Thomson
International Design UK Ltd.

HarperCollinsPublishers
77–85 Fulham Palace Road,
Hammersmith, London W6 8JB
www.**fire**and**water**.com

Published by HarperCollinsPublishers 2001
1 3 5 7 9 8 6 4 2

Copyright © Nick Danziger 2001

The Author asserts the moral right to be
identified as the author of this work

A catalogue record for this book is available
from the British Library

ISBN 0 00 257159 5 (hb)
ISBN 0 00 257160 9 (pb)

Printed and bound in Belgium by Proost NV,
Turnhout

All rights reserved. No part of this publication may be reproduced, stored in a retrieval system, or transmitted, in any form or by any means, electronic, mechanical, photocopying, recording or otherwise, without the prior permission of the publishers.

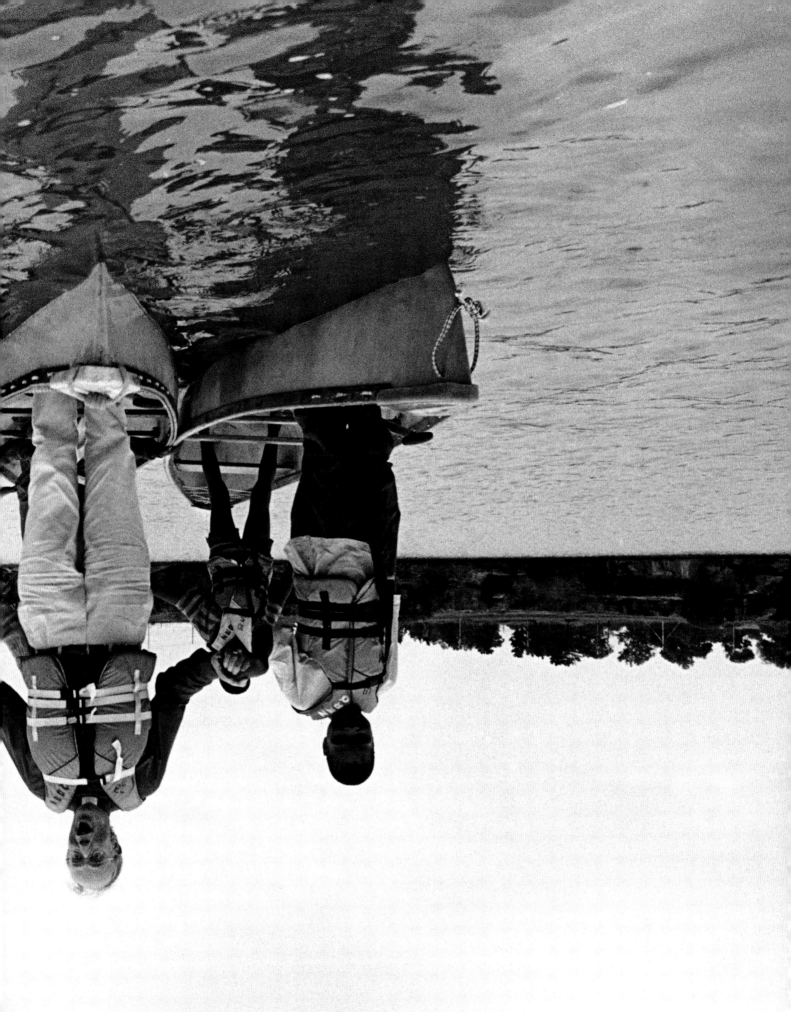

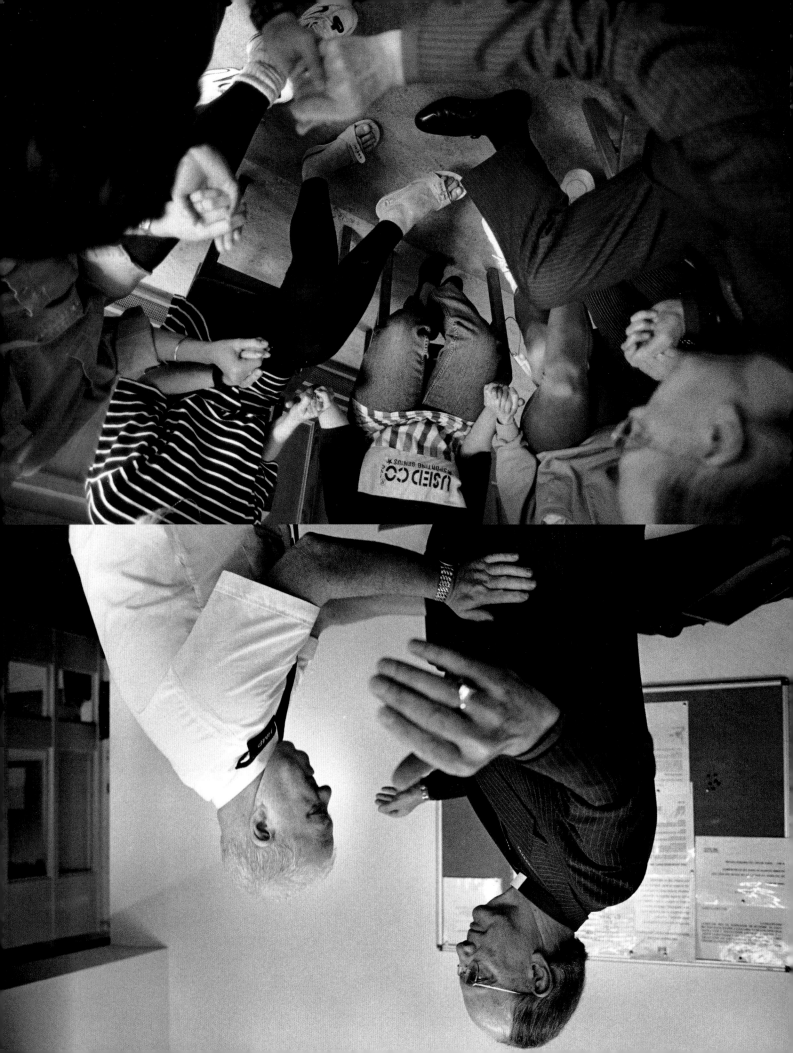

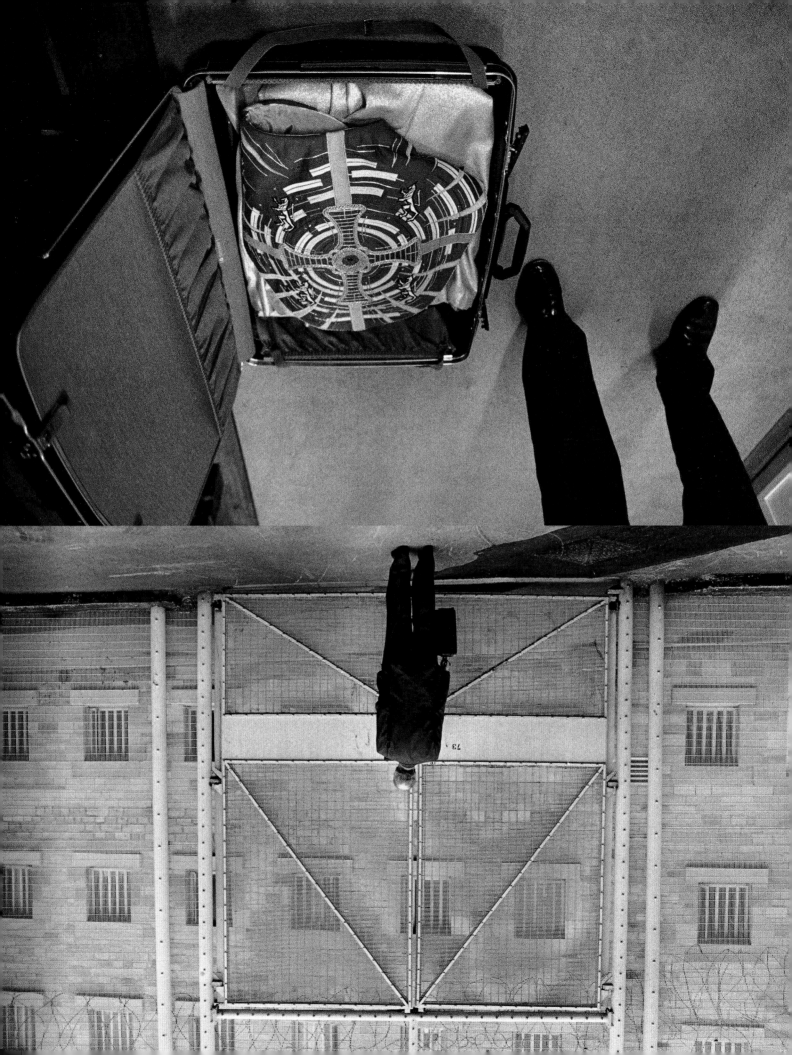

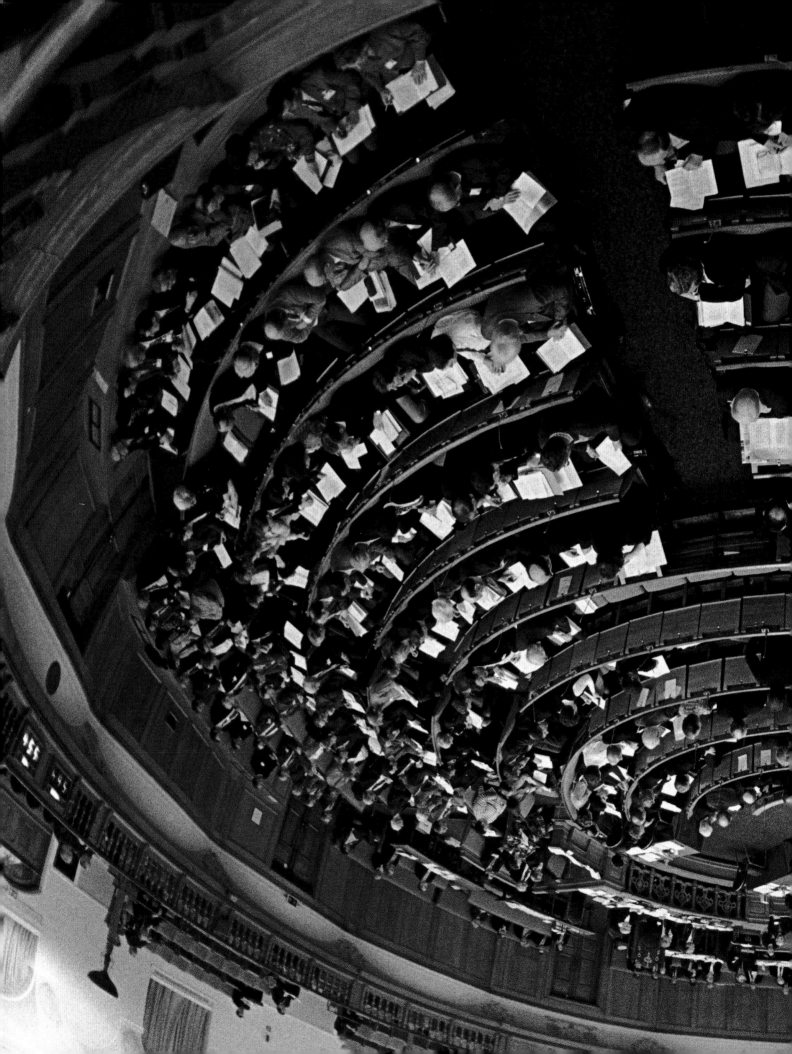

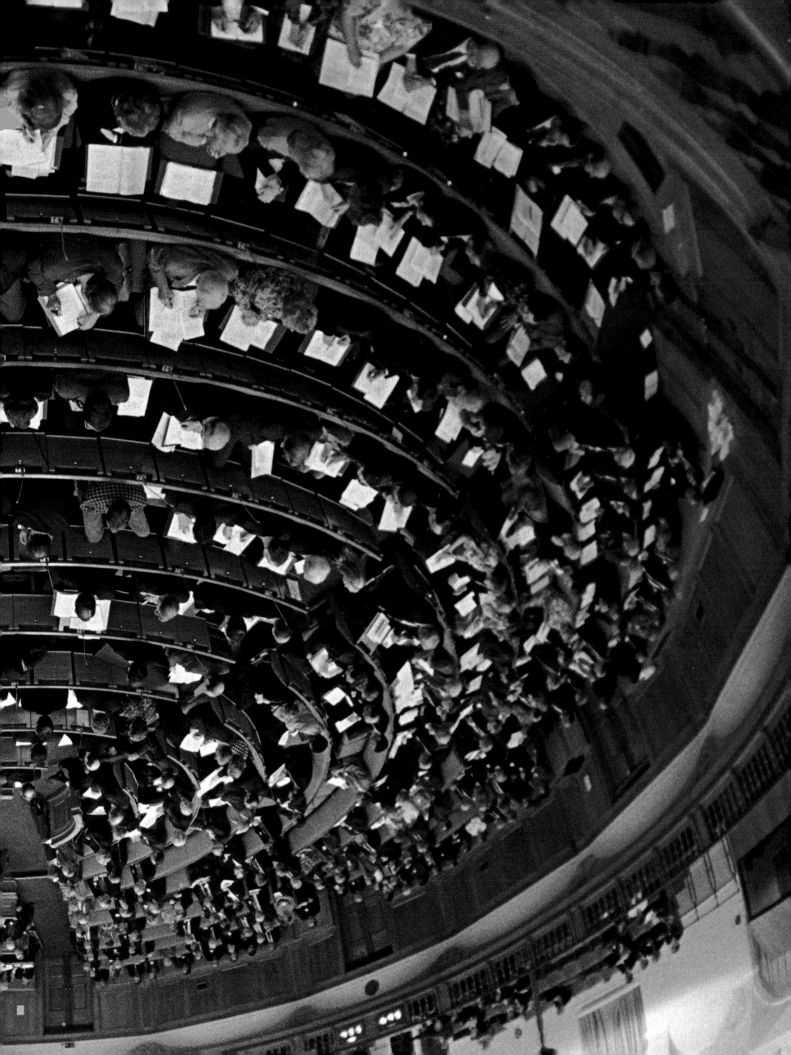

The Bishops

The Bishop of Durham on a trip to Lesotho in southern Africa, where he seemed liberated. In Maseru, the capital, a sheep was tethered to the local bishop's front door, which, unknown to us, was to be our dinner. In Africa, Bishop Michael was adored and fêted. Some of the photographs I took of him there could have been taken fifty years ago – and indeed he sees himself as a missionary both in the deprived council estates of the Northeast's former mining towns and in Africa. In Lesotho he said: 'When we got out to the middle of the lake and somebody said, "Stand up", I said: "There is no way I am going to stand up in this wobbly canoe!" Then we all linked hands side by side, and found we could stand up in each canoe with confidence because we had linked up. This was another illustration, I don't know whether it went home to them, but it certainly struck me, that when you hold on to people in the next boat there is a little stability.'

The Church of England still provides the moral framework for the State, yet it is the one pillar of the Establish-ment which may realistically fear for its future. The Bishop of Durham, the Right Reverend Michael Turnbull, feels the pressure of moving the Church of England forward into a more constructive future. As one of the Church's most senior bishops, it was Bishop Michael who headed the Turnbull Commission, which recommended some of the most important changes to the Church since the Reformation.

At the General Synod. The Bishop of Durham says, 'This is an impor-tant and historical step forward. The Church must modernize. We are not just shuffling deckchairs on a sort of Titanic ... this legislation embodies the partnership between the Church and the State.'

'The Church's ministry in prison is extremely important ... it's one that embraces everyone, whether they are a member of the House of Lords or whether they are a prisoner. In fact, these opposite ends of the spectrum are of equal value in the eyes of God,' says Bishop Michael, who is frisked before entering the prison wing to lead the women in prayer.

Durham's high security block for women prisoners.

Against a backdrop of uncertainty are the Bishop of Durham's own personal dilemmas: his struggle between the very private and solitary side of his faith that comes most naturally to him and the public duties that accompany the Bishop's office – he had once dreamed of playing cricket for England.

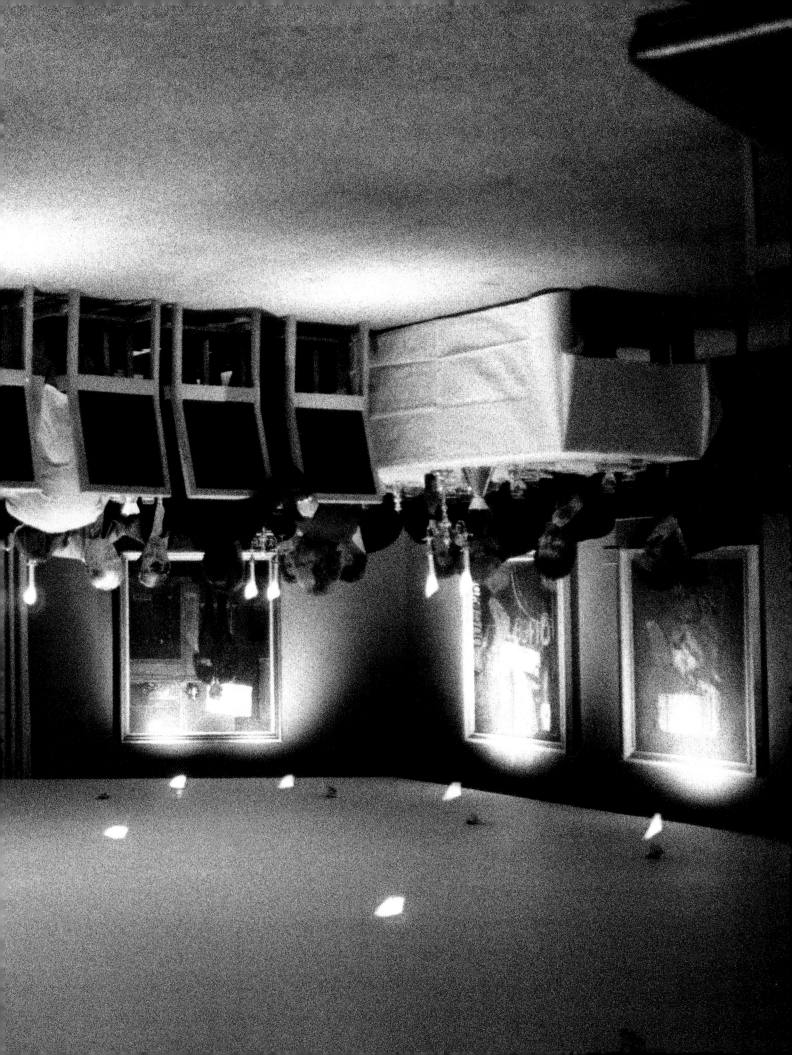

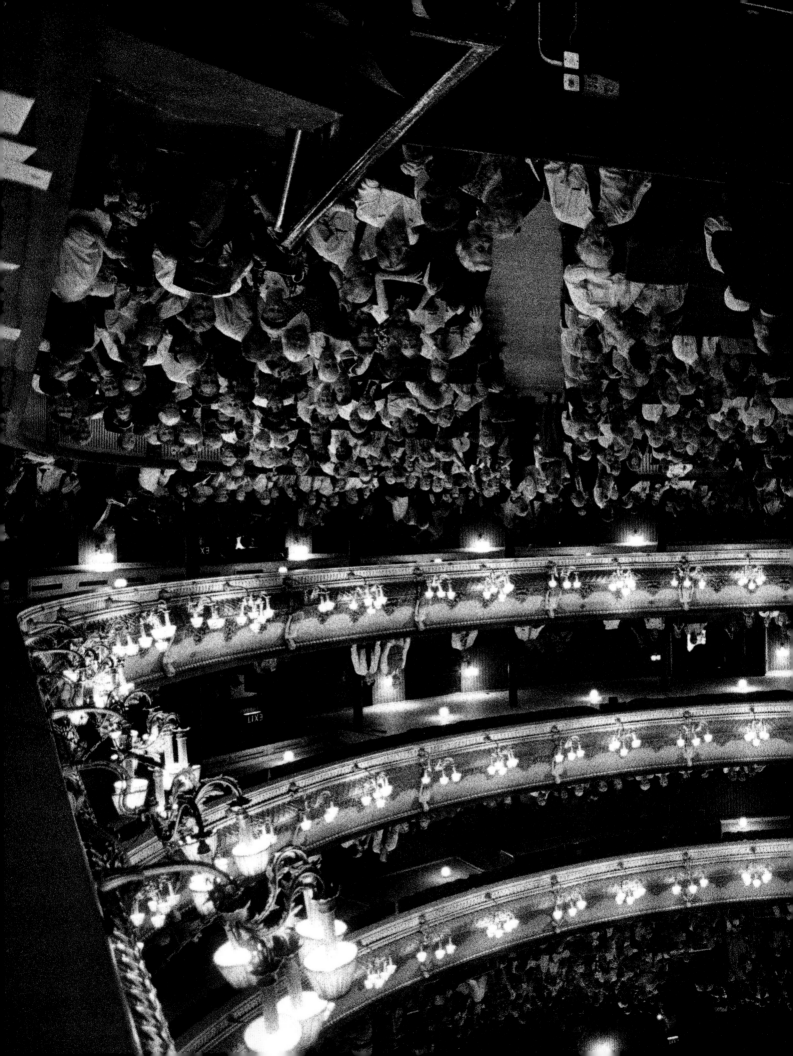

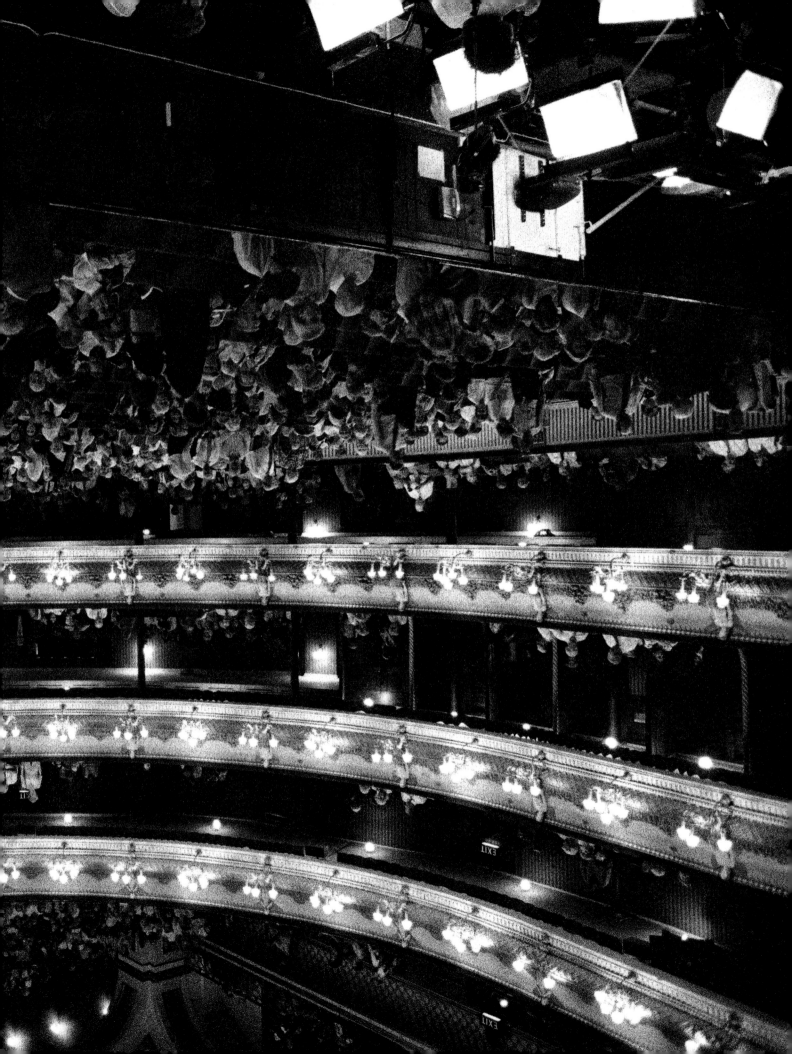

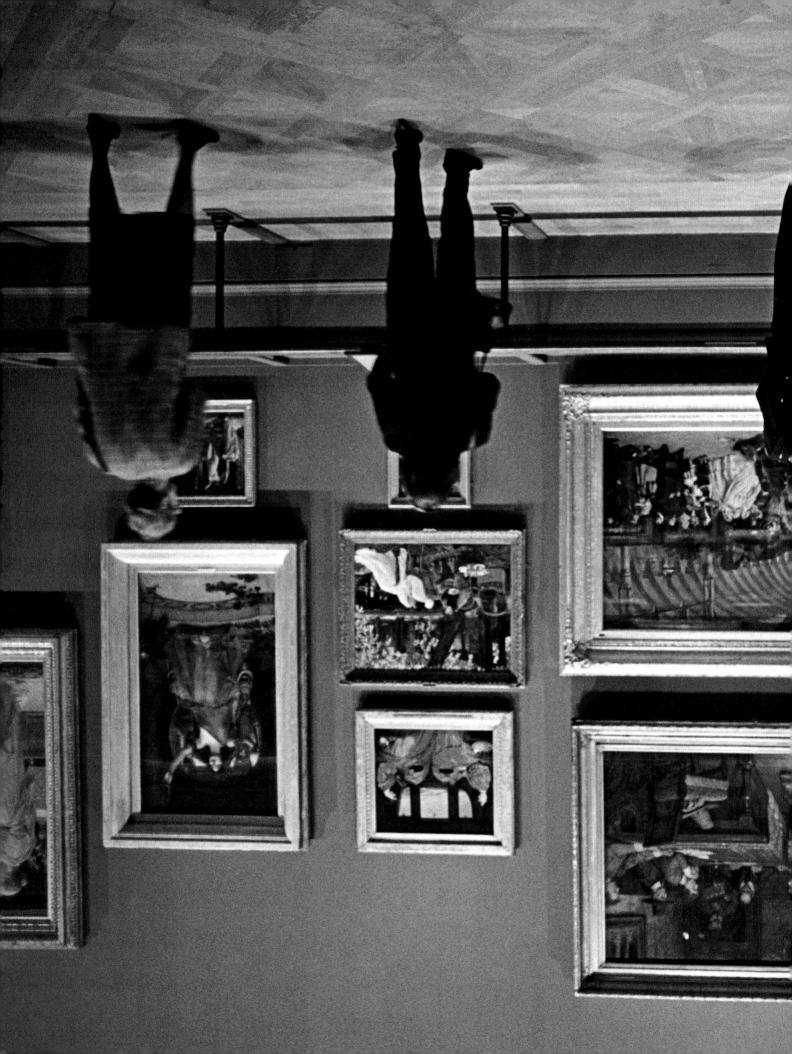

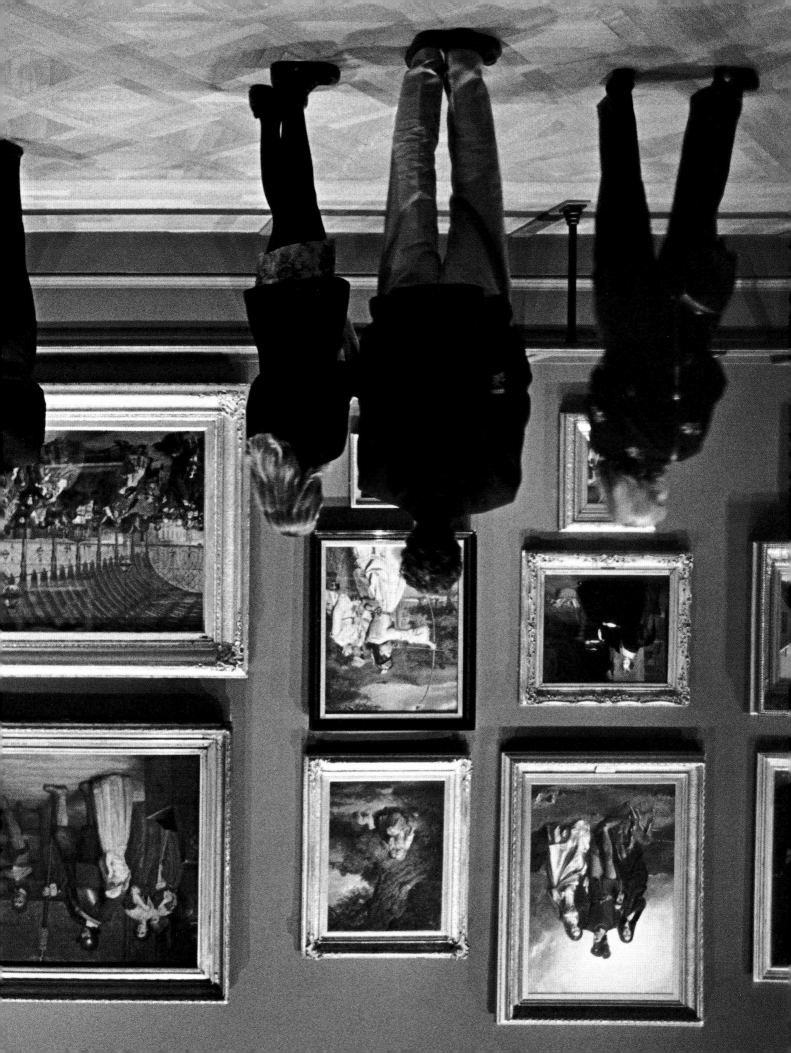

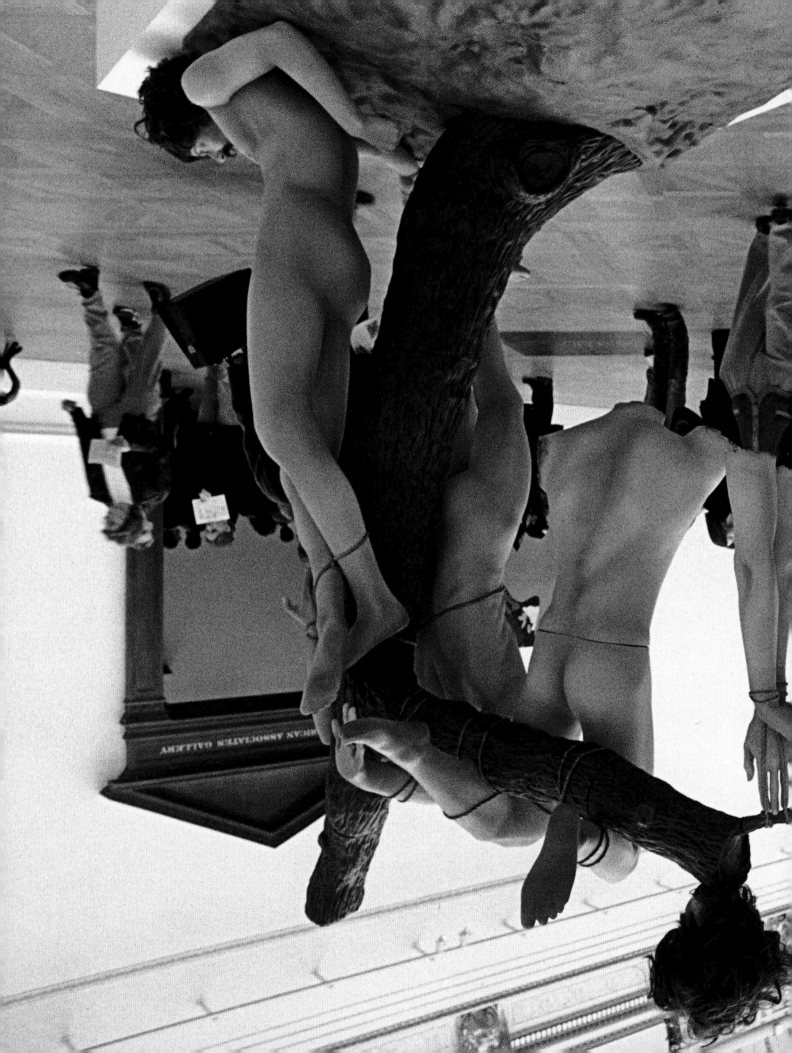

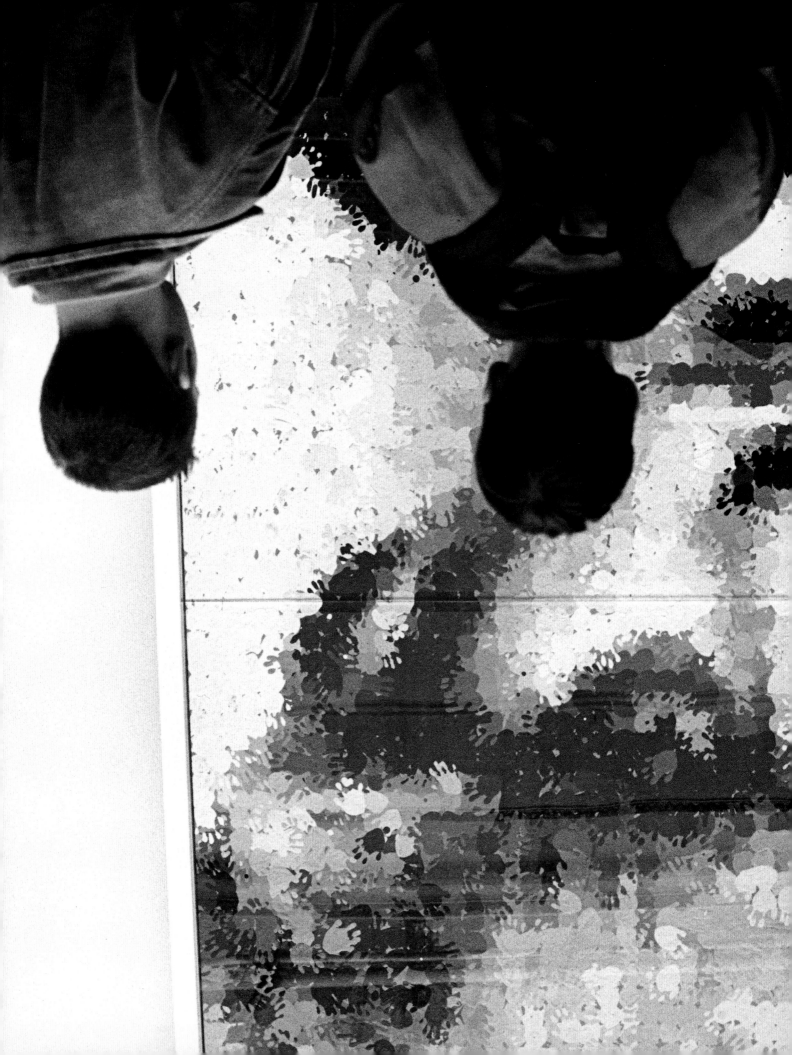

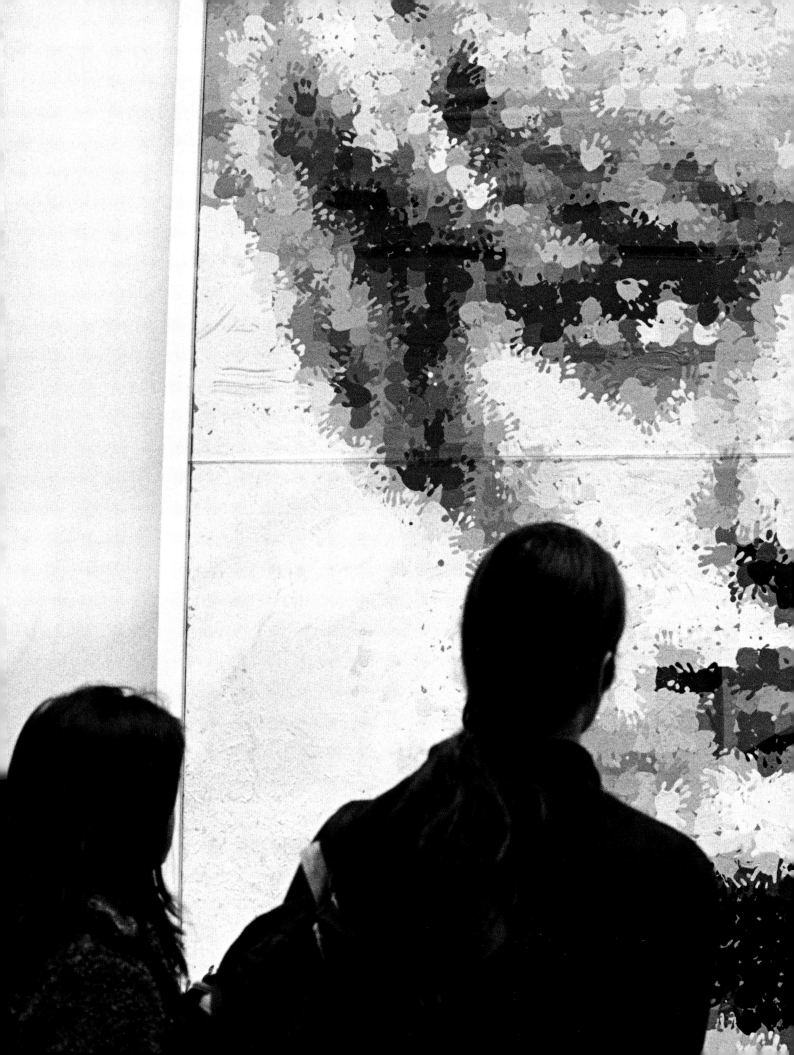

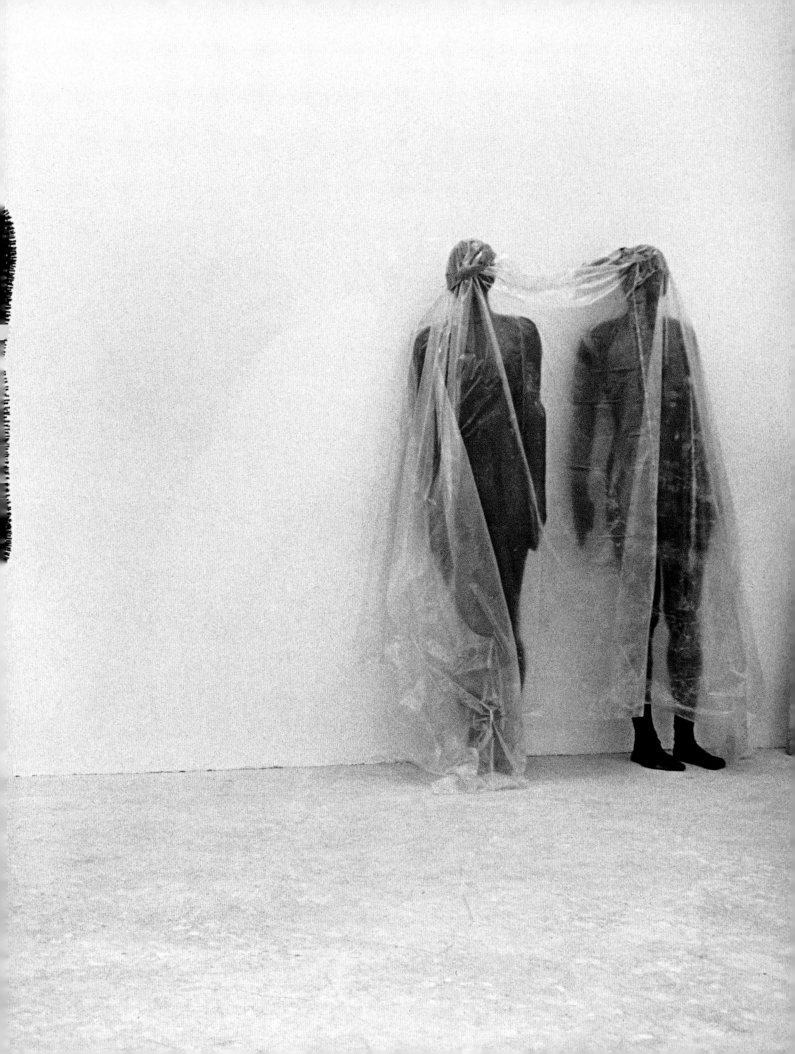

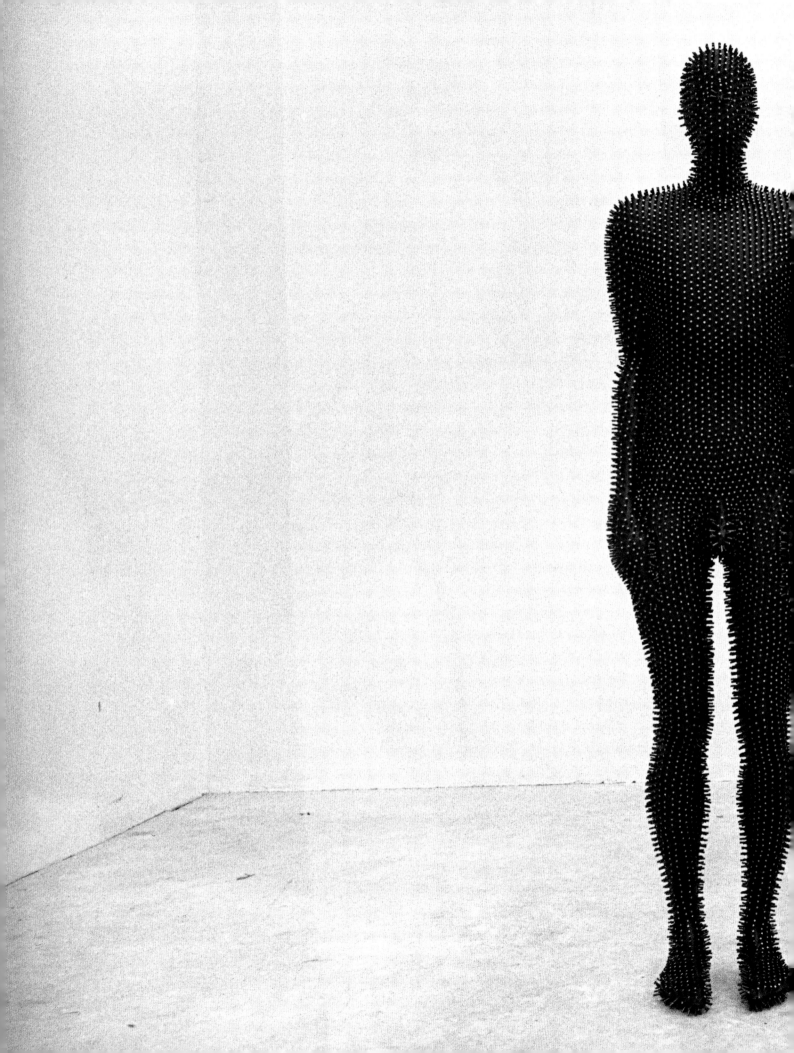

Backstage at the Barbican Theatre, London.

The last performance at the old Covent Garden Opera House before its refurbishment, funded by a £75-million National Lottery grant. At the time, the Royal Opera House was almost bankrupt and the grant caused a furore over lottery money being given to an institution seen as elitist and only for the wealthy.

Platée, which impartially sends up gods, humans and marsh nymphs. Costume designed by Isaac Mizrahi.

A farewell dinner at the Royal College of Art to honour Lord Gowrie – Alexander Patrick Greysteil Hore Ruthven, the outgoing chairman of the Arts Council of England. Lord Gowrie was educated at Eton and Balliol College, Oxford and brought up at Windsor Castle. He holds dear the principle that he was born to serve, in other words: to lead. 'I have always felt a sense of obligation, and that's very strong in my family and always was; we did always serve, and I do believe in the old-fashioned tradition of public service.'

'The British are trans-fixed by the idea that the arts are intellectual. The arts are much closer to sex. They come from the gut.' Lord Gowrie, former Conservative Government Minister and Chairman of the Arts Council of England.

Antony Gormley's studio. Gormley's sculptures are often from casts of his own body. He believes that it is 'silly' to try to invent natural bodies when he inhabits one of his own. 'The form is not invented, it is discovered.'

Marcus Harvey's portrait of Myra Hindley, made from children's handprints. This painting was among those exhibited in *Sensation* at the Royal Academy in 1997. It aroused violent passions, was physically attacked, and sparked a controversy that lasted weeks.

Sculpture by Dinos and Jake Chapman in *Sensation*. The show brought together the new generation of British artists from the Saatchi collection. It was seen by some as the demonstration of a vibrant new spirit in British art, and by others as evidence of the depths to which art had sunk.

Sensation was followed by *Art Treasures of England*. This is the same exhibition space and wall as the painting in the background on the previous page.

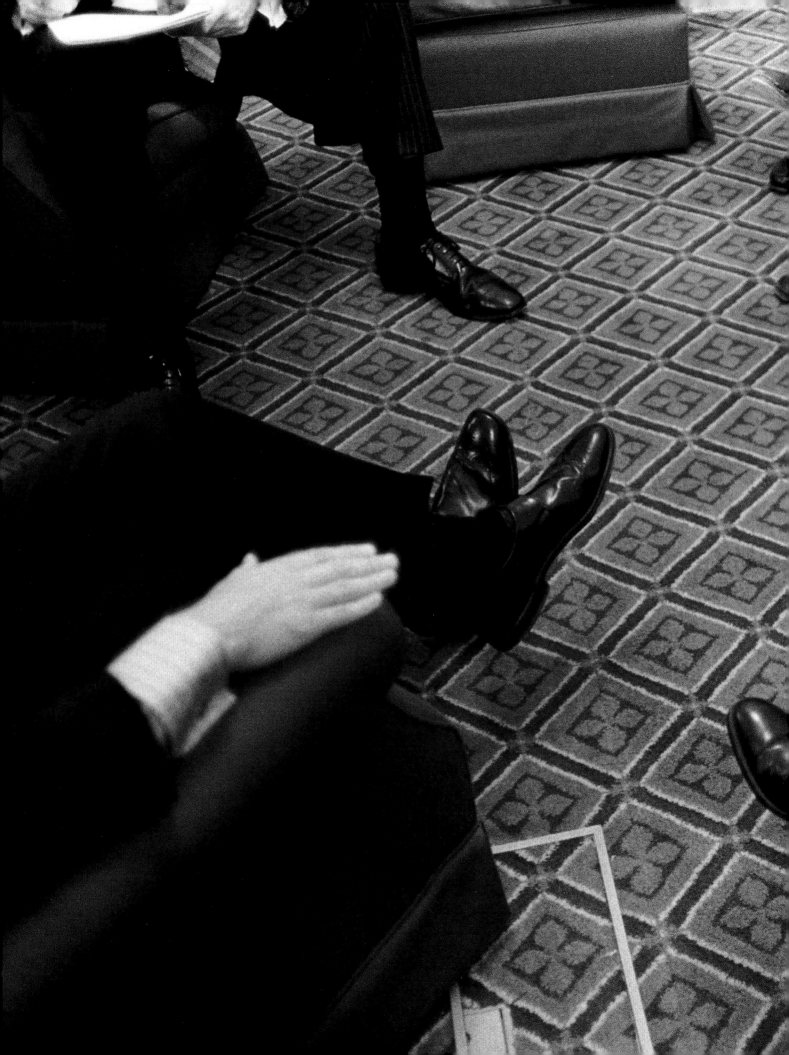

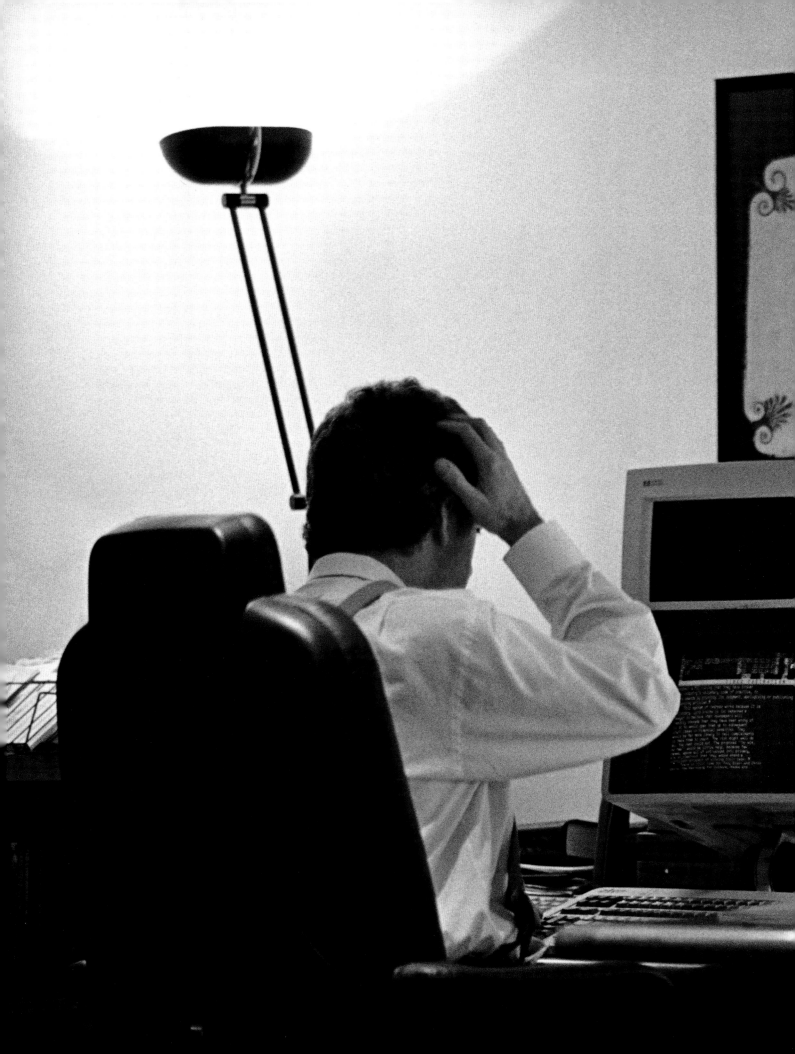

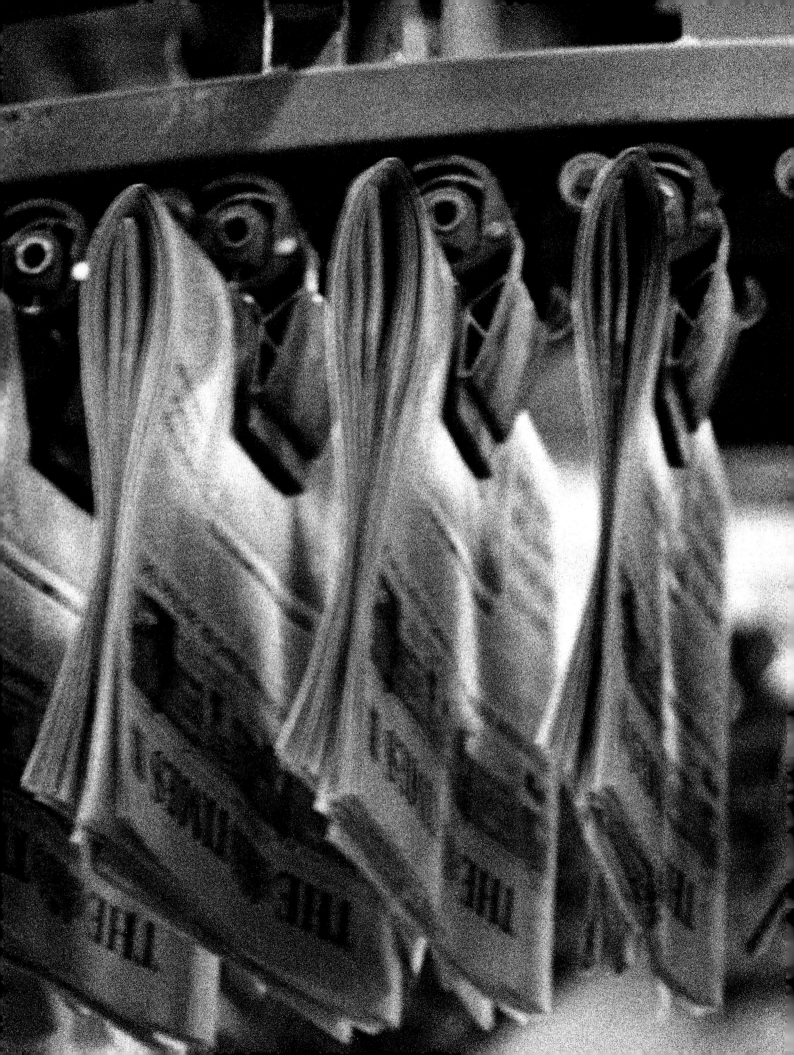

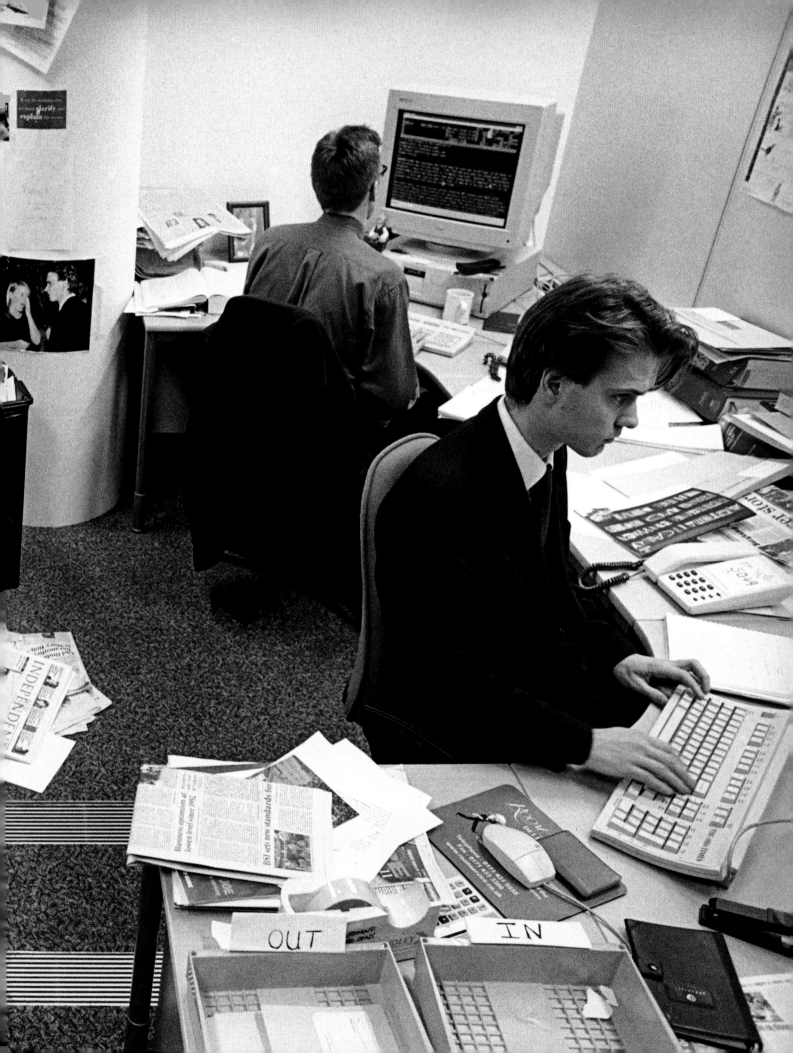

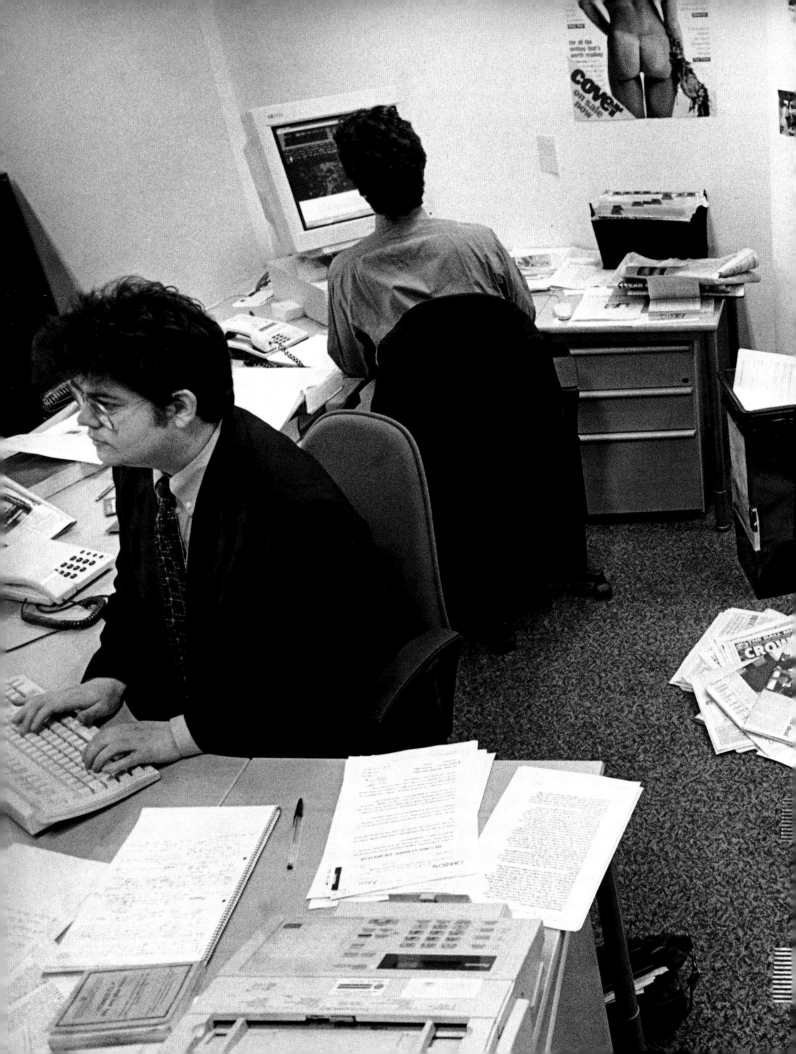

Peter's day at the paper starts at around 9 a.m., but he has already been working in the car, at home reading papers, or calling his writers to discuss ideas. At the end of the day the editor does a good deal of re-writing. If a really big story breaks, then the leader column will be entirely re-written by Peter.

The editor and several senior Times writers meet with William Hague (bottom left) in the Leader of the Opposition's Commons office. 'The Tory Party certainly had no intention of being helpful. I suspect some of them felt Rupert Murdoch had been unpleasant to them at the election, so why shouldn't they get a bit of their own back.'

The Times

The Times has always been seen as the noticeboard of the Establishment, and has been forming and informing public opinion over the last two hundred years. Peter Stothard has been the editor since 1992. In the cut-throat market place of the late Nineties' circulation war, the serialization of controversial books was one of Peter's main tactics to sell more papers.

The Times Diary has a central place in pricking the underbelly of the Establishment. The Diary desk is chaotic – littered with newspapers and cruel captions on photographs. It is one of the great Times institutions. Its stories are often picked up by other national newpapers.

Heading to the daily 10.45 a.m. conference – the first of several each day. Among those present will be the various editors and some experts.

The first edition of the paper runs off the presses at 9.30 p.m.

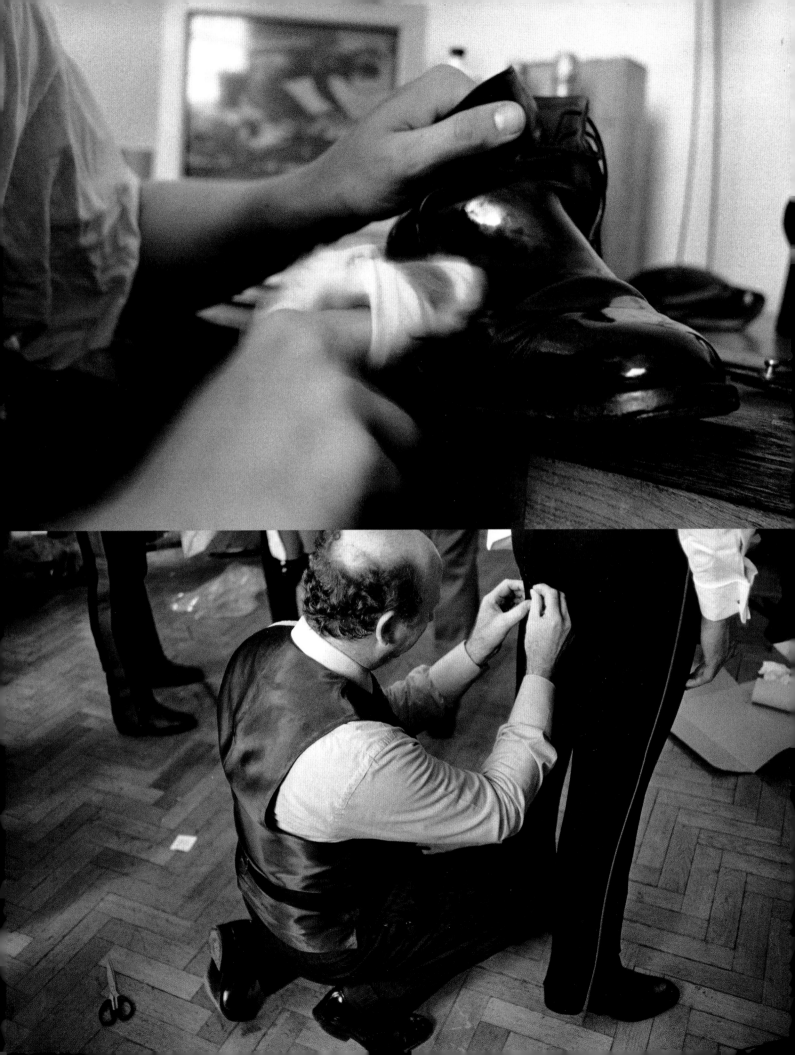

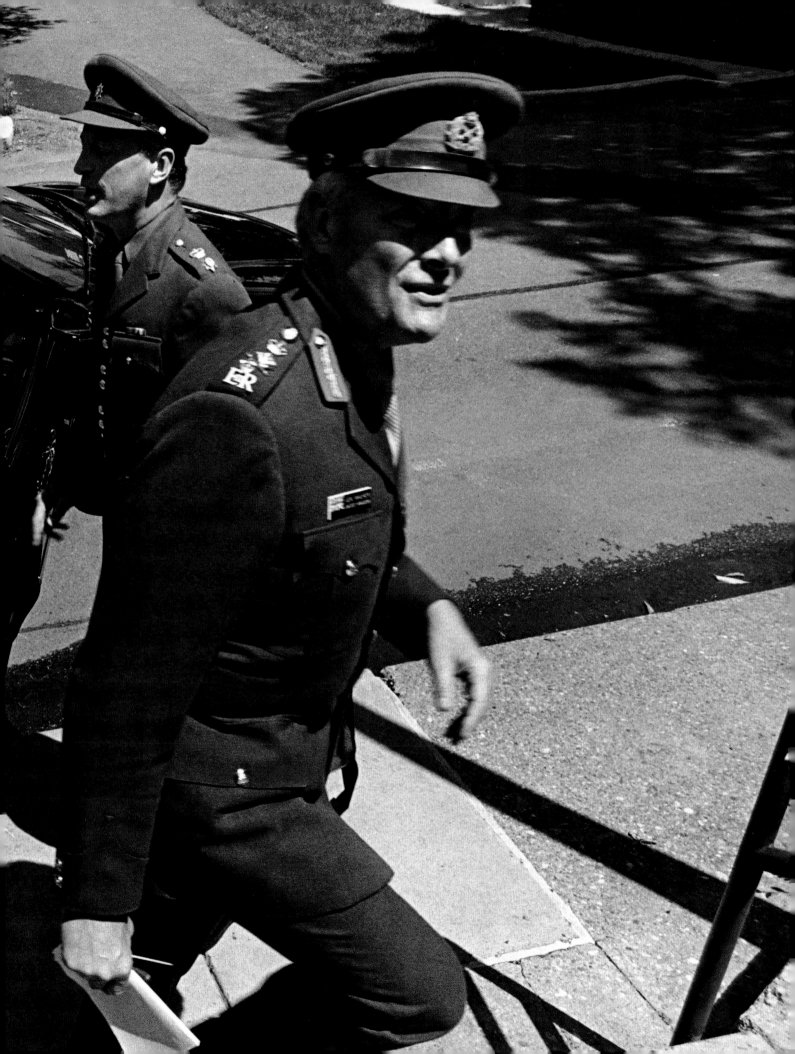

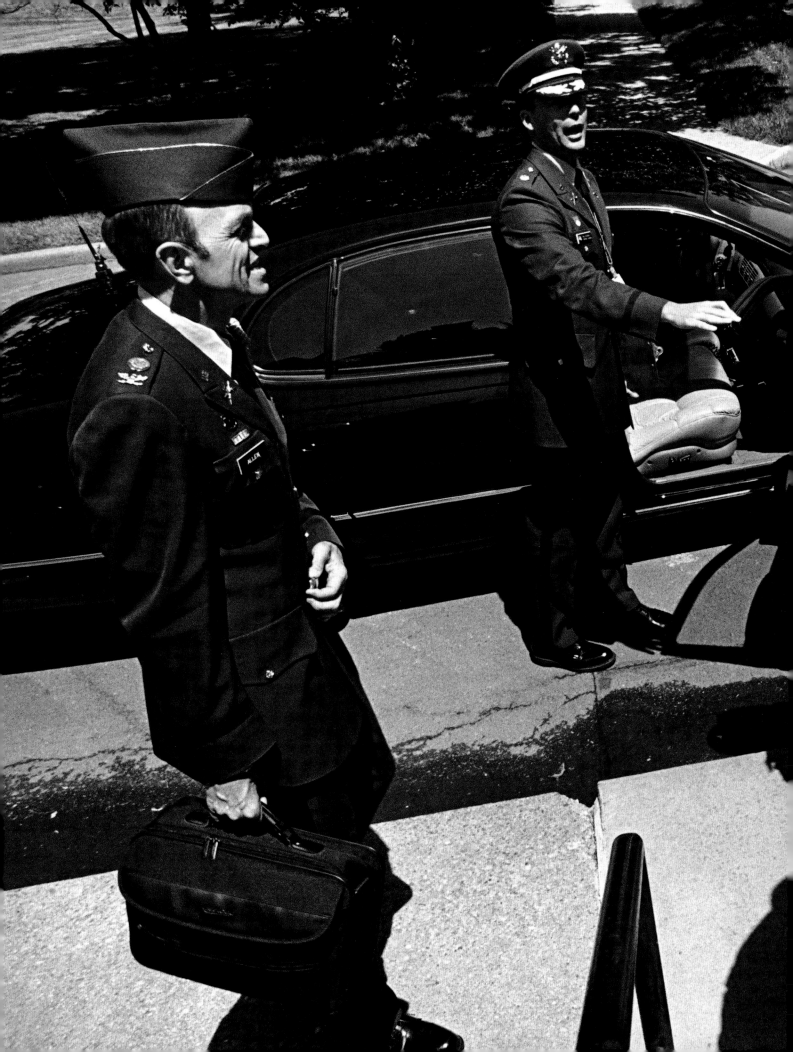

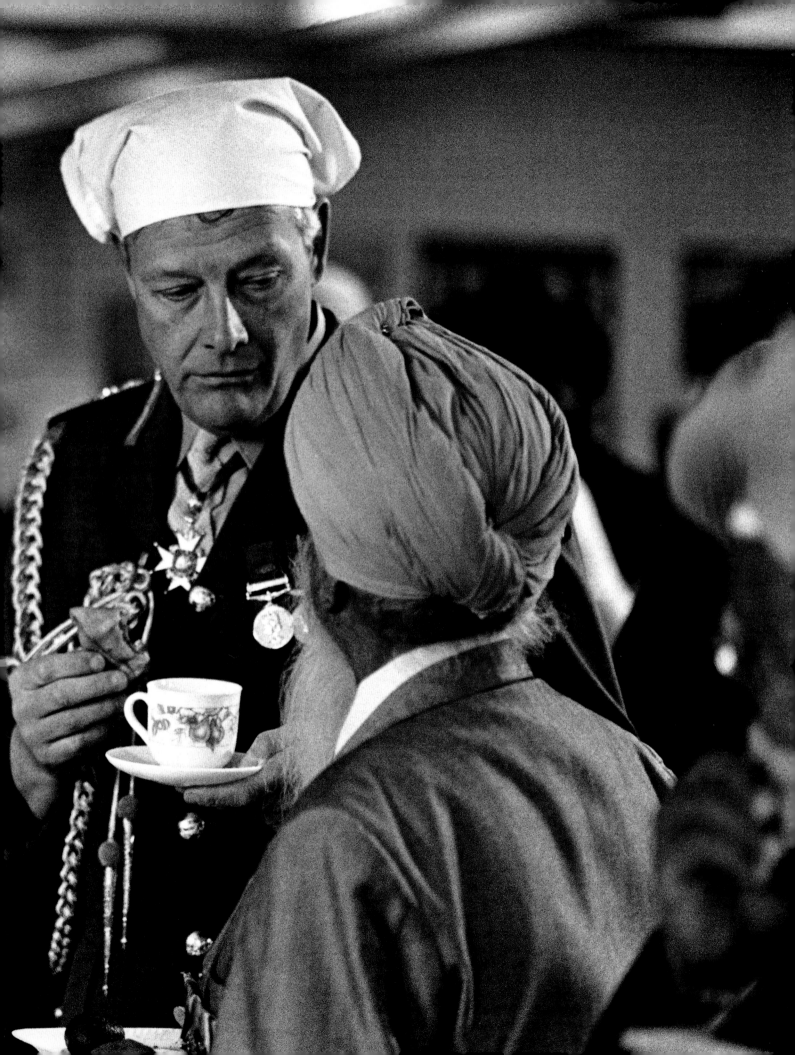

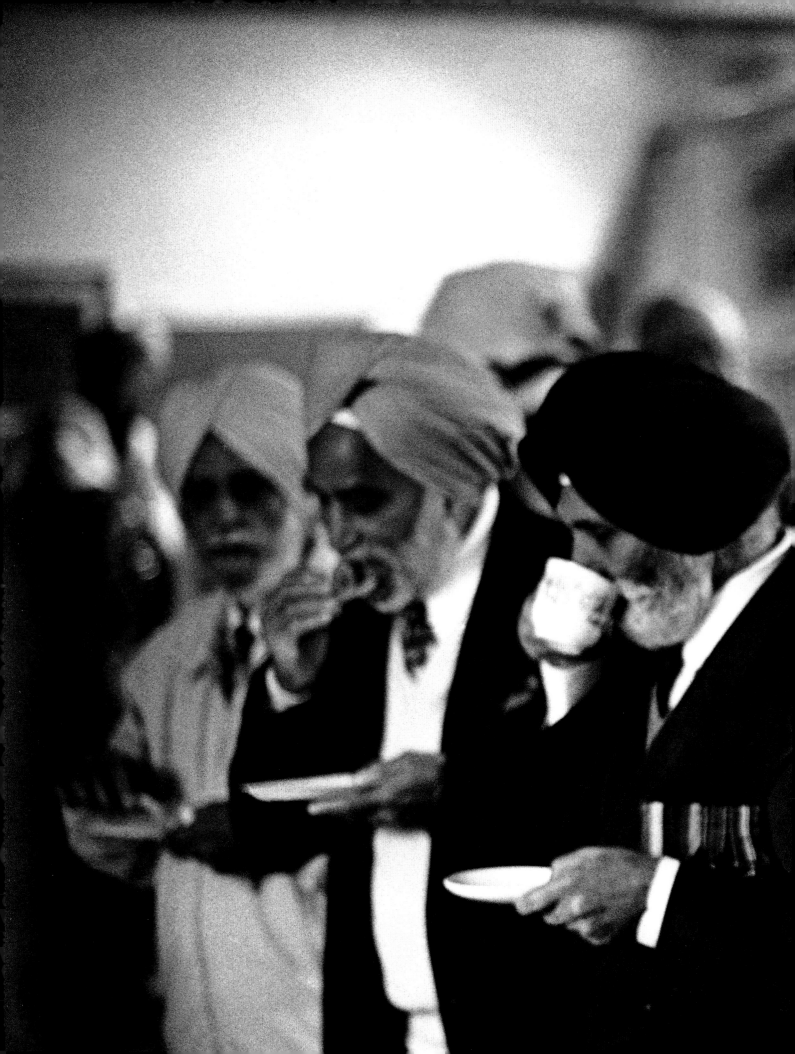

Matthew Woodison told me, 'When you are on your own in your room, with a bottle of Coke and a bar of chocolate, and you're polishing your shoes, you think to yourself, "Why the bloody hell am I doing this?" And then you just get on with it again. It's terrible to say, but I look at the average Joe Public in the street, and look at his shoes, and I think, "Oh God, they could do with a clean", or "He could do with a haircut".'

Prior to the Sandhurst Passing Out Parade a tailor adjusts Matthew's uniform.

Changing of the Guard, Windsor Castle.

Sergeant-Major, Sandhurst Parade Ground.

Sandhurst's Passing Out Parade. Sandhurst is where the Establishment turns young men into officers and gentlemen. Matthew Woodison says, 'What is good about our regimental system is that it's a club, it's a brotherhood of like-minded men, and they can only do better than the men who have gone before. Loyal to the end, and proud.'

The Army

Today's generals have to strike the correct balance between soldier and bureaucrat. General Sir Michael Walker, the Army's Commander in Chief (in charge of the men and, increasingly, women who make up Britain's army) does so. He has put together the most sweeping changes in defence policy that any single generation has ever seen. From the corridors of the Ministry of Defence to the battlefield of Bosnia, the General is as at ease with being in command as he is with diplomacy.

General Sir Michael Walker celebrating Vaisakhi, the Punjabi harvest festival, with Second World War Sikh veterans in Leicester's Gurdwara temple.

General Walker on the steps of the Pentagon on the way to meet the Chief of Staff of the US Army. As the former senior NATO commander in Bosnia, and the first British general to command US troops, 'General Mike' was given a hero's welcome for his service in Bosnia.

Matthew Woodison waits for the crucial interview after which he was hoping for a regular commission of twenty-five years in the Royal Anglians. His hopes were dashed by the board who awarded him only a SSC – a short service commission of three years.

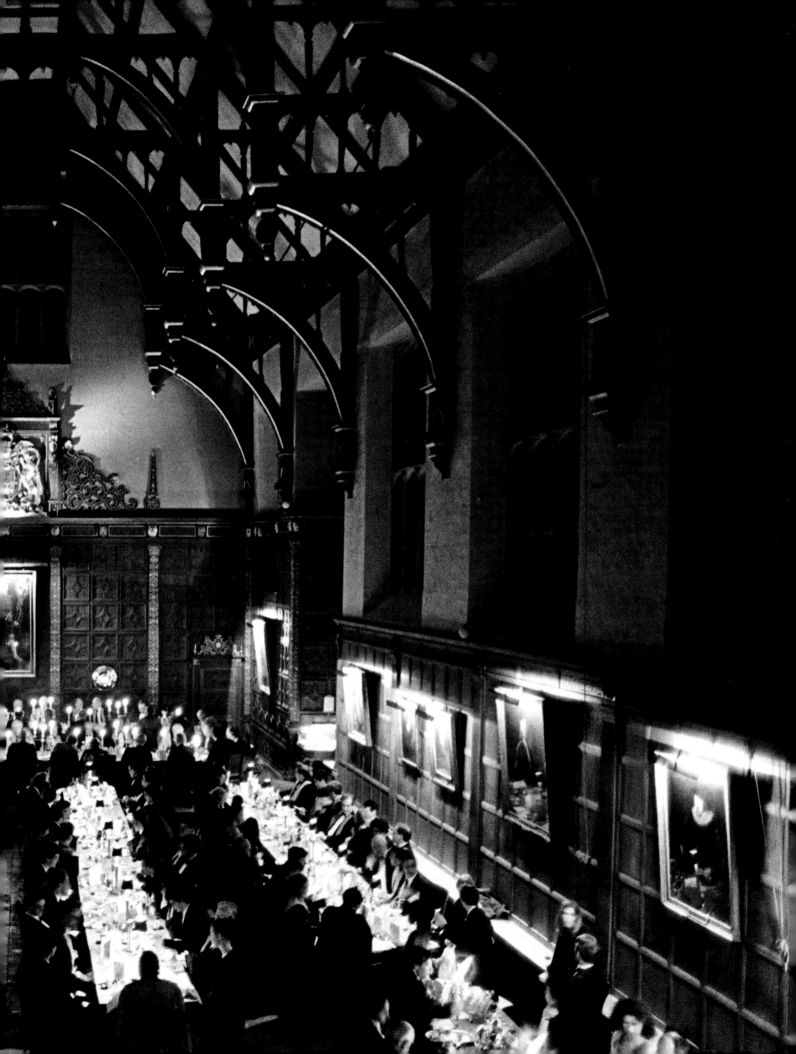

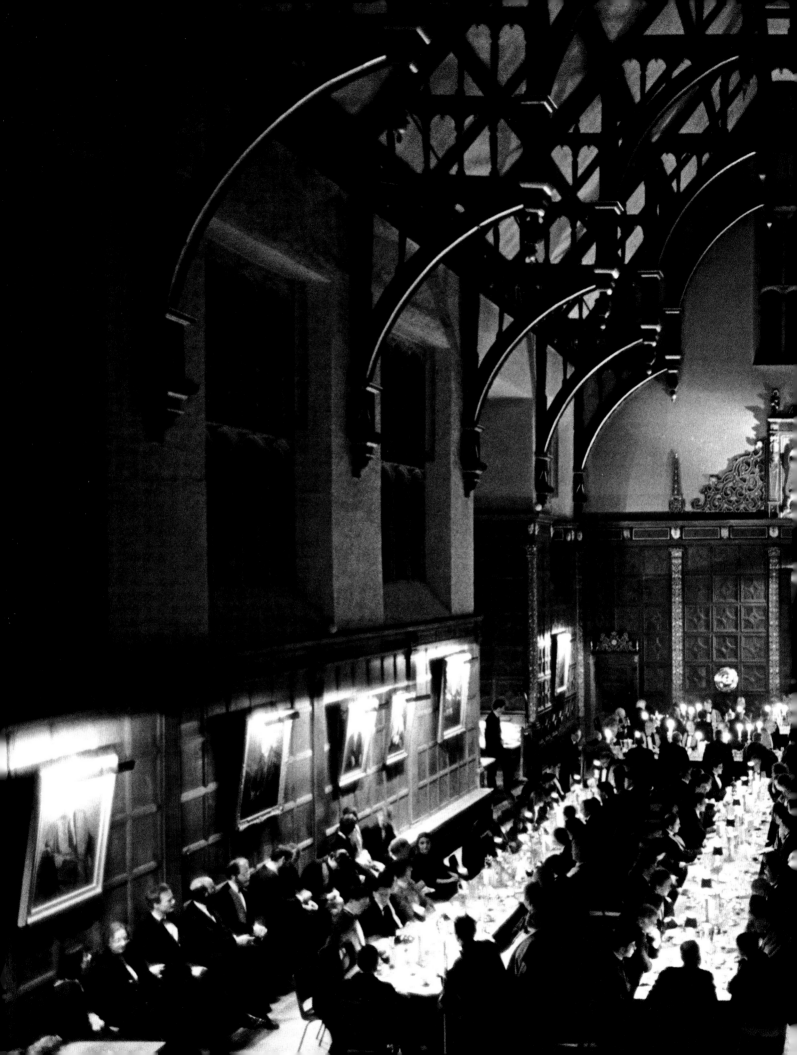

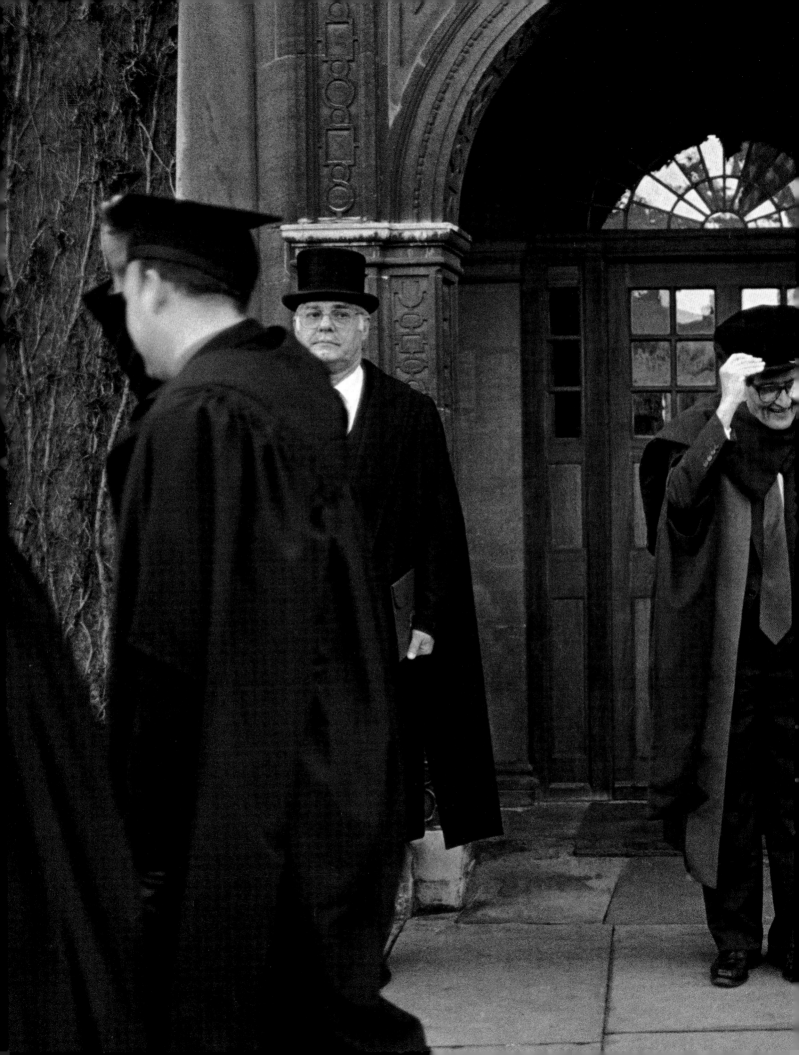

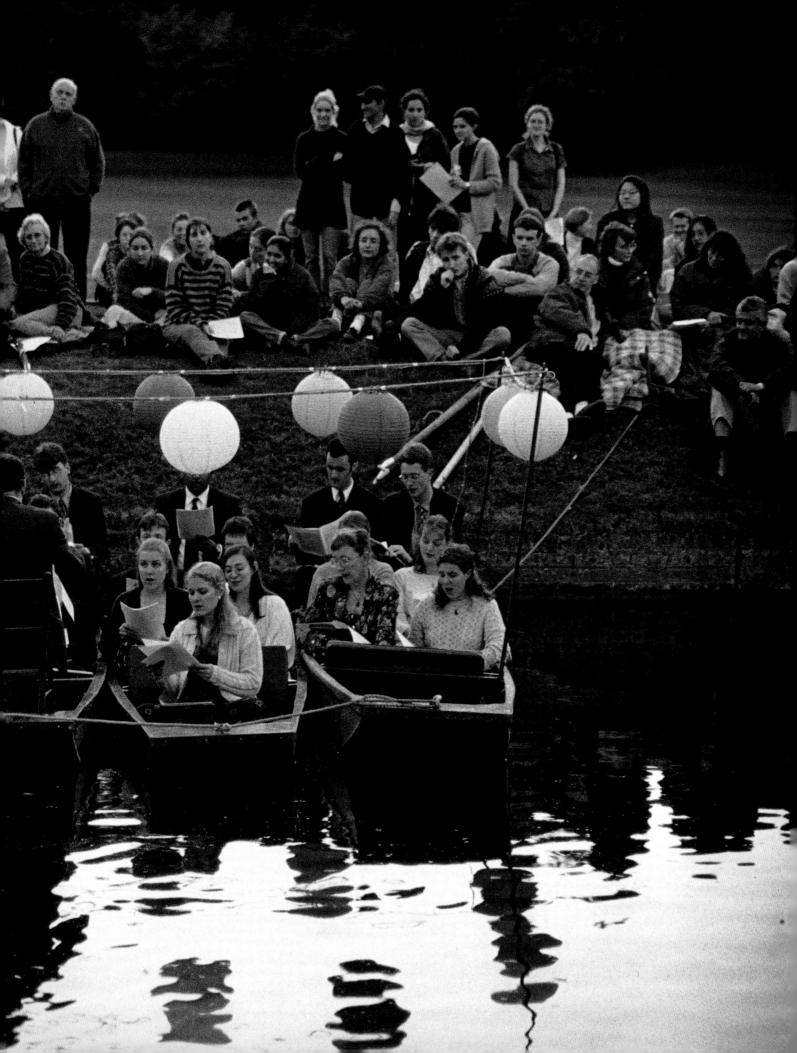

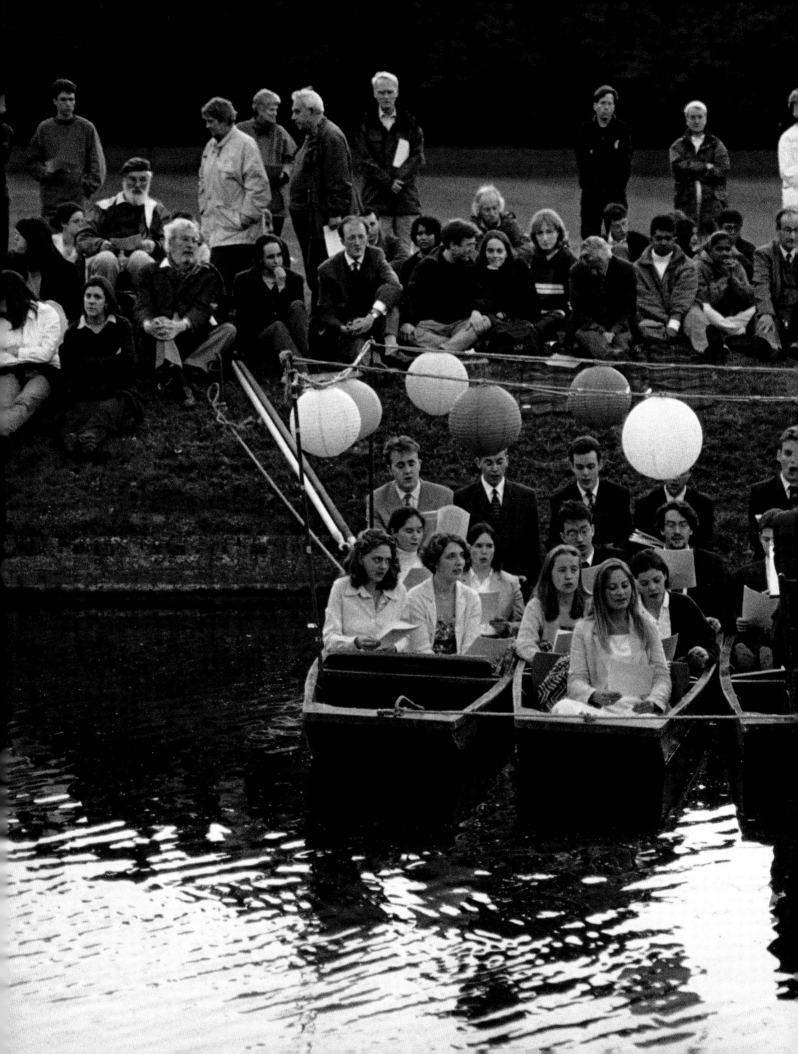

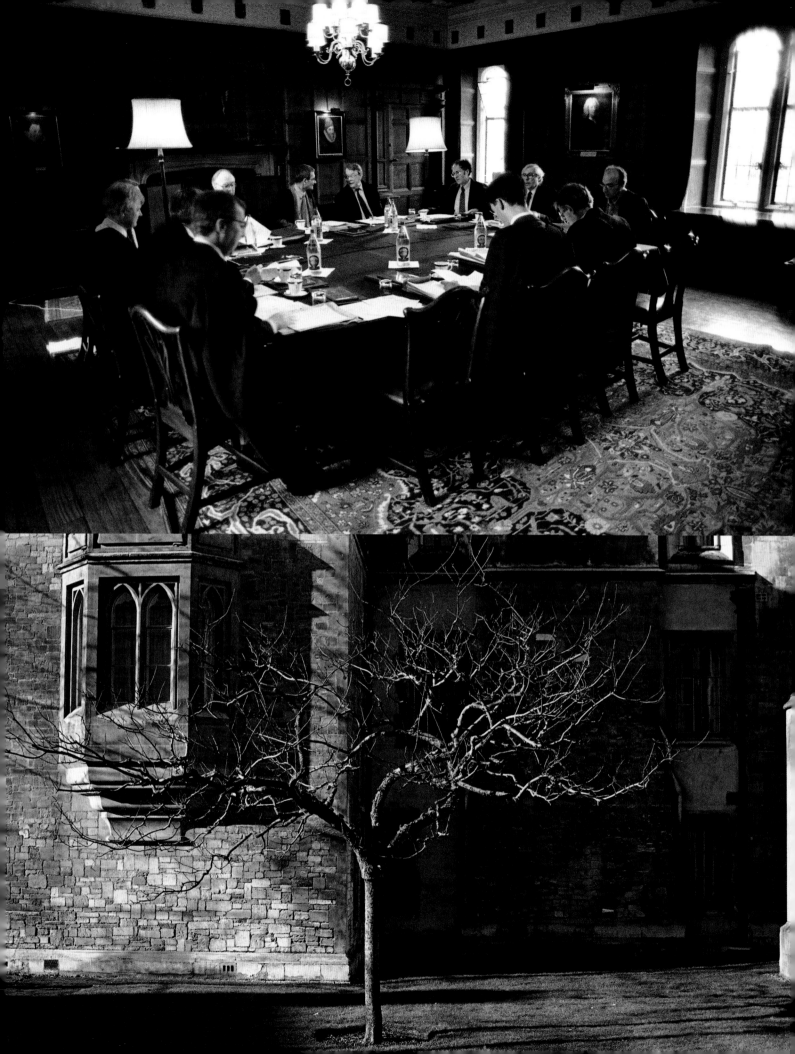

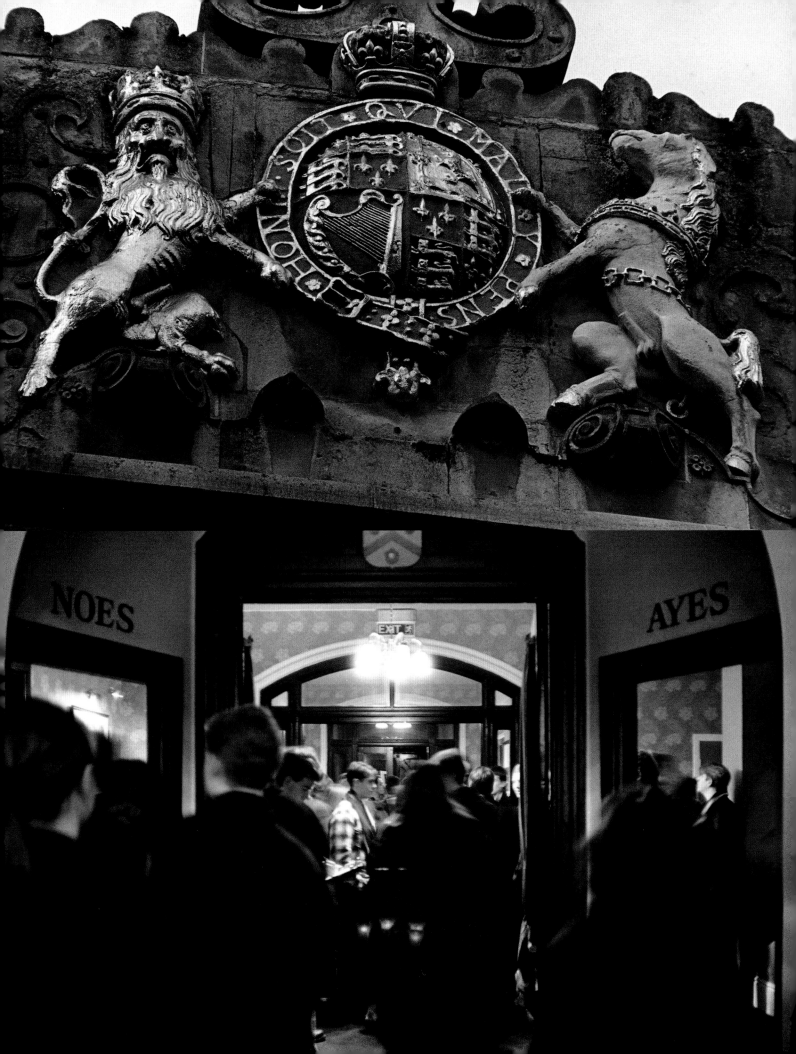

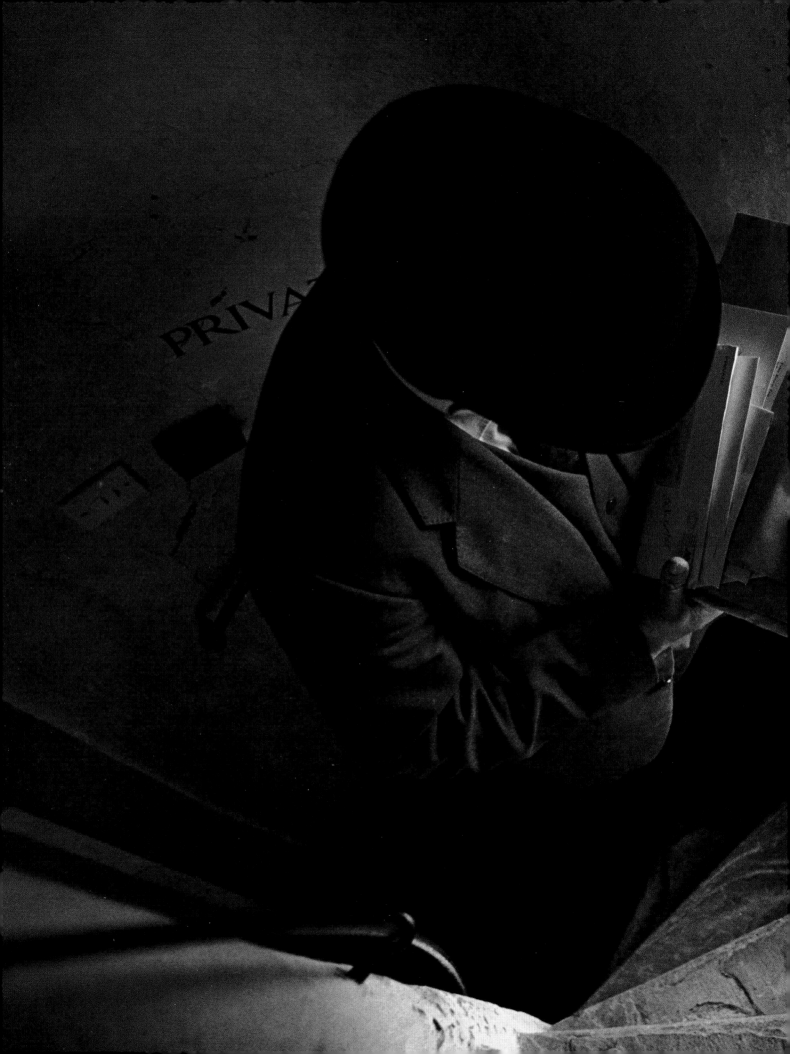

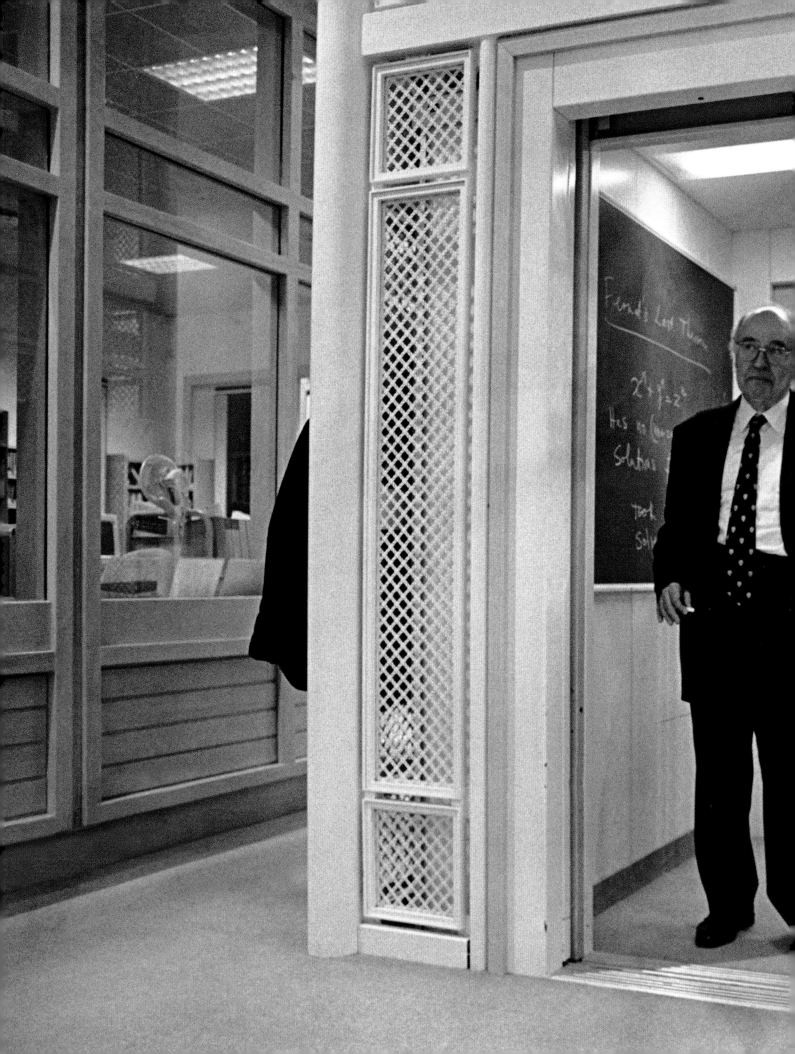

'I think Trinity resembles a medieval court with all the intricate politics, sometimes an old folk's home, other times a gentleman's club,' says Professor Gregory Winter, one of the fifteen Fellows who sit on the council. 'Machiavellian isn't quite right, because Machiavellian implies the whole thing is to do with scheming. Trinity is more like a Renaissance court in which there are many little interactions which dictate how it is run.'

The apple tree is a sapling (which doesn't bear fruit) on the site of Newton's original apple tree – in what was Newton's garden.

Waiting to enter Trinity's May Ball.

.

7 a.m. the morning after the Ball.

The proceedings for the Installation Ceremony of the New Master are set out in the college statutes of 1658. Professor Amartya Sen, appointed in January 1998, doffs his cap to the Fellows. The appointments secretary had offered two names to the Prime Minister. It was rumoured that he was asked to look again and the search became international. Amartya Sen, born in Bangladesh, is a former student at Trinity. He is one of the world's leading experts on the causes of poverty, is Professor Emeritus at Harvard University, and in October 1998 became a Nobel Laureate.

The Installation Feast to honour the new Master, Amartya Sen. The former Master, Sir Michael Atiyah, told me, 'Trinity, with its unbroken continuity, is rather unique. Where else in the world has lunch been taken on the same table for over four hundred years?'

Trinity College is the richest and largest Cambridge college. It has produced more Nobel prize winners than the whole of France and has a firmly established position at the forefront of national and international academia.

Great Court. The college was founded by Henry VIII in the sixteenth century and was endowed with land following the dissolution of the monasteries.

Sir Michael Atiyah, a former master of Trinity, emerges from a lift with its own blackboard in the Isaac Newton Institute for Mathematical Sciences. Sir Michael Atiyah was born in the Lebanon and educated at Trinity. He obtained his PhD at Oxford, and held fellowships at Cambridge and Harvard.

A porter delivers the post. 'It is our job to make sure the Fellows' life in the college runs as smoothly as possible. We're not pandering to them, we're rendering a service which they deserve.'

Wren Library and Porter's Lodge.

.

The Cambridge Union is a good training ground for the College Council, where the intrigues of college life are most apparent. This inner circle has to approve every decision on the running of Trinity. It's where the 150 Fellows fight it out through their elected representatives.

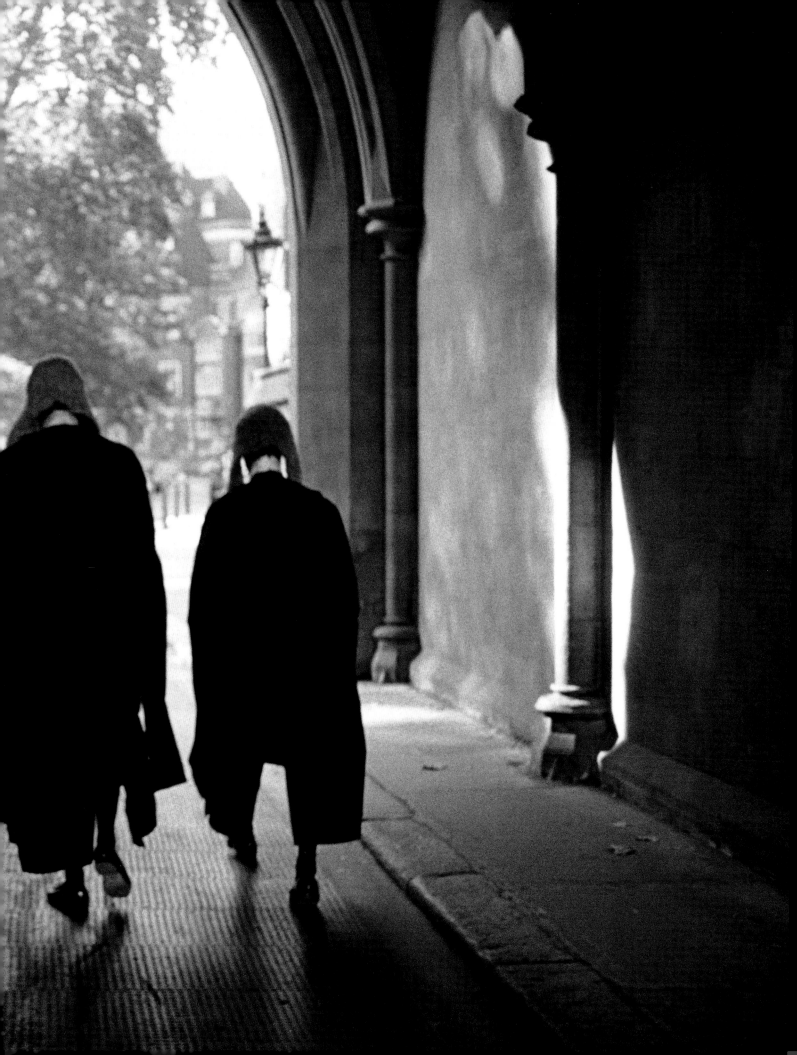

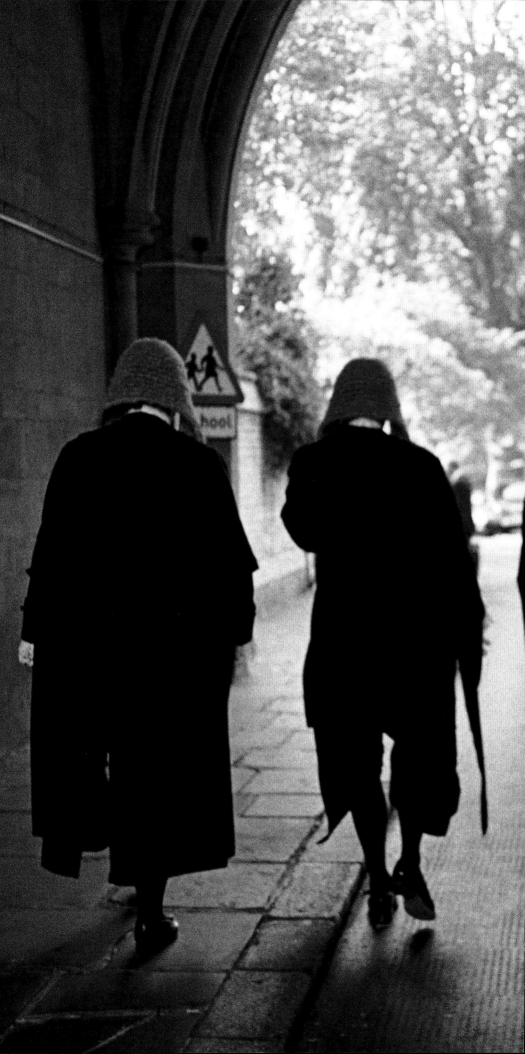

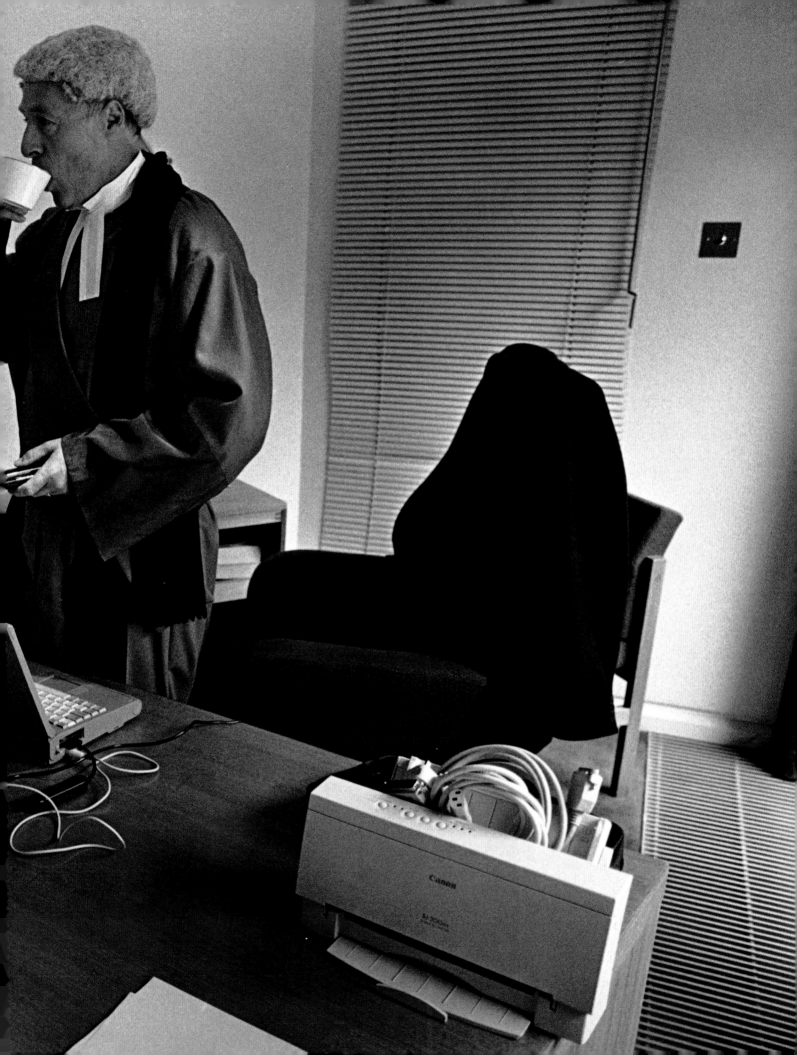

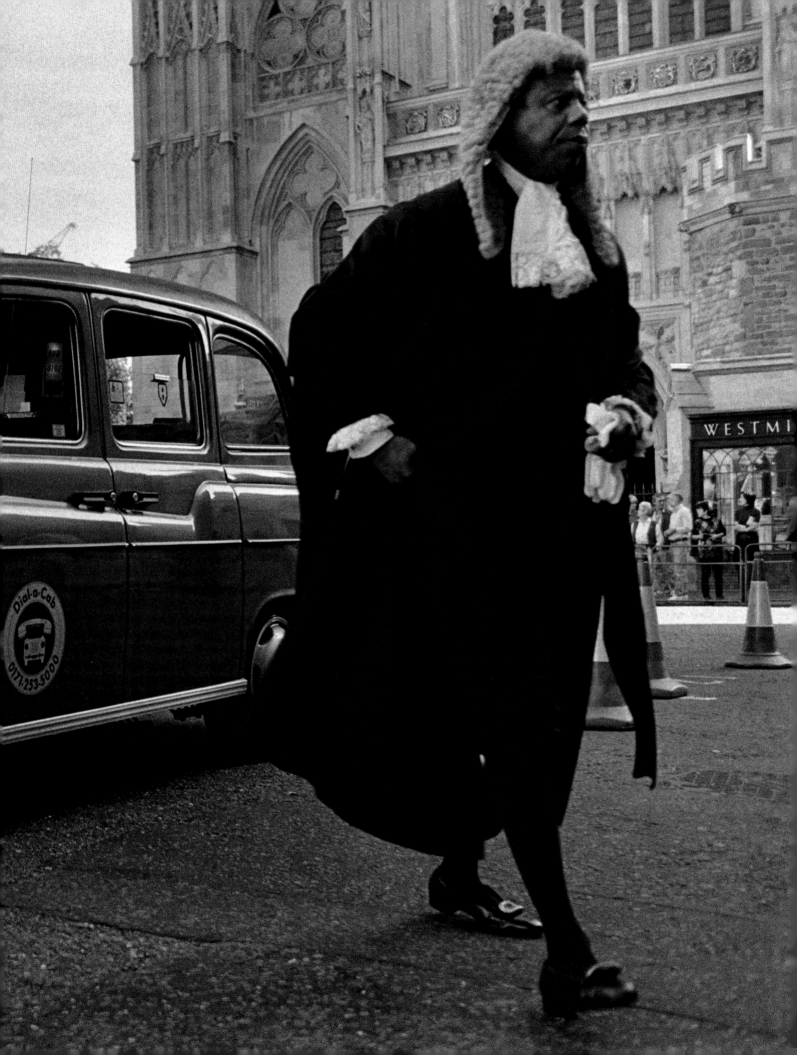

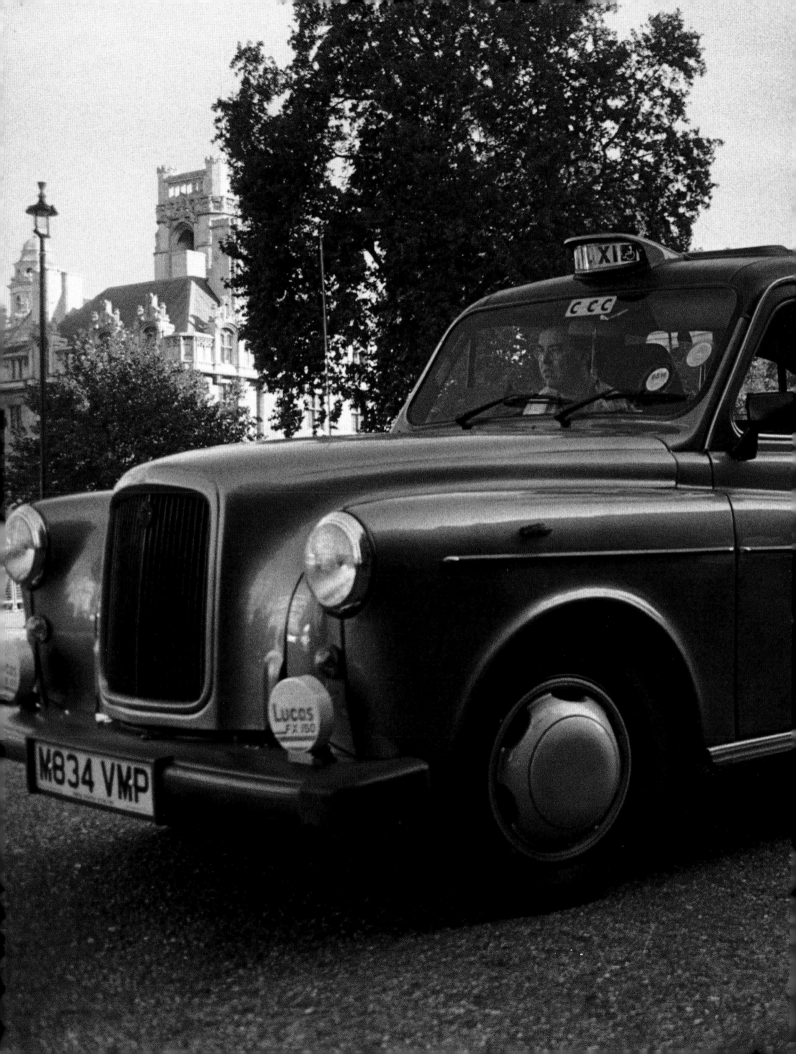

Honourable justices
outside Westminster
Abbey at the opening
of the New Legal Year.

The Judges

The start of the New Legal Year, on the first Monday of each October, is marked by a procession of judges arriving at Westminster Abbey from Temple Bar for a religious service. The custom goes back to the Middle Ages, and the prayers for the guidance of God, 'the final and supreme judge of all', today seek help 'in holding the wisdom of the past, the traditions in which we stand, and in discerning the developments of the future'. Up until the Reformation, the judges were required to fast, hence it became customary for the Lord Chancellor to offer them something to eat before they went into court.

Entering Westminster Abbey at the opening of the New Legal Year. The ceremonies are more or less as they have always been, but instead of the two-mile walk from Temple Bar to Westminster Abbey the judges now travel by car or taxi.

After a 45-minute service at Westminster Abbey, judges and QCs, in ceremonial dress, proceed on foot from Westminster Abbey to Westminster Hall in the Palace of Westminster for the Lord Chancellor's breakfast (a light buffet).

The Honourable Mr Justice Butterfield prior to presiding over a case at Truro Crown Court.

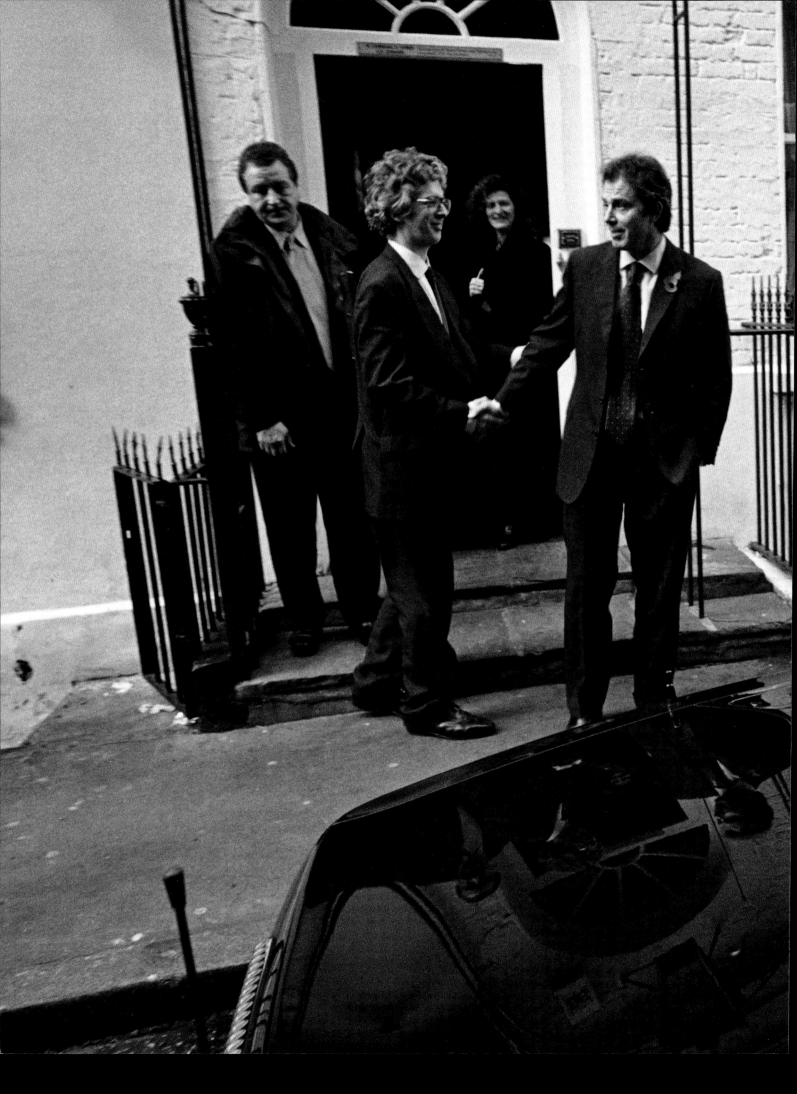

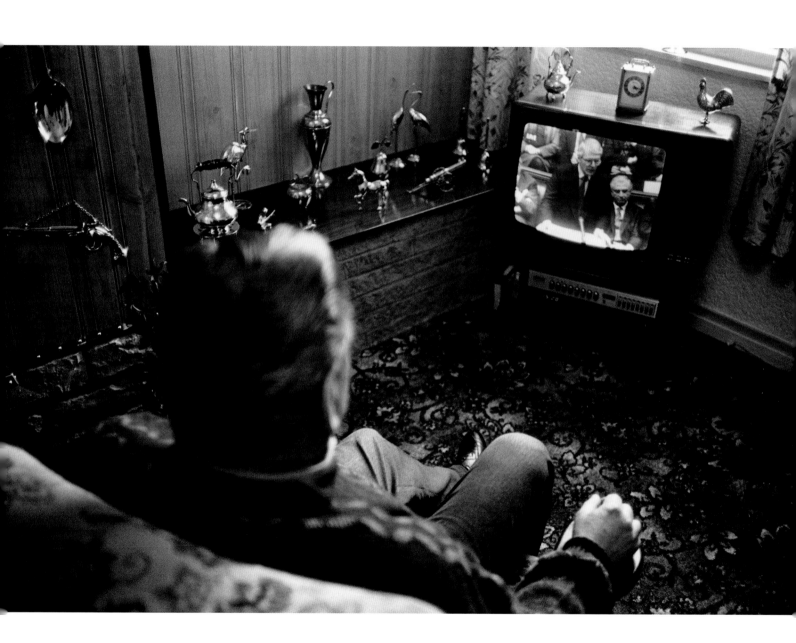

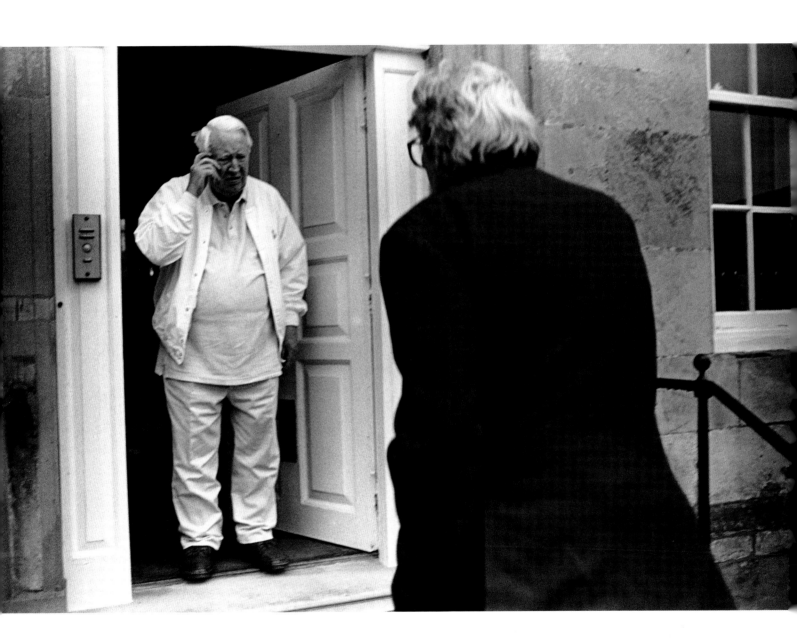

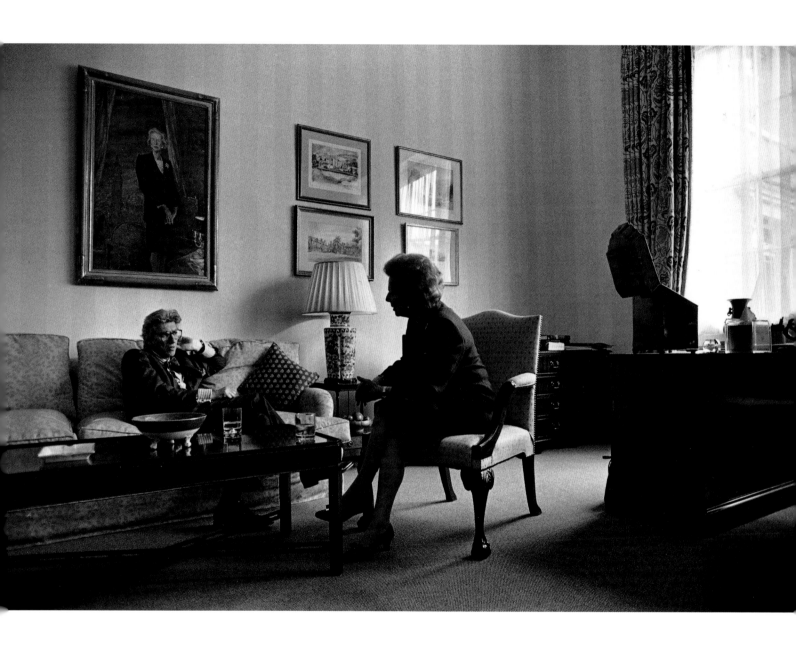

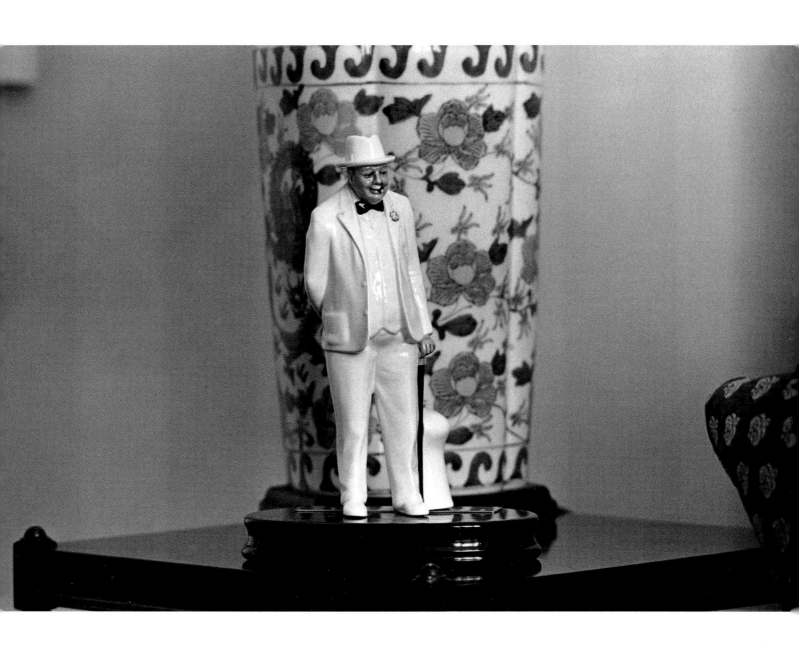

Tony Blair saying
his farewells after a
private lunch in
London's Soho.
'Education is the best
economic policy
there is.'

For those with access to 'Margaret', 'Tony', 'Ted' and 'John' there exists, in the words of Lord Gowrie, 'a chumminess; a radioactive influence of people', who move in the same circles and have the calling card of access – often from birth.

Margaret Thatcher in her study. 'Economics are the method; the object is to change the soul.' On one of two side tables next to her sofa is a porcelain statue of Sir Winston Churchill.

Ted Heath on the steps of his home in Salisbury. 'If politicians lived on praise and thanks they'd be forced into some other line of business.'

John Major during *Parliament Live*, as seen from a living room in Barrow-in-Furness. 'Fifty years on from now, Britain will still be the country of long shadows on county [cricket] grounds, warm beer, invincible green suburbs, dog lovers and old maids bicycling to Holy Communion through the morning mist.'

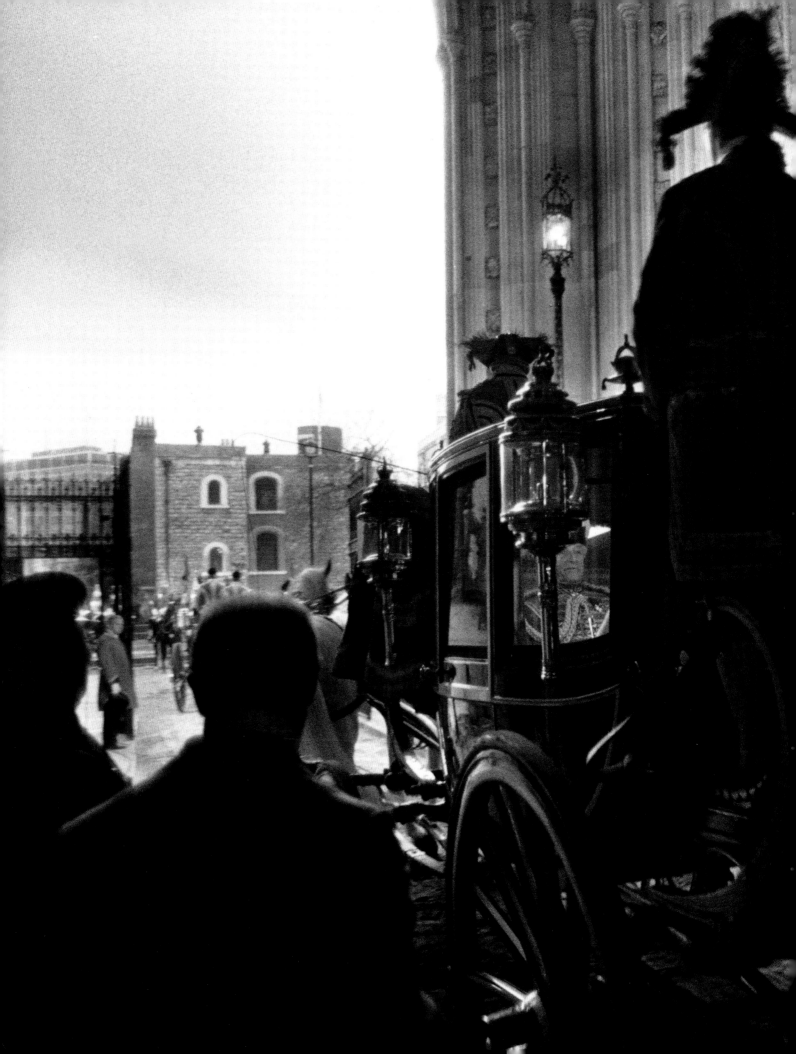

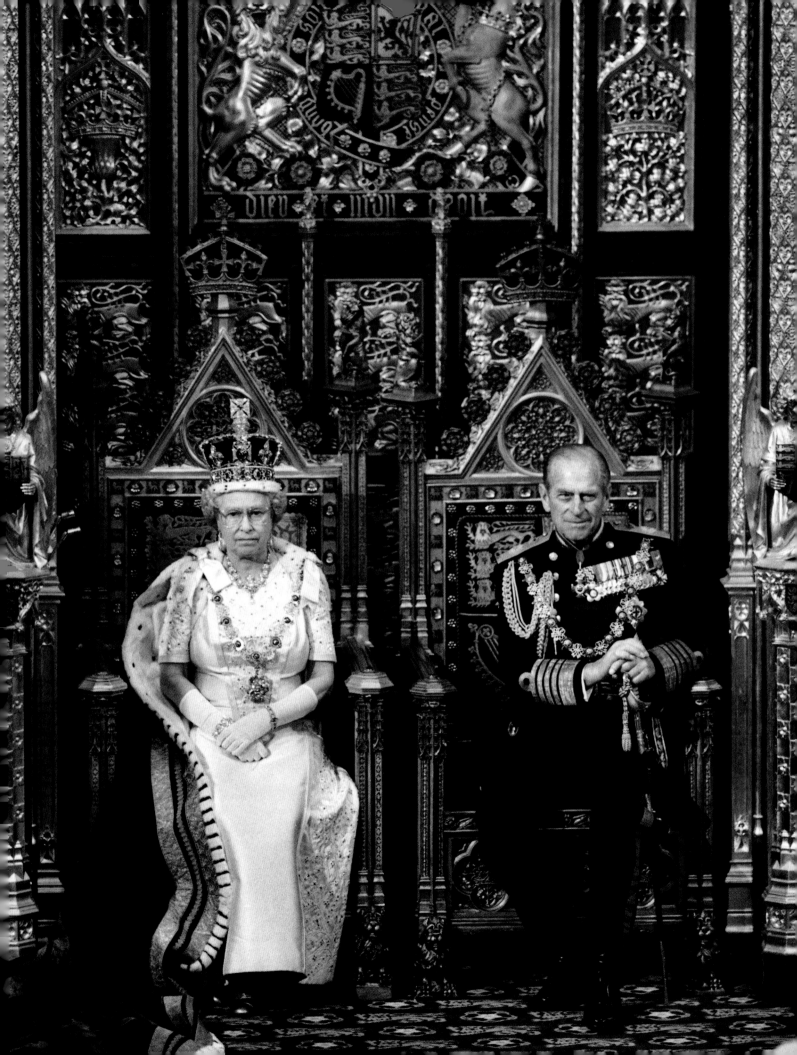

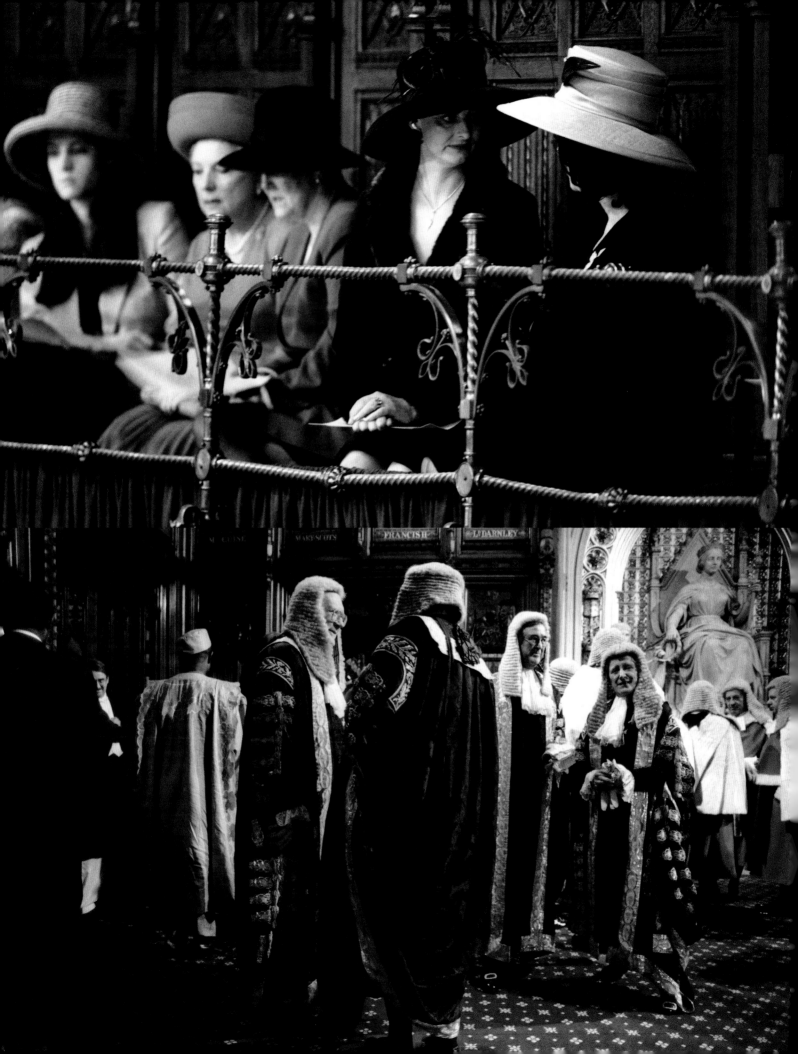

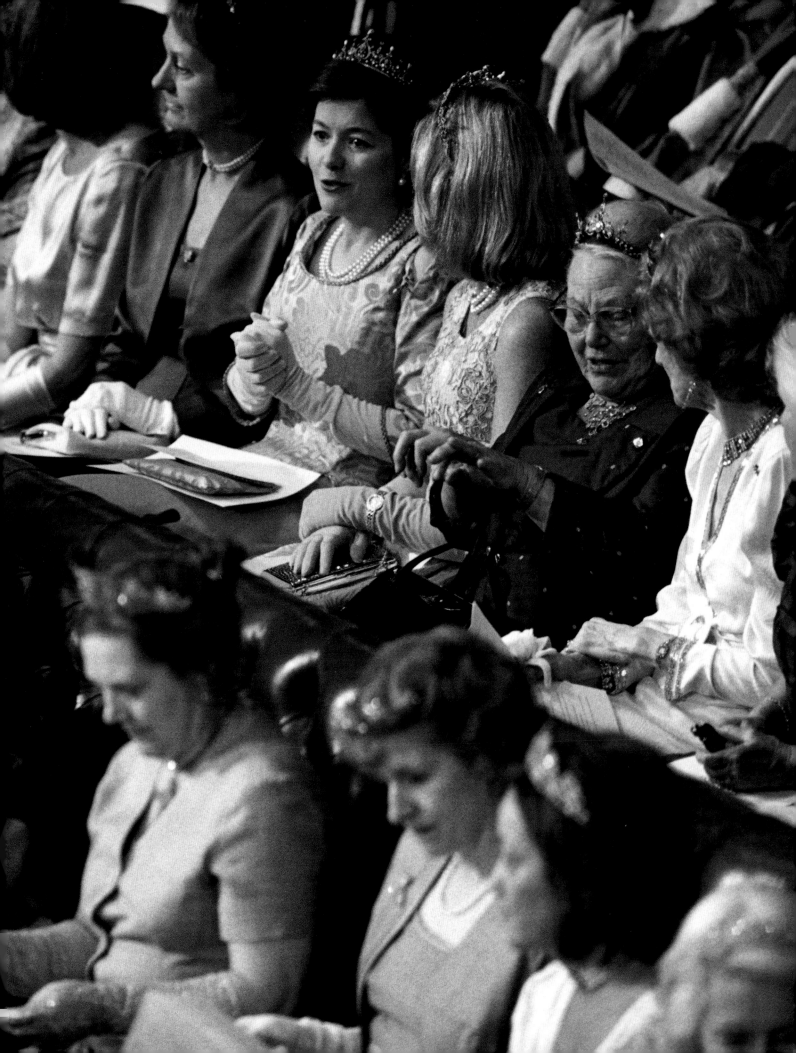

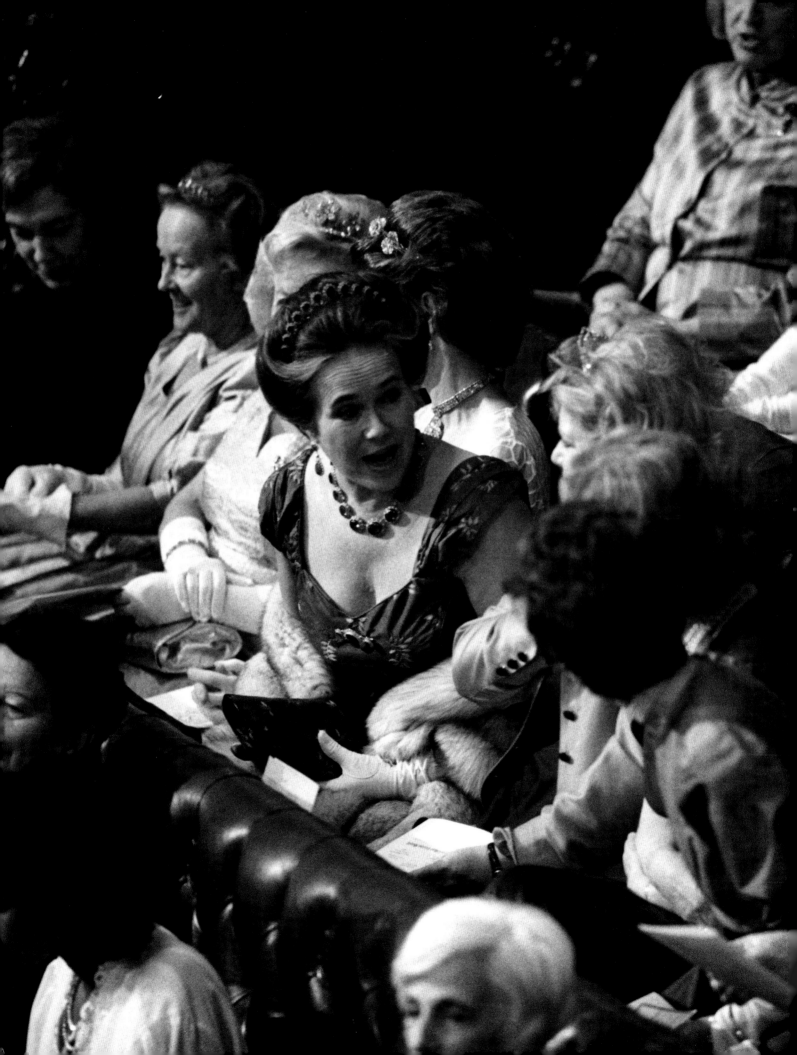

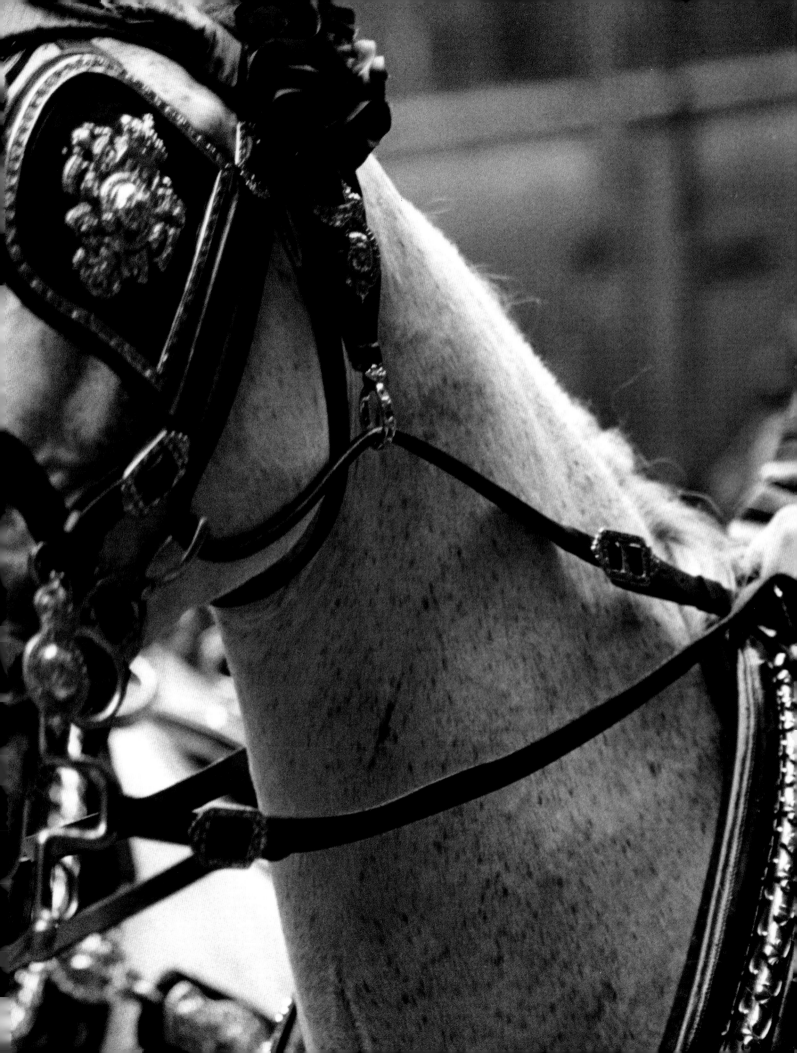

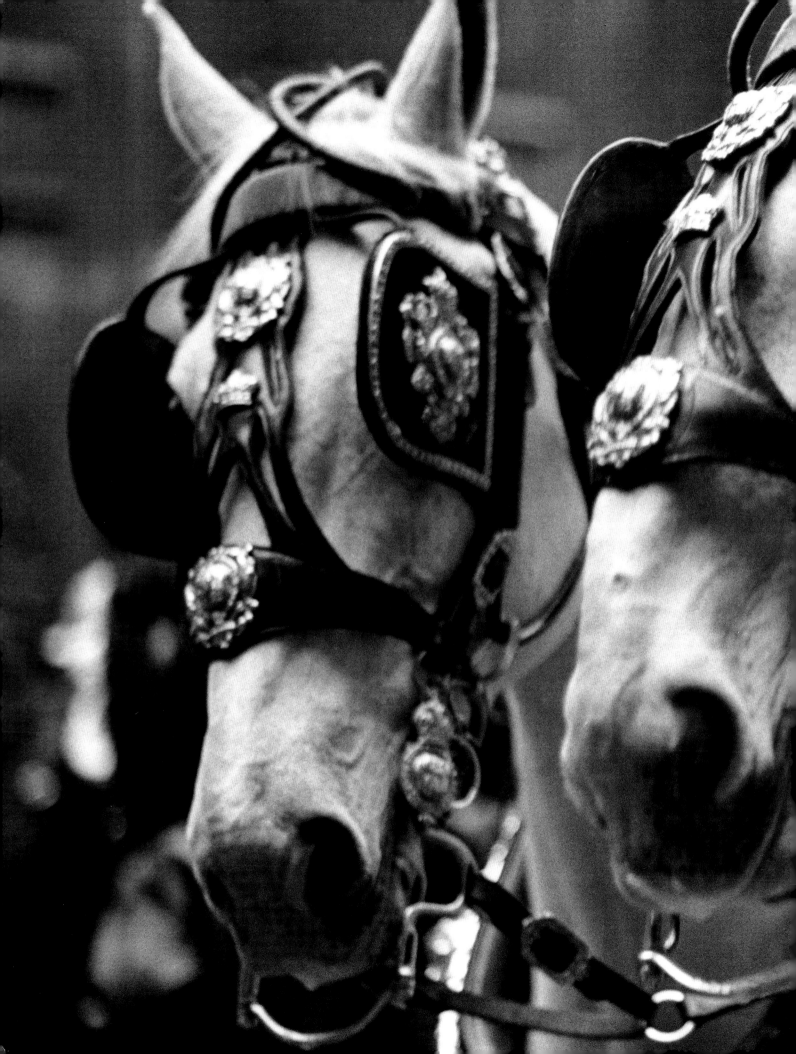

Her Majesty Queen
Elizabeth II, seated on
the throne, before
reading The Queen's
Speech.

The Irish State Coach
which carries Her
Majesty back to
Buckingham Palace.

Royalty

The Queen formally opens the new session of Parliament each year, usually in October or November.

Her Majesty's horses.

Peeresses in the Chamber before the State Opening of Parliament.

Cherie Blair in the Lords visitors' gallery.

Law lords and foreign ambassadors before entering the chamber to hear the Queen.

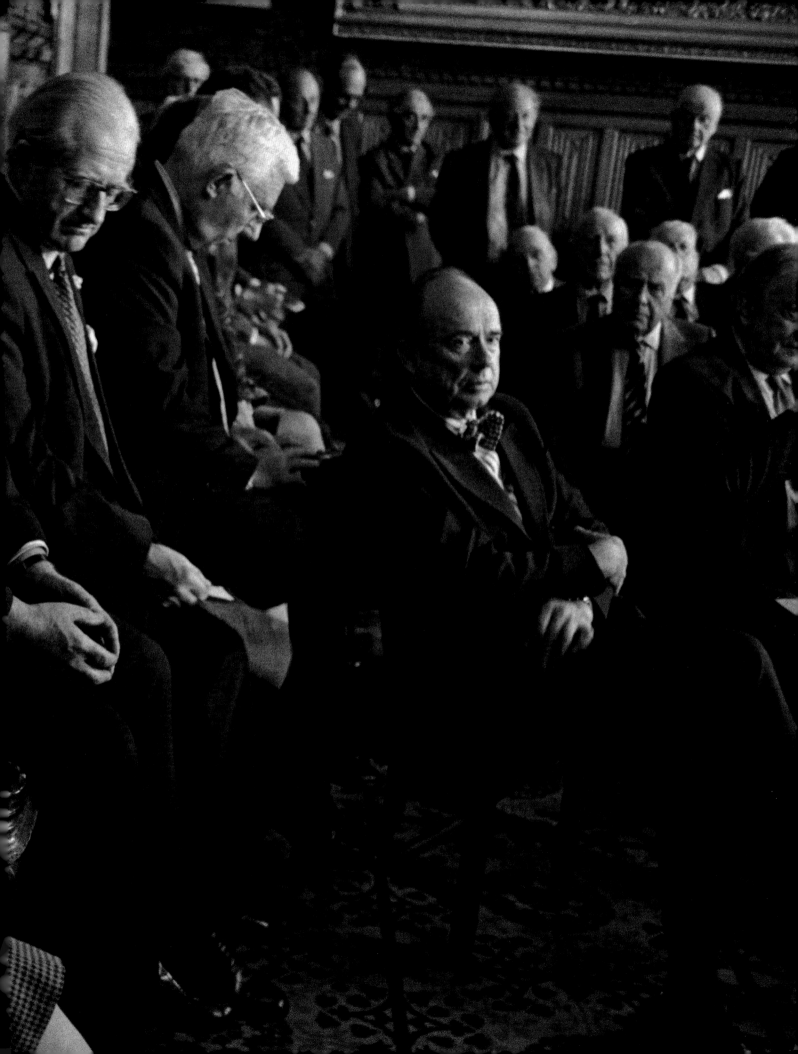

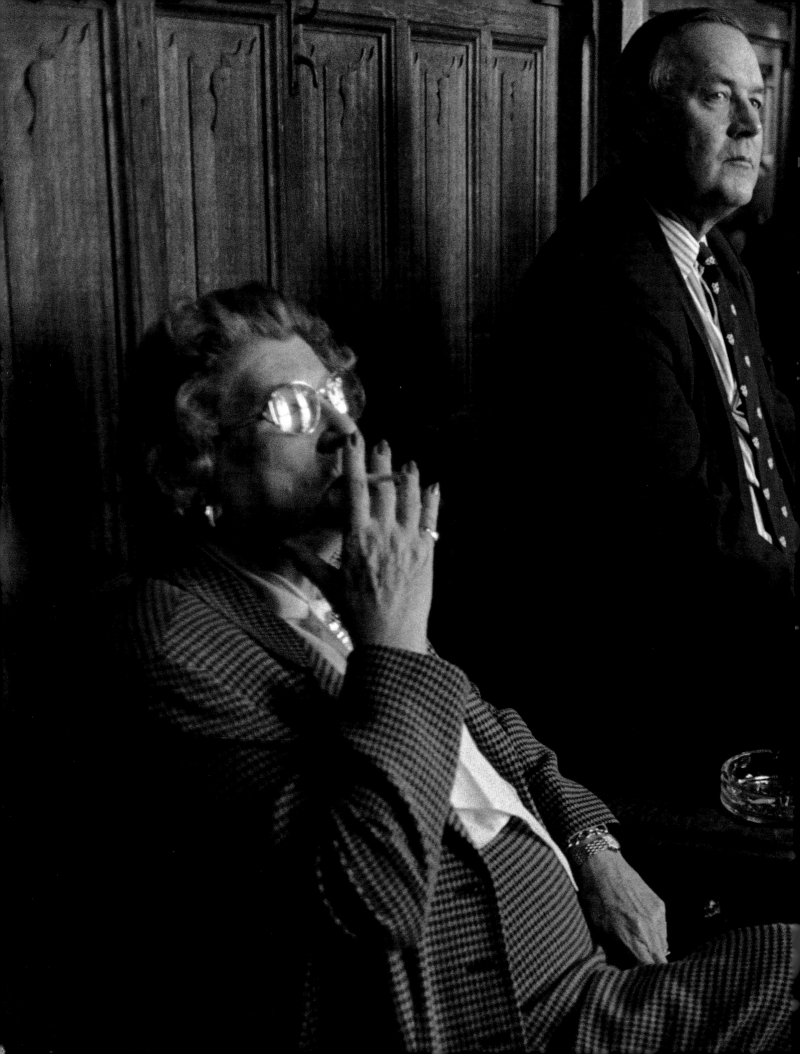

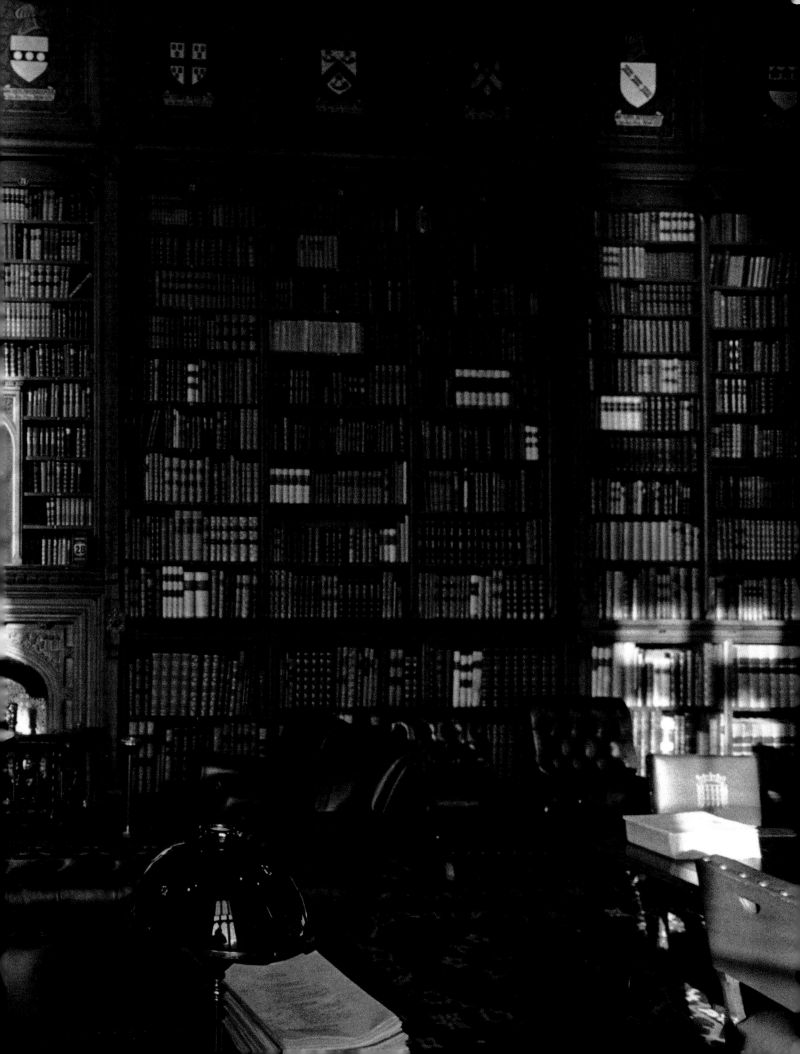

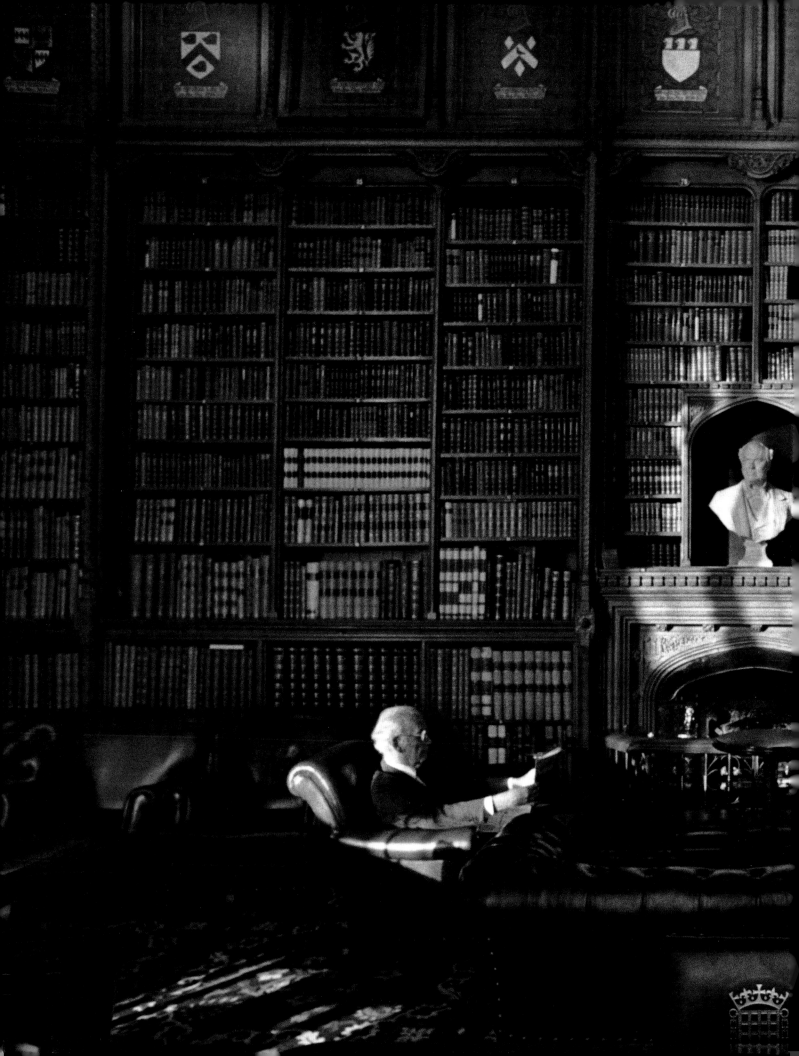

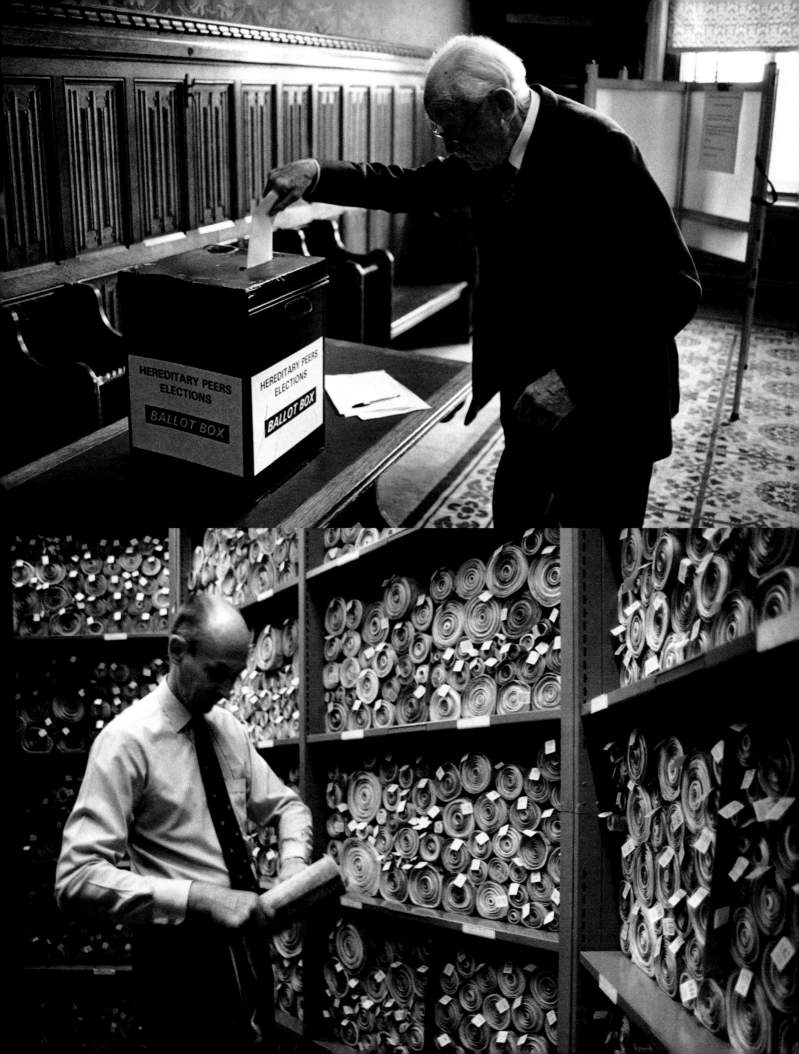

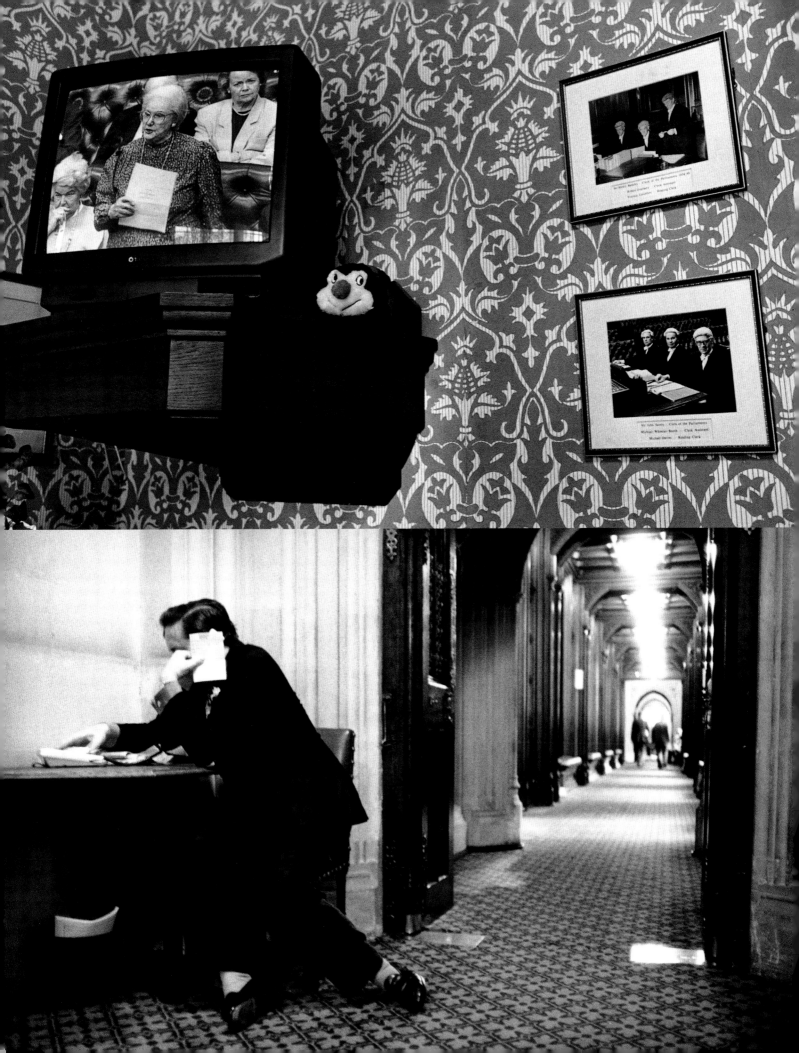

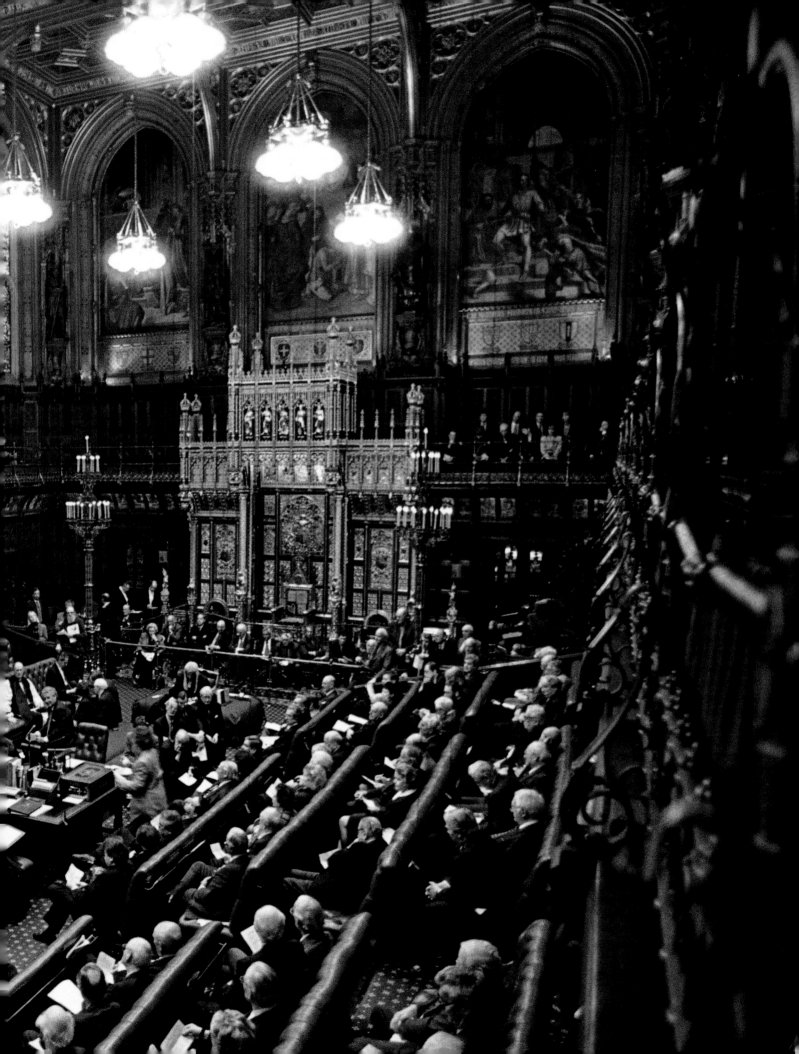

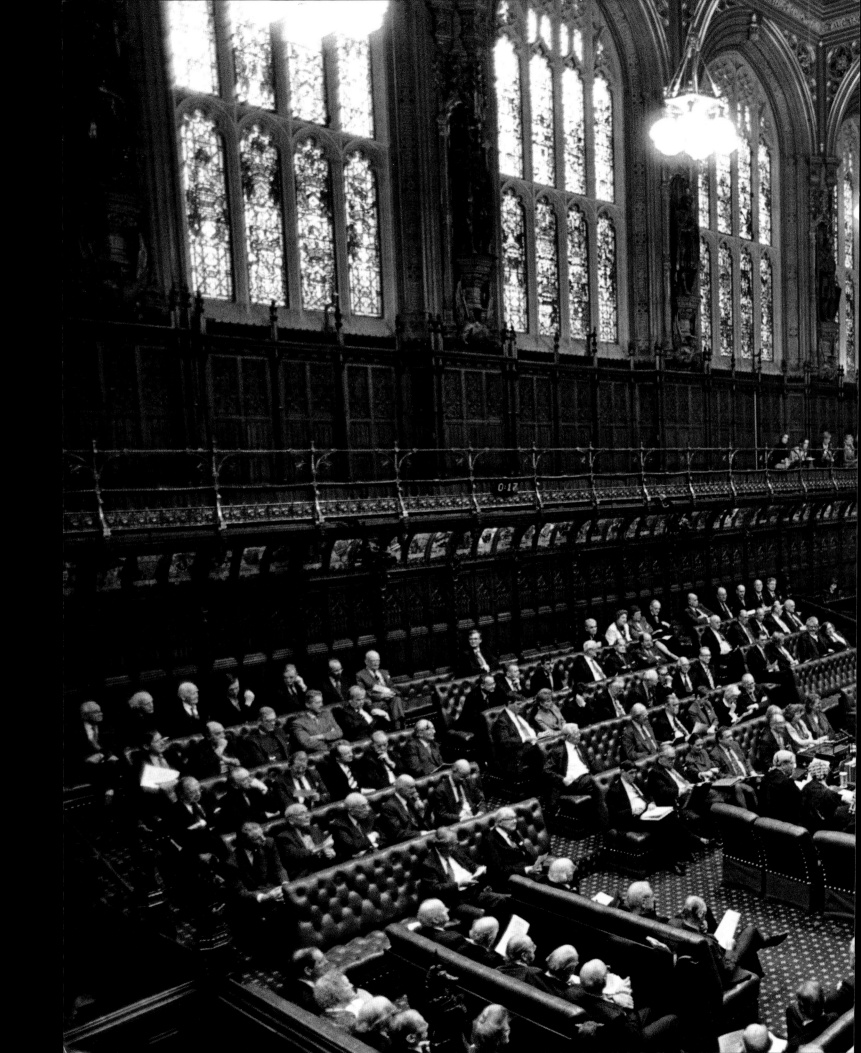

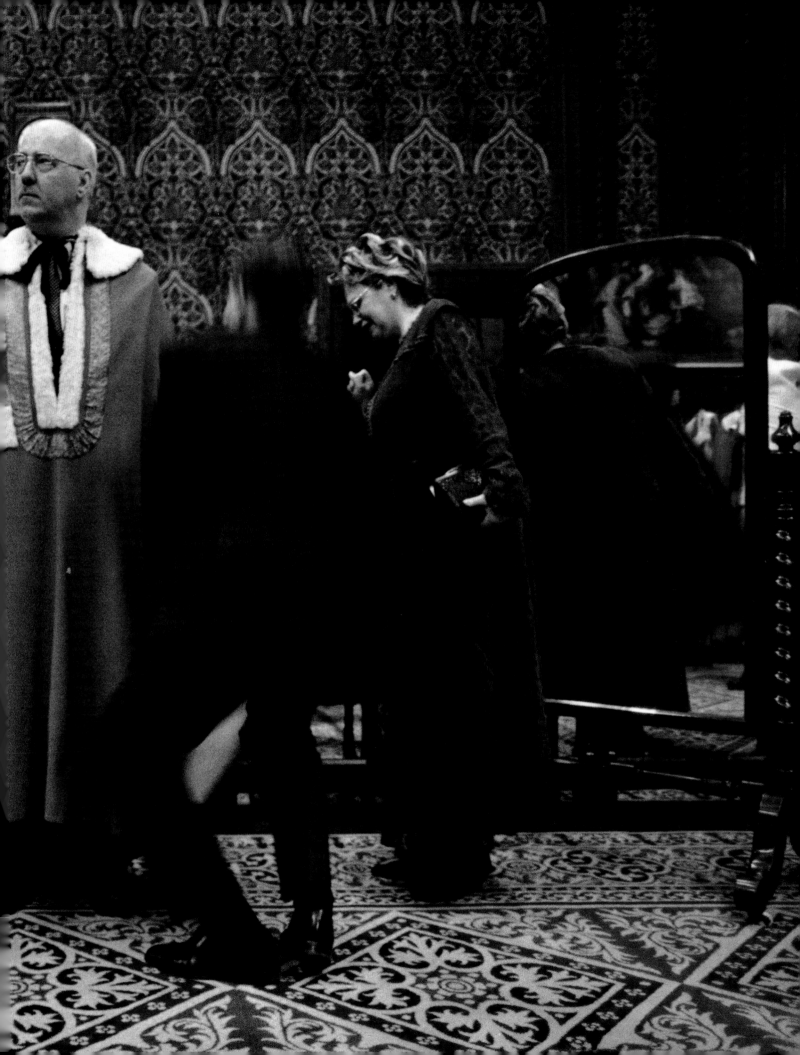

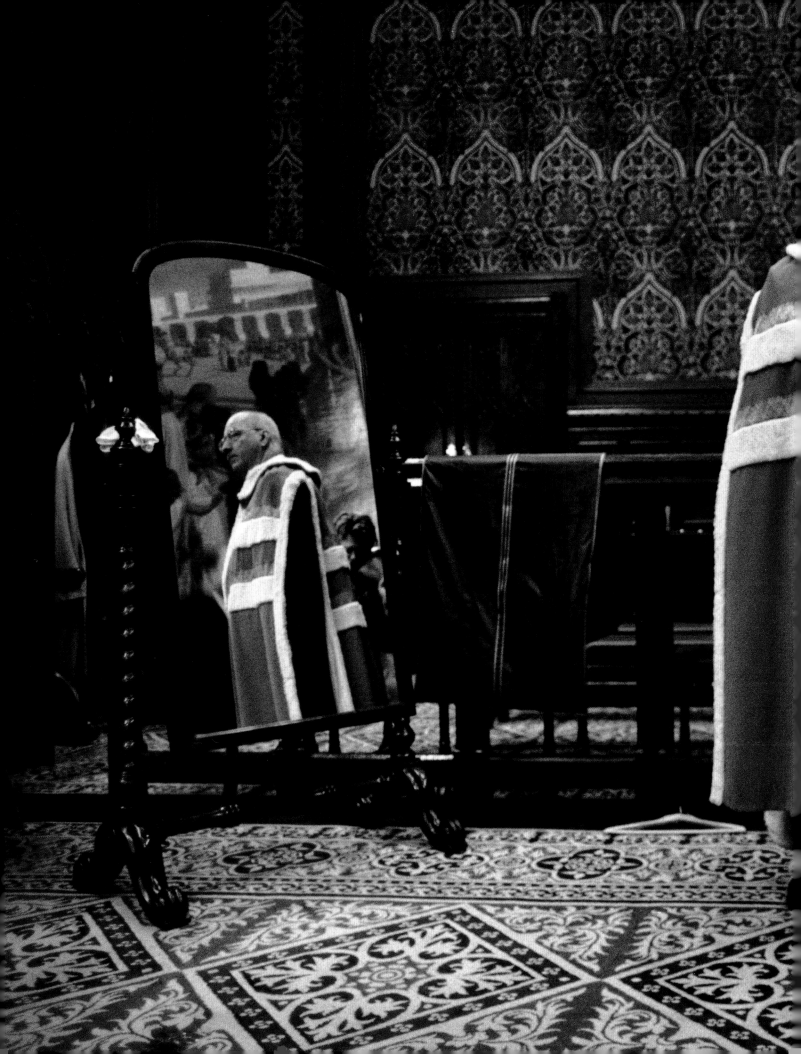

A Conservative hereditary peer voting in the autumn of 1999 for the ninety-two who will remain. Up until now their birth has protected them from the vulgarities of the electoral process. Most hereditaries departed in November 1999. As Lord Russell put it, 'It is very much what London must have been like the year of the Great Plague.'

Archives from 1497, including original Acts of Parliament, are kept in the Victoria Tower (the House of Lords Records office). They have always been handwritten on vellum, but it is unlikely that vellum will be used in future.

The House of Lords Library.

The last meeting of the Association of Conservative Peers before the voting-out of the hereditaries. Many of them saw public service as a duty – that being rich, they couldn't be bribed; being powerful, they couldn't be tempted. 'Nor are we under pressure from the electors,' Lord Ampthill told me, 'being far too old and decayed to put ourselves up for election.'

'The House of Lords is like heaven – you want to get there some day, but not while there is any life in you.'
Lord Denning

Robing in the Moses Room before the State Opening of Parliament. The robes cost £7000. They are lined with ermine, which in the Middle Ages was believed to symbolize moral purity. Most hereditary peers inherit their family's set of robes, while life peers tend to hire them from tailors such as Ede & Ravenscroft, who have been dressing peers since 1689.

Question Time in the Chamber of the House of Lords.

The televising of the House of Lords began in 1985, and the proceedings can be seen on the Parliamentary Channel when the House is sitting.

Lord Cranborne, former leader of the Conservative Opposition, deal-making in the corridors of power. There aren't enough offices in the House for everyone to have their own desk.

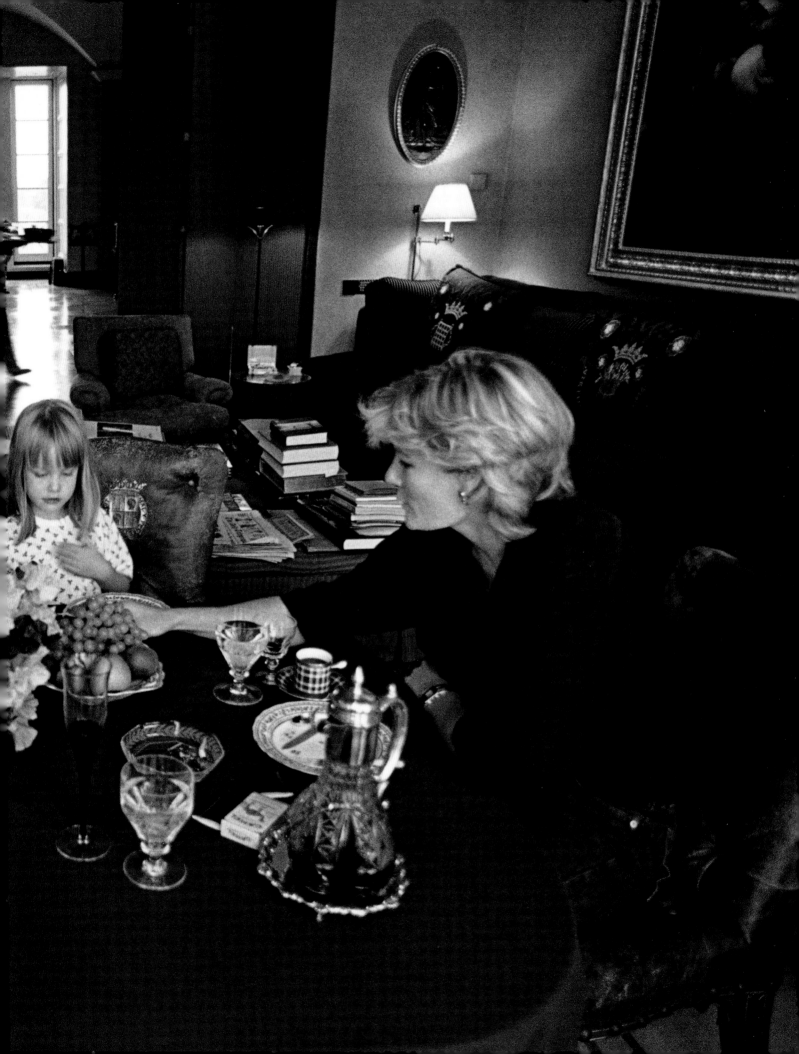

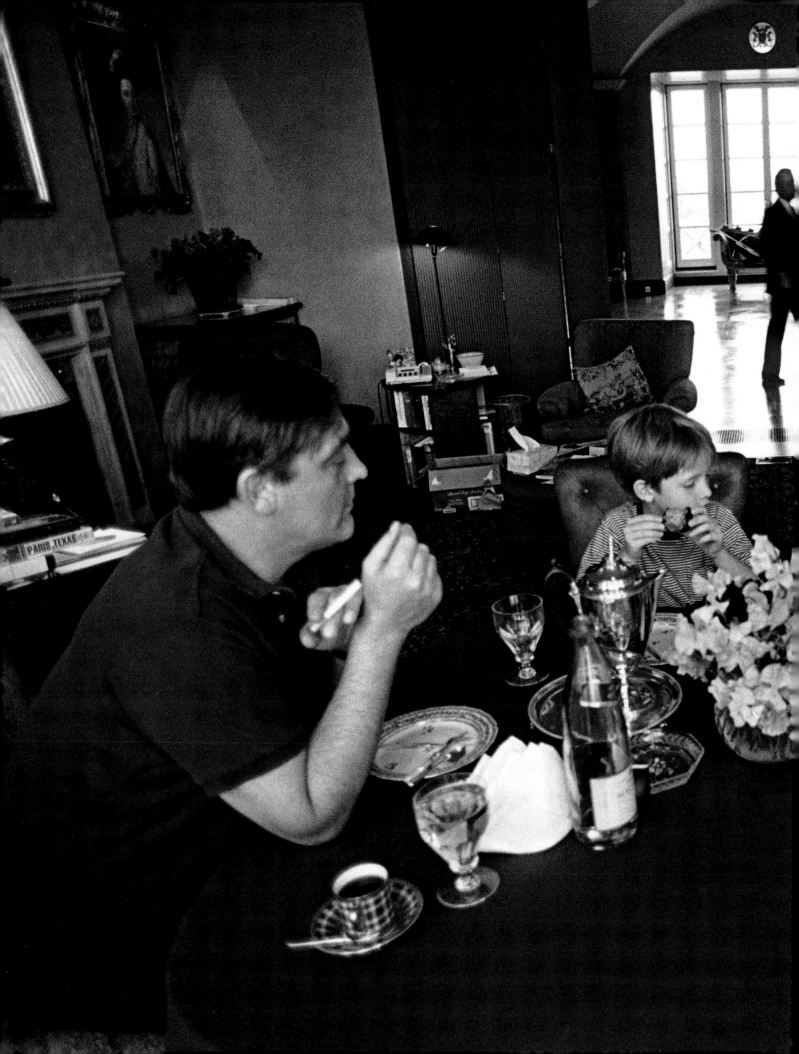

ESTMINSTER,

vate.

DUKE OF W
Pri

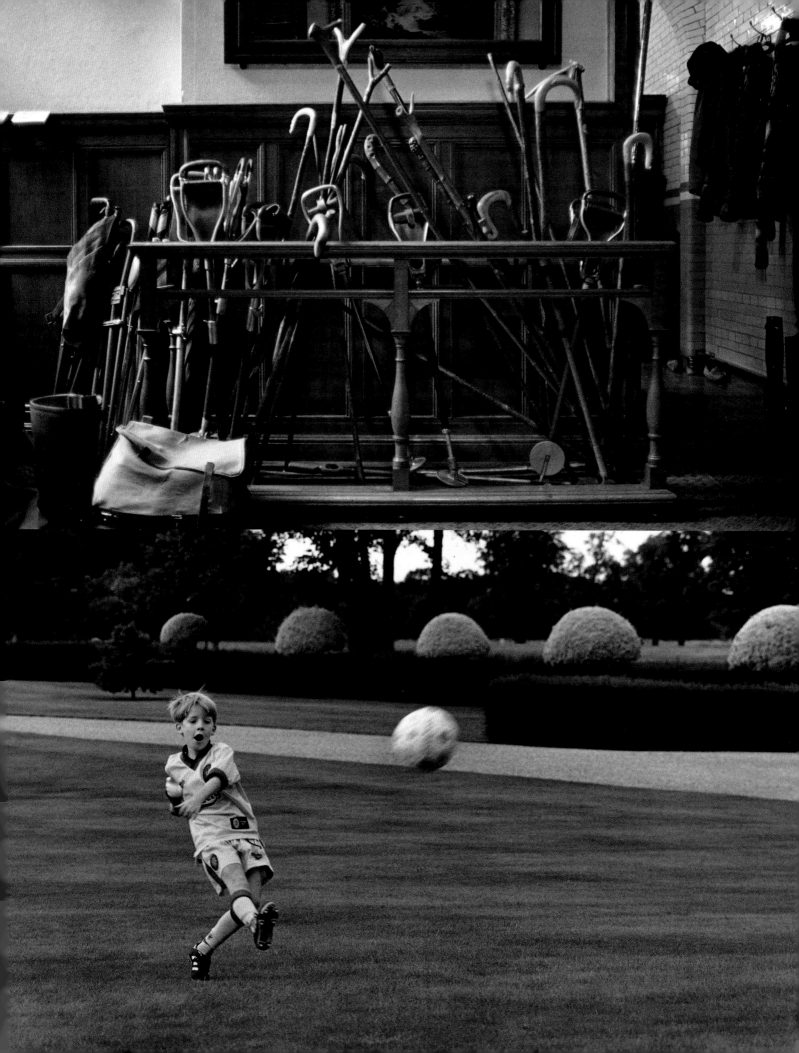

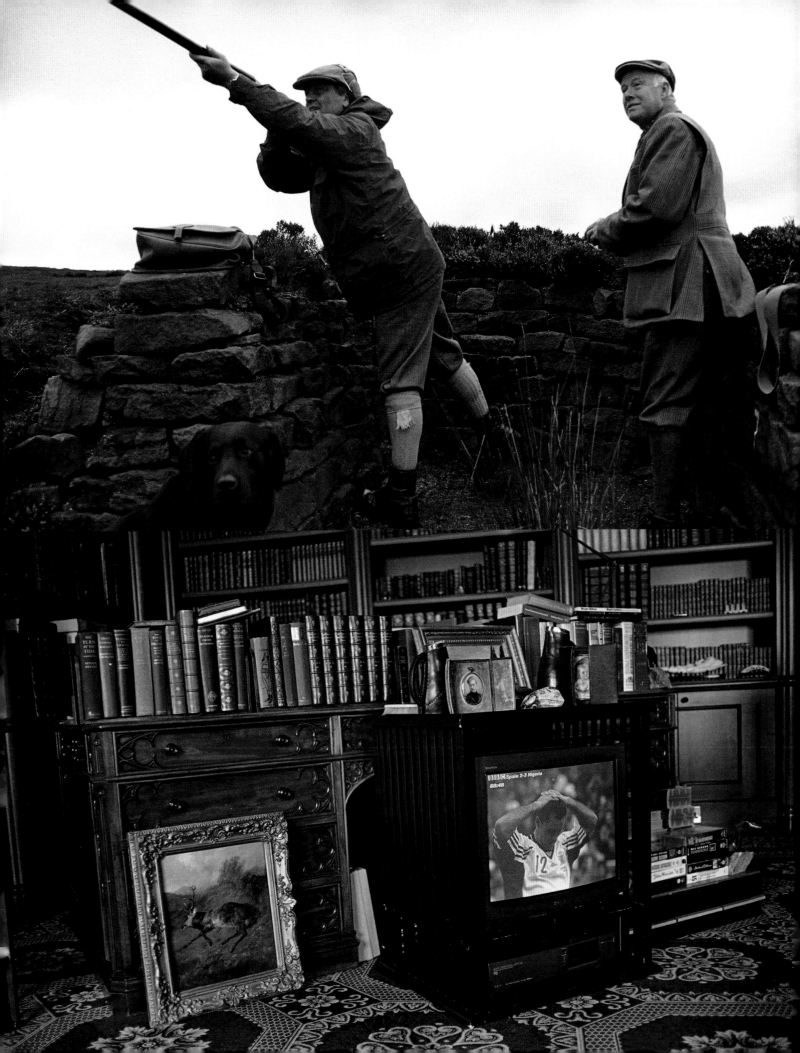

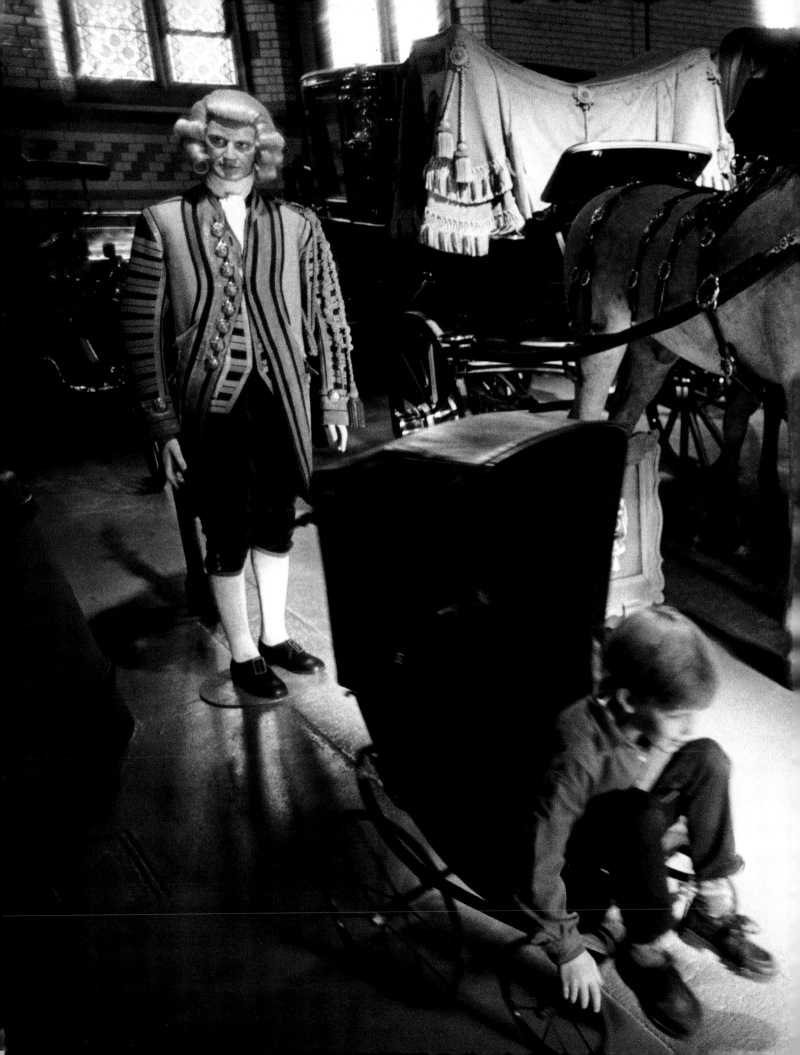

The Glorious Twelfth.
'People say we should
stop shooting and
everything will be all
right. Fine, but those
are the people who
don't understand the
dynamics of upland
bird life, because if you
get an over-population
of grouse, they will die
out. It's no different to
a deer cull: you shoot
deer to keep their
numbers down.
We shoot grouse to
control the population.
And the fact is, one
enjoys it.'

The Duke watches
the World Cup in his
study. He told me he
could have been a
beef farmer living in
Northern Ireland
had life worked out
differently, or possibly
a professional foot-
baller. He now plays
football with his son.

The Duke of West-
minster's ancestry can
be traced back to
William the Con-
queror. The family
archives include boxes
with centuries-old
charters and deeds.

'One of the reasons we
are still here is because
we've been able to
keep up with the
change in social trends
and have adjusted to
that change. It's like I
said to some of my
French friends: that's
why we've still got our
heads on.'

The Duke

Gerald Cavendish Grosvenor is the sixth Duke of Westminster and the biggest land-owner in Britain. His real estate, spread throughout the world, includes more than 140,000 acres of London, Cheshire, Lancashire and Scotland. He maintains that only he knows what he is worth, but his fortune is generally estimated at 3.7 billion pounds.

The Duke of Westminster had not expected to inherit, but at the age of fifteen, following the death of his uncle, who had no heir of his own, and the succession of his father, Gerald Grosvenor was burdened with the knowledge that he would one day have to leave his childhood home in Northern Ireland to take up the family seat at Eaton Hall in Cheshire.

The family museum. The Duke says, 'Hugh, like most boys, wants to do twenty different things at once. He's football mad, and he's army barmy – not surprisingly, because I am both. I think I'd like to point him towards a career in the army. No matter how he turns out, there's somebody beyond me, which is very important to me, and it's very important to those who live and work here. Though I don't think it's terribly important to the outside world.'

The Duke regrets having been uprooted from his home and school in Northern Ireland. 'Why was I dug up from a life that I loved and transported to a life I simply did not understand? I was used to being judged for what I was, not for what I was born to.'

Inspired by a sense of adventure and by the fictional world of Tintin, I left home alone for the first time in 1971 at the age of thirteen, bound for Paris. My travels subsequently took me further afield – to South and Central America, to the Middle and Far East, and to Africa. As I travelled, I became more and more interested in documenting people's lives. I have often lived rough and visited people on the margins of society in Afghanistan, Mexico and Mongolia; I have focused on people in war zones, areas of great social conflict and extreme traumatic circumstances. Writing, photography and documentary film-making are equal ways for me of capturing and recording what I see. In 1992, I decided to focus on Britain, the country of my birth, and one I barely knew. To use the words of T.S. Eliot, the American poet who chose to make his home in Europe, and who expressed his sense of wonder in his Four Quartets: 'And the end of all our exploring will be to arrive where we started and know the place for the first time.'

In 1994, I began my journey around Britain with the support of my publishers HarperCollins and a Fellowship from the National Museum of Photography, Film and Television, in conjunction with the Bradford and Ilkley Community College. I travelled to inner cities, towns, villages and remote farming communities. Initially, I took over five thousand photographs. Subsequently, John Willis, then Director of Programmes at Channel 4, commissioned me to make a television documentary series revisiting some of the same communities, and visiting others. The series, Postcards from the Edge, used a completely new set of my black-and-white stills. A second television series was commissioned, The Fight for Hearts and Minds, focusing on the work of junior doctors in two hospitals – Harefield in Hertfordshire, where they perform heart and lung transplants, and the Maudsley in South London, which is a hospital with an emergency clinic for people suffering from mental health problems. Most of the photographs of the people and places I have visited during the research for these projects have never been published before.

For The Establishment, the third television series based on my photographs, I set out to discover where and how power is exerted in Britain. I chose to look at the arts, the military, the judiciary, the Church, the media, landowners and the aristocracy. I walked the corridors of power in search of Britain's executive, rather than the homeless, unemployed shipbuilders in Barrow-in-Furness, ex-miners in Wales, heroin abusers, and runaways from care whom I had photographed in Postcards From the Edge. I decided to turn my lens on those in authority: army generals, dukes and duchesses, bishops, judges, politicians.

Growing up on the Continent in a half-American, half-British family, I was brought up to believe that the British gave notions of justice and fairness to the world. Maybe so, but on these journeys through Britain I have never been more struck by the class divisions in society. Accent is the first giveaway; regional accents are superseded by class accents, and as soon as someone speaks you can tell their background. All too often, I was reminded of what a bursar from an Oxbridge college told me, 'Change is good, but no change is better.' When change has taken place it has sometimes been superficial. I was allowed unprecedented access to the House of Lords to photograph behind the hallowed portals during the partial transition from hereditary peers to appointed peers, but it seems one unelected system has been replaced by another.

Sometimes, as in trying to photograph areas of the working life of Trinity College, Cambridge, I found myself up against an iron wall as difficult to penetrate as the KGB (no doubt that is why some alumni did well in both spheres). Everything I wanted to record had to be put before the college council. However, unlike the East End of Glasgow, my hosts didn't insist on a chaperone for protection, and only twice during these journeys was I asked to refrain from taking photographs: on the Queen's flight (en route to one of NATO's largest military exercises with the Army's Commander in Chief) I was informed that 'Her Majesty would be offended', and at a private lunch I was asked not to take a photograph of the Prime Minister while he was eating. I have already forgotten what I was not meant to hear during the Army's Strategic Defence Review when I was told, 'Danziger, close your ears.'

Having made several journeys through Britain, and having focused on both the marginalized and the people in power, I have become aware that the old definitions of class no longer hold true. Britain has a working class which no longer works and a ruling class which no longer rules. However, I did discover many similarities: these Brits, in adversity or comfort, are a brave people who can face anything with stoicism. As for their notion of equality, each and every one I met knew themselves to be as good as the next person, but also that the next person was not half as good as they were.

Britain has never been my 'home', but six years and some hundred thousand photographs later, at the end of this particular journey through the Nineties, I feel both at home and abroad in Britain, poised between cultures: both insider and outsider – a local stranger.

When setting out on this journey I never imagined that I would experience so much happiness and laughter, such pain and anguish, or that I would be confronted so often with matters of life and death. I owe the following photographs to those who allowed me into some of the most intimate moments of their lives, when they were either at their most vulnerable or at their most joyful.

Britain, I felt, is still a country of unfulfilled promise, caught between beauty and decay. Being among the friends and acquaintances encountered on my photographic journey made my world a much richer and more exciting place. **Nick Danziger** London, 2001

The British

Nick Danziger

TRAVELLERS BRITAIN
DATA FILE

GW00646616

Travellers' Britain Data File

Designed and Edited by
M.J. Cottingham FRGS

Produced and Published by
Geographia Ltd
63 Fleet Street
London EC4

© Copyright Geographia Ltd 1984/85

Manufactured in Great Britain by
Blantyre Printing and Binding Company Limited
London and Glasgow
and Anchor-Brendon Limited
Tiptree, Essex

Crown Copyright reserved

The maps in this Atlas are based upon the Ordnance Survey maps with the sanction of the Controller of H.M. Stationery Office.

The representation on these maps of a road, track or footpath is no evidence of the existence of a Right of Way.

The entire contents of this publication are copyright in all countries signatory to the Berne and Universal Conventions. Reproduction in part, or in whole is strictly reserved to the Publishers, Geographia Ltd.

All details given in this Atlas are believed correct at the time of compilation. Nevertheless the Publishers can accept no responsibility for errors or omissions or for subsequent changes.

Preface

Early road atlases were devised for an era in which motoring was both a pleasure and an adventure, when Sunday afternoons were devoted to sedate trips to the countryside and the ultimate in sophistication was a touring holiday in the family car. Today, the label 'Sunday motorist' is a term of ridicule and the fashionable motoring holiday has become a part of history. Indeed, nowadays many people feel that holiday fun begins only after the disagreeable business of motoring is over.

Doubtless to the horror of traditionalists, the Travellers' Britain Data File recognises the gradual decline in motoring for pleasure and accepts that motoring is now more of a means to an end. The driver of the 80s travels further, faster and more often than ever before and the 300-mile journey, which was once such an adventure, is now a spontaneous 5-hour dash down the motorway.

By linking together the daily travel data provided by the media to a comprehensive series of conventional road maps, Travellers' Britain Data File enables the user to plan and carry out a journey with maximum efficiency. In an age when time, distance and cost are all important, a modern definition of motoring pleasure might be to arrive at the correct destination, on time and with minimum inconvenience.

M.J. Cottingham FRGS

Contents

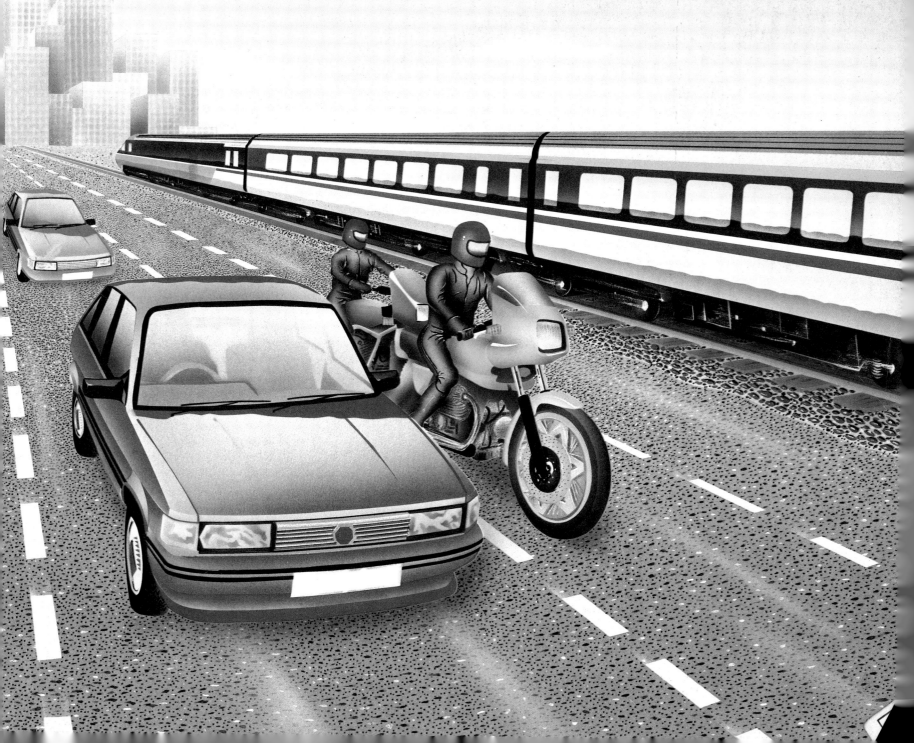

TRAVELLING IN BRITAIN

Planning A Journey

When planning a journey for a specific appointment, the driver would normally know six facts:
1 Point of departure
2 Destination
3 Purpose of the journey
4 People or goods to be transported
5 Time and probable duration of appointment
6 Who or what to expect at the destination
Examination of these details leads to four simple decisions:
1 How to travel: by road, rail, air, etc
2 When to depart in order to arrive on time
3 Whether to make a round trip, stay overnight for a few days
4 What to take on the journey: documentation, luggage, goods, etc

Points of Departure & Destination

In the past most journeys started from the home or office but now, with the increasing use of the radio telephone, it is possible to be directed from appointment to appointment even when on the road. Irrespective of the starting point the first question to be asked is 'How far is it?' A rough estimate can then be made of how long the journey will take, using the map. Finding the town is usually very simple but locating the address within the town can present a problem. When motoring, many people still insist on heading for the town and then stopping the first likely pedestrian to ask directions. This time-wasting, unreliable and sometimes dangerous practice should be discouraged because:
1 It involves stopping suddenly on a busy road.
2 The directions received may be incorrect, especially as there can be several streets with the same name even in a small town.
3 The information given must be committed to memory.
4 Some of the streets will no doubt turn out to be no entry, one way or pedestrian only.
Often these problems will mean that the driver must keep stopping to ask for further directions. A far better plan is to have full details written down prior to setting off; it is also desirable to have a good town plan with the route through the town and the exact destination clearly marked on it.
Arriving by passenger transport—bus, coach, train or aeroplane—is usually much simpler; to avoid problems, either arrange to be met at the station or catch a taxi to the destination.

Purpose

The importance of the trip will dictate the amount of effort devoted to planning it. A simple day trip to the seaside might require an early start to avoid heavy traffic, but the exact time of arrival is unimportant. Travelling overseas to a vital business meeting, on the other hand, would need far more precise planning.

Passengers & Luggage

Passengers, luggage or goods are often the deciding factor in selecting the means of travel. Whilst it is very relaxing to 'travel light' by air, rail or coach, this may not be the answer if you need to take bulky goods, samples or lots of luggage. Also, if 3 or 4 people are travelling together, public transport can be very expensive. Most journeys start and end in a car anyway, so the plan must include how to get to the airport or station; if you choose to drive there, you will need to know where to park safely.

Time & Duration of Appointment

Once an appointment is made it is best to make travel plans by working back from the time of the meeting, calculating the departure time and allowing an appropriate margin for safety. When travelling by train, coach or aeroplane a suitable departure time, any necessary connections and other timing details must be worked out well in advance; provision must also be made for getting from the station or airport to town in time to keep the appointment. The major drawback of passenger transport is that it lacks the control and flexibility of motoring. Weather, accident and industrial action can conspire to cause delays and frustration and rigid timetables limit the time available for business and socialising. If you can work out a suitable travel timetable, though, passenger travel is more relaxing than driving and the journey time can generally be used to advantage—perhaps in preparing for the meeting ahead.

Arriving

A precise address, detailed instructions on how to get there and the name of a contact are essential for planning a trouble-free journey. Vague generalities cause preoccupation during the trip and delays and problems on arrival.
Once the initial decisions have been made and any problems resolved, all the information needed to plan a journey is available from the reference and maps contained in this book.

MOTORING IN BRITAIN

Documentation

To own or drive a private motor vehicle in Great Britain the following documents are required:
1 Driving licence
2 Insurance certificate
3 Registration document
4 MOT certificate
5 Road Fund licence

Driving licence

To drive a motor vehicle, unsupervised on a public road, it is necessary to hold a full licence to drive that class of vehicle. The licence must be current and signed in ink by the driver. A driving licence lasts until the holder is 70 years old or for 3 years, whichever is the longer. After the age of 70 a licence will run for 3 years or less depending on the health of the driver.

Insurance certificate

Before using a motor vehicle on a public road a valid insurance in respect of third-party risks or a security covering the use of that vehicle must be in force. This insurance or security must comply with the Road Traffic Act 1972.

Registration document

The registration document is obtained when the vehicle is first registered with the Driver and Vehicle Licensing Centre [DVLC]. The document must be produced when taxing the vehicle. If any changes are made to the vehicle which affect the registration particulars—eg colour or number of seats—or the condition or use of the vehicle is altered so as to incur a higher rate of duty, then the document must be returned to the **local** Vehicle Licensing Office and a new document issued. If you change your address or if the vehicle is destroyed or permanently exported then the document must be returned to the DVLC for amendment or destruction.

Ministry of Transport (MOT) certificate

Private motor vehicles over 3 years old must pass an annual road-worthiness test if they are to be used on any public road. The test certificate indicating that the vehicle was found to be road-worthy [MOT certificate] is valid for 1 year and must be produced when taxing the vehicle.

Vehicle licence

A motor vehicle kept or used on a public road must have a current vehicle [Road Fund] licence. This licence is available through the local Vehicle Licensing Office or certain post offices upon production of:
1 Completed application form [V10]
2 Registration document [V5]
3 Current insurance certificate
4 Current MOT certificate
5 Duty payable
The licence itself must be in a holder to protect it from the effects of weather and must be clearly visible in daylight from the near side pavement. Vehicle documents must be produced on demand to the police. In general, the onus is on the driver to prove he or she has the relevant documents and not on the police to prove otherwise. A driver may elect to present required vehicle documents to a nominated police station within 5 days of being asked to produce them, however, so it is neither necessary nor advisable to keep them in the car.

MOTORING IN EUROPE

Passport/Visa

To travel outside the British Isles it is necessary to have either a UK Passport or a British Visitor's Passport. For travel in certain countries it is necessary to obtain a visa from the appropriate Embassy; these are only available to UK passport holders.

Driving Licence

A valid, full, British Driving Licence can be used for short-term travel in most European countries but before travelling check with the information office of the country/countries to be visited or with a Motoring Organisation.

Registration Document

The registration document for the vehicle must be carried even if the vehicle is borrowed or hired.

Insurance Certificate

Vehicle insurance is compulsory in most European countries. Different countries, however, require different forms of insurance. Suitable cover should be arranged through a Motoring Organisation although on-the-spot insurance can be arranged at some international frontiers.

MOTORING IN BRITAIN

Breakdowns

Breakdowns are usually preceded by some sort of indication such as a faltering engine, a strange noise or a dashboard warning light. The consequences of a breakdown can be serious. The degree of danger depends on:

1 The speed of the vehicle
2 The time of day
3 The weather
4 The volume of traffic
5 The type of road
6 The reactions of the driver

Immediate Action

When faced with a breakdown, the driver's first priority is to avoid causing an accident. Once a breakdown or possible fault is indicated:

1 Check for traffic coming from behind
2 Give a 'slowing down' signal
3 Pull off the road onto the verge or hard shoulder
4 Get out of the car, if possible using the near side door
5 Move passengers, particularly children, to a safe distance from the road

Warning Others

The second priority is to warn other drivers of the breakdown. This is done by:

1 Four-way flashing indicators
2 A red warning triangle placed 50 yds behind the car on a normal road or 150 yds on a motorway. [This is compulsory when travelling on the Continent.]
3 A purpose-made, red, flashing warning lamp or torch

If none of these warnings are available, improvised ways to indicate a breakdown include:

1 Opening both the car boot and bonnet
2 Removing the rear seat and placing it against the rear of the car
3 Getting a passenger to walk back along the road and signal traffic to slow down. This is often necessary when the breakdown occurs around a dangerous bend or over the brow of a hill

Getting Help

Only the simplest of repairs—changing a wheel, replacing a fan belt etc—should be undertaken at the roadside. More complex faults should be referred to a garage, motoring organisation or vehicle rescue service. If the breakdown occurs on the motorway, find an emergency telephone. These are connected directly to the police and are placed at 1-mile intervals. The direction of the nearest telephone is indicated by marker posts at the outer edge of the hard shoulder. Always note the number and letter on the post; quoting them will enable the breakdown to be located easily. When the driver telephones for assistance, the police will want to know details of the vehicle and some indication of what is wrong. Motorway telephones are one-way only; the operator cannot call back, so do not replace the receiver until told to do so. If the breakdown occurs on any road other than a motorway, call a garage, motoring organisation or vehicle rescue service from the nearest public or private telephone.

Repairs & Recovery

Whatever organisation you summon to assist you, only minor repairs will be carried out at the roadside. For more serious faults the vehicle will be towed to a garage for repair. The total bill for recovery and repairs can be considerable, and for people travelling on business the delay, inconvenience and consequent re-scheduling can be even more costly in both time and money. To minimise the inconvenience, many motorists now belong to a vehicle rescue service.

Vehicle Rescue Services

Joining a vehicle rescue organisation is, in effect, an insurance against a breakdown. The plan chosen and the subscriptions paid decide which type of assistance will be offered. There are 5 nationwide rescue services available to the motoring public. All of them offer assistance with minor roadside repairs or transporting the vehicle and passengers to their destination. Details of the vehicle recovery services are listed below:

The Automobile Association [AA], Fanum House, Basingstoke, Hampshire RG21 2EA. Tel [0256] 20123.

Royal Automobile Club [RAC], Motoring Services Ltd, RAC House, Lansdowne Road, Croydon, Surrey CR9 2JA. Tel [01] 686 2525.

Red Rovers, 55–57 Albert Street, Rugby CV21 2SG. Tel [0788] 6074.

National Breakdown Recovery Club [NBRC], Cleckheaton Road, Low Moor, Bradford, West Yorkshire BD12 0ND. Tel [0274] 671299.

Gold Star Emergency Service, Station Tower, Station Square, Coventry CV1 2GR. Tel [0203] 555411.

MOTORING IN BRITAIN

Road Accidents

A driver must **stop** if his or her vehicle is involved in a road accident which causes injury or damage to:

1 Any person (other than the person driving that vehicle)
2 Any vehicle (other than that vehicle or a trailer drawn by it)
3 Any animal (other than any animal in that vehicle or its trailer)
4 Any property (constructed on, fixed to, growing in or otherwise forming part of the land on which the road is situated or land adjacent to it)

The driver must also provide certain information on request to any other person with reasonable grounds for requiring it, as follows:

1 Name and address of driver
2 Name and address of vehicle owner
3 Insurance details (if the accident involves personal injury)

Details of such accidents must also be reported to the police as soon as possible and in any case within 24 hours. Driving documents must be produced for police inspection when reporting the accident, or within 5 days at a police station of the driver's choice.

The police may be requested to attend the scene of an accident but are not obliged to do so. Even if they do attend, others involved in the accident and witnesses are not obliged to wait for them unless the accident involves personal injury.

If you are involved in a road accident which does not involve personal injury, you should:

1 Say as little as possible
2 Never admit any blame
3 Not make an immediate statement
4 Record for your own benefit the following information:
 a) Registration number of other vehicle(s) involved
 b) Names and addresses of other people involved and if possible details of any witnesses
 c) Details of other driver's insurance company and insurance certificate number
 d) Time, date, place and weather conditions
 e) Amount of traffic at the scene of the accident

It is also advisable to prepare a sketch plan or take photographs of the scene of the accident, taking measurements where possible. The plan should show:

1 Position of all vehicles involved
2 Road names, traffic signs, one-way streets etc
3 Street lamps, bus stops and pedestrian crossings

To cover every eventuality in case of an accident, the following items should be regarded as essential and carried in the car:

1 First aid kit
2 Notebook and pencil
3 Camera, tape measure and chalk
4 Warning triangle or flashing red lamp

As soon as possible following an accident you should notify your insurance company or insurance broker.

Continuing Your Journey

If your vehicle is incapacitated through breakdown or accident but it is important that you complete your journey, you will need to use either passenger transport or a hired car.

The Driver & The Law

As well as stopping at the scene of an accident, a driver must also stop when signalled to do so by:

1 A policeman in uniform
2 A traffic warden controlling either traffic or pedestrians
3 A school crossing patrol
4 A workman controlling traffic at a roadworks with a Stop/Go sign

The Police

The police may stop a driver for any motoring offence or:

1 To search a vehicle if they suspect that the driver is in possession of firearms, drugs or stolen goods.
2 To carry out a roadside check for vehicle defects. Police or Transport Examiners who carry out these checks should be in possession of a certificate authorising them to inspect motor vehicles.
3 To assist persons carrying out a vehicle survey or census. (Although a driver must stop by law, he or she is not obliged to provide any information to assist the survey or census and must not be unnecessarily delayed by questioning.)
4 For any good reason.

Traffic Wardens

Traffic wardens are appointed and trained by the police and must wear a uniform. They are authorised to perform certain police traffic duties, including:

1 Acting as street parking attendants
2 Controlling traffic
3 Acting as a school crossing patrol
4 Operating the fixed penalty system (except for cases of obstruction or when a vehicle has been left in a dangerous position)

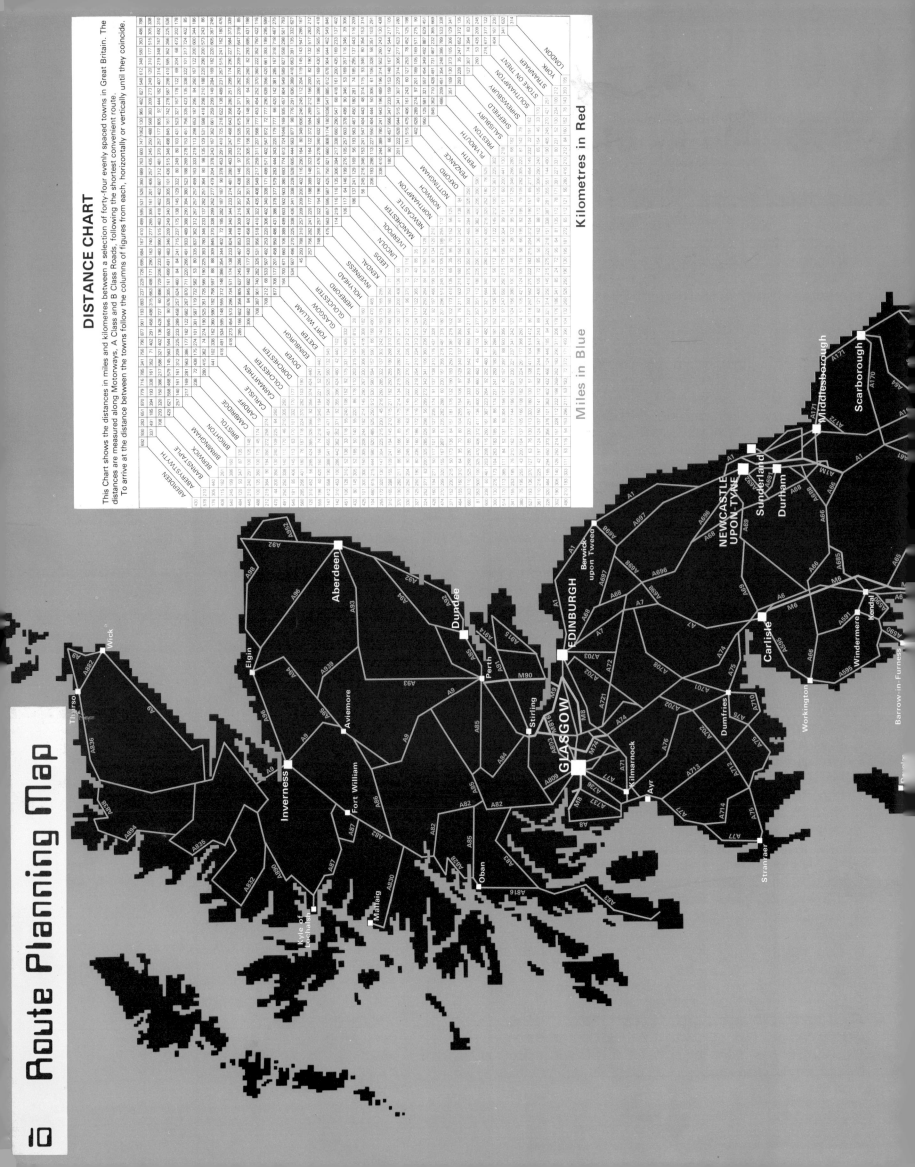

Route Planning Map

DISTANCE CHART

This Chart shows the distances in miles and kilometres between a selection of forty-four evenly spaced towns in Great Britain. The distances are measured along Motorways, A Class and B Class Roads, following the shortest convenient route.

To arrive at the distance between the towns follow the columns of figures from each, horizontally or vertically until they coincide.

Miles in Blue

Kilometres in Red

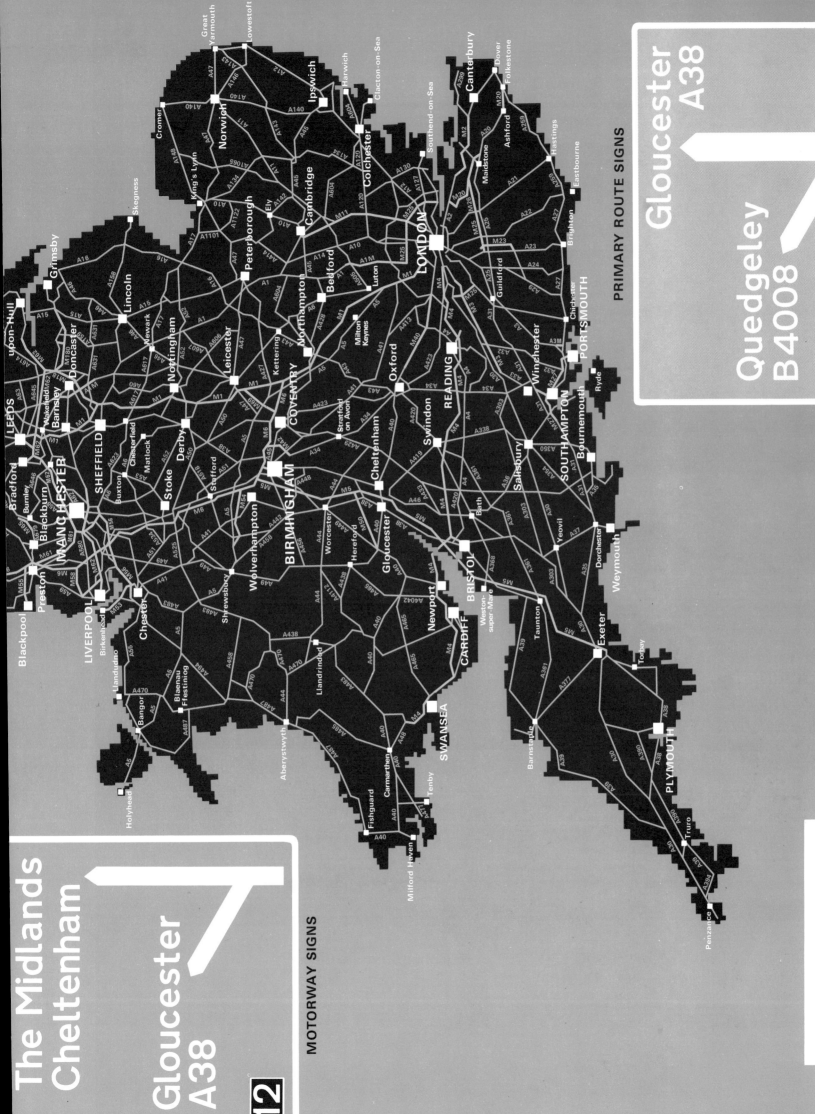

The Midlands
Cheltenham

Gloucester
A38

12

MOTORWAY SIGNS

PRIMARY ROUTE SIGNS

Gloucester
A38

Quedgeley
B4008

LEGEND

Motorways
Primary Routes

11

Warning:
Teletex pages are subject to continuous change. Always check with the main index for the latest page number or for any new information pages.

British Telecom	Prestel	Ceefax (BBC 1)
Check with Preliminary Pages of Local Directories.	MCL Main Index IP Information Page	Check with A-Z Index 19

Weather

Land
Sea
Air

British Telecom
For Weatherline
Local Summaries
See Local Information
Section pages 114-153

Prestel
Weather MCL 11
Met Office IP 209
UK Weather IP 20904
UK Shipping IP 2093
UK Aviation IP 20971
Weather Abroad
 MCL 1420

Ceefax
Weather and Travel Inde
 15
Weather Maps 15
Weather Forecast 15
U.K. resort reports
and World Weather 15

Roads

Conditions
Delays
Diversions
Accidents

British Telecom
Traveline National Road Summary
Tel. 01-246 8031
For Local Summary see Local Information section pages 114-153

Prestel
Driving MCL 143
Motoring Advice
 MCL 1431
Travel News MCL 1130
Commuter News IP 441121
A.A. IP 35045840
R.A.C. IP2402

Ceefax
Travel Key 155
Motorways 156
Regional Summaries
 157-163

Rail

Timetables
Cancellations
Delays

British Telecom
Traveline National Rail Summary
Tel. 01-246 8030
(Inter City & London Services)
For Local Summary see Local Information Section pages 114-153

Prestel
Rail Travel MCL 140
British Rail IP 221
B.R. Timetables & Fares
 IP 22170
Public Transport
 MCL 1417

Ceefax
Rail Cancellations 151
Commuter lines 164
Inter-City services 165
Engineering Works 166
London Transport
(tubes & buses) 168

Sea

Sailings
Car/Passenger
Freight

British Telecom
Traveline National Sea Summary
Tel. 01-246 8032
For Local Information
See Local Information Section pages 114-153

Prestel
Car Ferries MCL 1413
Passenger Ferries
 MCL 14131
Passport Advice
 MCL 1424
Cruises MCL 14132
Shipping MCL 46
Shipping Directory IP 29099

Ceefax
Ferries &
Sea Conditions 168

Air

Schedule
Charter
Freight
Helicopter

British Telecom
Traveline National Air Summary
Tel. 01-246 8033
For Local Information
See Local Information Section pages 114-153

Prestel
Air Travel MCL 149
Aircraft Charter & Hire
 MCL 133113
Airlines MCL 1499
Airports MCL 1497

Ceefax
Flight Arrivals 167

Coach

Timetables
Companies
Hire

British Telecom
See Local Information
Section pages 114 153

Prestel
Coach Travel MCL 14174
Scheduled Services
 MCL 141741
Coach Tours MCL 14223
Overseas Coaches
 MCL 141743
National Express IP 34011

Ceefax
London Transport
(tubes & buses)168

12

British Telecom	Prestel	Ceefax (BBC 1)

Ceefax (BBC2)	Oracle (ITV)	Oracle (Chn. 4)	Other Media Sources
Check with A-Z Index 299	Check with A-Z Index 195	Check with A-Z Index 495	

	Weather Index 106	Weather Index 406	
Information not available at the time of going to press. . .	National Weather Maps 188	Weather Forecasts	
	Shipping Forecast 189	Regional 486-490	
	Regional Forecasts 320	European Weather 491	
		Pollen/Skiing Forecast 492	

Television

BBC TV Provide weather forecasts by Met.Office Weathermen. See Radio Times for details

ITV Provide scripted weather forecasts from Met.Office information. See TV Times for details.

Motoring Magazine 263

Travel Index 107

London Road Reports 184

National A.A. Road Reports 185

Information not available at the time of going to press. . .

British Rail Services 125

Rail News 186

Information not available at the time of going to press. . .

National Radio

Radio 4 Carries the main live weather forecasts (4 times daily)

Radio 1,2 & 3 Provide brief scripted forecasts at regular intervals See Radio Times for details.

Information not available at the time of going to press. . .

Information not available at the time of going to press. . .

Information not available at the time of going to press. . .

Air News 187

British Airways

Flight Arrivals 176

Information not available at the time of going to press. . .

National Newspapers

Brief weather forecasts, charts and maps are issued regularly by the Met.Office to National Newspapers for daily publication. Some Newspapers also include summaries for Coastal Resorts. In addition The Times Information Service offers a daily Road Report

Information not available at the time of going to press. . .

Information not available at the time of going to press. . .

Information not available at the time of going to press. . .

Ceefax (BBC 2)	Oracle (ITV)	Oracle (Chn. 4)	13

FROM	TO	DATE	DISTANCE	TIME	NOTES

FROM	TO	DATE	DISTANCE	TIME	NOTES

CAR HIRE

Introduction

It is possible to hire a car from most towns, airports, ferry terminals or main railway stations.

To hire a car two conditions apply:

1 The hirer must produce a full, valid driving licence which must have been held for at least one year.

2 The hirer must be over 18 (23 for some companies) but in many cases customers aged 18–22 must arrange their own fully comprehensive insurance or take out supplementary insurance. Customers aged 18–22 are usually restricted to cars under 1600cc.

The main problem with hiring a car is that it is usually done in a hurry. This means the hirer often neglects to read and understand fully the small print on the contract. This can lead to misunderstanding and even financial loss when returning the vehicle or if involved in a breakdown or accident.

Before driving off:

1 Note any damage to the vehicle.

2 Check the spare wheel and toolkit.

3 Establish the breakdown/accident procedures.

4 Check the insurance cover.

Major Car Rental Companies within the UK (in alphabetical order) are:

Avis Rent a Car Ltd
UK Headquarters Trident House
Station Road
Hayes, Middlesex UB3 4DJ.
Tel: 01-848 8733. Telex: 933936

Budget Rent a Car International Inc.
International House
85 Great North Road
Hatfield, Herts A19 5EF.
Tel: 070 72 60321. Reservations: Telex: 264401

Godfrey Davis Eurocar
Davis House
Wilton Road
London SW1. Tel: 01-828 7700. Telex: 25468

Hertz Rent a Car
Radnor House
1272 London Road
Norbury, London SW16 4XW.
Tel: 01-679 1799. Reservations: Telex: 22362

Swan National Car Rental
305–307 Chiswick High Road
London W4 4HH.
Tel: 01-995 4665. Reservations: Telex: 935102

CONTACT ON THE MOVE

Automatic Radiophones

The British Telecom Radiophone Service provides a fast and efficient means of mobile communications, 24 hours a day. The service operates in virtually the same way as the normal telephone; to make a call from the vehicle just dial the normal exchange number. To be contacted on the Radiophone in a vehicle the subscriber simply dials the individual's private Radiophone number prefixed by a zone code. Full use can be made of outgoing international direct dialling facilities but incoming international facilities are not yet available.

Radiophone Zones

The Automatic Radiophone Service is available in selected areas throughout Britain. The country has been divided up into 4 zones—South East, Midlands, North and Scotland. To save on costs users can subscribe to as many or as few zones as they wish. For full information on the Automatic Radiophones dial the operator and ask for Freefone 'Radiophone Sales'.

Radiopaging

1. **Tone Page** is a British Telecom radiopager designed to keep your office in touch with you nation-wide. They dial your radiopager number, your pager bleeps and you phone back to pick up the message.

2. **Display Page** is a pager with a crystal display which gives you a numeric visual message. You can receive telephone numbers, coded instructions, commodity prices—virtually any information that can be conveyed in up to 10 digits. With Display Page a communication can be sent from almost anywhere in the world **direct** to your pager via a central bureau.

3. **Silent Page** (expected to be available later in 1984) is a pager which functions in exactly the same way as a Tone Pager but, when required, it can be set to vibrate to alert the user. Ideal for when it's too noisy to hear a bleep or when you want to be alerted discreetly.

The pagers are pocket-sized and battery-operated and can be programmed for country-wide coverage in the UK if required.

British Telecom Radiopaging provide a wide range of paging services to meet the needs of business customers and new services will shortly be launched. For full information on Radiopaging dial 100 and ask the operator for Freefone 'Radiopaging'.

Key Map and Legend

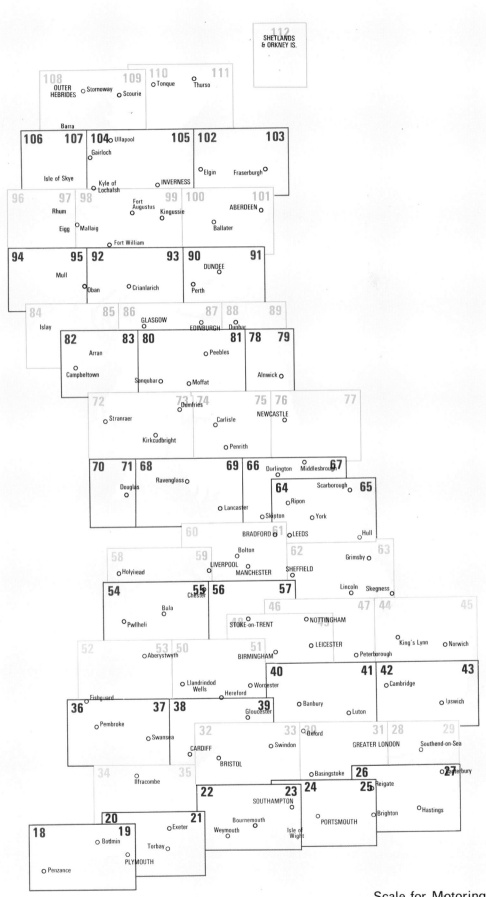

Motorway with Service Areas & Distances in Miles		
Motorway Junction with/without number		
Restricted Motorway Junction with/without number		
Motorway under construction		
Primary Route, single/dual carriageways	with distances in miles	
'A' Class Road, single/dual carriageways		
'B' Class Road		
'C' Class Road		
Town - City		
National Park		
Area of Outstanding Natural Beauty		
National - County Boundary		
Beach		
River - Canal - Vehicular Ferry		
Road Toll & Steep Hill		Toll
Lighthouse		
TV or Wireless Mast		
Battlesite		
Triangulation point - Height in feet		▲628 6•
Airport		
Motor Racing Circuit		
Racecourse		
Golf Course		
Place of Interest		• Ragley Hall

Every reasonable care has been taken to ensure that the information given in this publication is correct at the time of publication. Nevertheless the Publishers can accept no responsibility for errors or omissions or changes in the details given.

The representation on this map of a road, track or footpath is no evidence of the existence of a right of way.

Based upon the Ordnance Survey Maps, with the sanction of The Controller of Her Majesty's Stationery Office, with additions supplied by Local Authorities

Red numbered boxes indicate map pages which continue from left to right.

Blue numbered boxes indicate map pages which continue from right to left.

Scale for Motoring Maps

1:250,000 3.9457 Miles to 1 Inch 2½ Kilometres to 1 centimetre

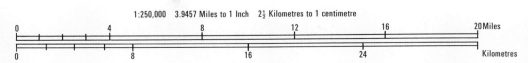

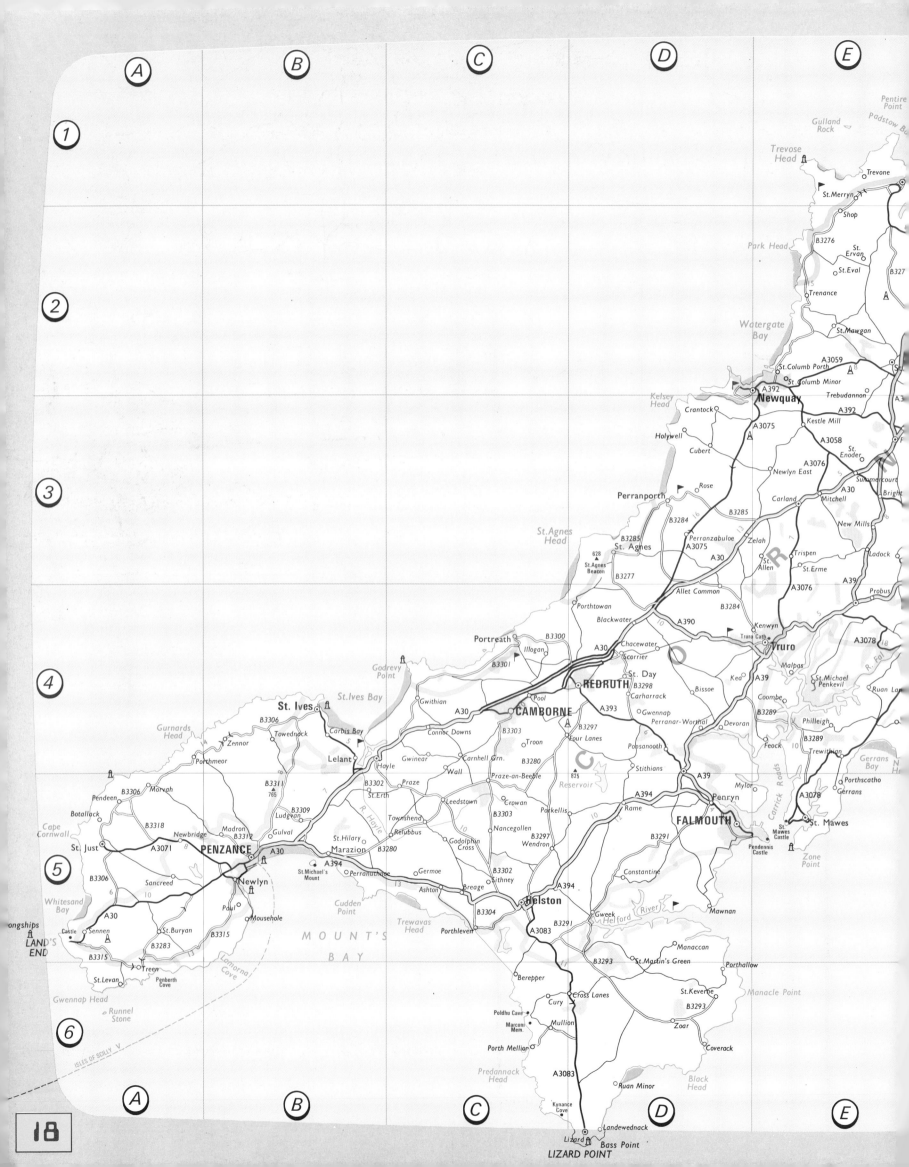

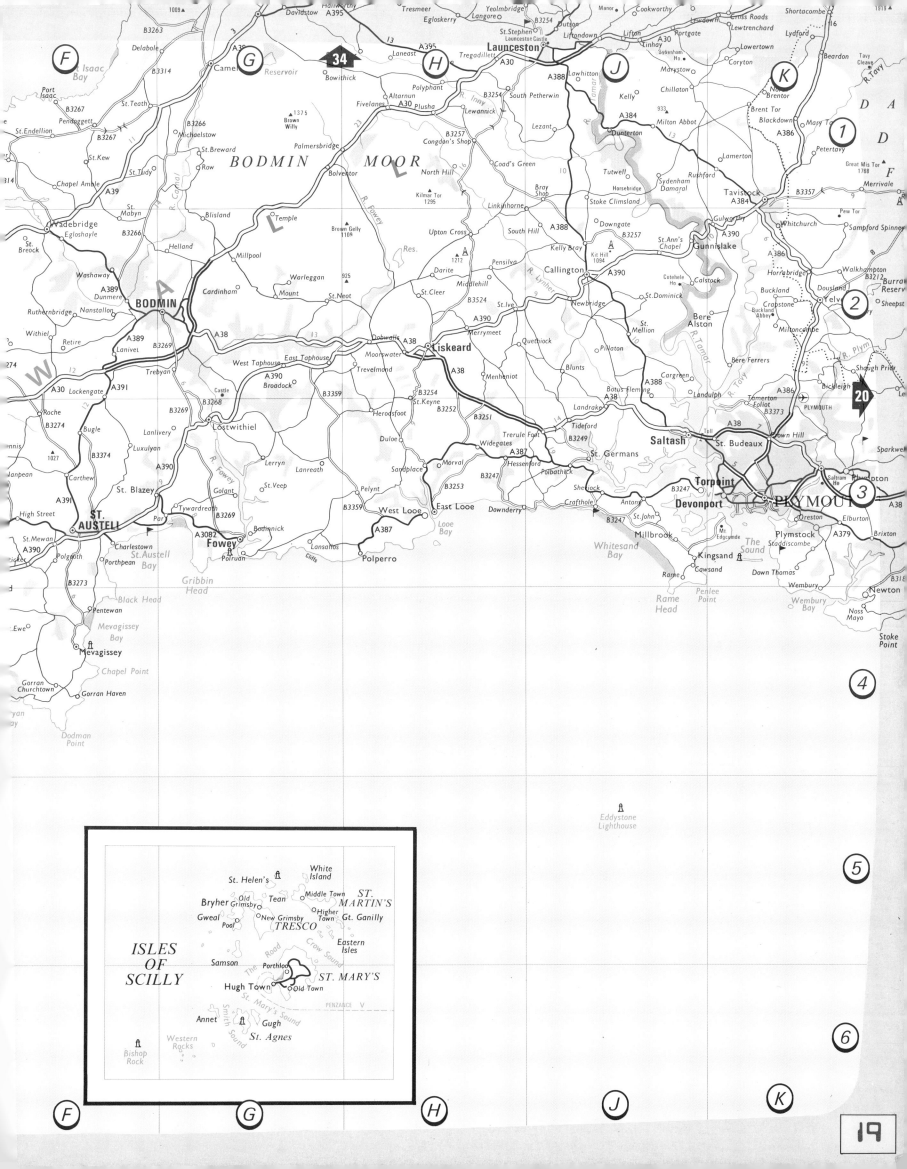

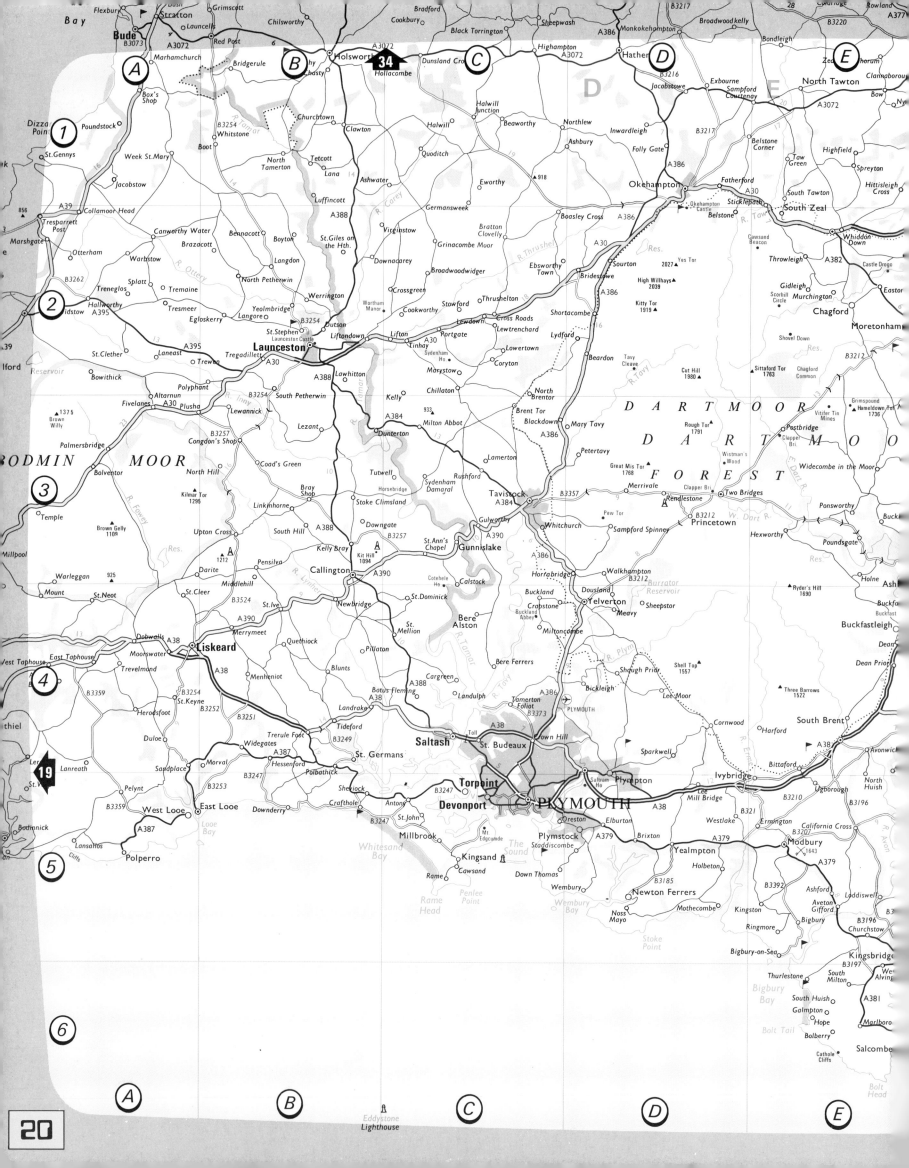

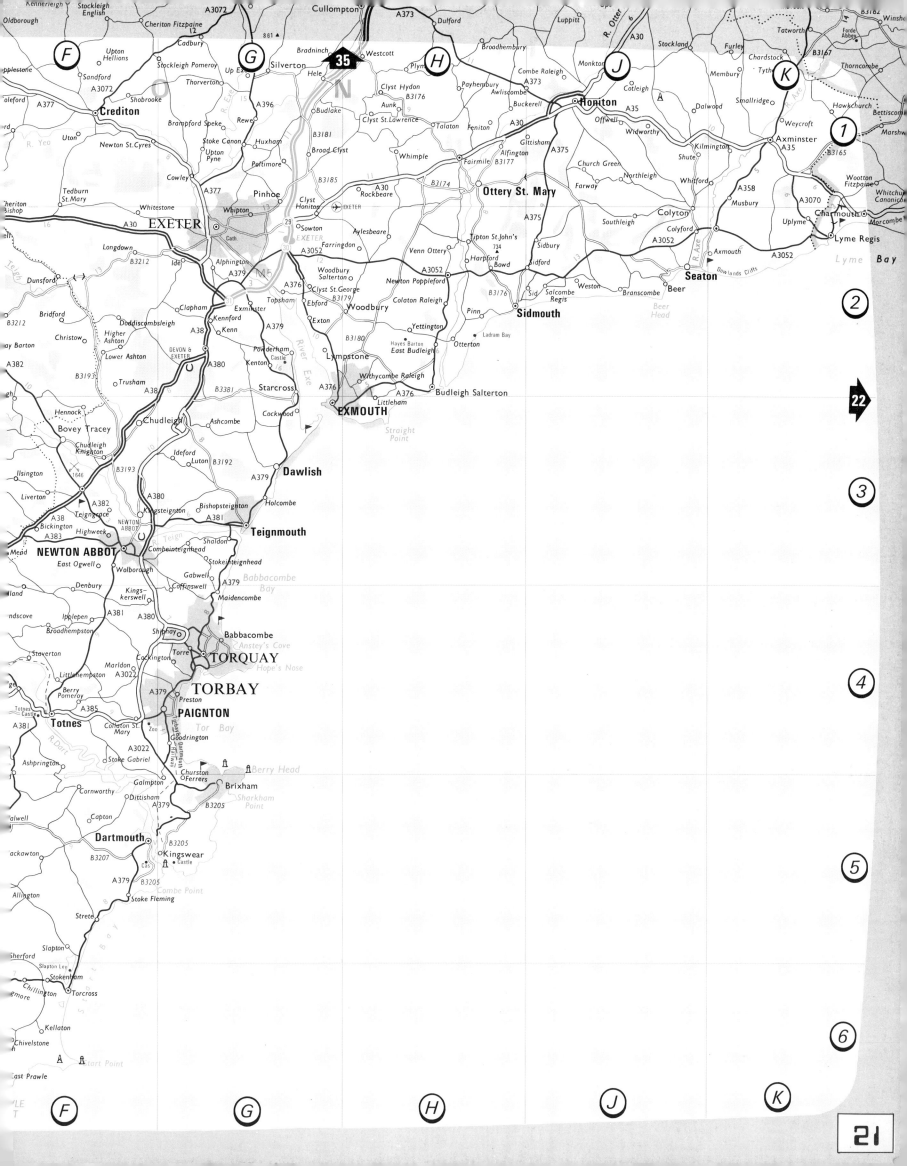

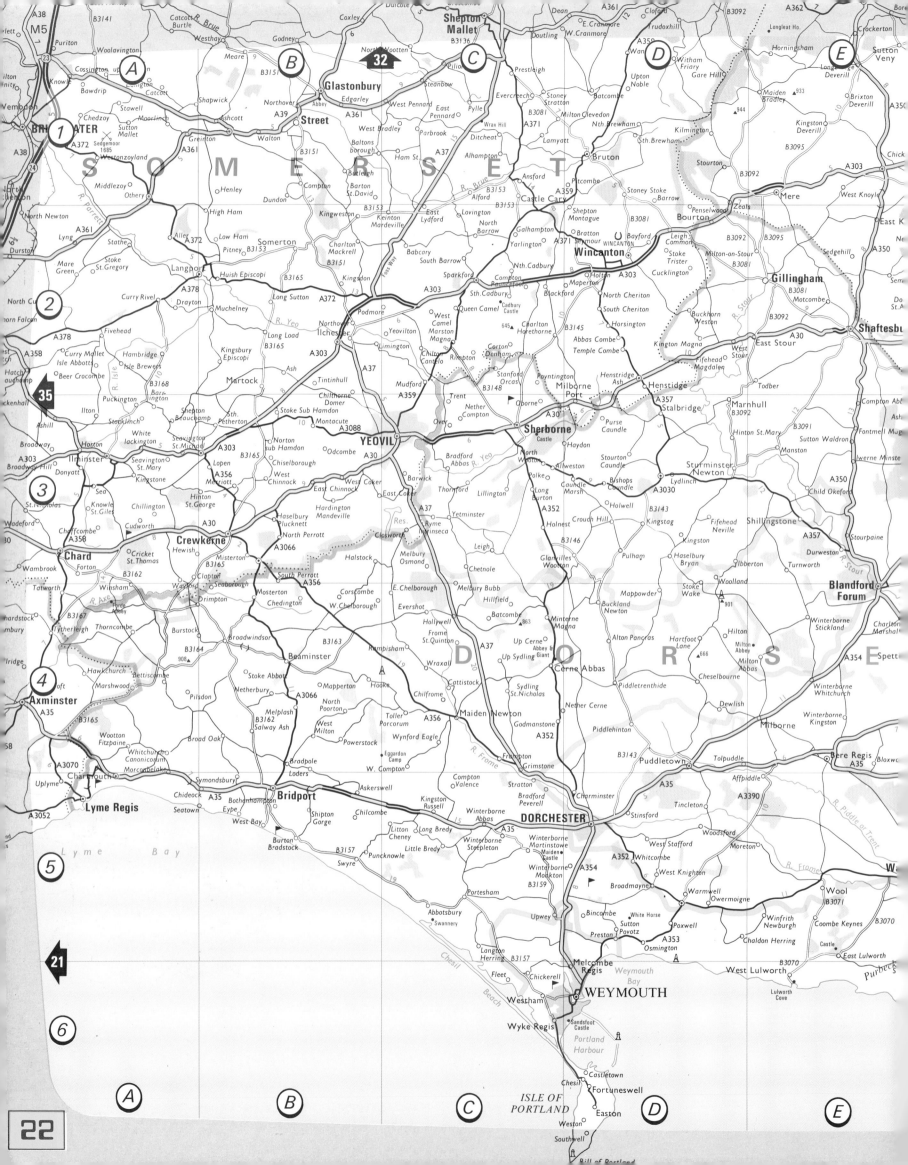

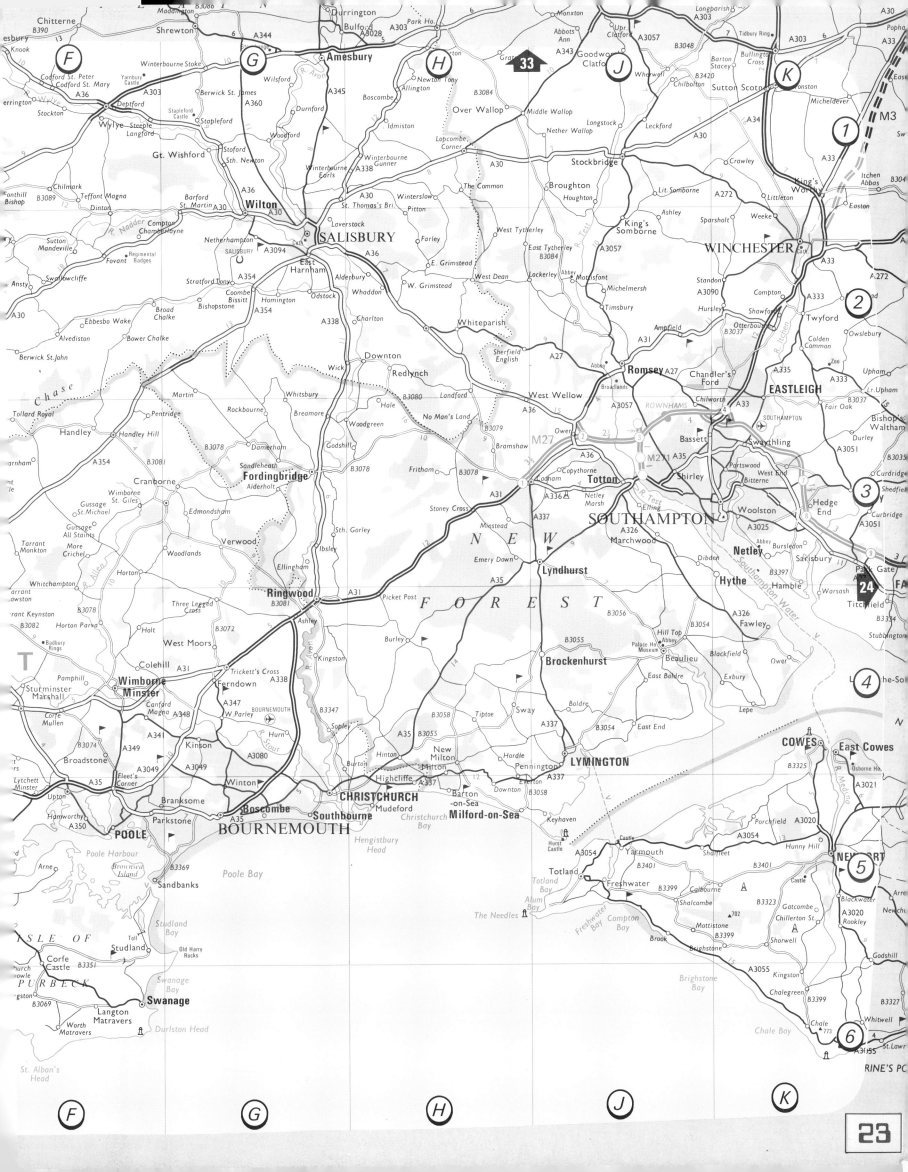

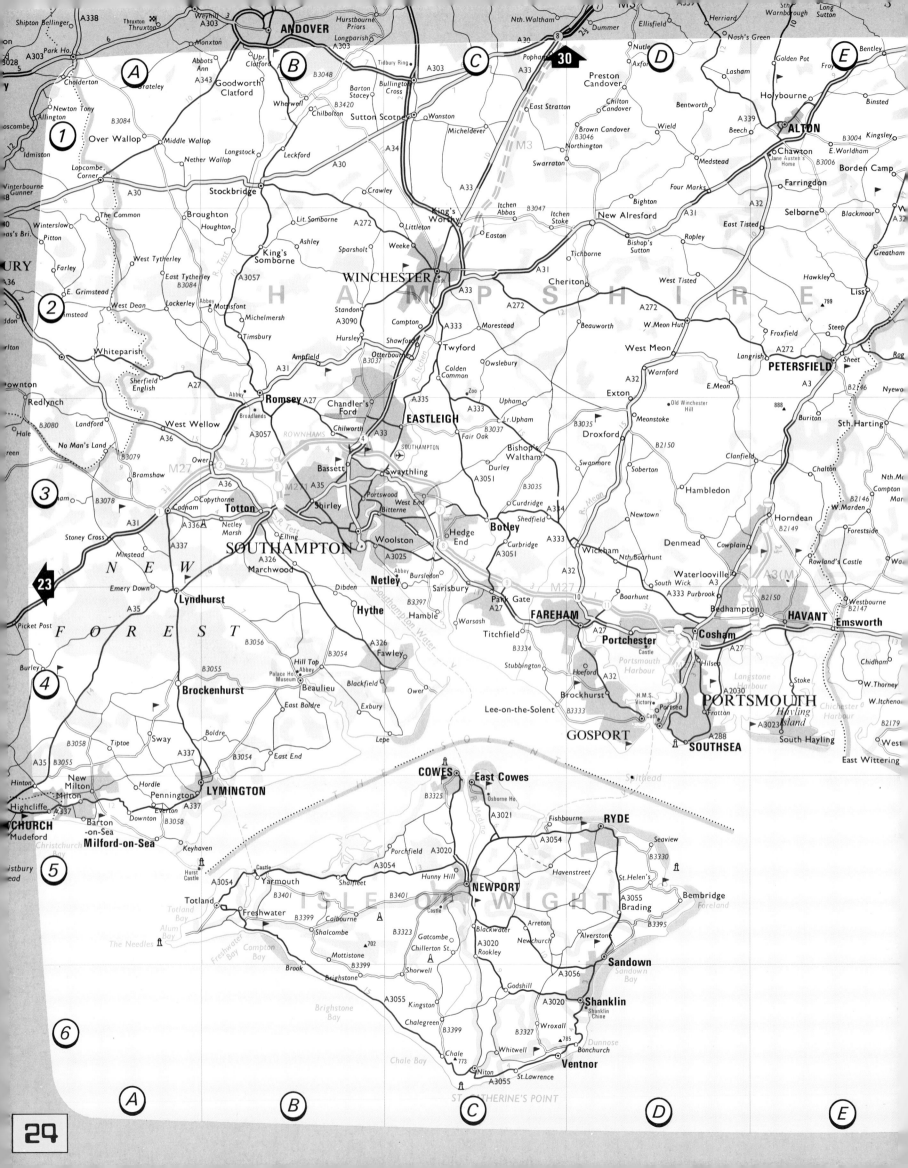

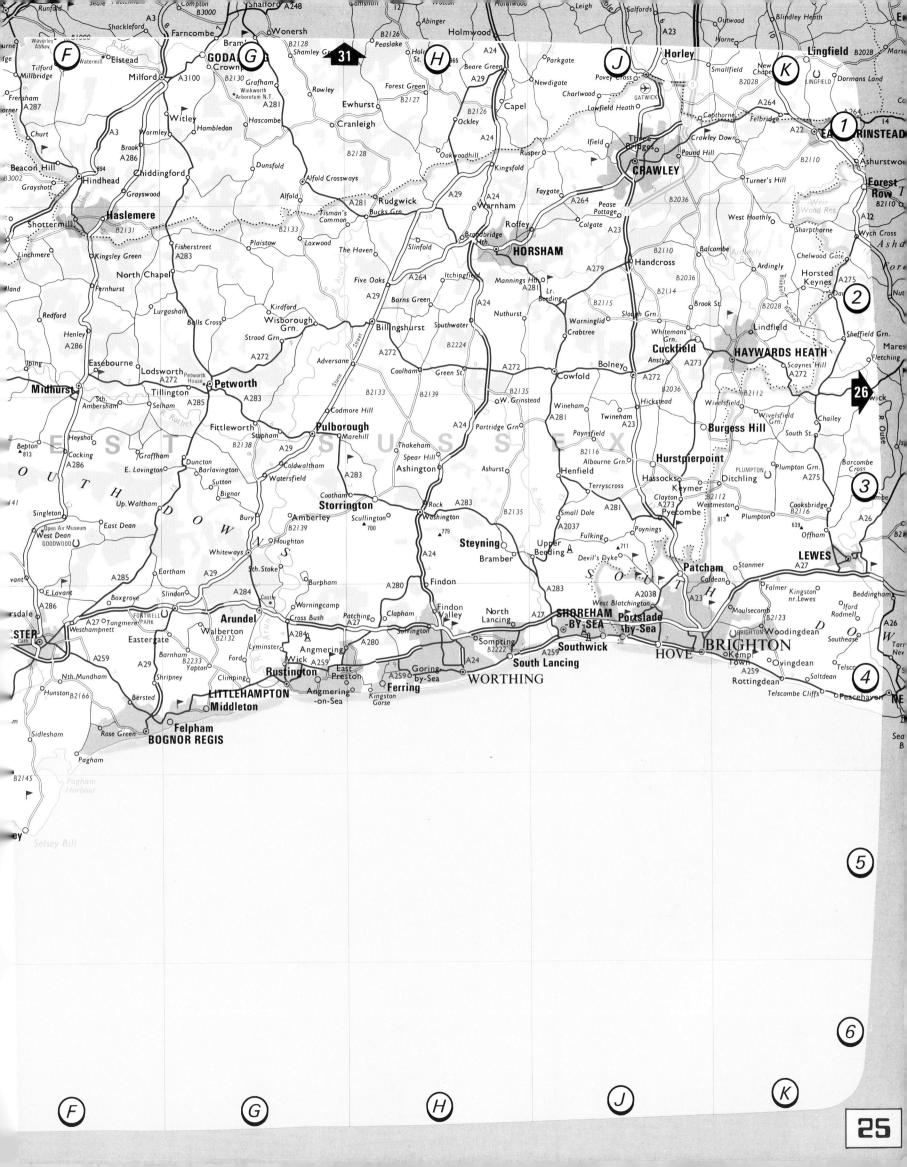

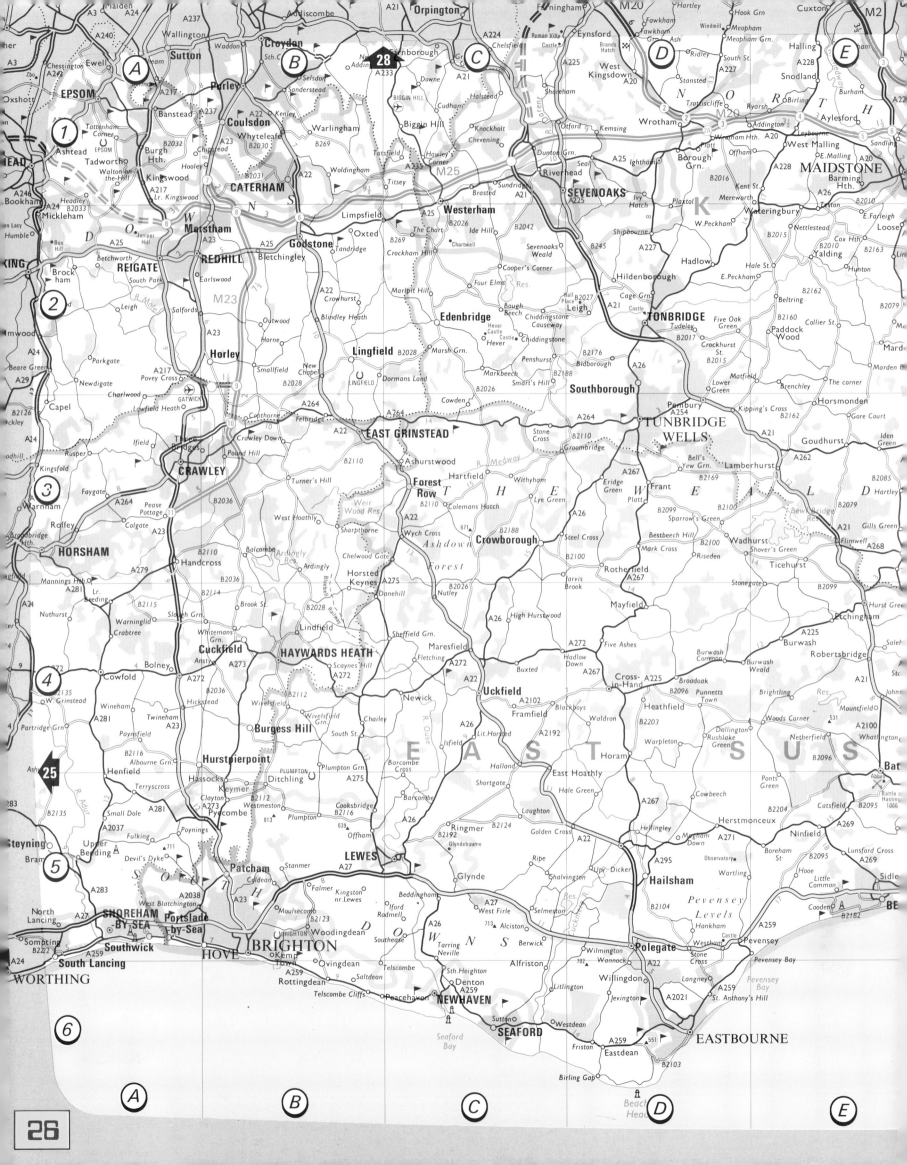

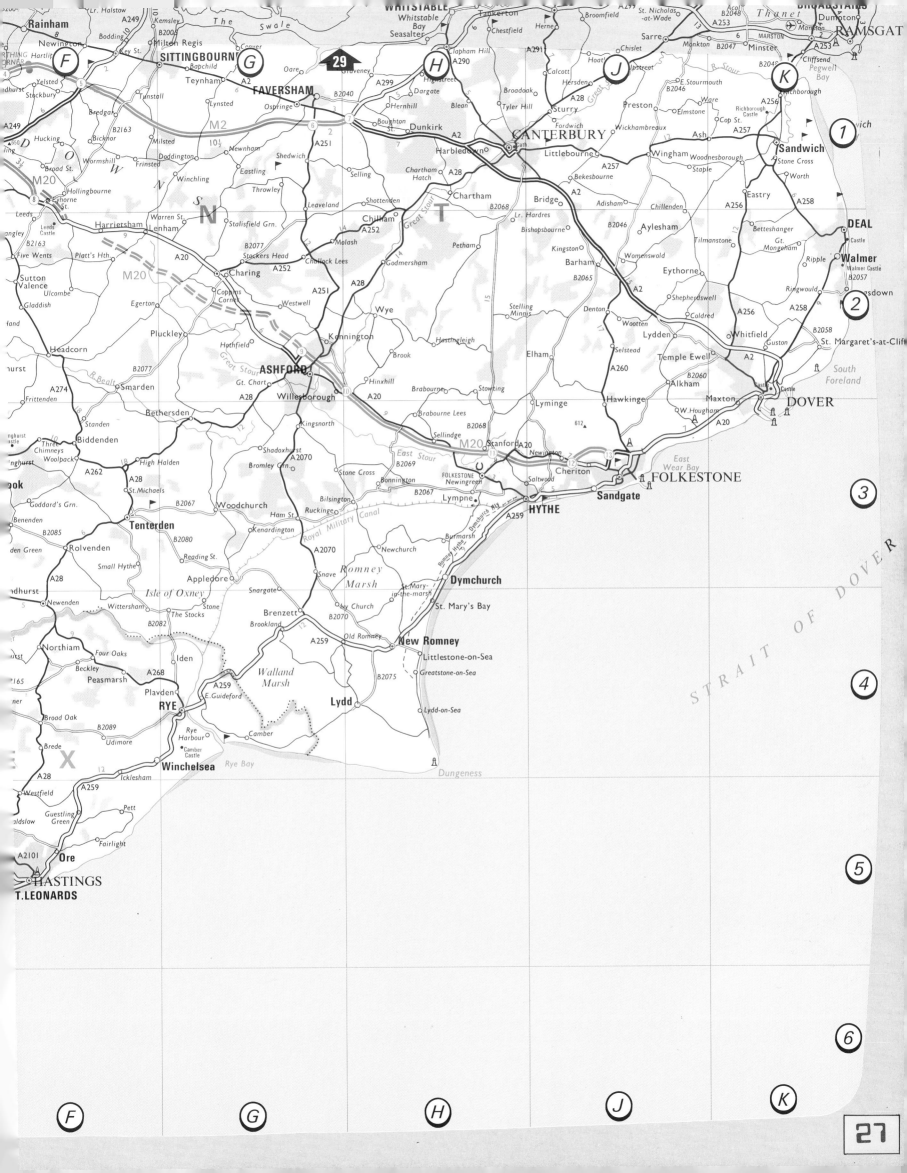

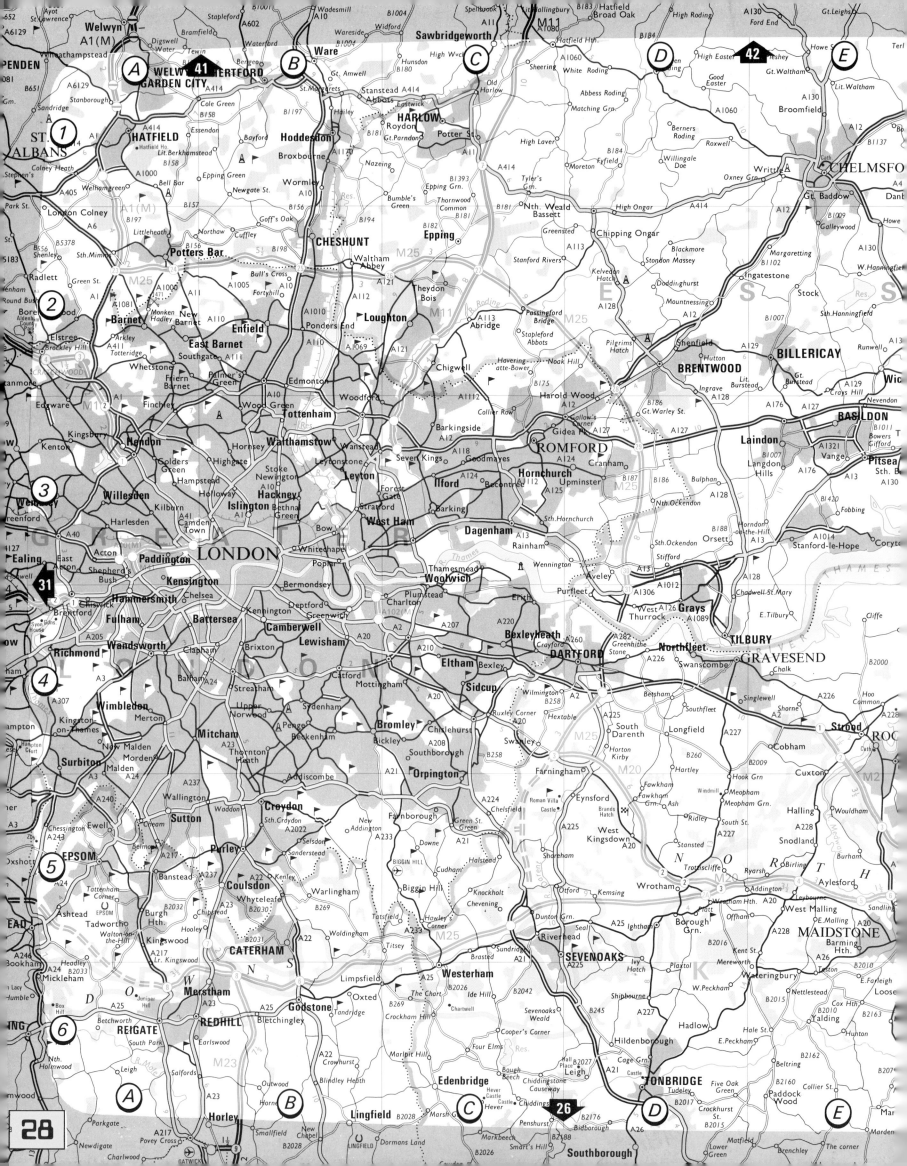

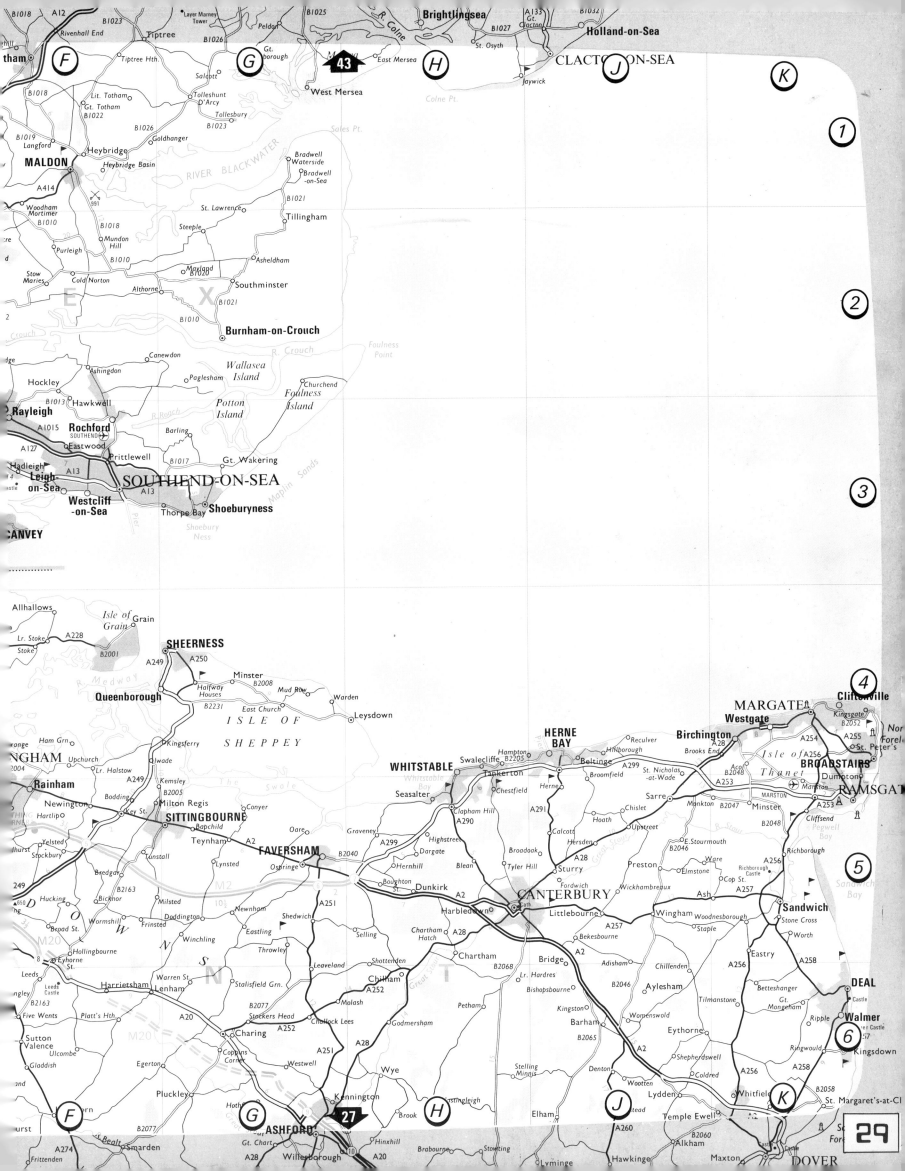

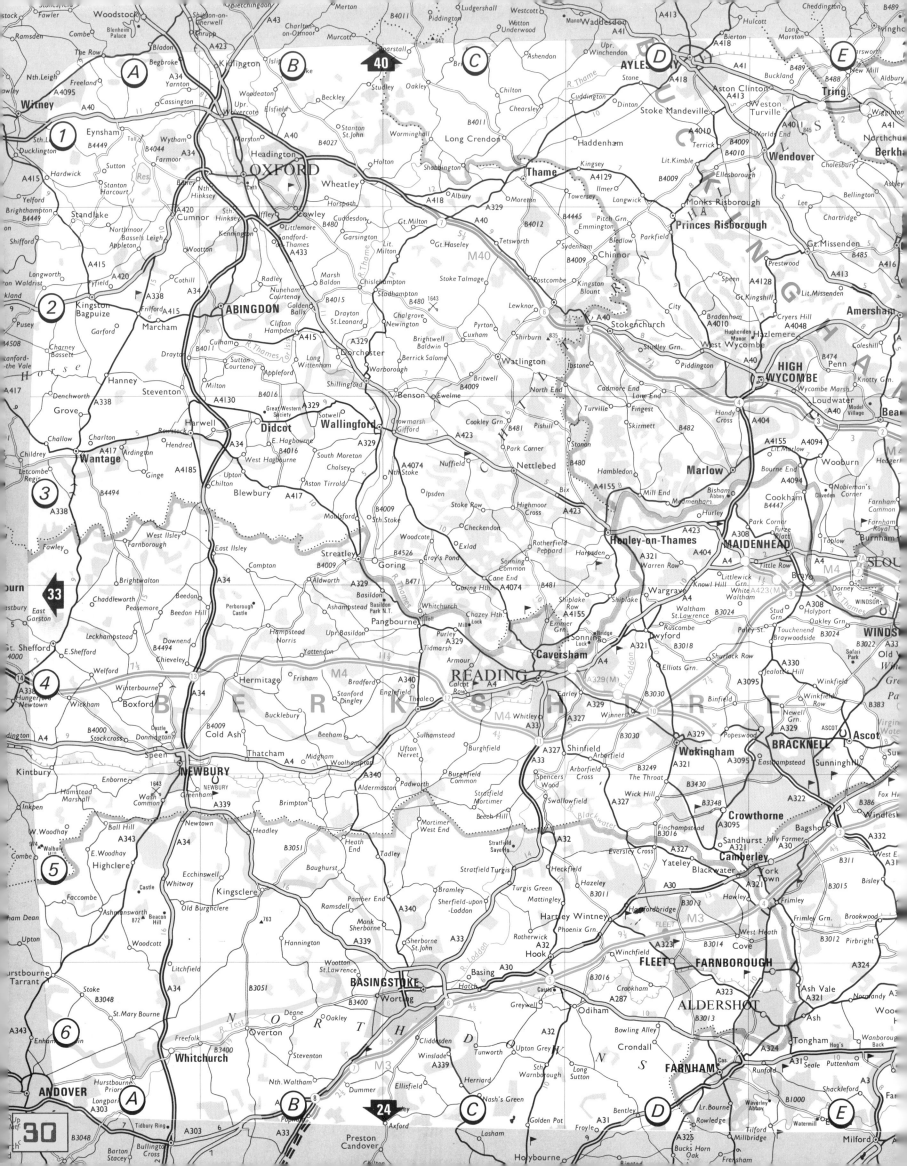

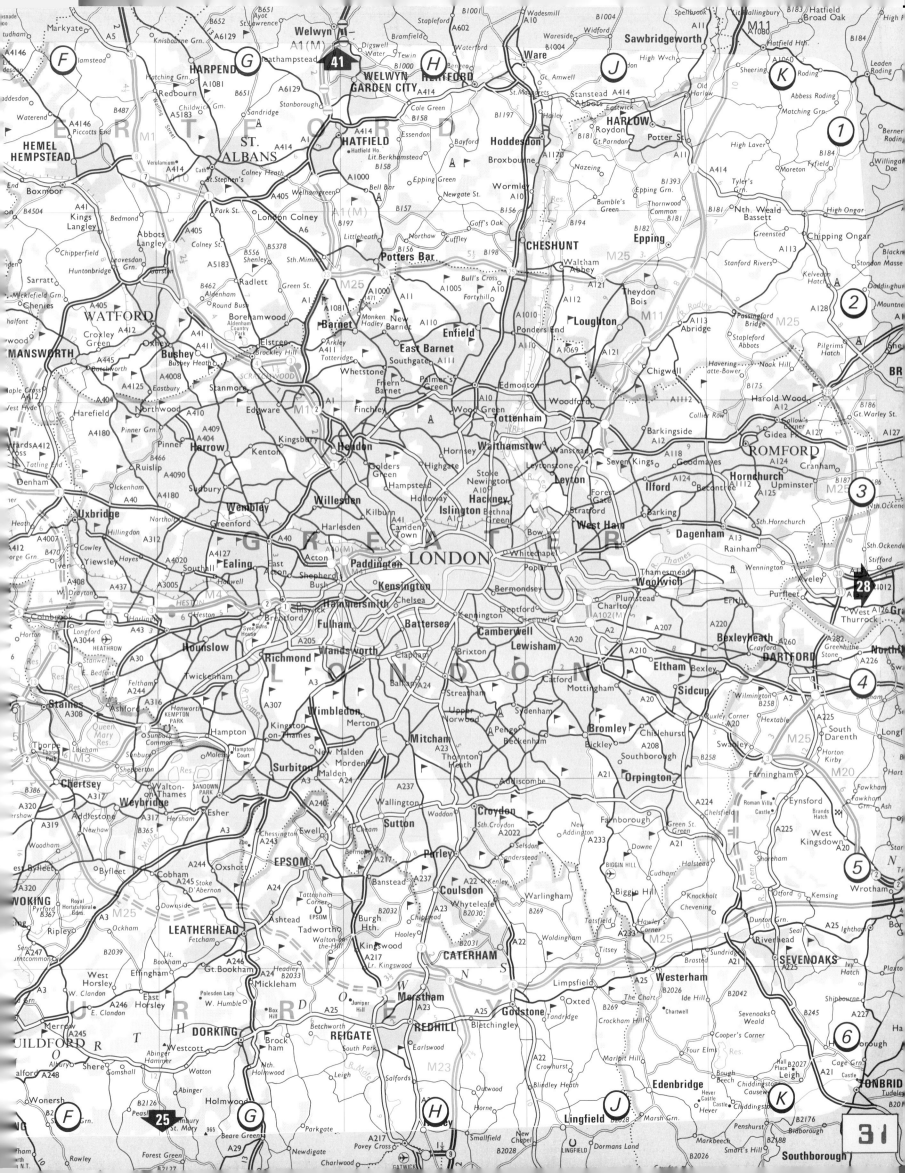

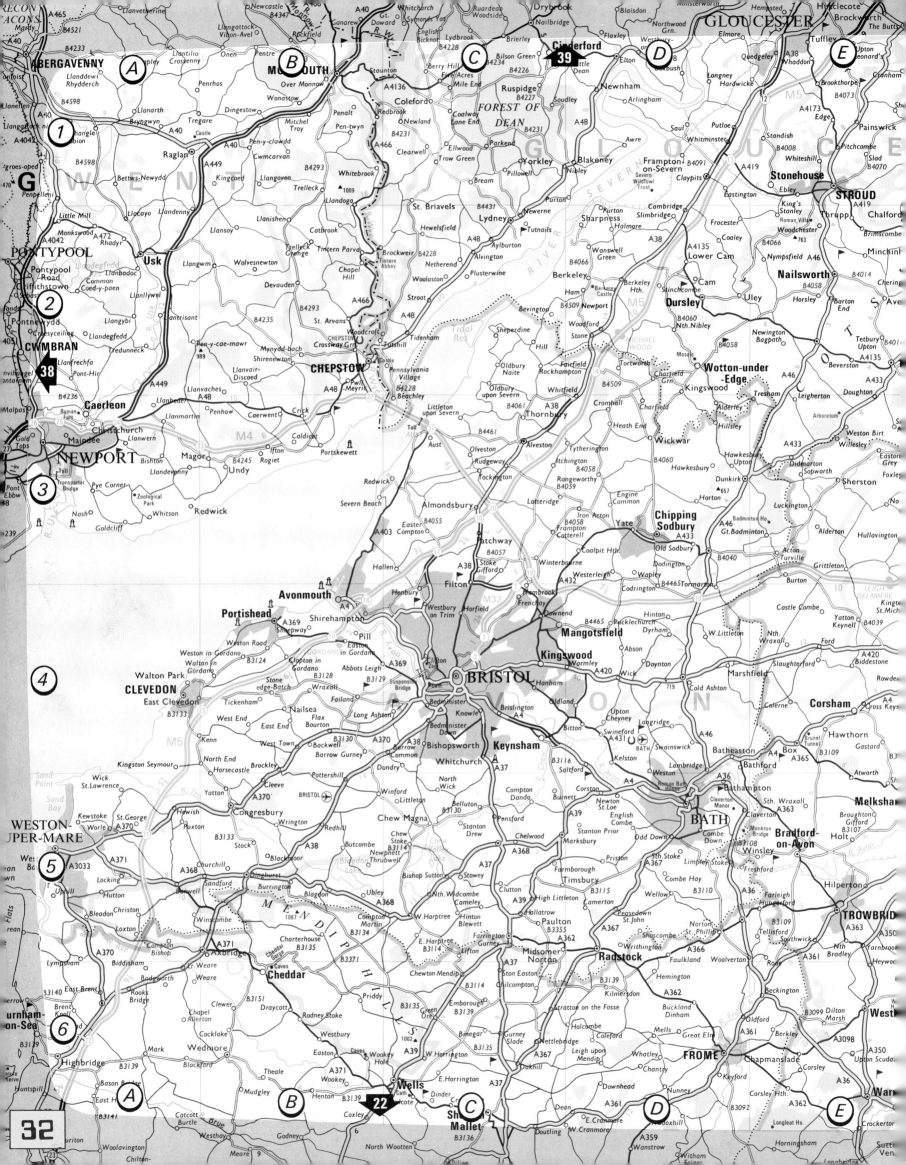

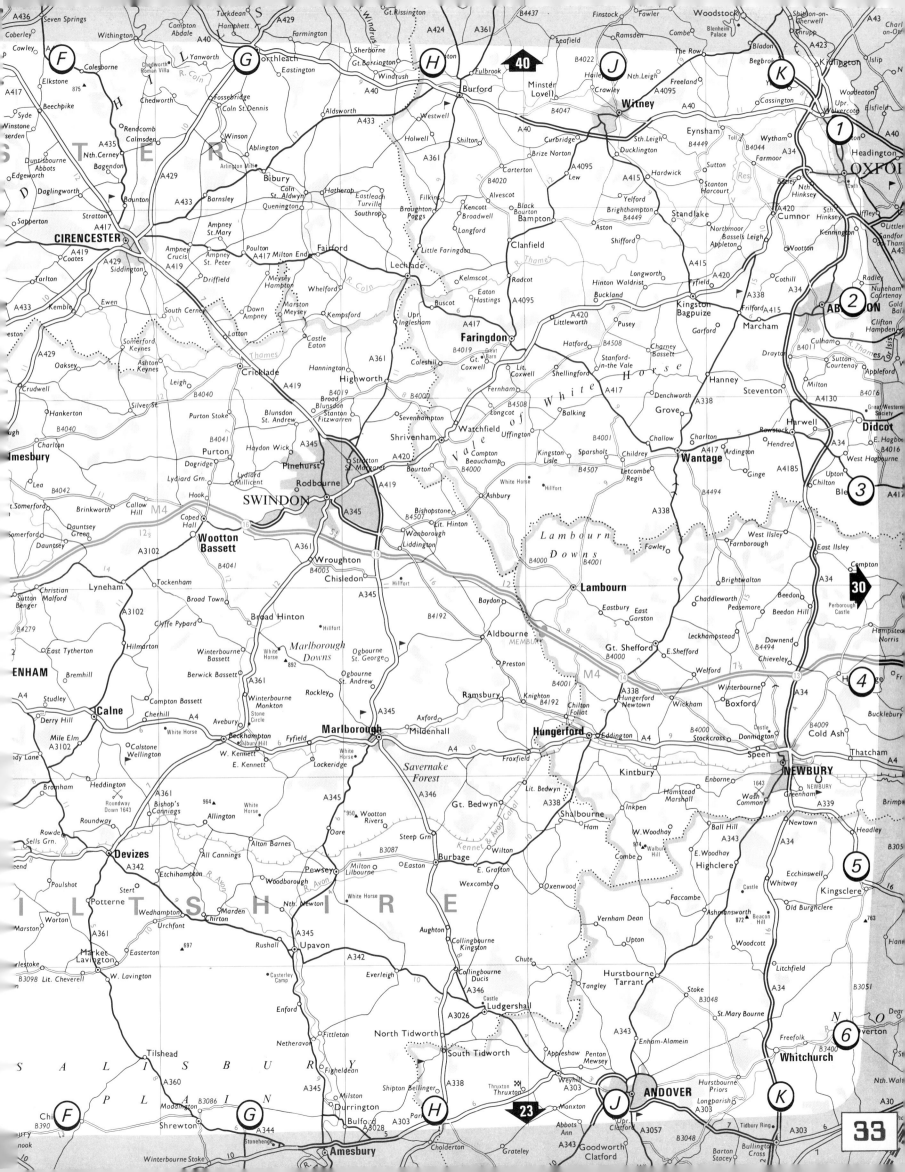

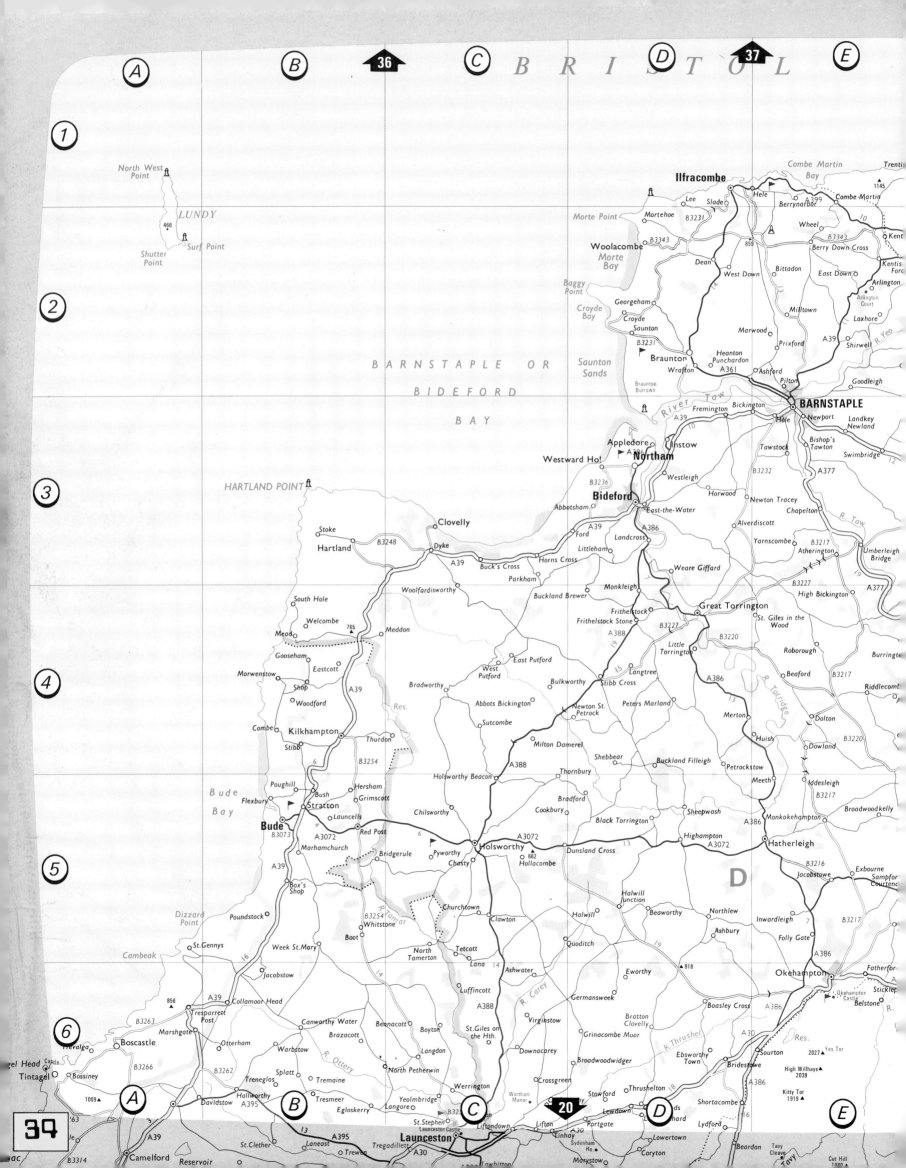

Map — Devon / Somerset

Grid references (top): F G H **38** J K

Grid references (right): 1 2 3 4 5 6

Grid references (bottom): F G H **21** J K

BRIDGWATER BAY

CHANNEL

Burnham-on-...

Berrow Flats

Stert Flats

Lynmouth Bay — Foreland Point — Countisbury
Lynton — Lynmouth — Valley of the Rocks — Brendon — Oare — A39
Porlock — Porlock Weir — B3225 — Bossington — Allerford — Selworthy — Higher Town
Minehead — Alcombe — Periton — Luccombe — Minehead
Dunster — Dunster Castle — Blue Anchor Bay — Watchet
Wootton Courtney — Carhampton — Old Cleeve — B3190
Timbercombe — Washford — Williton — East Quantoxhead — Kilve — Lilstock
Withycombe — Cleeve Abbey — Sampford Brett — West Quantoxhead — Holford — A39
Rodhuish — Monksilver — Bicknoller — Stringston — Dodington
Luxborough — Roadwater — Nettlecombe — Stogumber — Crowcombe
Kingsbridge — Treborough — Elworthy — Over Stowey — Nether Stowey

EXMOOR FOREST — EXMOOR
Challacombe — Simonsbath — R. Exe — B3358
Withypool — Exford — B3224 — Winsford
Brayford — High Bray — Withypool — Bridgetown — Exton — Withiel Florey
North Molton — Hawkridge — Dulverton — Brompton Regis — Brompton Ralph
South Molton — Molland — West Anstey — East Anstey — Bury — Skilgate — Raddington
Newtown — A361 — Bishop's Nympton — Ash Mill — Knowstone — Brushford — Exebridge — Morebath — Petton — Waterrow — Clayhanger
Mariansleigh — Rose Ash — Oakfordbridge — Shillingford — Bampton — Bathealton — Stawley
Romansleigh — Meshaw — Oakford — Huntsham — Hockworthy — Ashbrittle — Sampford Arundel
Creacombe — Rackenford — Stoodleigh — Cove — Holcombe Rogus — Burlescombe
Week — Loxbeare — Washfield — Bolham — Chevithorne — Uplowman — Whitnage
Chulmleigh — East Worlington — West Worlington — Templeton — Calverleigh — Sampford Peverell — A38
Cheldon Barton — Chawleigh — No Man's Land — Withleigh — **Tiverton** — Halberton — Uffculme — Craddock
Lapford — Nymet Rowland — Morchard Bishop — Washford Pyne — Pennymoor — Puddington — Smithincott — Ashill
Coldridge — Woolfardisworthy — Poughill — Cadeleigh — Bickleigh — Butterleigh — Kentisbeare — Sheldon — Dunkeswell
Kennerleigh — Stockleigh English — Cadbury — Bradninch — Westcott — Plymtree — Broadhembury — Luppitt
Clannaborough — Copplestone — Sandford — Stockleigh Pomeroy — Up Exe — Silverton — Hele — Clyst Hydon — Payhembury — Awliscombe — Combe Raleigh
Bow — Nymet Tracey — Coleford — Shobrooke — Tharverton — **Crediton** — Brampford Speke — Rewe — Clyst St. Lawrence — Talaton — Feniton — Buckerell — **Honiton**
Yeoford — Colebrooke — Uton — Newton St. Cyres — Stoke Canon — Huxham — Budlake — Aunk — Fairmile — Alfington — Gittisham
Hittisleigh Cross — Cheriton Bishop — Tedburn St. Mary — Upton Pyne — Broad Clyst — Whimple — Ottery St. Mary — Farway
Spreyton — Longdown — Whitestone — Cowley — Pinhoe — Rockbeare — B3174
Whiddon Down — Crockernwell — Ide — Whipton — **EXETER** — Clyst Honiton — Sowton — Farringdon — Sidbury — Colyton — Colyford
Drewsteignton — Dunsford — Alphington — Woodbury Salterton — Venn Ottery — Harpford — Sidford — Seaton — Beer
Easton — Christow — Clapham — Kennford — Topsham — Clyst St. George — Woodbury — Newton Poppleford — Sidmouth — Beer Head
Doccombe — Bridford — Lower Ashton — Exminster — Ebford — Exton — Colaton Raleigh — Yettington — Salcombe Regis
North Bovey — Wray Barton — DEVON & EXETER — Powderham Castle — Kenton — Lympstone — East Budleigh — Otterton — Ladram Bay

DEVON — **Quantock Hills** — **Brendon Hills** — **Black Down Hills**

TAUNTON — Wiveliscombe — Milverton — Wellington — Bishop's Lydeard — West Bagborough
BRIDGWATER

Motorway: M5

35

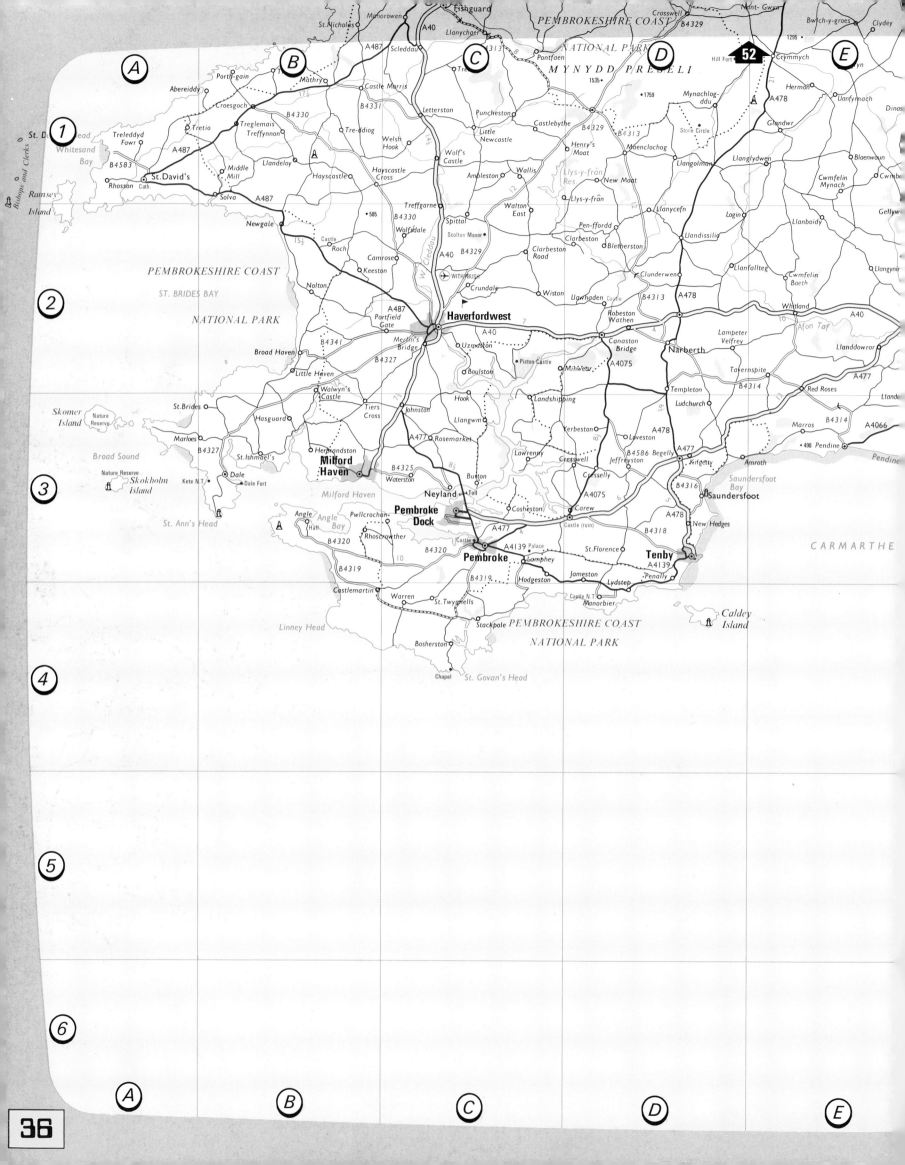

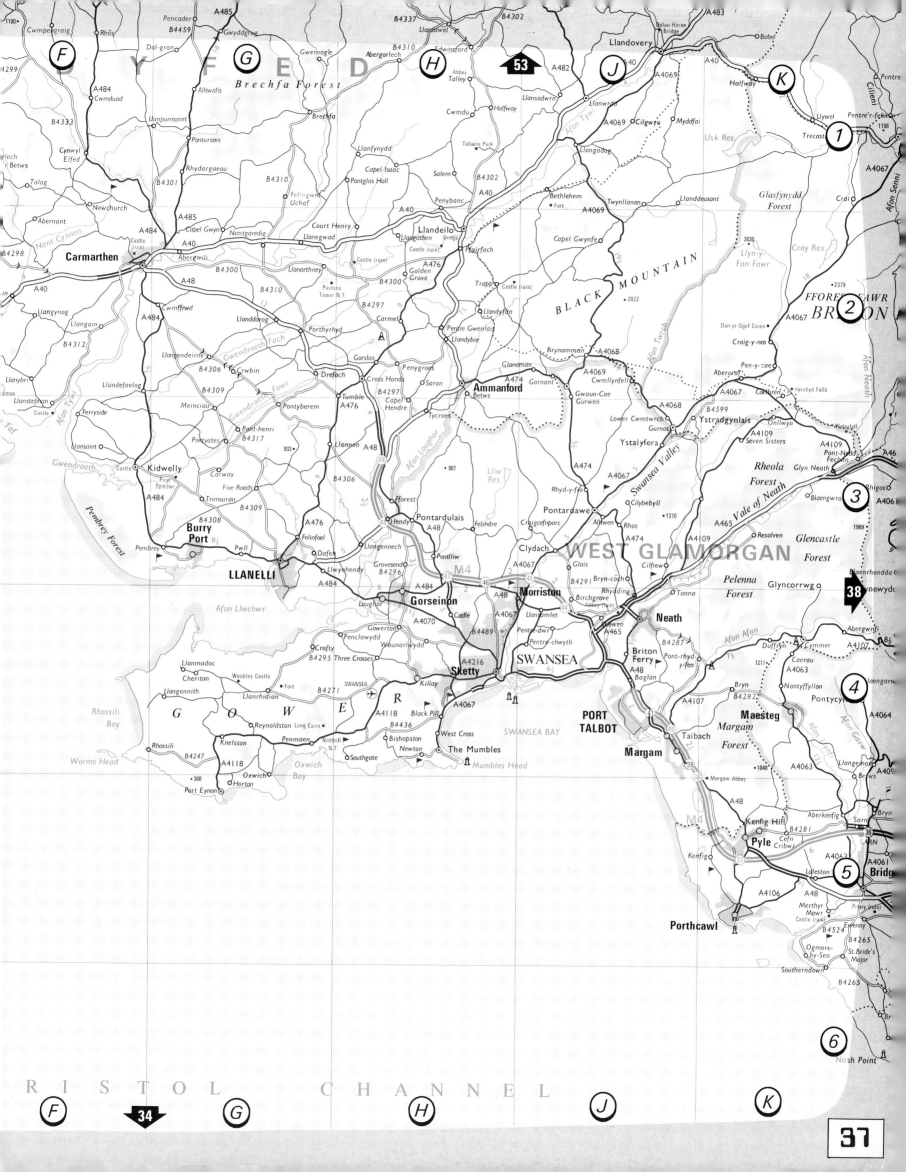

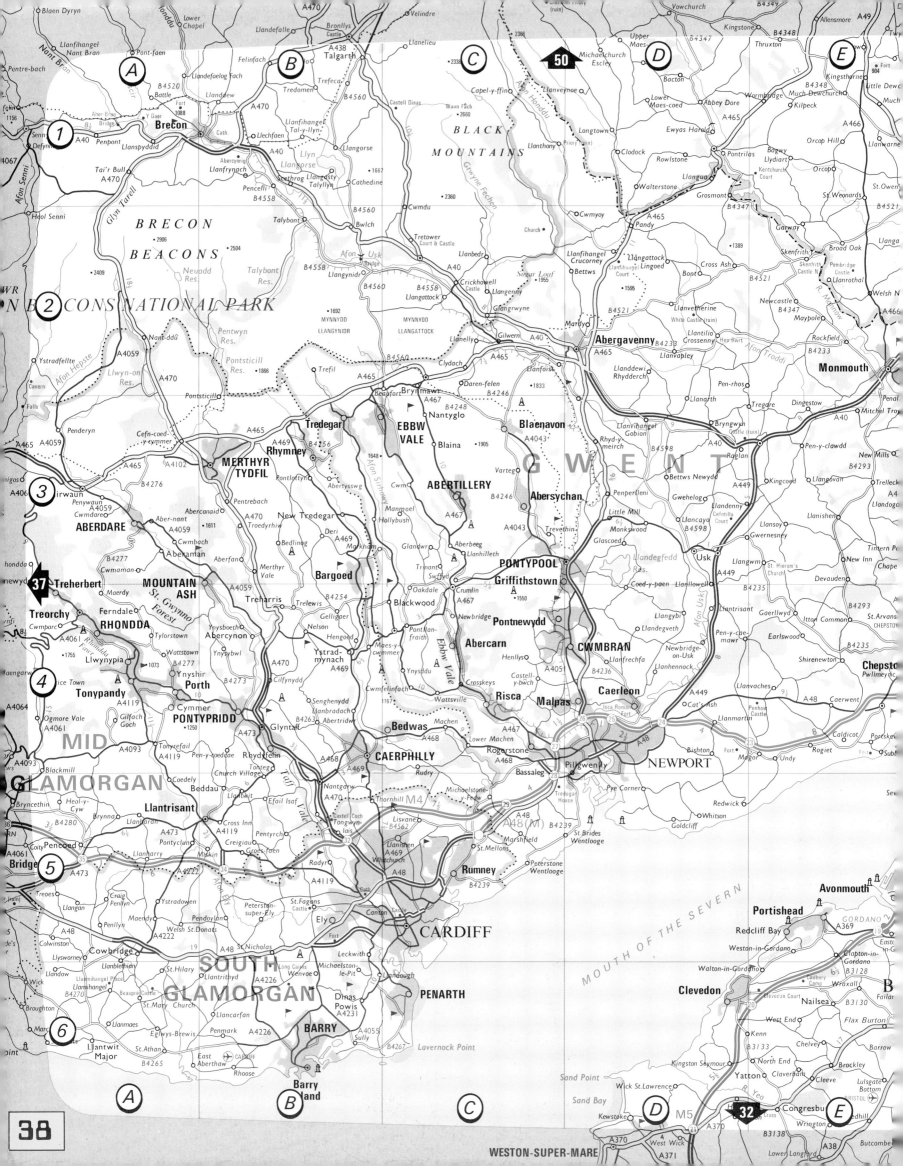

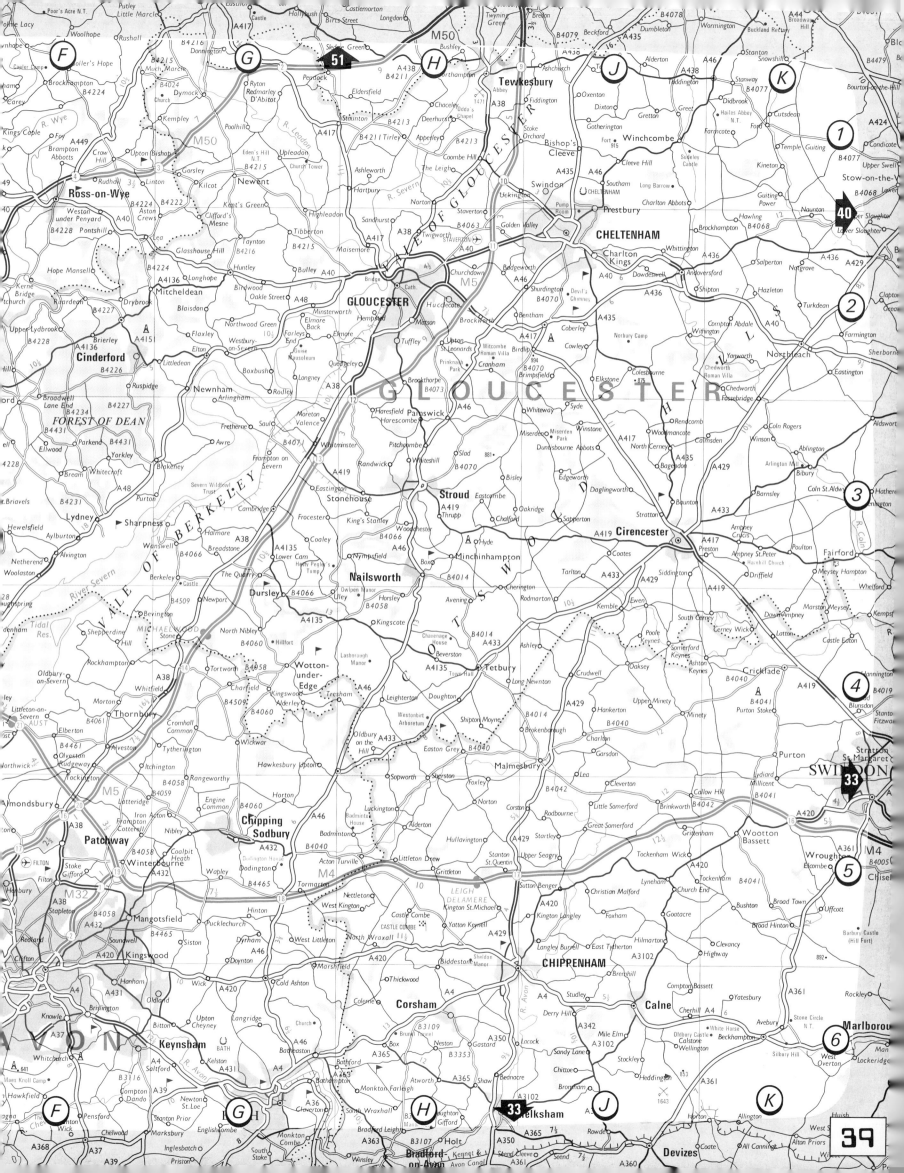

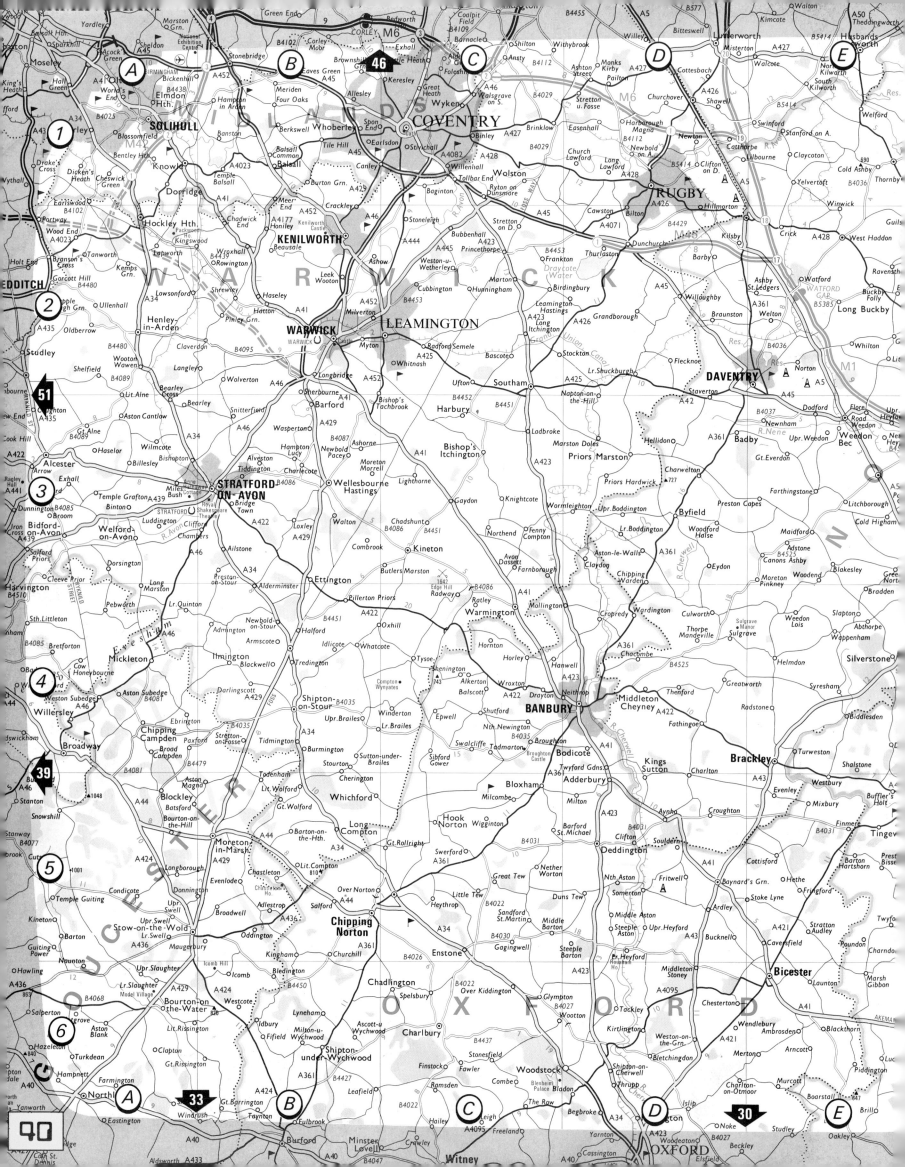

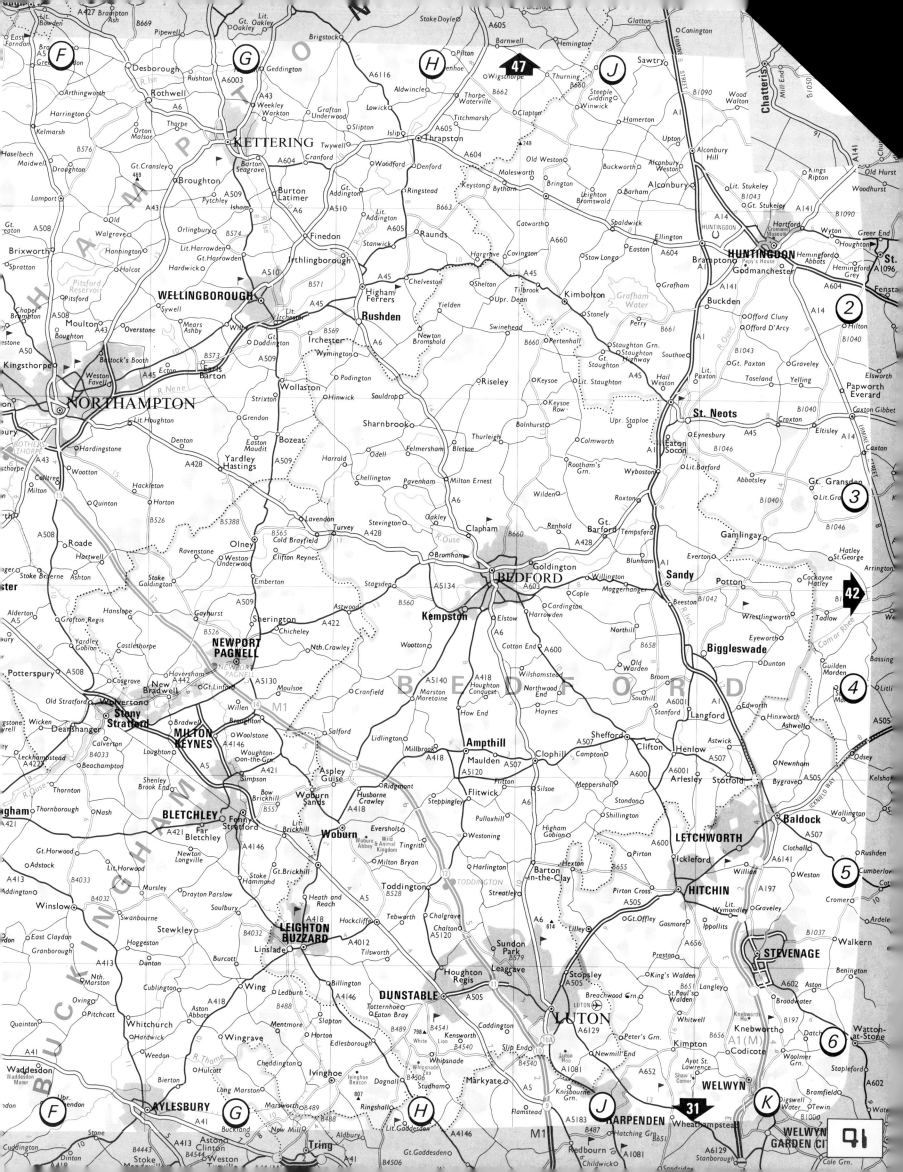

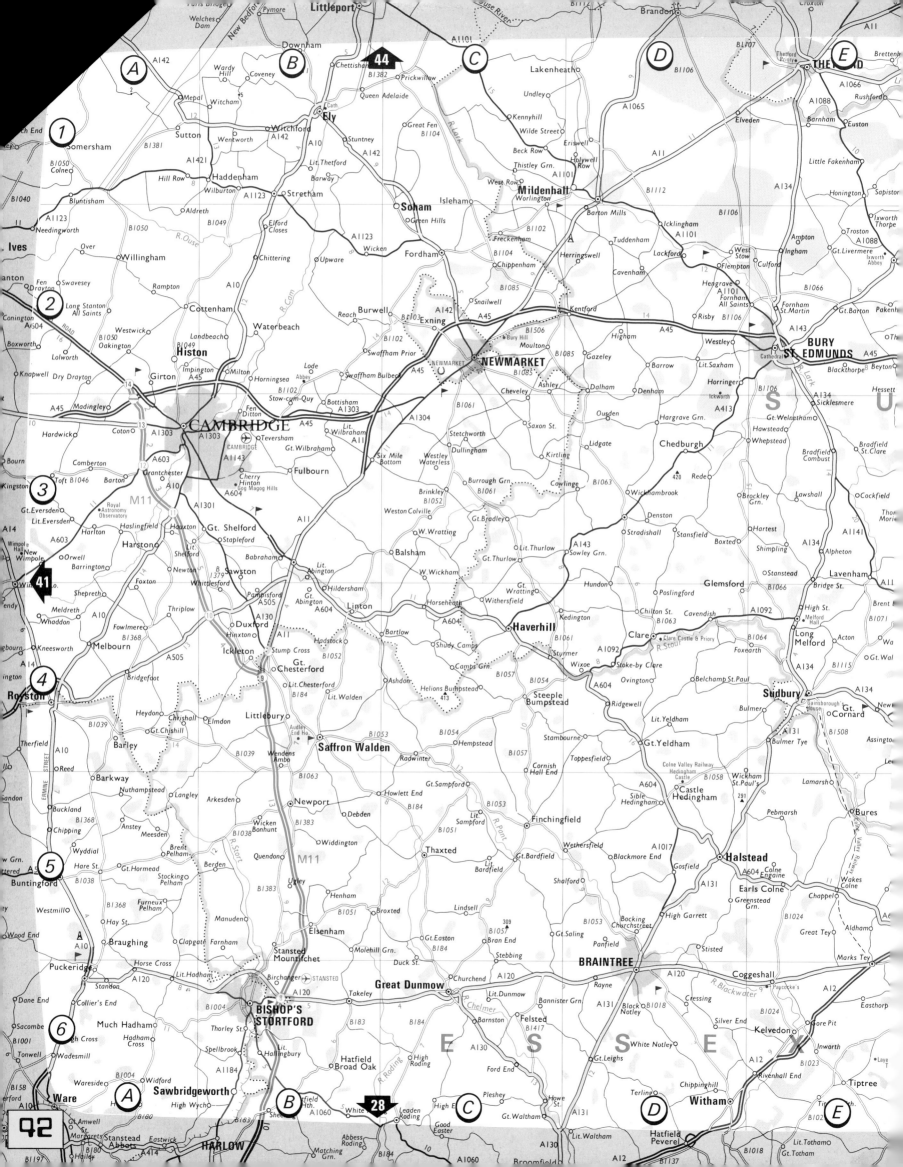

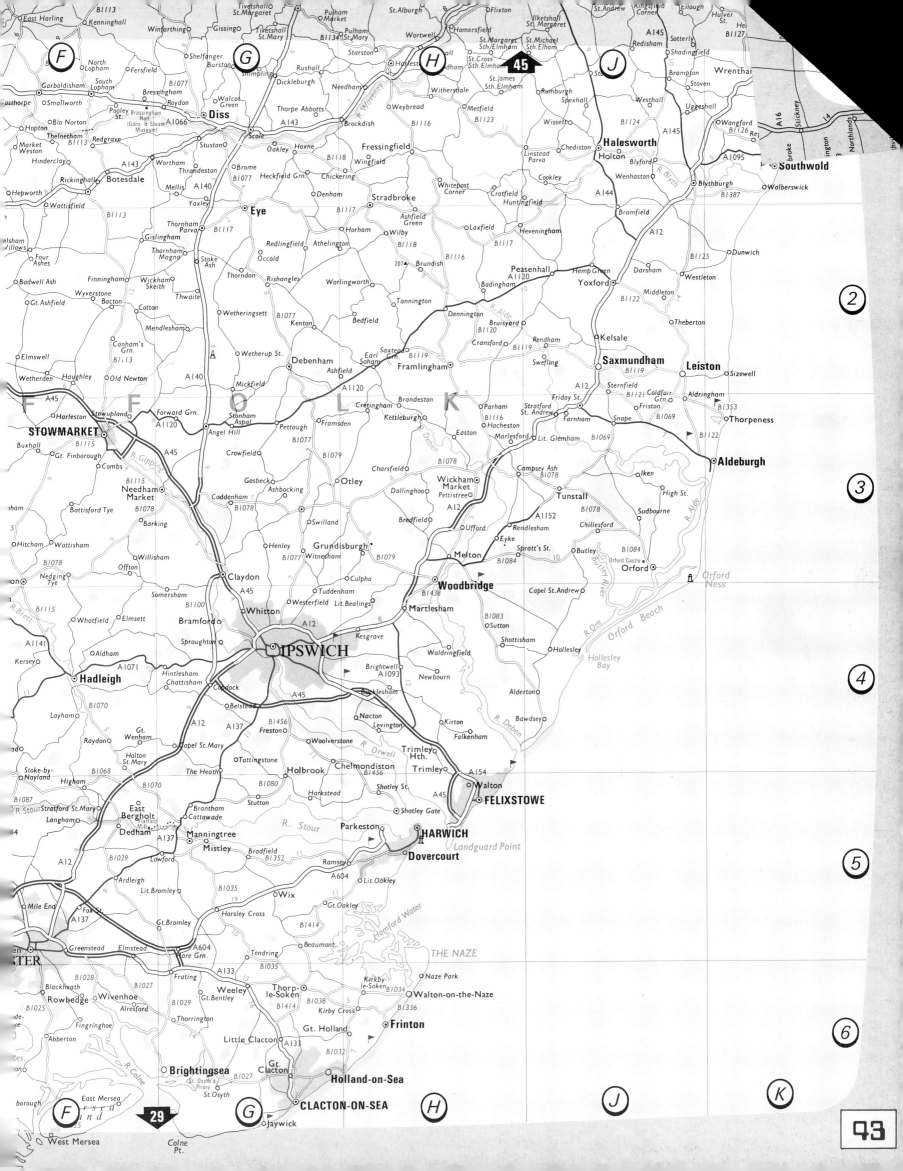

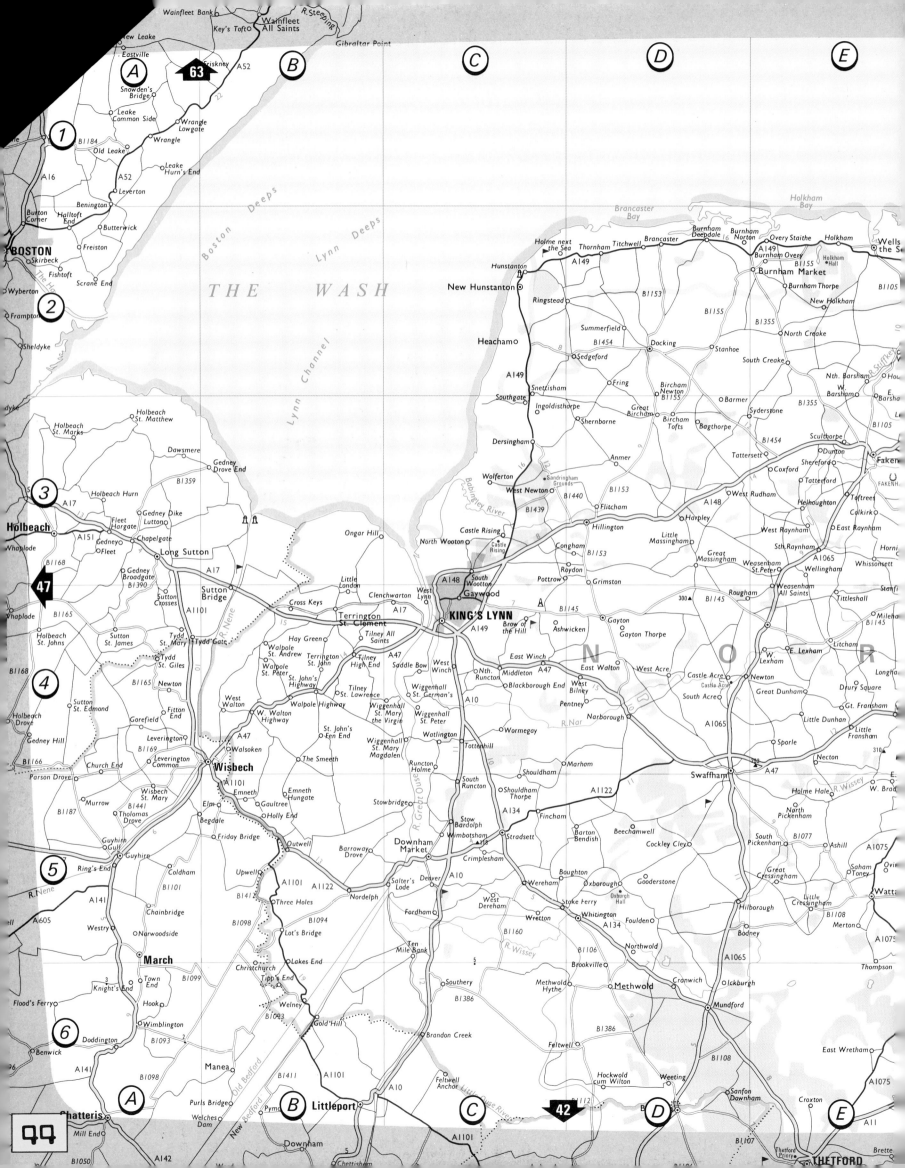

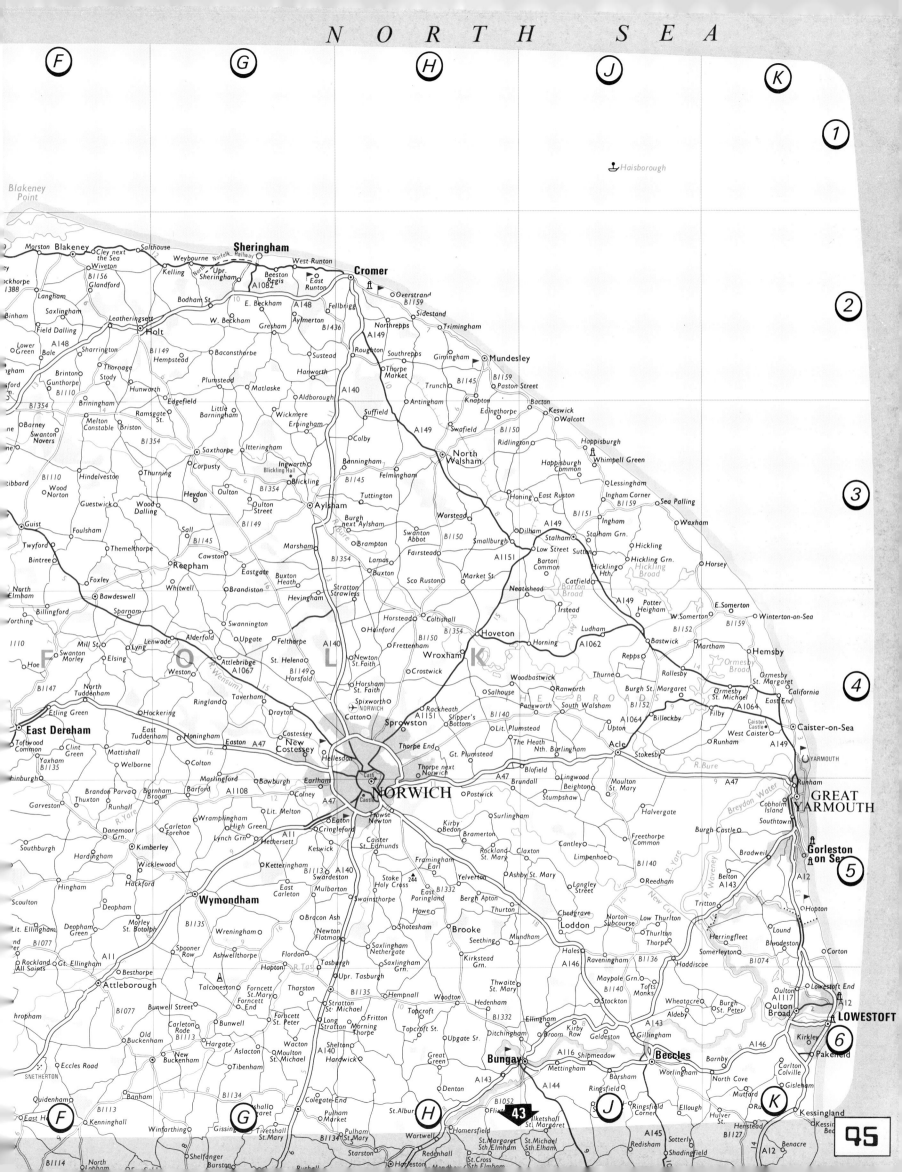

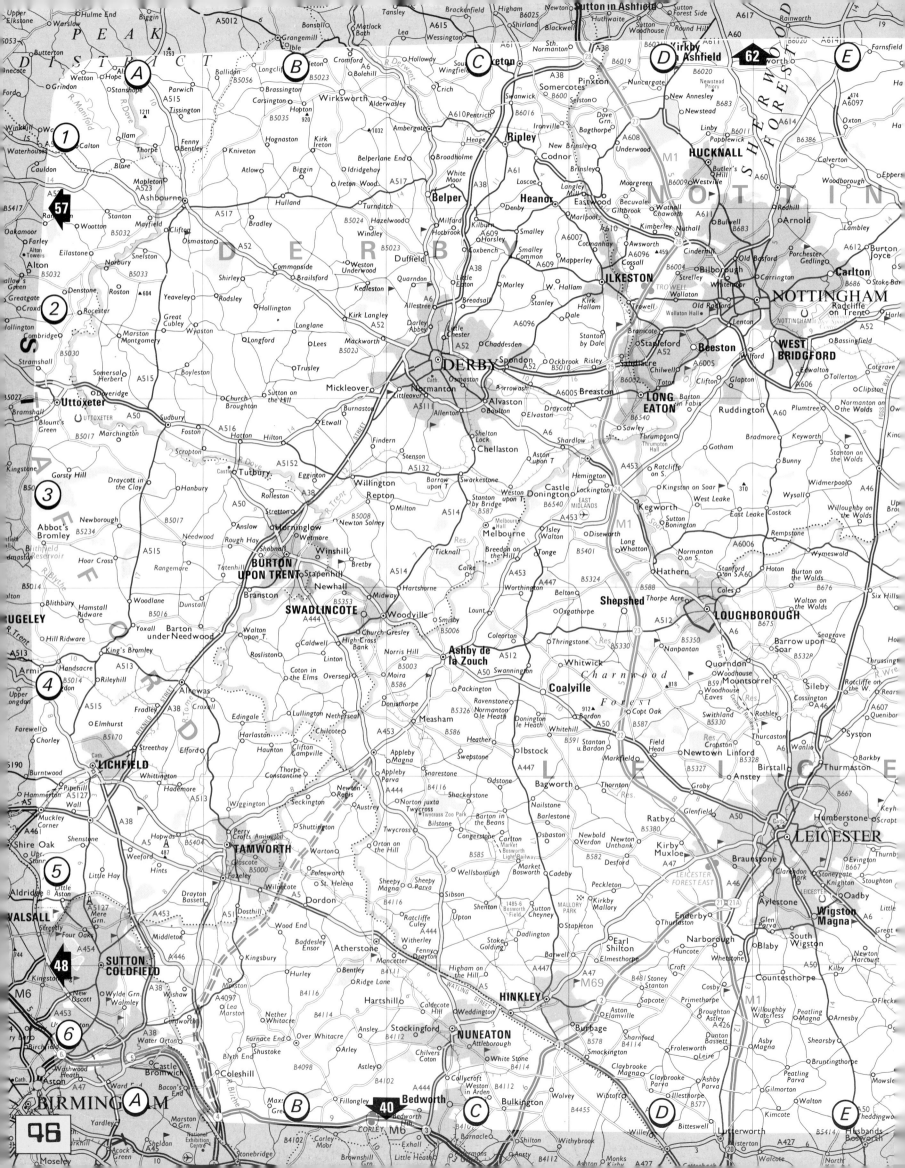

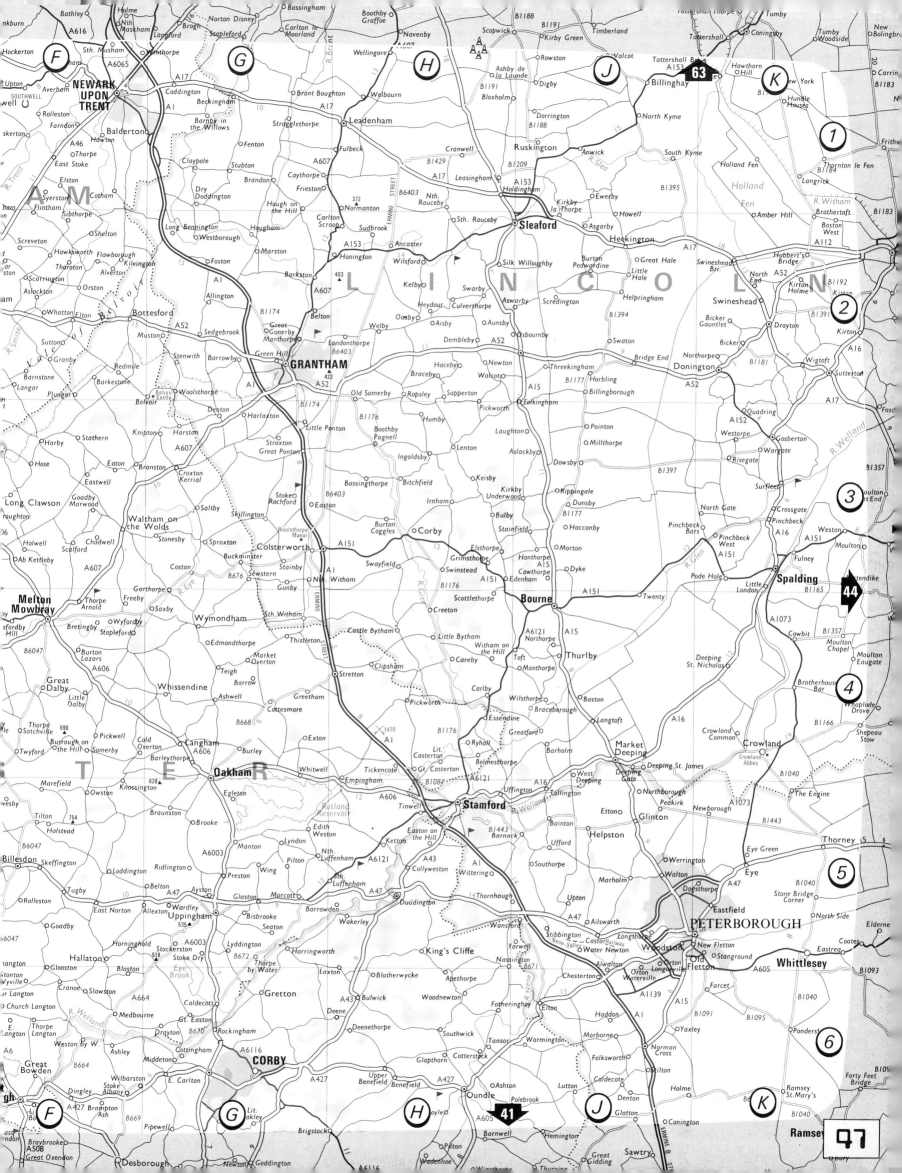

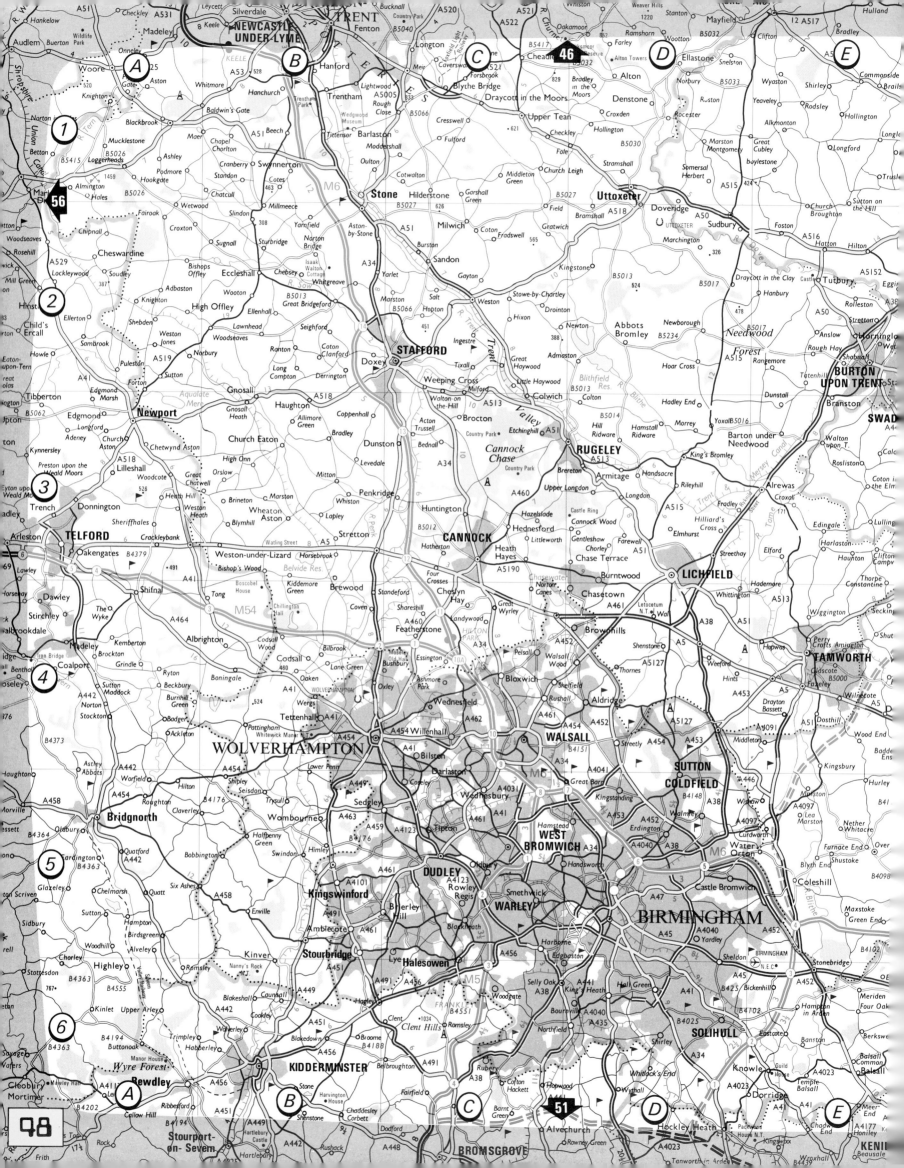

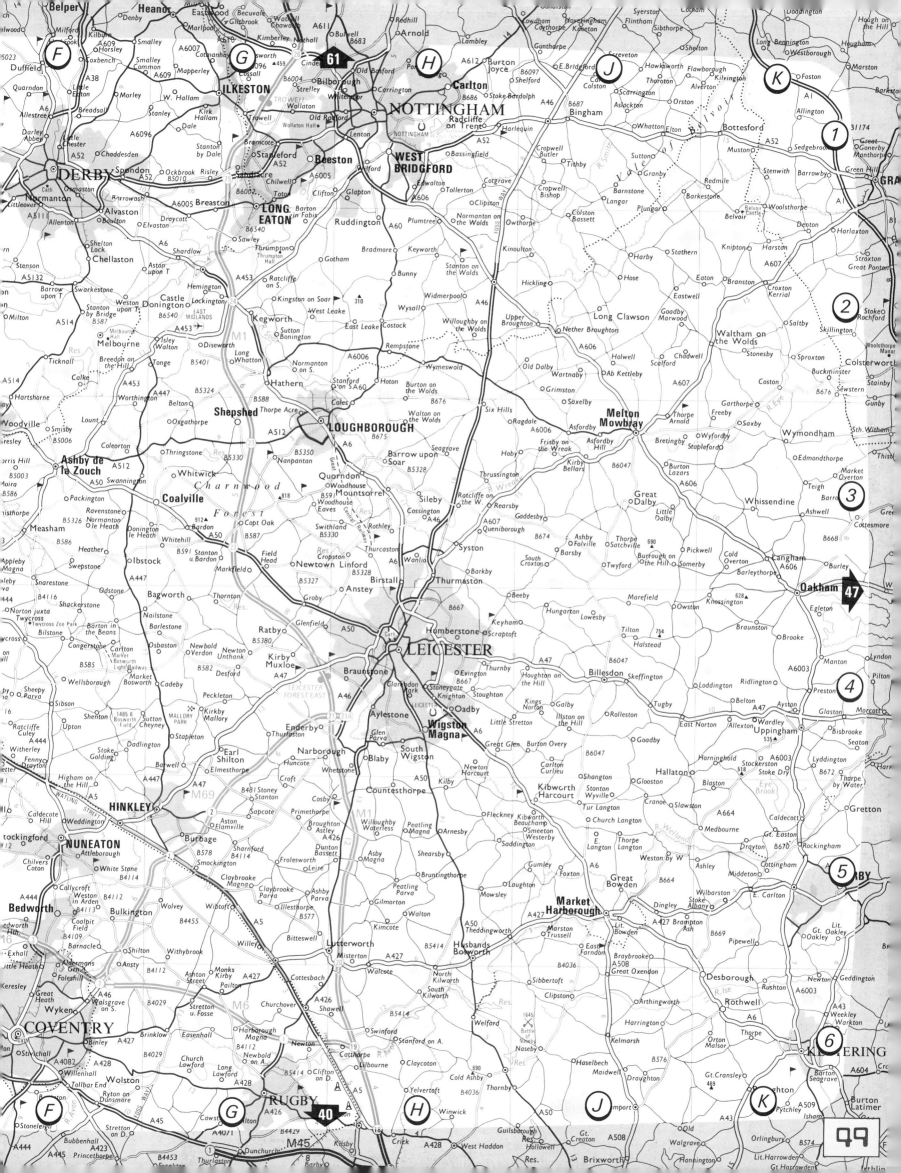

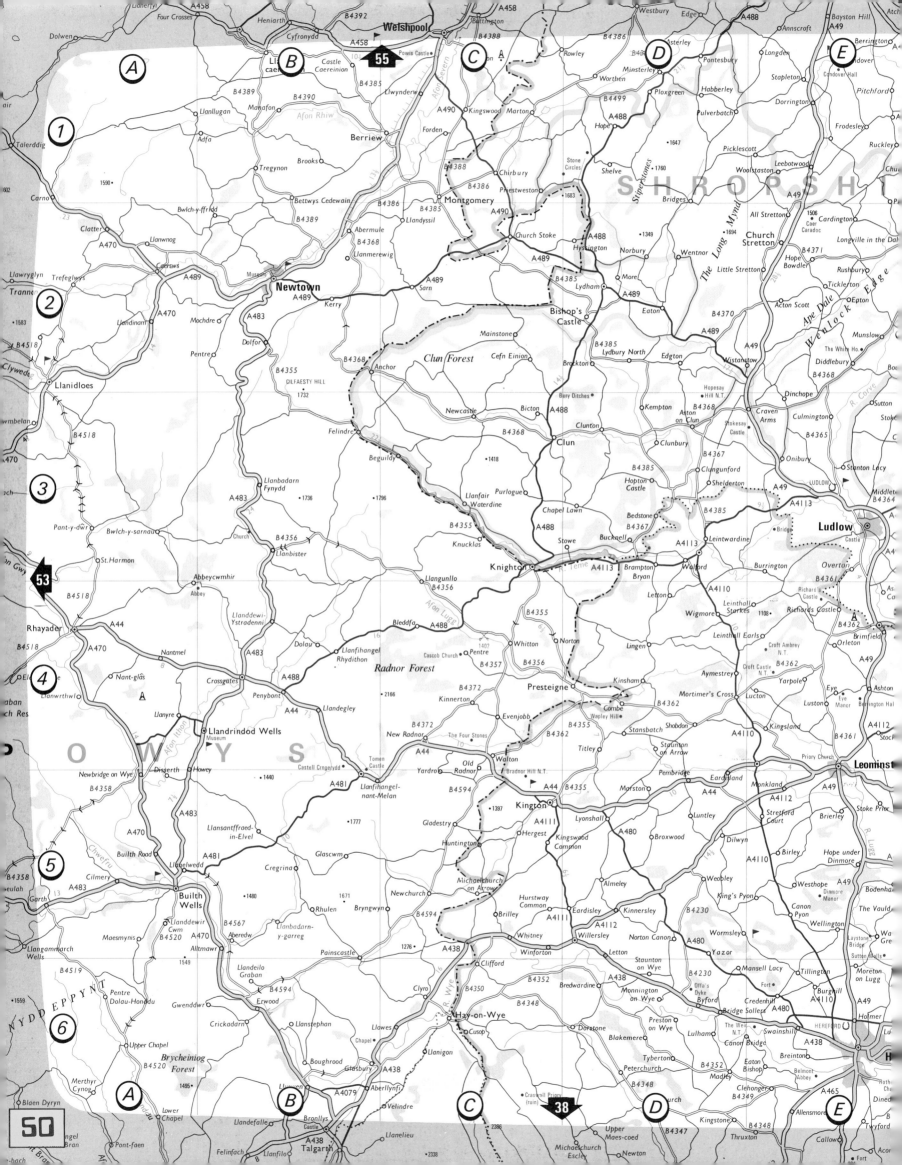

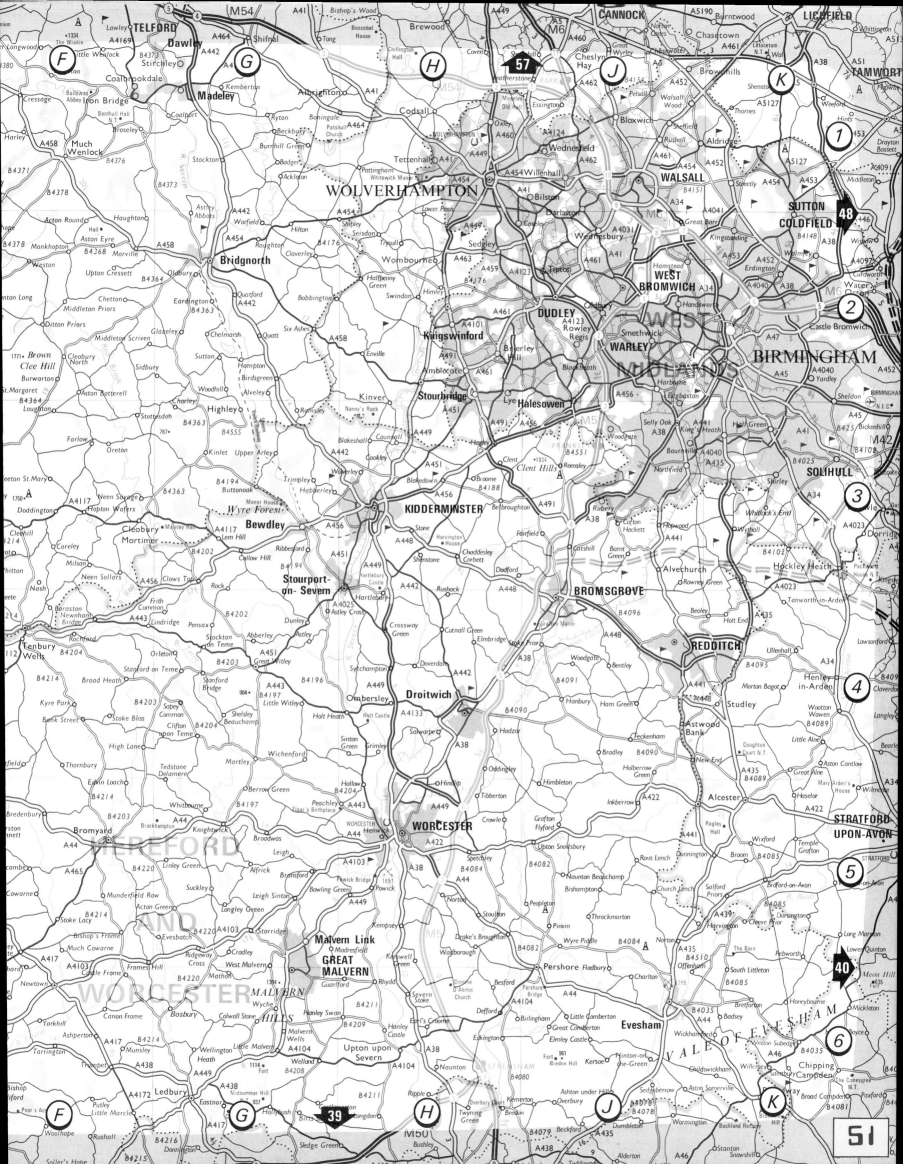

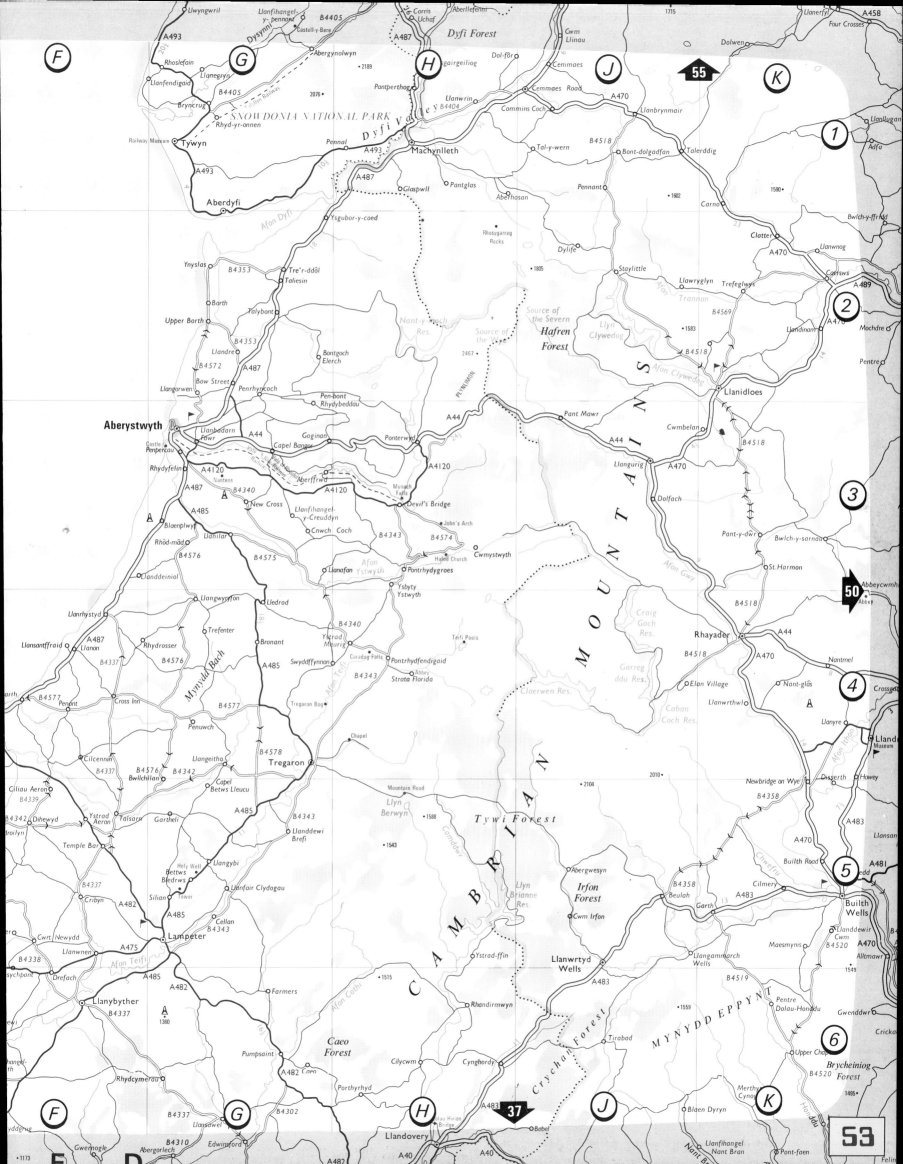

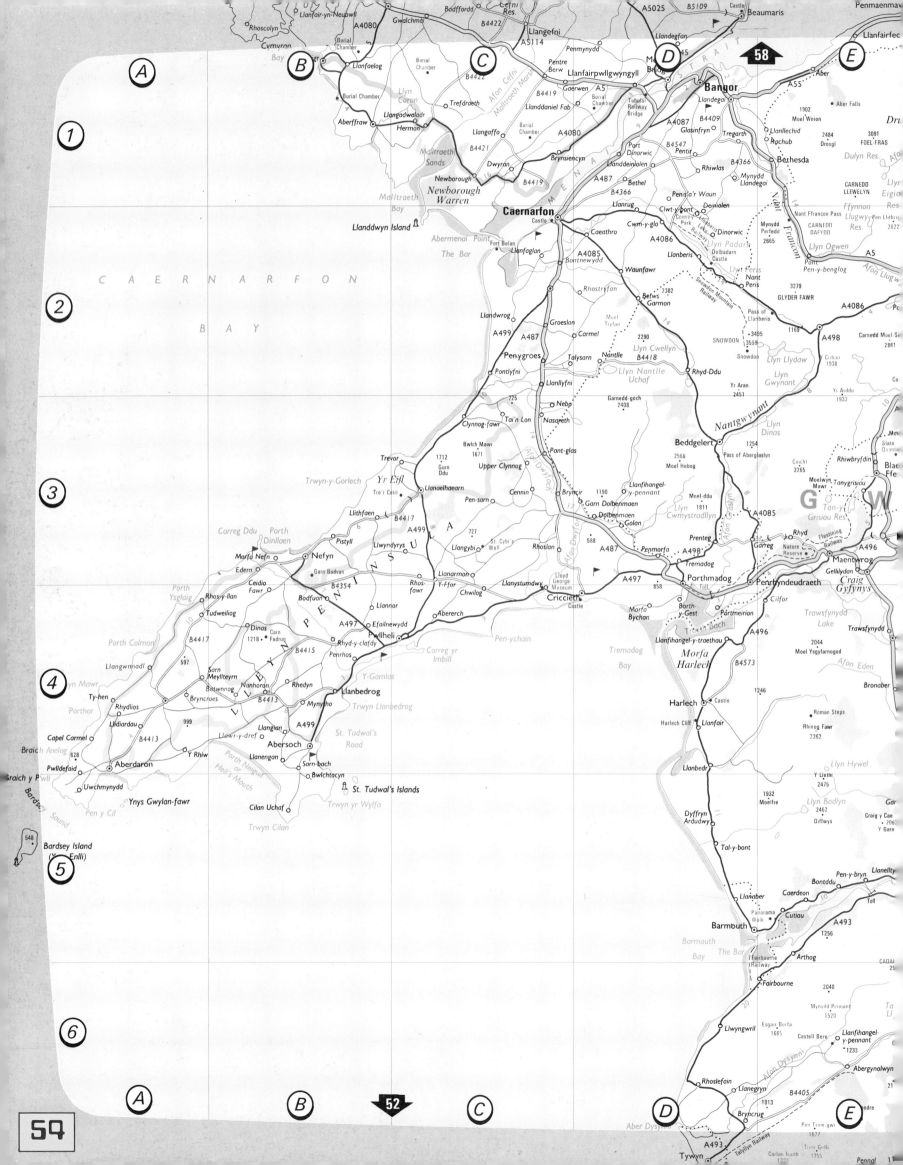

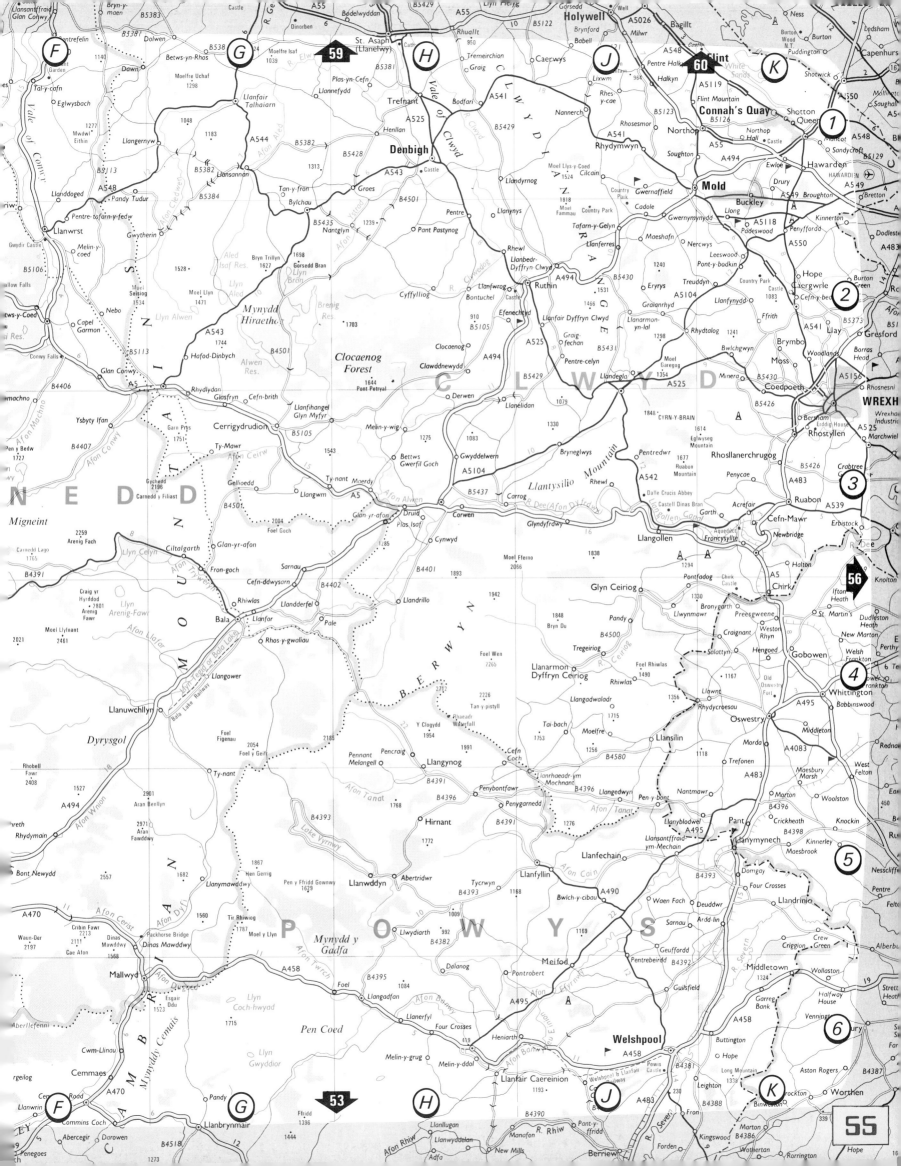

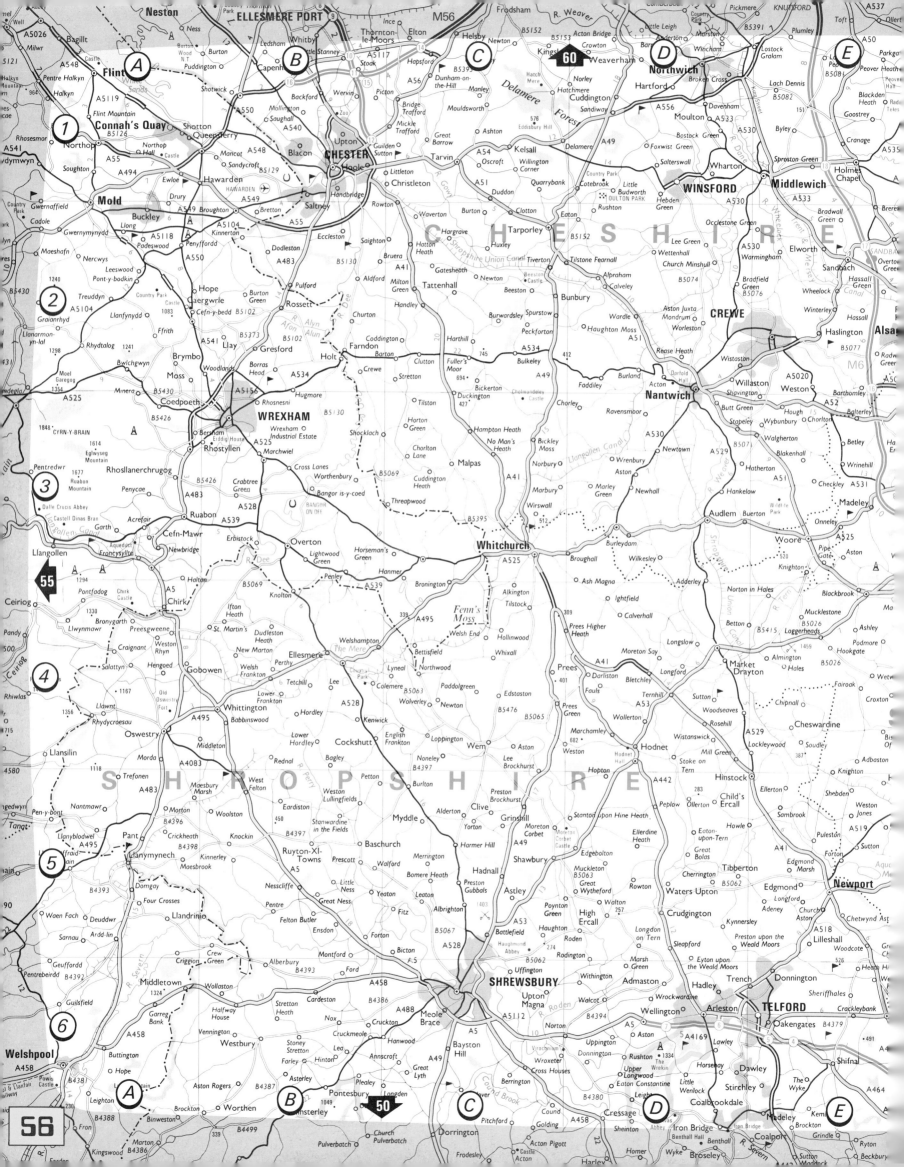

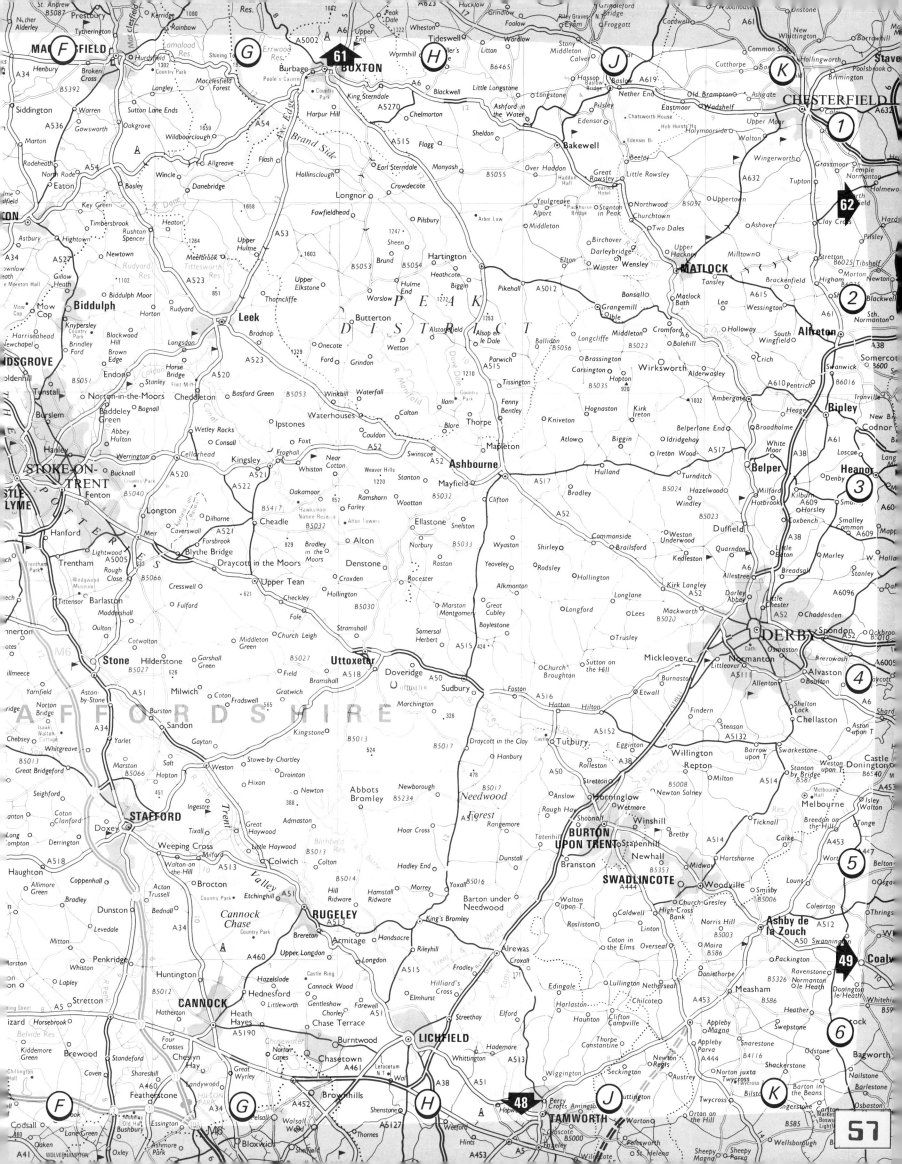

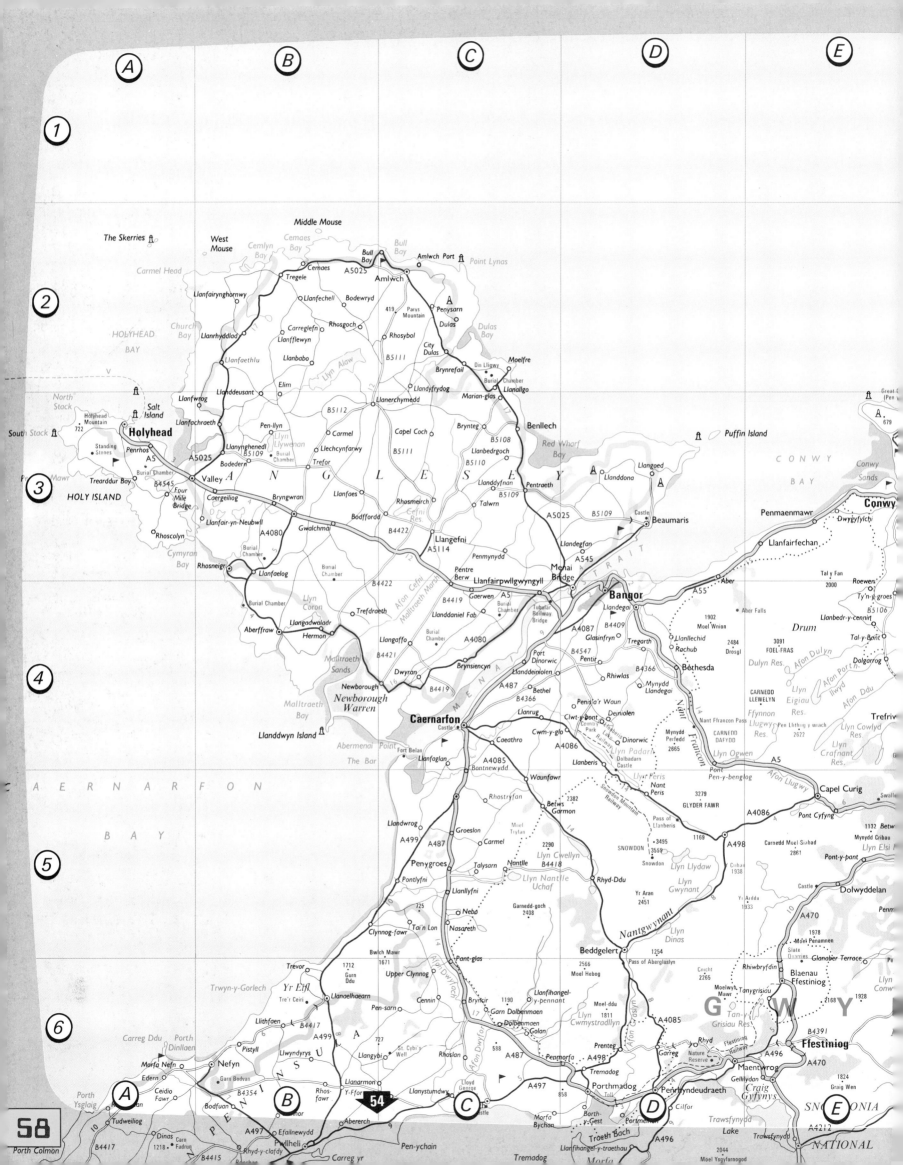

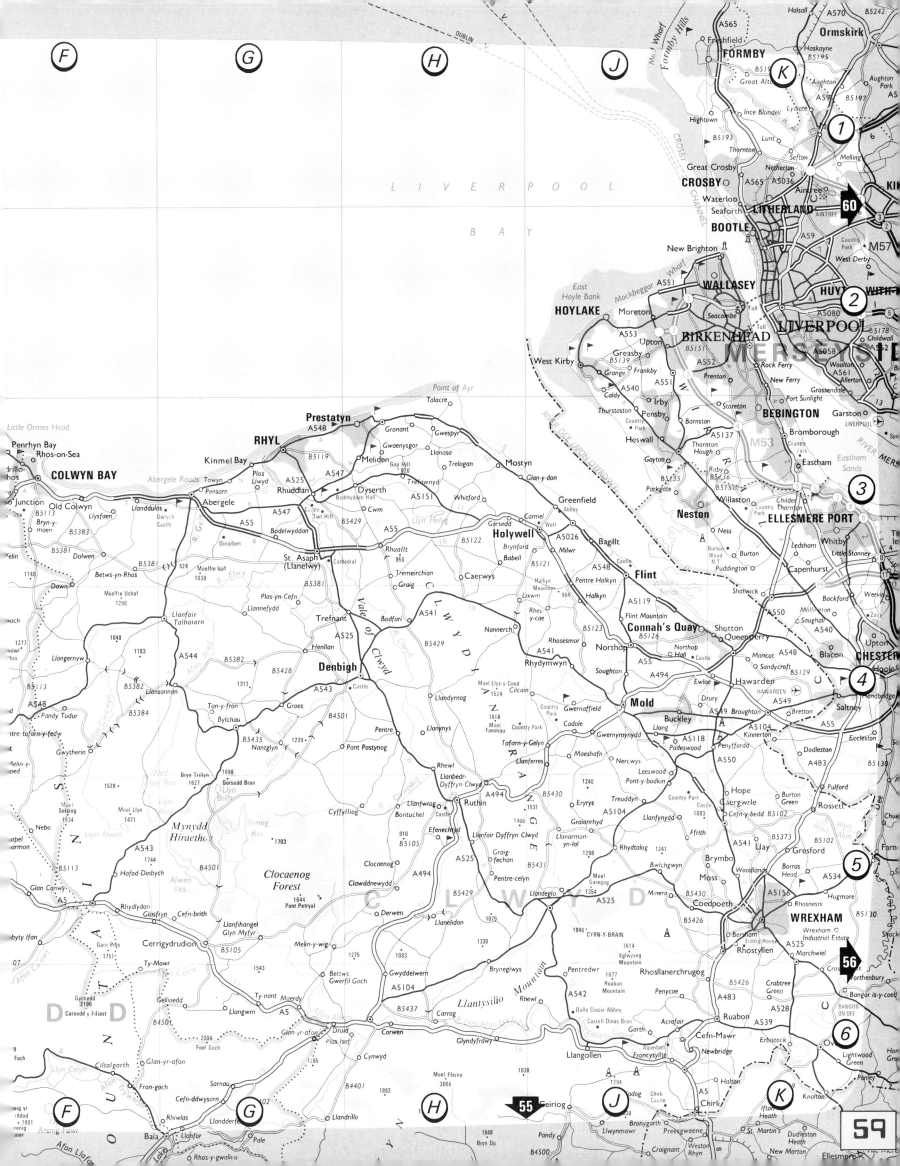

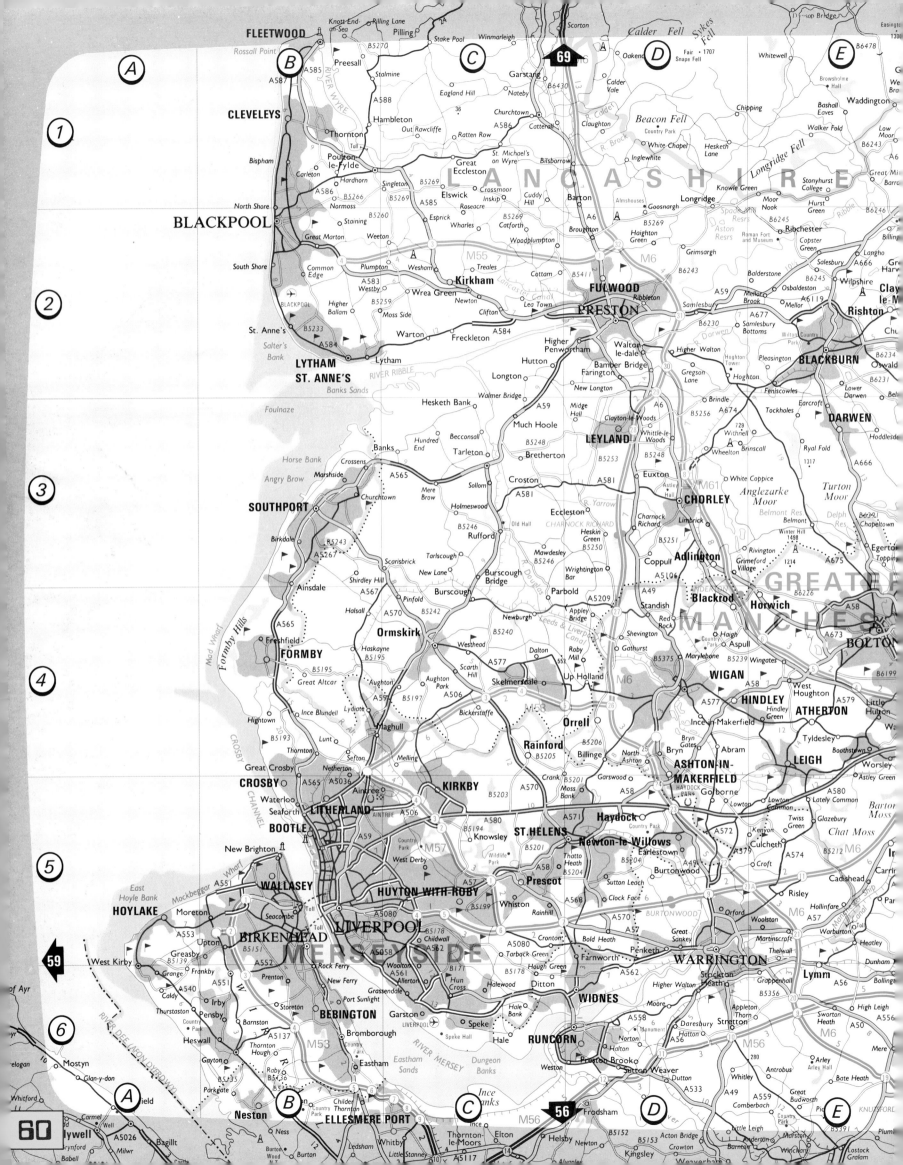

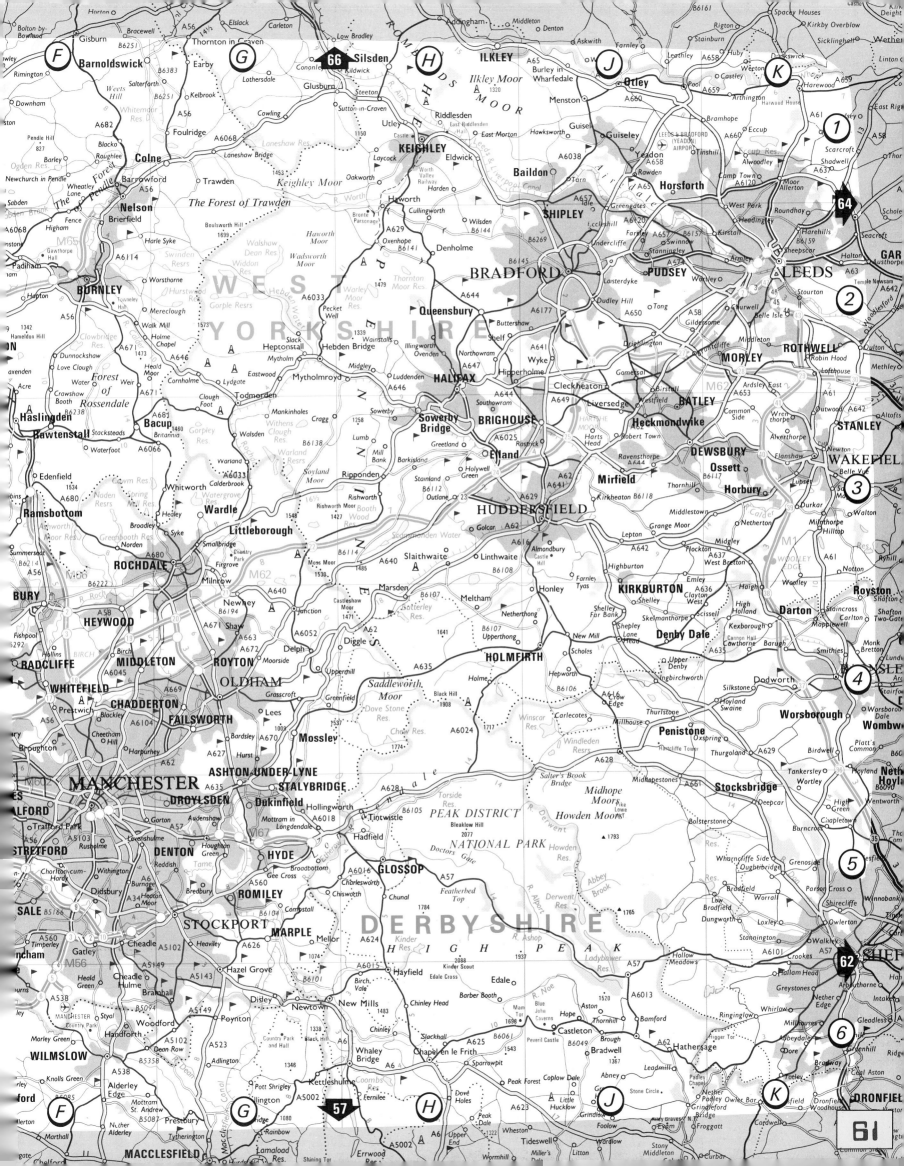

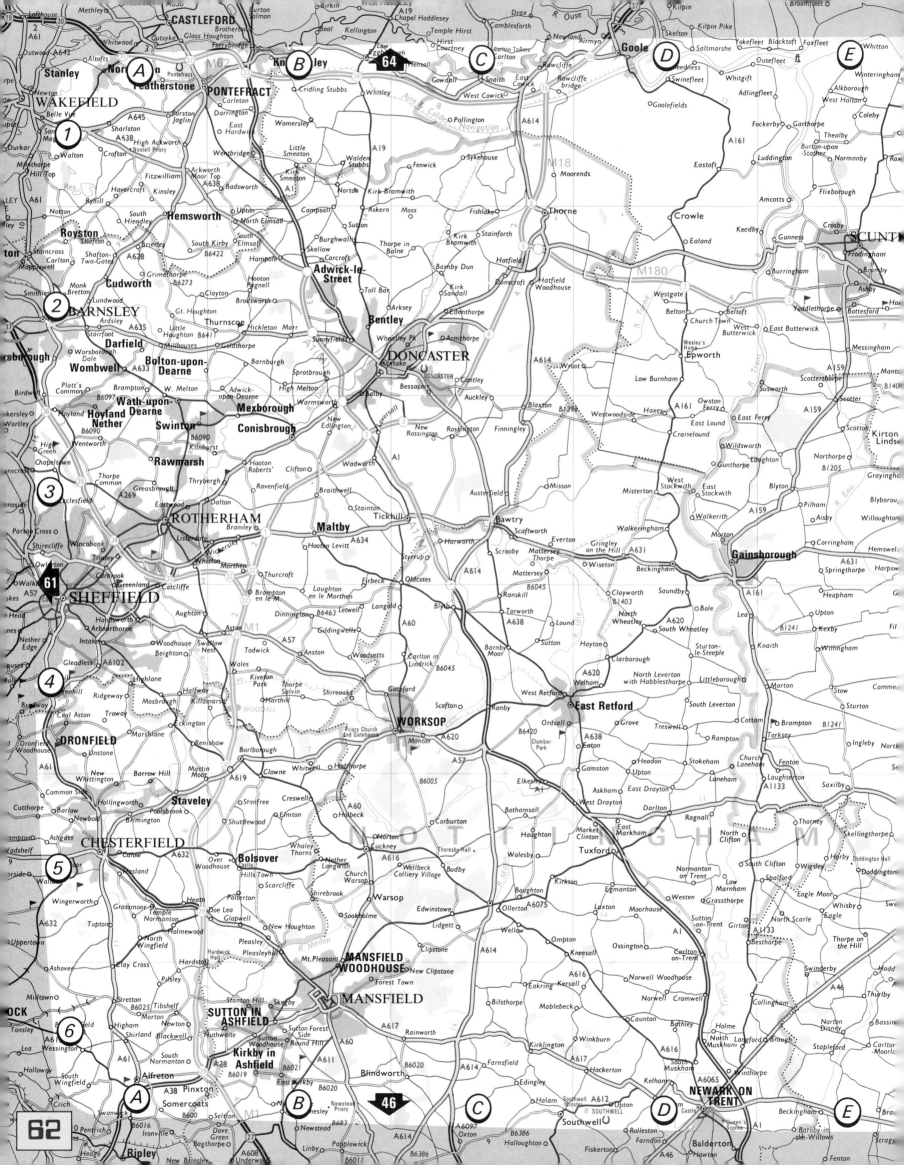

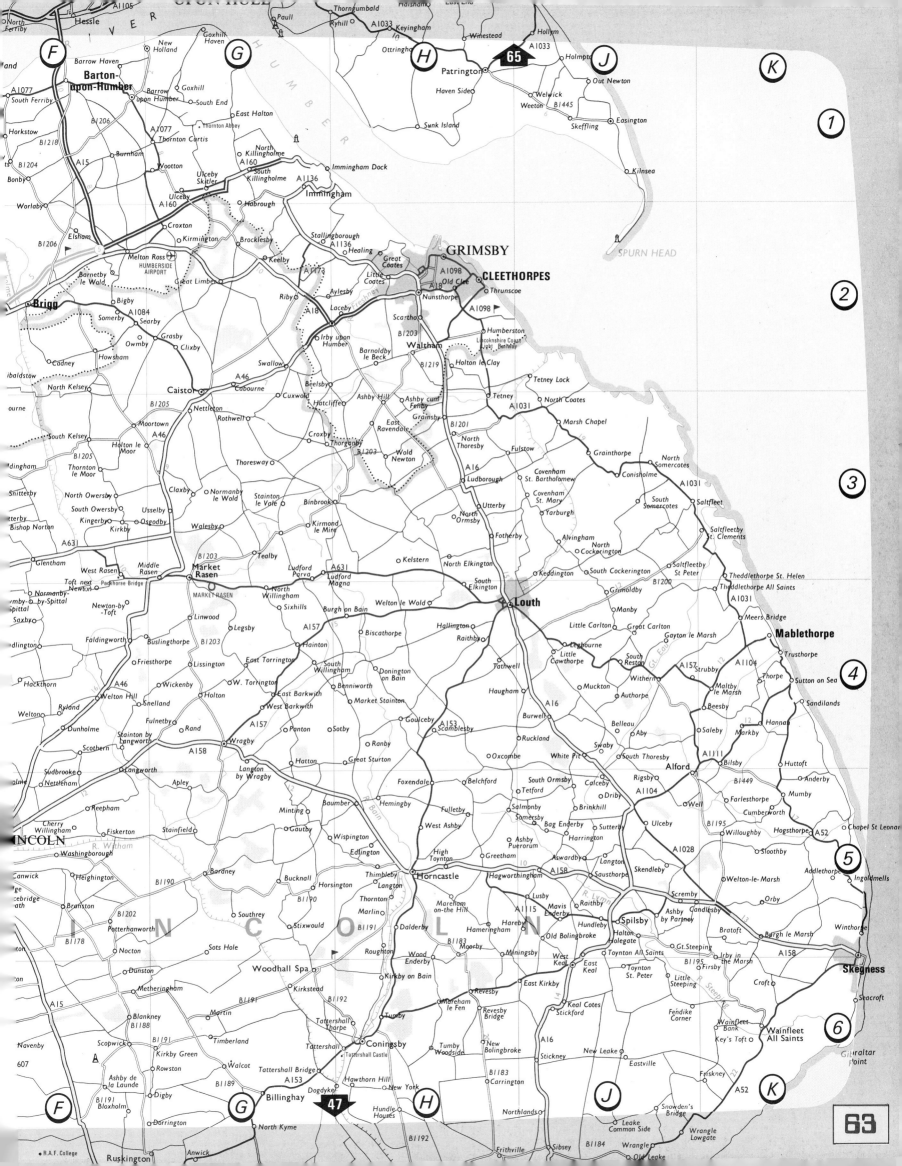

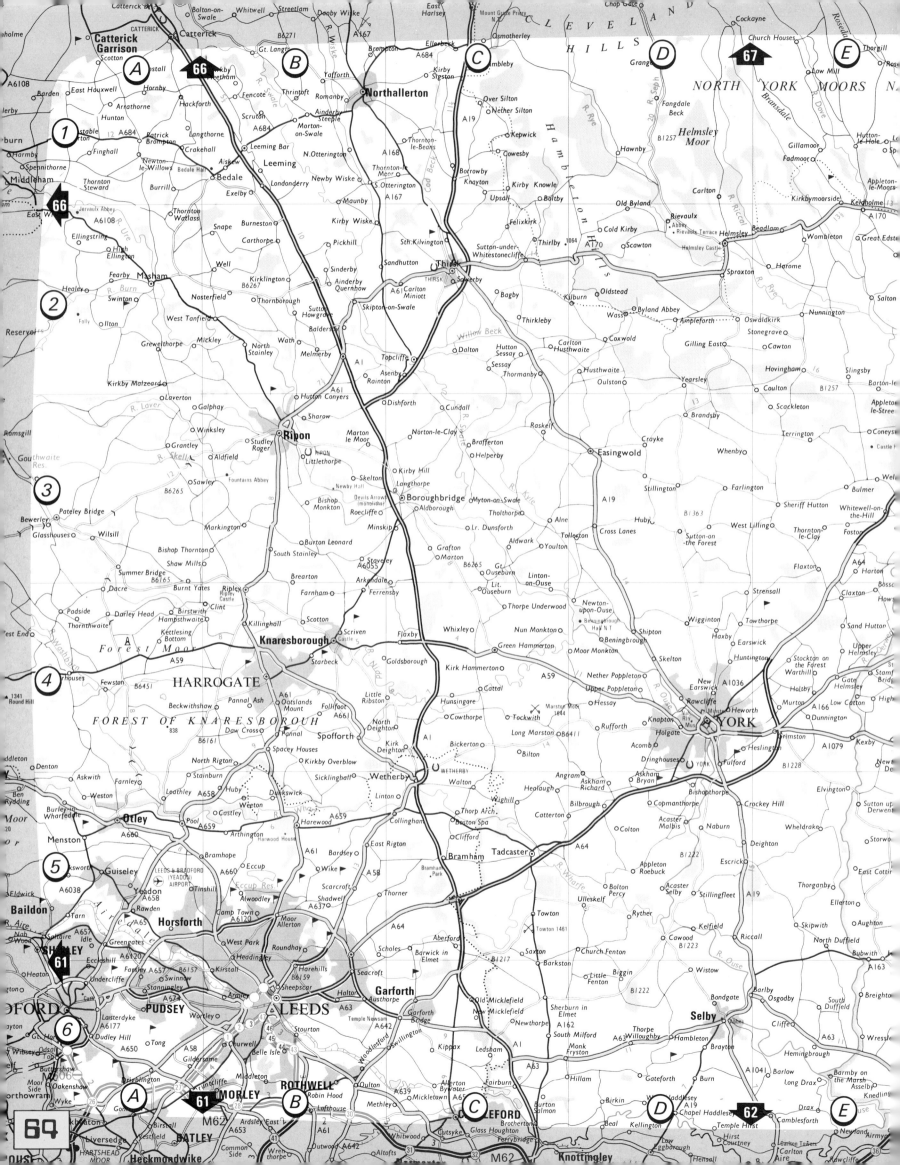

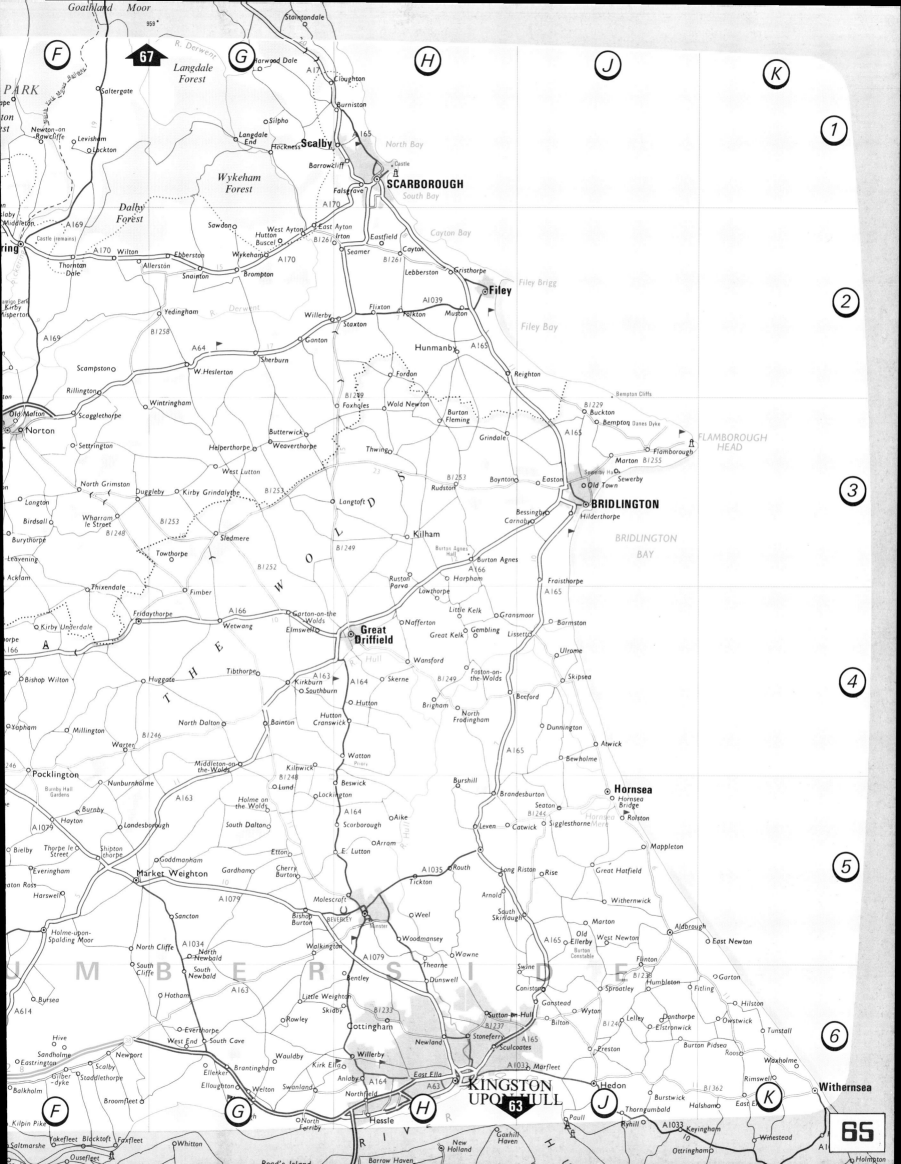

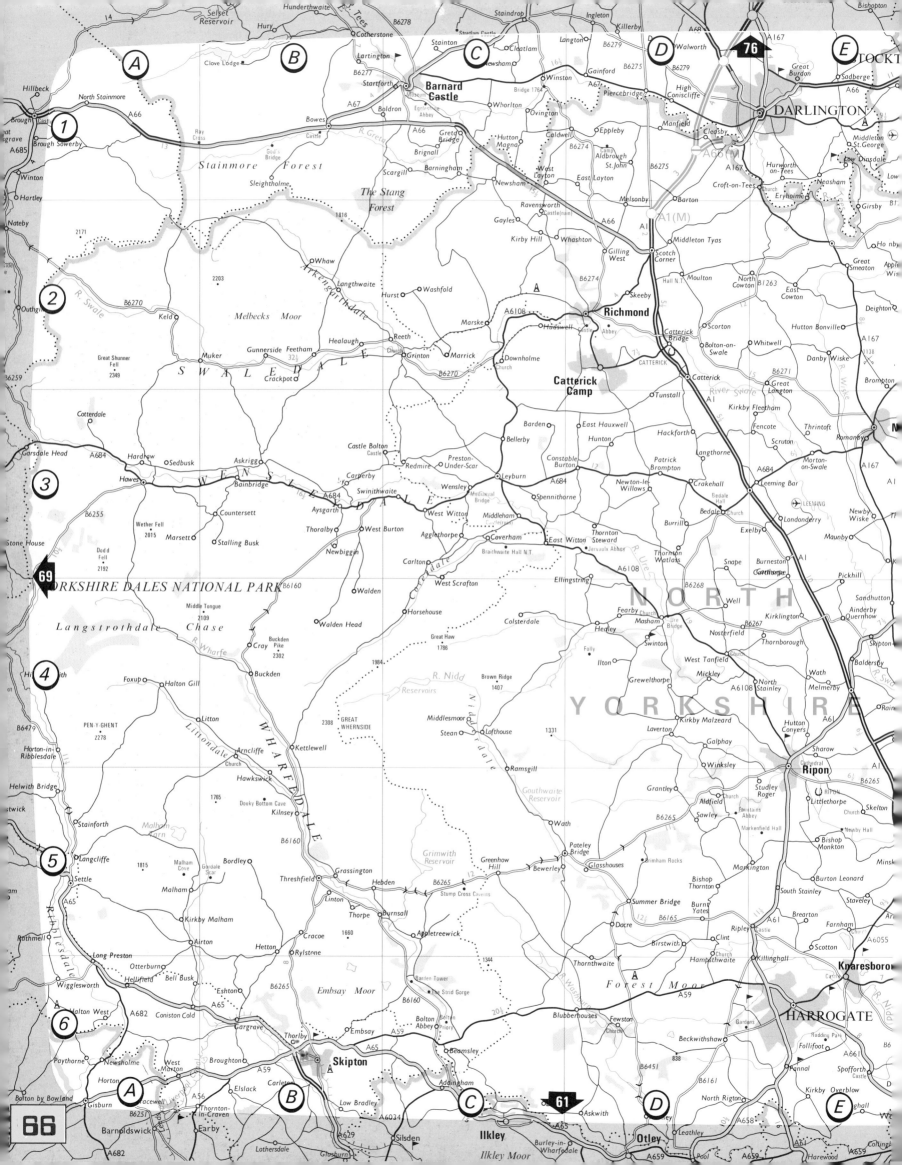

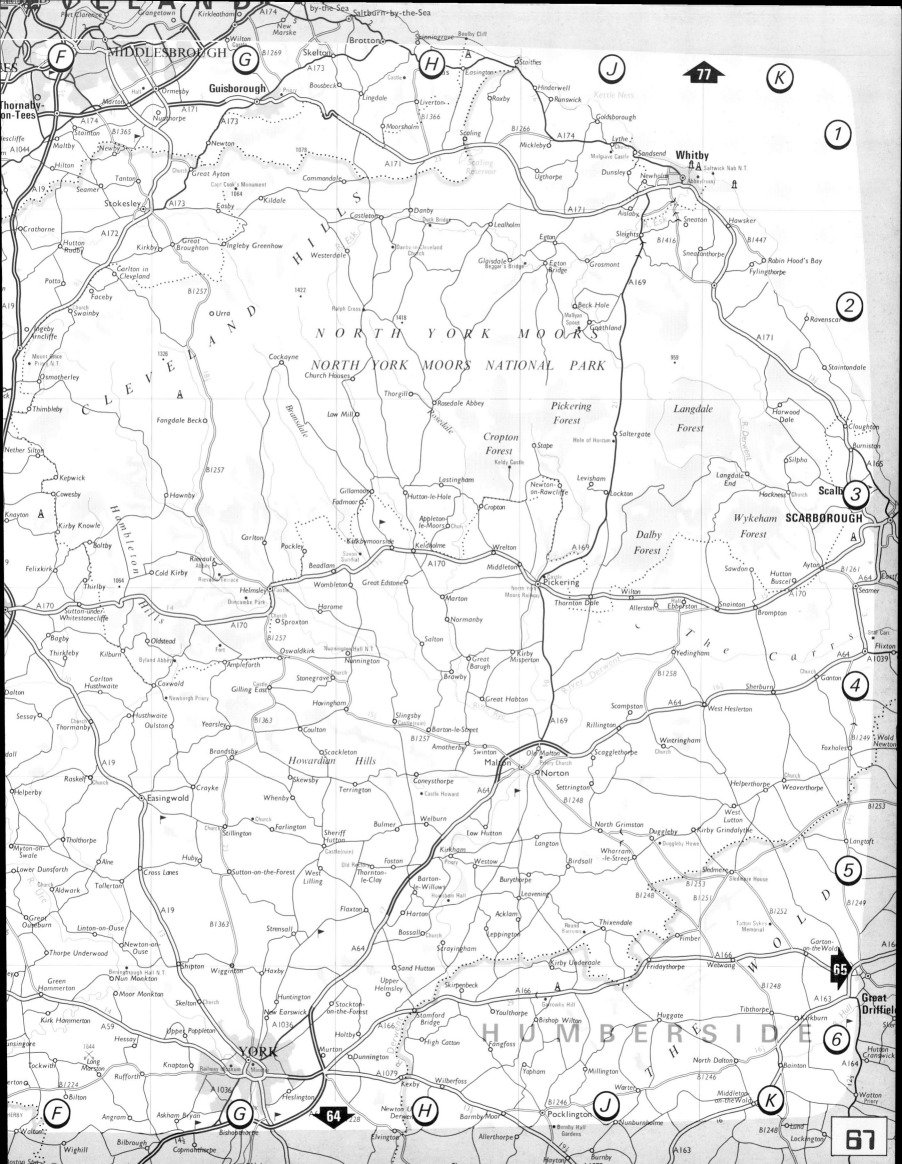

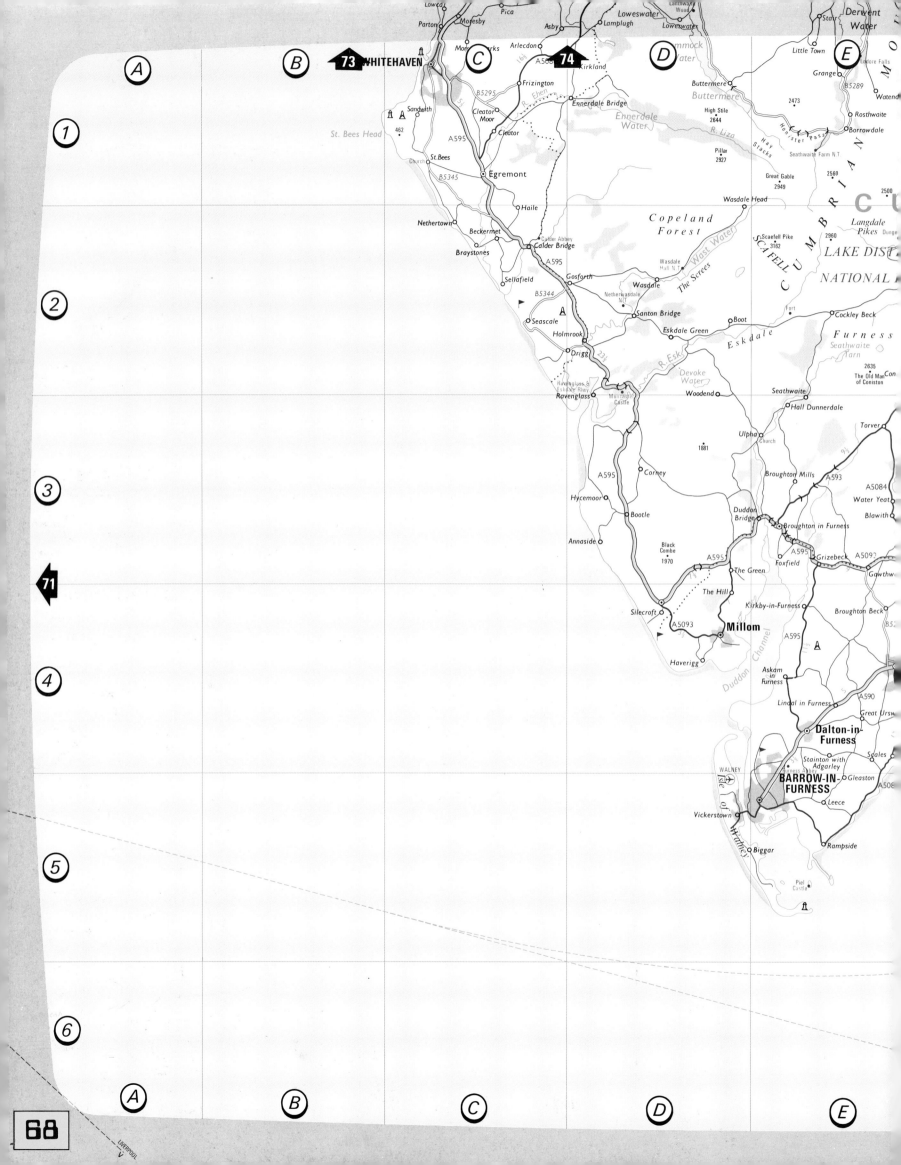

Lowca
Parton
Moresby
Pica
Loweswater
Loweswater
Lamplugh
Derwent Water

Asby

Moresby Parks
Arlecdon
A5086
Kirkland
Little Town
Grange
Lodore Falls

Buttermere
Watend
B5289

Frizington
Cleator Moor
Ennerdale Bridge
Buttermere
High Stile 2644
Ennerdale Water
R. Liza
Rosthwaite
Borrowdale

B5295
R. Ehen

St. Bees Head
462
Sandwith
St.Bees
Church
A595
Cleator
Pillar 2927
Hay Stacks
Seathwaite Farm N.T

Egremont
B5345

Haile
Wasdale Head
Great Gable 2949
2560
CU
2500
CUMBRIAN MO

Nethertown
Beckermet
Braystones
Calder Abbey
Calder Bridge
A595
Copeland Forest
Wast Water
Scaefell Pike 3162
SCAEFELL
Langdale Pikes Dunge
2960
LAKE DIST
NATIONAL

Sellafield
Gosforth
Netherwasdale N.T
Wasdale
Wasdale Hall N.T
The Screes

Seascale
B5344
Santon Bridge
Boot
Fort
Eskdale Green
Cockley Beck
Furness

Holmrook
Drigg
23¼
R. Esk
Eskdale
Seathwaite Tarn

Ravenglass & Eskdale Rlwy.
Ravenglass
Muncaster Castle
Devoke Water
Woodend
Seathwaite
2635
The Old Man of Coniston
Con

Ulpha Church
Hall Dunnerdale
Torver

1881

A595
Corney
Broughton Mills
A593
A5084
Water Yeat

Hycemoor
Duddon Bridge
Blawith

Bootle
Broughton in Furness

Annaside
Black Combe 1970
A595
Foxfield
The Green
Grizebeck
A5092
Gawthw

71

The Hill
Kirkby-in-Furness
Broughton Beck
B52

Silecroft
A5093
Millom
A595

Haverigg
Askam in Furness
Duddon Channel

Great Ursw
A590

Lindal in Furness
Dalton-in-Furness
Great Urswick

WALNEY
Isle of Walney
Furness Abbey
Stainton with Adgarley
Scales
Gleaston
A508

BARROW-IN-FURNESS
Leece

Vickerstown
Isle of Walney

Biggar
Rampside

Piel Castle

LIVERPOOL V

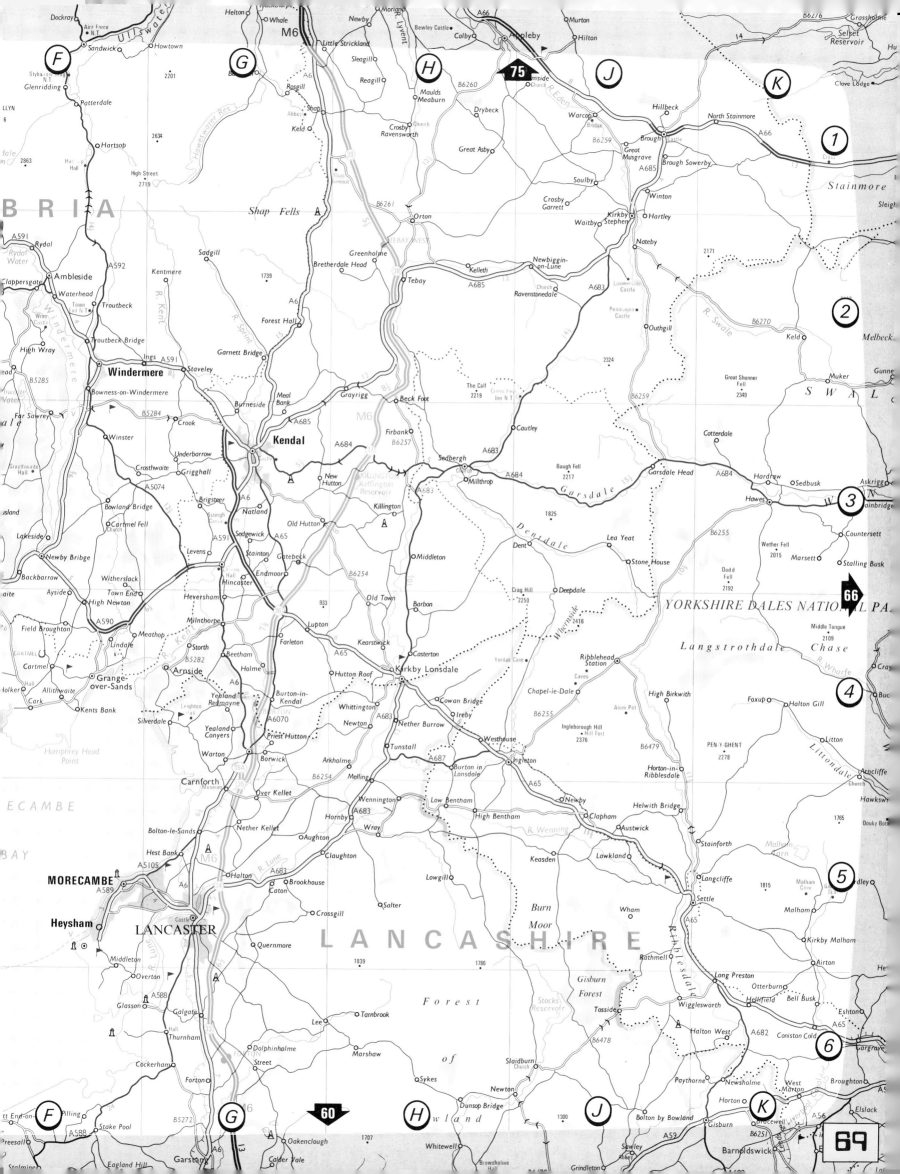

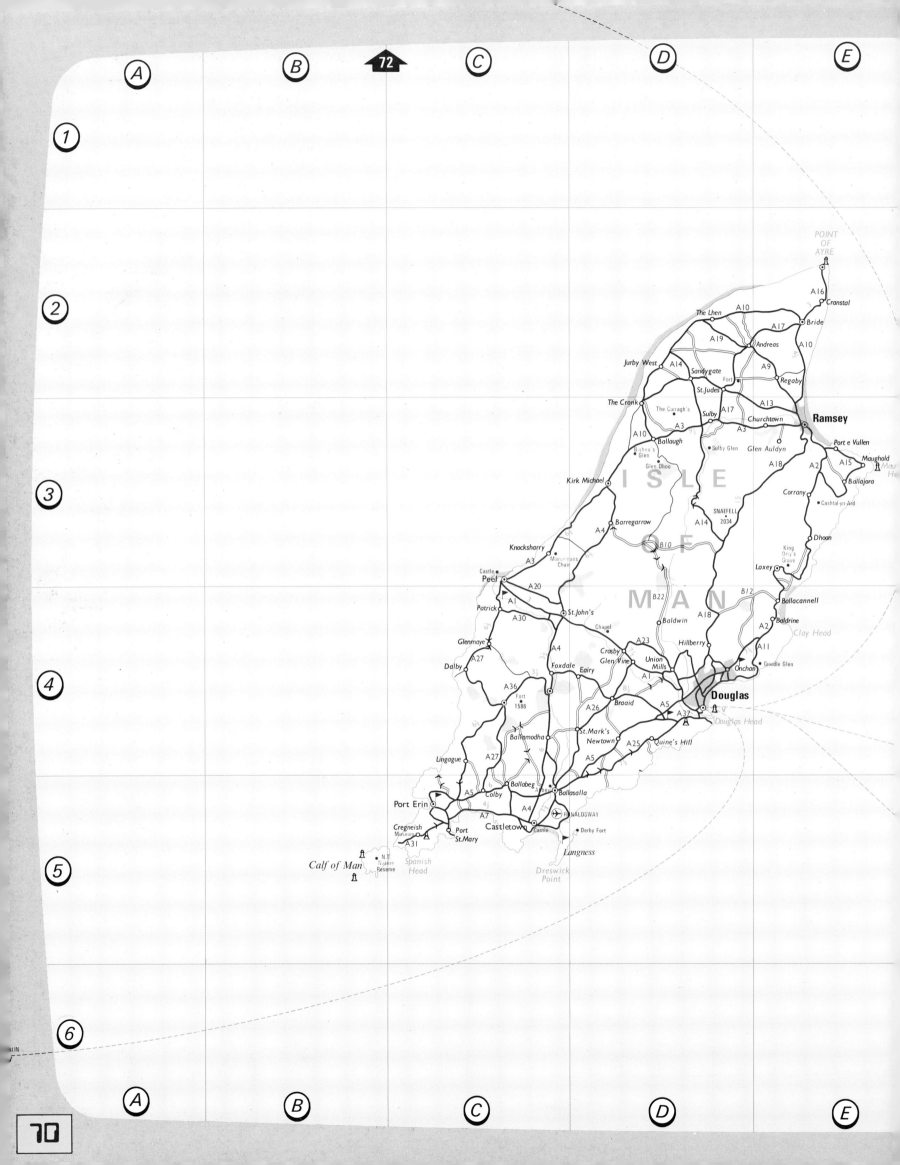

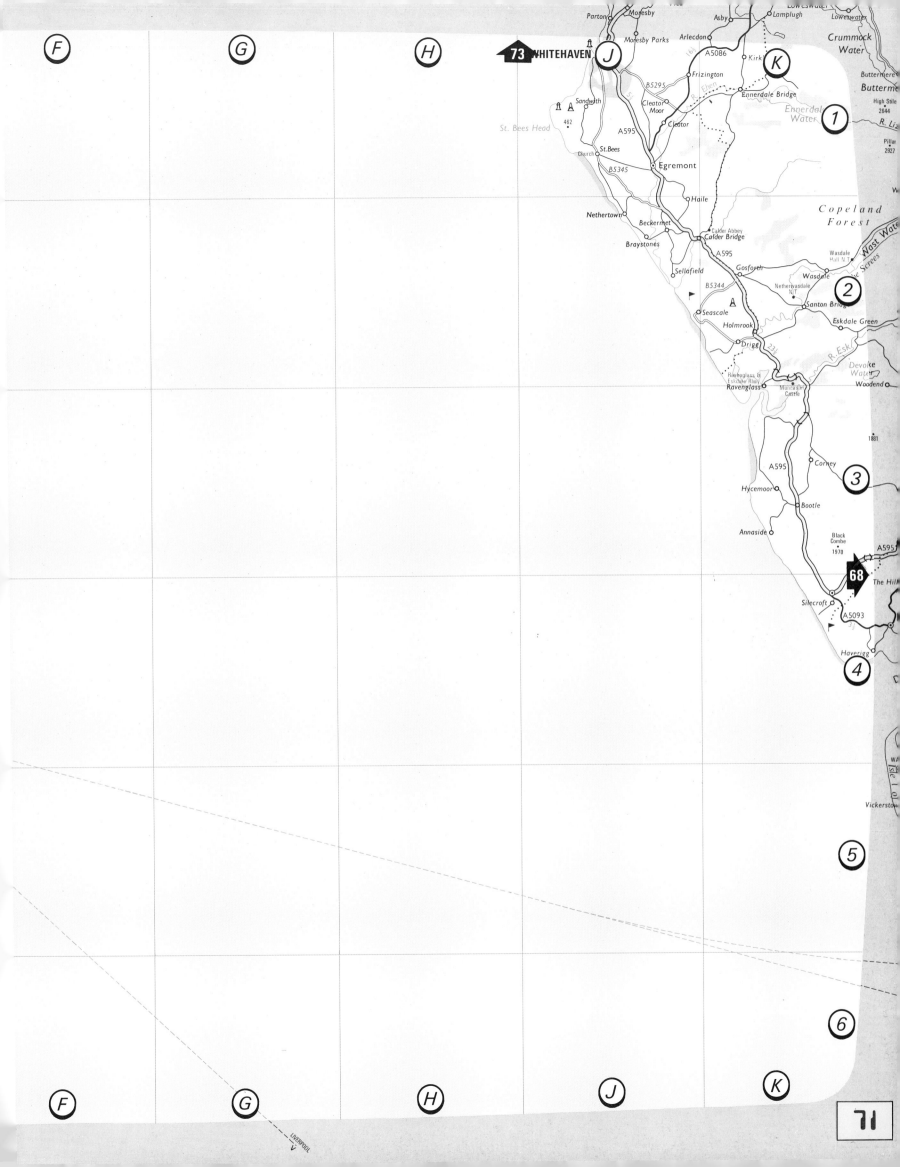

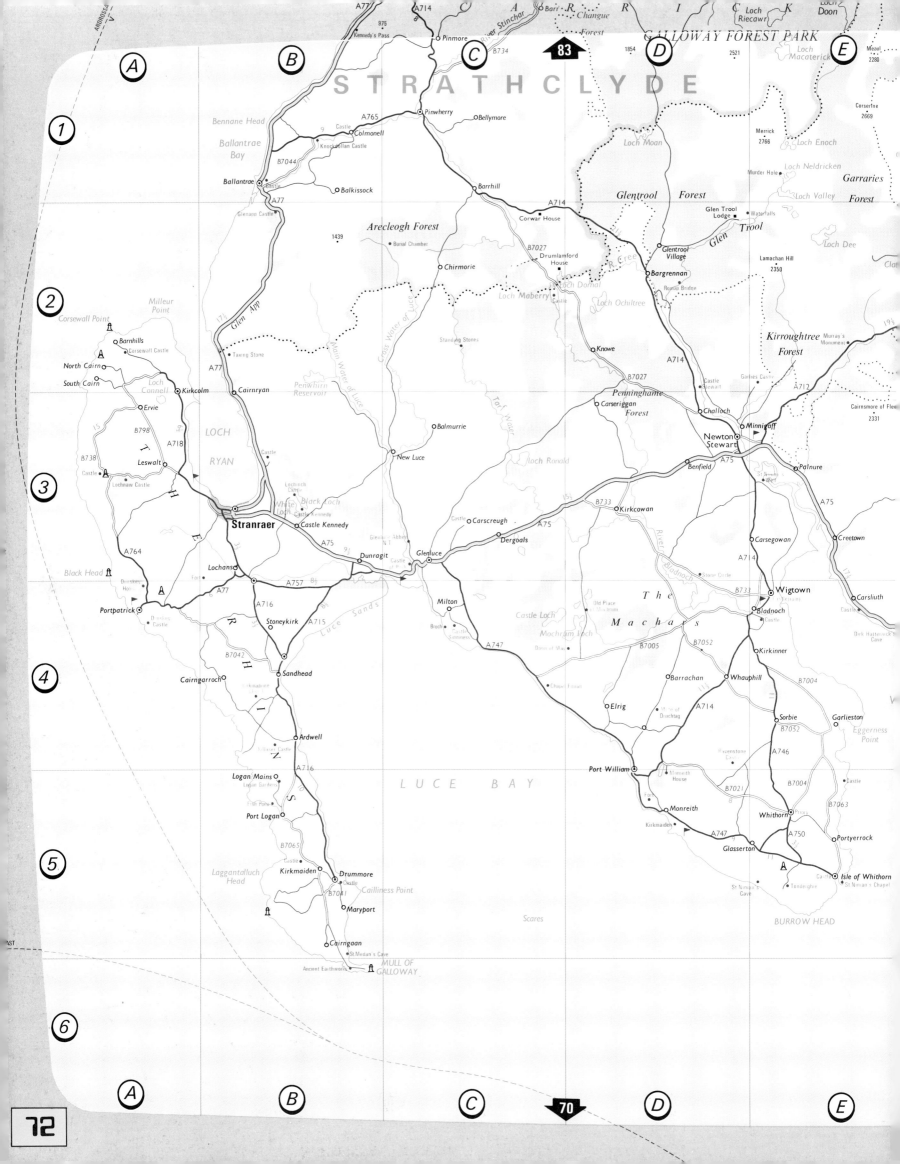

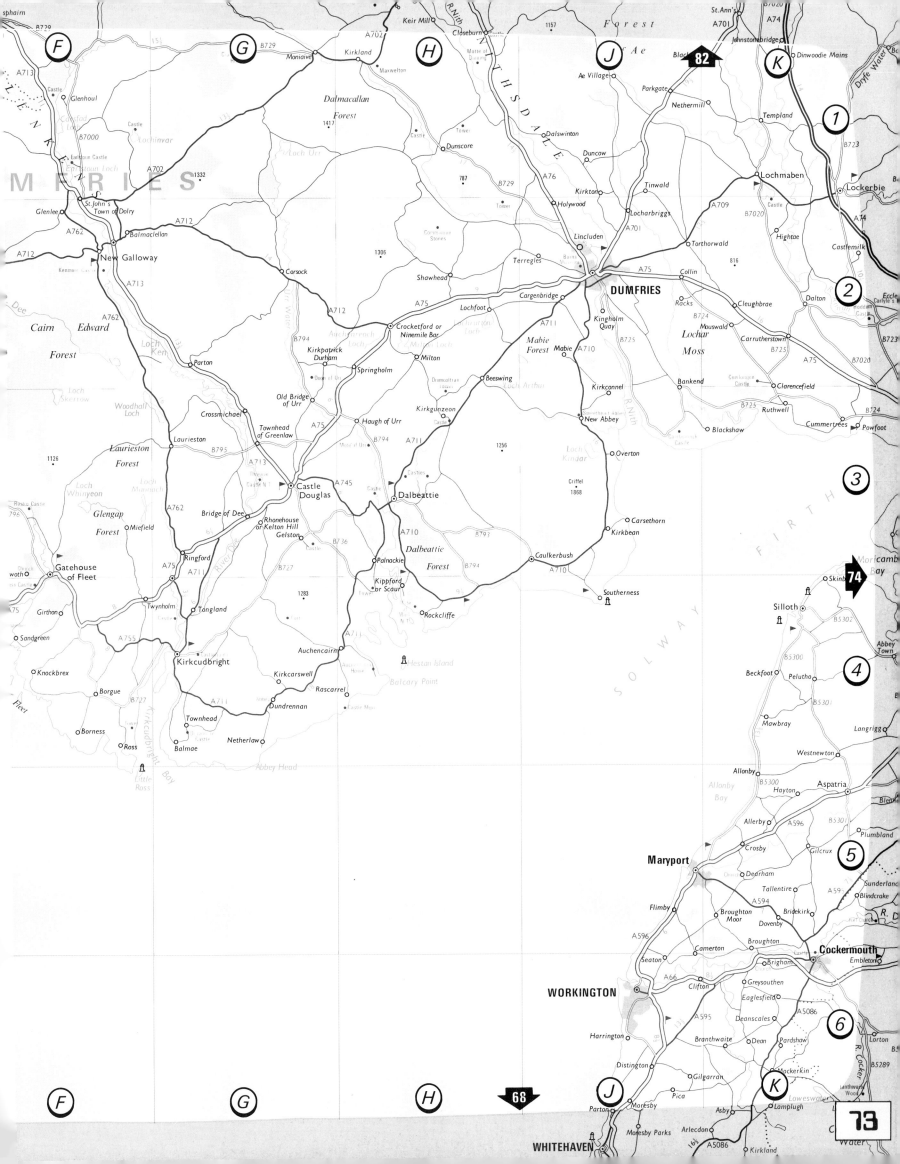

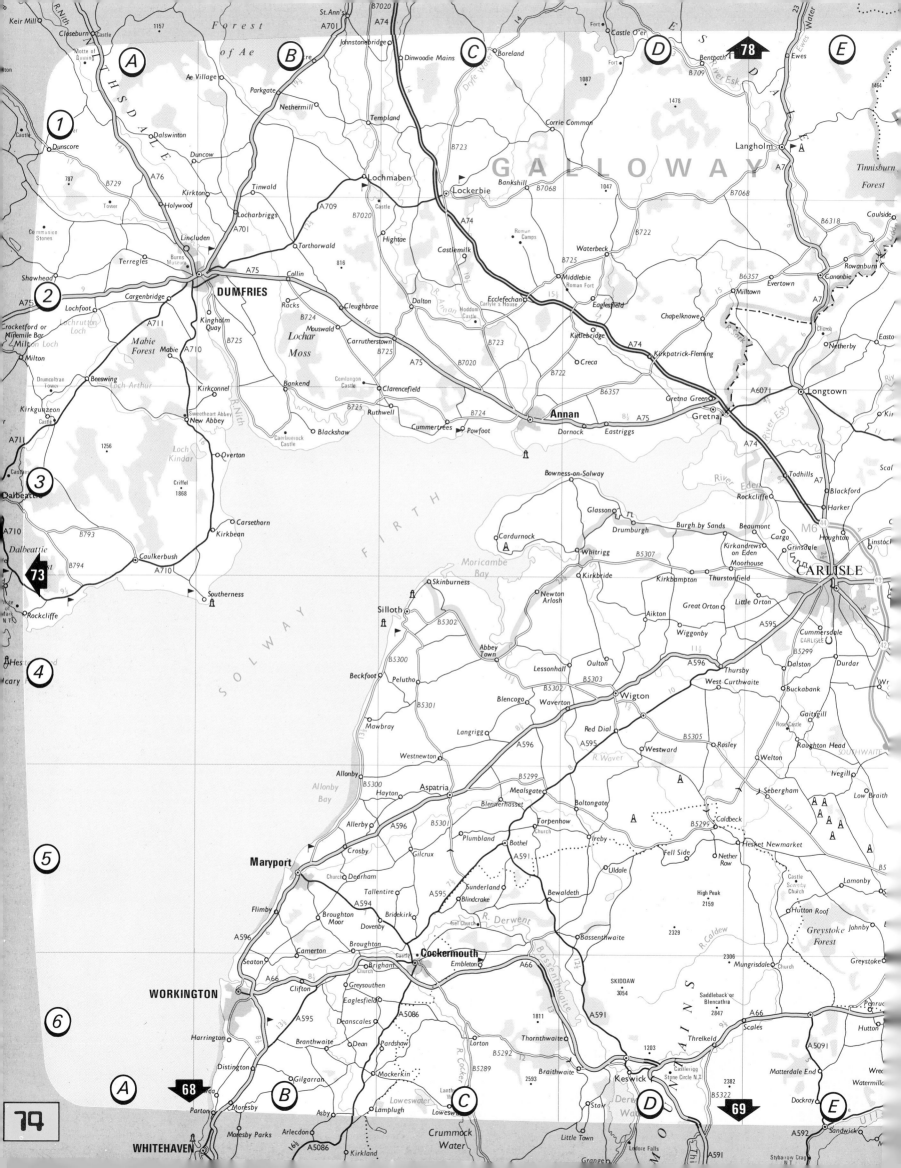

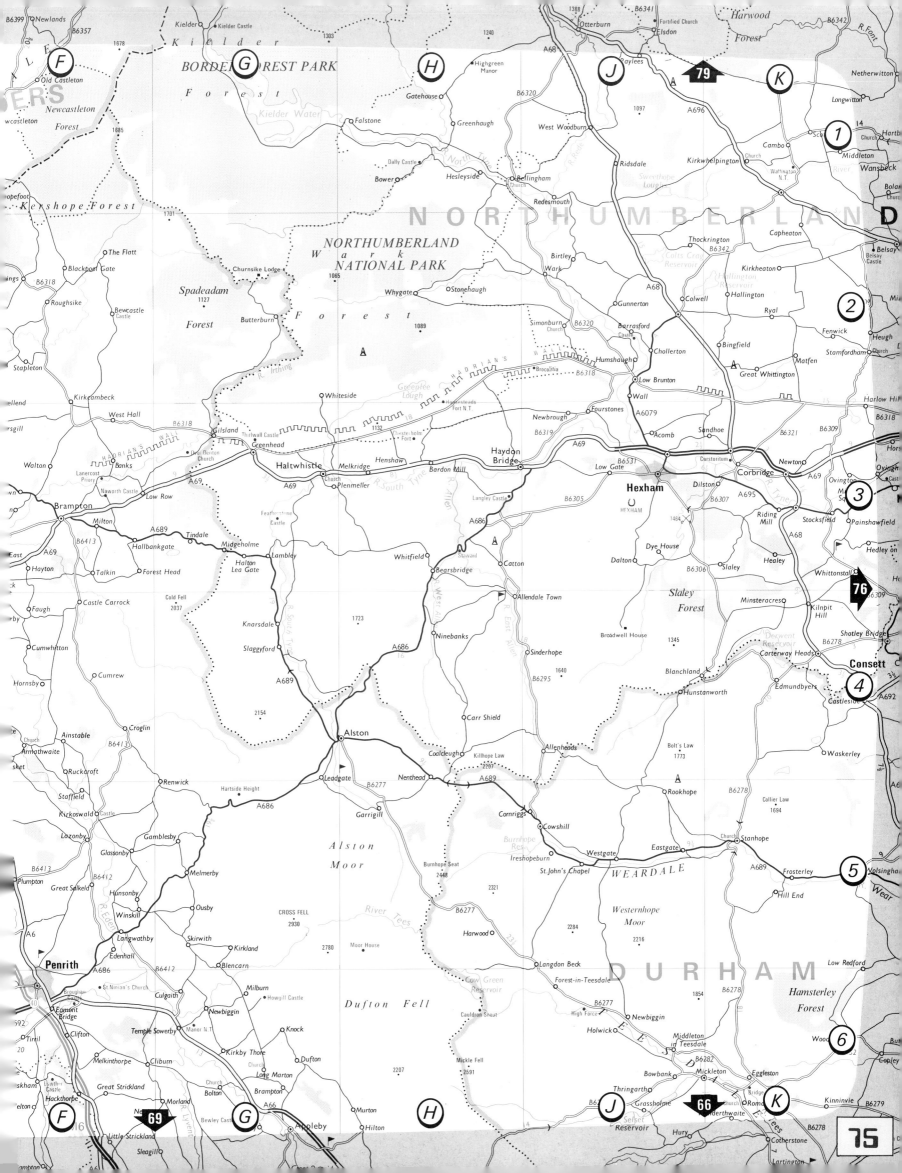

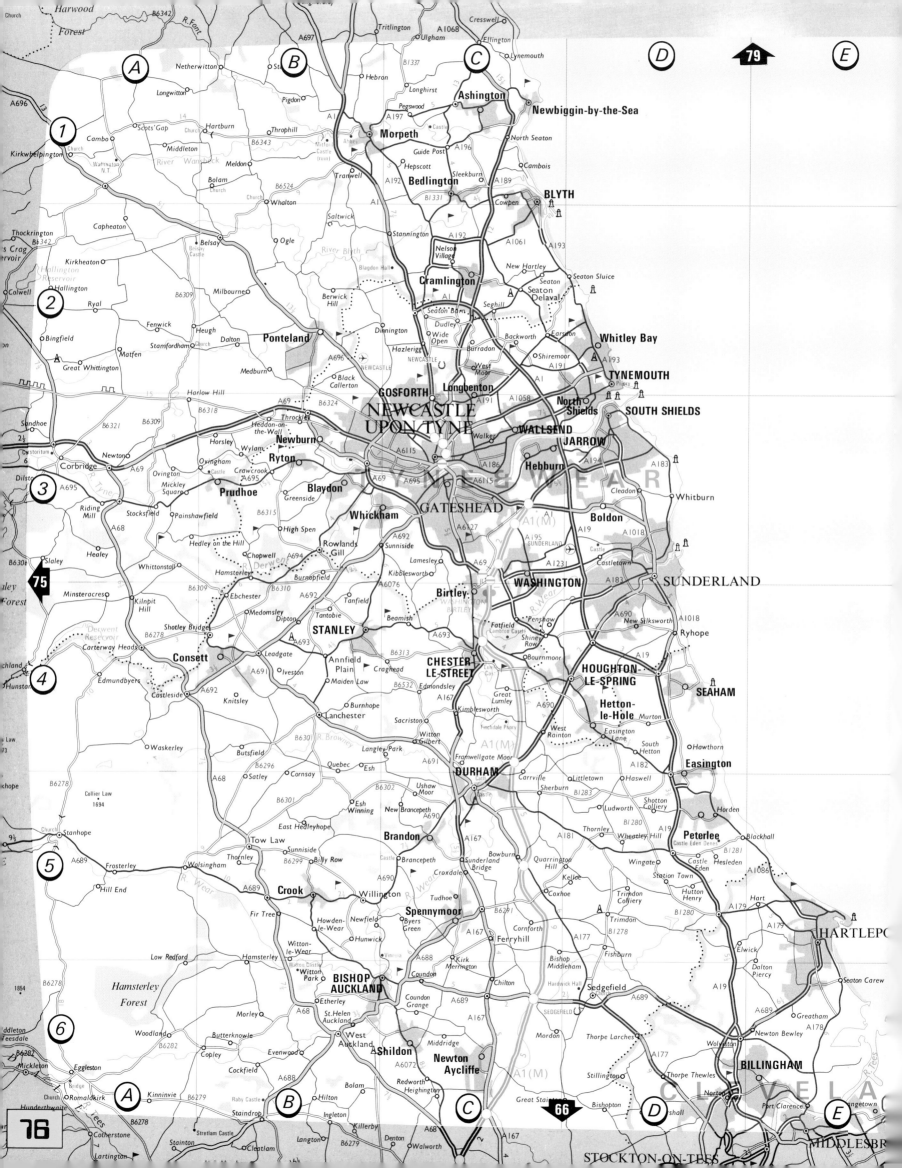

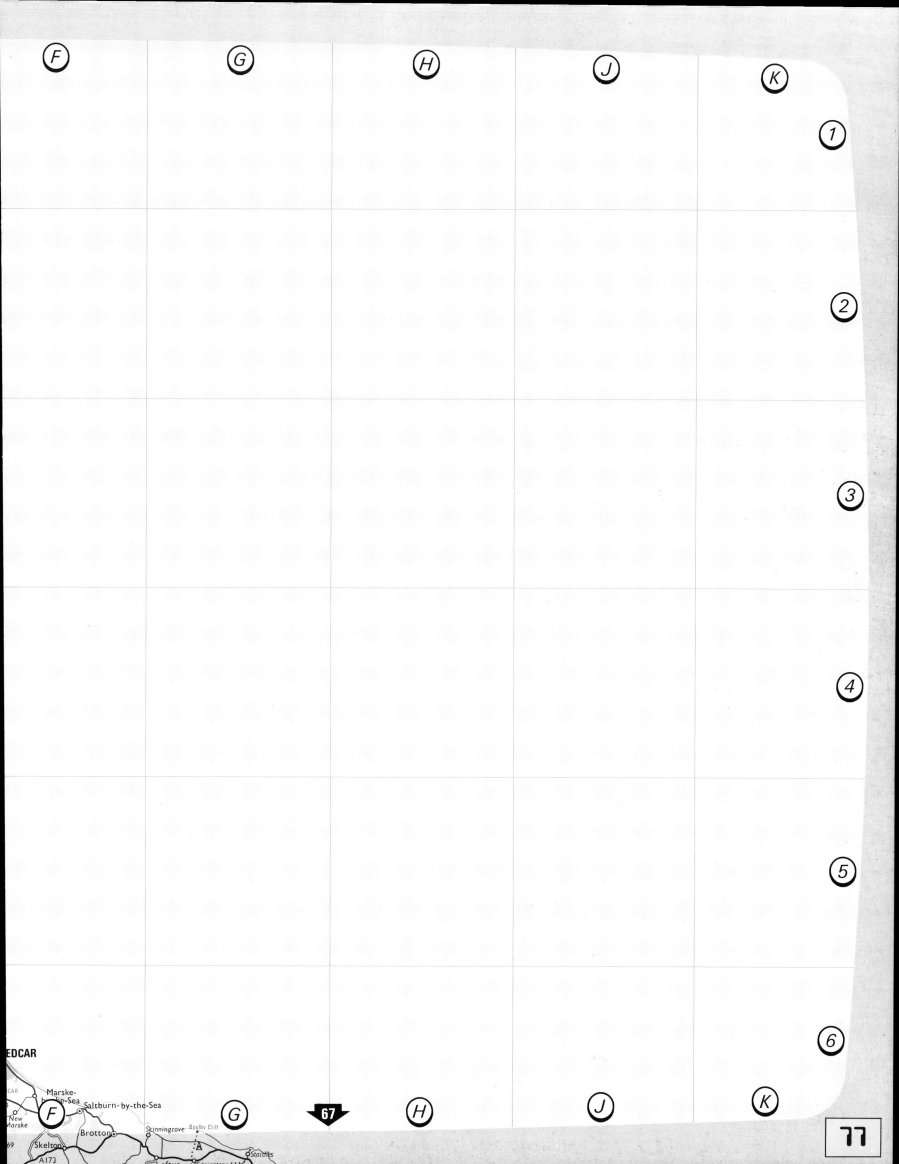

REDCAR

New
Marske

Marske-
by-the-Sea

Saltburn-by-the-Sea

Brotton

Skinningrove Boulby Cliff

Skelton

A173

Staithes

A

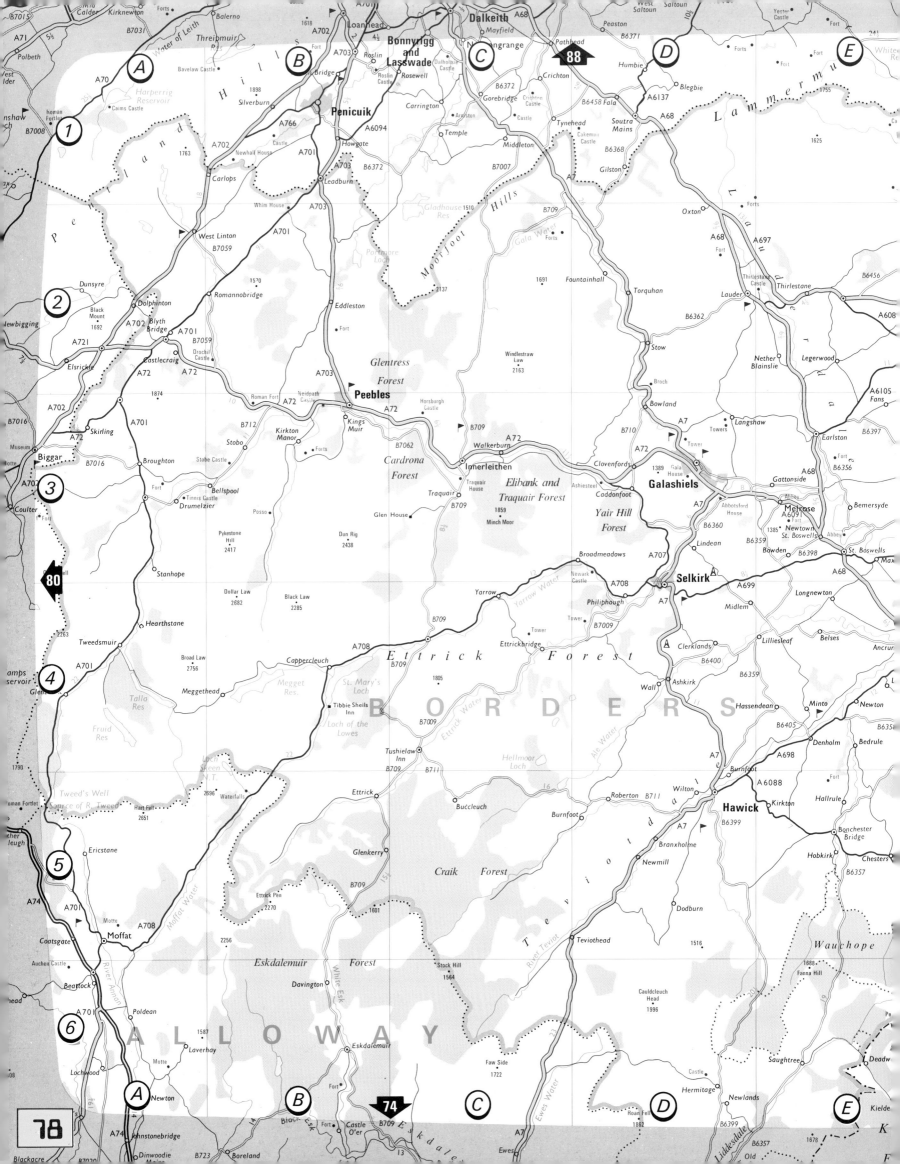

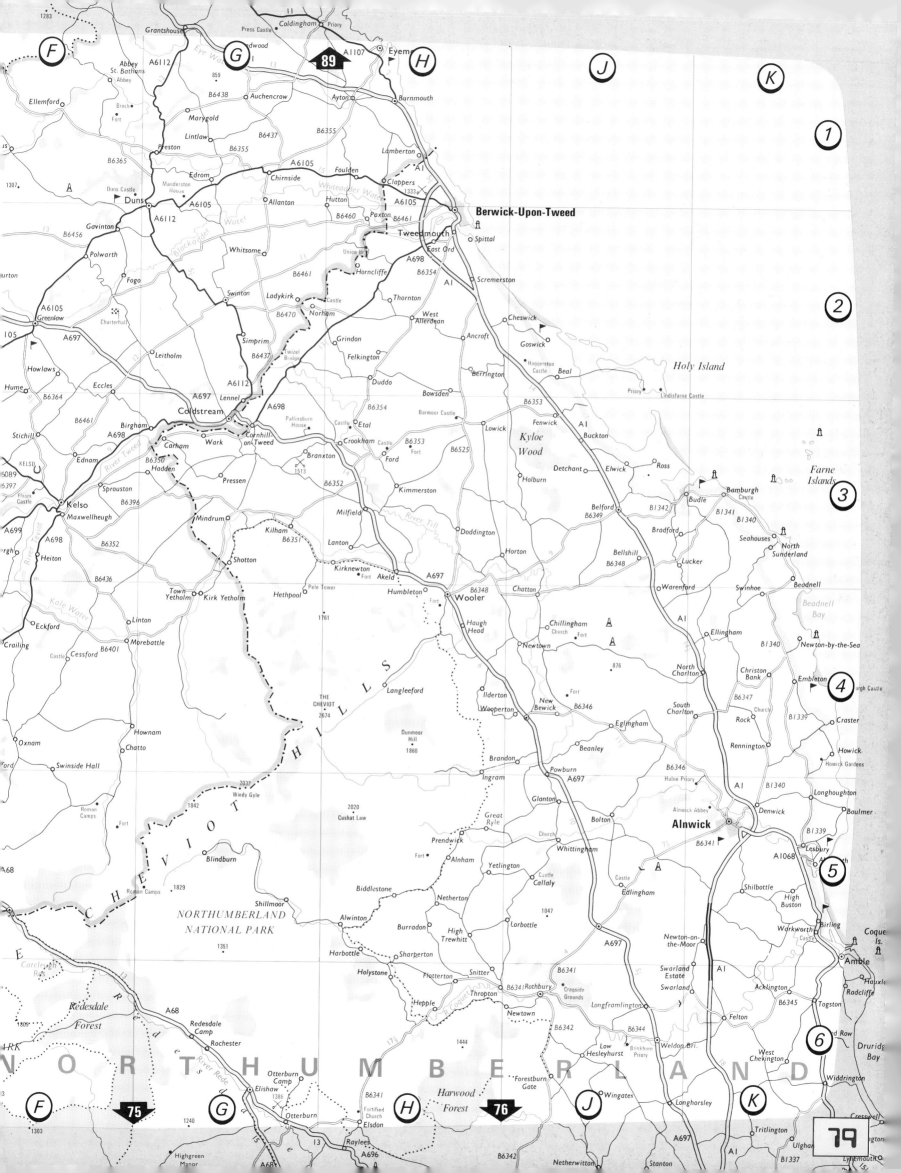

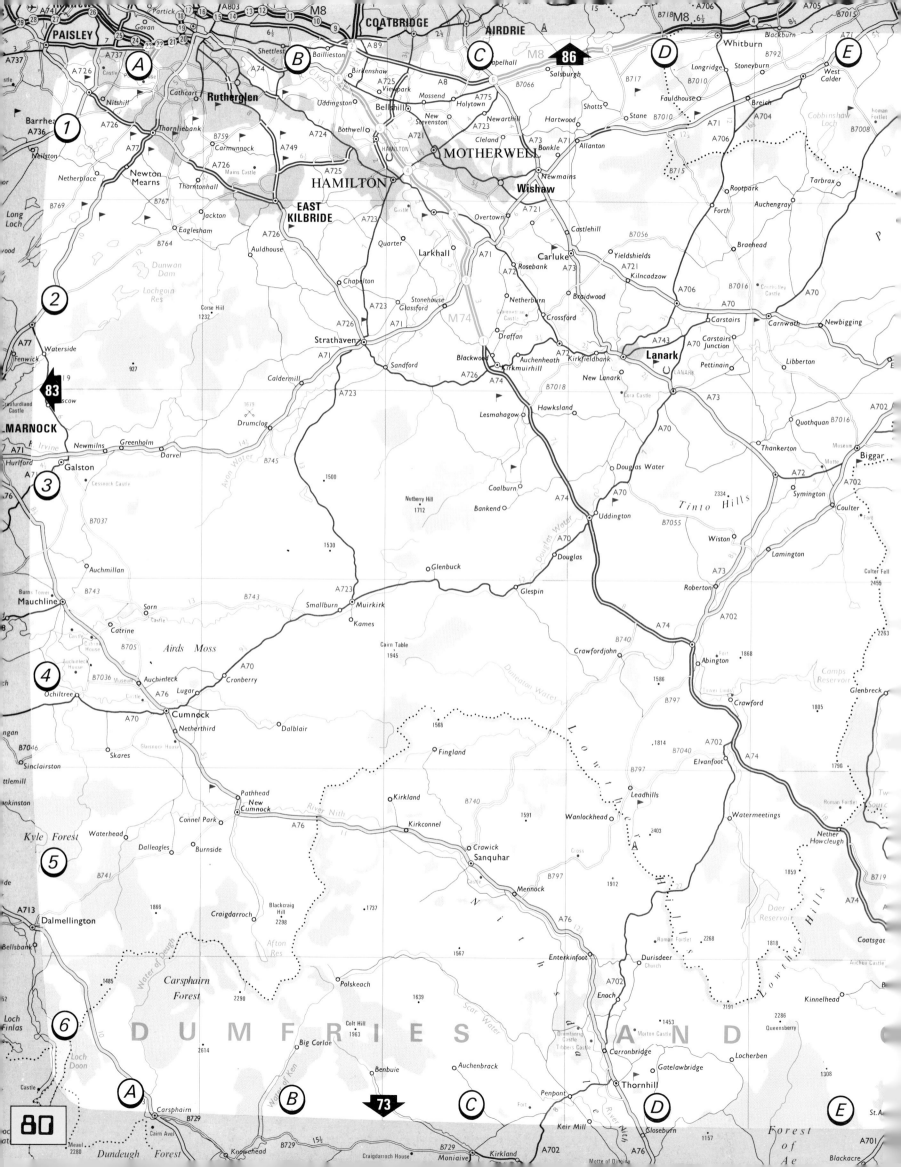

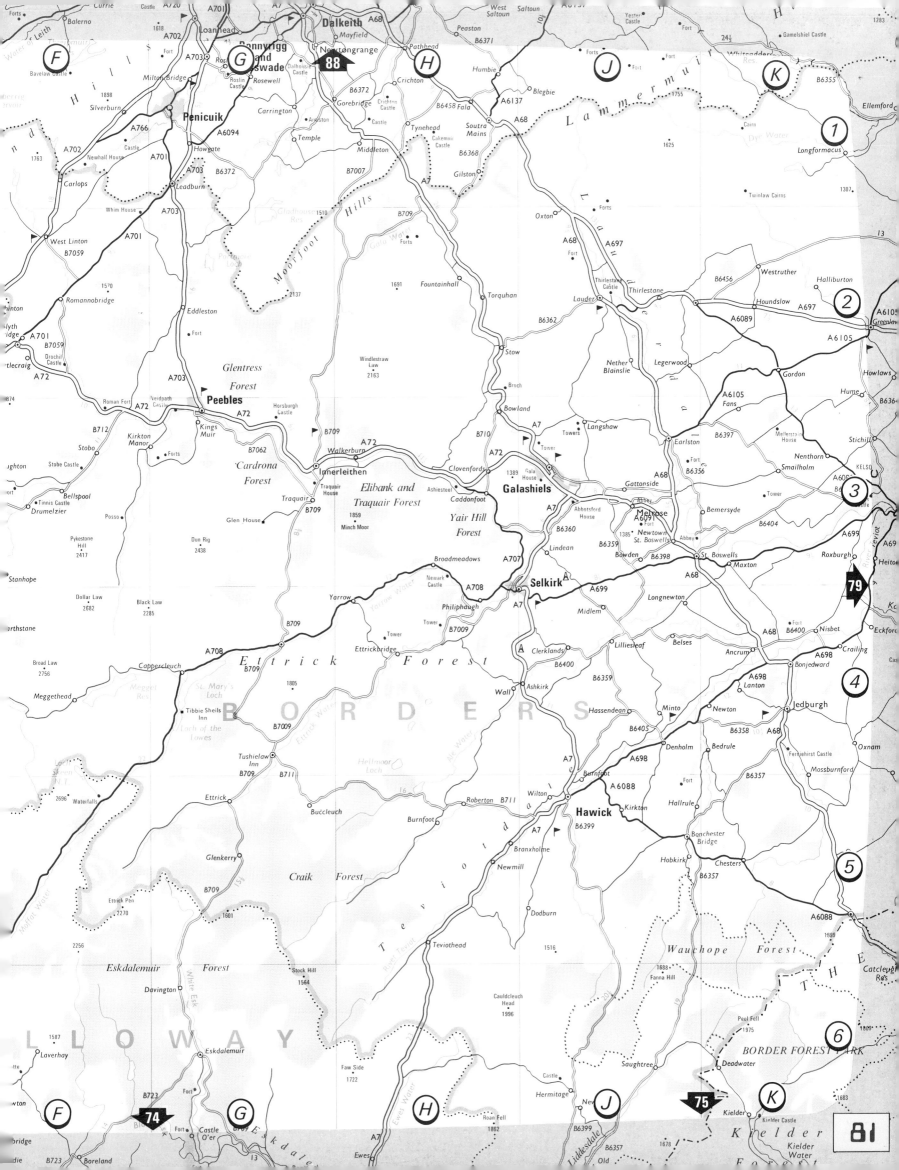

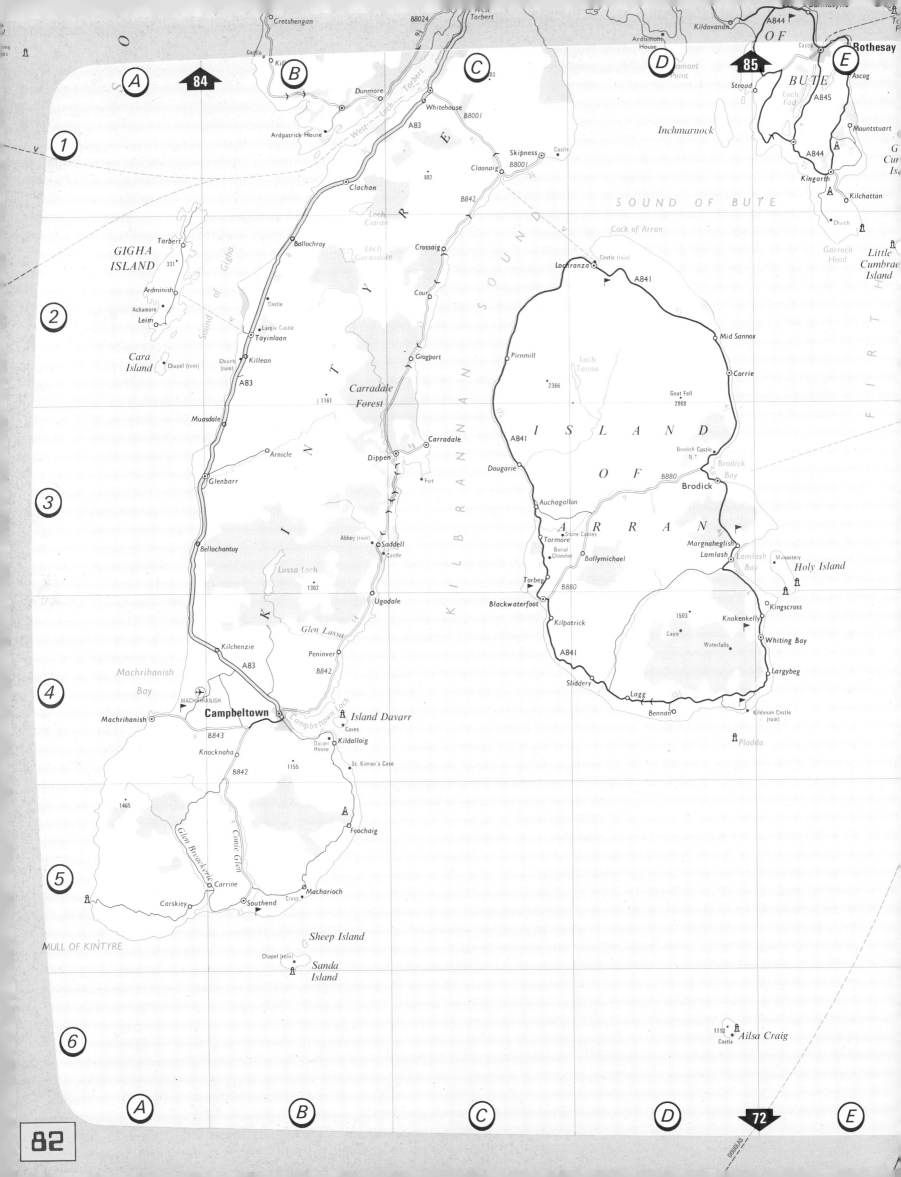

Cretshengan

West Tarbert

Kildavanan A844 OF BUTE Rothesay

Ardlamont House Castle Ascog

Castle Kilb Dunmore Whitehouse B8024 Lamont Point Straad BUTE A845

Ardpatrick House West Loch Tarbert A83 B8001 Inchmarnock Loch Fad Mountstuart

Skipness Castle A845 A

Clachan Claonaig B8001 A844 Cur Little Isle

882 B842 Kingarth Cumbrae

GIGHA Tarbert Ballochroy Loch Ciaran SOUND OF BUTE Kilchattan Isle

ISLAND 331 Loch Garasdale Crossaig Church

Ardminish Cock of Arran Garroch Little

Achamore Castle (ruin) Head Cumbrae

Leim Cour Lochranza A841 Island

Cara Largie Castle Tayinloan Grogport Pirnmill Loch Tanna Mid Sannox

Island Chapel (ruin) Killean Church (ruin) 2366 Goat Fell Corrie

A83 Carradale Forest 2868

Muasdale 1161 ISLAND Brodick Castle Brodick

Arnicle Carradale A841 OF NT Bay

Glenbarr Dippen Dougarie B880 Brodick

Bellochantuy Fort Auchagallon ARRAN

Abbey (ruin) Saddell Tormore Stone Circles Margnaheglish

Lussa Loch Castle Burial Ballymichael Lamlash Monastery Holy Island

1302 Chamber Lamlash Bay

Ugadale Torbeg B880 1503 Kingscross

Glen Lussa Blackwaterfoot Knokenkelly

Kilchenzie Peninver Kilpatrick Cairn Waterfalls Whiting Bay

A83 B842 A841 Largybeg

Machrihanish Sliddery Lagg

Bay MACHRIHANISH Campbeltown Island Davarr Bennan Kildonan Castle (ruin)

Machrihanish Caves Pladda

B843 Kildalloig

Knocknaha Davarr House St. Kieran's Cave

B842 1155

1465

Glen Breakerie Comic Glen Feochaig

Carrine Macharioch

Carskiey Cross Southend

MULL OF KINTYRE Sheep Island

Chapel (ruin) Sanda Island

1110 Ailsa Craig

Castle

FIRTH

KILBRANNAN SOUND

KINTYRE

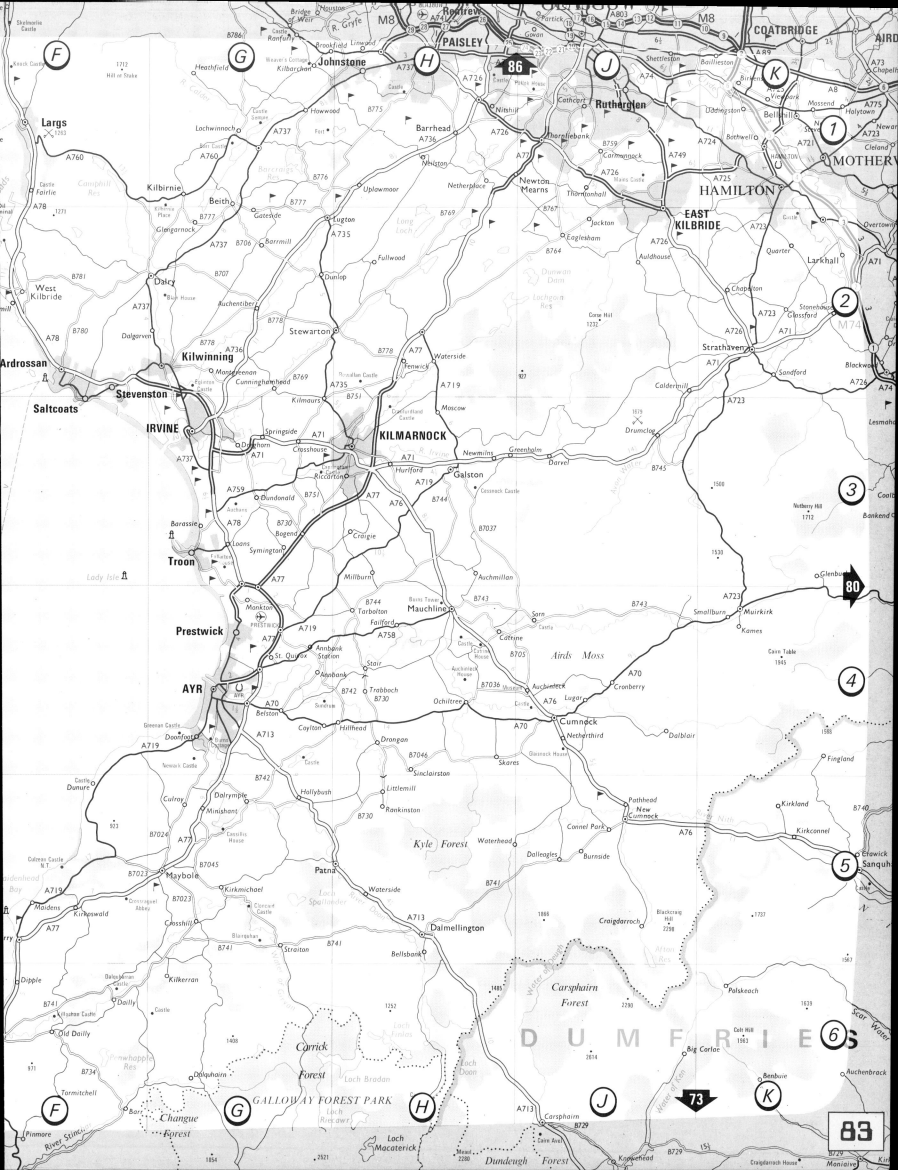

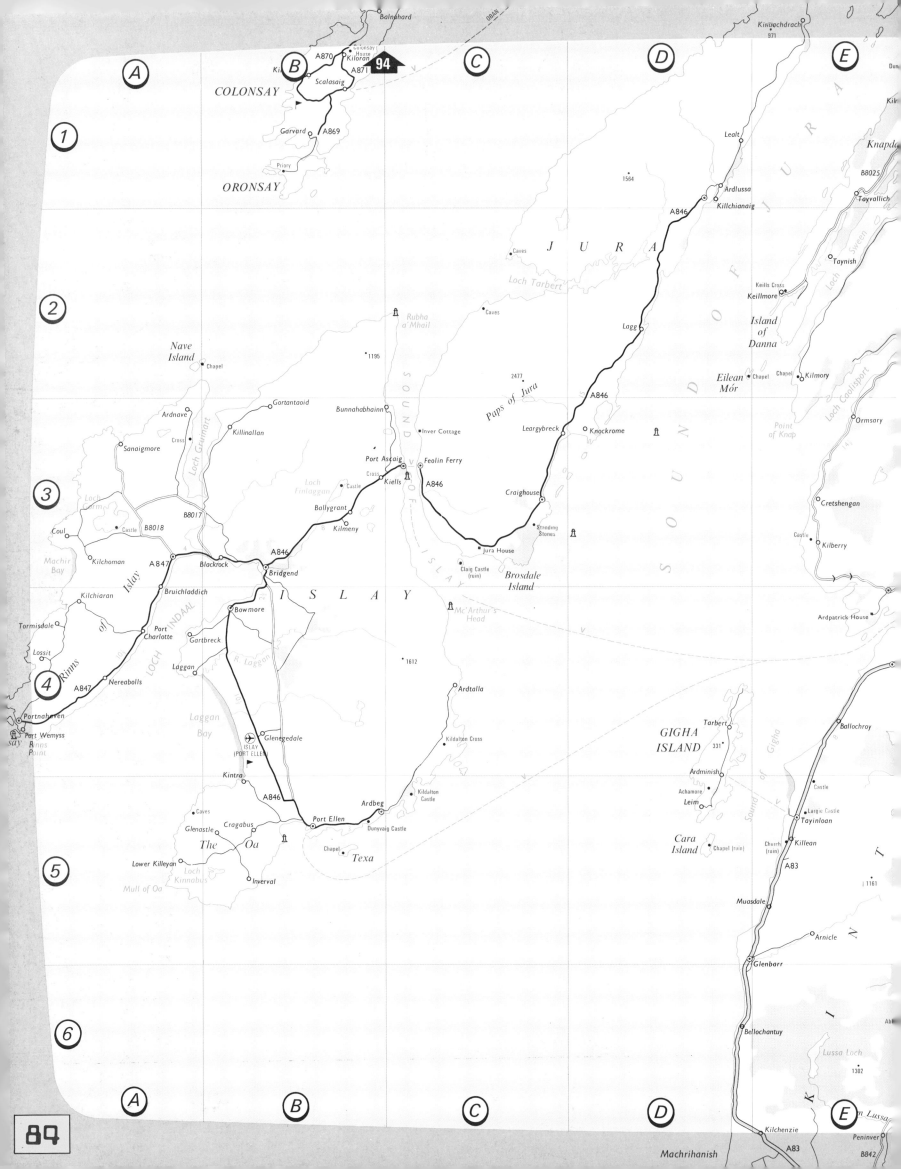

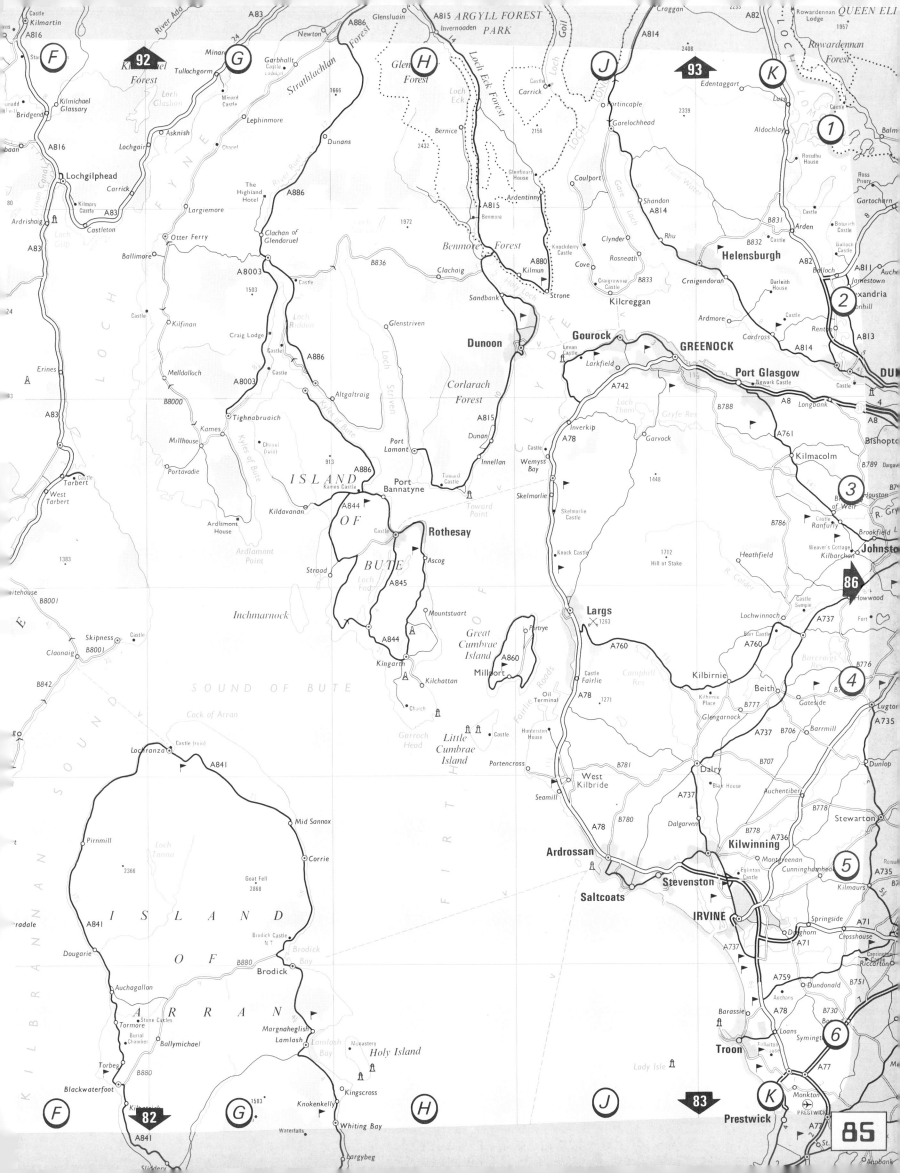

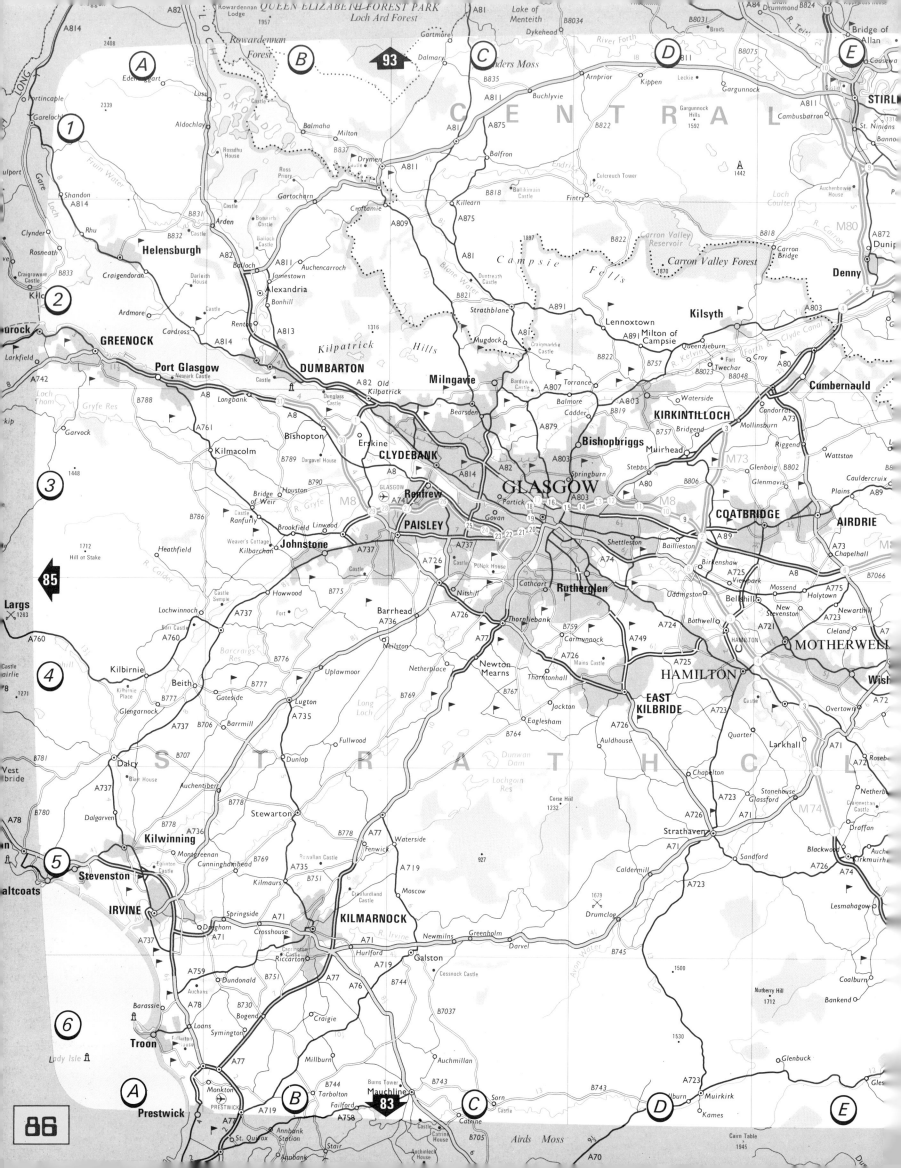

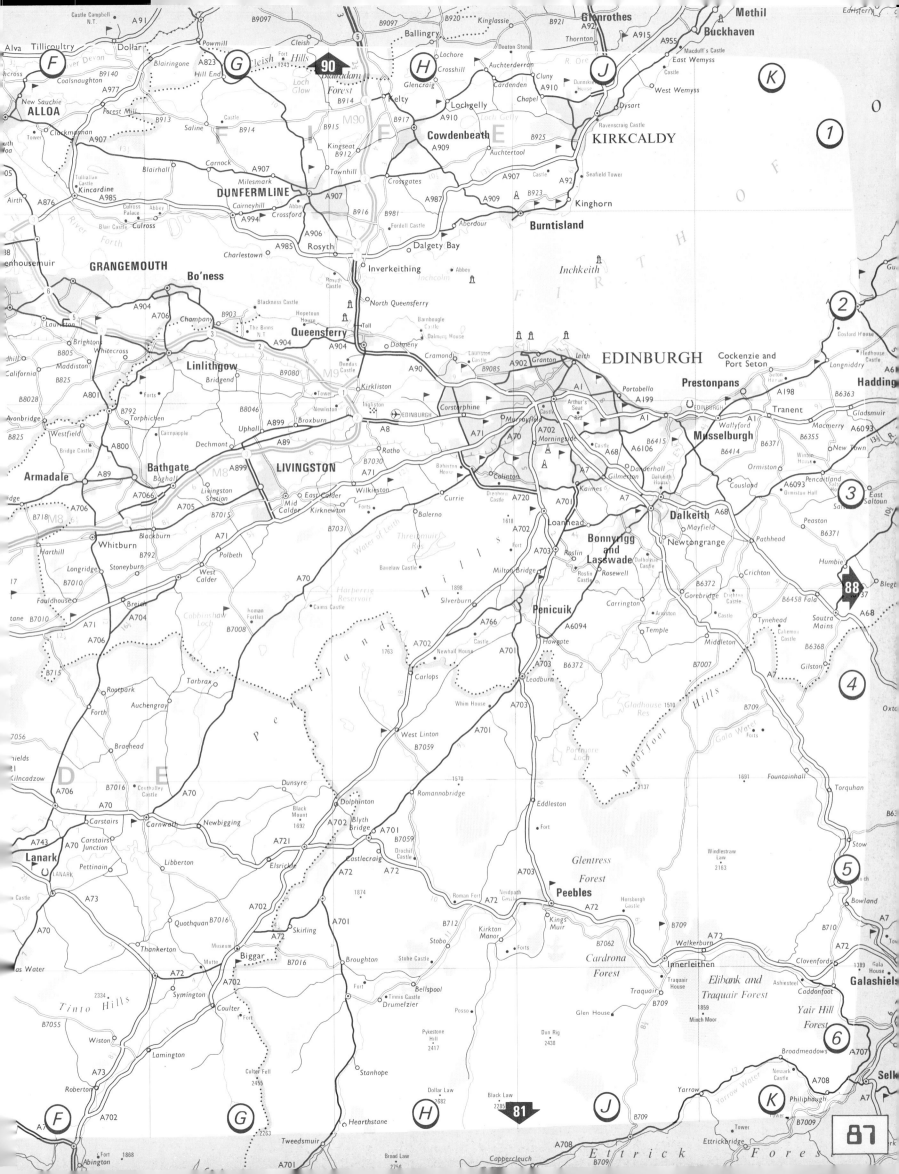

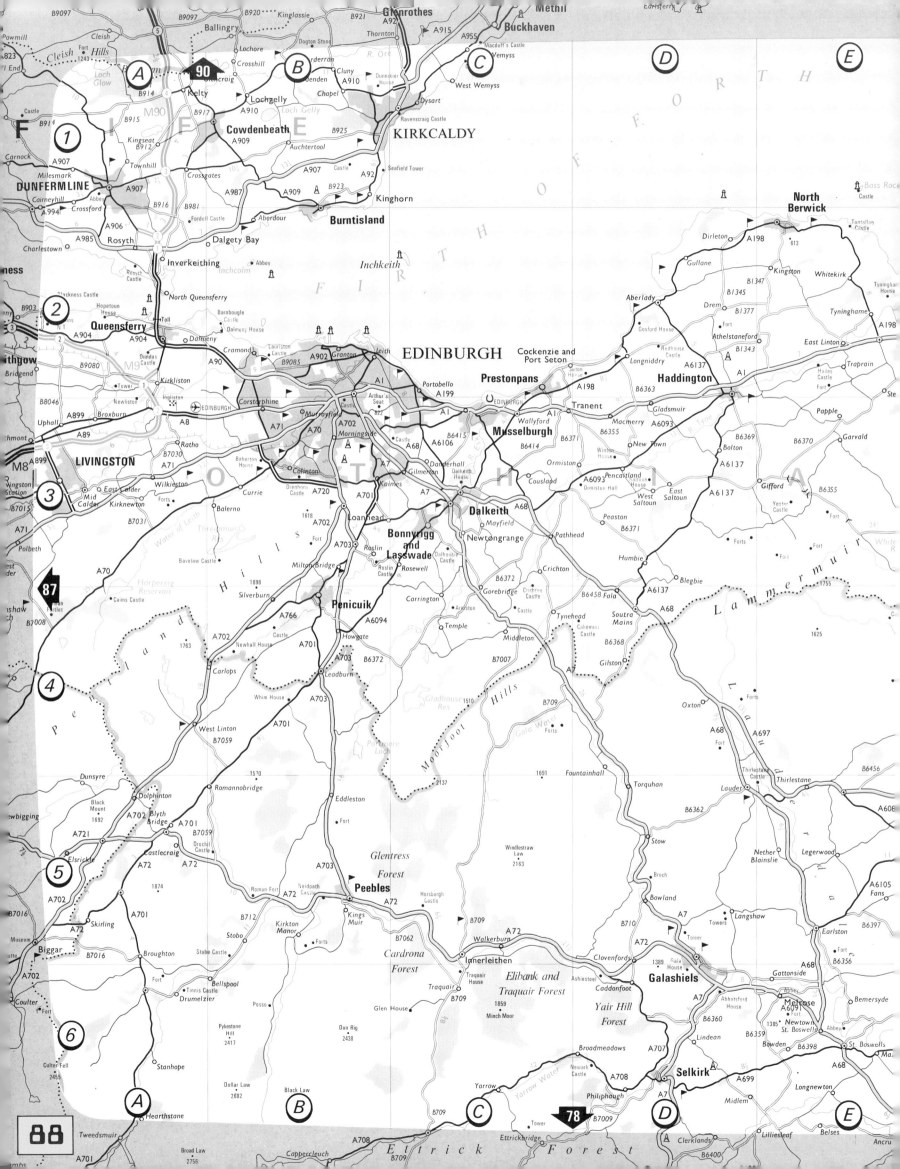

F 91 G H J K

1

2

Dunbar

Innerwick • Thorntonloch
Oldhamstocks
Ecclaw
Cockburnspath
A1 A1107
Fast Castle
Lumsdaine
Forts
ST. ABB'S HEAD
St.Abbs
1283
Grantshouse
Press Castle Coldingham Priory
Houndwood
A6112 A1 A1107 Eyemouth
Abbey St. Bathans
Abbey
859
Ellemford B6438 • Auchencrow Ayton Burnmouth
Broch •
Fort
Marygold
Lintlaw B6355 B6355
Preston B6437
B6365 Lamberton A1
Edrom A6105 Foulden
Chirnside Clappers 1333
1307 •
Duns Castle Manderston House Hutton A6105
Duns Allanton A6105 Berwick-Upon-Tweed
A6105 Paxton B6461
Gavinton A6112 B6460 Tweedmouth • Spittal
B6456 Whitsome Union Br. East Ord
Polwarth A698
burton Fogo B6461 Horncliffe B6354 A1 Scremerston
Swinton Ladykirk Castle Thornton
A6105 B6470 Norham West Allerdean Cheswick
Greenlaw Charterhall Simprim Grindon Ancroft Goswick
6105 A697 B6437 Twizel Bridge Felkington Holy Island
Howlaws Leitholm Duddo Berrington Haggerston Castle Beal
Hume Eccles A6112 Duddo Bowsden Barmoor Castle Priory Lindisfarne Castle
B6364 A697 Lennel A698 Castle • Etal B6353
Stichill Birgham A698 Pallinsburn House B6354 Fenwick A1 Buckton Farne Islands
KELSO Carham Wark Cornhill-on-Tweed Crookham Castle Lowick Kyloe Wood Detchant Elwick Ross
A6089 Hadden B6350 Branxton Ford Fort B6525 Holburn Belford B1342 Budle Bamburgh Castle B1341 B1340
B6397 Sprouston B6396 1513 B6352 Kimmerston B6349 Bradford Seahouses North Sunderland
Kelso Mindrum Milfield Doddington Horton Bellshill B6348 Lucker
Maxwellheugh Kilham Lanton Chatton Warenford Swinhoe Beadnell
A699 B6352 Heiton B6351 A697 B6348 Wooler A1 Ellingham B1340 New
A698 Shotton Kirknewton Akeld Chillingham Church North Charlton Christon
burgh B6436 Town Yetholm Kirk Yetholm Hethpool Pele Tower Humbleton Fort Haugh Head 876
Crailing Linton Cessford B6401 Morebattle

Kate Water Katie Water River Tweed Eye Water Whiteadder Water Blackadder Water River Till

F G 79 H J K

3

4

5

6

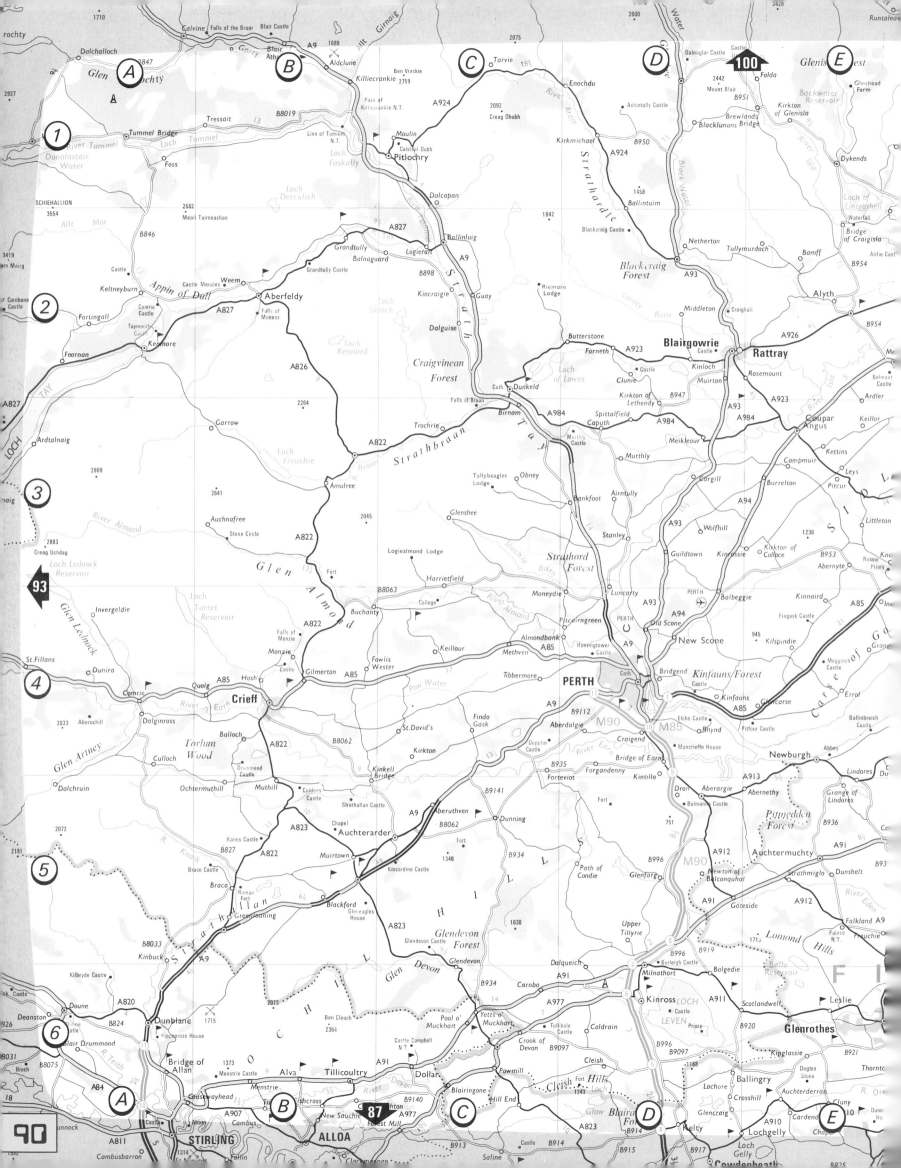

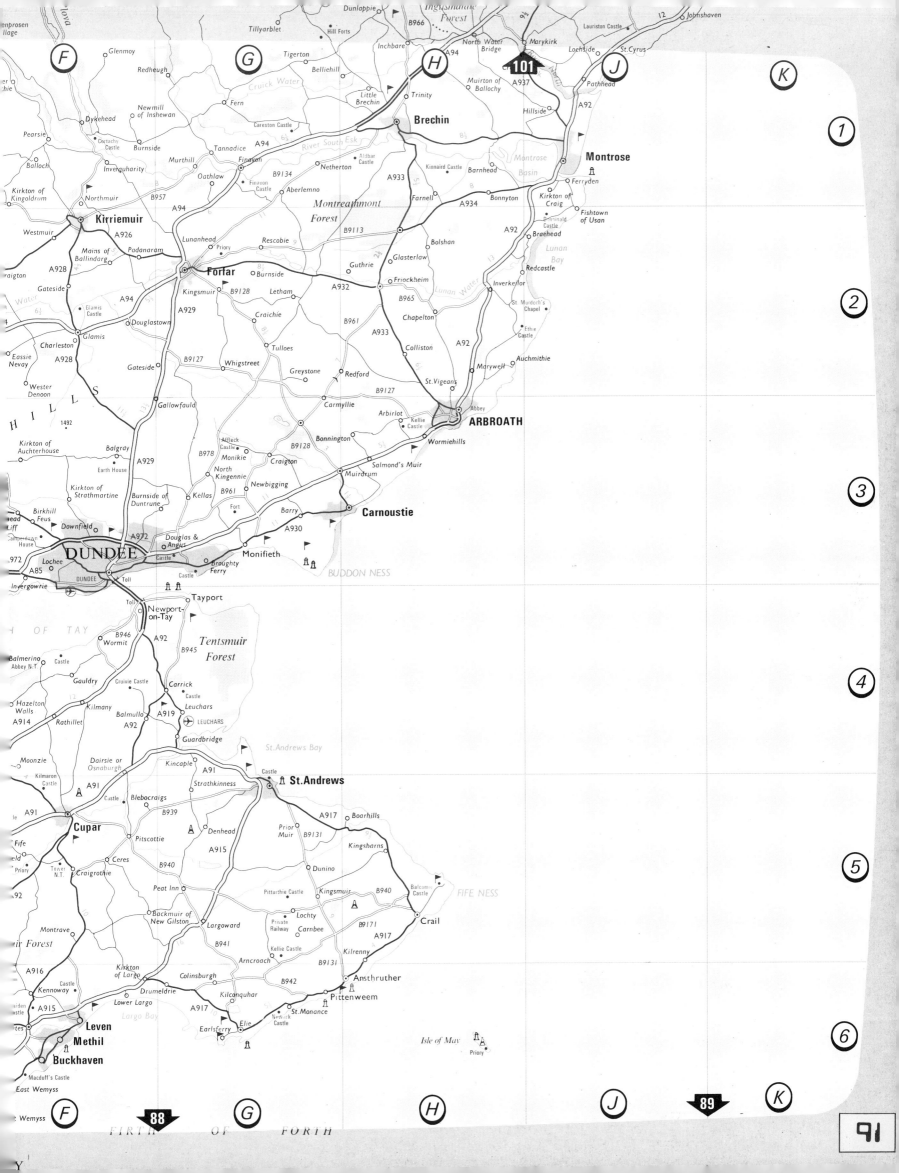

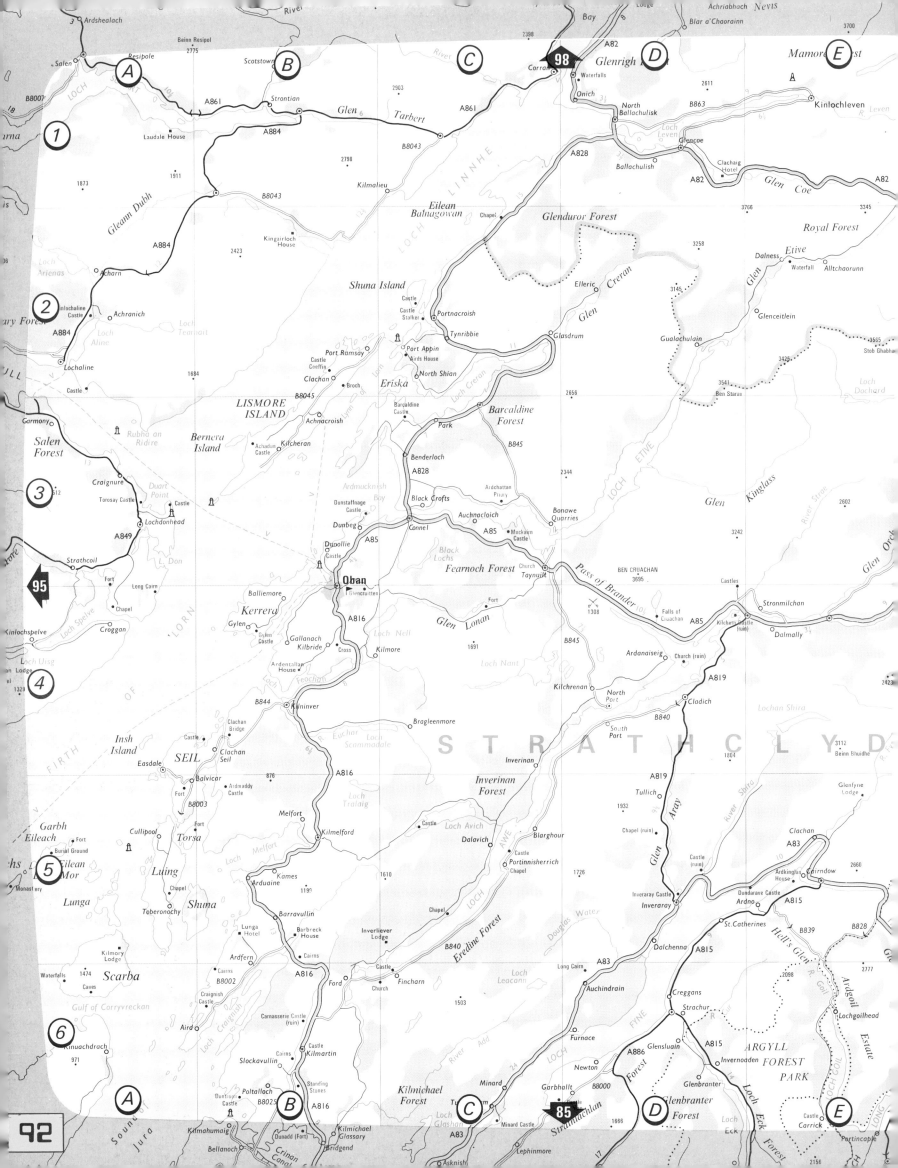

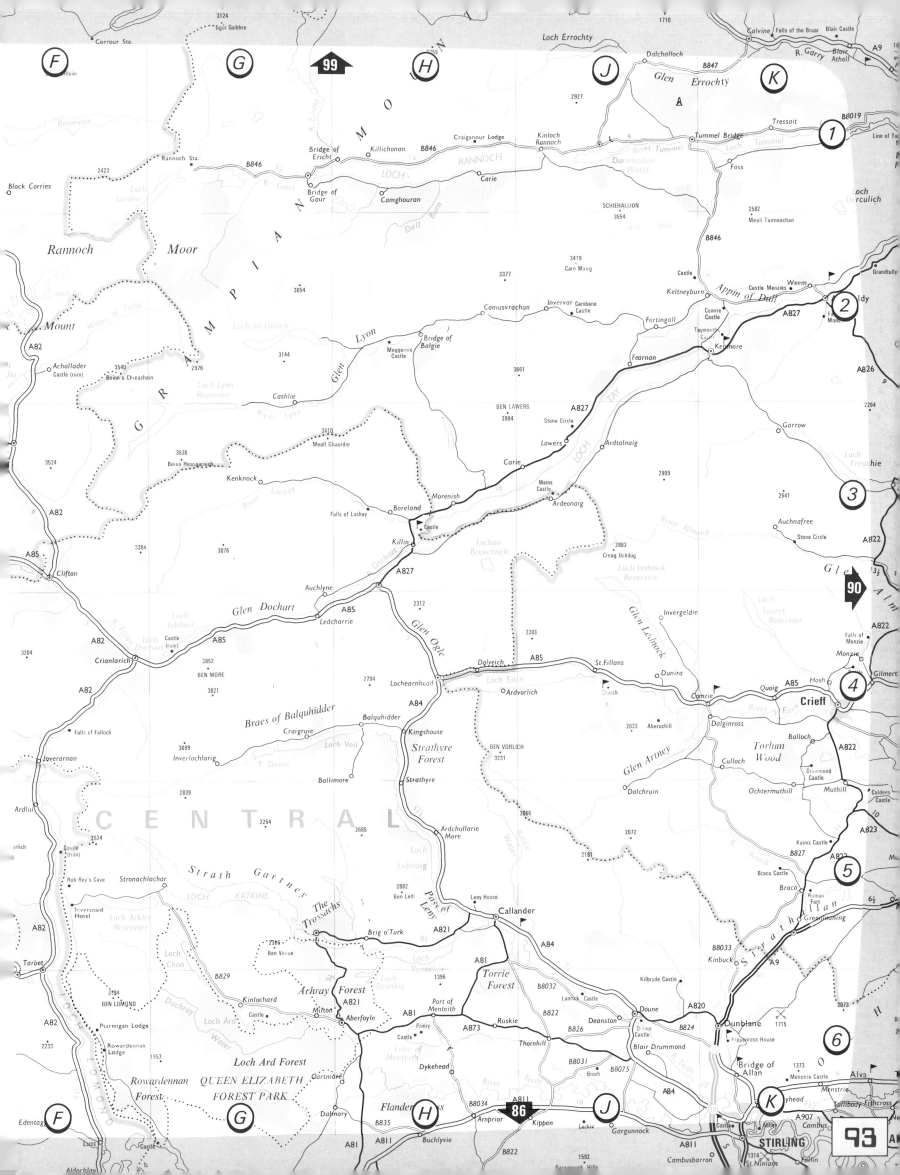

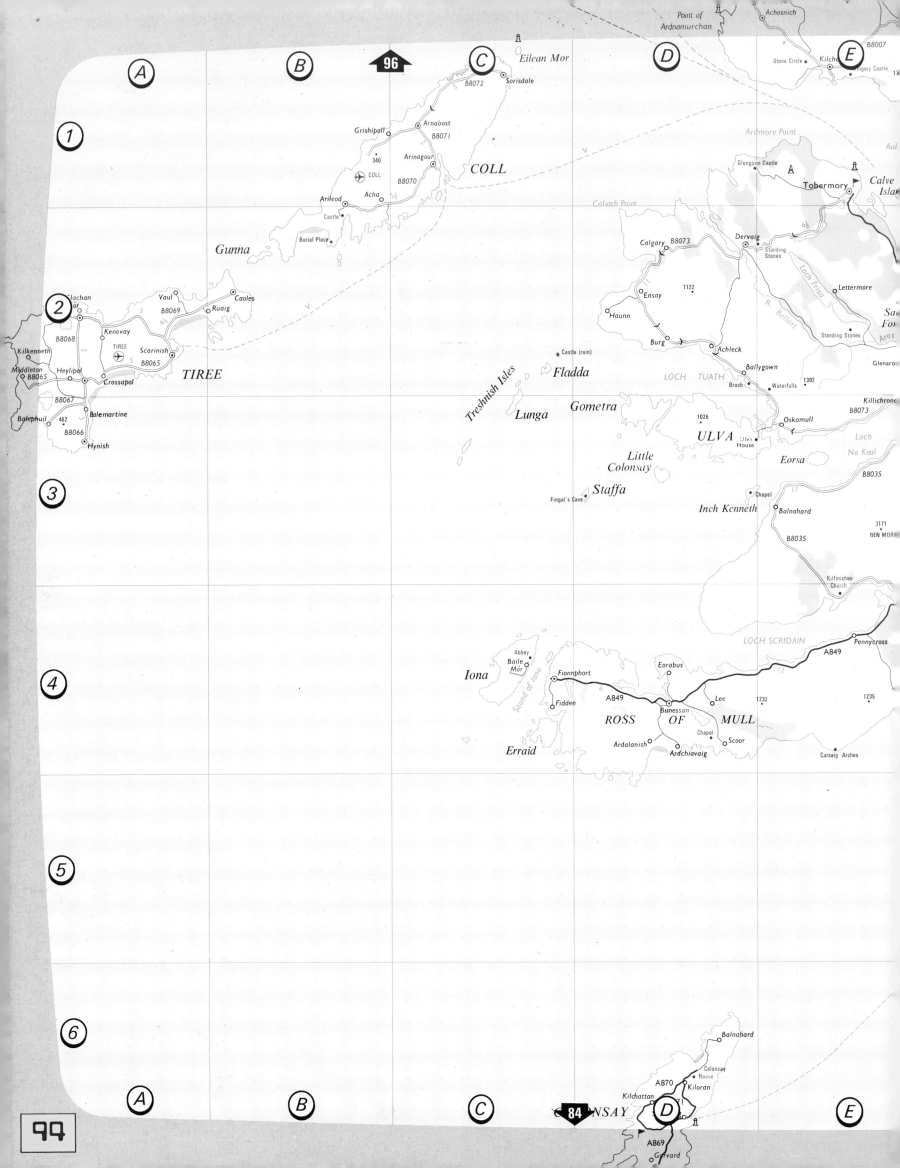

Point of
Ardnamurchan

Achosnich

Stone Circle Kilcho **E** B8007

Kingary Castle

A **B** **C** Eilean Mor **D** **E**

1

B8072 Sorisdale

Ardmore Point

Aul

Grishipoll Arnabost

B8071

COLL

Glengorm Castle A

340 Arinagour

Tobermory Calve
Islan

COLL

Caliach Point

B8070

Arileod Acha

Dervaig Standing
Stones

Castle

Calgary B8073

Loch Friso

Burial Place

Lettermore

Gunna

Ensay

1122

Sa
For

2 Slachan
or Vaul Caoles

Haunn

B8069 Ruaig

Kenovay

Burg Achleck

Standing Stones

B8068

TIREE

Ballygown

Aros

Kilkenneth Scarinish

Broch Waterfalls 1392

Glenaro

B8065

Middleton Heylipol

LOCH TUATH

B8065 Crossapol TIREE

Killichronc

Bolephuil B8067

Treshnish Isles Fladda

Gometra ULVA Oskamull B8073

462 Balemartine

Lunga 1026 Ulva Loch

B8066 Hynish

House Na Keal

Eorsa

Little
Colonsay B8035

3

Staffa Chapel

Fingal's Cave Inch Kenneth Balahard

3171
BEN MOR

B8035

Kilfinichen
Church

LOCH SCRIDAIN Pennycross

Abbey A849

Baile Eorabus

4 Iona Mór Fionnphort

Sound of Iona A849 Lee 1232 1235

Fidden Bunessan

ROSS OF MULL

Chapel

Ardalanish Scoor

Erraid Ardchiavaig Carsaig Arches

5

6 Balnahard

Colonsay
House

A870

Kilchattan Kiloran

A **B** **C** 84 NSAY **D** **E**

A869

Gorvard

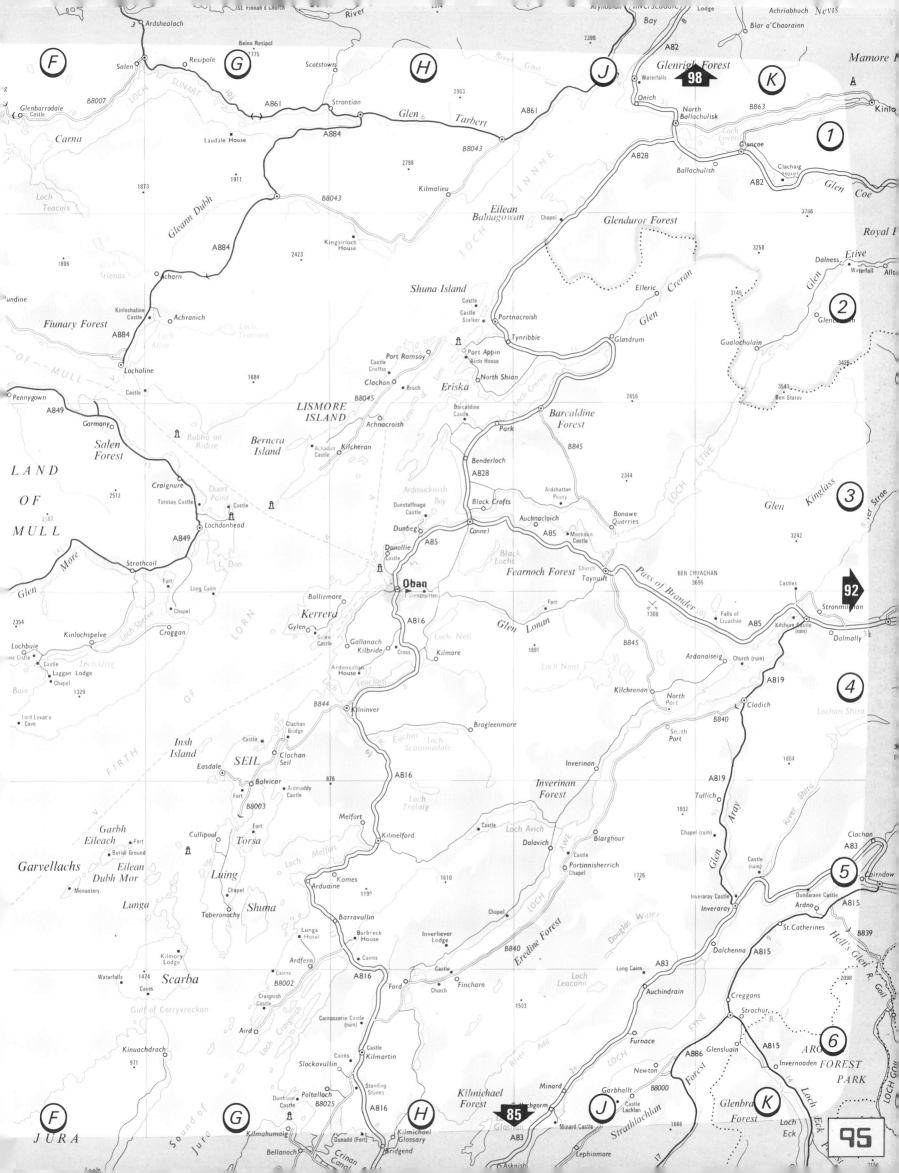

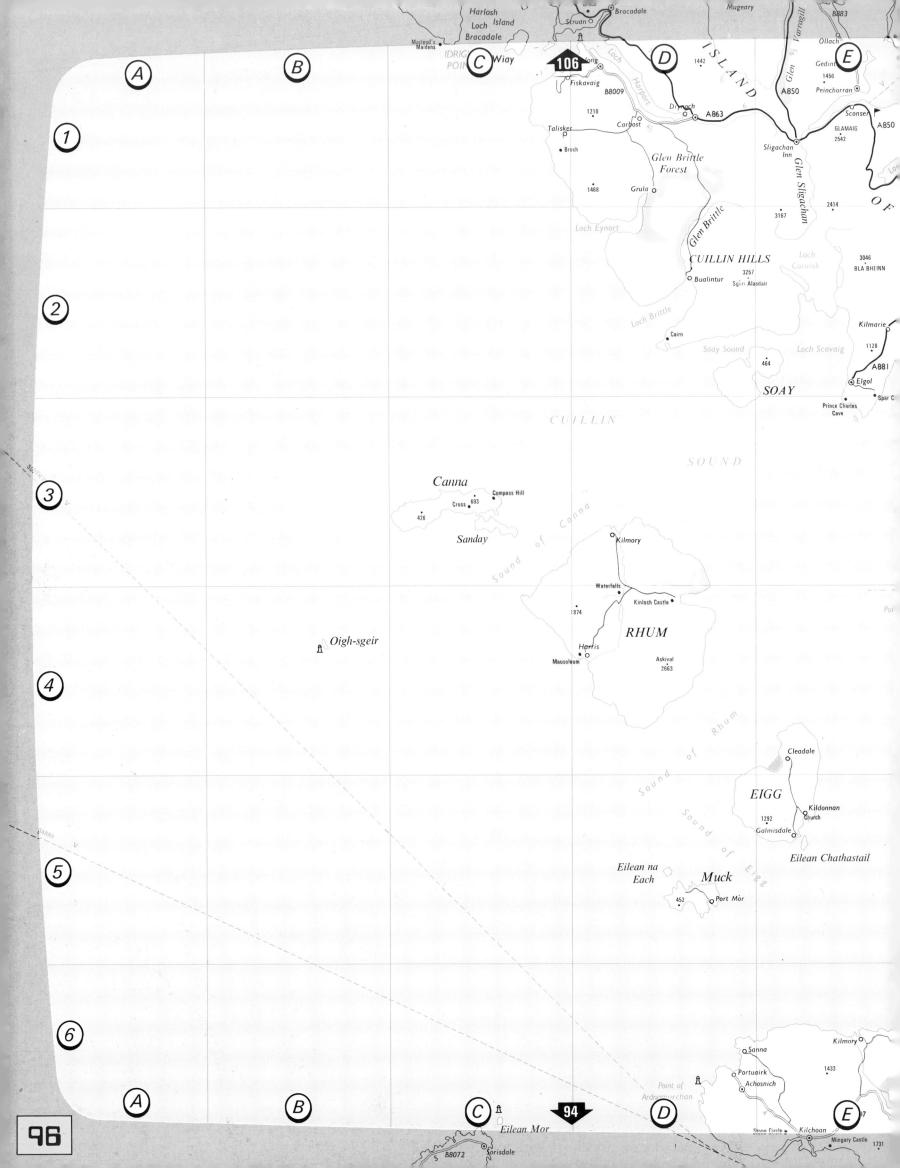

Harlosh
Island
Loch
Bracadale
Macleod's
Maidens
IDRIGILL
POINT
Wiay

Bracadale
Struan
Mugeary

B883

Ollach
Gedintailor
1456
Peinchorran

ISLAND

Glen Varragill

A850

Fiskavaig
Portnalong
B8009

Loch Harport

Drynoch
Carbost
A863

Sconser
GLAMAIG
2542
A850

OF

Talisker
1210

Broch

Glen Brittle
Forest

Sligachan
Inn
Glen Sligachan

1442

1468
Grula

Loch Eynort

Glen Brittle

2414

3167

CUILLIN HILLS

Loch
Coruisk

3046
BLA BHEINN

Bualintur
3257
Sgùr Alasdair

Kilmarie

Cairn

Soay Sound

Loch Scavaig

1128

464

A881

Elgol
Spar C

SOAY

Prince Charles
Cave

CUILLIN

SOUND

Canna
Compass Hill
Cross 693
426

Sound of Canna

Kilmory

Sanday

Waterfalls

Kinloch Castle

1874

RHUM

Oigh-sgeir

Harris
Mausoleum

Askival
2663

Cleadale

Sound of Rhum

EIGG

Kildonnan
Church

1292

Galmisdale

Sound of Eigg

Eilean Chathastail

Eilean na
Each

Muck

452
Port Mòr

Sanna
Kilmory

Portuairk
Achosnich

1433

Point of
Ardnamurchan

Kilchoan
Mingary Castle
1731

Stone Circle

Eilean Mor

Sorisdale
B8072

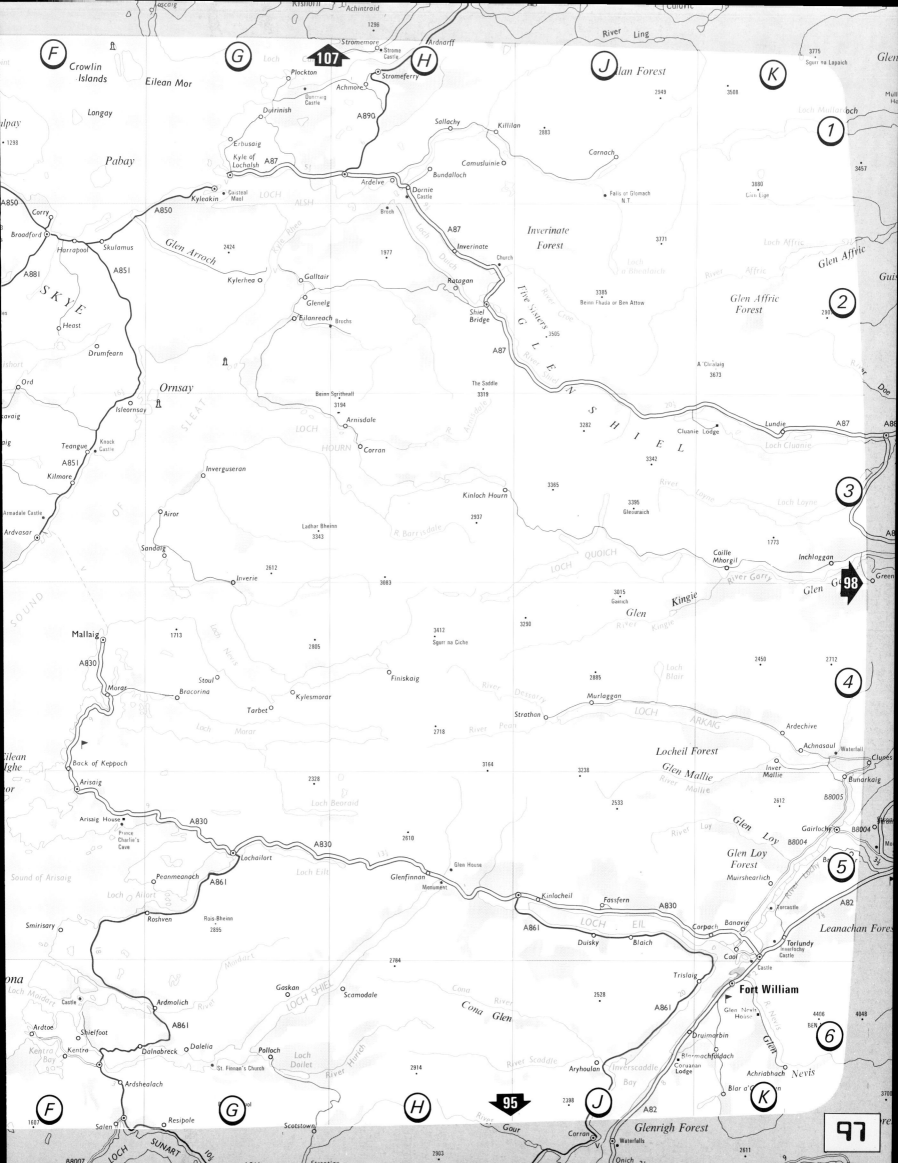

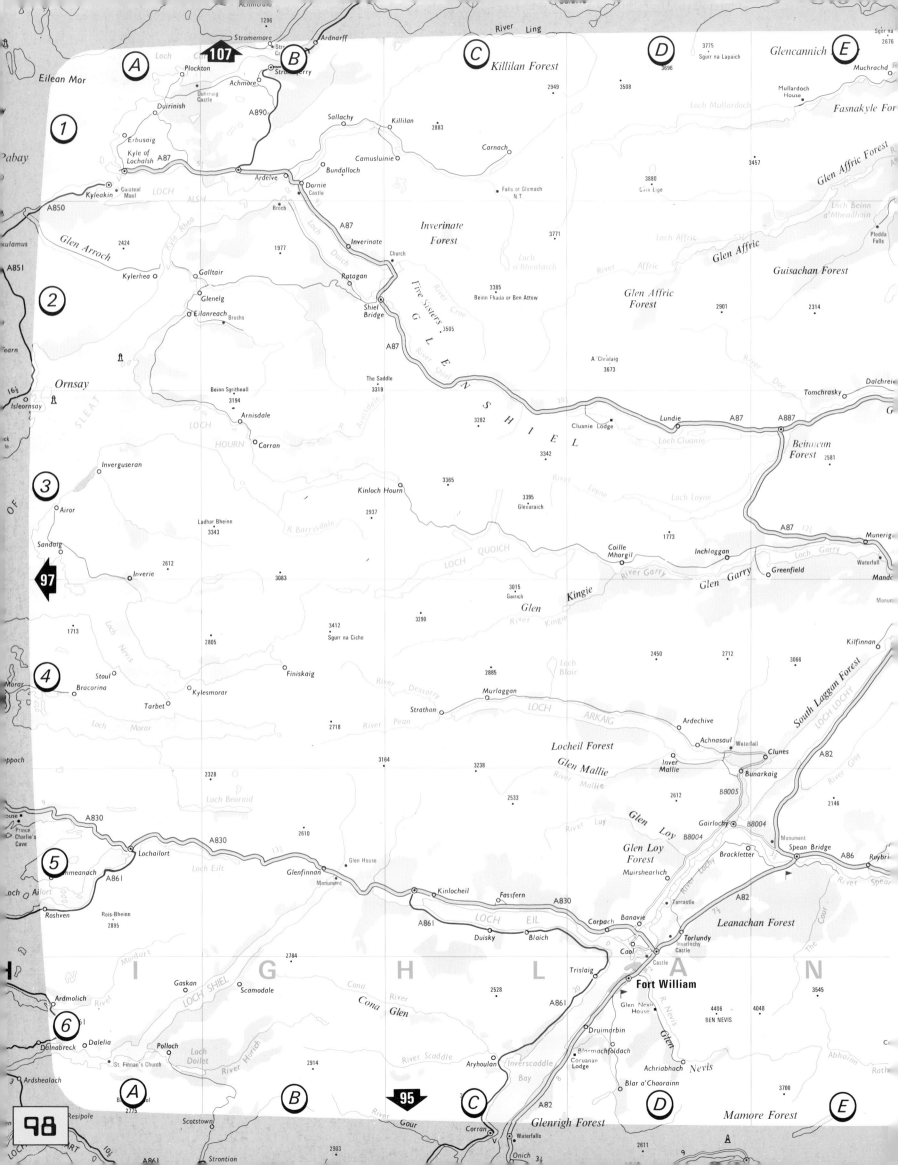

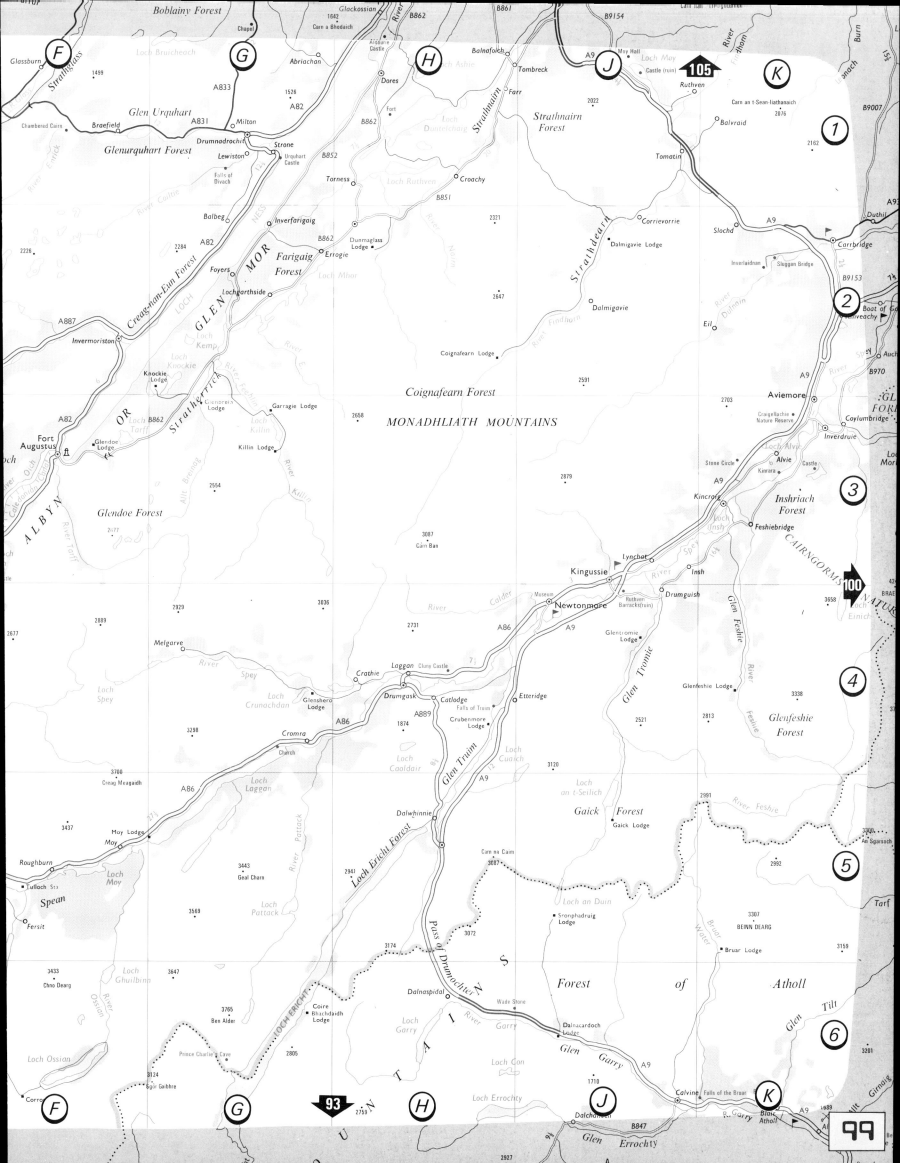

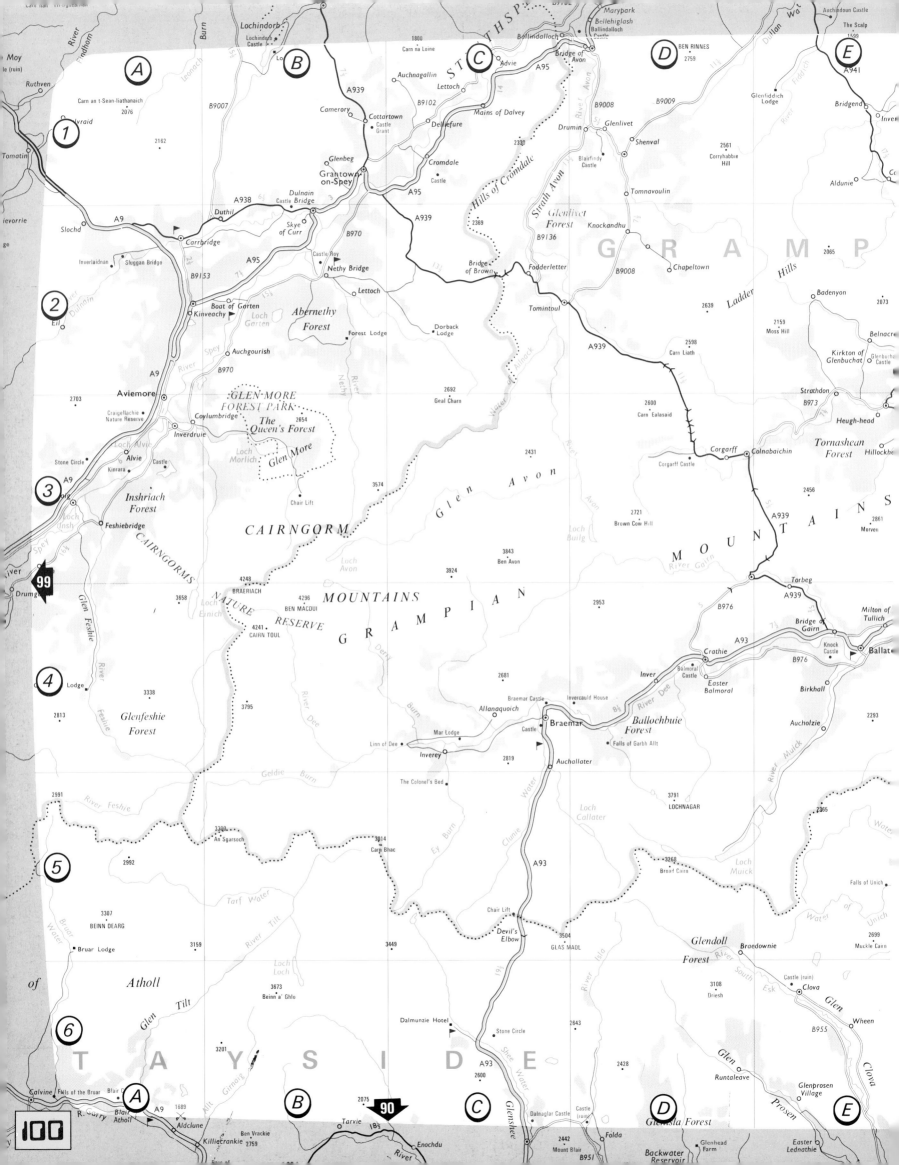

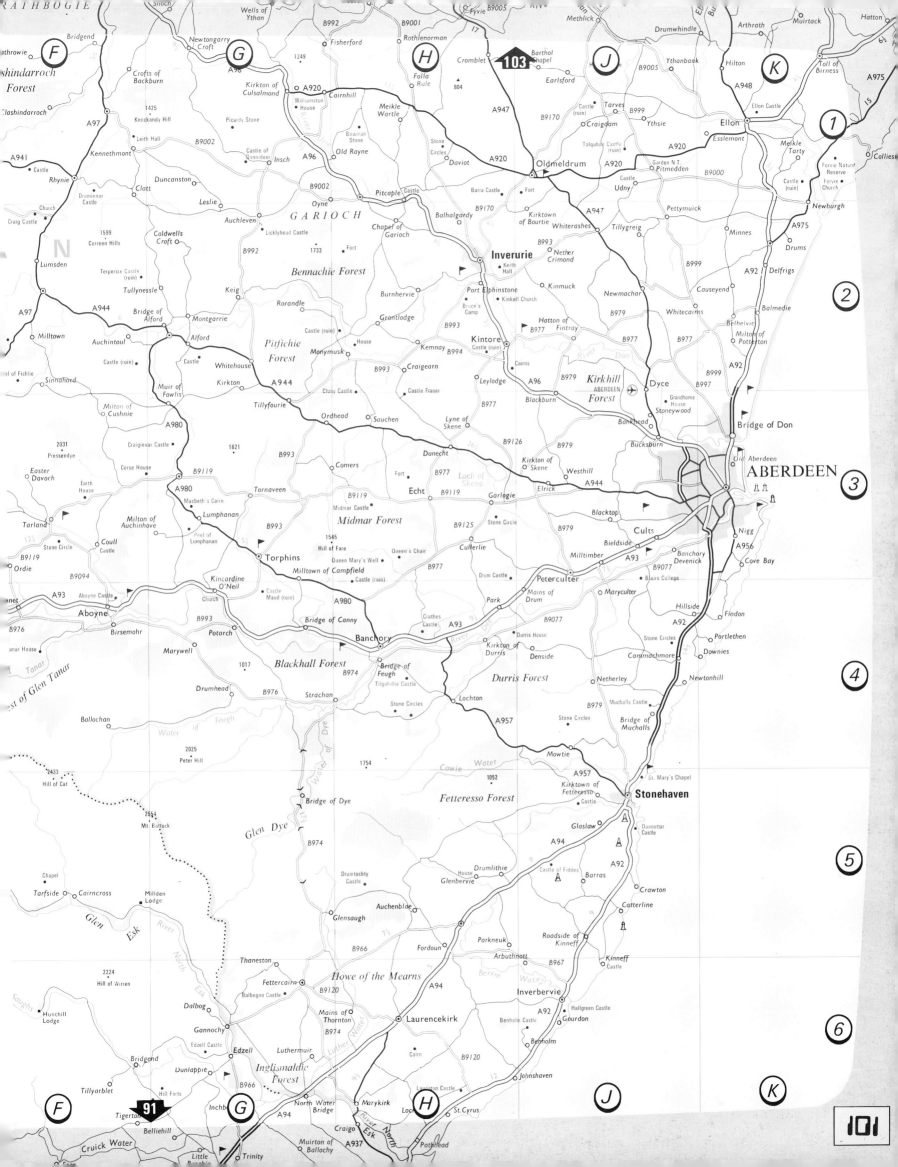

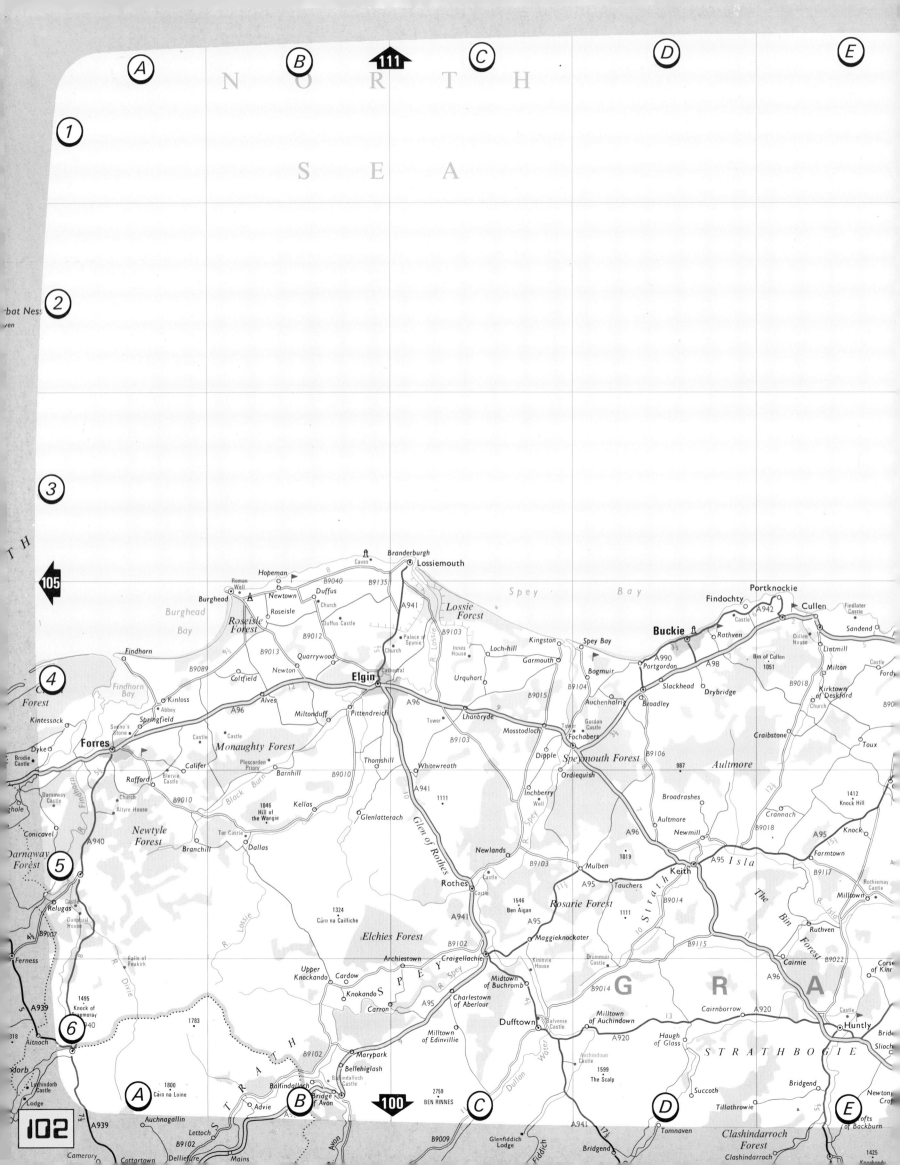

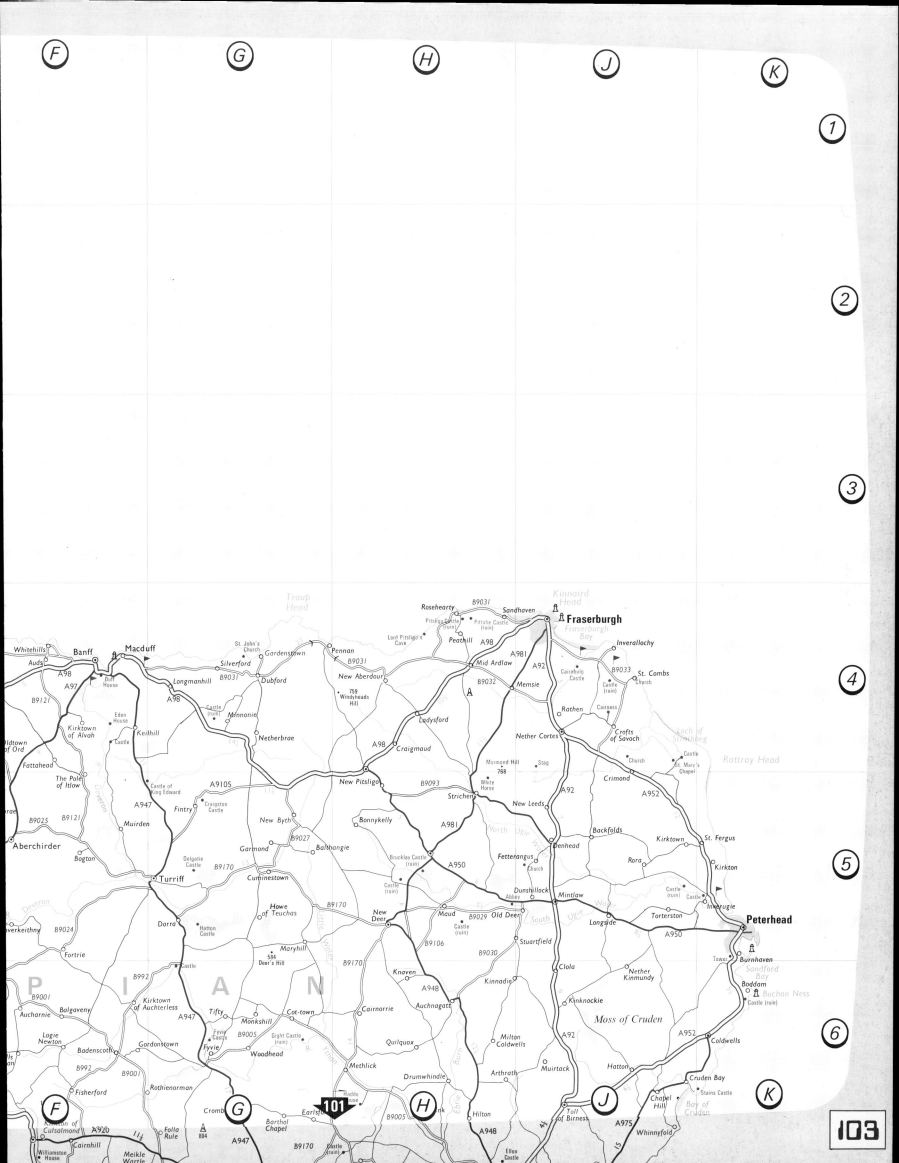

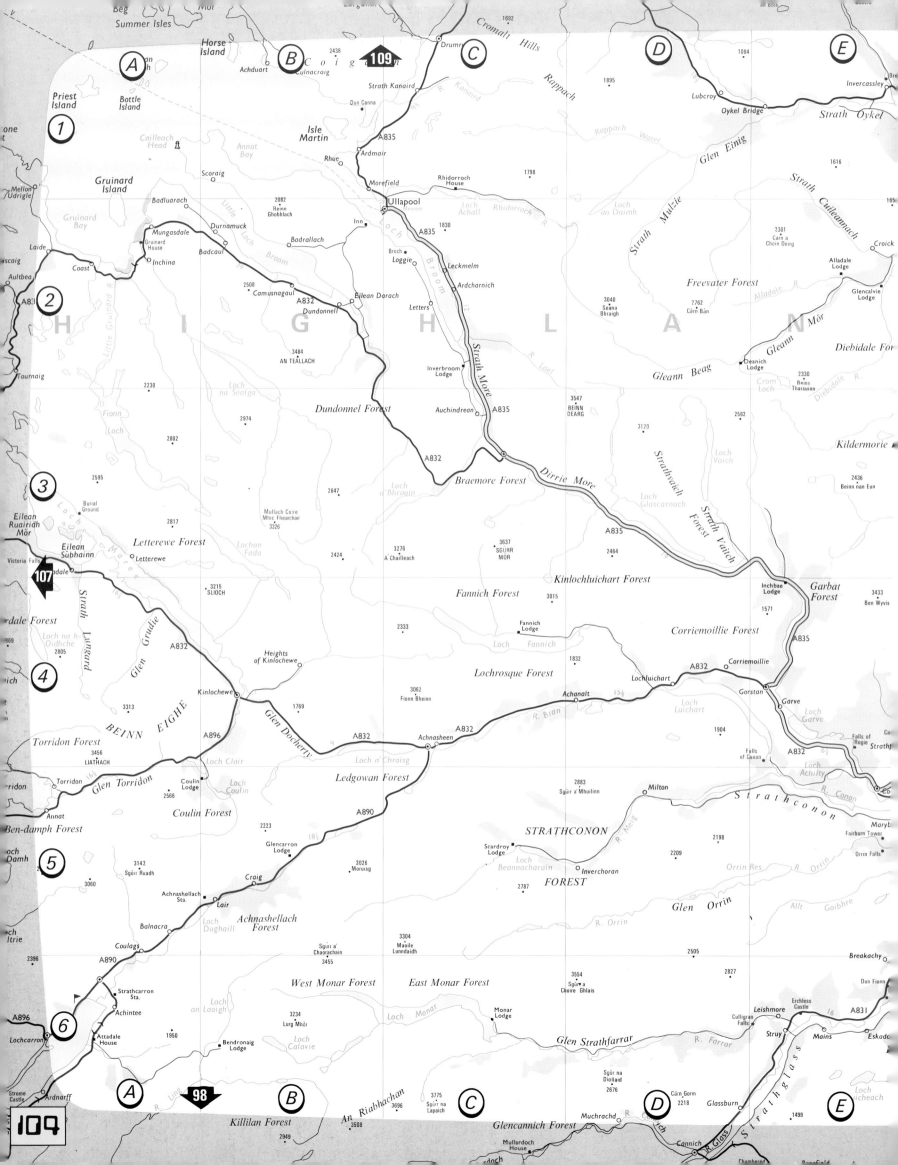

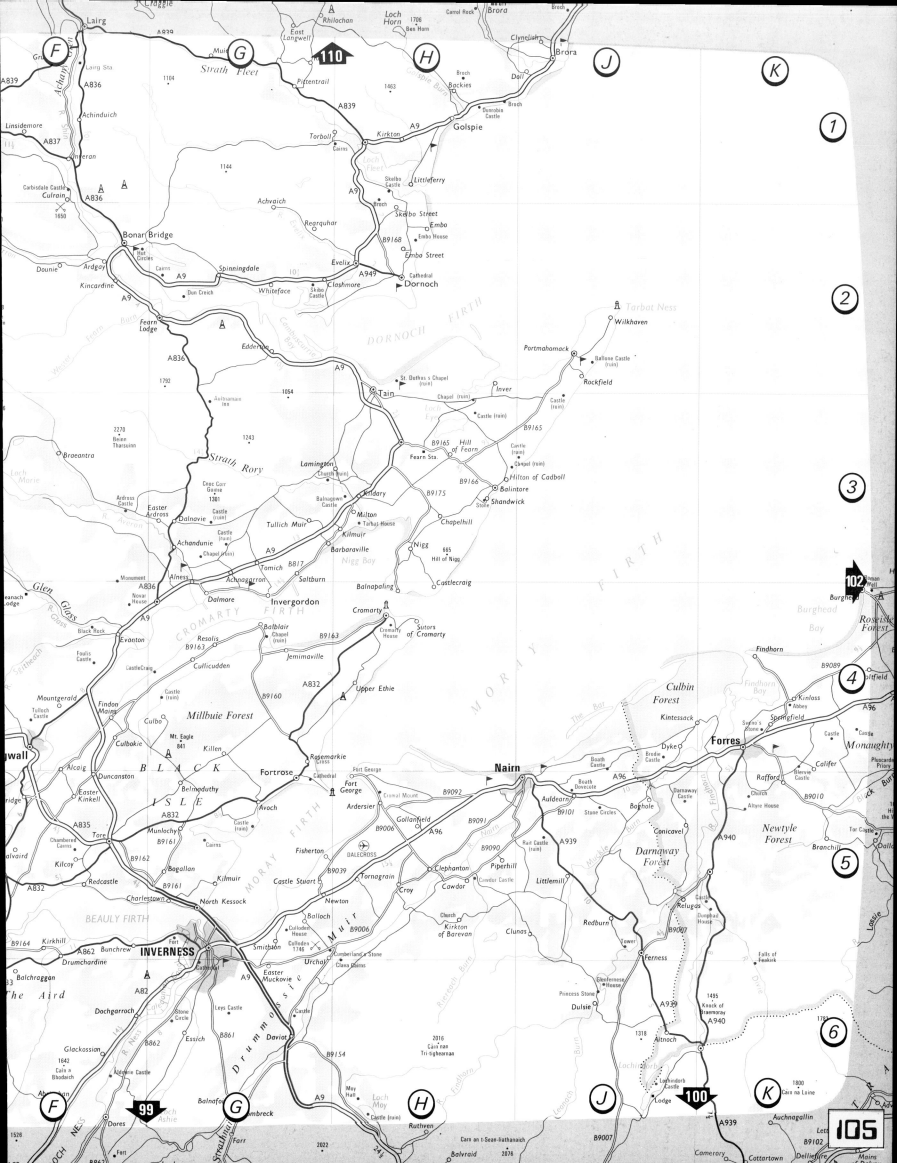

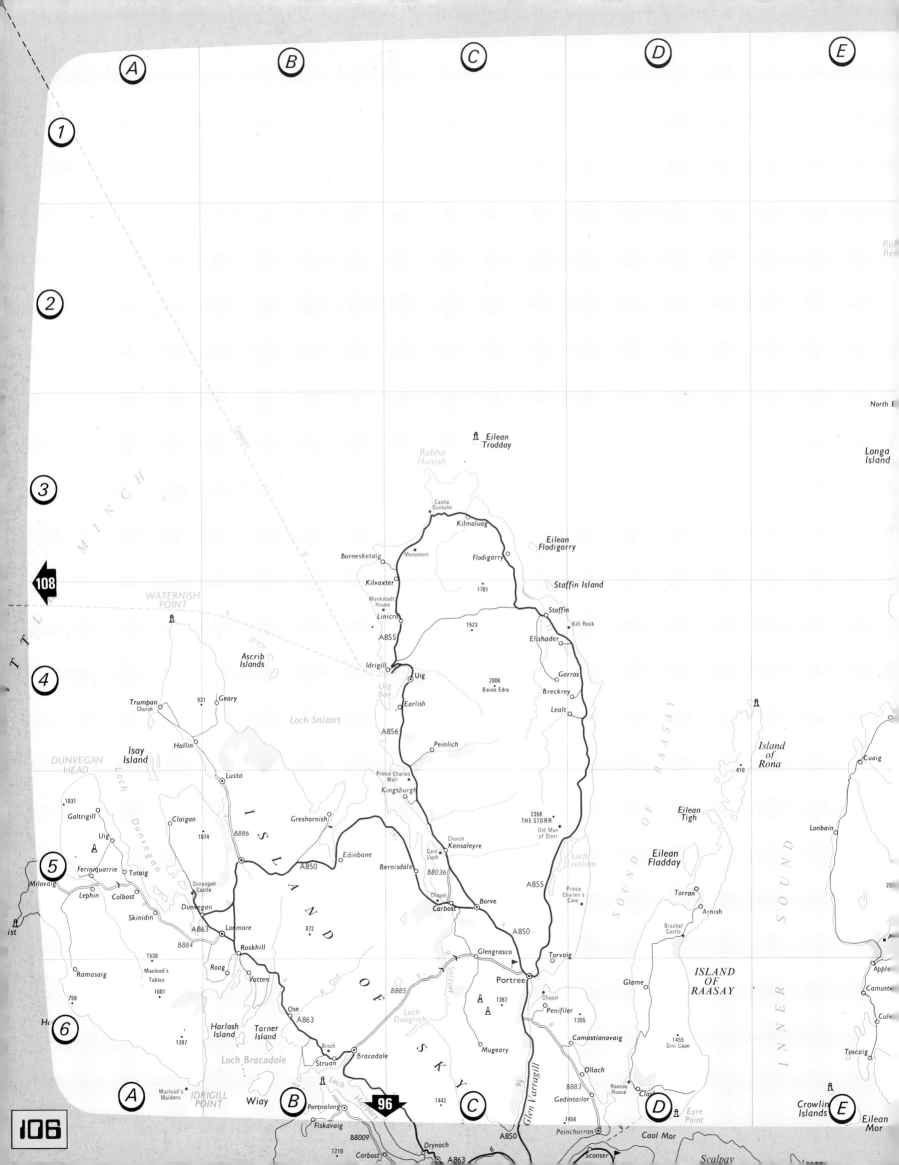

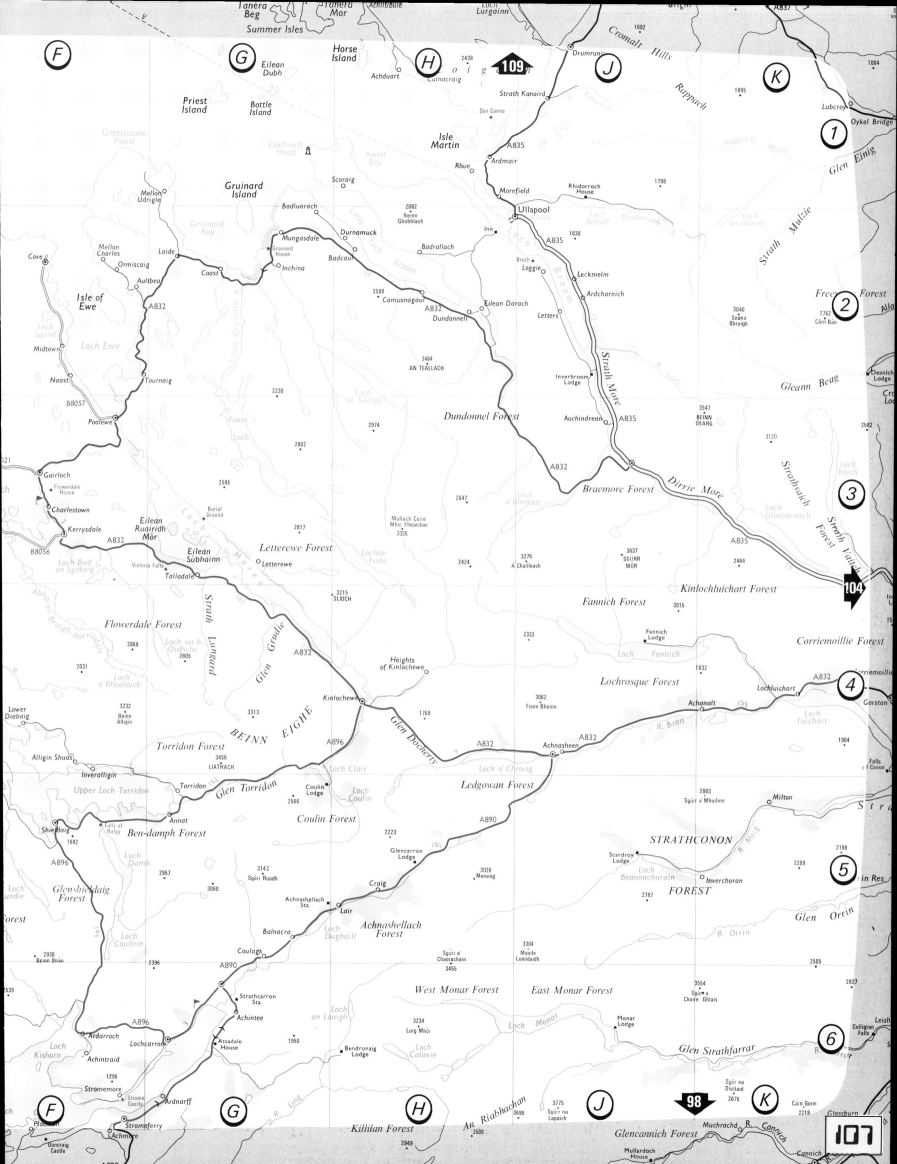

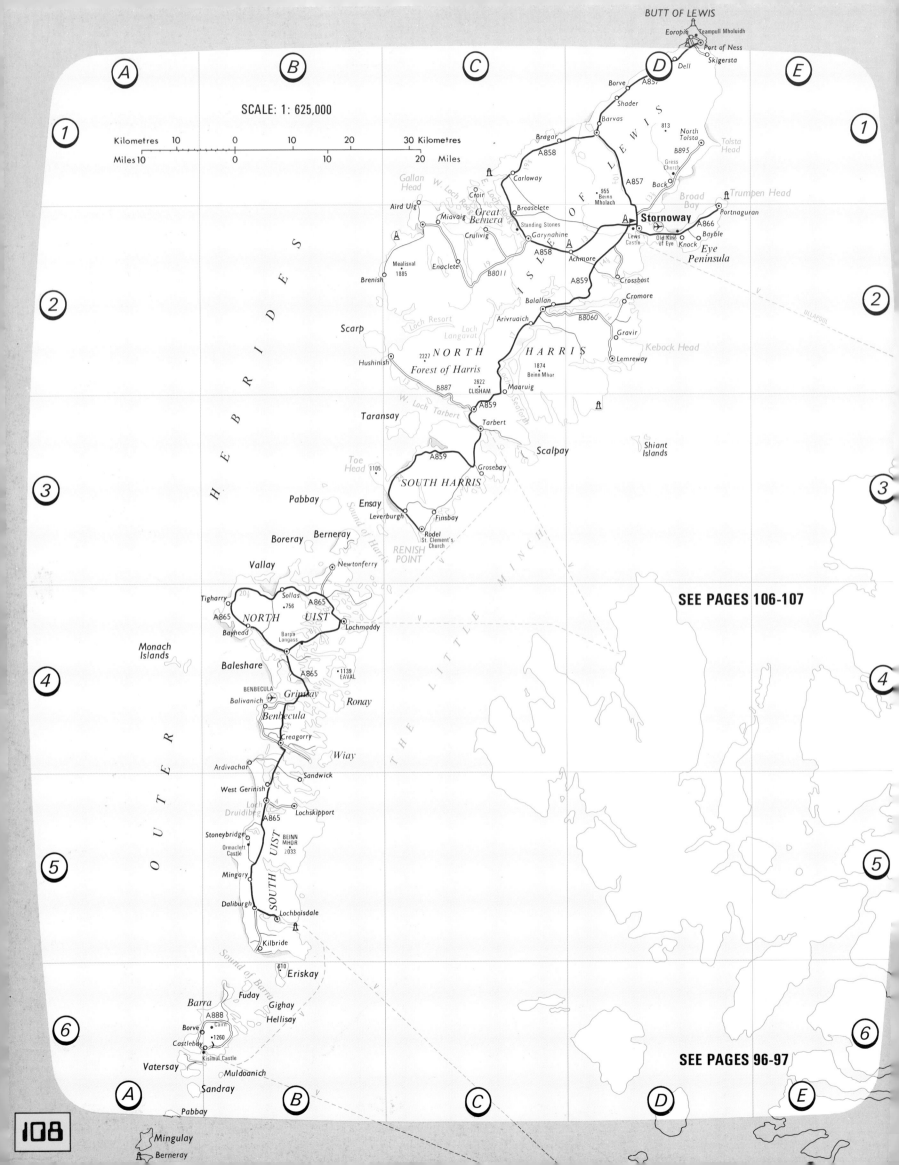

BUTT OF LEWIS

SCALE: 1: 625,000

Kilometres 10 0 10 20 30 Kilometres
Miles 10 0 10 20 Miles

Eoropie Teampull Mholuidh
Port of Ness
Dell Skigersta

Borve A857
Shader
Barvas
Bragar
Carloway A858
Choir
Aird Uig
Miavaig Great Bernera
Cruluig Breasclete
Standing Stones
Garynahine
A858
Mealisval 1885
Enaclete
Brenish B8011

813
North Tolsta
B895
Gress Church
Broad Bay
Tolsta Head
Trumpen Head

955 Beinn Mholach
A857
Back
Lews Castle
Stornoway
Old Kirk of Eye Knock
A866 Bayble
Portnaguran
Eye Peninsula
Achmore
A859
Crossbost
Cromore
Balallan
Arivruaich B8060
Gravir
Lemreway
Kebock Head

H E B R I D E S

Scarp
Loch Resort
Loch Langavat
NORTH HARRIS
2227
Hushinish
Forest of Harris
B887
2622 CLISHAM
Maaruig
1874 Beinn Mhor

Taransay
W. Loch Tarbert
A859
Tarbert
Scalpay
Shiant Islands

Toe Head
1105
A859
SOUTH HARRIS
Grosebay

Pabbay
Ensay
Leverburgh
Finsbay
Rodel
St. Clement's Church
Boreray Berneray
Vallay
RENISH POINT

Newtonferry
Tigharry 20½ Sollas A865
A865 .756
NORTH UIST
Bayhead
Barpa Langass
Lochmaddy

SEE PAGES 106-107

Monach Islands
Baleshare
A865
1139 EAVAL
BENBECULA
Balivanich Grimsay
Benbecula
Ronay
Creagorry
Wiay
Ardivachar
Sandwick
West Gerinish
Loch Druidibeg Lochskipport
A865
Stoneybridge
BEINN MHOR 2033
Ormaclett Castle
Mingary
SOUTH UIST
Daliburgh
Lochboisdale
Kilbride

O U T E R

T H E L I T T L E M I N C H

ULLAPOOL

SEE PAGES 96-97

610
Eriskay
Barra
Fuday Gighay
A888 Hellisay
Borve Cairn
Castlebay 1260
Kisimul Castle
Vatersay
Muldoanich
Sandray
Pabbay

Mingulay
Berneray

108

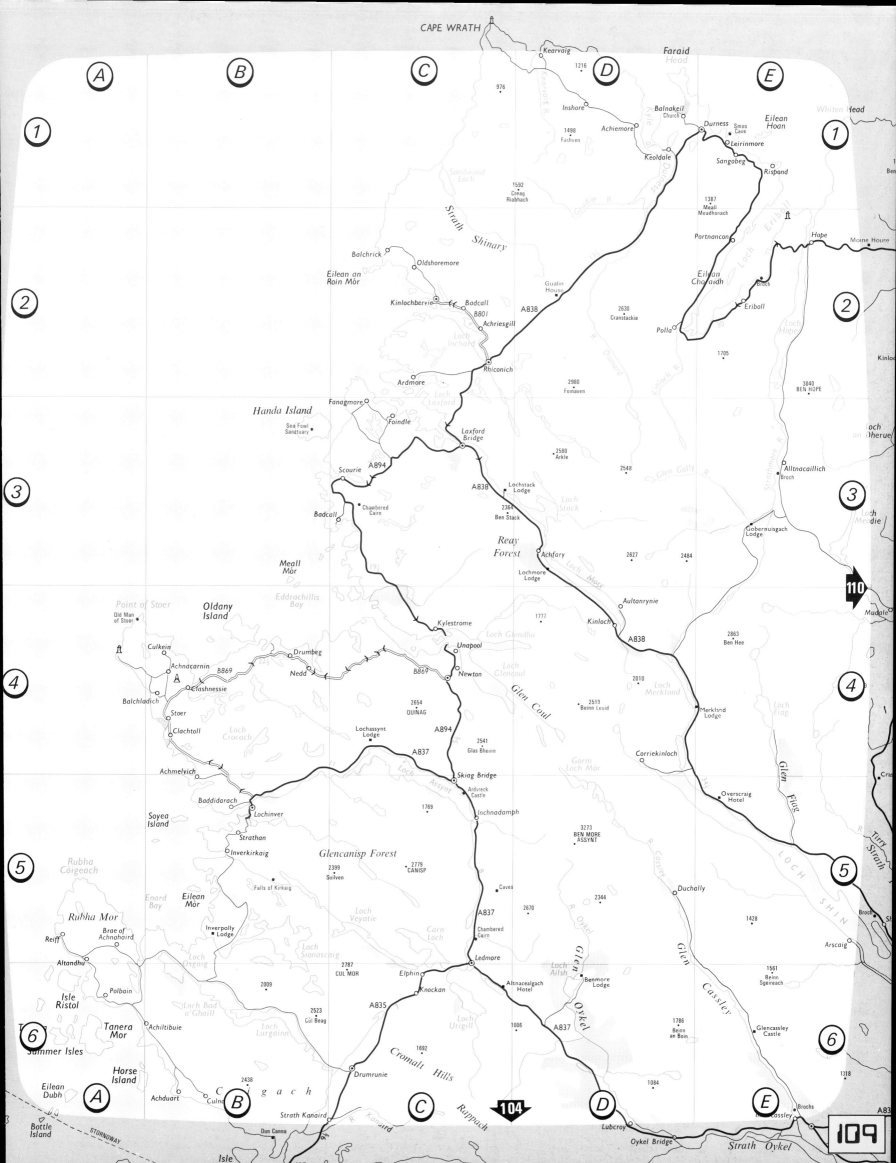

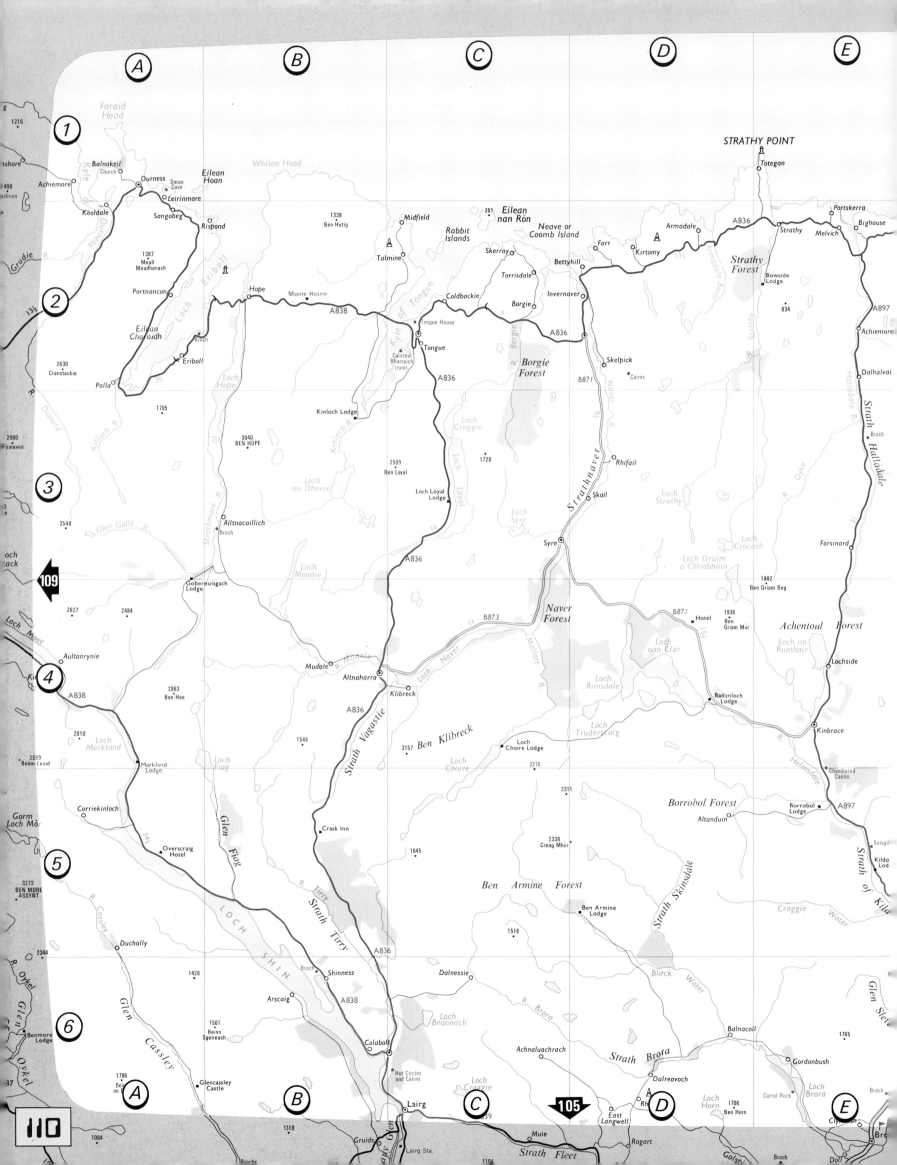

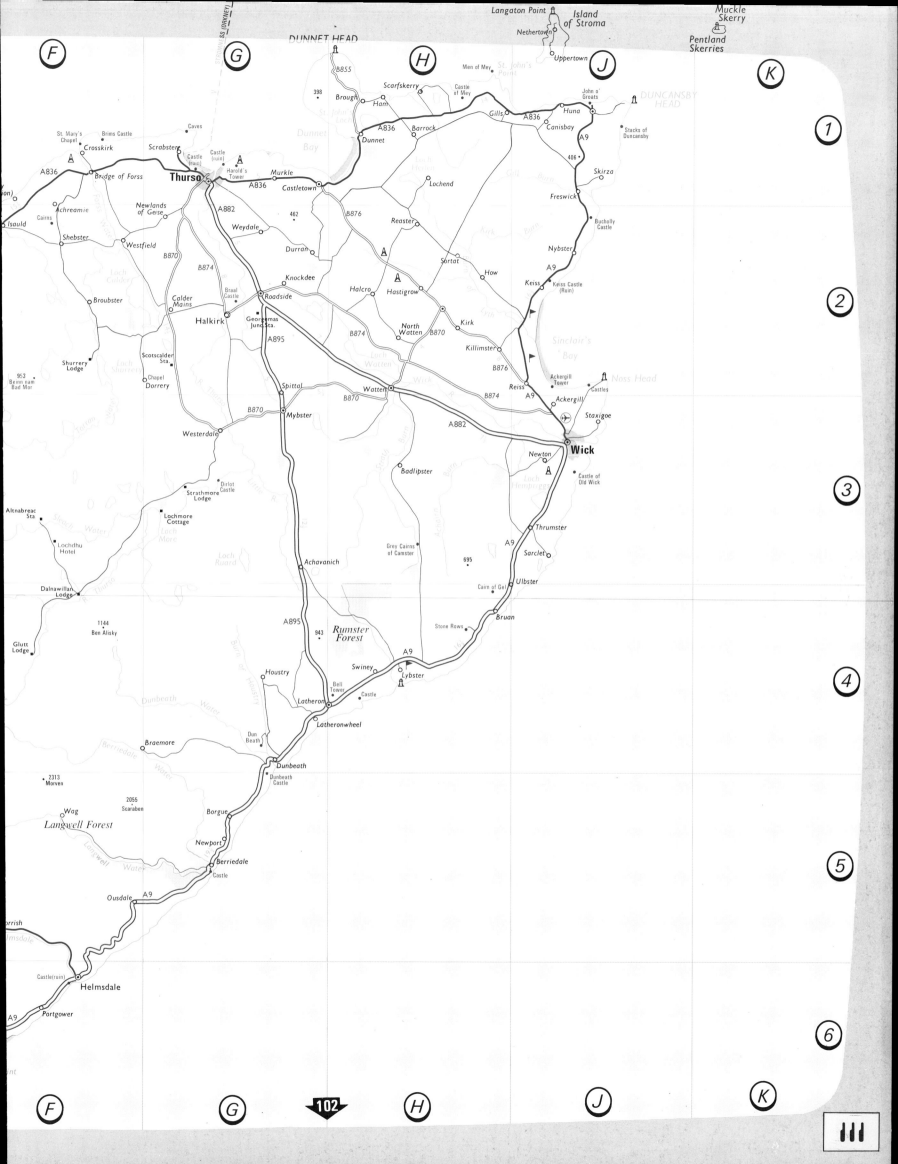

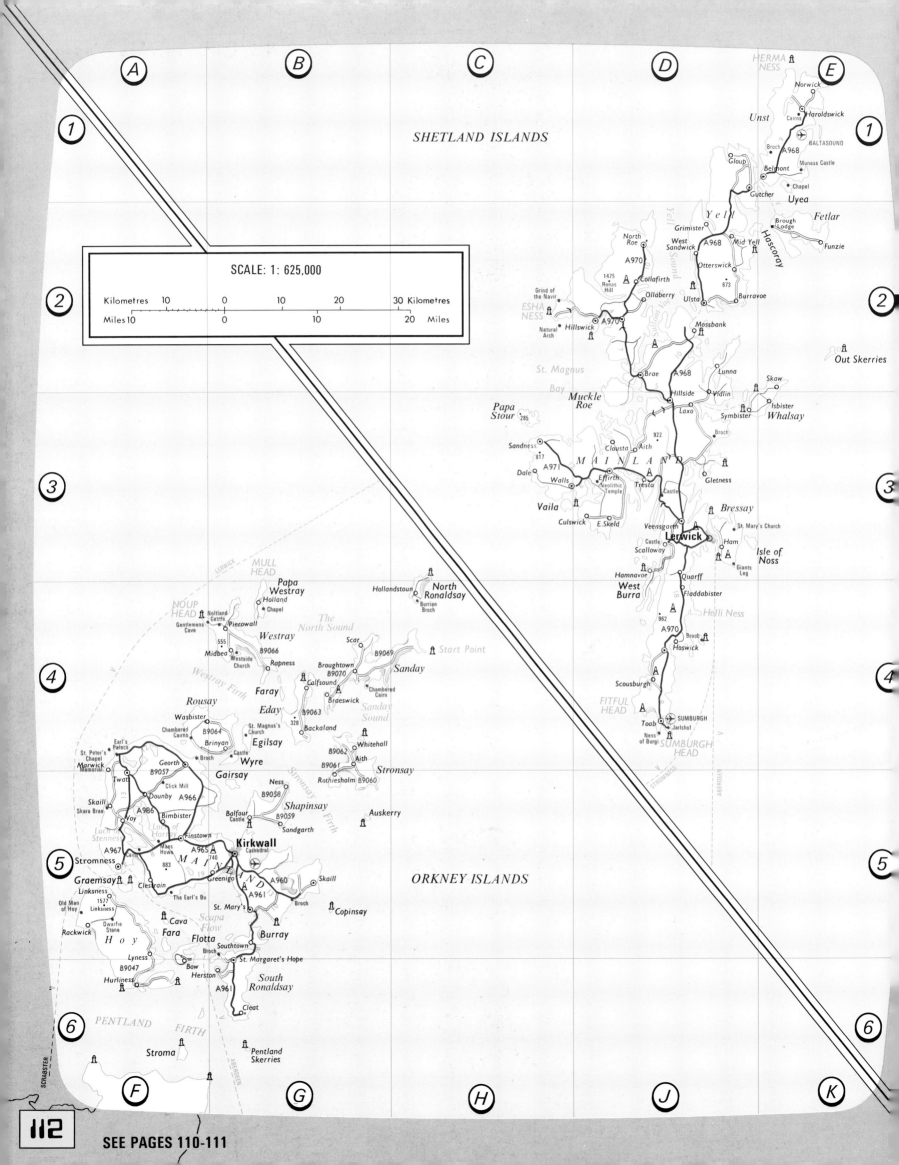

SHETLAND ISLANDS

Scale map (inset):
SCALE: 1: 625,000
Kilometres 10 — 0 — 10 — 20 — 30 Kilometres
Miles 10 — 0 — 10 — 20 Miles

A B C D E
1 2 3 4 5 6
F G H J K

Shetland Islands labels:

HERMA NESS
Norwick
Unst
Cairn — Haroldswick
Broch — A968 — BALTASOUND
Gloup — Belmont — Muness Castle
Chapel
Gutcher — Uyea
Grimister — Yell — Brough Lodge — Fetlar
North Roe — West Sandwick — A968 — Mid Yell — Hascoray
A970 — Otterswick — Funzie
1475 Ronas Hill — Collafirth — 673 — Burravoe
Grind of the Navir — Ollaberry — Ulsta
ESHA NESS — Natural Arch — A970 — Hillswick — Mossbank — Out Skerries
St. Magnus Bay — Brae — A968 — Lunna
Muckle Roe — Hillside — Vidlin — Skaw
Papa Stour — 285 — Laxo — Isbister
Sandness — Clousta — Aith — 922 — Symbister — Whalsay
817 — M A I N L A N D — Broch
Dale — A971 — Effirth — Tresta — Gletness
Walls — Neolithic Temple — Castle
Vaila — Bressay — St. Mary's Church
Culswick — E.Skeld — Veensgarth — Lerwick — Ham
Castle — Isle of Noss
Scalloway — Giants Leg
Hamnavoe — Quarff — Fladdabister
West Burra — Helli Ness
962 — A970 — Broch — Hoswick
Scousburgh
FITFUL HEAD — Toab — SUMBURGH — Jarlshof
Ness of Burgi — SUMBURGH HEAD

Orkney Islands labels:

LERWICK
MULL HEAD
Papa Westray — Holland — Chapel
NOUP HEAD — Noltland Castle — Pierowall
Gentlemens Cave — Hollandstoun — North Ronaldsay
555 — Westray — Burrian Broch
Midbea — B9066 — Westside Church — Rapness — Scar — Start Point
The North Sound
B9069
Westray Firth — Broughtown — B9070 — Sanday
Rousay — Faray — Calfsound — Chambered Cairn
Wasbister — Eday — Braeswick — Sanday Sound
Chambered Cairns — B9064 — B9063 — Backaland
Brinyan — 328 — St. Magnus's Church
St. Peter's Chapel — Earl's Palace — Egilsay — Whitehall
Marwick Memorial — Georth — Castle — Wyre — B9062 — Aith
B9057 — Broch — B9061 — Stronsay
Twatt — Gairsay — Rothiesholm — B9060
Skaill — Click Mill — Ness
Skara Brae — Dounby — A966 — B9058 — Auskerry
Voy — A986 — Bimbister — Shapinsay
Loch of Harray — Balfour Castle — B9059 — Sandgarth
A967 — Finstown — Maes Howe — 740 — Kirkwall — Cathedral
Stromness — 883 — M A I N L A N D — 19
Graemsay — Clestrain — Greenigo — A960 — Skaill
Linksness — Earl's Bu — A961 — Broch — Copinsay
Old Man of Hoy — 1577 — Linksness — St. Mary's
Dwarfie Stane — Cava — Fara — Flotta — Burray — ORKNEY ISLANDS
Rackwick — Hoy — Southtown
Lyness — Broch — St. Margaret's Hope
B9047 — Bow — Herston — South Ronaldsay
Hurliness — A961 — Cleat
PENTLAND FIRTH — Stroma — Pentland Skerries
Scapa Flow
SCRABSTER — ABERDEEN — STROMNESS

II2

SEE PAGES 110-111

KEY TO LOCAL INFORMATION


M56 ⊖⁸	MOTORWAY with JUNCTION
A56	PRIMARY THROUGH ROUTES
A572	'A' CLASS ROADS
	OTHER ROADS
	RAILWAY with STATION
	COACH/BUS STATION
	CAR PARK
i	TOURIST INFORMATION
G.P.O.	MAIN POST OFFICE
	POLICE
	COLLEGE/UNIVERSITY/MUNICIPAL BLDS
	CASTLE
	CATHEDRAL
	HOSPITAL
	INDUSTRIAL ESTATE

ABERDEEN (130)

DUNDEE (138)

GLASGOW (118-121)

EDINBURGH (139)

NEWCASTLE (145)

YORK (149)

KINGSTON -UPON- HULL (140)

BLACKPOOL (131)

BRADFORD (132)

LEEDS (142)

BLACKBURN (131)

MANCHESTER (122-125)

LIVERPOOL (144)

SHEFFIELD (150)

LINCOLN (141)

STOKE (152)

DERBY (138)

NOTTINGHAM (146)

LEICESTER (143)

NORWICH (141)

BIRMINGHAM (126-129)

COVENTRY (137)

CAMBRIDGE (134)

GLOUCESTER (135)

CHELTENHAM (135)

OXFORD (147)

SWANSEA (153)

CARDIFF (136)

BRISTOL (133)

READING (149)

LONDON (114-117)

CANTERBURY (134)

BATH (130)

SOUTHAMPTON (151)

PORTSMOUTH (148)

PLYMOUTH (147)

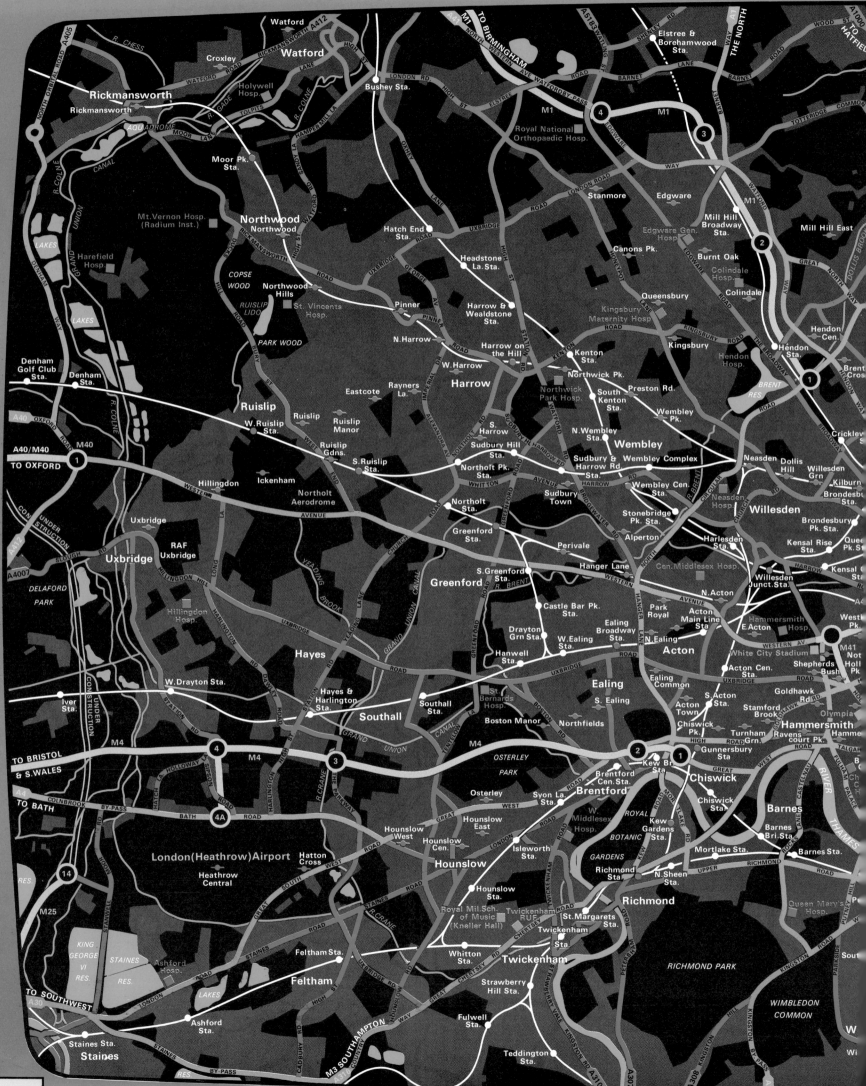

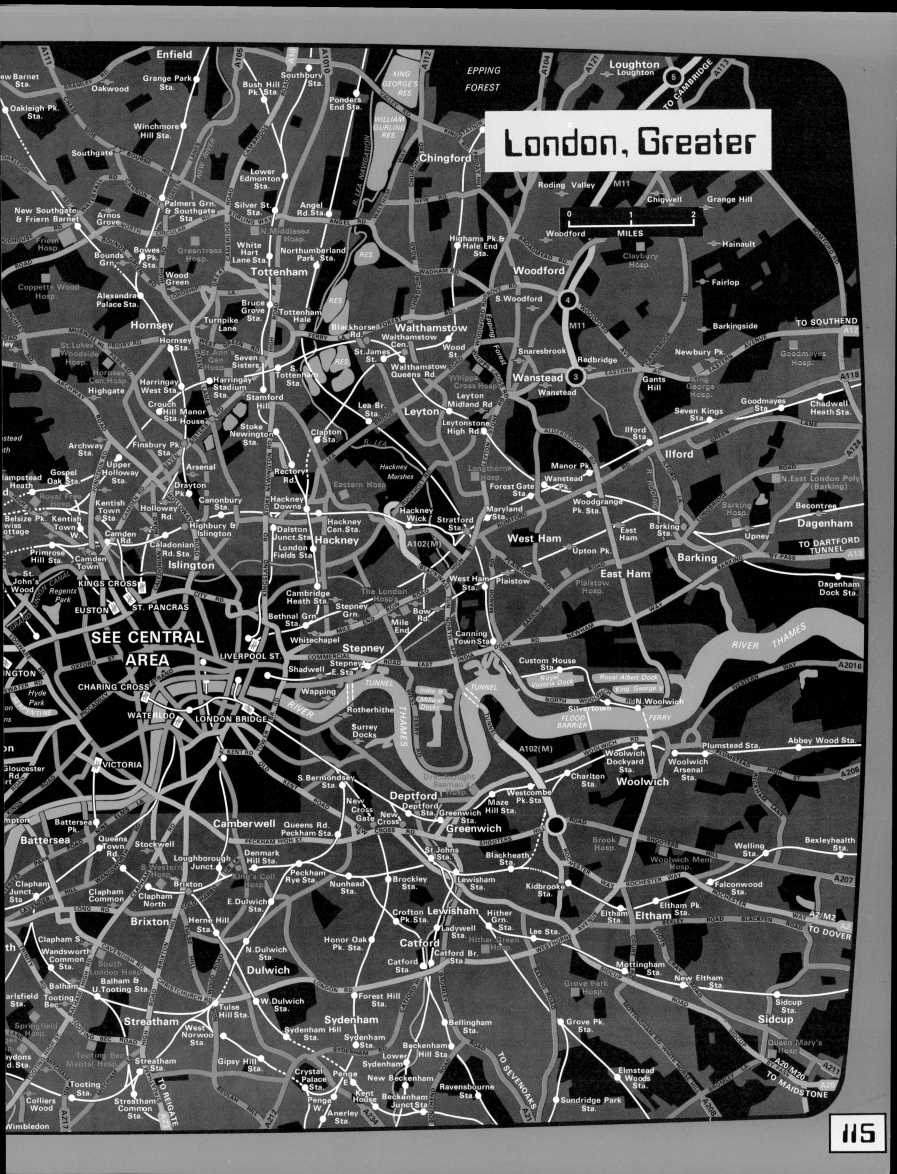

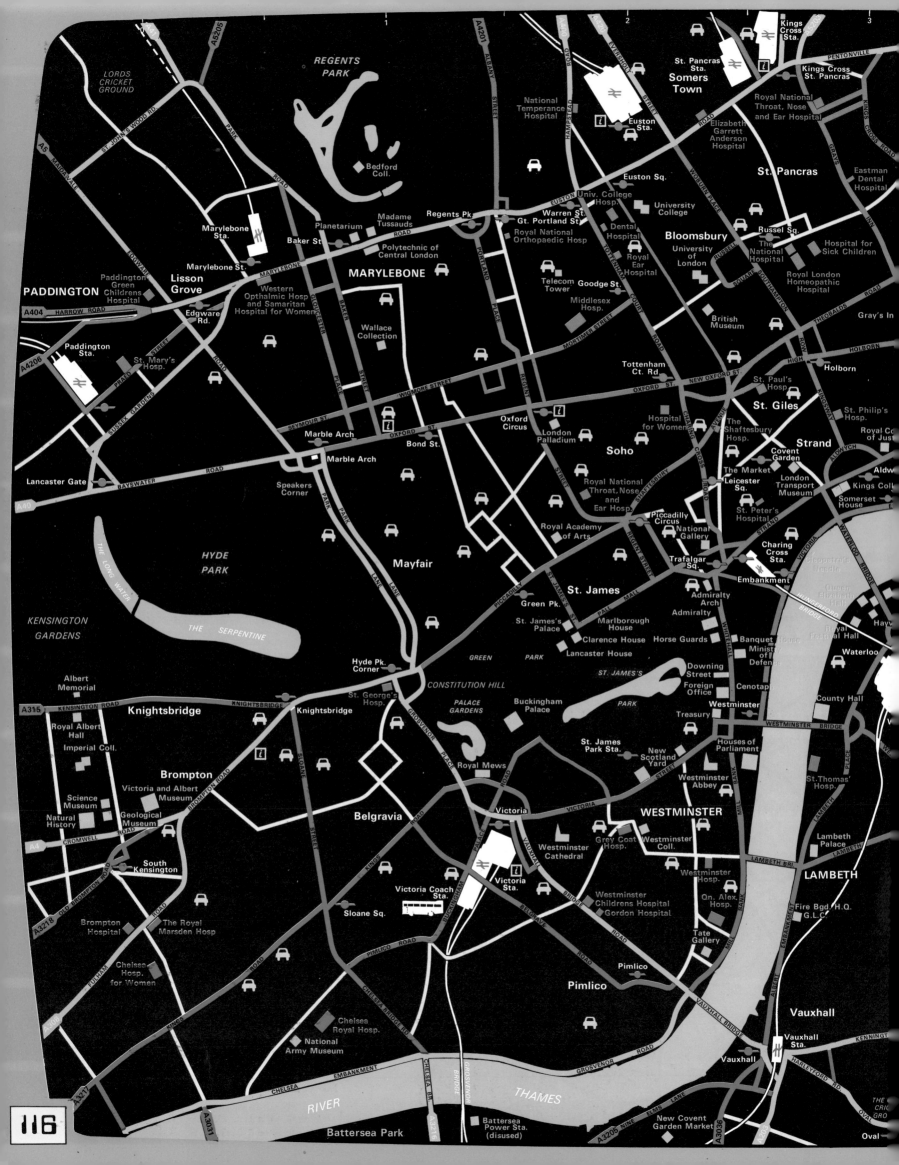

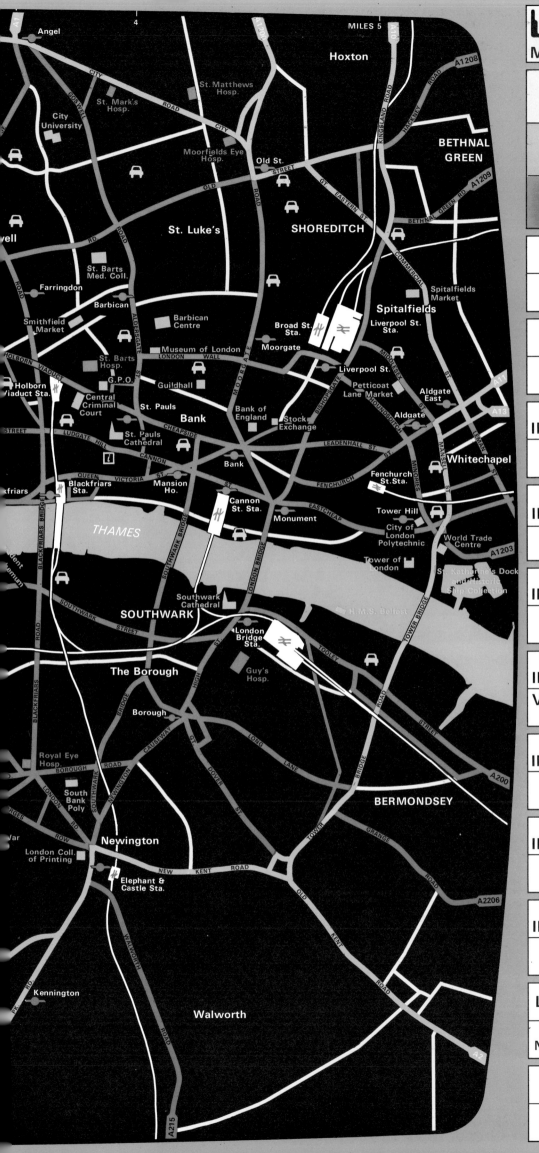

London, Central
Map No. 41

STD CODE	☎ 01
POLICE	☎ 230 1212
HOSPITAL	☎ 262-8011 Health Authorities 40 Eastbourne Terrace London W2 2QR

WEATHER SERVICE ☎ 246 8099

London Area

TRAVELINE ☎ 246 8021

70 miles around London

TOURIST INFORMATION ☎ 730-0791
Telephone Information Service
London Tourist Board

COUNCIL INFORMATION ☎ 633-500
Greater London Council, The County Hall, London

RAILWAY INFORMATION ☎ 246-8030
Daily summary of alterations to rail services to London

BUS/COACH INFORMATION ☎ 730-0202
Victoria Coach Station Ltd. 164, Buckingham Palace Road London SW1 WTP

AIRPORT INFORMATION
☎ 01-759 4321 Heathrow
☎ 0293 28822 Gatwick
☎ 0582 36061 Luton
☎ 0279 502380 Stansted

POSTAL INFORMATION ☎ 631-2345
Post Office Headquarters
23, Howland Street W.1.

UNIVERSITY INFORMATION ☎ 636-8000
University of London Senate House
Malet Street, London WC1E 7HU

LOCAL RADIO
BBC Radio 206m 1458 kHz
Capital Radio 194m 1548. kHz
London
News & Information 261m 1152 kHz VHF973 MHz

TV AREA
London weekdays - Thames TV
London weekends - LWT

117

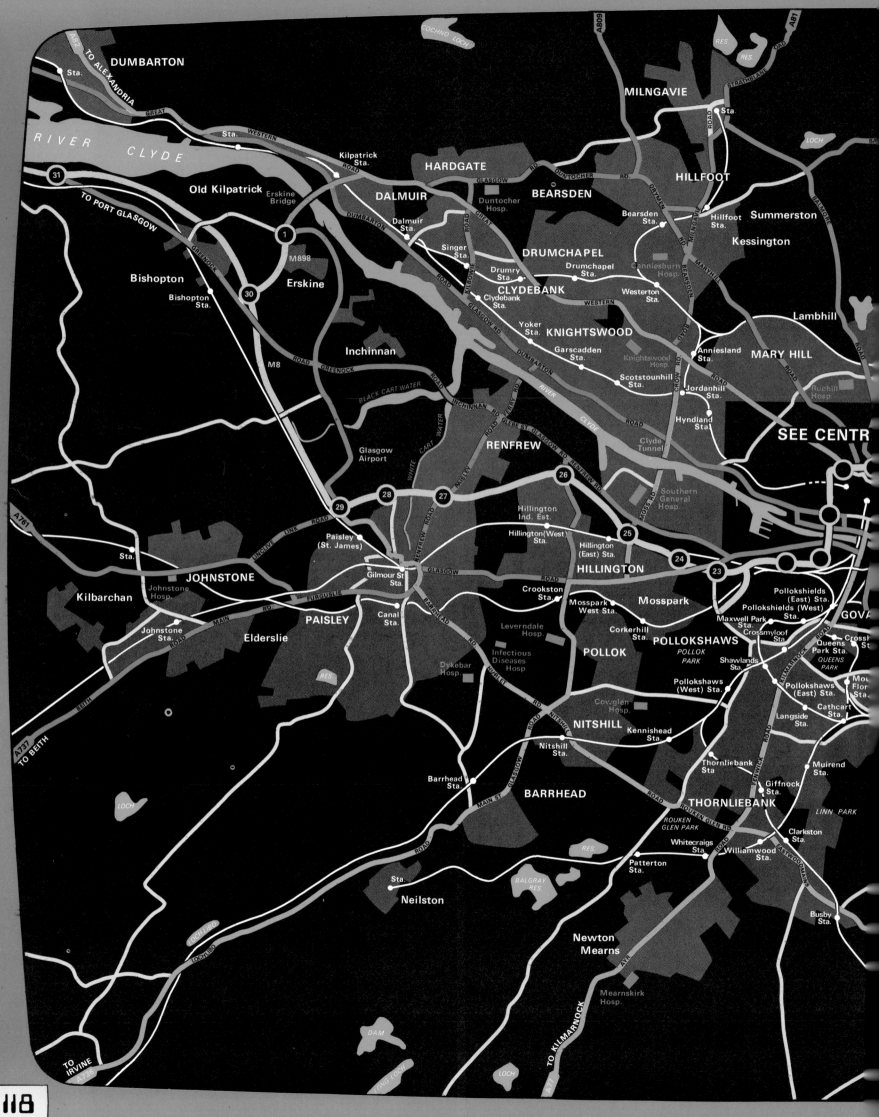

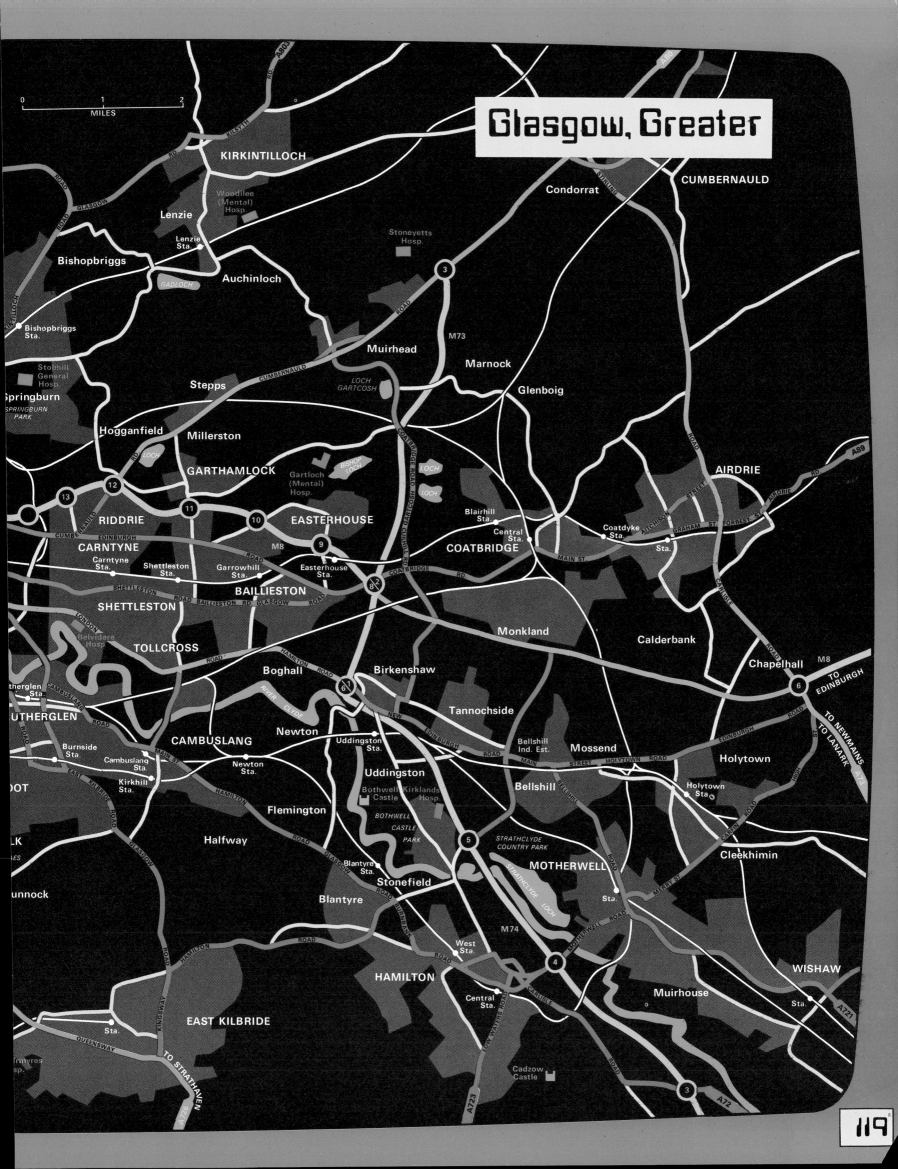

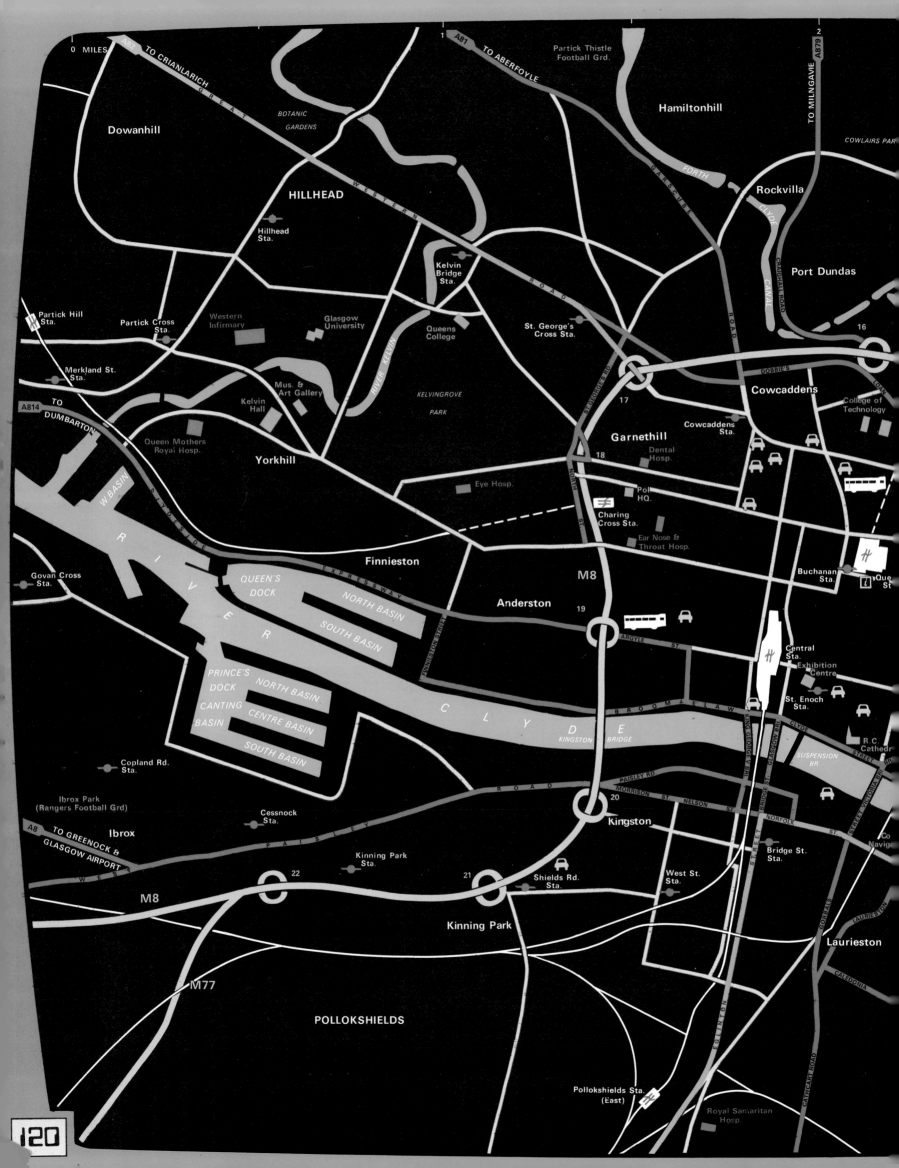

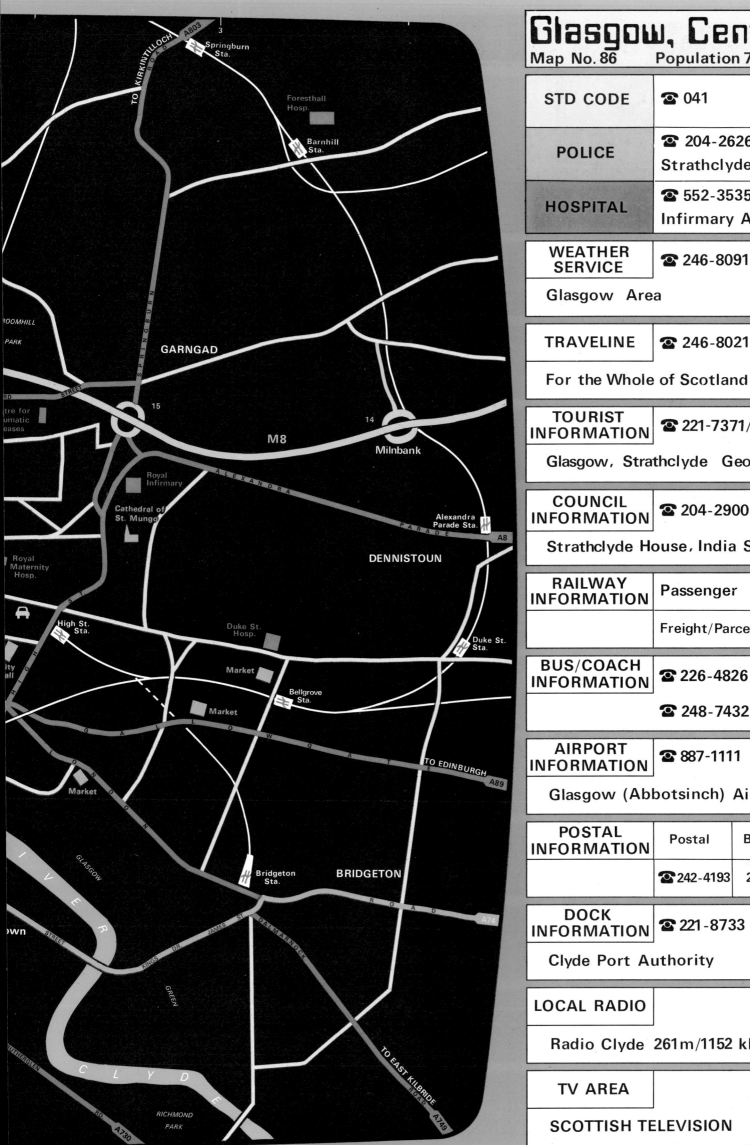

Glasgow, Central

Map No. 86 Population 790,000

STD CODE	☎ 041
POLICE	☎ 204-2626 Strathclyde Police HQ.
HOSPITAL	☎ 552-3535 Glasgow Royal Infirmary Accident & Emerg.

WEATHER SERVICE	☎ 246-8091
	Glasgow Area

TRAVELINE	☎ 246-8021
	For the Whole of Scotland

TOURIST INFORMATION	☎ 221-7371/2
	Glasgow, Strathclyde George Square

COUNCIL INFORMATION	☎ 204-2900
	Strathclyde House, India Street, Glasgow

RAILWAY INFORMATION	Passenger	204-2844
	Freight/Parcels	332-9811

BUS/COACH INFORMATION	☎ 226-4826 Buchanan St.
	☎ 248-7432 Anderson Cross

AIRPORT INFORMATION	☎ 887-1111
	Glasgow (Abbotsinch) Airport

POSTAL INFORMATION	Postal	Business	Postcode
	☎ 242-4193	242-4148	242-4159

DOCK INFORMATION	☎ 221-8733
	Clyde Port Authority

LOCAL RADIO	
	Radio Clyde 261m/1152 kHz VHF 95.1 MHz

TV AREA	
SCOTTISH TELEVISION	

121

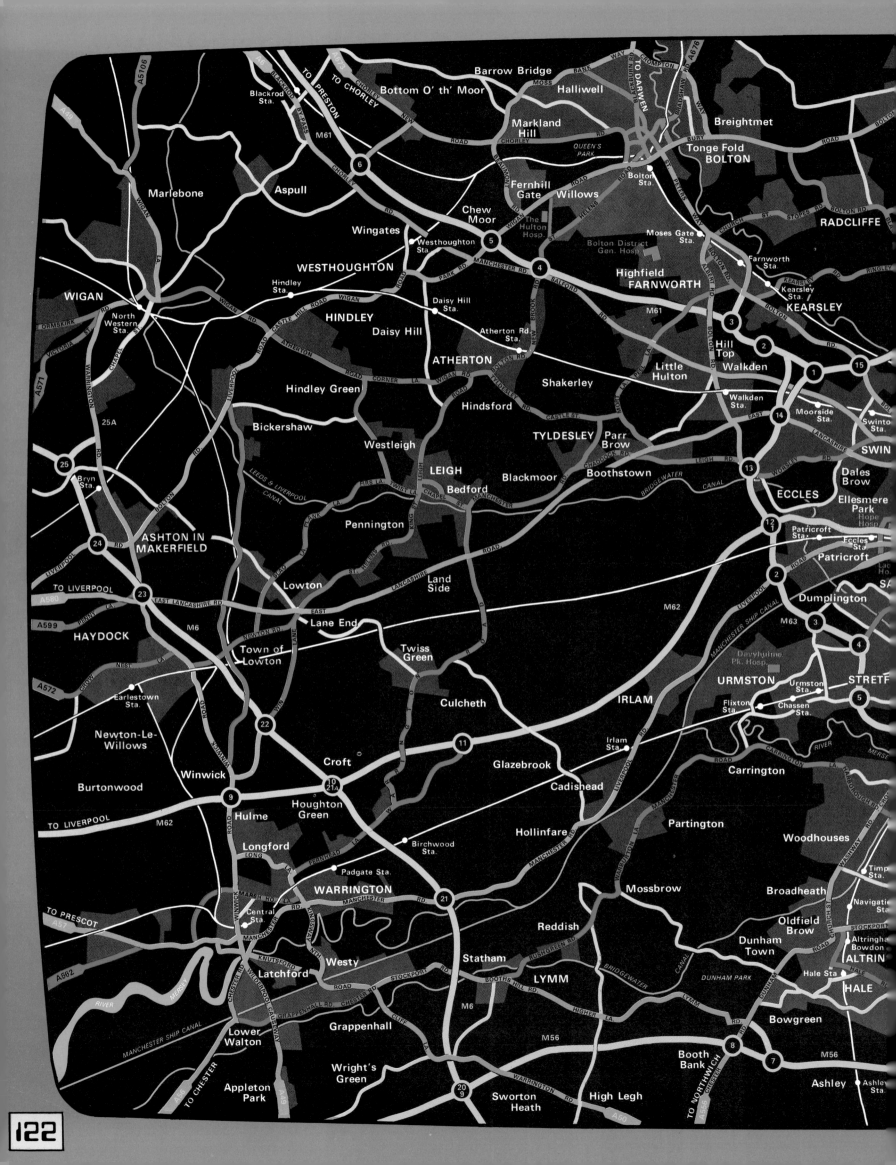

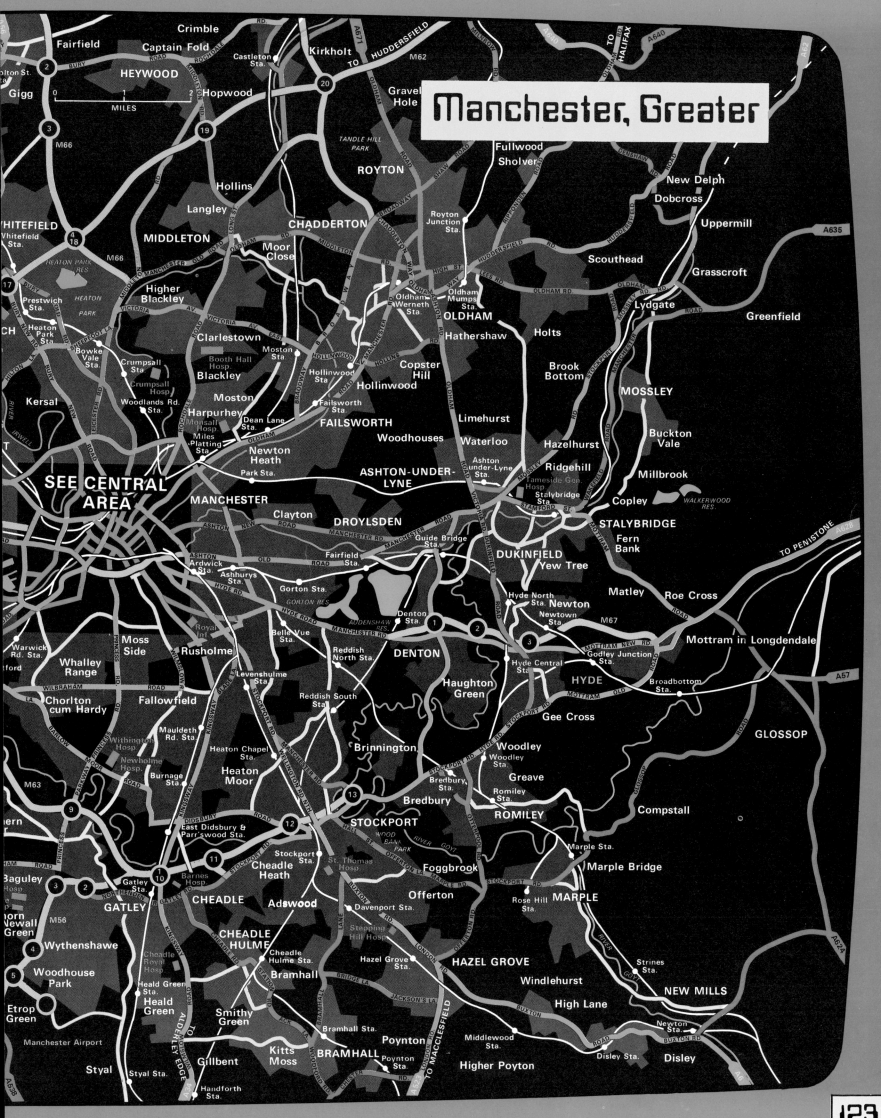

Manchester, Greater

Fairfield
Crimble
Captain Fold
Castleton Sta.
Kirkholt
Gravel Hole
Fullwood
Sholver
New Delph
Dobcross
Uppermill
Gigg
HEYWOOD
Hopwood
ROYTON
Scouthead
Grasscroft
MILES
Royton Junction Sta.
Lydgate
Greenfield
Hollins
CHADDERTON
WHITEFIELD
Langley
MIDDLETON
Moor Close
Holts
Whitefield Sta.
Oldham Werneth Sta.
Oldham Mumps Sta.
Higher Blackley
OLDHAM
Hathershaw
Brook Bottom
MOSSLEY
Prestwich Sta.
Clarlestown
Moston Sta.
Copster Hill
Buckton Vale
Bowker Vale Sta.
Crumpsall Sta.
Blackley
Hollinwood Sta.
Hollinwood
Limehurst
Millbrook
Kersal
Crumpsall Hosp.
Woodlands Rd. Sta.
Moston
Failsworth Sta.
Waterloo
Hazelhurst
Copley
Harpurhey
FAILSWORTH
Ashton under-Lyne Sta.
Ridgehill
Monsall Hosp.
Dean Lane Sta.
Woodhouses
Stalybridge Sta.
WALKERWOOD RES.
Miles Platting Sta.
Newton Heath
ASHTON-UNDER-LYNE
STALYBRIDGE
Park Sta.
Fern Bank
SEE CENTRAL AREA
MANCHESTER
Clayton
DROYLSDEN
Guide Bridge Sta.
DUKINFIELD
Yew Tree
Ardwick Sta.
Fairfield Sta.
Hyde North Sta.
Matley
Roe Cross
Ashbury Sta.
Gorton Sta.
Newton
Warwick Rd. Sta.
Moss Side
Rusholme
Belle Vue Sta.
Denton Sta.
Newtown Sta.
Mottram in Longdendale
Whalley Range
Reddish North Sta.
DENTON
Hyde Central Sta.
Godley Junction Sta.
Chorlton cum Hardy
Fallowfield
Levenshulme Sta.
Reddish South Sta.
Haughton Green
HYDE
Broadbottom Sta.
Mauldeth Rd. Sta.
Gee Cross
GLOSSOP
Withington Hosp.
Heaton Chapel Sta.
Brinnington
Woodley
Newholme Hosp.
Burnage Sta.
Heaton Moor
Woodley Sta.
Greave
Compstall
Bredbury Sta.
Romiley Sta.
East Didsbury & Parr'swood Sta.
Bredbury
ROMILEY
Marple Sta.
STOCKPORT
Cheadle Heath
Foggbrook
Marple Bridge
Baguley
Gatley Sta.
Stockport Sta.
St. Thomas' Hosp.
Offerton
MARPLE
GATLEY
CHEADLE
Adswood
Davenport Sta.
Rose Hill Sta.
Newall Green
Wythenshawe
CHEADLE HULME
Stepping Hill Hosp.
Strines Sta.
Woodhouse Park
Cheadle Royal Hosp.
Cheadle Hulme Sta.
Hazel Grove Sta.
HAZEL GROVE
Windlehurst
Etrop Green
Heald Green Sta.
Bramhall
NEW MILLS
Manchester Airport
Heald Green
Smithy Green
High Lane
Styal
Styal Sta.
Gillbent
Kitts Moss
BRAMHALL
Poynton
Middlewood Sta.
Newton Sta.
Disley
Handforth Sta.
Poynton Sta.
Higher Poynton
Disley Sta.

123

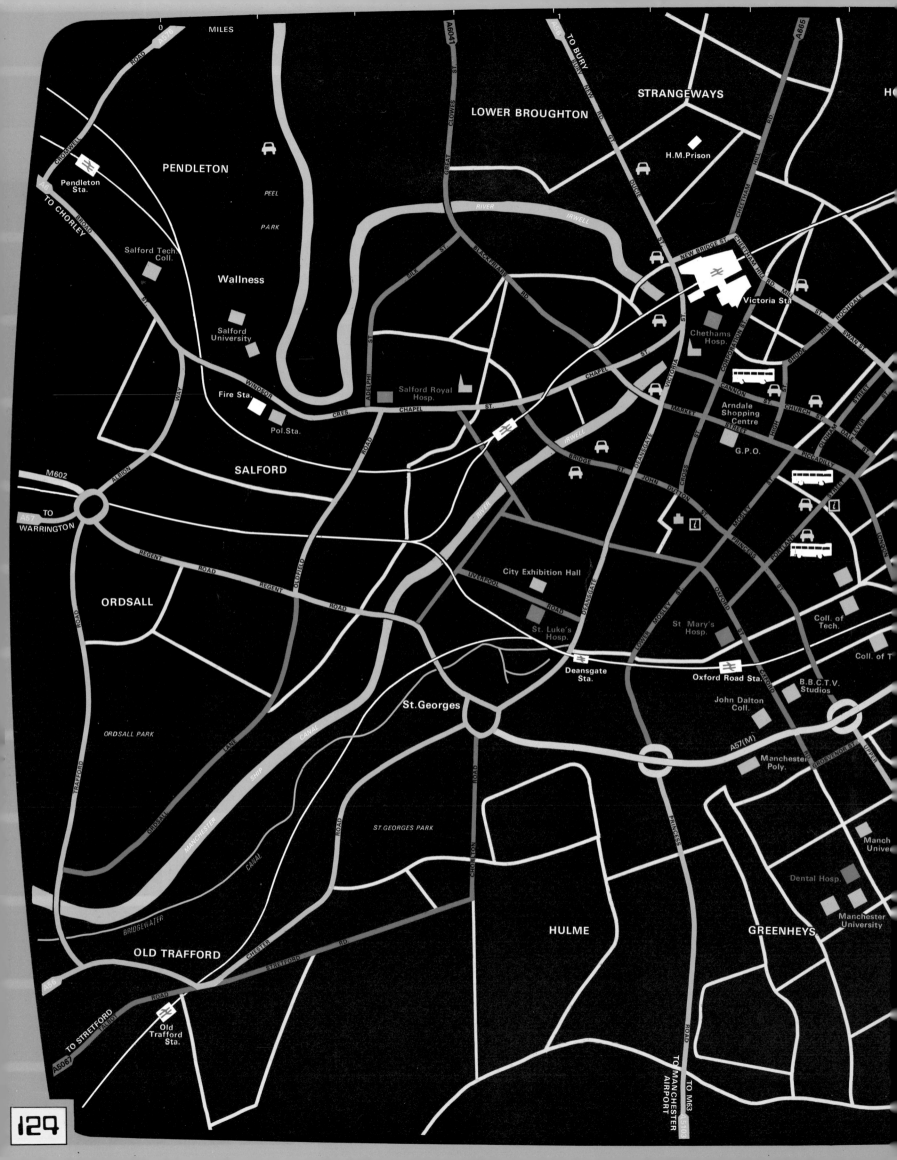

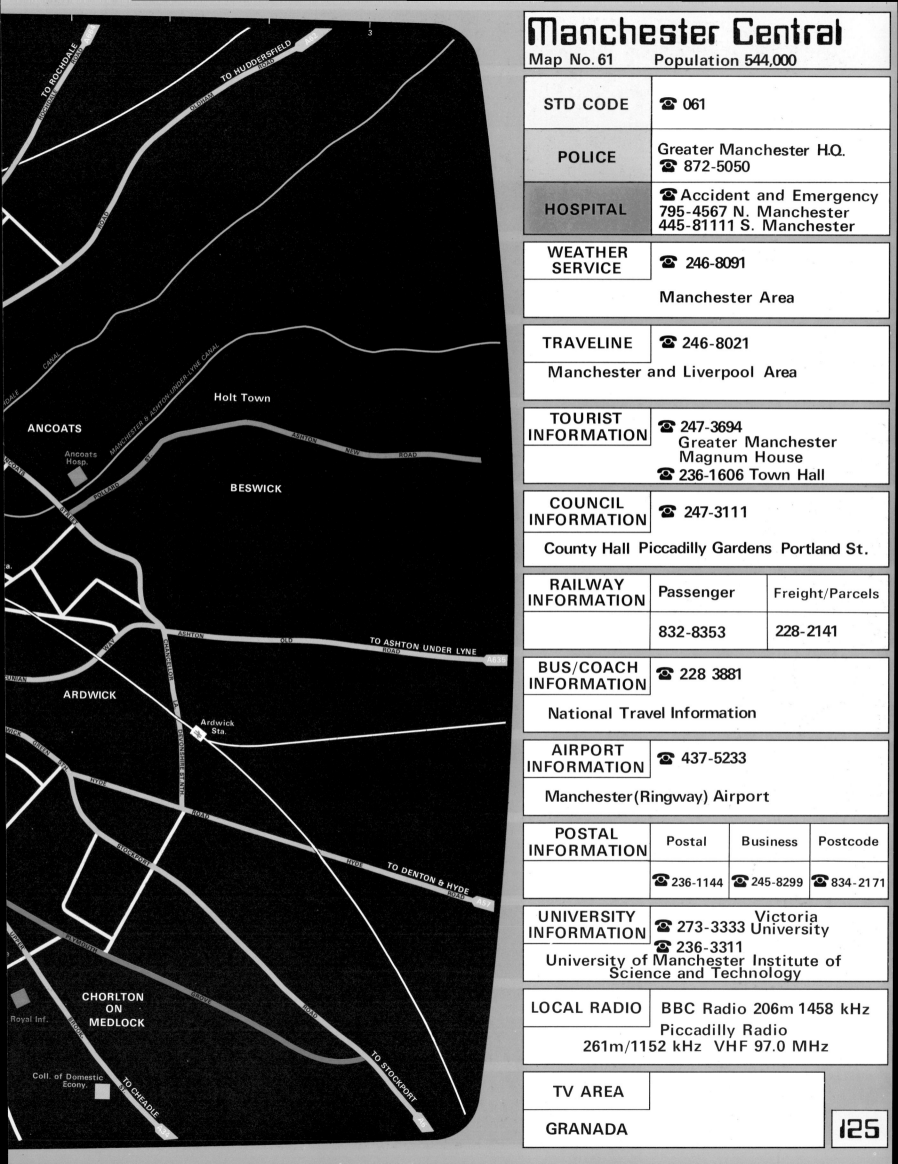

Manchester Central

Map No. 61 Population 544,000

STD CODE	☎ 061
POLICE	Greater Manchester H.Q. ☎ 872-5050
HOSPITAL	☎ Accident and Emergency 795-4567 N. Manchester 445-81111 S. Manchester
WEATHER SERVICE	☎ 246-8091 Manchester Area
TRAVELINE	☎ 246-8021 Manchester and Liverpool Area
TOURIST INFORMATION	☎ 247-3694 Greater Manchester Magnum House ☎ 236-1606 Town Hall
COUNCIL INFORMATION	☎ 247-3111 County Hall Piccadilly Gardens Portland St.

RAILWAY INFORMATION	Passenger	Freight/Parcels
	832-8353	228-2141

BUS/COACH INFORMATION	☎ 228 3881 National Travel Information
AIRPORT INFORMATION	☎ 437-5233 Manchester (Ringway) Airport

POSTAL INFORMATION	Postal	Business	Postcode
	☎ 236-1144	☎ 245-8299	☎ 834-2171

UNIVERSITY INFORMATION	☎ 273-3333 Victoria University ☎ 236-3311 University of Manchester Institute of Science and Technology
LOCAL RADIO	BBC Radio 206m 1458 kHz Piccadilly Radio 261m/1152 kHz VHF 97.0 MHz

TV AREA	
GRANADA	

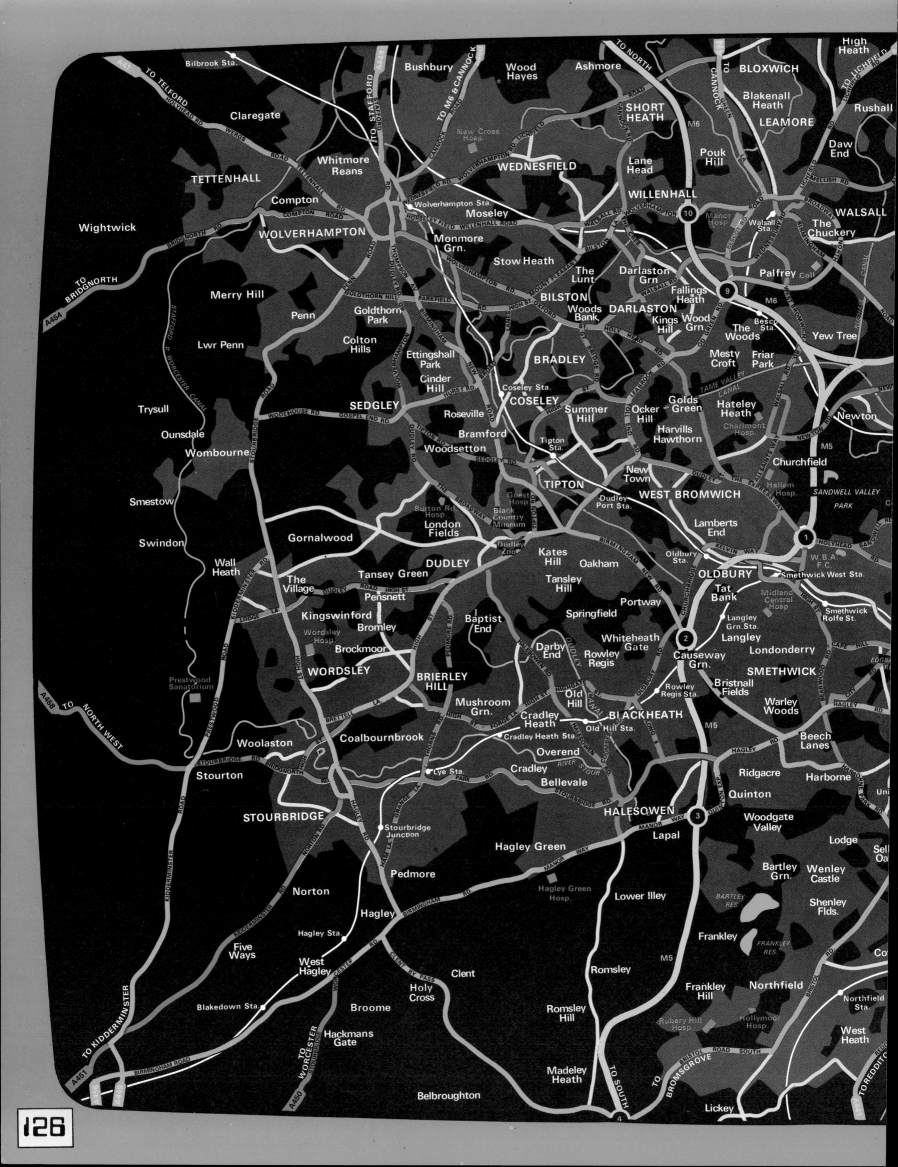

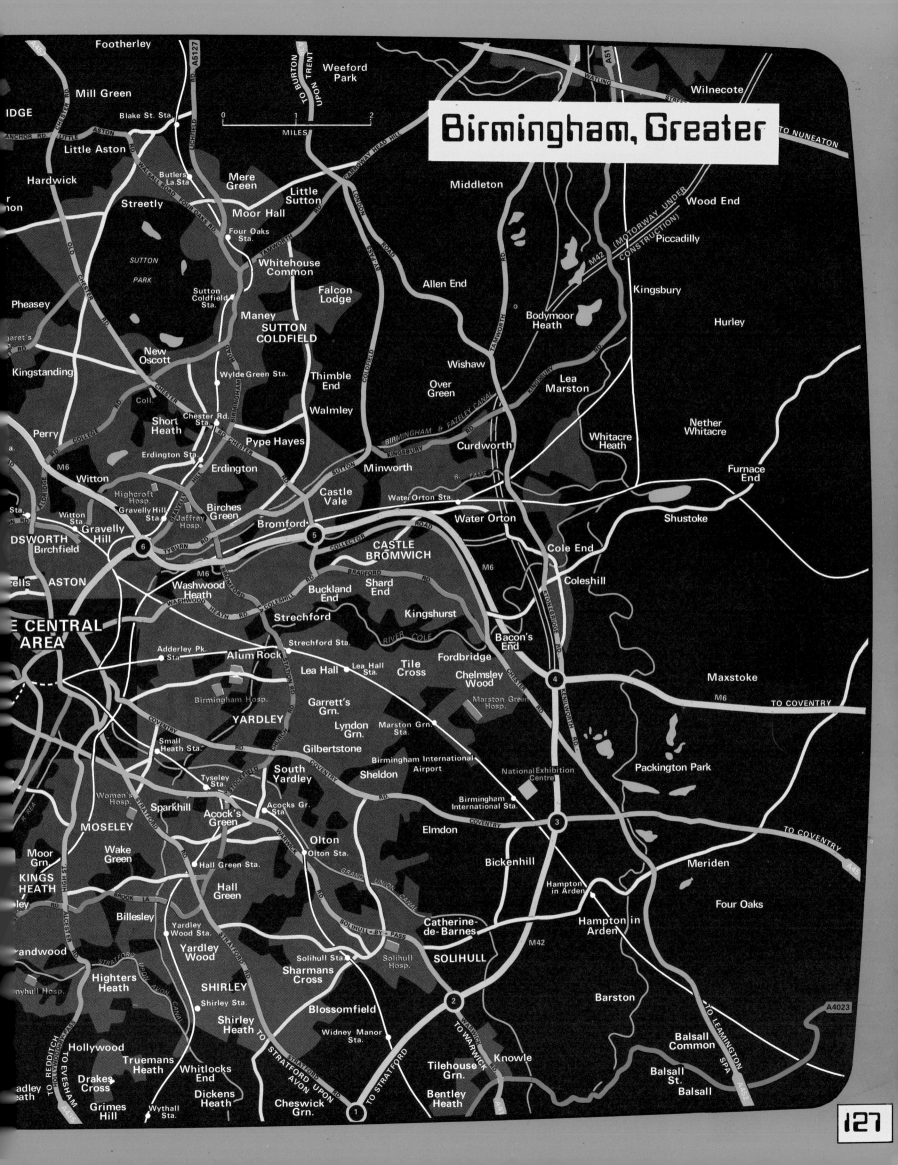

Birmingham, Greater

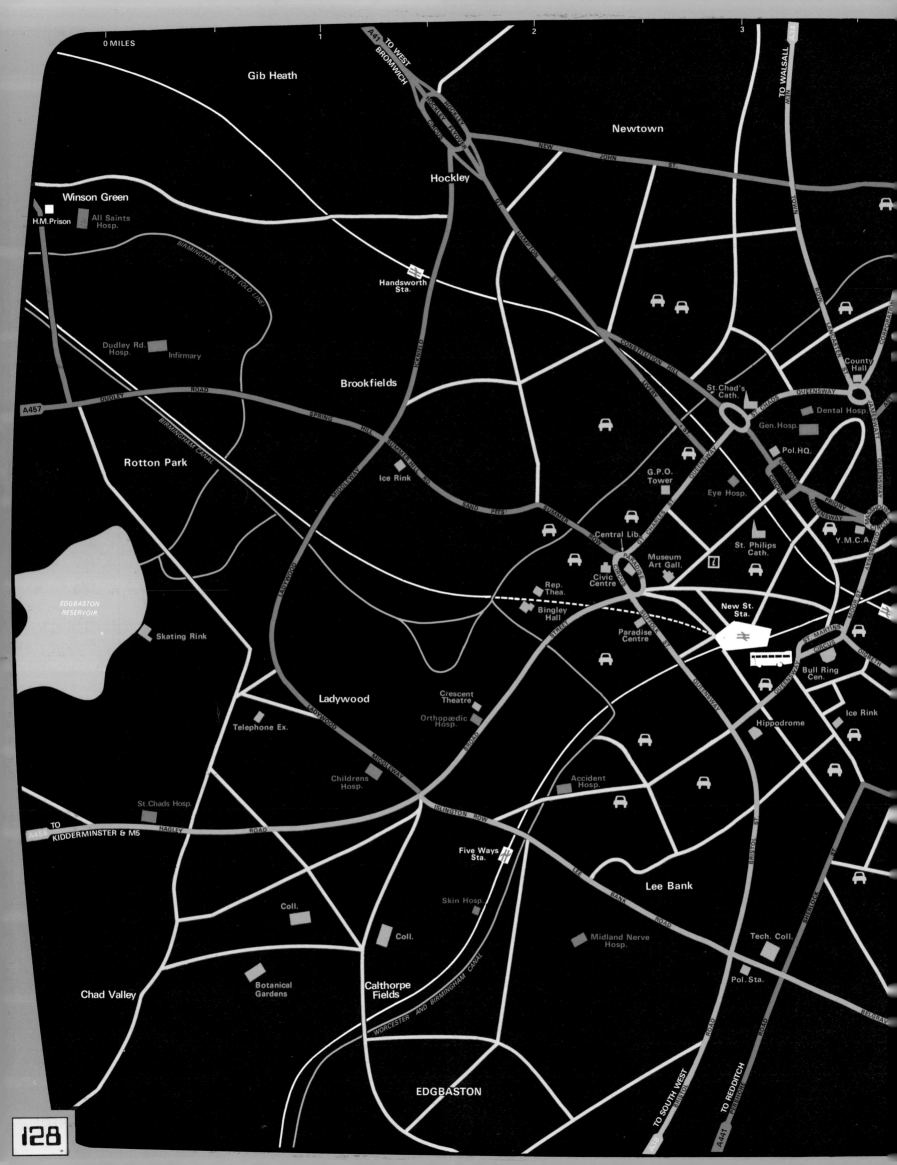

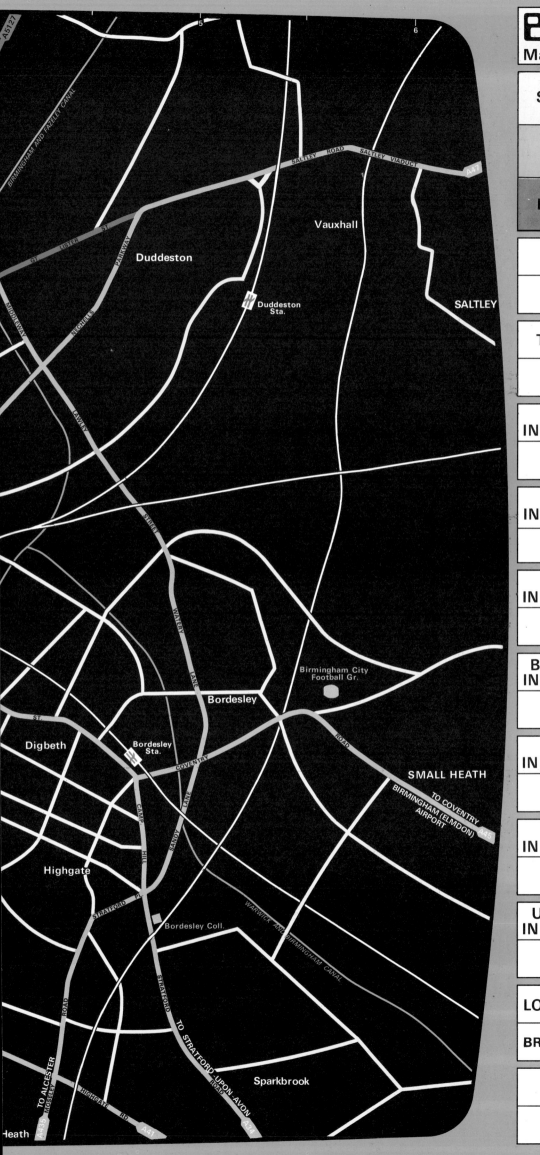

Birmingham, Central

Map No. 48 Population 1,008,000

STD CODE	☎ 021
POLICE	☎ 236-5000 Birmingham Police H.Q.
HOSPITAL	☎ 236-8611 General Hospital
WEATHER SERVICE	☎ 246-8091 Birmingham Area
TRAVELINE	☎ 246-8021 50 miles around Birmingham
TOURIST INFORMATION	☎ 235-3411 / 780-4141 National Exhibition Centre 110 Colmore Row
COUNCIL INFORMATION	☎ 235-3411 County Hall, Lancaster Circus. Queensway.

RAILWAY INFORMATION	Passengers	☎ 643-2711
	Freight/Parcels	☎ 643-1073

BUS/COACH INFORMATION	☎ 622-4373 Digbeth Coach Station
AIRPORT INFORMATION	☎ 743-4272 Birmingham Airport

POSTAL INFORMATION	Postal	Business	Postcodes
	☎ 262-4987	☎ 262-2257	☎ 643-1152

UNIVERSITY INFORMATION	☎ 359-3611 University of Aston ☎ 472-1301 University of Birmingham
LOCAL RADIO	BBC Radio 206m/1458 kHz BRMB Radio 261m/1152 kHz VHF 94.8 MHz
TV AREA	Central TV

129

Aberdeen, Grampian

Map No.101 **Population 210,000 E.C.Wed.**

WEATHER SERVICE	Aberdeen and Grampian ☎ 8091
TRAVELINE	Information for Scotland ☎ 031-246-8021
TOURIST INFORMATION	Broad Street, Aberdeen ☎ 632727
COUNCIL INFORMATION	Town House, Aberdeen ☎ 642121

RAILWAY INFORMATION	Passenger ☎ 594222	Freight/Parcels 586288

BUS/COACH INFORMATION	Guild Street, Aberdeen ☎ 596265
AIRPORT INFORMATION	Aberdeen (Dyce) Airport ☎ 722331
DOCKS INFORMATION	Aberdeen Harbour Board ☎ 592571

POSTAL INFORMATION	Postal ☎ 576141	Business Ext.210	Postcode Ext.227

LOCAL RADIO	North Sound 290m/1035kHz, VHF 96·9 MHz
INDEPENDENT TV AREA	GRAMPIAN

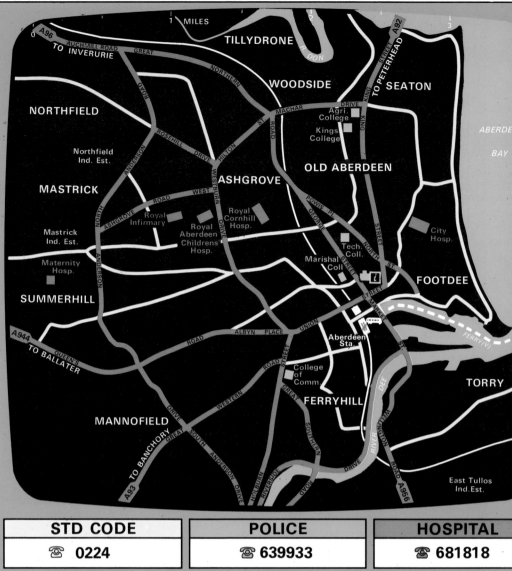

STD CODE	POLICE	HOSPITAL
☎ 0224	☎ 639933	☎ 681818

Bath, Avon

Map No. 32 **Population 84,000 E.C.Mon**

WEATHER SERVICE	Somerset and Avon ☎ 0272-8091
TRAVELINE	70 Miles Around Bristol ☎ 0272-8021
TOURIST INFORMATION	Abbey Churchyard, Bath ☎ 62831/60521
COUNCIL INFORMATION	Guildhall, Bath ☎ 61111

RAILWAY INFORMATION	Passenger ☎ 63075	Freight/Parcels 64151

BUS/COACH INFORMATION	Manvers Street, Bath ☎ 64446
AIRPORT INFORMATION	Bristol (Lulsgate) Airport ☎ 027587-4441
UNIVERSITY INFORMATION	University of Bath ☎ 61244

POSTAL INFORMATION	Postal ☎ 825266	Business 825264	Postcode 825217

LOCAL RADIO	BBC Radio - 194m/1548 kHz Radio West - 238m/1260 kHz VHF 96.3 MHz
TV AREA	HTV

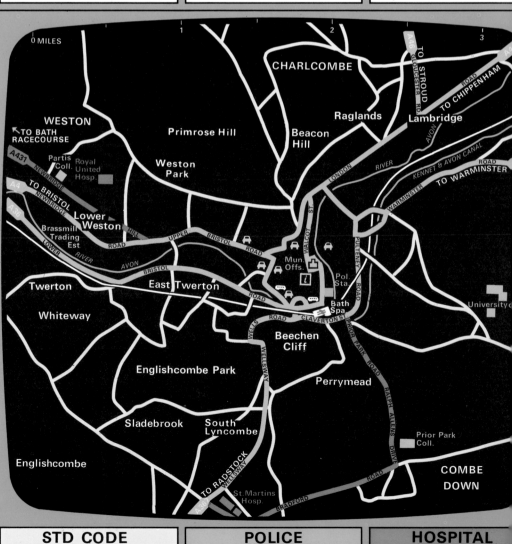

STD CODE	POLICE	HOSPITAL
☎ 0225	☎ 63451	☎ 28331

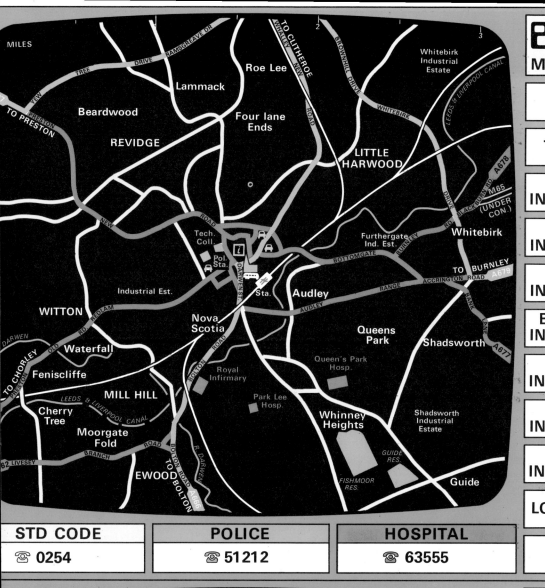

Blackburn, Lancashire

Map No.60 **Population 140,000 E.C.Thur.**

WEATHER SERVICE	North West England ☎ 8091
TRAVELINE	50 Miles Around Liverpool ☎ 061-246-8021
TOURIST INFORMATION	Town Hall, Blackburn ☎ 55201 Ext.214
COUNCIL INFORMATION	Town Hall, Blackburn ☎ 55201

RAILWAY INFORMATION	Passenger	Freight/Parcels
	☎ 662537	64944

BUS/COACH INFORMATION	Lower Way Road, Blackburn ☎ 51234
AIRPORT INFORMATION	Blackpool (Squires Gate) ☎ 0253-43061 Airport
COLLEGE INFORMATION	College of Tech Design ☎ 55144 Feildon Street

POSTAL INFORMATION	Postal	Business	Postcode
	☎ 59311	59311	59450

LOCAL RADIO	BBC Radio 351m/855 kHz
TV AREA	GRANADA

STD CODE	**POLICE**	**HOSPITAL**
☎ 0254	☎ 51212	☎ 63555

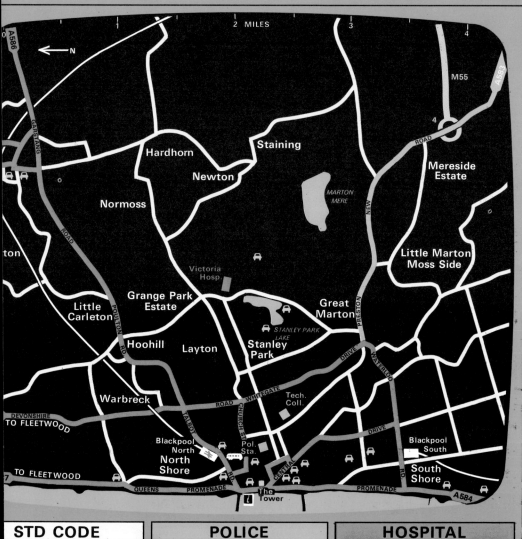

Blackpool, Lancashire

Map No.60 **Population 147,000 E.C.Wed.**

WEATHER SERVICE	North West England ☎ 0254-8091
TRAVELINE	50 Miles Around Liverpool ☎ 061-246-8021
TOURIST INFORMATION	Clifton Street, Blackpool ☎ 21623/25212
COUNCIL INFORMATION	Town Hall, Blackpool ☎ 25212

RAILWAY INFORMATION	Passenger	Freight/Parcels
	☎ 0772-59439	20389

BUS/COACH INFORMATION	Coliseum, Blackpool ☎ 20051
AIRPORT INFORMATION	Blackpool (Squires Gate) ☎ 43061 Airport
BLACKPOOL TOWER	Tower Buildings & Circus ☎ 27786 Promenade

POSTAL INFORMATION	Postal	Business	Postcode
	☎ 22244	22244	22244/234

LOCAL RADIO	BBC Radio 351m/855kHz Red Rose Radio 301m/999kHz VHF 97.3 MHz

STD CODE	**POLICE**	**HOSPITAL**	**TV AREA**	GRANADA	**131**
☎ 0253	☎ 293933	☎ 34111			

STD CODE	POLICE	HOSPITAL
☎ 0274	☎ 723422	☎ 42200

Map of Bradford, West Yorkshire

Locations shown: Cottingley, SHIPLEY, Wrose, IDLE, Thackley, Thorpe, Greengates, CALVERLEY, Bank Top, Eccleshill, Ravenscliffe, Frizinghall, Stoney Ridge Hosp., Isolation Hosp., New Brighton, Heaton, Bolton, Moor Side, Fagley, Caverley Hosp., Daisy Hill, LAKE, Heaton Res., Childs. Hosp., Undercliffe, Royal Infirmary, Waddiloves Hosp., Manningham, Wapping, Fairweather Green, Allerton, Birks, Lister Hills, Forster Sq. Sta., Leeds Road Hosp., University of Bradford, Pol. H.Q., City Hall, Exchange Sta., Laisterdyke, Scholemoor, Tech. Coll., Thornton, Searbridge, McMillan Coll., Pol. H.Q., Tyersal, Clayton, Dirk Hill, Morley, St. Luke's Hosp., Broomfields, Bowling, Tyersal Gate, Great Horton, Little Horton, West Bowling, Dudley Hill, Thornton View Hosp., Wibsey, Staygate, The Park Hosp., Newhall, Tong Street, Scarlet Heights, Westwood Hosp., Slack Side, Truncliffe, Northern View Hosp., Odsal Top, Bierley Hall Hosp., QUEENSBURY, Ambler, Buttershaw, Beck Hill, M606, East Bierley, Birkenshaw, Westgate Hill

WEATHER SERVICE	West Yorkshire ☎ 8091	**BUS/COACH INFORMATION**	Metro Travel Interchange, Bradford ☎ 728731
TRAVELINE	South and West Yorkshire ☎ 8021	**AIRPORT INFORMATION**	Leeds/Bradford (Yeadon) Airport ☎ 0532-503431
TOURIST INFORMATION	City Hall, Bradford ☎ 752111 Ext.425	**UNIVERSITY INFORMATION**	University of Bradford ☎ 733466
COUNCIL INFORMATION	City Hall, Bradford ☎ 752111	**CATHEDRAL INFORMATION**	Bradford Cathedral, Church Bank ☎ 728955　　　　　Brad

	Passenger	Freight/Parcels		Postal	Business	Postcode
RAILWAY INFORMATION	☎ 733994	☎ 723151/392660	**POSTAL INFORMATION**	☎ 394466	☎ 394466	☎ 394466

132	**TV AREA**	YORKSHIRE	**LOCAL RADIO**	Pennine Radio 253m/1278kHz VHF 96.0M

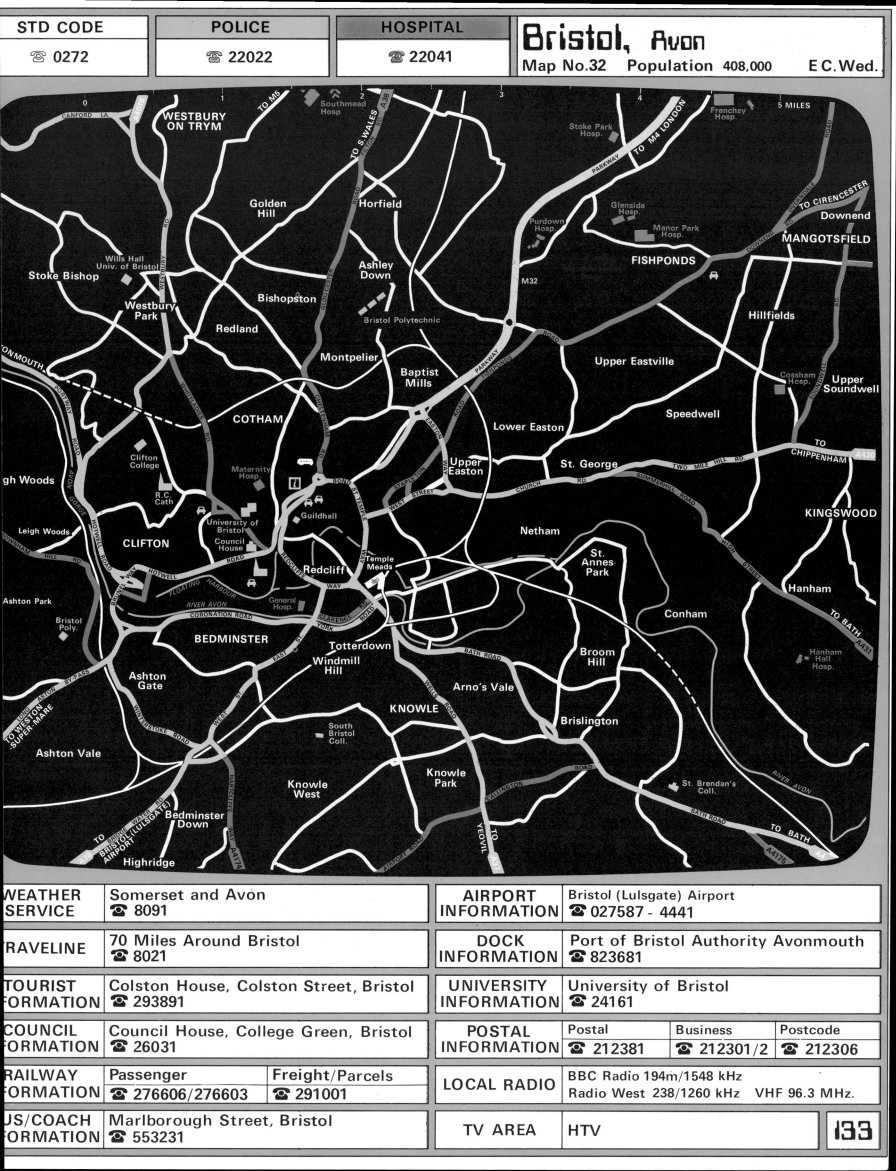

STD CODE	POLICE	HOSPITAL	Bristol, Avon
☎ 0272	☎ 22022	☎ 22041	Map No.32 Population 408,000 E C. Wed.

WEATHER SERVICE	Somerset and Avon ☎ 8091	AIRPORT INFORMATION	Bristol (Lulsgate) Airport ☎ 027587 - 4441
TRAVELINE	70 Miles Around Bristol ☎ 8021	DOCK INFORMATION	Port of Bristol Authority Avonmouth ☎ 823681
TOURIST INFORMATION	Colston House, Colston Street, Bristol ☎ 293891	UNIVERSITY INFORMATION	University of Bristol ☎ 24161

COUNCIL INFORMATION	Council House, College Green, Bristol ☎ 26031	POSTAL INFORMATION	Postal ☎ 212381	Business ☎ 212301/2	Postcode ☎ 212306

RAILWAY INFORMATION	Passenger ☎ 276606/276603	Freight/Parcels ☎ 291001	LOCAL RADIO	BBC Radio 194m/1548 kHz Radio West 238/1260 kHz VHF 96.3 MHz.

BUS/COACH INFORMATION	Marlborough Street, Bristol ☎ 553231	TV AREA	HTV	133

Cambridge, Cambridgeshire

Map No. 42 Population 105,000 E.C.Thur.

WEATHER SERVICE	East Anglia ☎ 0473-8091
TRAVELINE	70 Miles Around London ☎ 01-246-8021
TOURIST INFORMATION	Wheeler Street, Cambridge ☎ 358977 Sat/Sun 353363
COUNCIL INFORMATION	The Guildhall, Cambridge ☎ 358977

RAILWAY INFORMATION	Passenger	Freight/Parcels
	☎ 311999	358800

BUS/COACH INFORMATION	Victoria Coach Sta. Camb. ☎ 355554
AIRPORT INFORMATION	Cambridge Airport ☎ 61133 (Teversham)
UNIVERSITY INFORMATION	University of Cambridge ☎ 358933

POSTAL INFORMATION	Postal	Business	Postcode
	☎ 51212	51212/231	67851

LOCAL RADIO	BBC Radio 207m/1449 kHz
TV AREA	ANGLIA

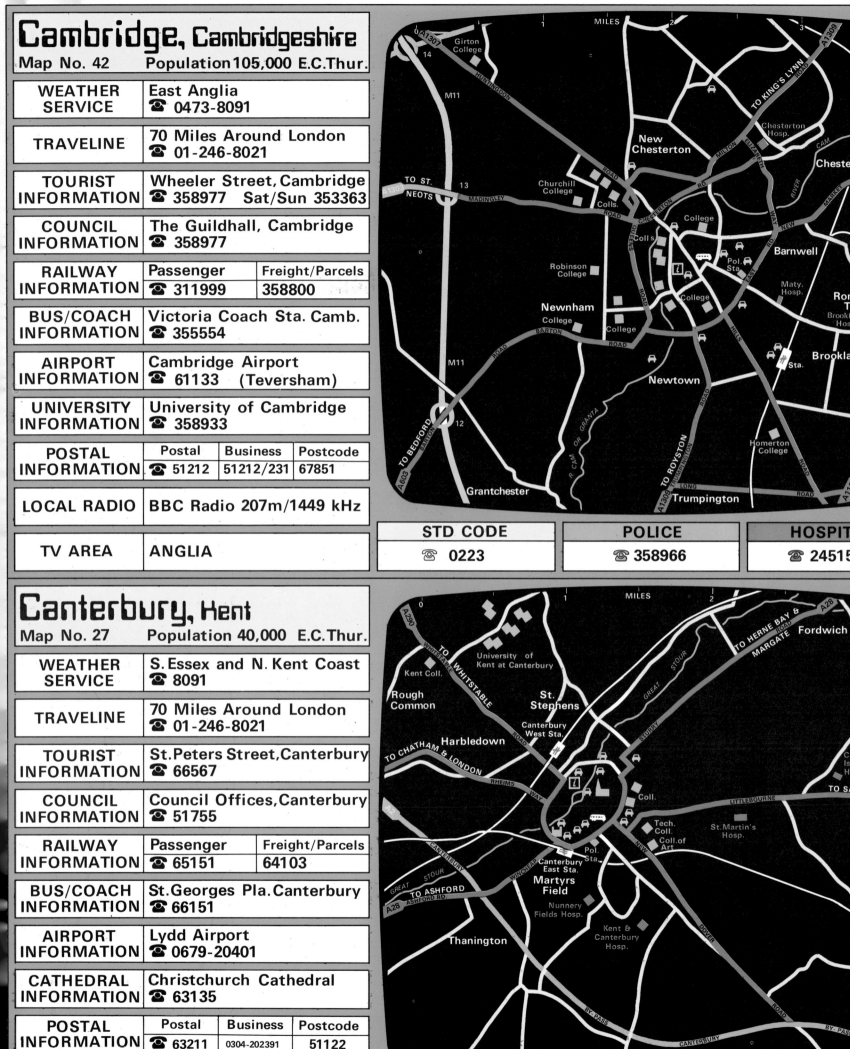

STD CODE	POLICE	HOSPITAL
☎ 0223	☎ 358966	☎ 245151

Canterbury, Kent

Map No. 27 Population 40,000 E.C.Thur.

WEATHER SERVICE	S. Essex and N. Kent Coast ☎ 8091
TRAVELINE	70 Miles Around London ☎ 01-246-8021
TOURIST INFORMATION	St. Peters Street, Canterbury ☎ 66567
COUNCIL INFORMATION	Council Offices, Canterbury ☎ 51755

RAILWAY INFORMATION	Passenger	Freight/Parcels
	☎ 65151	64103

BUS/COACH INFORMATION	St. Georges Pla. Canterbury ☎ 66151
AIRPORT INFORMATION	Lydd Airport ☎ 0679-20401
CATHEDRAL INFORMATION	Christchurch Cathedral ☎ 63135

POSTAL INFORMATION	Postal	Business	Postcode
	☎ 63211	0304-202391	51122

LOCAL RADIO	Radio Medway
TV AREA	TVS

134

STD CODE	POLICE	HOSPITAL
☎ 0227	☎ 55444	☎ 66877

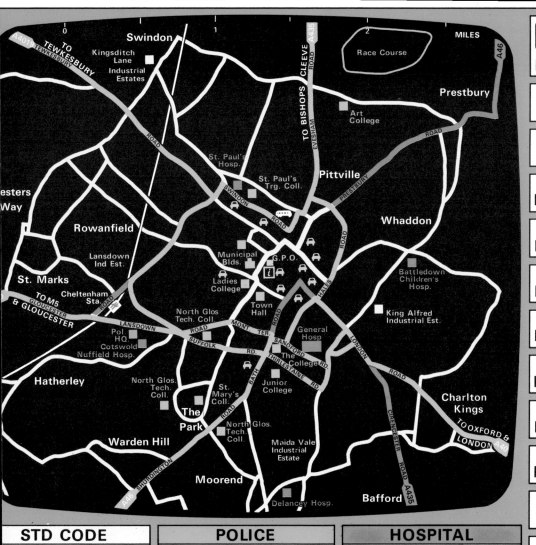

Cheltenham, Gloucester.

Map No. 39 Population 87,000 E.C.Wed.

WEATHER SERVICE	South West Midlands ☎ 8091
TRAVELINE	70 Miles Around Bristol ☎ 8021
TOURIST INFORMATION	The Promenade, Cheltenham ☎ 522878
COUNCIL INFORMATION	Municipal Offices, Chelt. ☎ 521333

RAILWAY INFORMATION	Passenger	Freight/Parcels
	☎ 0452-29501	0452 21121

BUS/COACH INFORMATION	St Margarets Road, Chelt. ☎ 584111
AIRPORT INFORMATION	Gloucester/Cheltenham ☎ 0452-713481 (Staverton)
COLLEGE INFORMATION	College of St. Paul St. Mary ☎ 513836

POSTAL INFORMATION	Postal	Business	Postcode
	☎ 0452-423761	0452-28588	0452-416094

LOCAL RADIO	Severn 388m/774 kHz Sound VHF 95.0 MHz
TV AREA	CENTRAL

STD CODE	**POLICE**	**HOSPITAL**
☎ 0242	☎ 528282	☎ 580344

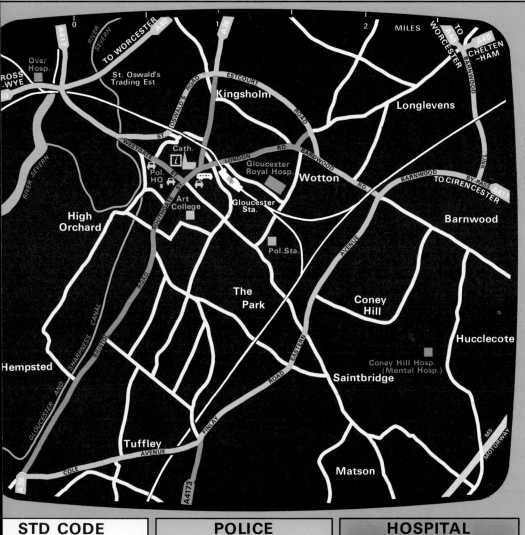

Gloucester, Gloucestershire

Map No. 39 Population 92,000 E.C.Thur.

WEATHER SERVICE	South West Midlands ☎ 8091
TRAVELINE	70 Miles Around Bristol ☎ 8021
TOURIST INFORMATION	College Street, Gloucester ☎ 421188
COUNCIL INFORMATION	Guildhall Gloucester ☎ 22232

RAILWAY INFORMATION	Passenger	Freight/Parcels
	☎ 29501	21121

BUS/COACH INFORMATION	Station Road Gloucester ☎ 27516
AIRPORT INFORMATION	Gloucester/Cheltenham ☎ 713481 (Staverton)
CATHEDRAL INFORMATION	Gloucester Cathedral ☎ 28095

POSTAL INFORMATION	Postal	Business	Postcode
	☎ 423761	28588	416094

LOCAL RADIO	Severn 388m/774kHz Sound VHF 95.0MHz
TV AREA	CENTRAL

STD CODE	**POLICE**	**HOSPITAL**
☎ 0452	☎ 21201	☎ 28555

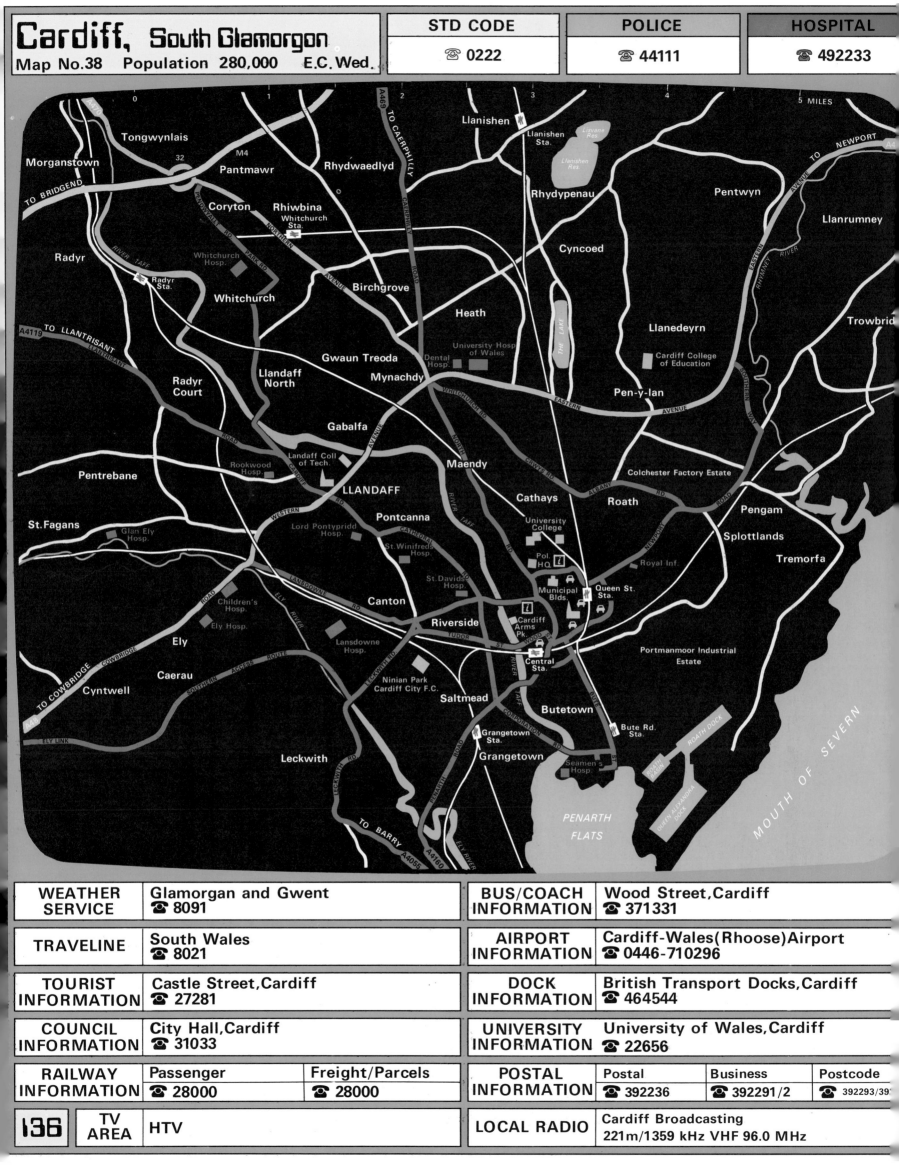

Cardiff, South Glamorgan	STD CODE	POLICE	HOSPITAL
Map No.38 Population 280,000 E.C. Wed.	☎ 0222	☎ 44111	☎ 492233

WEATHER SERVICE	Glamorgan and Gwent ☎ 8091	**BUS/COACH INFORMATION**	Wood Street, Cardiff ☎ 371331
TRAVELINE	South Wales ☎ 8021	**AIRPORT INFORMATION**	Cardiff-Wales (Rhoose) Airport ☎ 0446-710296
TOURIST INFORMATION	Castle Street, Cardiff ☎ 27281	**DOCK INFORMATION**	British Transport Docks, Cardiff ☎ 464544
COUNCIL INFORMATION	City Hall, Cardiff ☎ 31033	**UNIVERSITY INFORMATION**	University of Wales, Cardiff ☎ 22656

RAILWAY INFORMATION	Passenger ☎ 28000	Freight/Parcels ☎ 28000	**POSTAL INFORMATION**	Postal ☎ 392236	Business ☎ 392291/2	Postcode ☎ 392293/39

136	**TV AREA**	HTV	**LOCAL RADIO**	Cardiff Broadcasting 221m/1359 kHz VHF 96.0 MHz

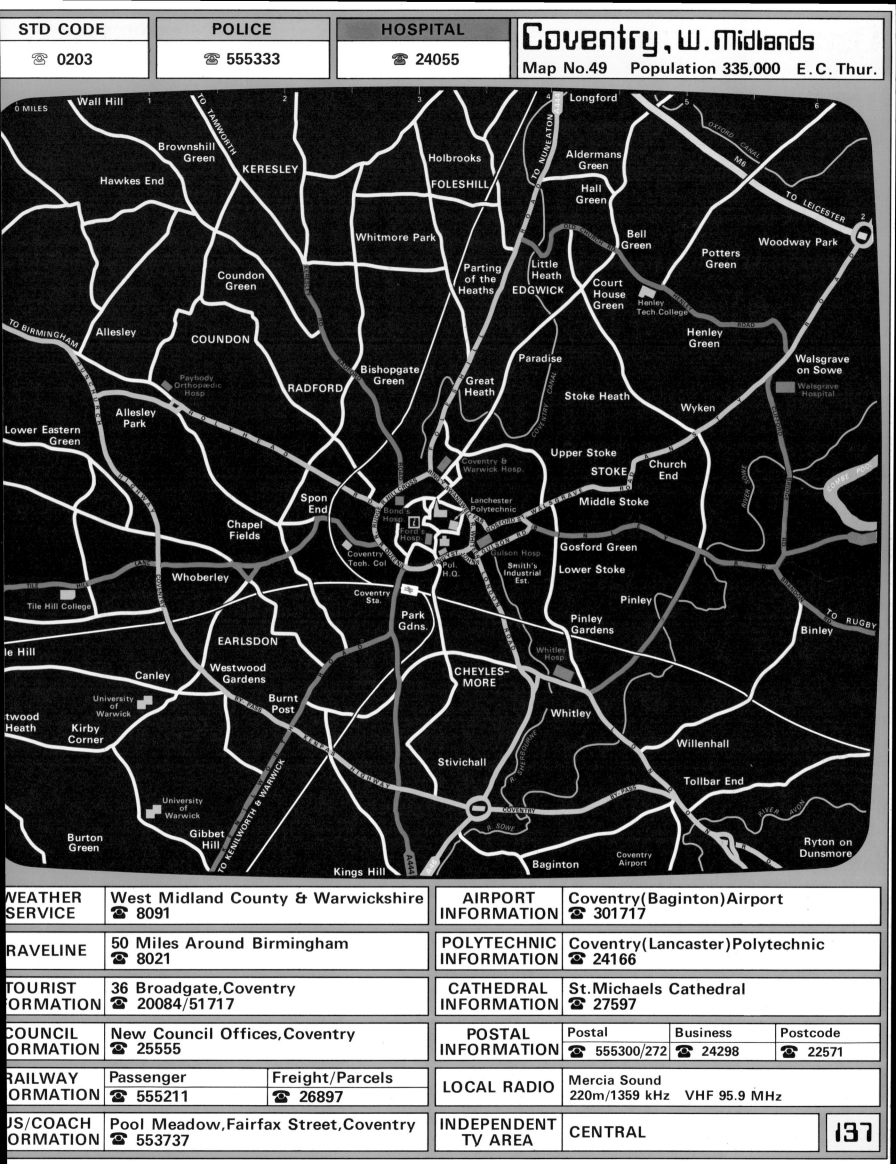

STD CODE ☎ 0203	**POLICE** ☎ 555333	**HOSPITAL** ☎ 24055	**Coventry, W. Midlands** Map No.49 Population 335,000 E.C. Thur.

WEATHER SERVICE	West Midland County & Warwickshire ☎ 8091		**AIRPORT INFORMATION**	Coventry(Baginton)Airport ☎ 301717
TRAVELINE	50 Miles Around Birmingham ☎ 8021		**POLYTECHNIC INFORMATION**	Coventry(Lancaster)Polytechnic ☎ 24166
TOURIST INFORMATION	36 Broadgate, Coventry ☎ 20084/51717		**CATHEDRAL INFORMATION**	St.Michaels Cathedral ☎ 27597
COUNCIL INFORMATION	New Council Offices, Coventry ☎ 25555		**POSTAL INFORMATION**	Postal ☎ 555300/272 Business ☎ 24298 Postcode ☎ 22571
RAILWAY INFORMATION	Passenger ☎ 555211	Freight/Parcels ☎ 26897	**LOCAL RADIO**	Mercia Sound 220m/1359 kHz VHF 95.9 MHz
BUS/COACH INFORMATION	Pool Meadow, Fairfax Street, Coventry ☎ 553737		**INDEPENDENT TV AREA**	CENTRAL

137

Derby, Derbyshire
Map No. 49 Population 217,000 E.C. Wed

WEATHER SERVICE	East Midlands ☎ 8091
TRAVELINE	50 Miles Around Birmingham ☎ 021-246-8021
TOURIST INFORMATION	Central Library, Wardwick ☎ 31111 Ext. 2185
COUNCIL INFORMATION	The Council House, Derby ☎ 31111

RAILWAY INFORMATION	Passenger ☎ 32051	Freight/Parcels ☎ 42442

BUS/COACH INFORMATION	The Morledge, Derby ☎ 368291
AIRPORT INFORMATION	East Midlands (Castle Donington) ☎ 810621
COLLEGE INFORMATION	Derby Lonsdale Coll. of F.E. ☎ 47181

POSTAL INFORMATION	Postal ☎ 40292/229	Business ☎ 40292/222	Postcode ☎ 40292/236

LOCAL RADIO	BBC Radio 269m/1116 kHz
TV AREA	CENTRAL

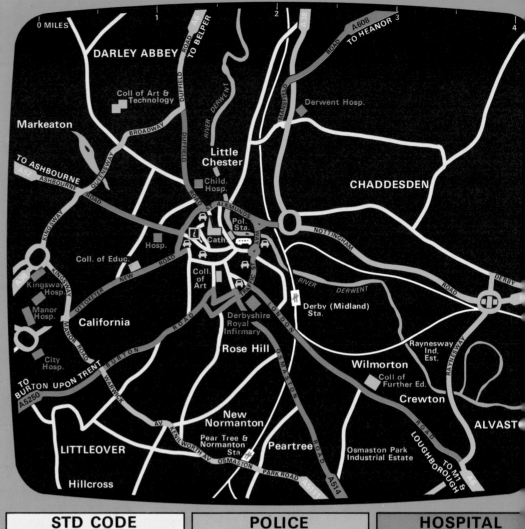

STD CODE	POLICE	HOSPITAL
☎ 0332	☎ 40224	☎ 47141

Dundee, Tayside
Map No. 90 Population 192,000 E.C. Wed.

WEATHER SERVICE	Aberdeen and Grampian ☎ 0224-8091
TRAVELINE	Scotland ☎ 031-246-8021
TOURIST INFORMATION	16 City Square, Dundee ☎ 27723
COUNCIL INFORMATION	City Chambers, Dundee ☎ 23141

RAILWAY INFORMATION	Passenger ☎ 21041	Freight/Parcels ☎ 21041

BUS/COACH INFORMATION	Seagate Bus Station, Dundee ☎ 28054
AIRPORT INFORMATION	Dundee (Riverside) Airport ☎ 643242
UNIVERSITY INFORMATION	University of Dundee ☎ 23181

POSTAL INFORMATION	Postal ☎ 29191/208	Business ☎ 29191/217/8	Postcode ☎ 29191/235

LOCAL RADIO	Radio Tay 258m/1161 kHz VHF 95.8 MHz
TV AREA	SCOTTISH

STD CODE	POLICE	HOSPITAL
☎ 0382	☎ 23200	☎ 23125

FIRTH OF FORTH

MILES

College
Cramond
Silverknowes
Pilton
Trinity
Newhaven
North Leith
GRANTON HARBOUR
LEITH HARBOUR & DOCKS
Wardie
Leith Hosp.
SOUTH LEITH
Seafield
Muirhouse
Northern Gen. Hosp.
Bonnington
DAVIDSON'S MAINS
Inverleith
Eastern Gen. Hosp.
TO DUNFERMLINE
FORTH ROAD BRIDGE
Drylaw
Broughton
Craigentinny
Blackhall
Western Gen. Hosp.
Craigleith
New Town
Abbeyhill
Restalrig
Clermiston
Pol. H.Q.
Royal Victoria Hosp.
Hillside
Maternity Hosp.
Piershill
Portobello
Craigcrook Castle
West End
Waverley Sta.
Palace of Holyroodhouse
Northfield
Ravelston
Stewart Melville Coll.
The Castle
HOLYROOD PARK
MURRAYFIELD
Coates
College of Art
Pol. Sta.
Corstophine
Haymarket Sta.
Murray House Coll. of Educ.
GLASGOW
M8
Roseburn
Royal Inf.
St. Leonards
Duddingston
TO BERWICK UPON TWEED
Carrick Knowe
Merchiston
Royal Edinburgh Hosp.
DUDDINGSTON LOCH
Broomhouse
Napier Tech. College
The Grange
Newington
Niddrie
Gorgie
Church Hill
Astley Ainslie Hosp.
Craigmillar
Tech Coll.
Royal Edinburgh Hosp.
Slateford
Morningside
TO MOTHERWELL
Longstone
Kings Blds. (University)
Craiglockhart
West Mains
Kingsknowe
City Hosp.
Liberton
Southfield Hosp.
Hailes
Comiston
Liberton Hosp.
TO LANARK
Colinton
Fairmilehead
Gracemount
Gilmerton
TO DALKEITH
TO PENICUIK
Princess Margaret Rose Hosp.
Mortonhall
TO CARLISLE
BY-PASS

WEATHER SERVICE	Edinburgh, Lothian ☎ 031-246-8091		AIRPORT INFORMATION	Edinburgh(Turnhouse)Airport ☎ 031-333-1000		
TRAVELINE	Scotland ☎ 031-246-8021		UNIVERSITY INFORMATION	University of Edinburgh ☎ 031-667-1011		
TOURIST INFORMATION	5 Waverley Bridge, Edinburgh ☎ 031-226-6591		CATHEDRAL INFORMATION	St.Mary's Scottish Episcopal Cathedral ☎ 031-225-6293		
COUNCIL INFORMATION	City Chambers, High Street, Edinburgh ☎ 031-225-2424		POSTAL INFORMATION	Postal ☎ 031-550-8232	Business ☎ 031-550-8326	Postcode ☎ 031-550-8301
RAILWAY INFORMATION	Passenger ☎ 031-556-2451	Freight/Parcels ☎ 031-556-0277	LOCAL RADIO	Radio Forth ☎ 194m/1548kHz VHF 96.8MHz		
BUS/COACH INFORMATION	St.Andrews Square,Edinburgh ☎ 031-556-8464		TV AREA	SCOTTISH		

Kingston upon Hull, Humb.
Map No. 65 Pop. 280,000 E.C.Mon/Thur.

STD CODE	POLICE	HOSPITAL
☎ 0482	☎ 26111	☎ 28541

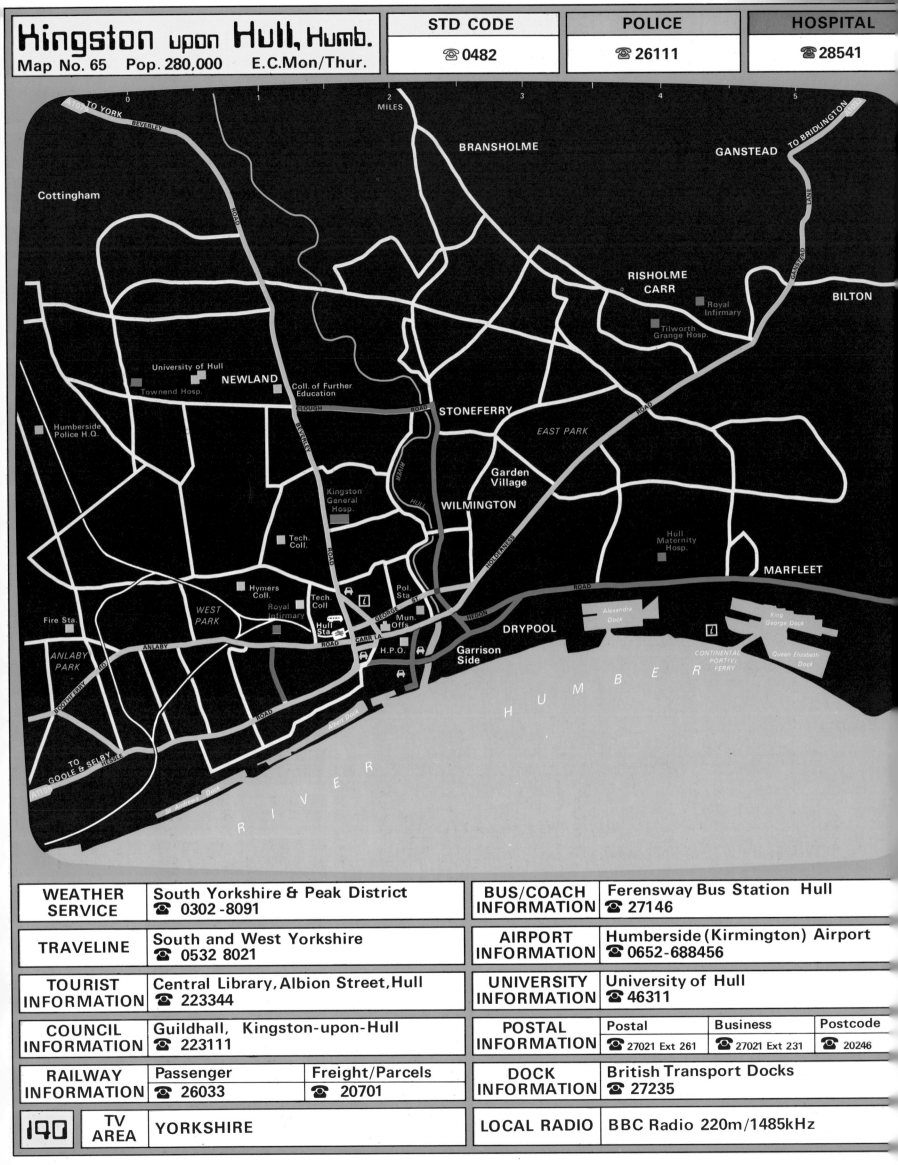

WEATHER SERVICE	South Yorkshire & Peak District ☎ 0302-8091	
TRAVELINE	South and West Yorkshire ☎ 0532 8021	
TOURIST INFORMATION	Central Library, Albion Street, Hull ☎ 223344	
COUNCIL INFORMATION	Guildhall, Kingston-upon-Hull ☎ 223111	
RAILWAY INFORMATION	Passenger ☎ 26033	Freight/Parcels ☎ 20701

BUS/COACH INFORMATION	Ferensway Bus Station Hull ☎ 27146
AIRPORT INFORMATION	Humberside (Kirmington) Airport ☎ 0652-688456
UNIVERSITY INFORMATION	University of Hull ☎ 46311
POSTAL INFORMATION	Postal ☎ 27021 Ext 261 — Business ☎ 27021 Ext 231 — Postcode ☎ 20246
DOCK INFORMATION	British Transport Docks ☎ 27235

190	**TV AREA**	YORKSHIRE	**LOCAL RADIO**	BBC Radio 220m/1485kHz

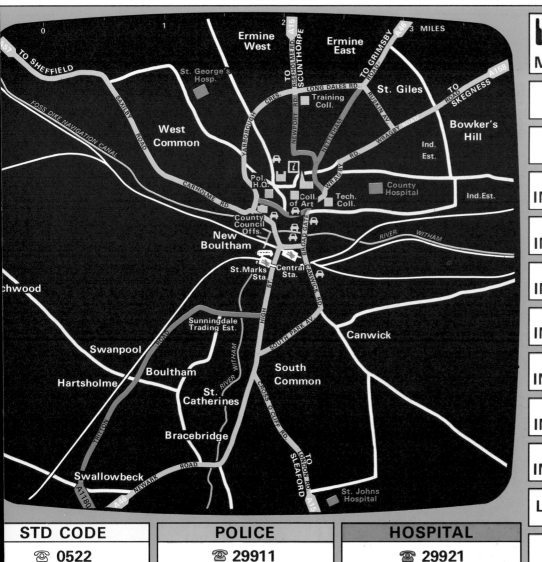

Lincoln, Lincolnshire

Map No.63 **Population 72,000 E.C.Wed**

WEATHER SERVICE	Lincolnshire & Humberside ☎ 8091		
TRAVELINE	South and West Yorkshire ☎ 0302-8021		
TOURIST INFORMATION	City Hall, Beaumont Fee, ☎ 32151 Ext 515 Lincoln		
COUNCIL INFORMATION	City Hall, Beaumont Fee, ☎ 32151 Lincoln		
RAILWAY INFORMATION	Passenger ☎ 39502		Freight/Parcels ☎ 26291
BUS/COACH INFORMATION	St Marks Street, Lincoln ☎ 22255		
AIRPORT INFORMATION	Humberside (Kirmington) ☎ 0652-688456 Airport		
CATHEDRAL INFORMATION	Lincoln Cathedral ☎ 30320		
POSTAL INFORMATION	Postal ☎ 23418	Business ☎ 32070	Postcode ☎ 31718
LOCAL RADIO	BBC Radio 219m/1368 kHz		
TV AREA	YORKSHIRE		

STD CODE	POLICE	HOSPITAL
☎ 0522	☎ 29911	☎ 29921

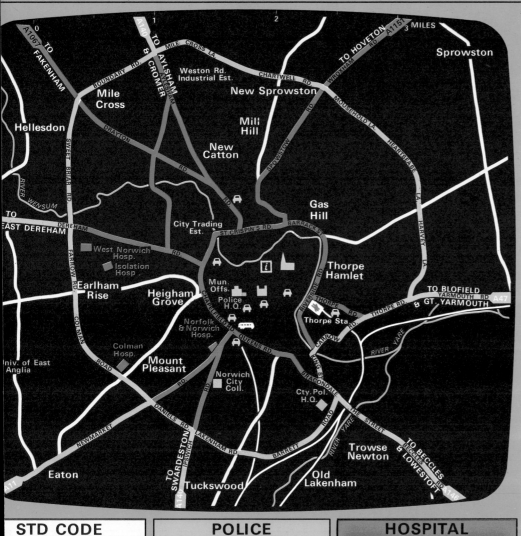

Norwich, Norfolk

Map No.45 **Population 122,000 E.C.Thur.**

WEATHER SERVICE	East Anglia ☎ 8091		
TRAVELINE	70 miles Around London ☎ 01-246-8021		
TOURIST INFORMATION	Augustine Steward House ☎ 23445		
COUNCIL INFORMATION	City Hall, Norwich ☎ 22233		
RAILWAY INFORMATION	Passenger ☎ 20255		Freight/Parcels ☎ 22093
BUS/COACH INFORMATION	Surrey Street, Norwich ☎ 20491		
AIRPORT INFORMATION	Norwich (Horsham St.Faith) ☎ 411923 Airport		
CATHEDRAL INFORMATION	Norwich Cathedral ☎ 20715		
POSTAL INFORMATION	Postal ☎ 27171	Business ☎ 27171	Postcode ☎ 27779
LOCAL RADIO	BBC Radio 351m/855 kHz		
TV AREA	ANGLIA		191

STD CODE	POLICE	HOSPITAL
☎ 0603	☎ 21212	☎ 28377

Leeds, W. Yorkshire

Map No.61 Population 725,000 E.C. Wed.

STD CODE	POLICE	HOSPITAL
☎ 0532	☎ 435353	☎ 432799

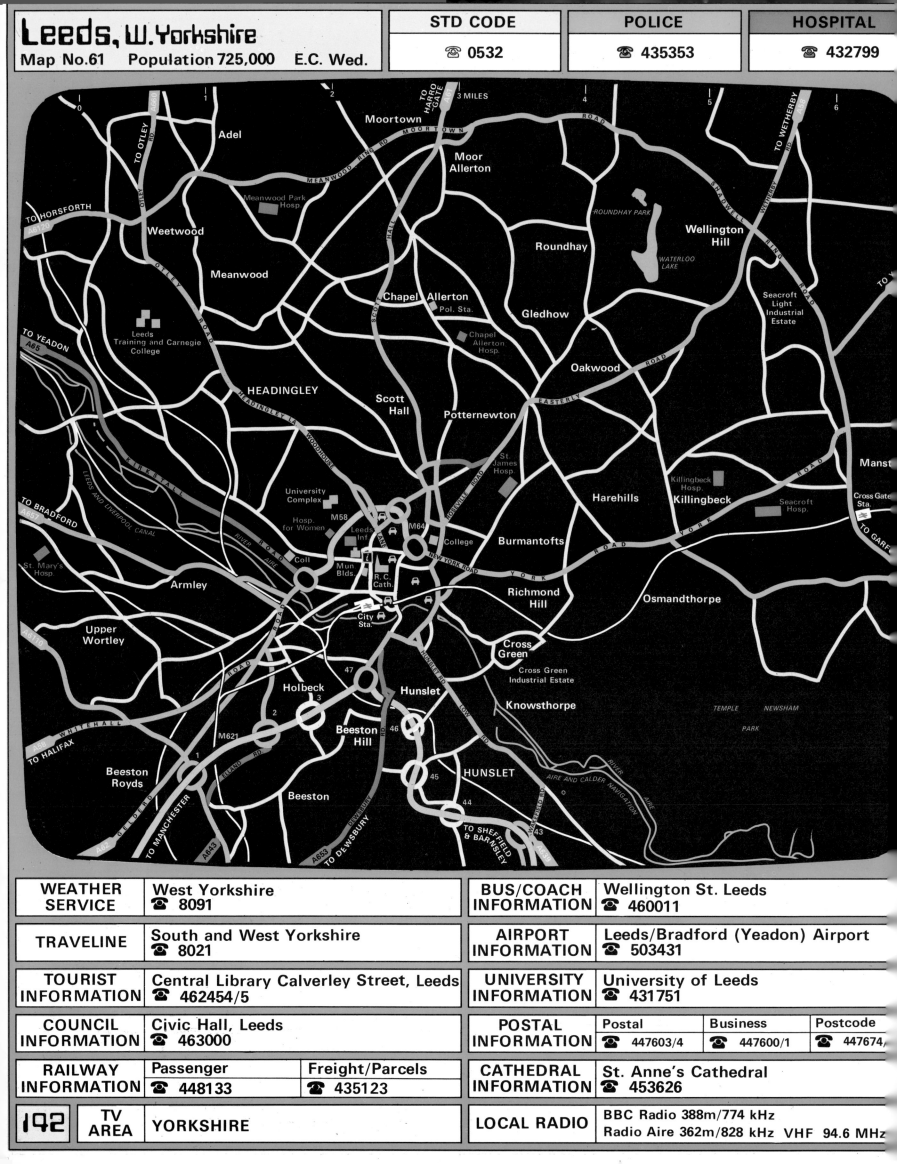

WEATHER SERVICE	West Yorkshire ☎ 8091	**BUS/COACH INFORMATION**	Wellington St. Leeds ☎ 460011	
TRAVELINE	South and West Yorkshire ☎ 8021	**AIRPORT INFORMATION**	Leeds/Bradford (Yeadon) Airport ☎ 503431	
TOURIST INFORMATION	Central Library Calverley Street, Leeds ☎ 462454/5	**UNIVERSITY INFORMATION**	University of Leeds ☎ 431751	
COUNCIL INFORMATION	Civic Hall, Leeds ☎ 463000	**POSTAL INFORMATION**	Postal ☎ 447603/4	Business ☎ 447600/1 / Postcode ☎ 447674
RAILWAY INFORMATION	Passenger ☎ 448133 / Freight/Parcels ☎ 435123	**CATHEDRAL INFORMATION**	St. Anne's Cathedral ☎ 453626	

192	**TV AREA**	YORKSHIRE	**LOCAL RADIO**	BBC Radio 388m/774 kHz / Radio Aire 362m/828 kHz VHF 94.6 MHz

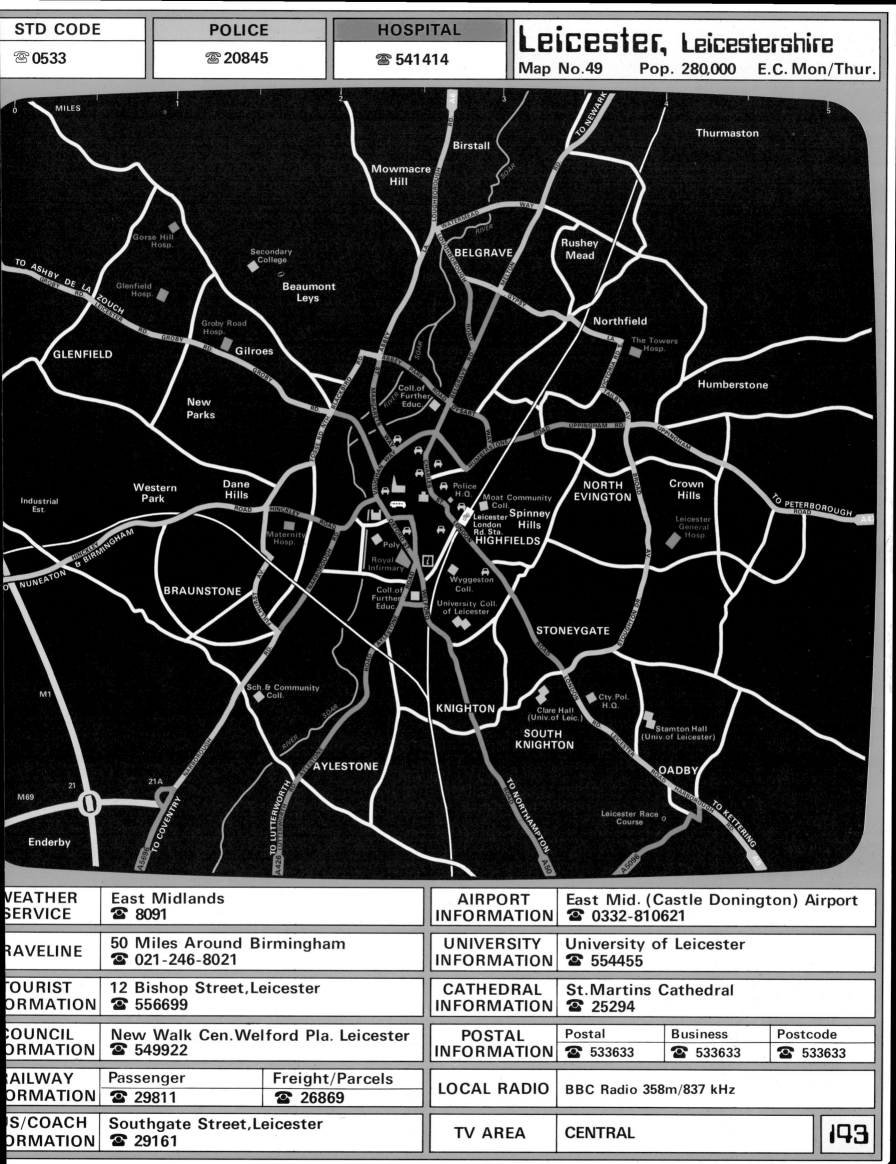

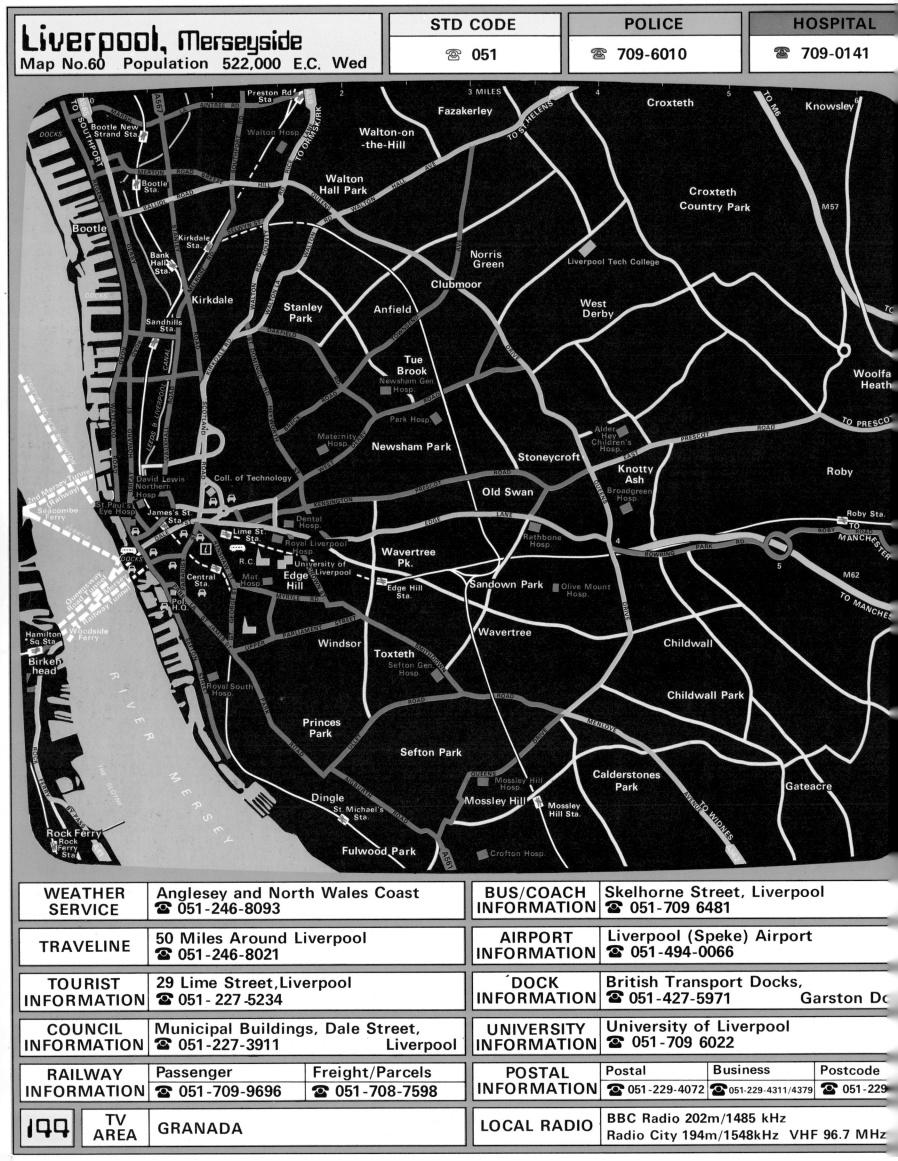

Liverpool, Merseyside
Map No.60 Population 522,000 E.C. Wed

STD CODE	POLICE	HOSPITAL
☎ 051	☎ 709-6010	☎ 709-0141

WEATHER SERVICE	Anglesey and North Wales Coast ☎ 051-246-8093	**BUS/COACH INFORMATION**	Skelhorne Street, Liverpool ☎ 051-709 6481
TRAVELINE	50 Miles Around Liverpool ☎ 051-246-8021	**AIRPORT INFORMATION**	Liverpool (Speke) Airport ☎ 051-494-0066
TOURIST INFORMATION	29 Lime Street, Liverpool ☎ 051- 227-5234	**DOCK INFORMATION**	British Transport Docks, ☎ 051-427-5971 Garston Do
COUNCIL INFORMATION	Municipal Buildings, Dale Street, ☎ 051-227-3911 Liverpool	**UNIVERSITY INFORMATION**	University of Liverpool ☎ 051-709 6022

RAILWAY INFORMATION	Passenger ☎ 051-709-9696	Freight/Parcels ☎ 051-708-7598	**POSTAL INFORMATION**	Postal ☎ 051-229-4072	Business ☎ 051-229-4311/4379	Postcode ☎ 051-229

IQQ	**TV AREA**	GRANADA	**LOCAL RADIO**	BBC Radio 202m/1485 kHz Radio City 194m/1548kHz VHF 96.7 MHz

STD CODE	POLICE	HOSPITAL	**Newcastle, Tyne & Wear**
☎ 0632	☎ 321253	☎ 325131	Map No.76 Population 290,000 E.C. Wed.

Map labels:

TO OTTERBURN A696 · MILES · TO MORPETH A6125 · TO BLYTH A189 · Longbenton Sta. · Four Lanes End · A188 · A191 · BENTON RD · PARK RD

St. Nicholas Hospital (Mental Hosp.) · St. Nicholas Hosp. · Sanderson Orthopaedic Hosp. · Dept. of Health & Social Security · Freeman Hosp. · Northern Counties Coll.

KENTON · GOSFORTH · Blakelaw · KENTON LANE · SALTERS · CHURCH AV · South Gosforth Sta. · Ilford Rd. · HADDRICKS MILL RD

PONTELAND RD · Cowgate · Town Moor · West Jesmond Sta. · HIGH HEATON · TO TYNEMOUTH A1058 · NEWCASTLE TYNMOUTH COAST ROAD

CENTRAL · Hunters Moor Hosp. · Princess Mary Maternity Hosp. · JESMOND · BENTON BANK · Walkergate Hosp. · A193

FENHAM · Fleming Memorial Hosp · Jesmond · HEATON · Walkergate Sta. · CHILLINGHAM RD · Chillingham Rd.

Newcastle General Hosp. · Univ. of Newcastle upon Tyne · Civic Cen · Heaton Sta. · SHIELDS RD

Arthurs Hill · Royal Victoria Infirmary · Haymarket · Poly. · BYKER · WALKER · Byker

BENWELL · WESTGATE ROAD · St. James · Coll. of Further Educ. · Monument · Manors · SHIELDS RD · St. Peters · A186

ELSWICK · Coll. of Art · Central Sta. · NEVILLE ST · Sta. · St. Peters · WALKER RD · St. Anthony

SCOTSWOOD ROAD · RIVER TYNE · Mun. Offs. · Salt Meadows

TO BLAYDON · Redheugh Low Team · Gateshead · Pol. H.Q · Gateshead Stadium · ABBOTSFORD RD · FELLING

SWALWELL · DUNSTON · R. TEAM · GATESHEAD · Mount Pleasant · Felling Sta. · FELLING BY PASS · Heworth · A185

Whickham · WESTERN BY PASS · BENSHAM · Shipcote · Saltwell · Queen Elizabeth Hosp. · Carr Hill · Heworth · TO SUNDERLAND A6111

Dunston Hill General Hosp. · WESTWAY A69 · Bensham General Hosp. · TO DURHAM A612

WEATHER SERVICE	North East England ☎ 8091	AIRPORT INFORMATION	Newcastle (Woolsington) Airport ☎ 860966
TRAVELINE	Northern England ☎ 8021	UNIVERSITY INFORMATION	University of Newcastle-Upon-Tyne ☎ 328511
TOURIST INFORMATION	Central Library, Princess Square, ☎ 610691	METRO INFORMATION	Tyne and Wear Transport Travel Centre ☎ 325325
COUNCIL INFORMATION	Civic Centre, Newcastle-upon-Tyne ☎ 28520	POSTAL INFORMATION	Postal ☎ 353333 / Business ☎ 353333 Ext.214 / Postcode ☎ 353333 Ext. 224
RAILWAY INFORMATION	Passenger ☎ 326262 / Freight/Parcels ☎ 324859	LOCAL RADIO	BBC Radio 260m/1458 kHz / Metro Radio 261m/1152 kHz VHF 97.0 MHz
BUS/COACH INFORMATION	Gallowgate Bus Station, ☎ 616007	INDEPENDENT TV AREA	TYNE TEES

195

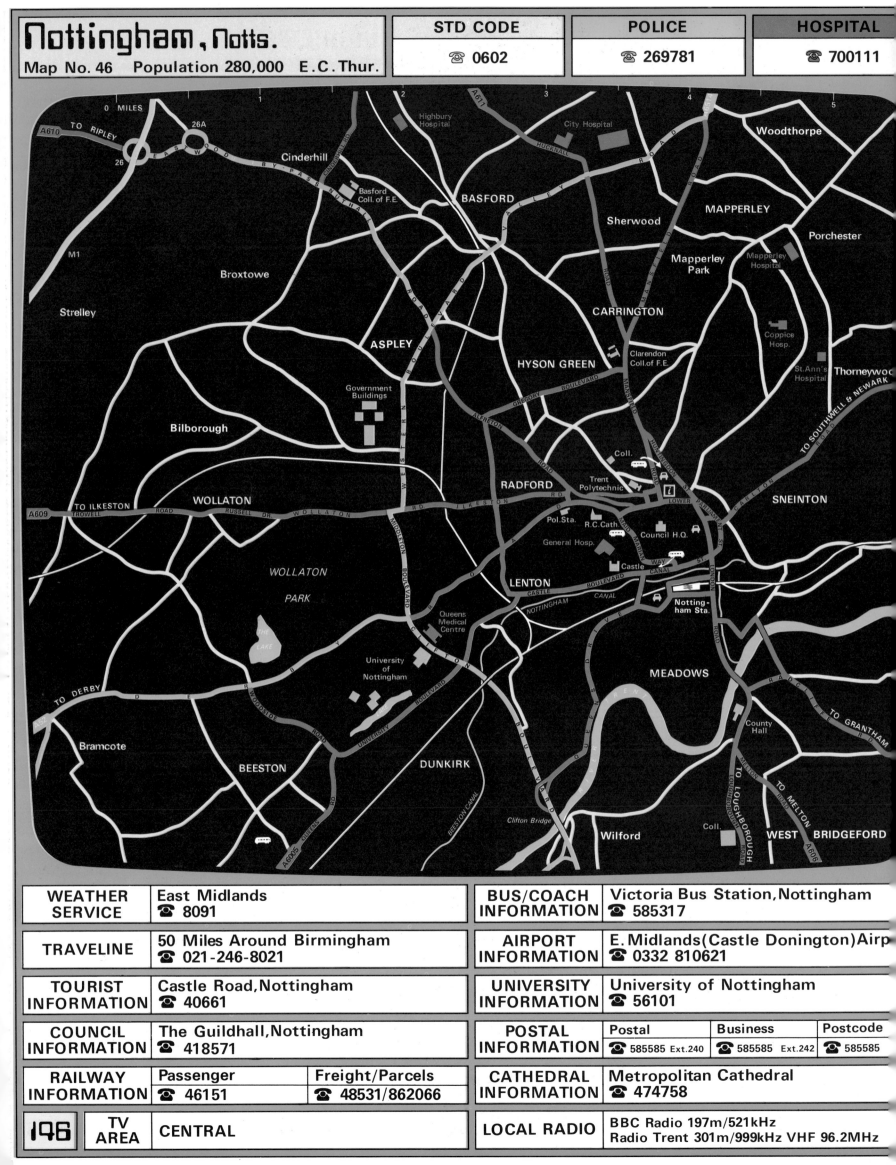

		STD CODE	POLICE	HOSPITAL
Nottingham, Notts.		☎ 0602	☎ 269781	☎ 700111
Map No. 46 Population 280,000 E.C. Thur.				

WEATHER SERVICE	East Midlands ☎ 8091	**BUS/COACH INFORMATION**	Victoria Bus Station, Nottingham ☎ 585317
TRAVELINE	50 Miles Around Birmingham ☎ 021-246-8021	**AIRPORT INFORMATION**	E. Midlands (Castle Donington) Airp ☎ 0332 810621
TOURIST INFORMATION	Castle Road, Nottingham ☎ 40661	**UNIVERSITY INFORMATION**	University of Nottingham ☎ 56101
COUNCIL INFORMATION	The Guildhall, Nottingham ☎ 418571	**POSTAL INFORMATION**	Postal ☎ 585585 Ext.240 · Business ☎ 585585 Ext.242 · Postcode ☎ 585585

RAILWAY INFORMATION	Passenger ☎ 46151	Freight/Parcels ☎ 48531/862066	**CATHEDRAL INFORMATION**	Metropolitan Cathedral ☎ 474758

196	**TV AREA**	CENTRAL	**LOCAL RADIO**	BBC Radio 197m/521kHz Radio Trent 301m/999kHz VHF 96.2MHz

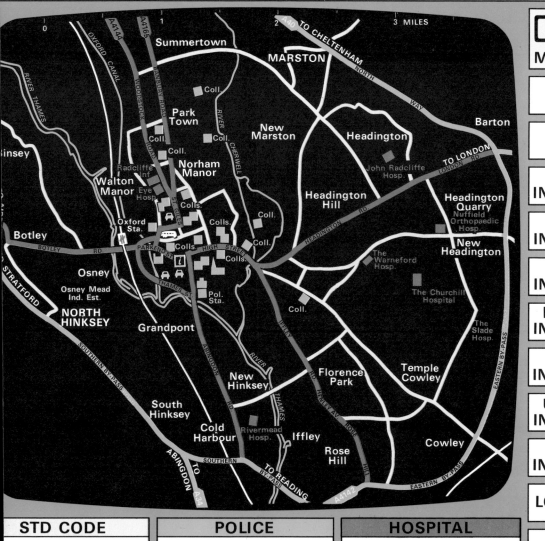

Oxford, Oxfordshire

Map No.30 Population 123,000 E.C. Thur

WEATHER SERVICE	Oxford, Berks and Bucks ☎ 8091	
TRAVELINE	70 Miles Around London ☎ 8021	
TOURIST INFORMATION	St. Aldates, Oxford ☎ 726871/2	
COUNCIL INFORMATION	St. Aldates, Oxford ☎ 249811	
RAILWAY INFORMATION	Passenger ☎ 722333	Freight/Parcels ☎ 722333
BUS/COACH INFORMATION	Gloucester Green, Coach ☎ 240504 Station	
AIRPORT INFORMATION	Heathrow Airport ☎ 01-759-4321	
UNIVERSITY INFORMATION	University of Oxford ☎ 56747	

POSTAL INFORMATION	Postal ☎ 814581	Business ☎ 814581	Postcode ☎ 3555 Freephone

LOCAL RADIO	BBC Radio 202m/1485 kHz

STD CODE ☎ 0865	POLICE ☎ 249881	HOSPITAL ☎ 64711

TV AREA	CENTRAL

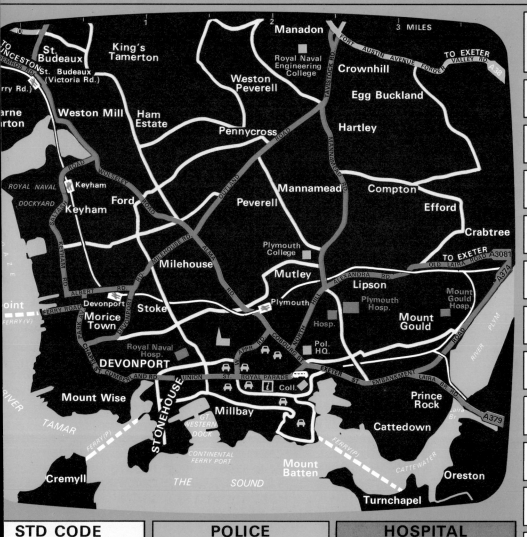

Plymouth, Devon

Map No.20 Population 260,000 E.C. Wed.

WEATHER SERVICE	Devon & Cornwall ☎ 8091	
TRAVELINE	No Regional Coverage	
TOURIST INFORMATION	Civic Centre Plymouth ☎ 264849/264850	
COUNCIL INFORMATION	Civic Centre, Plymouth ☎ 57328	
RAILWAY INFORMATION	Passenger ☎ 21300	Freight/Parcels ☎ 662888
BUS/COACH INFORMATION	Bretonside Coach Station ☎ 664013	
AIRPORT INFORMATION	Plymouth Airport ☎ 772752 (Roborough)	
CATHEDRAL INFORMATION	St. Mary's & St. Boniface ☎ 662357 Wyndham St. R.C.	

POSTAL INFORMATION	Postal ☎ 668055	Business ☎ 668055	Postcode ☎ 668055

LOCAL RADIO	Plymouth Sound 261m/1152 kHz VHF 96.0 MHz

STD CODE ☎ 0752	POLICE ☎ 701188	HOSPITAL ☎ 668080

TV AREA	TSW

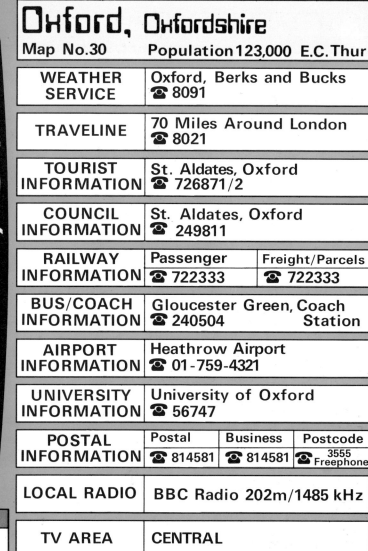

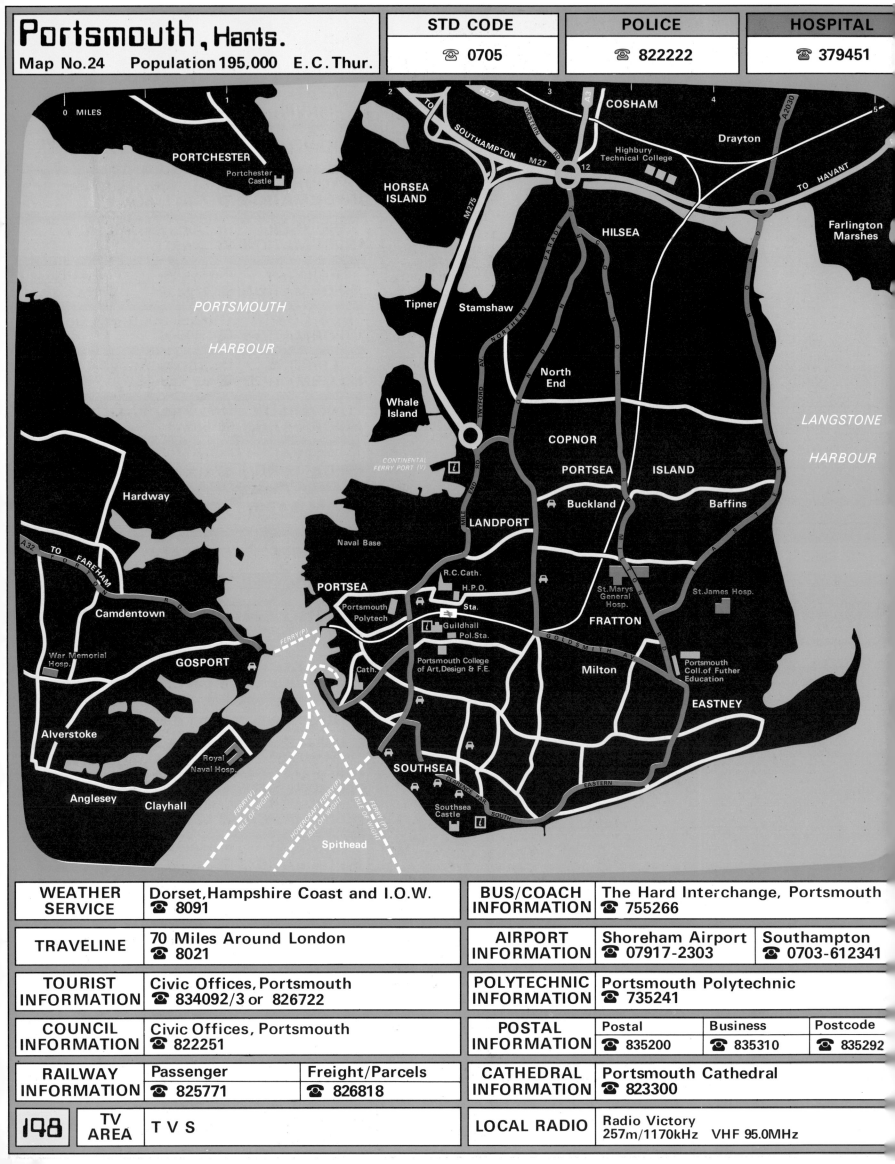

Portsmouth, Hants.
Map No.24 Population 195,000 E.C. Thur.

STD CODE	POLICE	HOSPITAL
☎ 0705	☎ 822222	☎ 379451

WEATHER SERVICE	Dorset, Hampshire Coast and I.O.W. ☎ 8091	
TRAVELINE	70 Miles Around London ☎ 8021	
TOURIST INFORMATION	Civic Offices, Portsmouth ☎ 834092/3 or 826722	
COUNCIL INFORMATION	Civic Offices, Portsmouth ☎ 822251	

RAILWAY INFORMATION	Passenger ☎ 825771	Freight/Parcels ☎ 826818

BUS/COACH INFORMATION	The Hard Interchange, Portsmouth ☎ 755266	
AIRPORT INFORMATION	Shoreham Airport ☎ 07917-2303	Southampton ☎ 0703-612341
POLYTECHNIC INFORMATION	Portsmouth Polytechnic ☎ 735241	

POSTAL INFORMATION	Postal ☎ 835200	Business ☎ 835310	Postcode ☎ 835292

CATHEDRAL INFORMATION	Portsmouth Cathedral ☎ 823300	

198	**TV AREA**	T V S

LOCAL RADIO	Radio Victory 257m/1170kHz VHF 95.0MHz

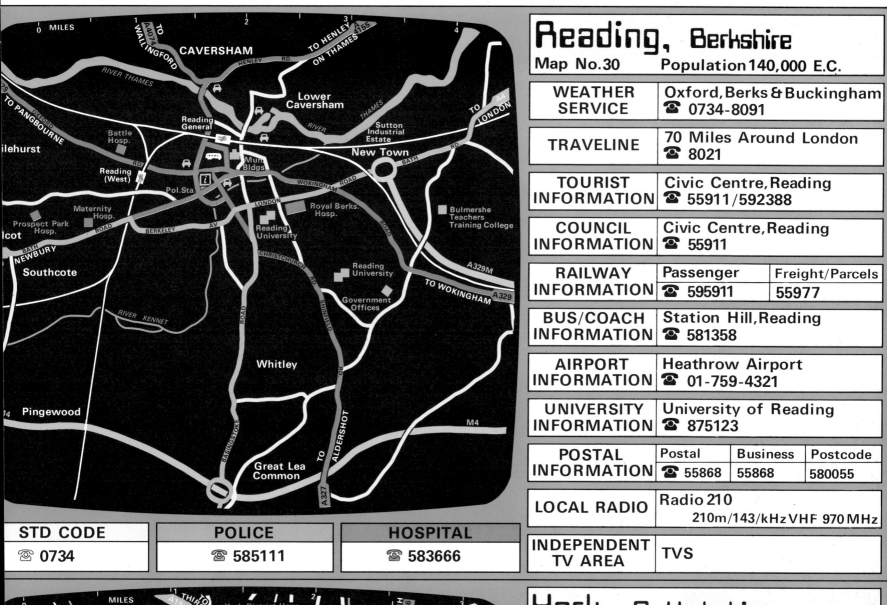

Reading, Berkshire

Map No.30 Population 140,000 E.C.

WEATHER SERVICE	Oxford,Berks & Buckingham ☎ 0734-8091
TRAVELINE	70 Miles Around London ☎ 8021
TOURIST INFORMATION	Civic Centre, Reading ☎ 55911/592388
COUNCIL INFORMATION	Civic Centre, Reading ☎ 55911

RAILWAY INFORMATION	Passenger	Freight/Parcels
	☎ 595911	55977

BUS/COACH INFORMATION	Station Hill, Reading ☎ 581358
AIRPORT INFORMATION	Heathrow Airport ☎ 01-759-4321
UNIVERSITY INFORMATION	University of Reading ☎ 875123

POSTAL INFORMATION	Postal	Business	Postcode
	☎ 55868	55868	580055

LOCAL RADIO	Radio 210 210m/143/kHz VHF 970 MHz
INDEPENDENT TV AREA	TVS

STD CODE	POLICE	HOSPITAL
☎ 0734	☎ 585111	☎ 583666

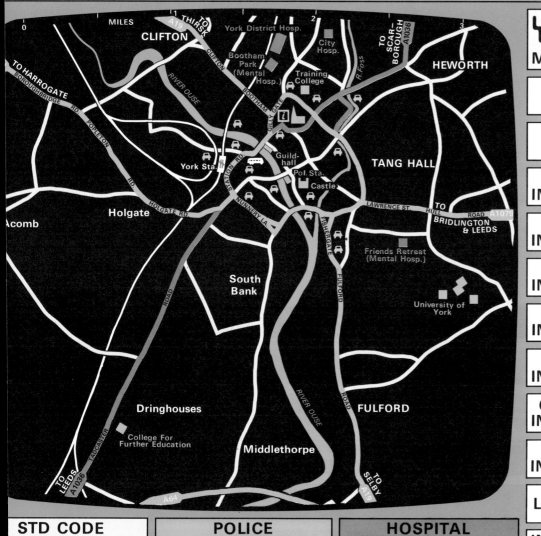

York, N. Yorkshire

Map No. 64 Population 100,000 E.C.Wed.

WEATHER SERVICE	West Yorkshire ☎ 0532-8091
TRAVELINE	South and West Yorkshire ☎ 0532-8021
TOURIST INFORMATION	De Grey Rooms, York ☎ 21756/7
COUNCIL INFORMATION	Guildhall, York ☎ 59881

RAILWAY INFORMATION	Passenger	Freight/Parcels
	☎ 37547	53022

BUS/COACH INFORMATION	Rougier Street, York ☎ 24161
AIRPORT INFORMATION	Leeds/Bradford(Yeadon) ☎ 0532-503431 Airport
CATHEDRAL INFORMATION	York Minster Cathedral ☎ 24426

POSTAL INFORMATION	Postal	Business	Postcode
	☎ 28901 Ext.239	23337	28901

LOCAL RADIO	BBC Radio York 450m 666kHz
INDEPENDENT TV AREA	YORKSHIRE

STD CODE	POLICE	HOSPITAL
☎ 0904	☎ 31321	☎ 31313

Sheffield, South Yorkshire

Map No. 62 Population 540,000 E.C.Thur.

STD CODE	POLICE	HOSPITAL
☎ 0742	☎ 78522	☎ 26484

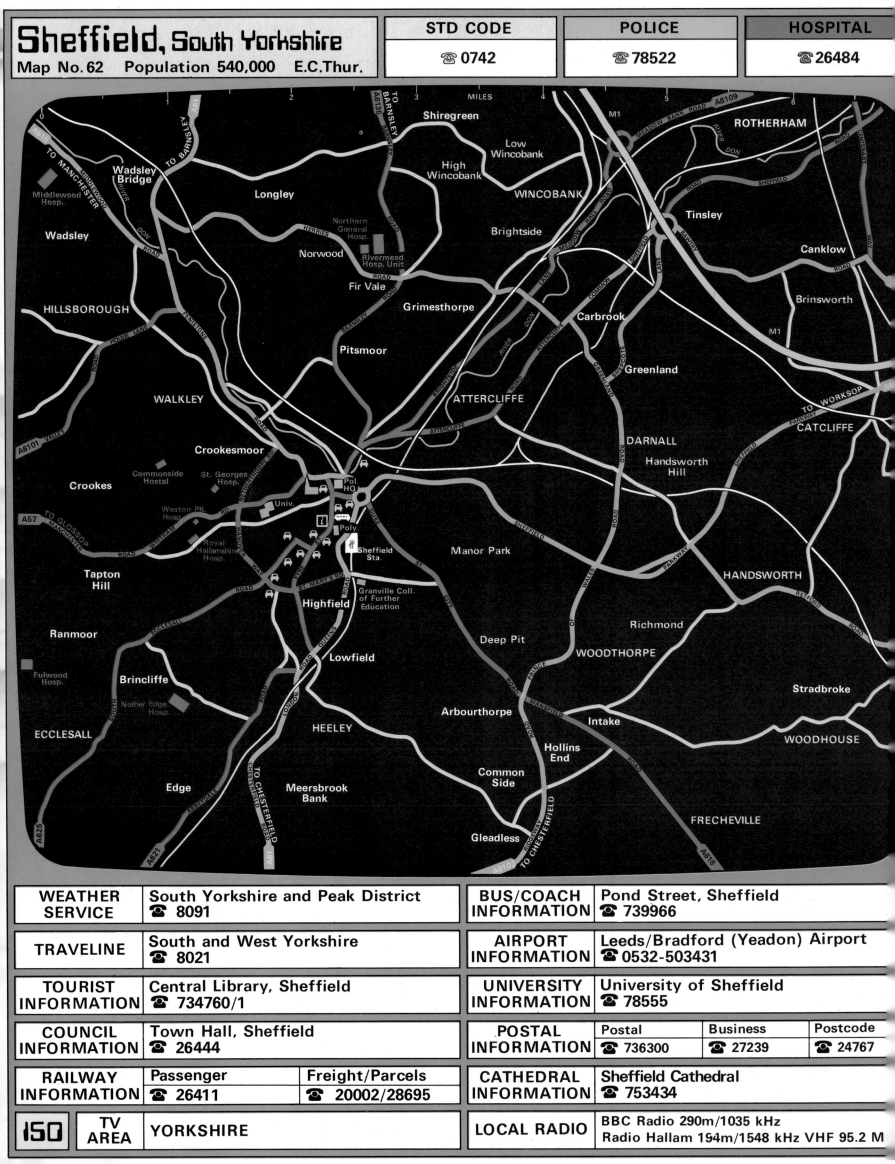

WEATHER SERVICE	South Yorkshire and Peak District ☎ 8091		**BUS/COACH INFORMATION**	Pond Street, Sheffield ☎ 739966
TRAVELINE	South and West Yorkshire ☎ 8021		**AIRPORT INFORMATION**	Leeds/Bradford (Yeadon) Airport ☎ 0532-503431
TOURIST INFORMATION	Central Library, Sheffield ☎ 734760/1		**UNIVERSITY INFORMATION**	University of Sheffield ☎ 78555

COUNCIL INFORMATION	Town Hall, Sheffield ☎ 26444

POSTAL INFORMATION	Postal	Business	Postcode
	☎ 736300	☎ 27239	☎ 24767

RAILWAY INFORMATION	Passenger ☎ 26411	Freight/Parcels ☎ 20002/28695

CATHEDRAL INFORMATION	Sheffield Cathedral ☎ 753434

150	**TV AREA**	YORKSHIRE

LOCAL RADIO	BBC Radio 290m/1035 kHz Radio Hallam 194m/1548 kHz VHF 95.2 M

WEATHER SERVICE	Dorset, Hampshire Coast & I.O.W. ☎ 8091	AIRPORT INFORMATION	Southampton(Eastleigh)Airport ☎ 612341
TRAVELINE	70 Miles Around Bristol ☎ 8021	DOCK INFORMATION	British Transport Docks, ☎ 23844 Western Docks, Southampton
TOURIST INFORMATION	Above Bar Precinct, Southampton ☎ 23855 Ext. 2615 Sat. 21106	UNIVERSITY INFORMATION	University of Southampton ☎ 559122

COUNCIL INFORMATION	Civic Centre, Southampton ☎ 23855	POSTAL INFORMATION	Postal ☎ 831381	Business ☎ 831369	Postcode ☎ 831335

RAILWAY INFORMATION	Passenger ☎ 29393	Freight/Parcels ☎ 23838/24029	LOCAL RADIO	BBC Radio Solent 300m/999 kHz

BUS/COACH INFORMATION	Bedford Place, Southampton ☎ 23222	INDEPENDENT TV AREA	TVS	151

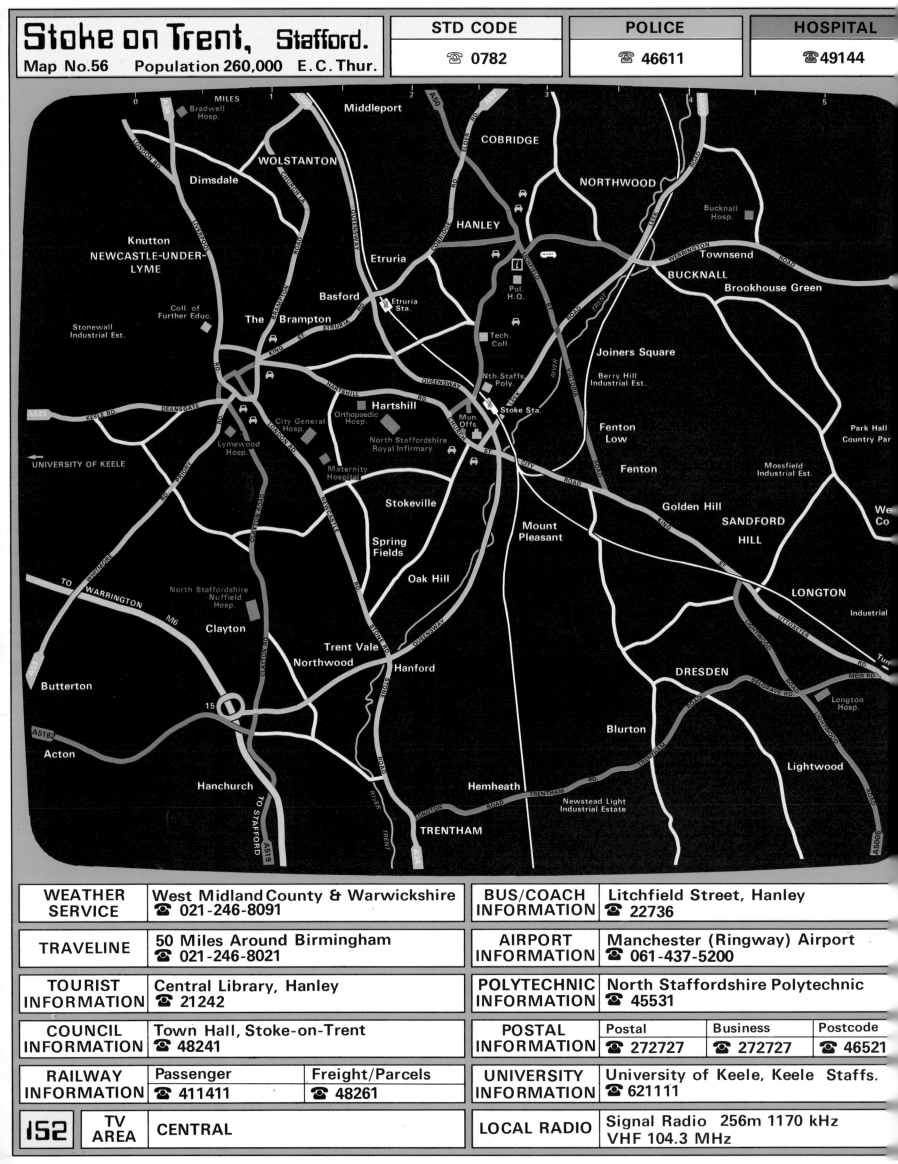

Stoke on Trent, Stafford.

Map No.56 Population 260,000 E.C. Thur.

STD CODE	POLICE	HOSPITAL
☎ 0782	☎ 46611	☎ 49144

WEATHER SERVICE	West Midland County & Warwickshire ☎ 021-246-8091	**BUS/COACH INFORMATION**	Litchfield Street, Hanley ☎ 22736	
TRAVELINE	50 Miles Around Birmingham ☎ 021-246-8021	**AIRPORT INFORMATION**	Manchester (Ringway) Airport ☎ 061-437-5200	
TOURIST INFORMATION	Central Library, Hanley ☎ 21242	**POLYTECHNIC INFORMATION**	North Staffordshire Polytechnic ☎ 45531	
COUNCIL INFORMATION	Town Hall, Stoke-on-Trent ☎ 48241	**POSTAL INFORMATION**	Postal ☎ 272727 — Business ☎ 272727 — Postcode ☎ 46521	

RAILWAY INFORMATION	Passenger ☎ 411411	Freight/Parcels ☎ 48261	**UNIVERSITY INFORMATION**	University of Keele, Keele Staffs. ☎ 621111

152	**TV AREA**	CENTRAL	**LOCAL RADIO**	Signal Radio 256m 1170 kHz VHF 104.3 MHz

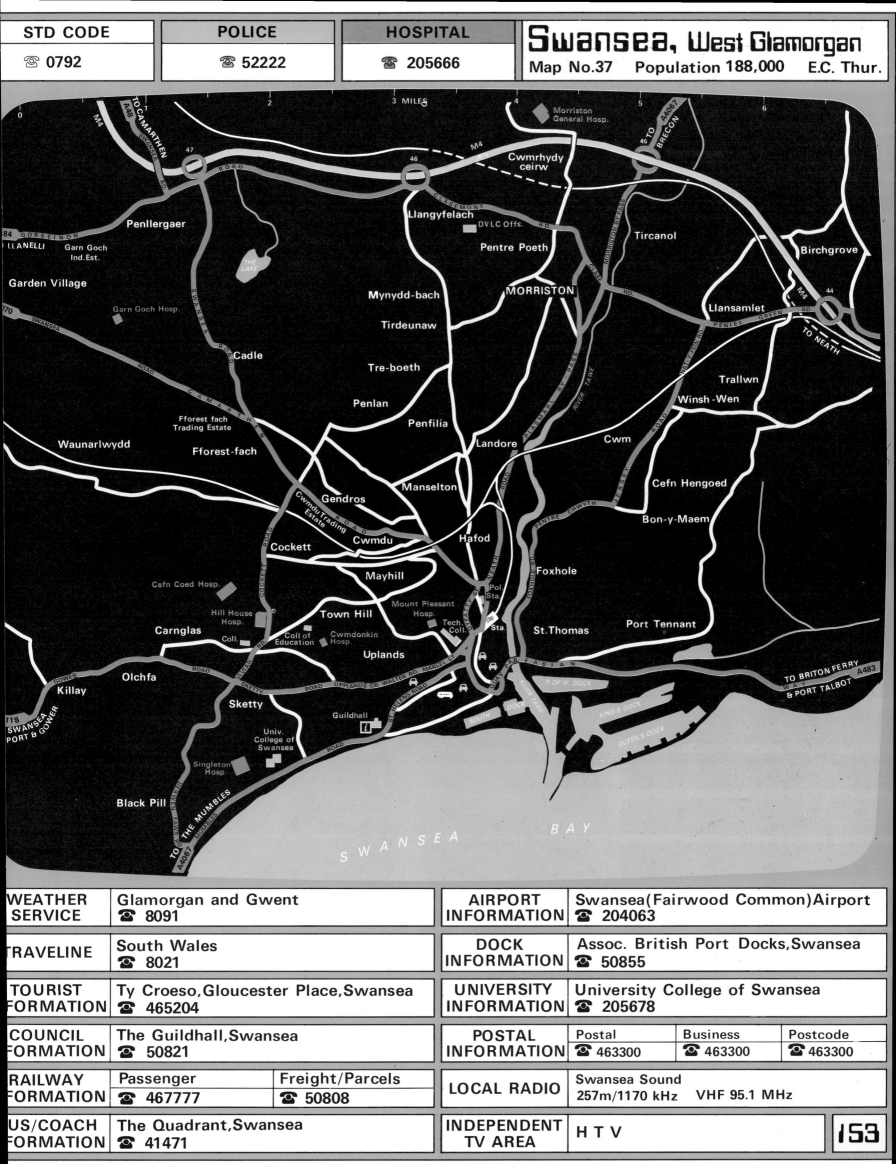

STD CODE	POLICE	HOSPITAL	**Swansea, West Glamorgan**
☎ 0792	☎ 52222	☎ 205666	Map No.37 Population 188,000 E.C. Thur.

(Map of Swansea showing places including:)

TO CAMARTHEN · M4 · A48 · Penllergaer · GORSEINON · LLANELLI · Garn Goch Ind.Est. · Garden Village · Garn Goch Hosp. · Cadle · THE LAKE · SWANSEA ROAD · CAMARTHEN ROAD · Waunarlwydd · Fforest fach Trading Estate · Fforest-fach · Gendros · Cwmdu Trading Estate · Cwmdu · Cockett · Cefn Coed Hosp. · Hill House Hosp. · Carnglas · Coll. · Coll of Education · Cwmdonkin Hosp. · Town Hill · Mayhill · Mount Pleasant Hosp. · Uplands · Olchfa · Killay · GOWER ROAD · SKETTY ROAD · VIVIAN RD · Sketty · Guildhall · Univ. College of Swansea · Singleton Hosp. · Black Pill · TO THE MUMBLES · A4067 · SWANSEA PORT & GOWER · A718 · Llangyfelach · DVLC Offs. · Pentre Poeth · Mynydd-bach · Tirdeunaw · Tre-boeth · Penlan · Penfilia · Manselton · Hafod · Landore · CLASEMONT RD · Cwmrhydy ceirw · Morriston General Hosp. · MORRISTON · RIVER TAWE · PLASMARL BY PASS · Foxhole · Pol. Sta. · Tech. Coll. · Sta. · St.Thomas · QUAY PAR FABIAN · Tircanol · Birchgrove · Llansamlet · TO NEATH · M4 · Trallwn · Winsh-Wen · Cwm · Cefn Hengoed · Bon-y-Maem · Port Tennant · TO BRITON FERRY & PORT TALBOT · A483 · P OF W DOCK · SOUTH DOCK · KING'S DOCK · QUEEN'S DOCK · RIVER TAWE · TO BRECON · A4067 · MORRISTON BY-PASS · CHASE RD · PENIEL GREEN · NANT-Y-FENDROD · JERSEY RD · PENTRE CHWYTH · FOXHOLE RD · NEATH RD · SWANSEA BAY

WEATHER SERVICE	Glamorgan and Gwent ☎ 8091			AIRPORT INFORMATION	Swansea(Fairwood Common)Airport ☎ 204063		
TRAVELINE	South Wales ☎ 8021			DOCK INFORMATION	Assoc. British Port Docks,Swansea ☎ 50855		
TOURIST INFORMATION	Ty Croeso,Gloucester Place,Swansea ☎ 465204			UNIVERSITY INFORMATION	University College of Swansea ☎ 205678		
COUNCIL INFORMATION	The Guildhall,Swansea ☎ 50821			POSTAL INFORMATION	Postal ☎ 463300	Business ☎ 463300	Postcode ☎ 463300
RAILWAY INFORMATION	Passenger ☎ 467777	Freight/Parcels ☎ 50808		LOCAL RADIO	Swansea Sound 257m/1170 kHz VHF 95.1 MHz		
BUS/COACH INFORMATION	The Quadrant,Swansea ☎ 41471			INDEPENDENT TV AREA	H T V		153

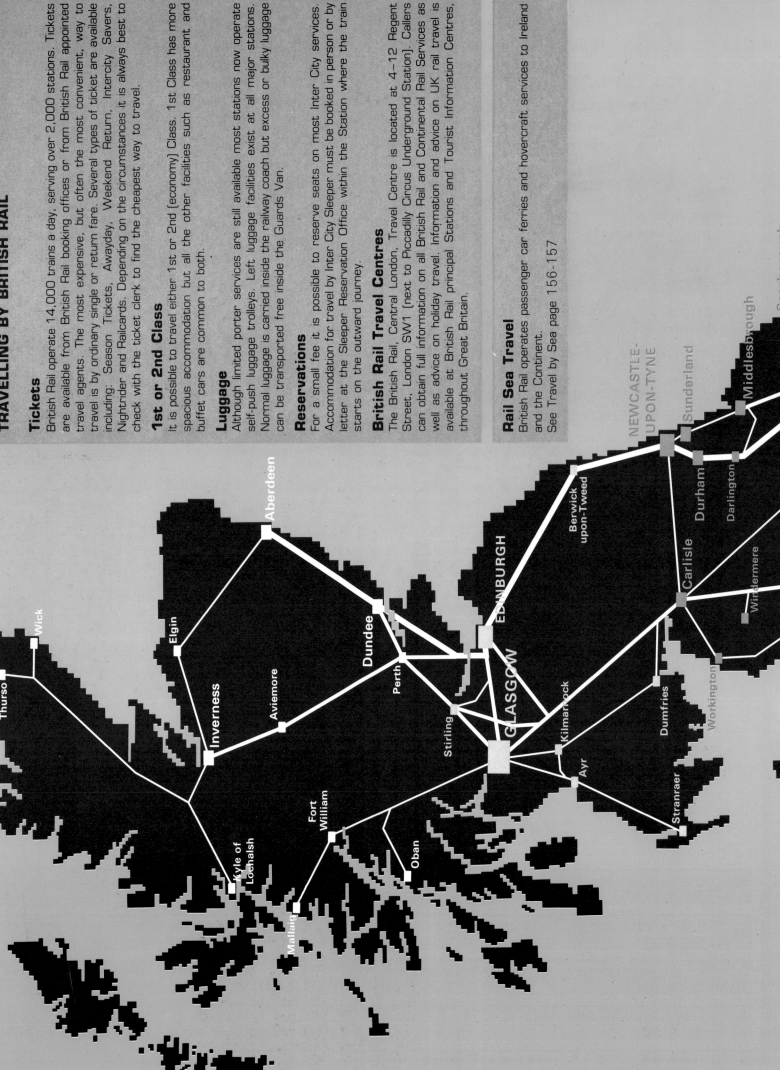

TRAVELLING BY BRITISH RAIL

Tickets

British Rail operate 14,000 trains a day, serving over 2,000 stations. Tickets are available from British Rail booking offices or from British Rail appointed travel agents. The most expensive, but often the most convenient, way to travel is by ordinary single or return fare. Several types of ticket are available including: Season Tickets, Awayday, Weekend Return, Intercity Savers, Nightrider and Railcards. Depending on the circumstances it is always best to check with the ticket clerk to find the cheapest way to travel.

1st or 2nd Class

It is possible to travel either 1st or 2nd (economy) Class. 1st Class has more spacious accommodation but all the other facilities such as restaurant and buffet cars are common to both.

Luggage

Although limited porter services are still available most stations now operate self-push luggage trolleys. Left luggage facilities exist at all major stations. Normal luggage is carried inside the railway coach but excess or bulky luggage can be transported free inside the Guards Van.

Reservations

For a small fee it is possible to reserve seats on most Inter City services. Accommodation for travel by Inter City Sleeper must be booked in person or by letter at the Sleeper Reservation Office within the Station where the train starts on the outward journey.

British Rail Travel Centres

The British Rail, Central London, Travel Centre is located at 4–12 Regent Street, London SW1 (next to Piccadilly Circus Underground Station). Callers can obtain full information on all British Rail and Continental Rail Services as well as advice on holiday travel. Information and advice on UK rail travel is available at British Rail principal Stations and Tourist Information Centres, throughout Great Britain.

Rail Sea Travel

British Rail operates passenger car ferries and hovercraft services to Ireland and the Continent.
See Travel by Sea page 156-157

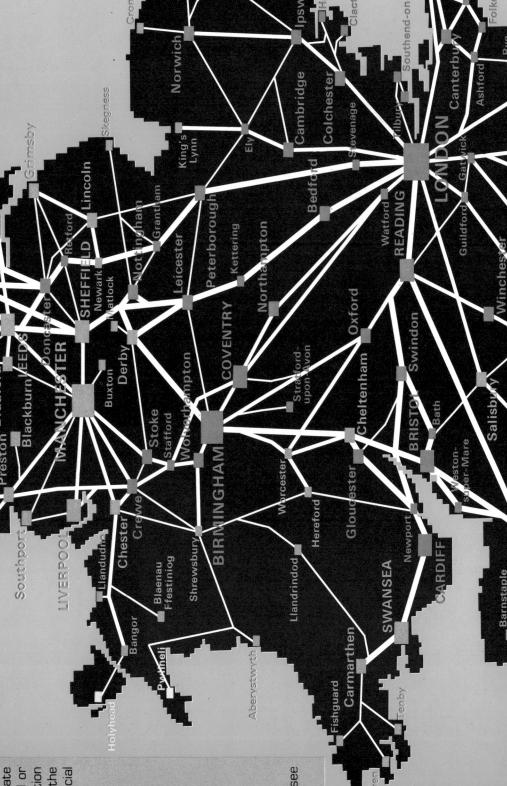

Motorail / Inter City Sleeper Service

Motorail/Inter City Sleeper Services operate from London to Scotland, Northern England or the West Country. Sleeper accommodation with room service is available for the passengers. Vehicles are transported in special covered Motorail vans.

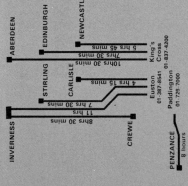

ABERDEEN
EDINBURGH
NEWCASTLE
5 hrs 45 mins
7hrs 30 mins
10hrs 30 mins
INVERNESS
STIRLING
CARLISLE
4 hrs 15 mins
7 hrs 30 mins
11 hrs
8hrs 30 mins
Euston King's
01-387-8541 Cross
Paddington 01-837-4200
01-723-7000
PENZANCE
8 hours
CREWE

For the latest information on Motorail see Prestel page 2211.

LEGEND

125 Inter City
Inter City
Other services

Journey Times from London

Oxford — Under 2hrs.
Salisbury — 2-4 hrs.
Edinburgh — 4-6 hrs.
Aberdeen — Over 6hrs.

Rail-Drive Car Hire

National car rental companies either have offices or will deliver hire cars to the principal British Rail Stations throughout Great Britain. In conjunction with Godfrey Davis Europcar, British Rail offer discount car hire at 73 main line stations.
See Car Hire page 16

RAILAIR/COACH LINKS

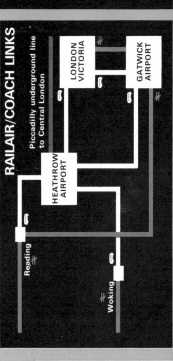

Piccadilly underground line to Central London

HEATHROW AIRPORT
LONDON VICTORIA
GATWICK AIRPORT
Reading
Woking

INTER-TERMINAL LINKS BY UNDERGROUND

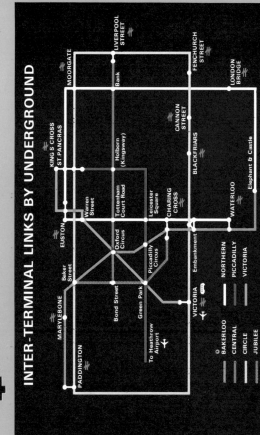

MOORGATE
LIVERPOOL STREET
KING'S CROSS
ST PANCRAS
Bank
FENCHURCH STREET
CANNON STREET
LONDON BRIDGE
BLACKFRIARS
Holborn (Kingsway)
EUSTON
Warren Street
Tottenham Court Road
Leicester Square
CHARING CROSS
Elephant & Castle
MARYLEBONE
Baker Street
Bond Street
Oxford Circus
Piccadilly Circus
Embankment
WATERLOO
PADDINGTON
To Heathrow Airport
Green Park
VICTORIA

BAKERLOO
CENTRAL
CIRCLE
JUBILEE
NORTHERN
PICCADILLY
VICTORIA

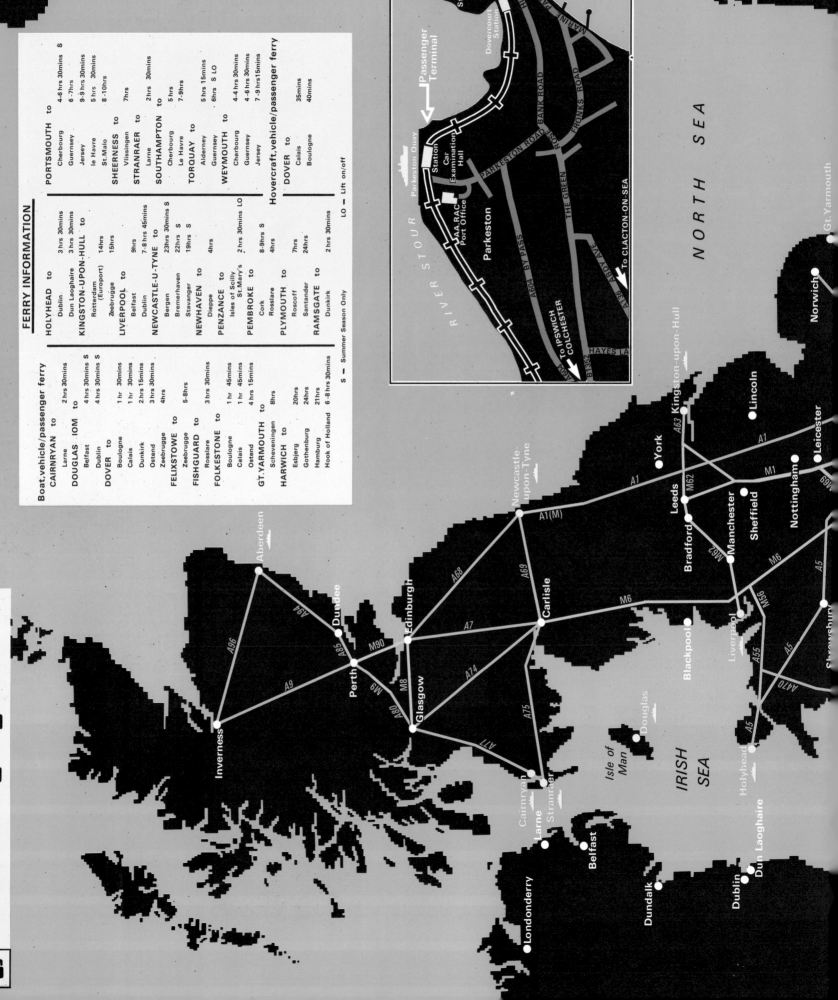

FERRY INFORMATION

Boat, vehicle/passenger ferry

CAIRNRYAN	to	
	Larne	2 hrs 30mins
DOUGLAS IOM	to	
	Belfast	4 hrs 30mins S
	Dublin	4 hrs 30mins S
DOVER	to	
	Boulogne	1 hr 30mins
	Calais	1 hr 30mins
	Dunkirk	2 hrs 15mins
	Ostend	3 hrs 30mins
	Zeebrugge	4hrs
FELIXSTOWE	to	
	Zeebrugge	5-8hrs
FISHGUARD	to	
	Rosslare	3 hrs 30mins
FOLKESTONE	to	
	Boulogne	1 hr 45mins
	Calais	1 hr 45mins
	Ostend	4 hrs 15mins
GT. YARMOUTH	to	
	Scheveningen	8hrs
HARWICH	to	
	Esbjerg	20hrs
	Gothenburg	24hrs
	Hamburg	21hrs
	Hook of Holland	6-8 hrs 30mins

HOLYHEAD	to	
	Dublin	3 hrs 30mins
	Dun Laoghaire	3 hrs 30mins
KINGSTON-UPON-HULL	to	
	Rotterdam (Europort)	14hrs
	Zeebrugge	15hrs
LIVERPOOL	to	
	Belfast	9hrs
	Dublin	7-8 hrs 45mins
NEWCASTLE-U-TYNE	to	
	Bergen	23hrs 30mins S
	Bremerhaven	22hrs S
	Stavanger	19hrs S
NEWHAVEN	to	
	Dieppe	4hrs
PENZANCE	to	
	Isles of Scilly St. Mary's	2 hrs 30mins LO
PEMBROKE	to	
	Cork	8-9hrs S
	Rosslare	4hrs
PLYMOUTH	to	
	Roscoff	7hrs
	Santander	24hrs
RAMSGATE	to	
	Dunkirk	2 hrs 30mins

PORTSMOUTH	to	
	Cherbourg	4-6 hrs 30mins S
	Guernsey	6-7hrs
	Jersey	9-9 hrs 30mins
	le Havre	5 hrs 30mins
	St. Malo	8-10hrs
SHEERNESS	to	
	Vlissingen	7hrs
STRANRAER	to	
	Larne	2 hrs 30mins
SOUTHAMPTON	to	
	Cherbourg	5 hrs
	Le Havre	7-9hrs
TORQUAY	to	
	Alderney	5 hrs 15mins
	Guernsey	6hrs S LO
WEYMOUTH	to	
	Cherbourg	4-4 hrs 30mins
	Guernsey	4-6 hrs 30mins
	Jersey	7-9 hrs15mins

Hovercraft, vehicle/passenger ferry

DOVER	to	
	Calais	35mins
	Boulogne	40mins

LO — Lift on/off
S — Summer Season Only

HARWICH

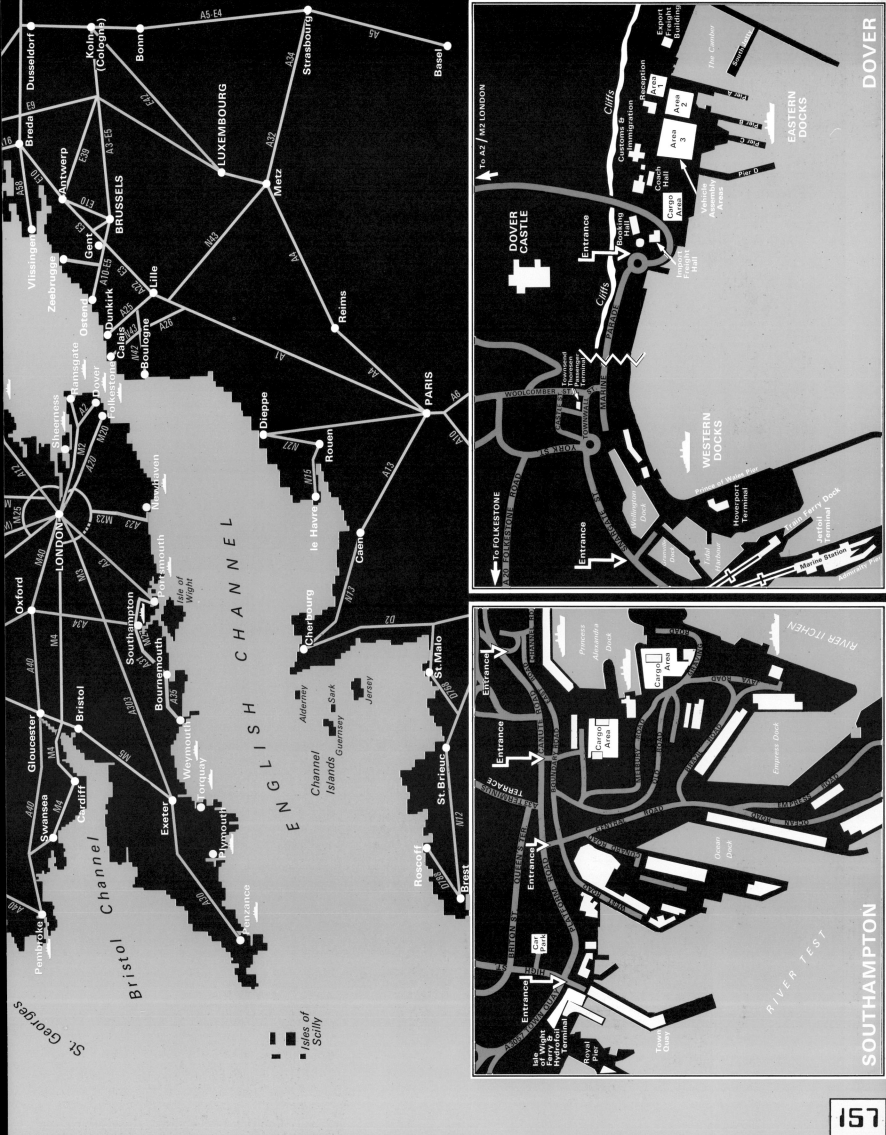

A5-E4

Dusseldorf
Koln (Cologne)
Bonn
Strasbourg
Basel
A5

LUXEMBOURG
Metz
A32
A34
A4
Reims
Breda
A16
E63
Antwerp
E39
BRUSSELS
Gent
E40
Vlissingen
Zeebrugge
Ostend
Lille
A10-E5
E3
A58
Dunkirk
A25
Calais
N43
Ramsgate
Folkestone
Boulogne
N42
A26
Sheerness
Dover
A2
M2
M20
A20
A1
A4
A12
A28
A34
M40
M4
M3
M25(M)
LONDON
Oxford
Dieppe
N27
Rouen
N15
PARIS
A6
A13
A10
Caen
N13
Cherbourg
D2
Newhaven
A23
M23
Portsmouth
Isle of Wight
le Havre
Southampton
A31
M27
Bournemouth
A35
A303
Bristol
Gloucester
A40
Swansea
Cardiff
M4
Pembroke
A40
ENGLISH CHANNEL
Weymouth
Torquay
Exeter
A30
Plymouth
A38
Penzance
Isles of Scilly
St Georges Channel
Bristol Channel
Alderney
Sark
Guernsey
Jersey
Channel Islands
St.Malo
D768
D786
St.Brieuc
N12
Roscoff
D788
Brest

DOVER

To A2 / M2 LONDON
Cliffs
DOVER CASTLE
Customs & Immigration
Reception
Area 1
Area 2
Area 3
Export Freight Building
The Camber
South Jetty
Pier A
Pier B
Pier C
Pier D
EASTERN DOCKS
Coach Hall
Cargo Area
Vehicle Assembly Areas
Entrance
Booking Hall
Import Freight Hall
Cliffs
MARINE PARADE
Townsend Thoresen Passenger Terminal
WOOLCOMBER ST
CASTLE ST
TOWNWALL ST
YORK ST
To FOLKESTONE
A20 FOLKESTONE ROAD
SNARGATE ST
Entrance
Wellington Dock
Granville Dock
Tidal Harbour
WESTERN DOCKS
Prince of Wales Pier
Hoverport Terminal
Train Ferry Dock
Jetfoil Terminal
Marine Station
Admiralty Pier

SOUTHAMPTON

RIVER ITCHEN
Princess Alexandra Dock
HERBERT WALKER AVENUE
Cargo Area
DOCK ROAD
Entrance
Entrance
CANUTE ROAD
Cargo Area
MERSEY ROAD
BELVIDERE ROAD
BOUNDARY ROAD
TERMINUS TERRACE
A33 TERMINUS
QUEEN'S TERRACE
Entrance
BRITON ST
PLATFORM ROAD
HIGH ST
CENTRAL ROAD
GATE ROAD
W45 ROAD
Empress Dock
Ocean Dock
Empress Dock
EMPRESS ROAD
OCEAN ROAD
CUNARD ROAD
Car Park
Entrance
A3057 TOWN QUAY
Town Quay
Isle of Wight Ferry & Hydrofoil Terminal
Royal Pier
RIVER TEST

157

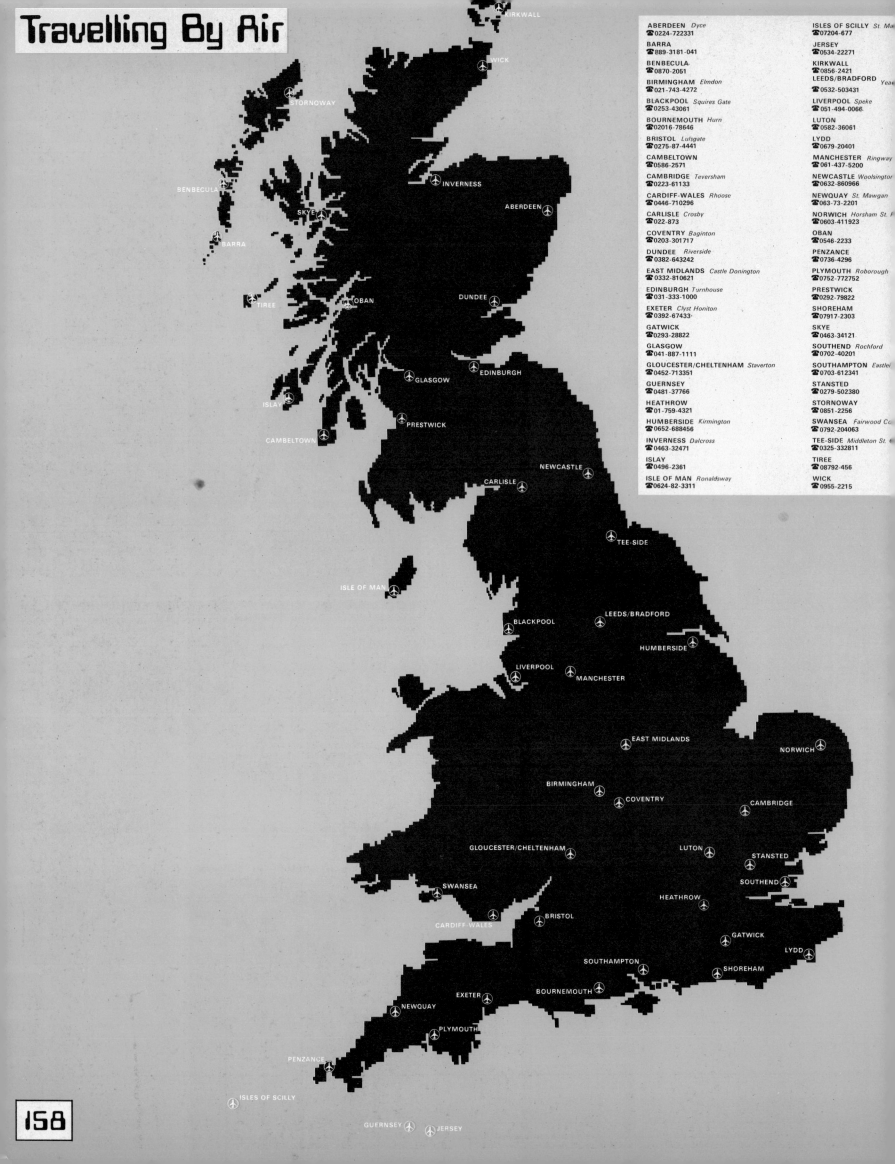

ABERDEEN *Dyce* ☎ 0224-722331	**ISLES OF SCILLY** *St. Ma* ☎ 07204-677
BARRA ☎ 889-3181-041	**JERSEY** ☎ 0534-22271
BENBECULA ☎ 0870-2051	**KIRKWALL** ☎ 0856-2421
BIRMINGHAM *Elmdon* ☎ 021-743-4272	**LEEDS/BRADFORD** *Yea* ☎ 0532-503431
BLACKPOOL *Squires Gate* ☎ 0253-43061	**LIVERPOOL** *Speke* ☎ 051-494-0066
BOURNEMOUTH *Hurn* ☎ 02016-78646	**LUTON** ☎ 0582-36061
BRISTOL *Lulsgate* ☎ 0275-87-4441	**LYDD** ☎ 0679-20401
CAMBELTOWN ☎ 0586-2571	**MANCHESTER** *Ringway* ☎ 061-437-5200
CAMBRIDGE *Teversham* ☎ 0223-61133	**NEWCASTLE** *Woolsington* ☎ 0632-860966
CARDIFF-WALES *Rhoose* ☎ 0446-710296	**NEWQUAY** *St. Mawgan* ☎ 063-73-2201
CARLISLE *Crosby* ☎ 022-873	**NORWICH** *Horsham St. F* ☎ 0603-411923
COVENTRY *Baginton* ☎ 0203-301717	**OBAN** ☎ 0546-2233
DUNDEE *Riverside* ☎ 0382-643242	**PENZANCE** ☎ 0736-4296
EAST MIDLANDS *Castle Donington* ☎ 0332-810621	**PLYMOUTH** *Roborough* ☎ 0752-772752
EDINBURGH *Turnhouse* ☎ 031-333-1000	**PRESTWICK** ☎ 0292-79822
EXETER *Clyst Honiton* ☎ 0392-67433·	**SHOREHAM** ☎ 07917-2303
GATWICK ☎ 0293-28822	**SKYE** ☎ 0463-34121
GLASGOW ☎ 041-887-1111	**SOUTHEND** *Rochford* ☎ 0702-40201
GLOUCESTER/CHELTENHAM *Staverton* ☎ 0452-713351	**SOUTHAMPTON** *Eastle* ☎ 0703-612341
GUERNSEY ☎ 0481-37766	**STANSTED** ☎ 0279-502380
HEATHROW ☎ 01-759-4321	**STORNOWAY** ☎ 0851-2256
HUMBERSIDE *Kirmington* ☎ 0652-688456	**SWANSEA** *Fairwood Co* ☎ 0792-204063
INVERNESS *Dalcross* ☎ 0463-32471	**TEE-SIDE** *Middleton St. G* ☎ 0325-332811
ISLAY ☎ 0496-2361	**TIREE** ☎ 08792-456
ISLE OF MAN *Ronaldsway* ☎ 0624-82-3311	**WICK** ☎ 0955-2215

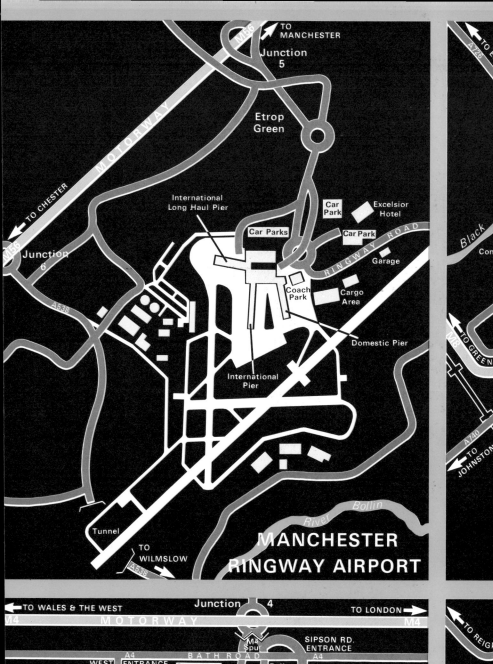

MANCHESTER RINGWAY AIRPORT

To Manchester
M56
Junction 5
Etrop Green
International Long Haul Pier
Car Park
Excelsior Hotel
Car Parks
Car Park
Garage
RINGWAY ROAD
TO CHESTER
A556
Junction 6
A538
Coach Park
Cargo Area
Domestic Pier
International Pier
Tunnel
River Bollin
TO WILMSLOW
A538

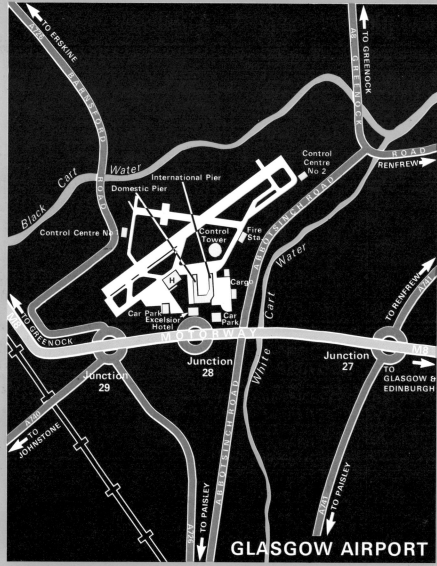

GLASGOW AIRPORT

TO ERSKINE
A726
A8 TO GREENOCK
Black Cart Water
BARNSFORD ROAD
ABBOTSINCH ROAD
RENFREW ROAD
Control Centre No 2
International Pier
Domestic Pier
Control Centre No 1
Control Tower
Fire Sta.
White Cart Water
H
Cargo
TO RENFREW A741
Car Park
Excelsior Hotel
Car Park
M8 TO GREENOCK
MOTORWAY
Junction 29
Junction 28
Junction 27
M8
A740 TO JOHNSTONE
A726
TABBOLSINCH ROAD
A741 TO PAISLEY
TO GLASGOW & EDINBURGH
A741 TO PAISLEY

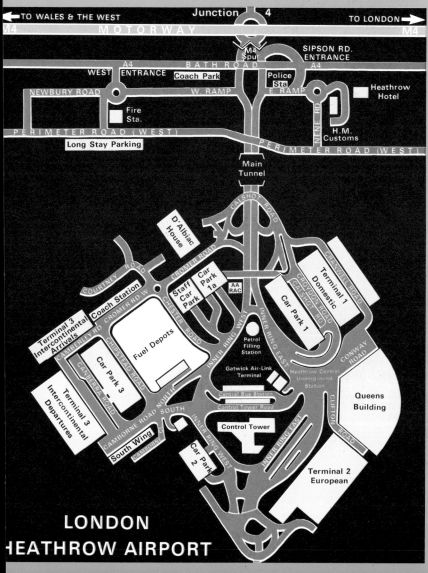

LONDON HEATHROW AIRPORT

TO WALES & THE WEST
Junction 4
TO LONDON
M4 MOTORWAY M4
Main Spur
SIPSON RD. ENTRANCE
A4 BATH ROAD A4
WEST ENTRANCE
Coach Park
Police Sta.
Heathrow Hotel
NEWBURY ROAD
W. RAMP
E. RAMP
Fire Sta.
NINE RD
H.M. Customs
PERIMETER ROAD (WEST)
PERIMETER ROAD (WEST)
Long Stay Parking
Main Tunnel
CALSHOT ROAD
D'Albiac House
Car Park 1a
Staff Car Park
AA RAC
Terminal 1 Domestic
CROMWELL ROAD
CROYDON ROAD
CHESTER ROAD
Terminal 3 Intercontinental Arrivals
Coach Station
COURTNEY ROAD
CROMER ROAD
Fuel Depots
Petrol Filling Station
Car Park 1
CAMBERLEY RD
CHESTER ROAD
Car Park 3
Gatwick Air-Link Terminal
INNER RING EAST
CONWAY ROAD
Heathrow Central Underground Station
Terminal 3 Intercontinental Departures
CAMBERLEY ROAD
Central Bus Station
Queens Building
CAMBORNE ROAD NORTH
Control Tower Road
CLIFTON ROAD
South Wing
Control Tower
INNER RING WEST
INNER RING EAST
Car Park 2
CAMBORNE
Terminal 2 European

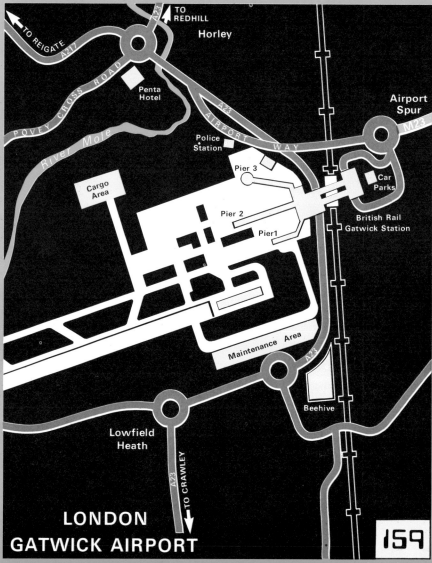

LONDON GATWICK AIRPORT

A22
TO REDHILL
Horley
TO REIGATE A217
A23
Penta Hotel
POVEY CROSS ROAD
AIRPORT WAY
Airport Spur
M23
River Mole
Police Station
Pier 3
Cargo Area
Pier 2
Pier 1
Car Parks
British Rail Gatwick Station
Maintenance Area
A23
Beehive
Lowfield Heath
A23 TO CRAWLEY

159

TRAVELLING BY COACH

Bus or Coach

Many people still consider that a coach is simply a luxury bus used for pri
hire or holiday tours. The distinction between bus and coach can, howe
be more clearly defined. The bus provides an efficient local service
frequent stops to pick up or set down passengers. The coach, as we
providing luxury charter, now operates long-distance scheduled serv
between most of the major towns and cities within the United Kingdom

Coach Routes

Coach services vary in frequency depending on whether it is summer
winter so it is always advisable to check with the coach company or tr
agent before planning the journey.
Coach stations in key towns and cities are designated 'Interchang
Coaches from all over the country stop at these interchanges to a
passengers to change from one coach route to another.

Accommodation

The standard luxury coach seats about 50 passengers in comparative lux
Some services have a WC, wash basin, hostess service for drinks
snacks, piped music and even video films.
On a bus all luggage travels inside; on a coach, however, only hand lugg
travels inside, larger items go in the boot. Because of this it is advisab
tell the driver your destination so that luggage can be loaded in strict r
tion—this saves time on arrival.

Coach Travel

Coach travel has several advantages for the long-distance traveller or reg
commuter:
1. For the individual traveller it is still the cheapest form of passe
travel.
2. Due to the height and window area coach passengers get a good vie
the immediate surroundings. Coaches go through, rather than around,
towns so passengers see the town's façade rather than the more '
street' railway outlook.
3. Coach service is a very personal form of travel. Help is available for
disabled or elderly and in an emergency the coach can stop almost anywh

SCOTTISH BUS GROUP

Up-to-date information on principal Scottish Bus Group express services
is available on PRESTEL.

PRESTEL users should key the numbers below for details of times and
fares; the information is regularly updated, and the "What's New?"
frame gives details of new facilities.

Scottish Title Page	*4681101 #
Express Services Index	*468110103 #
What's New?	*46811015 #
Coach Hire	*46811014 #
Coach Tours	*46811016 #
Brochure Orders	*468110169 #

NATIONAL EXPRESS

The National Express database contains details
of services from London to 450 destinations together with details of
principal services from the list of towns shown below:

Main Index	*34011 #
How to use database	*340114 #
Message Frame	*340116 #
London	*340111 #
Heathrow Airport	*340216 #
Gatwick Airport	*340215 #
Birmingham	*340210 #
Bournemouth	*340211 #
Bristol	*340212 #
Coventry	*340214 #
Leeds	*340217 #
Liverpool	*340200 #
Manchester	*340222 #
Sheffield	*340226 #

LEGEND

- ■ Main Interchange
- London service. High frequency
- London service. Low frequency
- Other daily services. High frequency
- Other daily services. Low frequency

Map labels: Elgin, Inverness, Aberdeen, Fort William, Dundee, Oban, Largs, Kennacraig, GLASGOW, EDINBURGH, Ayr, Ashington, Newcastle-upon-Tyne, Stranraer, Carlisle, Sunderland, Durham, Middlesbrough, Workington, Whitehaven, Scarborough, Barrow-in-Furness, Morecombe, Keighley, York, Kingston-upon-Hull, Fleetwood, Blackpool, Blackburn, Bradford, LEEDS, Preston, Rochdale, Grimsby, Southport, Manchester, Doncaster, Liverpool, Barnsley, Holyhead, Birkenhead, Sheffield, Lincoln, Bangor, Chester, Caernarfon, Stoke, Nottingham, Hunstanton, Sheringham, Derby, King's Lynn, Norwich, Gt. Yarmouth, Shrewsbury, Leicester, Lowestoft, Wolverhampton, Peterborough, BIRMINGHAM, Coventry, Northampton, Cambridge, Ipswich, Hereford, Bedford, Felixstowe, Cardigan, Cheltenham, Luton, Colchester, Haverfordwest, Gloucester, OXFORD, LONDON, Pembroke, Abercynon, Newport, Swindon, Southend on Sea, Swansea, Cardiff, Reading, Margate, Weston Super Mare, BRISTOL, Canterbury, Ilfracombe, Wells, Winchester, Dover, Barnstaple, Southampton, Brighton, Folkestone, Bideford, Bournemouth, Portsmouth, Hastings, Exeter, Eastbourne, Weymouth, Newquay, Torquay, PLYMOUTH, Penzance, Helston

Index to
Travellers Britain
Data File

Abbreviations

Ald.	Alderney	Leics.	Leicester
Angl.	Anglesey	Lincs.	Lincoln
Beds.	Bedford	Loth.	Lothian Region
Berks.	Berkshire	Mld.	Mainland
Bord.	Borders Region	Mer.	Merseyside
Bucks.	Buckingham	M.Glam.	Mid. Glamorgan
Cambs.	Cambridge	N.F.P.	National Forest Park
Cen.	Central Region	N.P.	National Park
C.I.	Channel Islands	N.T.	National Trust
Ches.	Cheshire	Norf.	Norfolk
Cleve.	Cleveland	Northants.	Northampton
Corn.	Cornwall	Northumb.	Northumberland
Cumb.	Cumbria	N.Yorks.	North Yorkshire
Der.	Derby	Notts.	Nottingham
Dev.	Devon	Ork.	Orkney Islands Area
Dor.	Dorset	Oxon.	Oxford
D.& G.	Dumfries & Galloway Region	Shet.	Shetland Islands Area
Dur.	Durham	Salop.	Shropshire
E.Suss.	East Sussex	Som.	Somerset
G.L.	Greater London	S.Glam.	South Glamorgan
Glos.	Gloucester	S.Yorks.	South Yorkshire
Gram.	Grampian Region	Staffs.	Stafford
Grt.M.	Greater Manchester	Stra.	Strathclyde Region
Guern.	Guernsey	Suff.	Suffolk
Gwyn.	Gwynedd	Surr.	Surrey
H.& W.	Hereford & Worcester	Tay.	Tayside Region
Hants.	Hampshire	T.& W.	Tyne & Wear
Herts.	Hertford	War.	Warwick
High.	Highland Region	W.Is.	Western Isles Islands Area
Hum.	Humberside	W.Glam.	West Glamorgan
I.o.M.	Isle of Man	W.Mid.	West Midlands
I.o.W.	Isle of Wight	W.Suss.	West Sussex
Is.o.S.	Isles of Scilly	W.Yorks.	West Yorkshire
Jer.	Jersey	Wilts.	Wiltshire
Lancs.	Lancashire		

Ashley, Hants. B2 24
Ashley, Northants. K5 49
Ashley, Staffs. E4 56
Ashmansworth, Hants. J5 33
Ashmore Park, W.Mid. C4 48
Ashmore, Dor. E3 22
Ashorne, War. B3 40
Ashover, Derby. K2 57
Ashow, War. B2 40
Ashperton, H.&W. F6 51
Ashprington, Dev. F4 21
Ashreigney, Dev. E4 34
Ashtead, Surr. G5 31
Ashton Keynes, Wilts. K4 39
Ashton Street, War. D1 40
Ashton under Hill, H.&W. J6 51
Ashton, Ches. C1 56
Ashton, Corn. C5 18
Ashton, H.&W. E4 50
Ashton, Northants. F3 41
Ashton-in-Makerfield, Grt.M. D4 60
Ashton-under-Lyne, Grt.M. G4 61
Ashton-upon-Mersey, Grt.M. F5 61
Ashurst, W.Suss. H3 25
Ashurstwood, W.Suss. C3 26
Ashwater, Dev. C1 20
Ashwell, Herts. K4 41
Ashwell, Leics. G4 47
Ashwellthorpe, Norf. G5 45
Ashwicken, Norf. C4 44
Askam in Furness, Cumb. E4 68
Askern, S.Yorks. B2 62
Askerswell, Dor. B5 22
Askham Bryan, N.Yorks. D5 64
Askham Richard, N.Yorks. D5 64
Askham Richard, N.Yorks. G6 67
Askham, Cumb. F6 75
Askham, Notts. D5 62
Asklockton, Notts. J1 49
Asknish, Stra. G1 85
Askrigg, N.Yorks. B3 66
Askwith, N.Yorks. D6 66
Aslackby, Lincs. J3 47
Aslacton, Norf. G6 45
Aslockton, Notts. F2 47
Aspatria, Cumb. C5 74
Aspley Guise, Beds. H5 41
Aspull, Grt.M. D4 60
Asselby, Hum. E6 64
Assington, Suff. E4 42
Astbury, Ches. F2 57
Asterley, Salop. D1 50
Astley Abbots, Salop. A4 48
Astley Cross, H.&W. G4 51
Astley Green, Grt.M. E4 60
Astley, H.&W. G4 51
Astley, Salop. C5 56
Astley, War. F5 49
Aston Abbots, Bucks. G6 41
Aston Blank, Glos. A6 40
Aston Botterell, Salop. F2 51
Aston Cantlow, War. K4 51
Aston Clinton, Bucks. E1 30
Aston Crews, H.&W. G2 39
Aston Elamville, Leics. G5 49
Aston Eyre, Salop. F2 51
Aston Flamville, Leics. D6 46
Aston Juxta Mondrum, Ches. D2 56
Aston Magna, Glos. B5 40
Aston on Clun, Salop. D3 50
Aston Rogers, Salop. B6 56
Aston Somerville, H.&W. J6 51
Aston Subedge, Glos. A4 40
Aston Tirrold, Oxon. B3 30
Aston upon Trent, Derby. C3 46
Aston, Ches. D3 56
Aston, Derby. J6 61
Aston, Herts. K6 41
Aston, Oxon. J2 33
Aston, S.Yorks. B4 62
Aston, Salop. C4 56
Aston, Staffs. E3 56
Aston, W.Mid. A6 46
Aston-by-Stone, Staffs. F4 57
Aston-le-Walls, Northants. D3 40
Astwick, Beds. K4 41
Astwood Bank, H.&W. J4 51
Astwood, Bucks. H4 41
Aswarby, Lincs. H2 47
Aswardby, Lincs. J5 63
Athelington, Suff. H2 43
Athelstaneford, Loth. D2 88
Atherington, Dev. E3 34
Atherstone, War. B5 46
Atherton, Grt.M. E4 60
Atlow, Derby. J2 57
Atterby, Lincs. F3 63
Attleborough, Norf. F6 45
Attleborough, War. F5 49
Attlebridge, Norf. G4 45
Atwick, Hum. J4 65
Atworth, Wilts. E5 32
Aubourn, Lincs. E6 62
Auchagallon, Island of Arran D3 82
Auchallater, Gram. C5 100
Aucharnie, Gram. F6 103
Auchenblae, Gram. H5 101
Auchenbrack, D.&G. C6 80
Auchencairn, D.&G. G4 73
Auchencrow, Bord. G4 89
Auchengray, Stra. E4 86
Auchenhalrig, Gram. D4 102
Auchenheath, Stra. C2 80
Auchenreoch Loch, D.&G. H2 73
Auchentiber, Stra. G2 83
Auchgourish, High. B2 100
Auchindrain, Stra. C6 92
Auchindoun, High. C3 104
Auchinleck, Stra. J4 83

Auchintoul, Gram. F2 101
Auchleven, Gram. G2 101
Auchleven, Cen. G3 93
Auchmillan, Stra. H3 83
Auchmithie, Tay. H2 91
Auchnacloich, Stra. C3 92
Auchnafree, Tay. B3 90
Auchnagallin, Gram. K6 105
Auchnagallin, High. B1 100
Auchnagatt, Gram. H6 103
Aucholzie, Gram. E4 100
Auchterarder, Tay. C5 90
Auchterderran, Fife B1 88
Auchtermuchty, Fife E5 90
Auchtertool, Fife B1 88
Auckley, S.Yorks. C3 62
Audenshaw, Grt.M. G5 61
Audlem, Ches. D3 56
Audley, Staffs. E3 56
Auds, Gram. F4 103
Aughton Park, Lancs. C4 60
Aughton, Hum. E5 64
Aughton, Lancs. C4 60
Aughton, S.Yorks. A4 62
Aughton, Wilts. H5 33
Auldearn, High. J5 105
Auldhouse, Stra. B4 86
Aultanrynie, High. D4 109
Aultbea, High. F2 107
Aultmore, Gram. D5 102
Aunk, Dev. J5 35
Aunsby, Lincs. H2 47
Aust, Avon F4 39
Austendike, Lincs. K3 47
Austerfield, S.Yorks. C3 62
Austhorpe, W.Yorks. K2 61
Austrey, War. F4 49
Austwick, N.Yorks. A5 66
Authorpe, Lincs. J4 63
Avebury, Wilts. G4 33
Aveley, Essex D3 28
Avening, Glos. E2 32
Averham, Notts. D6 62
Aveton Gifford, Dev. E5 20
Aviemore, High. A3 100
Avoch, High. G5 105
Avon Dassett, War. C3 40
Avonbridge, Cen. D3 86
Avonmouth, Avon B4 32
Avonwick, Dev. E4 20
Awliscombe, Dev. J5 35
Awre, Glos. G3 39
Awsworth, Notts. D2 46
Axbridge, Som. B5 32
Axford, Wilts. H4 33
Axminster, Dev. K1 21
Axmouth, Dev. K2 21
Aylburton, Glos. F3 39
Aylesbeare, Dev. H2 21
Aylesbury, Bucks. G6 41
Aylesby, Hum. G2 63
Aylesford, Kent E5 28
Aylesham, Kent J2 27
Aylestone, Leics. E5 46
Aylmerton, Norf. G2 45
Aylsham, Norf. G3 45
Aynho, Northants. D5 40
Ayot St. Lawrence, Herts. K6 41
Ayr, Stra. G4 83
Aysgarth, N.Yorks. B3 66
Ayside, Cumb. F3 69
Ayston, Leics. G5 47
Ayton, N.Yorks. K3 67
Ayton, Bord. H4 89
Babbacombe, Dev. G4 21
Babbinswood, Salop. B4 56
Babcary, Som. C2 22
Babel, Dyfed K1 37
Babell, Clwyd H3 59
Babraham, Cambs. B3 42
Back of Keppoch, High. F4 97
Back, Isle of Lewis D1 108
Backaland, Ork. G4 112
Backbarrow, Cumb. F3 69
Backfolds, Gram. J5 103
Backford, Ches. K4 59
Backies, High. H1 105
Backmuir of New Gilston, Fife G5 91
Backwell, Avon B4 32
Backworth, T.&W. C2 76
Bacons End, W.Mid. A6 46
Baconsthorpe, Norf. G2 45
Bacton, H.&W. D1 38
Bacton, Norf. J3 45
Bacton, Suff. F2 43
Bacup, Lancs. F3 61
Badachro, High. F3 107
Badby, Northants. D3 40
Baddeley Green, Staffs. F2 57
Baddesley Ensor, War. E4 48
Baddidarach, High. B5 109
Badeaul, High. A2 104
Badenscoth, Gram. F6 103
Badenyon, Gram. E2 100
Badger, Salop. G1 51
Badgeworth, Glos. H2 39
Badgworth, Som. A6 32
Badingham, Suff. H2 43
Badlipster, High. G3 111
Badluarach, High. G2 107
Badminton, Avon H5 39
Badrallach, High. H2 107
Badsey, H.&W. K6 51
Badsworth, W.Yorks. B1 62
Badwell Ash, Suff. F2 43
Bag Enderby, Lincs. J5 63
Bagby, N.Yorks. F4 67
Bagendon, Glos. J3 39
Bagillt, Clwyd J3 59
Baginton, War. F6 49
Baglan, W.Glam. J4 37
Bagley, Salop. B4 56
Bagnall, Staffs. G3 57
Bagshot, Surr. E5 30
Bagthorpe, Norf. D3 44
Bagthorpe, Notts. D1 46
Bagworth, Leics. G4 49

Bagwy Llydiart, H.&W. E1 38
Baildon, W.Yorks. J1 61
Baile Mor, Isle of Mull C4 94
Baillieston, Stra. B3 86
Bainbridge, N.Yorks. B3 66
Bainton, Cambs. J5 47
Bainton, Hum. G4 65
Bakewell, Derby. J1 57
Bala, Gwyn. G4 55
Balallan, Isle of Lewis C2 108
Balbeg, High. G2 99
Balbeggie, Tay. D3 90
Balblair, High. G4 105
Balby, S.Yorks. B2 62
Balcary Point, D.&G. H4 73
Balchladich, High. B4 109
Balchraggan, High. F6 105
Balchrick, High. C2 109
Balcombe, W.Suss. B3 26
Baldersby, N.Yorks. E4 66
Balderstone, Lancs. E2 60
Balderton, Notts. F1 47
Baldock, Herts. K5 41
Baldrine, I.o M. E4 70
Baldslow, E.Suss. F5 27
Baldwin, I.o M. D4 70
Baldwins Gate, Staffs. E3 56
Bale, Norf. F2 45
Balehelly, Derby. J2 57
Balemartine, Isle of Tiree A3 94
Balephuil, Isle of Tiree A3 94
Balerno, Loth. B3 88
Balfour, Ork. G5 112
Balfron, Cen. A1 86
Balgaveny, Gram. F6 103
Balgedie, Tay. D5 90
Balgray, Tay. F3 91
Balhalgardy, Gram. H2 101
Balham, G.L. B4 28
Balintore, High. H3 105
Balintore, Tay. E1 90
Balivanich, N.Uist B4 108
Balkholm, Hum. F6 65
Balking, Oxon. J3 33
Balkissock, Stra. B1 72
Ball Hill, Hants. J5 33
Ballabeg, I.o M. C5 70
Ballacannell, I.o M. E4 70
Ballachulish, High. K1 95
Ballachulish, Stra. D1 92
Ballajora, I.o M. E3 70
Ballamodha, I.o M. C4 70
Ballantrae, Stra. B1 72
Ballasalla, I.o M. C5 70
Ballater, Gram. E4 100
Ballaugh, I.o M. D3 70
Ballidon, Derby. J2 57
Balliemore, Stra. B4 92
Ballimore, Cen. G4 93
Ballimore, Stra. G2 85
Ballindalloch, Gram. B6 102
Ballingham, H.&W. F1 39
Ballingry, Fife B1 88
Ballinluig, Tay. C2 90
Ballintuim, Tay. D1 90
Balloch, High. G5 105
Balloch, Stra. K2 85
Balloch, Tay. B4 90
Ballochan, Gram. F4 101
Ballochroy, Kintyre E4 84
Balls Cross, W.Suss. G2 25
Ballygown, Isle of Mull E2 94
Ballygrant, Isle of Islay B3 84
Ballymichael, Island of Arran D3 82
Ballymichael, Island of Arran G6 85
Balmaclellan, D.&G. F2 73
Balmae, D.&G. G4 73
Balmedie, Gram. K2 101
Balmerino, Fife F4 91
Balmore, Stra. B3 86
Balmullo, Fife F4 91
Balmurrie, D.&G. C3 72
Balnacoil, High. D6 110
Balnacra, High. G5 107
Balnafoich, High. G6 105
Balnaguard, Tay. C2 90
Balnahard, Isle of Colonsay D6 94
Balnahard, Isle of Mull E3 94
Balnakeil, High. D1 109
Balnapaling, High. H3 105
Balquhidder, Cen. G4 93
Balsall Common, W.Mid. E6 48
Balsall, W.Mid. E6 48
Balscott, Oxon. C4 40
Balsham, Cambs. C3 42
Balterley, Staffs. E3 56
Balthangie, Gram. G5 103
Baltonsborough, Som. B1 22
Balvaird, High. F5 105
Balvicar, Stra. G4 95
Balvraid, High. K1 99
Bamber Bridge, Lancs. D2 60
Bamburgh, Northumb. K3 79
Bamff, Tay. E2 90
Bampton, Cumb. G1 69
Bampton, Dev. H3 35
Bampton, Oxon. J2 33
Banavie, High. D5 98
Banbury, Oxon. D4 40
Banchory Devenick, Gram. J3 101
Banchory, Gram. H4 101
Bancyfelin, Dyfed F2 37
Banff, Gram. F4 103
Bangor, Gwyn. D3 58
Bangor-is-y-coed, Ches. B3 56
Banham, Norf. F6 45
Bank Street, H.&W. F4 51
Bankend, D.&G. B2 74
Bankend, Stra. C3 80
Bankfoot, Tay. D3 90
Bankhead, Gram. J3 101
Banks, Cumb. F3 75
Banks, Lancs. C3 60
Bankshill, D.&G. C1 74

Banningham, Norf. H3 45
Bannister Green, Essex C6 42
Bannockburn, Cen. D1 86
Banstead, Surr. H5 31
Banston, W.Mid. B1 40
Banwell, Avon A5 32
Bapchild, Kent G5 29
Barassie, Stra. G3 83
Barbaraville, High. G3 105
Barber Booth, Derby. H6 61
Barbon, Cumb. H4 69
Barby, Northants. D2 40
Barcombe Cross, E.Suss. C5 26
Barcombe, E.Suss. C5 26
Barden, N.Yorks. C3 66
Bardon Mill, Northumb. H3 75
Bardon, Leics. D4 46
Bardsea, Cumb. F4 69
Bardsey, W.Yorks. B5 64
Bardsey, Grt.M. G4 61
Bardwell, Suff. E2 42
Barford St. Martin, Wilts. G2 23
Barford St. Michael, Oxon. C5 40
Barford, War. B3 40
Bargoed, M.Glam. B3 38
Bargrennan, D.&G. D2 72
Barham, Cambs. J1 41
Barham, Kent J2 27
Barholm, Lincs. J4 47
Barkby, Leics. E4 46
Barkestone, Leics. F2 47
Barking, G.L. C3 28
Barking, Suff. F3 43
Barkingside, G.L. C3 28
Barkisland, W.Yorks. H3 61
Barkston, Lincs. G2 47
Barkston, N.Yorks. C6 64
Barkway, Herts. A5 42
Barlaston, Staffs. F4 57
Barlavington, W.Suss. G3 25
Barlborough, Derby. B4 62
Barlby, N.Yorks. E6 64
Barlestone, Leics. G4 49
Barley, Lancs. F1 61
Barleythorpe, Leics. G4 47
Barling, Essex G3 29
Barlow, Derby. A5 62
Barlow, N.Yorks. E6 64
Barmby Moor, Hum. F4 65
Barmby on the Marsh, Hum. E6 64
Barmer, Norf. D3 44
Barming Heath, Kent E5 28
Barmouth, Gwyn. D5 54
Barmston, Hum. J4 65
Barnack, Cambs. J5 47
Barnacle, War. F5 49
Barnard Castle, Dur. C1 66
Barnburgh, S.Yorks. B2 62
Barnby Dun, S.Yorks. C2 62
Barnby Moor, Notts. C4 62
Barnby, Suff. K6 45
Barnby-in-the-Willows, Notts. E6 62
Barnet, G.L. H2 31
Barnetby le Wold, Hum. F2 63
Barney, Norf. F3 45
Barnham Broom, Norf. G5 45
Barnham, Suff. E1 42
Barnham, W.Suss. G4 25
Barnhead, Tay. H1 91
Barnhill, Gram. B4 102
Barnhills, D.&G. A2 72
Barningham, Dur. C1 66
Barningham, Suff. F1 43
Barnmouth, Bord. H4 89
Barnoldby le Beck, Hum. H2 63
Barnoldswick, Lancs. G1 61
Barns Green, W.Suss. H2 25
Barnsley, Glos. K3 39
Barnsley, S.Yorks. K4 61
Barnstaple, Dev. E3 34
Barnston, Essex C6 42
Barnston, Mer. J3 59
Barnstone, Notts. F2 47
Barnt Green, H.&W. J3 51
Barnton, Ches. D1 56
Barnwell, Northants. H6 47
Barr, Stra. G6 83
Barrachan, D.&G. D4 72
Barras, Gram. J5 101
Barrasford, Northumb. J2 75
Barravullin, Stra. B5 92
Barregarrow, I.o M. D3 70
Barrhead, Stra. A4 86
Barrhead, Stra. H1 83
Barrhill, Stra. C1 72
Barrington, Cambs. A3 42
Barrington, Som. A3 22
Barrmill, Stra. G2 83
Barrock, High. G1 111
Barrow Common, Avon C4 32
Barrow Gurney, Avon B4 32
Barrow Haven, Hum. F1 63
Barrow Hill, Derby. A5 62
Barrow upon Humber, Hum. F1 63
Barrow upon Soar, Leics. E4 46
Barrow upon Trent, Derby. C3 46
Barrow, Lancs. E1 60
Barrow, Leics. G4 47
Barrow, Som. D1 22
Barrow, Suff. D2 42
Barrow-in-Furness, Cumb. E5 68
Barroway Drove, Norf. B5 44
Barrowby, Lincs. G2 47
Barrowcliffe, N.Yorks. H1 65
Barrowden, Leics. H5 47
Barrowford, Lancs. F1 61
Barrowhill, Derby. K1 57
Barry Island, S.Glam. B6 38
Barry, S.Glam. B6 38
Barry, Tay. G3 91
Barsby, Leics. F4 47
Barsham, Suff. J6 45

Barthol Chapel, Gram. J1 101
Barthomley, Ches. E2 56
Bartlow, Cambs. C4 42
Barton Bendish, Norf. D5 44
Barton Common, Norf. J3 45
Barton End, Glos. E2 32
Barton Hartshorn, Bucks. E5 40
Barton in Fabis, Notts. D3 46
Barton in the Beans, Leics. F4 49
Barton Mills, Suff. D2 42
Barton Seagrave, Northants. G1 41
Barton St. David, Som. B1 22
Barton under Needwood, Staffs. E3 48
Barton, Cambs. A3 42
Barton, Ches. C2 56
Barton, Glos. A5 40
Barton, Lancs. D1 60
Barton, N.Yorks. D1 66
Barton-in-the-Clay, Beds. J5 41
Barton-le-Street, N.Yorks. E2 64
Barton-le-Willows, N.Yorks. H5 67
Barton-on-Sea, Hants. A5 24
Barton-on-the-Heath, War. B5 40
Barton-upon-Humber, Hum. F1 63
Barugh, S.Yorks. K4 61
Barvas, Isle of Lewis D1 108
Barway, Cambs. B1 42
Barwell, Leics. G4 49
Barwick in Elmet, W.Yorks. C5 64
Barwick, Som. C3 22
Baschurch, Salop. C5 56
Bascote, War. C2 40
Basford Green, Staffs. G2 57
Bashall Eaves, Lancs. E1 60
Basildon, Berks. B4 30
Basildon, Essex E3 28
Basing, Hants. C6 30
Basingstoke, Hants. C6 30
Baslow, Derby. J1 57
Bassaleg, Gwent C4 38
Bassels Leigh, Oxon. K2 33
Bassenthwaite, Cumb. D5 74
Bassett, Hants. B3 24
Bassingfield, Notts. E2 46
Bassingham, Lincs. G1 47
Bassingthorpe, Lincs. H3 47
Baston, Lincs. J4 47
Bastwick, Norf. J4 45
Batchworth, Herts. F2 31
Batcombe, Dor. C4 22
Batcombe, Som. D1 22
Bate Heath, Ches. E6 60
Bath, Avon D5 32
Bathampton, Avon D5 32
Bathealton, Som. J3 35
Batheaston, Avon D4 32
Bathford, Avon D4 32
Bathgate, Loth. E3 86
Bathley, Notts. D6 62
Bathpool, Som. K3 35
Batley, W.Yorks. J2 61
Batsford, Glos. A5 40
Battersea, G.L. H4 31
Battisford Tye, Suff. F3 43
Battle, E.Suss. E4 26
Battle, Powys A1 38
Battlefield, Salop. C5 56
Battlesbridge, Essex E2 28
Batts Corner, Surr. F1 25
Baughurst, Hants. B5 30
Baumber, Lincs. H5 63
Baunton, Glos. J3 39
Bawburgh, Norf. G4 45
Bawdeswell, Norf. F4 45
Bawdrip, Som. A1 22
Bawdsey, Suff. J4 43
Bawtry, S.Yorks. C3 62
Baxenden, Lancs. F2 61
Bayble, Isle of Lewis D2 108
Baycliff, Cumb. F4 69
Baydon, Wilts. H4 33
Bayford, Herts. H1 31
Bayford, Som. D2 22
Bayford, Herts. B1 28
Bayhead, N.Uist B4 108
Baynards Green, Oxon. D5 40
Bayston Hill, Salop. C6 56
Beachampton, Bucks. F4 41
Beachley, Glos. F4 39
Beaconsfield, Bucks. E3 30
Beadlam, N.Yorks. G3 67
Beadnell, Northumb. K3 79
Beaford, Dev. E4 34
Beal, N.Yorks. B1 62
Beal, Northumb. J2 79
Beaminster, Dor. B4 22
Beamish, Dur. C4 76
Beamsley, N.Yorks. C6 66
Beanacre, Wilts. E5 32
Beanley, Northumb. J4 79
Beardon, Dev. D2 20
Beare Green, Surr. A2 26
Bearley Cross, War. A3 40
Bearley, War. A3 40
Bearsbridge, Northumb. H3 75
Bearsden, Stra. A3 86
Bearsted, Kent F5 29
Beattock, D.&G. A6 78
Beaufort, Gwent C2 38
Beaulieu, Hants. B4 24
Beauly, High. F5 105
Beaumaris, Angl. D3 58
Beaumont, Cumb. E3 74
Beaumont, Essex G5 43
Beausale, War. B2 40

Place	Ref
Beauvale, Notts.	D1 46
Beauworth, Hants.	D2 24
Beaworthy, Dev.	D5 34
Bebington, Mer.	K3 59
Beccles, Suff.	J6 45
Becconsall, Lancs.	C3 60
Beck Foot, Cumb.	H2 69
Beck Hole, N.Yorks.	J2 67
Beckbury, Salop.	A4 48
Beckbury, Salop.	G1 51
Beckenham, G.L.	B4 28
Beckermet, Cumb.	C2 68
Beckfoot, Cumb.	C4 74
Beckford, H.&W.	J6 51
Beckhampton, Wilts.	G4 33
Beckingham, Lincs.	E6 62
Beckingham, Notts.	D3 62
Beckington, Som.	E6 32
Beckley, E.Suss.	F4 27
Beckley, Oxon.	B1 30
Beckrow, Suff.	C1 42
Beckwithshaw, N.Yorks.	B4 64
Becontree, G.L.	C3 28
Becuvale, Notts.	G1 49
Bedale, N.Yorks.	D3 66
Beddau, M.Glam.	B5 38
Beddgelert, Gwyn.	D3 54
Beddingham, E.Suss.	C5 26
Bedfield, Suff.	H2 43
Bedford, Beds.	H3 41
Bedhampton, Hants.	E4 24
Bedlington, Northumb.	C1 76
Bedlinog, M.Glam.	B3 38
Bedminster, Avon	C4 32
Bedminster Down, Avon	C4 32
Bedmond, Herts.	F2 31
Bednall, Staffs.	C3 48
Bedrule, Bord.	E4 78
Bedstone, Salop.	D3 50
Bedwas, M.Glam.	C4 38
Bedworth, War.	F5 49
Bedworth Heath, War.	F5 49
Beeby, Leics.	H4 49
Beech Hill, Berks.	C5 30
Beech, Hants.	D1 24
Beech, Staffs.	F4 57
Beechamwell, Norf.	D5 44
Beechpike, Glos.	F1 33
Beedon Hill, Berks.	B4 30
Beedon, Berks.	A4 30
Beeford, Hum.	H4 65
Beeham, Berks.	B4 30
Beelsby, Hum.	G2 63
Beenham, Berks.	C5 30
Beer Crocombe, Som.	A2 22
Beer, Dev.	J2 21
Beesby, Lincs.	K4 63
Beeston Regis, Norf.	G2 45
Beeston, Beds.	J4 41
Beeston, Ches.	C2 56
Beeston, Notts.	D2 46
Beeswing, D.&G.	H2 73
Beetham, Cumb.	G4 69
Beetley, Norf.	F4 45
Begbroke, Oxon.	A1 30
Begdale, Cambs.	B5 44
Begelly, Dyfed	D3 36
Beguildy, Powys	C3 50
Beighton, Norf.	J5 45
Beighton, S.Yorks.	A4 62
Beith, Stra.	K4 85
Bekesbourne, Kent	J5 29
Belbroughton, H.&W.	H3 51
Belchamp St. Paul, Essex	D4 42
Belchford, Lincs.	H5 63
Belford, Northumb.	J3 79
Belhalvie, Gram.	K2 101
Bell Bar, Herts.	H1 31
Bell Busk, N.Yorks.	A6 66
Bellanoch, Stra.	F1 85
Belle Isle, W.Yorks.	K2 61
Belle Vue, W.Yorks.	K3 61
Belleau, Lincs.	J4 63
Bellehiglash, Gram.	D1 100
Bellerby, N.Yorks.	C3 66
Belliehill, Tay.	H1 91
Bellingham, Northumb.	H1 75
Bellington, Bucks.	E1 30
Bellochantuy, Kintyre	B3 82
Bells Yew Green, E.Suss.	D3 26
Bellsbank, Stra.	H5 83
Bellshill, Northumb.	J3 79
Bellshill, Stra.	C4 86
Bellshill, Stra.	K1 83
Bellspool, Bord.	F3 81
Belluton, Avon	C5 32
Bellymore, Stra.	C1 72
Belmaduthy, High.	G5 105
Belmesthorpe, Leics.	H4 47
Belmont, G.L.	H5 31
Belmont, Lancs.	E3 60
Belmont, Shet.	E1 112
Belnacraig, Gram.	E2 100
Belper, Derby.	K3 57
Belperlane End, Derby.	K3 57
Belsay, Northumb.	B2 76
Belses, Bord.	E4 78
Belstead, Suff.	G4 43
Belston, Stra.	G4 83
Belstone Corner, Dev.	E5 34
Belstone, Dev.	D2 20
Belthorn, Lancs.	E2 60
Beltinge, Kent	J4 29
Beltoft, Hum.	D2 62
Belton, Hum.	D2 62
Belton, Leics.	D4 46
Belton, Lincs.	G2 47
Belton, Norf.	K5 45
Beltring, Kent	E2 26
Belvoir, Leics.	F2 47
Bembridge, I.o.W.	D5 24
Bemersyde, Bord.	E3 78
Bempton, Hum.	J3 65
Ben Rhydding, W.Yorks.	A5 64
Benacre, Suff.	K1 43
Benbuie, D.&G.	B6 80
Benderloch, Stra.	B3 92
Benefield, Northants.	H6 47
Benenden, Kent	F3 27
Benfield, D.&G.	D3 72
Bengeo, Herts.	B1 28
Benholm, Gram.	J6 101
Beningbrough, N.Yorks.	D4 64
Benington, Herts.	K6 41
Benington, Lincs.	A1 44
Benllech, Angl.	C3 58
Bennacott, Corn.	C6 34
Bennan, Island of Arran	D4 82
Bennane Head, Stra.	B1 72
Benniworth, Lincs.	G4 63
Benson, Oxon.	C2 30
Benthall, Salop.	A4 48
Bentham, Glos.	H2 39
Bentley Heath, W.Mid.	A1 40
Bentley, H.&W.	J4 51
Bentley, Hants.	D6 30
Bentley, Hum.	H6 65
Bentley, S.Yorks.	B2 62
Bentley, War.	E5 48
Bentpath, D.&G.	D1 74
Bentworth, Hants.	D1 24
Benvie, Tay.	F3 91
Benwick, Cambs.	A6 44
Beoley, H.&W.	K4 51
Bepton, W.Suss.	F3 25
Berden, Essex	B5 42
Bere Alston, Dev.	C4 20
Bere Ferrers, Dev.	C4 20
Bere Regis, Dor.	E4 22
Berepper, Corn.	C6 18
Bergh Apton, Norf.	H5 45
Berkeley Heath, Glos.	D2 32
Berkeley, Glos.	G3 39
Berkhamstead, Herts.	F1 31
Berkley, Som.	E6 32
Berkswell, W.Mid.	B1 40
Bermondsey, G.L.	B4 28
Berners Roding, Essex	D1 28
Bernice, Stra.	K6 95
Bernisdale, Isle of Skye	C5 106
Berrick Salome, Oxon.	C2 30
Berriedale, High.	F5 111
Berriew, Powys	C1 50
Berrington, Northumb.	H5 89
Berrington, Salop.	E1 50
Berrow Green, H.&W.	G5 51
Berry Down Cross, Dev.	E2 34
Berry Hill, Glos.	F2 39
Berry Pomeroy, Dev.	F4 21
Berrynarbor, Dev.	E1 34
Bersham, Ches.	B3 56
Bersham, Clwyd	K3 55
Bersted, W.Suss.	F4 25
Berwick Bassett, Wilts.	G4 33
Berwick Hill, Northumb.	B2 76
Berwick St. John, Wilts.	F2 23
Berwick, E.Suss.	C5 26
Berwick-upon-Tweed, Northumb.	H4 89
Besford, H.&W.	H6 51
Bessacarr, S.Yorks.	C2 62
Bessingby, Hum.	J3 65
Bestbeech Hill, E.Suss.	D3 26
Besthorpe, Notts.	D5 62
Beswick, Hum.	H5 65
Betchworth, Surr.	A2 26
Bethel, Gwyn.	C4 58
Bethersden, Kent	G3 27
Bethesda, Gwyn.	D4 58
Bethlehem, Dyfed	J1 37
Bethnal Green, G.L.	H3 31
Betley, Staffs.	E3 56
Betsham, Kent	D4 28
Betteshanger, Kent	K6 29
Bettiscombe, Dor.	A4 22
Bettisfield, Clwyd	C4 56
Betton, Salop.	E4 56
Betton, Staffs.	A1 48
Bettws Bledrws, Dyfed	G5 53
Bettws Gwerfil Goch, Clwyd	H3 55
Bettws Newydd, Gwent	D3 38
Bettws, Gwent	D2 38
Bettws Cedewain, Powys	B1 50
Bettyhill, High.	C2 110
Betws Garmon, Gwyn.	C5 58
Betws, Dyfed	H2 37
Betws, M.Glam.	K4 37
Betws-y-Coed, Gwyn.	F2 55
Betws-yn-Rhos, Clwyd	F3 59
Beulah, Dyfed	D6 52
Beulah, Powys	J5 53
Beverston, Glos.	H4 39
Bevington, Glos.	F4 39
Bewaldeth, Cumb.	C5 74
Bewcastle, Cumb.	F2 75
Bewdley, H.&W.	G3 51
Bewerley, N.Yorks.	C5 66
Bewholme, Hum.	J4 65
Bexhill, E.Suss.	E5 26
Bexley, G.L.	C4 28
Bexleyheath, G.L.	C4 28
Beyton, Suff.	E2 42
Bibury, Glos.	K3 39
Bicester, Oxon.	E6 40
Bickacre, Essex	F2 29
Bickenhill, W.Mid.	A1 40
Bicker Gauntlet, Lincs.	K2 47
Bicker, Lincs.	K2 47
Bickerstaffe, Lancs.	C4 60
Bickerton, Ches.	C2 56
Bickerton, N.Yorks.	C4 64
Bickington, Dev.	E3 34
Bickleigh, Dev.	D4 20
Bickley Moss, Ches.	C3 56
Bickley, G.L.	J4 31
Bicknoller, Som.	J2 35
Bicknor, Kent	F5 29
Bicton, Salop.	C3 50
Bidborough, Kent	D2 26
Biddenden, Kent	F3 27
Biddestone, Wilts.	E4 32
Biddisham, Som.	A6 32
Biddlesden, Bucks.	E4 40
Biddlestone, Northumb.	H5 79
Biddulph Moor, Staffs.	F2 57
Biddulph, Staffs.	F2 57
Bideford, Dev.	D3 34
Bidford-on-Avon, War.	A3 40
Bielby, Hum.	F5 65
Bieldside, Gram.	J3 101
Bierton, Bucks.	G6 41
Big Corlae, D.&G.	B6 80
Big Sand, High.	E3 106
Bigbury, Dev.	E5 20
Bigbury-on-Sea, Dev.	E5 20
Bigby, Lincs.	F2 63
Biggar, Cumb.	E5 68
Biggar, Stra.	E3 80
Biggin Hill, G.L.	C5 28
Biggin, Derby.	H2 57
Biggleswade, Beds.	K4 41
Bighouse, High.	D2 110
Bighton, Hants.	D1 24
Bignor, W.Suss.	G3 25
Bilborough, Notts.	D2 46
Bilbrook, Staffs.	B4 48
Bilbrough, N.Yorks.	D5 64
Bildeston, Suff.	F3 43
Billericay, Essex	E2 28
Billesdon, Leics.	F5 47
Billesley, War.	A3 40
Billingborough, Lincs.	J2 47
Billinge, Mer.	D4 60
Billingford, Norf.	F4 45
Billingham, Cleve.	E6 76
Billinghay, Lincs.	J1 47
Billinghurst, W.Suss.	H2 25
Billington, Beds.	G6 41
Billington, Lancs.	E2 60
Billockby, Norf.	J4 45
Billy Row, Dur.	B5 76
Bilsborrow, Lancs.	D1 60
Bilsby, Lincs.	K4 63
Bilson Green, Glos.	C1 32
Bilsthorpe, Notts.	C6 62
Bilston, W.Mid.	C4 48
Bilstone, Leics.	F4 49
Bilstone, Leics.	K6 57
Bilton, Hum.	J6 65
Bilton, N.Yorks.	C4 64
Bilton, War.	D2 40
Bimbister, Ork.	F5 112
Binbrook, Lincs.	H3 63
Bincombe, Dor.	D5 22
Binegar, Som.	C6 32
Binfield, Berks.	D4 30
Bingfield, Northumb.	K2 75
Bingham, Notts.	F2 47
Binham, Norf.	F2 45
Binley, W.Mid.	C1 40
Binton, War.	A3 40
Bintree, Norf.	F3 45
Binweston, Salop.	B6 56
Birch Vale, Derby.	H5 61
Birch, Essex	E6 42
Birch, Grt.M.	F4 61
Bircham Newton, Norf.	D2 44
Bircham Tofts, Norf.	D3 44
Birchanger, Essex	B6 42
Birchfield, W.Mid.	A6 46
Birchgrove, W.Glam.	J4 37
Birchington, Kent	K4 29
Birchover, Derby.	J2 57
Birdham, W.Suss.	F4 25
Birdingbury, War.	C2 40
Birdlip, Glos.	J2 39
Birdsall, N.Yorks.	F3 65
Birdsgreen, Salop.	G2 51
Birdwell, S.Yorks.	K4 61
Birdwood, Glos.	G2 39
Birgham, Bord.	G5 89
Birkdale, Mer.	B3 60
Birkenhead, Mer.	B5 60
Birkenshaw, Stra.	C3 86
Birkhall, Gram.	E4 100
Birkhill Feus, Tay.	F3 91
Birkin, N.Yorks.	D6 64
Birley, H.&W.	E5 50
Birling Gap, E.Suss.	D6 26
Birling, Kent	E5 28
Birling, Northumb.	K5 79
Birlingham, H.&W.	J6 51
Birmingham, W.Mid.	D5 48
Birnam, Tay.	C2 90
Birsemohr, Gram.	F4 101
Birstall, Leics.	H3 49
Birstall, W.Yorks.	J2 61
Birstwith, N.Yorks.	D5 66
Birtley, Northumb.	J2 75
Birtley, T.&W.	C4 76
Birts Street, H.&W.	G6 51
Bisbrooke, Leics.	K4 49
Biscathorpe, Lincs.	H4 63
Bish Mill, Dev.	F3 35
Bisham, Berks.	D3 30
Bishampton, H.&W.	J5 51
Bishop Auckland, Dur.	C6 76
Bishop Burton, Hum.	G5 65
Bishop Middleham, Dur.	C5 76
Bishop Monkton, N.Yorks.	B3 64
Bishop Norton, Lincs.	F3 63
Bishop Sutton, Avon	C5 32
Bishop Thornton, N.Yorks.	B3 64
Bishop Wilton, Hum.	F4 65
Bishopbriggs, Stra.	B3 86
Bishops Cannings, Wilts.	F5 33
Bishops Castle, Salop.	D2 50
Bishops Caundle, Dor.	D3 22
Bishops Cleeve, Glos.	J1 39
Bishops Frome, H.&W.	F5 51
Bishops Hull, Som.	K3 35
Bishops Itchington, War.	C3 40
Bishops Lydeard, Som.	K3 35
Bishops Nympton, Dev.	F3 35
Bishops Offley, Staffs.	E4 56
Bishops Stortford, Herts.	B6 42
Bishops Sutton, Hants.	D2 24
Bishops Tachbrook, War.	B2 40
Bishops Tawton, Dev.	E3 34
Bishops Waltham, Hants.	C3 24
Bishops Wood, Som.	K4 35
Bishops Wood, Staffs.	B3 48
Bishopsbourne, Kent	J2 27
Bishopsteignton, Dev.	G3 21
Bishopston, W.Glam.	H4 37
Bishopstone, Wilts.	H3 33
Bishopsworth, Avon	C4 32
Bishopthorpe, N.Yorks.	D5 64
Bishopton, Dur.	D6 76
Bishopton, Stra.	A3 86
Bishopton, War.	A3 40
Bishton, Gwent	D4 38
Bisley, Glos.	H3 39
Bisley, Surr.	E5 30
Bispham, Lancs.	B1 60
Bissoe, Corn.	D4 18
Bitchfield, Lincs.	H3 47
Bittadon, Dev.	E2 34
Bitterley, Salop.	F3 51
Bitterne, Hants.	B3 24
Bitteswell, Leics.	G5 49
Bitton, Avon	D4 32
Bix, Oxon.	C3 30
Blaby, Leics.	H4 49
Black Bourton, Oxon.	H1 33
Black Callerton, T.&W.	B2 76
Black Corries, High.	E1 92
Black Crofts, Stra.	H3 95
Black Loch, D.&G.	B3 72
Black Mount, Stra.	E2 92
Black Notley, Essex	D6 42
Black Pill, W.Glam.	H4 37
Black Torrington, Dev.	D5 34
Blackacre, D.&G.	K1 73
Blackawton, Dev.	F5 21
Blackborough End, Norf.	C4 44
Blackboys, E.Suss.	C4 26
Blackbrook, Staffs.	E3 56
Blackburn, Gram.	J3 101
Blackburn, Lancs.	E2 60
Blackburn, Loth.	E3 86
Blackden Heath, Ches.	E1 56
Blackdown, Dev.	C3 20
Blackfield, Hants.	B4 24
Blackford, Cumb.	E3 74
Blackford, Som.	C2 22
Blackford, Tay.	B5 90
Blackhall, Dur.	D5 76
Blackheath, Essex	F6 43
Blackheath, W.Mid.	J2 51
Blackley, Grt.M.	F4 61
Blackmill, M.Glam.	A4 38
Blackmoor Gate, Dev.	E2 34
Blackmoor, Avon	B5 32
Blackmoor, Hants.	E2 24
Blackmore End, Essex	D5 42
Blackmore, Essex	D2 28
Blacko, Lancs.	F1 61
Blackpool Gate, Cumb.	F2 75
Blackpool, Lancs.	B1 60
Blackridge, Loth.	D3 86
Blackrock, Isle of Islay	B3 84
Blackrod, Grt.M.	D4 60
Blackshaw, D.&G.	B3 74
Blackthorn, Oxon.	E6 40
Blackthorpe, Suff.	E2 42
Blacktoft, Hum.	E1 62
Blacktop, Gram.	J3 101
Blackwater, Corn.	D4 18
Blackwater, Hants.	D5 30
Blackwater, I.o.W.	C5 24
Blackwater, Suff.	K1 43
Blackwaterfoot, Island of Arran	D4 82
Blackwell, Derby.	D1 46
Blackwell, War.	B4 40
Blackwood Hill, Staffs.	F2 57
Blackwood, Gwent	C4 38
Blackwood, Stra.	C2 80
Blacon, Ches.	K4 59
Bladnoch, D.&G.	E4 72
Bladon, Oxon.	D6 40
Blaen Dyryn, Powys	A6 50
Blaenannerch, Dyfed	D5 52
Blaenau Ffestiniog, Gwyn.	E3 54
Blaenavon, Gwent	C3 38
Blaengarw, M.Glam.	K4 37
Blaengwrach, W.Glam.	G3 37
Blaenplwy, Dyfed	G3 53
Blaenrhondda, W.Glam.	K3 37
Blaenwaun, Dyfed	E1 36
Blagdon, Avon	B5 32
Blaich, High.	C5 98
Blaina, Gwent	C3 38
Blair Atholl, Tay.	K1 93
Blair Drummond, Cen.	J6 93
Blairgowrie, Tay.	D2 90
Blairhall, Fife	E1 86
Blairingone, Tay.	E1 86
Blaisdon, Glos.	G2 39
Blakedown, H.&W.	H3 51
Blakemere, H.&W.	D6 50
Blakeney, Glos.	G3 39
Blakeney, Norf.	F2 45
Blakenhall, Ches.	E3 56
Blakeshall, H.&W.	H3 51
Blakesley, Northants.	E3 40
Blanchland, Northumb.	J4 75
Blandford Forum, Dor.	E4 22
Blankney, Lincs.	F6 63
Blar a'Chaorainn, High.	D6 98
Blarghour, Stra.	C5 92
Blarmachfoldach, High.	D6 98
Blaston, Leics.	K4 49
Blatherwycke, Northants.	H6 47
Blawith, Cumb.	F3 69
Blaxton, S.Yorks.	C3 62
Blaydon, T.&W.	B3 76
Bleadon, Avon	A5 32
Bleasby, Notts.	F1 47
Blebocraigs, Fife	F5 91
Bleddfa, Powys	C4 50
Bledington, Glos.	B6 40
Bledlow, Bucks.	D2 30
Blegbie, Loth.	D3 88
Blencarn, Cumb.	G5 75
Blencogo, Cumb.	C4 74
Blencow, Cumb.	E5 74
Blennerhasset, Cumb.	C5 74
Bletchingdon, Oxon.	D6 40
Bletchingley, Surr.	B2 26
Bletchley, Bucks.	G5 41
Bletchley, Salop.	D4 56
Bletherston, Dyfed	D2 36
Bletsoe, Beds.	H3 41
Blewbury, Oxon.	B3 30
Blickling, Norf.	G3 45
Blidworth, Notts.	E1 46
Blindburn, Northumb.	G5 79
Blindcrake, Cumb.	C5 74
Blindley Heath, Surr.	B2 26
Blindworth, Notts.	C6 62
Blisland, Corn.	G2 19
Blisworth, Northants.	F3 41
Blithbury, Staffs.	A4 46
Blo Norton, Norf.	F1 43
Blockley, Glos.	A5 40
Blofield, Norf.	J4 45
Blore, Staffs.	H3 57
Blossomfield, W.Mid.	A1 40
Blounts Green, Staffs.	A3 46
Bloxham, Oxon.	C5 40
Bloxholm, Lincs.	H1 47
Bloxwich, W.Mid.	C4 48
Bloxworth, Dor.	E4 22
Blubberhouses, N.Yorks.	A4 64
Blundeston, Suff.	K5 45
Blunham, Beds.	J3 41
Blunsdon St. Andrew, Wilts.	G3 33
Bluntisham, Cambs.	A1 42
Blunts, Corn.	J2 19
Blyborough, Lincs.	E3 62
Blyford, Suff.	J1 43
Blymhill, Staffs.	B3 48
Blyth Bridge, Bord.	F5 87
Blyth End, War.	E5 48
Blyth, Northumb.	C1 76
Blyth, Notts.	C4 62
Blythburgh, Suff.	J1 43
Blythe Bridge, Staffs.	G3 57
Blyton, Lincs.	E3 62
Bo'ness, Cen.	E2 86
Boarhills, Fife	H5 91
Boarhunt, Hants.	D4 24
Boarstall, Bucks.	E6 40
Boasley Cross, Dev.	C2 20
Boat of Garten, High.	B2 100
Bobbington, Staffs.	H2 51
Bocking Churchstreet, Essex	D5 42
Boddam, Gram.	K6 103
Bodding, Kent	F5 29
Bodedern, Angl.	B3 58
Bodelwyddan, Clwyd	G3 59
Bodenham, H.&W.	E5 50
Bodewryd, Angl.	B2 58
Bodfari, Clwyd	H4 59
Bodffordd, Angl.	C3 58
Bodfuan, Gwyn.	B4 54
Bodham Street, Norf.	G2 45
Bodiam, E.Suss.	E4 26
Bodicote, Oxon.	D4 40
Bodinnick, Corn.	G3 19
Bodmin, Corn.	G2 19
Bodney, Norf.	D5 44
Bogallan, High.	F5 105
Bogend, Stra.	K6 85
Boghall, Loth.	E3 86
Boghole, High.	J5 105
Bogmuir, Gram.	C4 102
Bogniebrae, Gram.	E5 102
Bognor Regis, W.Suss.	F4 25
Bogton, Gram.	F5 103
Bolam, Dur.	B6 76
Bolam, Northumb.	B1 76
Bolberry, Dev.	E6 20
Boldon, T.&W.	D3 76
Boldre, Hants.	B4 24
Boldron, Dur.	B1 66
Bole, Notts.	D4 62
Bolehill, Derby.	B1 46
Bolehill, S.Yorks.	A4 62
Bolham Water, Dev.	K4 35
Bolham, Dev.	H4 35
Bollington, Ches.	E5 60
Bolney, W.Suss.	A4 26
Bolnhurst, Beds.	J3 41
Bolshan, Tay.	H2 91
Bolsover, Derby.	B5 62
Bolsterstone, S.Yorks.	K5 61
Boltby, N.Yorks.	F3 67
Bolton Abbey, N.Yorks.	C6 66
Bolton by Bowland, Lancs.	J6 69
Bolton Percy, N.Yorks.	D5 64
Bolton, Grt.M.	G6 75
Bolton, Grt.M.	E4 60
Bolton, Hum.	F4 65
Bolton, Loth.	D3 88
Bolton, Northumb.	J5 79
Bolton-by-Bowland, Lancs.	A6 66
Bolton-le-Sands, Lancs.	G5 69
Bolton-on-Swale, N.Yorks.	D2 66
Bolton-upon-Dearne, S.Yorks.	A2 62
Boltonfellend, Cumb.	F2 75
Boltongate, Cumb.	D5 74
Bolventor, Corn.	G1 19
Bomere Heath, Salop.	C5 56
Bonar Bridge, High.	F2 105
Bonawe Quarries, Stra.	C3 92
Bonby, Hum.	F1 63
Boncath, Dyfed	D6 52
Bonchester Bridge, Bord.	E5 78
Bonchurch, I.o.W.	D6 24
Bondgate, N.Yorks.	D6 64
Bondleigh, Dev.	E5 34
Bonehill, Staffs.	J6 57
Bonhill, Stra.	K2 85

Place	Ref		Place	Ref		Place	Ref
Bryneglwys, Clwyd	J3 55		Burley, Hants.	A4 24		Butt Green, Ches.	D2 56
Brynford, Clwyd	J3 59		Burley, Leics.	G4 47		Butterburn, Cumb.	G2 75
Bryngwran, Angl.	B3 58		Burleydam, Ches.	D3 56		Buttercrambe, N.Yorks.	E4 64
Bryngwyn, Gwent	D3 38		Burlton, Salop.	C5 56		Butterknowle, Dur.	B6 76
Bryngwyn, Powys	C5 50		Burmarsh, Kent	H3 27		Butterleigh, Dev.	H5 35
Brynhoffnant, Dyfed	E5 52		Burmington, War.	B4 40		Buttermere, Cumb.	E1 68
Brynna, M.Glam.	A5 38		Burn, N.Yorks.	D6 64		Buttershaw, W.Yorks.	J2 61
Brynrefail, Angl.	C2 58		Burnage, Grt.M.	F5 61		Butterstone, Tay.	D2 90
Brynsiencyn, Angl.	C4 58		Burnaston, Derby.	B3 46		Butterton, Staffs.	H2 57
Brynsiencyn, Gwyn.	C1 54		Burnby, Hum.	F5 65		Butterwick, Lincs.	A2 44
Brynteg, Angl.	C3 58		Burncross, S.Yorks.	K5 61		Butterwick, N.Yorks.	G3 65
Bualintur, Isle of Syke	D2 96		Burneston, N.Yorks.	B2 64		Buttington, Powys	A6 56
Bubbenhall, War.	C2 40		Burnett, Avon	C5 32		Buttocks Booth, Northants.	F2 41
Buccleuch, Bord.	C5 78		Burnfoot, Bord.	D5 78		Buttonoak, H.& W.	A6 48
Buchanty, Tay.	C4 90		Burnham Deepdale, Norf.	D2 44		Buttonoak, Salop.	G3 51
Buchlyvie, Cen.	B1 86		Burnham Market, Norf.	E2 44		Buxhall, Suff.	F3 43
Buckabank, Cumb.	E4 74		Burnham Norton, Norf.	D2 44		Buxted, E.Suss.	C4 26
Buckby Folly, Northants.	E2 40		Burnham Overy, Norf.	E2 44		Buxton Heath, Norf.	G3 45
Buckden, Cambs.	K2 41		Burnham Thorpe, Norf.	E2 44		Buxton, Derby.	H1 57
Buckden, N.Yorks.	B4 66		Burnham, Bucks.	E3 30		Buxton, Norf.	H3 45
Buckerell, Dev.	J5 35		Burnham, Hum.	F1 63		Bwlch, Powys	B2 38
Buckfast, Dev.	E4 20		Burnham-on-Crouch, Essex	G2 29		Bwlch-y-cibau, Powys	J5 55
Buckfastleigh, Dev.	E4 20		Burnhaven, Gram.	K5 103		Bwlch-y-ffrnidd, Powys	B2 50
Buckhorn Weston, Dor.	D2 22		Burnhervie, Gram.	H2 101		Bwlch-y-groes, Dyfed	E1 36
Buckie, Gram.	D4 102		Burnhill Green, Staffs.	G1 51		Bwlch-y-sarnau, Powys	K3 53
Buckingham, Bucks.	F5 41		Burniston, N.Yorks.	K3 67		Bwlchgwyn, Clwyd	A2 56
Buckland Brewer, Dev.	D4 34		Burnley, Lancs.	F2 61		Bwlchtocyn, Gwyn.	B5 54
Buckland Dinham, Som.	D6 32		Burnmouth, Bord.	H1 79		Bwllchllan, Dyfed	G5 53
Buckland Filleigh, Dev.	D4 34		Burnopfield, Dur.	B3 76		Byers Green, Dur.	C5 76
Buckland in the Moor, Dev.	E3 20		Burnsall, N.Yorks.	B5 66		Byfield, Northants.	D3 40
Buckland Newton, Dor.	D4 22		Burnside of Duntrune, Tay.	G3 91		Byfleet, Surr.	F5 31
Buckland, Bucks.	E1 30		Burnside, Stra.	J5 83		Byford, H.& W.	D6 50
Buckland, Dev.	C4 20		Burnside, Tay.	G2 91		Bygrave, Herts.	K5 41
Buckland, Herts.	A5 42		Burnt Yates, N.Yorks.	D5 66		Byland Abbey, N.Yorks.	D2 64
Buckland, Oxon.	J2 33		Burntcommon, Surr.	F5 31		Bylchau, Clwyd	G4 59
Bucklebury, Berks.	B4 30		Burntisland, Fife	G2 87		Byley, Ches.	E1 56
Bucklesham, Suff.	H4 43		Burntwood, Staffs.	D3 48		Bythorn, Cambs.	H1 41
Buckley, Clwyd	J4 59		Burpham, W.Suss.	G3 25			
Buckminster, Leics.	G3 47		Burradon, Northumb.	H5 79		Cabourne, Lincs.	G2 63
Bucknall, Lincs.	G5 63		Burradon, T.& W.	C2 76		Cabrach, Gram.	E1 100
Bucknall, Staffs.	F3 57		Burravoe, Shet.	D2 112		Cadbury, Dev.	G1 21
Bucknell, Oxon.	D5 40		Burrelton, Tay.	E3 90		Cadbury, Dev.	H5 35
Bucknell, Salop.	D3 50		Burrill, N.Yorks.	D3 66		Cadder, Stra.	B3 86
Bucks Cross, Dev.	C3 34		Burringham, Hum.	E2 62		Caddington, Beds.	H6 41
Bucks Green, W.Suss.	H2 25		Burrington, Avon	B5 32		Caddonfoot, Bord.	D3 78
Bucksburn, Gram.	J3 101		Burrington, Dev.	E4 34		Cadeby, Leics.	C5 46
Buckton, Hum.	J3 65		Burrington, H.& W.	E3 50		Cadeleigh, Dev.	H5 35
Buckton, Northumb.	J3 79		Burrough Green, Cambs.	C3 42		Cadishead, Grt.M.	E5 60
Buckworth, Cambs.	J1 41		Burrough on the Hill, Leics.	F4 47		Cadle, W.Glam.	H4 37
Budby, Notts.	C5 62		Burrow Head, D.& G.	E5 72		Cadmore End, Bucks.	D2 30
Bude, Corn.	B5 34		Burrowhill, Surr.	E5 30		Cadnam, Hants.	A3 24
Budlake, Dev.	H5 35		Burry Port, Dyfed	G3 37		Cadney, Hum.	F2 63
Budle, Northumb.	J3 79		Burscough Bridge, Lancs.	C3 60		Cadole, Clwyd	J2 55
Budleigh Salterton, Dev.	H2 21		Burscough, Lancs.	C3 60		Caeathro, Gwyn.	D2 54
Budwith, Hum.	E5 64		Bursea, Hum.	F6 65		Caenby Corner, Lincs.	F3 63
Buerton, Ches.	E3 56		Burshill, Hum.	H5 65		Caeo, Dyfed	G6 53
Bufflers Holt, Bucks.	E5 40		Bursledon, Hants.	C3 24		Caerau, M.Glam.	K4 37
Bugbrooke, Northants.	E3 40		Burslem, Staffs.	F3 57		Caerdeon, Gwyn.	E5 54
Bugle, Corn.	F3 19		Burstock, Dor.	B4 22		Caergeiliog, Angl.	B3 58
Bugthorpe, Hum.	F4 65		Burston, Norf.	G1 43		Caergwrle, Clwyd	B2 56
Builth Road, Powys	K5 53		Burston, Staffs.	G4 57		Caerleon, Gwent	D4 38
Builth Wells, Powys	A5 50		Burstwick, Hum.	J6 65		Caernarfon, Gwyn.	C4 58
Bulby, Lincs.	H3 47		Burton Agnes, Hum.	H3 65		Caerphilly, M.Glam.	B4 38
Bulford, Wilts.	G6 33		Burton Bradstock, Dor.	B5 22		Caersws, Powys	A2 50
Bulkeley, Ches.	C2 56		Burton Coggles, Lincs.	H3 47		Caerwent, Gwent	E4 38
Bulkington, War.	F5 49		Burton Corner, Lincs.	A2 44		Caerwys, Clwyd	H3 59
Bulkington, Wilts.	F5 33		Burton Fleming, Hum.	H3 65		Cage Green, Kent	D2 26
Bulkworthy, Dev.	C4 34		Burton Green, Clwyd	B2 56		Cailliness Point, D.& G.	B5 72
Bull Bay, Angl.	C2 58		Burton Green, W.Mid.	E6 48		Cairnbaan, Stra.	F1 85
Bulley, Glos.	G2 39		Burton Green, War.	B1 40		Cairnborrow, Gram.	D6 102
Bulls Cross, G.L.	H2 31		Burton in Lonsdale, N.Yorks.	H4 69		Cairncross, Gram.	F5 101
Bulmer, Essex	E4 42		Burton Joyce, Notts.	E2 46		Cairndow, Stra.	E5 92
Bulmer, N.Yorks.	E3 64		Burton Latimer, Northants.	G1 41		Cairneyhill, Fife	E1 86
Bulmertye, Essex	E4 42		Burton Lazars, Leics.	F4 47		Cairngaan, D.& G.	B5 72
Bulphan, Essex	D3 28		Burton Leonard, N.Yorks.	E5 66		Cairngarroch, D.& G.	B4 72
Bulwell, Notts.	D2 46		Burton on the Wolds, Leics.	E3 46		Cairnhill, Gram.	F6 103
Bulwick, Northants.	H6 47		Burton Overy, Leics.	E5 46		Cairnie, Gram.	E5 102
Bumbles Green, Essex	C1 28		Burton Pedwardine, Lincs.	J2 47		Cairnorrie, Gram.	H6 103
Bunarkaig, High.	E5 98		Burton Pidsea, Hum.	J6 65		Cairnryan, D.& G.	B2 72
Bunbury, Ches.	D2 56		Burton Salmon, N.Yorks.	C6 64		Caister St. Edmunds, Norf.	H5 45
Bunchrew, High.	F5 105		Burton upon Trent, Staffs.	B3 46		Caister-on-Sea, Norf.	K4 45
Bundalloch, High.	B1 98		Burton, Ches.	B6 60		Caistor, Lincs.	G2 63
Bunessan, Isle of Mull	D4 94		Burton, Dor.	G4 23		Calbourne, I.o.W.	B5 24
Bungay, Norf.	J6 45		Burton, Dyfed	C3 36		Calceby, Lincs.	J5 63
Bunnahabhainn, Isle of Islay	C3 84		Burton, Lincs.	E5 62		Calcot Row, Berks.	C4 30
Bunny, Notts.	E3 46		Burton, Som.	K2 35		Calcott, Kent	J5 29
Buntingford, Herts.	A5 42		Burton, Wilts.	E3 32		Caldbeck, Cumb.	D5 74
Bunwell Street, Norf.	G6 45		Burton-in-Kendal, Cumb.	G4 69		Caldecote Hill, War.	F5 49
Bunwell, Norf.	G6 45		Burton-upon-Stather, Hum.	E1 62		Caldecote, Cambs.	J6 47
Burbage, Derby.	G1 57		Burtonwood, Ches.	D5 60		Caldecott, Leics.	G6 47
Burbage, Leics.	G5 49		Burwardsley, Ches.	C2 56		Calder Bridge, Cumb.	D2 68
Burbage, Wilts.	H5 33		Burwarton, Salop.	F2 51		Calder Mains, High.	F2 111
Burcott, Bucks.	G5 41		Burwash Common, E.Suss.	D4 26		Calder Vale, Lancs.	D1 60
Bures, Essex	E5 42		Burwash Weald, E.Suss.	D4 26		Calderbrook, Grt.M.	G3 61
Burford, Oxon.	H1 33		Burwash, E.Suss.	E4 26		Caldermill, Stra.	B5 86
Burg, Isle of Mull	D2 94		Burwell, Cambs.	C2 42		Caldicot, Gwent	E4 38
Burgh by Sands, Cumb.	D3 74		Burwell, Lincs.	J4 63		Caldwell, Derby.	E3 48
Burgh Castle, Norf.	K5 45		Bury St. Edmunds, Suff.	E2 42		Caldwell, N.Yorks.	D1 66
Burgh Heath, Surr.	H5 31		Bury, Cambs.	K6 47		Caldy, Mer.	J2 59
Burgh le Marsh, Lincs.	K5 63		Bury, Grt.M.	F3 61		Calfsound, Ork.	G4 112
Burgh Next Aylsham, Norf.	H3 45		Bury, Som.	H3 35		Calgary, Isle of Mull	D2 94
Burgh on Bain, Lincs.	H4 63		Bury, W.Suss.	G3 25		Califer, Gram.	K4 105
Burgh St. Margaret, Norf.	J4 45		Burythorpe, N.Yorks.	F3 65		California Cross, Dev.	E5 20
Burgh St. Peter, Norf.	K6 45		Buscot, Oxon.	H2 33		California, Cen.	D2 86
Burghead, Gram.	K3 103		Bush, Corn.	B5 34		California, Norf.	K4 45
Burghfield Common, Berks.	C4 30		Bushbury, Staffs.	F6 57		Calke, Derby.	C3 46
Burghfield, Berks.	C4 30		Bushbury, W.Mid.	C4 48		Callaly, Northumb.	J5 79
Burghill, H.& W.	E6 50		Bushey Heath, Herts.	G2 31		Callander, Cen.	H5 93
Burghwallis, S.Yorks.	B2 62		Bushey, Herts.	G2 31		Callington, Corn.	J2 19
Burham, Kent	E5 28		Bushley, H.& W.	H1 39		Callow Hill, H.& W.	G3 51
Buriton, Hants.	E3 24		Bushton, Wilts.	K5 39		Callow Hill, Wilts.	F3 33
Burland, Ches.	D2 56		Buslingthorpe, Lincs.	F4 63		Callow, H.& W.	E6 50
Burlescombe, Dev.	J4 35		Butcombe, Avon	B5 32		Calmsden, Glos.	F1 33
Burley Gate, H.& W.	F5 51		Butleigh, Som.	B1 22		Calow, Derby.	A5 62
Burley in Wharfedale, W.Yorks.	D6 66		Butlers Hill, Notts.	D1 46		Calne, Wilts.	F4 33
			Butlers Marston, War.	C3 40		Calstone Wellington, Wilts.	F4 33
			Butley, Suff.	J3 43		Calthwaite, Cumb.	F5 75
			Butsfield, Dur.	B4 76		Calton, Staffs.	H3 57
						Calveley, Ches.	D2 56
						Calver, Derby.	J1 57
						Calverhall, Salop.	D4 56
						Calverleigh, Dev.	H4 35
						Calverswall, Staffs.	G3 57
						Calverton, Bucks.	F4 41
						Calverton, Notts.	E1 46
						Calvine, Tay.	J1 93
						Calvine, Tays.	A1 90
						Cam, Glos.	D2 32

Place	Ref		Place	Ref
Camastianavaig, Isle of Skye	D6 106		Carlton le Moorland,	G1 47
Camber, E.Suss.	G4 27		Carlton Miniott, N.Yorks.	E4 66
Camberley, Surr.	E5 30		Carlton Scroop, Lincs.	H2 47
Camberwell, G.L.	H4 31		Carlton, Leics.	F4 49
Camblesforth, N.Yorks.	E6 64		Carlton, N.Yorks.	G3 67
Cambo, Northumb.	K1 75		Carlton, Notts.	E2 46
Cambois, Northumb.	C1 76		Carlton, S.Yorks.	K4 61
Camborne, Corn.	C4 18		Carlton-le-Moorland, Lincs.	E6 62
Cambridge, Cambs.	A3 42		Carlton-on-Trent, Notts.	D5 62
Cambridge, Glos.	G3 39		Carluke, Stra.	D4 86
Cambus, Cen.	D1 86		Carmarthen, Dyfed	F2 37
Cambusbarron, Cen.	C1 86		Carmel, Angl.	B3 58
Cambuslang, Stra.	C5 86		Carmel, Clwyd	H3 59
Camden Town, G.L.	H3 31		Carmel, Gwyn.	C5 58
Cameley, Avon	C5 32		Carmunnock, Stra.	C4 86
Camelford, Corn.	G1 19		Carmyllie, Tay.	G2 91
Camelon, Avon	D5 32		Carnaby, Hum.	J3 65
Camerory, High.	B1 100		Carnach, High.	C1 98
Camerton, Avon	D5 32		Carnbee, Fife	G5 91
Camerton, Cumb.	B6 74		Carnbo, Tay.	C6 90
Camghouran, Tay.	G1 93		Carnforth, Lancs.	G5 69
Cammachmore, Gram.	J4 101		Carnhell Green, Corn.	C4 18
Cammeringham, Lincs.	E4 62		Carno, Powys	A1 50
Camp Town, W.Yorks.	B5 64		Carnock, Fife	E1 86
Campbeltown, Kintyre	B4 82		Carnoustie, Tay.	H3 91
Campmuir, Tay.	E3 90		Carnwath, Stra.	E2 80
Camps Green, Cambs.	C4 42		Carperby, N.Yorks.	B3 66
Campsall, S.Yorks.	B2 62		Carr Shield, Northumb.	H4 75
Campsey Ash, Suff.	H3 43		Carradale, Kintyre	C3 82
Campton, Beds.	J4 41		Carran, High.	C1 92
Camrose, Dyfed	C2 36		Carrbridge, High.	K2 99
Camuslluinie, High.	H1 97		Carreglefn, Angl.	B2 58
Camusnagaul, High.	H2 107		Carrick, Fife	G4 91
Camusteel, High.	E6 106		Carrick, Stra.	E6 92
Camusvrachan, Tay.	H2 93		Carrine, Kintyre	B5 82
Canal Foot, Cumb.	F4 69		Carrington, Grt.M.	E5 60
Canaston Bridge, Dyfed	D2 36		Carrington, Lincs.	H6 63
Candlesby, Lincs.	J5 63		Carrington, Loth.	H4 87
Cane End, Oxon.	C3 30		Carrington, Notts.	E2 46
Canewdon, Essex	F2 29		Carrog, Clwyd	H3 55
Canford Magna, Dor.	F4 23		Carron Bridge, Cen.	C2 86
Canhams Green, Suff.	F2 43		Carron, Gram.	B6 102
Canisbay, High.	H1 111		Carronbridge, D.& G.	D6 80
Canley, W.Mid.	F6 49		Carrutherstown, D.& G.	C2 74
Cannich, High.	F1 99		Carrville, Dur.	C4 76
Cannock Wood, Staffs.	D3 48		Carsaig, Isle of Mull	E4 94
Cannock, Staffs.	C3 48		Carscreugh, D.& G.	C3 72
Canon Bridge, H.& W.	E6 50		Carsegowan, D.& G.	E3 72
Canon Frome, H.& W.	F6 51		Carseriggan, D.& G.	D3 72
Canon Pyon, H.& W.	E5 50		Carsethorn, D.& G.	J3 73
Canonbie, D.& G.	E2 74		Carsfad Loch, D.& G.	F1 73
Canons Ashby, Northants.	E3 40		Carsington, Derby.	J2 57
Canterbury, Kent	H5 29		Carskiey, Kintyre	B5 82
Cantley, Norf.	J5 45		Carsluith, D.& G.	E4 72
Cantley, S.Yorks.	C2 62		Carsphairn, D.& G.	J6 83
Canton, S.Glam.	B5 38		Carstairs Junction, Stra.	E5 86
Canvey, Essex	F3 29		Carstairs, Stra.	D2 80
Canwick, Lincs.	F5 63		Carterton, Oxon.	H1 33
Canworthy Water, Corn.	B6 34		Carterway Heads, Northumb.	A4 76
Caol, High.	K5 97		Carthew, Corn.	F3 19
Caoles, Isle if Tiree	B2 94		Carthorpe, N.Yorks.	E3 66
Capel Bangor, Dyfed	G3 53		Cartmel Fell, Cumb.	G3 69
Capel Betws Lleucu, Dyfed	G5 53		Cartmel, Cumb.	F4 69
Capel Carmel, Gwyn.	A4 54		Carway, Dyfed	G3 37
Capel Coch, Angl.	C3 58		Cashlie, Tay.	G2 93
Capel Curig, Gwyn.	E2 54		Cessington, Oxon.	A1 30
Capel Cynon, Dyfed	E5 52		Castell-y-bwch, Gwent	C4 38
Capel Dewi, Dyfed	F6 53		Casterton, Cumb.	H4 69
Capel Garmon, Gwyn.	F5 59		Castle Acre, Norf.	D4 44
Capel Gwyn, Dyfed	G2 37		Castle Bolton, N.Yorks.	C3 66
Capel Gwynfe, Dyfed	J2 37		Castle Bromwich, W.Mid.	D5 48
Capel Hendre, Dyfed	H3 37		Castle Bytham, Lincs.	H4 47
Capel Isaac, Dyfed	H1 37		Castle Caereinion, Powys	J6 55
Capel Iwan, Dyfed	E1 36		Castle Carrock, Cumb.	F4 75
Capel St. Andrews, Suff.	J4 43		Castle Cary, Som.	C1 22
Capel St. Mary, Suff.	G4 43		Castle Combe, Wilts.	E4 32
Capel, Surr.	A3 26		Castle Donington, Leics.	D3 46
Capel-y-Ffin, Powys	C1 38		Castle Douglas, D.& G.	G3 73
Capenhurst, Ches.	K3 59		Castle Eaton, Wilts.	G2 33
Capheaton, Northumb.	A2 76		Castle Eden, Dur.	D5 76
Cappercleuch, Bord.	G4 81		Castle Frome, H.& W.	F6 51
Capton, Dev.	F5 21		Castle Hedingham, Essex	D5 42
Caputh, Tay.	D3 90		Castle Kennedy, D.& G.	B3 72
Car Colston, Notts.	F2 47		Castle Loch, D.& G.	C4 72
Carbis Bay, Corn.	B4 18		Castle Morris, Dyfed	B1 36
Carbost, Isle of Skye	C5 106		Castle O'er, D.& G.	G6 81
Carbrook, S.Yorks.	A3 62		Castle Rising, Norf.	C3 44
Carbrooke, Norf.	E5 44		Castle Stuart, High.	G5 105
Carburton, Notts.	C5 62		Castlebay, Barra	B6 108
Carcroft, S.Yorks.	B2 62		Castlebythe, Dyfed	C1 36
Cardenden, Fife	E6 90		Castlecary, Bord.	F5 87
Cardeston, Salop.	B6 56		Castlecraig, High.	H3 105
Cardiff, S.Glam.	C5 38		Castleford, W.Yorks.	C6 64
Cardigan, Dyfed	C6 52		Castlehill, Stra.	D4 86
Cardington, Beds.	J4 41		Castlemartin, Dyfed	B4 36
Cardington, Salop.	E2 50		Castlemilk, D.& G.	C2 74
Cardinham, Corn.	G2 19		Castlemorton, H.& W.	G6 51
Cardow, Gram.	B6 102		Castleside, Dur.	K4 75
Cardross, Stra.	K2 85		Castlethorpe, Bucks.	F4 41
Cardurnock, Cumb.	C3 74		Castleton, Derby.	J6 61
Careby, Lincs.	H4 47		Castleton, N.Yorks.	H2 67
Carew, Dyfed	D3 36		Castleton, Stra.	F2 85
Carey, H.& W.	F1 39		Castleton, Dor.	D6 22
Cargenbridge, D.& G.	J2 73		Castletown, High.	G1 111
Cargill, Tay.	D3 90		Castletown, I.o.M.	C5 70
Cargo, Cumb.	E3 74		Castletown, T.& W.	D3 76
Cargreen, Corn.	J2 19		Castley, N.Yorks.	B5 64
Carham, Northumb.	G3 79		Caston, Norf.	E5 44
Carhampton, Som.	H2 35		Castor, Cambs.	J5 47
Carharrack, Corn.	D4 18		Catbrook, Gwent	B2 32
Carie, Tay.	H3 93		Catcliffe, S.Yorks.	A4 62
Cark, Cumb.	F4 69		Catcott, Som.	A1 22
Carland, Corn.	E3 18		Caterham, Surr.	H5 31
Carlby, Lincs.	H4 47		Catfield, Norf.	J3 45
Carlecotes, S.Yorks.	J4 61		Catford, G.L.	B4 28
Carleton Forehoe, Norf.	G5 45		Catforth, Lancs.	C2 60
Carleton Rode, Norf.	G6 45		Cathcart, Stra.	B4 86
Carleton, Lancs.	B1 60		Cathedine, Powys	B1 38
Carleton, W.Yorks.	B1 62		Catlodge, High.	H4 99
Carlisle, Cumb.	E3 74		Catlowdy, Cumb.	E2 74
Carlops, Bord.	F4 87		Caton, Lancs.	G5 69
Carloway, Isle of Lewis	C1 108		Catrine, Stra.	J4 83
Carlton Colville, Suff.	K6 45		Cats Ash, Gwent	D4 38
Carlton Curlieu, Leics.	F5 47			
Carlton Husthwaite, N.Yorks.	C2 64			
Carlton in Cleveland, N.Yorks.	F2 66			
Carlton in Lindrick, Notts.	C4 62			

167

Place	Ref
Clutton, Ches.	C2 56
Clwt-y-Bont, Gwyn.	D2 54
Clydach, Gwent	C2 38
Clydach, W. Glam.	J3 37
Clydebank, Stra.	A3 86
Clydey, Dyfed	E1 36
Clyffe Pypard, Wilts.	G4 33
Clynder, Stra.	J2 85
Clynelish, High.	D6 110
Clynnog-fawr, Gwyn.	C3 54
Clyro, Powys	C6 50
Clyst Honiton, Dev.	G2 21
Clyst Hydon, Dev.	H5 35
Clyst St. George, Dev.	G2 21
Clyst St. Lawrence, Dev.	H5 35
Cnwch Coch, Dyfed	G3 53
Coads Green, Corn.	H1 19
Coalbrookdale, Salop.	D6 56
Coalburn, Stra.	C3 80
Coalcleugh, Northumb.	H4 75
Coaley, Glos.	D2 32
Coalpit Field, War.	F5 49
Coalpit Heath, Avon	D3 32
Coalport, Salop.	E6 56
Coalsnaughton, Cen.	B6 90
Coalsnaughton, Cen.	K6 93
Coalville, Leics.	C4 46
Coalway Lane End, Glos.	C1 32
Coast, High.	G2 107
Coatbridge, Stra.	C3 86
Coates, Cambs.	K5 47
Coates, Glos.	F2 33
Coatsgate, D. & G.	E5 80
Coberley, Glos.	J2 39
Cobham, Kent	E4 28
Cobham, Surr.	F5 31
Cobholm Island, Norf.	K5 45
Cockayne Hatley, Beds.	K3 41
Cockayne, N. Yorks.	G2 67
Cockburnspath, Bord.	F3 89
Cockenzie & Port Seton, Loth.	C2 88
Cockerham, Lancs.	G6 69
Cockermouth, Cumb.	K6 73
Cockfield, Dur.	B6 76
Cockfield, Suff.	E3 42
Cocking, W. Suss.	F3 25
Cockington, Dev.	G4 21
Cocklake, Som.	B6 32
Cockley Cley, Norf.	D5 44
Cockshutt, Salop.	C4 56
Cockthorpe, Norf.	F2 45
Cockwood, Dev.	G3 21
Coddenham, Suff.	G3 43
Coddington, Ches.	C2 56
Coddington, Notts.	G1 47
Codford St. Mary, Wilts.	F1 23
Codford St. Peter, Wilts.	F1 23
Codicote, Herts.	K6 41
Codmore Hill, W. Suss.	G3 25
Codnor, Derby.	K3 57
Codrington, Avon	D4 32
Codsall Wood, Staffs.	B4 48
Codsall, Staffs.	B4 48
Coed-y-Paen, Gwent	D4 38
Coedely, M. Glam.	A5 38
Coedpoeth, Clwyd	A2 56
Coelbren, Powys	K2 37
Coffinswell, Dev.	G4 21
Cofton Hackett, H. & W.	J3 51
Coggeshall, Essex	E6 42
Coille Mhorgil, High.	D4 98
Coity, M. Glam.	K5 37
Colaboll, High.	B6 110
Colaton Raleigh, Dev.	H2 21
Colbost, Isle of Skye	A5 106
Colby, Cumb.	G6 75
Colby, I.o.M.	C5 70
Colby, Norf.	H3 45
Colchester, Essex	F5 43
Cold Ash, Berks.	B4 30
Cold Ashby, Northants.	H6 49
Cold Ashton, Avon	D4 32
Cold Brayfield, Bucks.	G3 41
Cold Higham, Northants.	E3 40
Cold Kirby, N. Yorks.	D2 64
Cold Norton, Essex	F2 29
Cold Overton, Leics.	F4 47
Coldblackie, High.	B2 110
Coldean, E. Suss.	B5 26
Colden Common, Hants.	C2 24
Coldfair Green, Suff.	J3 43
Coldham, Cambs.	A5 44
Coldingham, Bord.	G3 89
Coldrain, Tay.	D6 90
Coldred, Kent	J2 27
Coldridge, Dev.	F5 35
Coldstream, Bord.	G3 79
Coldwaltham, W. Suss.	G3 25
Coldwells Croft, Gram.	G2 101
Coldwells, Gram.	J6 103
Cole Green, Herts.	B1 28
Colebrook, Dev.	F5 35
Coleby, Hum.	E1 62
Coleby, Lincs.	F6 63
Coleford, Dev.	F5 35
Coleford, Glos.	F3 39
Coleford, Som.	D6 32
Colegate-End, Norf.	G1 43
Colehill, Dor.	F4 23
Colemans Hatch, E. Suss.	C3 26
Colemere, Salop.	C4 56
Coleorton, Leics.	F3 49
Colerne, Wilts.	E4 32
Coles, Leics.	D4 46
Colesbourne, Glos.	J2 39
Coleshill, Bucks.	E2 30
Coleshill, Oxon.	H2 33
Coleshill, War.	E5 48
Colgate, W. Suss.	A3 26
Colinsburgh, Fife	G6 91
Colinton, Loth.	G3 87
Colkirk, Norf.	E3 44
Collafirth, Shet.	D2 112
Collamoor Mead, Corn.	B6 34
Collaton St. Mary, Dev.	F4 21
Collessie, Fife	E5 90
Collier Row, G.L.	C3 28
Collier St. Kent	E6 28
Collier Street, Kent	E2 26
Colliers End, Herts.	A6 42
Collieston, Gram.	K1 101
Collin, D. & G.	B2 74
Collingbourne Ducis, Wilts.	H6 33
Collingbourne Kingston, Wilts.	H5 33
Collingham, Notts.	D6 62
Collingham, W. Yorks.	C5 64
Colliston, Tay.	H2 91
Colltree, Northants.	F3 41
Collycroft, War.	F5 49
Collyweston, Northants.	H5 47
Colmonell, Stra.	B1 72
Colmworth, Beds.	J3 41
Coln Rogers, Glos.	K3 39
Coln St. Aldwyn, Glos.	G1 33
Coln St. Dennis, Glos.	G1 33
Colnabaichin, Gram.	D3 100
Colnbrook, Bucks.	F4 31
Colne Engaine, Essex	E5 42
Colne Point, Essex	G6 43
Colne, Cambs.	A1 42
Colne, Lancs.	G1 61
Colney Heath, Herts.	G1 31
Colney Street, Herts.	G2 31
Colney, Norf.	G5 45
Colsterdale, N. Yorks.	C4 66
Colsterworth, Lincs.	G3 47
Colston Bassett, Notts.	F3 47
Coltfield, Gram.	K4 105
Coltishall, Norf.	H4 45
Colton, N. Yorks.	D5 64
Colton, Norf.	G4 45
Colton, Staffs.	D3 48
Colwall Stone, H. & W.	G6 51
Colwell, Northumb.	J2 75
Colwich, Staffs.	C3 48
Colwinston, S. Glam.	A5 38
Colwyn Bay, Clwyd	F3 59
Colyford, Dev.	J2 21
Colyton, Dev.	J2 21
Combe Down, Avon	D5 32
Combe Florey, Som.	J3 35
Combe Hay, Avon	D5 32
Combe Martin, Dev.	E1 34
Combe Raleigh, Dev.	J5 35
Combe St. Nicholas, Som.	A3 22
Combe, Berks.	J5 33
Combe, Corn.	B4 34
Combe, H. & W.	D4 50
Combe, Oxon.	C6 40
Combeinteignhead, Dev.	G3 21
Comberbach, Ches.	E6 60
Comberton, Cambs.	A3 42
Combridge, Staffs.	A2 46
Combrook, War.	B3 40
Combs, Suff.	F3 43
Combwich, Som.	K2 35
Comers, Gram.	G3 101
Commins Coch, Powys	F6 55
Common Coed-y-paen, Gwent	A2 32
Common Edge, Lancs.	B2 60
Common Side, Derby.	A5 62
Common Side, W. Yorks.	B6 64
Common, The, Wilts.	A2 24
Commondale, N. Yorks.	H1 67
Commonside, Derby.	J3 57
Compstall, Grt.M.	G5 61
Compton Abbas, Dor.	E3 22
Compton Abdale, Glos.	K2 39
Compton Bassett, Wilts.	F4 33
Compton Beauchamp, Oxon.	H3 33
Compton Bishop, Som.	A5 32
Compton Chamberlayne, Wilts.	F2 23
Compton Dando, Avon	C5 32
Compton Martin, Avon	B5 32
Compton Pauncefool, Som.	C2 22
Compton Valence, Dor.	C5 22
Compton, Berks.	B3 30
Compton, Hants.	C2 24
Compton, Som.	B1 22
Compton, Surr.	E6 30
Compton, W. Suss.	E3 24
Comrie, Tay.	A4 90
Comrie, Tay.	J4 93
Condicote, Glos.	A5 40
Condorrat, Stra.	C3 86
Condover, Salop.	C6 56
Coney Weston, Suff.	E1 42
Coneysthorpe, N. Yorks.	E3 64
Congdons Shop, Corn.	H1 19
Congerstone, Leics.	F4 49
Congham, Norf.	D3 44
Congleton, Ches.	F2 57
Congresbury, Avon	B5 32
Conicavel, Gram.	J5 105
Coningsby, Lincs.	K1 47
Conington, Cambs.	A2 42
Conisbrough, S. Yorks.	B3 62
Conisholme, Lincs.	J3 63
Coniston Cold, N. Yorks.	K6 69
Coniston, Cumb.	F2 69
Coniston, Hum.	J6 65
Connahs Quay, Clwyd	J4 59
Connel Park, Stra.	B5 80
Connel, Stra.	B3 92
Connor Downs, Corn.	C4 18
Conon Bridge, High.	F5 105
Cononley, N. Yorks.	B6 66
Consall, Staffs.	G3 57
Consett, Dur.	B4 76
Constable Burton, N. Yorks.	D3 66
Constantine, Corn.	D5 18
Contin, High.	E5 104
Conwy, Gwyn.	E3 58
Conyer, Kent	G5 29
Cooden, E. Suss.	E5 26
Cookbury, Dev.	C5 34
Cookham, Berks.	E3 30
Cookley Green, Oxon.	C3 30
Cookley, H. & W.	H3 51
Cookley, Suff.	J1 43
Cooksbridge, E. Suss.	B5 26
Cookworthy, Dev.	C2 20
Coolham, W. Suss.	H2 25
Cooling, Kent	E4 28
Coombe Bissitt, Wilts.	G2 23
Coombe Hill, Glos.	H1 39
Coombe Keynes, Dor.	E5 22
Coombe, Corn.	E4 18
Coopers Corner, Kent	C2 26
Cootham, W. Suss.	H3 25
Cop Street, Kent	K5 29
Copdock, Suff.	G4 43
Coped Hall, Wilts.	G3 33
Cople, Beds.	J4 41
Copley, Dur.	B6 76
Coplow Dale, Derby.	J6 61
Copmanthorpe, N. Yorks.	D5 64
Coppenhall, Staffs.	B3 48
Coppins Corner, Kent	G2 27
Copplestone, Dev.	F1 21
Coppull, Lancs.	D3 60
Copster Green, Lancs.	E2 60
Copt Oak, Leics.	D4 46
Copthorne, Surr.	B3 26
Copythorne, Hants.	A3 24
Corbridge, Northumb.	K3 75
Corby, Lincs.	H3 47
Corby, Northants.	K5 49
Cordwell, Derby.	K6 61
Coreley, Salop.	F3 51
Corfe Castle, Dor.	F5 23
Corfe Mullen, Dor.	F4 23
Corfe, Som.	K4 35
Corgarff, Gram.	D3 100
Corley Moor, War.	E5 48
Corner, The, Kent	E2 26
Corney, Cumb.	D3 68
Cornforth, Dur.	C5 76
Cornhill, Gram.	E4 102
Cornhill-on-Tweed, Northumb.	G3 79
Cornholme, W. Yorks.	G2 61
Cornish Hall End, Essex	C4 42
Corniggs, Dur.	J5 75
Cornsay, Dur.	B5 76
Cornwood, Dev.	D4 20
Cornworthy, Dev.	F5 21
Corpach, High.	D5 98
Corpusty, Norf.	G3 45
Corran, High.	B3 98
Corrany, I.o.M.	E3 70
Corrie Common, D. & G.	C1 74
Corrie, Island of Arran	E2 82
Corrie, Island of Arran	H5 85
Corriekinloch, High.	D4 109
Corriemoillie, High.	D4 104
Corrievorrie, High.	J2 99
Corringham, Lincs.	E3 62
Corris Uchaf, Gwyn.	F6 55
Corry, Isle of Skye	F2 97
Corscombe, Dor.	B4 22
Corse of Kinnoir, Gram.	E6 102
Corsewall Point, D. & G.	A2 72
Corsham, Wilts.	E4 32
Corsley Heath, Wilts.	E6 32
Corsley, Wilts.	E6 32
Corsock, D. & G.	G2 73
Corston, Avon	D5 32
Corston, Wilts.	F3 33
Corstorphine, Loth.	B3 88
Corton Denham, Som.	C2 22
Corton, Suff.	K5 45
Corton, Wilts.	F1 23
Corwen, Clwyd	H3 55
Coryton, Dev.	C2 20
Coryton, Essex	E3 28
Cosby, Leics.	H5 49
Coseley, W. Mid.	J2 51
Cosgrove, Northants.	F4 41
Cosham, Hants.	D4 24
Cosheston, Dyfed	C3 36
Cossall, Notts.	D2 46
Cossington, Leics.	E4 46
Cossington, Som.	A1 22
Costock, Notts.	E3 46
Coston, Leics.	G3 47
Cot-town, Gram.	G6 103
Cotebrook, Ches.	D1 56
Cotehill, Cumb.	F4 75
Cotes, Staffs.	A4 57
Cotgrave, Notts.	E2 46
Cotham, Notts.	F1 47
Cothelstone, Som.	K3 35
Cotherstone, Dur.	B1 66
Cothill, Oxon.	K2 33
Cotleigh, Dev.	K5 35
Cotmanhay, Derby.	D2 46
Cotmanhay, Derby.	G1 49
Coton Clanford, Staffs.	F5 57
Coton in the Elms, Derby.	E3 48
Coton, Cambs.	A3 42
Coton, Staffs.	C2 48
Cottam, Lancs.	D2 60
Cottam, Notts.	D4 62
Cottartown, High.	B1 100
Cottenham, Cambs.	A2 42
Cotterdale, N. Yorks.	K3 69
Cottered, Herts.	A5 42
Cotterstock, Northants.	H6 47
Cottesbach, Leics.	D6 46
Cottesbach, Northants.	D1 40
Cottesmore, Leics.	G4 47
Cottingham, Hum.	H6 65
Cottingham, Northants.	G6 47
Cottingley, W. Yorks.	A5 64
Cottisford, Oxon.	E5 40
Cotton End, Beds.	J4 41
Cotton, Suff.	F2 43
Cotwalton, Staffs.	G4 57
Coul, Isle of Islay	A3 84
Coulags, High.	G5 107
Coull, Gram.	F3 101
Coulport, Stra.	J1 85
Coulsdon, G.L.	H5 31
Coulter, Stra.	E3 80
Coulton, N. Yorks.	E2 64
Cound, Salop.	F1 51
Coundon Grange, Dur.	C6 76
Coundon, Dur.	C6 76
Countersett, N. Yorks.	B3 66
Countesthorpe, Leics.	H5 49
Countisbury, Dev.	F1 35
Coupar Angus, Tay.	E3 90
Cour, Kintyre	C2 82
Court Henry, Dyfed	H2 37
Cousland, Loth.	C3 88
Cove Bay, Gram.	K4 101
Cove, Dev.	H4 35
Cove, Hants.	E5 30
Cove, High.	F2 107
Cove, Stra.	J2 85
Covehithe, Suff.	K1 43
Coven, Staffs.	B4 48
Coveney, Cambs.	B1 42
Covenham St. Bartholomew, Lincs.	J3 63
Covenham St. Mary, Lincs.	J3 63
Coventry, W. Mid.	C1 40
Coverack, Corn.	D6 18
Coverham, N. Yorks.	C3 66
Covington, Cambs.	H2 41
Cow Honeybourne, H. & W.	A4 40
Cowan Bridge, Lancs.	H4 69
Cowbeech, E. Suss.	D5 26
Cowbit, Lincs.	K4 47
Cowbridge, S. Glam.	A5 38
Cowden, Kent	C3 26
Cowdenbeath, Fife	B1 88
Cowes, I.o.W.	C4 24
Cowesby, N. Yorks.	F3 67
Cowfold, W. Suss.	A4 26
Cowie, Cen.	D1 86
Cowley, Dev.	G6 35
Cowley, G.L.	F3 31
Cowley, Glos.	J2 39
Cowley, Oxon.	B2 30
Cowling, N. Yorks.	G1 61
Cowlinge, Suff.	D3 42
Cowpen, Northumb.	C1 76
Cowplain, Hants.	D3 24
Cowshill, Dur.	J5 75
Cowthorpe, N. Yorks.	C4 64
Cox Heath, Kent	E2 26
Coxbench, Derby.	C2 46
Coxford, Norf.	E3 44
Coxhoe, Dur.	C5 76
Coxley, Som.	B6 32
Coxwold, N. Yorks.	G4 67
Coylton, Stra.	H4 83
Coylumbridge, High.	K3 99
Crabtree Green, Ches.	B3 56
Crabtree Green, Clwyd	K3 55
Crabtree, W. Suss.	A4 26
Crackley, War.	B2 40
Crackleybank, Salop.	A3 48
Crackpot, N. Yorks.	B2 66
Cracoe, N. Yorks.	B5 66
Craddock, Dev.	J4 35
Cradley, H. & W.	G5 51
Crafthole, Corn.	J3 19
Cragabus, Isle of Islay	B5 84
Cragg, W. Yorks.	H2 61
Craggan, Stra.	E6 92
Craghead, Dur.	C4 76
Crai, Powys	K1 37
Craibstone, Gram.	E4 102
Craichie, Tay.	G2 91
Craig Penllyn, S. Glam.	A5 38
Craig, Clwyd	H1 55
Craig, High.	B5 104
Craig-y-nos, Powys	K2 37
Craigcefnparc, W. Glam.	J3 37
Craigdam, Gram.	J1 101
Craigdarroch, Stra.	J5 83
Craigearn, Gram.	H2 101
Craigellachie, Gram.	C5 102
Craigend, Tay.	D4 90
Craigendoran, Stra.	K2 85
Craighouse, Jura	D3 84
Craigie, Stra.	H3 83
Craigmaud, Gram.	H4 103
Craignant, Salop.	A4 56
Craignure, Isle of Mull	G3 95
Craigo, Tay.	J1 91
Craigrothie, Fife	F5 91
Craigruie, Cen.	G4 93
Craigton, Stra.	G3 91
Crail, Fife	H5 91
Crailing, Bord.	F4 79
Craiselound, Hum.	D3 62
Crakehall, N. Yorks.	D3 66
Crambe, N. Yorks.	E3 64
Cramond, Loth.	B2 88
Cranage, Ches.	E1 56
Cranberry, Staffs.	F4 57
Cranborne, Dor.	G3 23
Cranbrook, Kent	E3 26
Cranfield, Beds.	H4 41
Cranford, Northants.	G1 41
Cranham, G.L.	D3 28
Cranham, Glos.	H2 39
Crank, Mer.	D4 60
Cranleigh, Surr.	G1 25
Crannach, Gram.	E5 102
Cranoe, Leics.	J5 49
Cransford, Suff.	H2 43
Cranstal, I.o.M.	E2 70
Cranswick, Hum.	K6 67
Crantock, Corn.	D3 18
Cranwell, Lincs.	H1 47
Cranwich, Norf.	D6 44
Cranworth, Norf.	F5 45
Crapstone, Dev.	C4 20
Craster, Northumb.	K4 79
Cratfield, Suff.	H1 43
Crathie, Gram.	D4 100
Crathie, High.	H4 99
Crathorne, N. Yorks.	F2 67
Craven Arms, Salop.	E3 50
Crawcrook, T. & W.	B3 76
Crawford, Stra.	D4 80
Crawfordjohn, Stra.	D4 80
Crawick, D. & G.	C5 80
Crawley Down, W. Suss.	B3 26
Crawley, Hants.	B1 24
Crawley, Oxon.	J1 33
Crawley, W. Suss.	A3 26
Crawshaw Booth, Lancs.	F2 61
Crawton, Gram.	J5 101
Cray, N. Yorks.	B4 66
Crayford, G.L.	C4 28
Crayke, N. Yorks.	D3 64
Crays Hill, Essex	E2 28
Crays Pond, Oxon.	C3 30
Creacombe, Dev.	G4 35
Creagorry, N.Uist	B4 108
Creca, D. & G.	D2 74
Credenhall, H. & W.	E6 50
Crediton, Dev.	G5 35
Creech St. Michael, Som.	K3 35
Creed, Corn.	E4 18
Creeton, Lincs.	H4 47
Creetown, D. & G.	E3 72
Creggans, Stra.	D6 92
Cregneish, I.o.M.	C5 70
Cregrina, Powys	B5 50
Creigiau, M.Glam.	B5 38
Cressage, Salop.	D6 56
Cresselly, Dyfed	D3 36
Cressett, Salop.	A5 48
Cressing, Essex	D6 42
Cresswell, Dyfed	D3 36
Cresswell, Staffs.	G3 57
Creswell, Derby.	B5 62
Cretingham, Suff.	H3 43
Cretshengan, Stra.	E3 84
Crew Green, Powys	B5 56
Crewe, Ches.	C2 56
Crewkerne, Som.	B3 22
Cnanlarich, Cen.	F4 93
Cribyn, Dyfed	F5 53
Criccieth, Gwyn.	D4 54
Crich, Derby.	C1 46
Crichton, Loth.	H3 87
Crick, Gwent	B3 32
Crick, Northants.	E2 40
Crickadarn, Powys	B6 50
Cricket St. Thomas, Som.	A3 22
Crickheath, Salop.	K5 55
Crickhowell, Powys	C2 38
Cricklade, Wilts.	G2 33
Cridling Stubbs, N. Yorks.	B1 62
Crieff, Tay.	B4 90
Crien, Derby.	K2 57
Criggion, Powys	B5 56
Crimond, Gram.	J4 103
Crimplesham, Norf.	C5 44
Cringleford, Norf.	G5 45
Cripps Corner, E. Suss.	E4 26
Croachy, High.	H1 99
Crockernwell, Dev.	E2 20
Crockerton, Wilts.	E6 32
Crocketford or Ninemile Bar, D. & G.	H2 73
Crockey Hill, N. Yorks.	D5 64
Crockham Hill, Kent	C2 26
Crockhurst Street, Kent	D2 26
Croesgoch, Dyfed	B1 36
Croft, Ches.	E5 60
Croft, Leics.	G5 49
Croft, Lincs.	K6 63
Croft-on-Tees, N. Yorks.	E1 66
Croftamie, Stra.	A2 86
Crofton, W. Yorks.	A1 62
Crofts of Backburn, Gram.	F1 101
Crofts of Savoch, Gram.	J4 103
Crofty, W. Glam.	G4 37
Croggan, Isle of Mull	G4 95
Croglin, Cumb.	F4 75
Croik, High.	E2 104
Croir, Isle of Lewis	C1 108
Cromarty, High.	H4 105
Cromblet, Gram.	G6 103
Cromdale, High.	C1 100
Cromer, Herts.	K5 41
Cromer, Norf.	H2 45
Cromford, Derby.	J2 57
Cromhall Common, Avon	G4 39
Cromhall, Avon	D3 32
Cromore, Isle of Lewis	D2 108
Cromra, High.	G4 99
Cromwell, Notts.	D6 62
Cronberry, Stra.	B4 80
Crondall, Hants.	D6 30
Cronk, The, I.o.M.	D3 70
Crook of Devon, Tay.	C6 90
Crook, Cumb.	G3 69
Crook, Dur.	B5 76
Crookes, S. Yorks.	K5 61
Crookham, Hants.	D6 30
Crookham, Northumb.	H3 79
Cropredy, Oxon.	D4 40
Cropston, Leics.	H3 49
Cropton, N. Yorks.	H3 67
Cropwell Bishop, Notts.	E2 46
Cropwell Butler, Notts.	E2 46
Crosby Garrett, Cumb.	J1 69
Crosby Ravensworth, Cumb.	H1 69
Crosby, Cumb.	E3 74
Crosby, Hum.	E2 62
Crosby, I.o.M.	D4 70
Crosby, Mer.	B4 60
Cross Ash, Gwent	D2 38
Cross Bush, W. Suss.	G4 25
Cross Hands, Dyfed	H2 37
Cross Houses, Salop.	C6 56
Cross Inn, Dyfed	E5 52
Cross Inn, M.Glam.	B5 38
Cross Keys, Gwent	C4 38
Cross Keys, Norf.	B4 44
Cross Keys, Wilts.	E4 32
Cross Lanes, Ches.	B3 56
Cross Lanes, Clwyd	K5 59
Cross Lanes, Corn.	D6 18
Cross Lanes, N. Yorks.	D3 64

170

Epwell, Oxon. C4 40
Epworth, Hum. D2 62
Erbistock, Ches. B3 56
Erbistock, Clwyd K3 55
Erbusaig, High. G1 97
Erdington, W.Mid. D5 48
Eriboll, High. E2 109
Ericstane, D.& G. E5 80
Eridge Green, E.Suss. D3 26
Erines, Stra. F2 85
Eriswell, Suff. D1 42
Erith, G.L. C4 28
Erlestoke, Wilts. F5 33
Ermington, Dev. E5 20
Erpingham, Norf. G3 45
Errogie, High. H2 99
Errol, Tay. E4 90
Erskine, Stra. A3 86
Ervie, D.& G. A3 72
Erwood, Powys B6 50
Eryholme, N.Yorks. E1 66
Eryrys, Clwyd J5 59
Escrick, N.Yorks. D5 64
Esgairgeiliog, Powys H1 53
Esh, Dur. B4 76
Esh Winning, Dur. B5 76
Esher, Surr. G5 31
Eshton, N.Yorks. B6 66
Eskadale, High. E6 104
Eskdale Green, Cumb. D2 68
Eskdalemuir, D.& G. G6 81
Esprick, Lancs. C1 60
Essendine, Leics. H4 47
Essendon, Herts. H1 31
Essich, High. G6 105
Essington, Staffs. C4 48
Esslemont, Gram. J1 101
Eston, Cleve. E6 76
Etal, Northumb. H3 79
Etchingham, E.Suss. E4 26
Etchinghill, Staffs. C3 48
Etchinghampton, Wilts. F5 33
Etherley, Dur. B6 76
Etling Green, Norf. F4 45
Eton, Berks. E4 30
Etteridge, High. J4 99
Ettington, War. B3 40
Etton, Cambs. J5 47
Etton, Hum. G5 65
Ettrick, Bord. G5 81
Ettrickbridge, Bord. H4 81
Etwall, Derby. B3 46
Euston, Suff. E1 42
Euxton, Lancs. D3 60
Evanton, High. F4 105
Evelix, High. G2 105
Evenjobb, Powys C4 50
Evenley, Northants. E5 40
Evenlode, Glos. B5 40
Evenwood, Dur. B6 76
Evercreech, Som. C1 22
Everingham, Hum. F5 65
Everleigh, Wilts. H6 33
Eversholt, Beds. H5 41
Evershot, Dor. C4 22
Eversley Cross, Hants. D5 30
Everthorpe, Hum. G6 65
Everton, Beds. K3 41
Everton, Hants. A5 24
Everton, Notts. C3 62
Evertown, D.& G. E2 74
Evesbatch, H.& W. G5 51
Evesham, H.& W. J6 51
Evington, Leics. E5 46
Ewell, Surr. G5 31
Ewelme, Oxon. C2 30
Ewen, Glos. F2 33
Ewenny, M.Glam. K5 37
Ewerby, Lincs. J1 47
Ewes, D.& G. E1 74
Ewhurst, E.Suss. F4 27
Ewhurst, Surr. H1 25
Ewloe, Clwyd B1 56
Eworthy, Dev. D6 34
Ewyas Harold, H.& W. D1 38
Exbourne, Dev. E5 34
Exbury, Hants. B4 24
Exebridge, Dev. H3 35
Exelby, N.Yorks. E3 66
Exeter, Dev. G2 21
Exford, Som. G2 35
Exhall, W.Mid. C1 40
Exhall, War. F5 49
Exlad, Oxon. C3 30
Exminster, Dev. G2 21
Exmouth, Dev. G3 21
Exning, Suff. C2 42
Exton, Dev. G2 21
Exton, Hants. D2 24
Exton, Leics. G4 47
Exton, Som. H3 35
Eyam, Derby. J6 61
Eydon, Northants. D3 40
Eye, Cambs. K5 47
Eye, H.& W. E4 50
Eye, Suff. G2 43
Eyemouth, Bord. H3 89
Eyeworth, Beds. K4 41
Eyhorne Street, Kent F5 29
Eyke, Suff. H3 43
Eynesbury, Cambs. J3 41
Eynsford, Kent D5 28
Eynsham, Oxon. A1 30
Eype, Dor. B5 22
Eyre, Salop. A5 48
Eythorne, Kent J2 27
Eyton upon the Weald Moors, Salop. D5 56
Faccombe, Hants. J5 33
Faceby, N.Yorks. F2 67
Faddiley, Ches. D2 56
Fadmoor, N.Yorks. H3 67
Failand, Avon B4 32
Failford, Stra. H4 83
Failsworth, Grt.M. G4 61
Fair Oak, Hants. C3 24
Fairbourne, Gwyn. D6 54
Fairburn, N.Yorks. C6 64
Fairfield, Avon C2 32
Fairfield, Derby. H1 57

Fairfield, H.& W. J3 51
Fairford, Glos. G2 33
Fairlie, Stra. J4 85
Fairlight, E.Suss. F5 27
Fairmile, Dev. J5 35
Fairoak, Staffs. E4 56
Fairstead, Norf. H3 45
Fakenham, Norf. E3 44
Fala, Loth. D4 88
Faldingworth, Lincs. F4 63
Falkenham, Suff. H4 43
Falkirk, Cen. D2 86
Falkland, Fife E5 90
Fallin, Cen. D1 86
Falmer, E.Suss. B5 26
Falmouth, Corn. D5 18
Falsgrave, N.Yorks. H1 65
Falstone, Northumb. H1 75
Fanagmore, High. C3 109
Fangdale Beck, N.Yorks. G3 67
Fangfoss, Hum. F4 65
Fans, Bord. E5 88
Far Bletchley, Bucks. G5 41
Far Sawrey, Cumb. F3 69
Farcet, Cambs. K6 47
Farden, Salop. F3 51
Fareham, Hants. D4 24
Farewell, Staffs. D3 48
Faringdon, Oxon. H2 33
Farington, Lancs. D2 60
Farleigh Hungerford, Som. E5 32
Farlesthorpe, Lincs. K5 63
Farleton, Cumb. G4 69
Farley, Salop. B6 56
Farley, Staffs. H3 57
Farley, Wilts. A2 24
Farleys End, Glos. G2 39
Farlington, N.Yorks. D3 64
Farlow, Salop. F3 51
Farmborough, Avon C5 32
Farmcote, Glos. K1 39
Farmers, Dyfed G6 53
Farmington, Glos. K2 39
Farmoor, Oxon. A1 30
Farmtown, Gram. E5 102
Farnborough, Berks. A3 30
Farnborough, G.L. C5 28
Farnborough, Hants. E6 30
Farnborough, War. C3 40
Farncombe, Surr. E6 30
Farndon, Ches. B2 56
Farndon, Notts. D6 62
Farne Islands, Northumb. K3 79
Farnell, Tay. H1 91
Farnham Common, Bucks. E3 30
Farnham Royal, Bucks. E3 30
Farnham, Dor. F3 23
Farnham, Essex B5 42
Farnham, N.Yorks. B4 64
Farnham, Suff. J3 43
Farnham, Surr. D6 30
Farningham, Kent D4 28
Farnley Tyas, W.Yorks. J3 61
Farnley, N.Yorks. A5 64
Farnsfield, Notts. C6 62
Farnworth, Ches. D5 60
Farnworth, Grt.M. E4 60
Farr, High. C2 110
Farringdon, Dev. H2 21
Farringdon, Hants. E1 24
Farrington Gurney, Avon C5 32
Farsley, W.Yorks. J2 61
Farthingstone, Northants. E3 40
Farway, Dev. J1 21
Fasnakyle, High. F1 99
Fassfern, High. C5 98
Fatfield, T.& W. C4 76
Fatherford, Dev. E6 34
Fathingoe, Northants. D4 40
Fattahead, Gram. F4 103
Faugh, Cumb. F4 75
Fauldhouse, Loth. D4 86
Faulkland, Som. D5 32
Fauls, Salop. D4 56
Faversham, Kent G5 29
Fawfieldhead, Staffs. H2 57
Fawkham Green, Kent D5 28
Fawkham, Kent D5 28
Fawler, Oxon. C6 40
Fawley, Berks. J3 33
Fawley, Hants. C4 24
Fawnhope, H.& W. F6 51
Faxfleet, Hum. E1 62
Faygate, W.Suss. A3 26
Fazeley, Staffs. E4 48
Fearby, N.Yorks. D4 66
Fearn Lodge, High. F2 105
Fearnan, Tay. J2 93
Fearnbeg, High. E4 106
Fearnmore, High. E4 106
Featherstone, Staffs. C4 48
Featherstone, W.Yorks. A1 62
Feckenham, H.& W. J4 51
Feetham, N.Yorks. B2 66
Felbridge, Surr. B3 26
Felbrigg, Norf. G2 45
Felindre, Powys B3 50
Felindre, W.Glam. H3 37
Felinfach, Powys B1 38
Felinfoel, Dyfed G3 37
Felin-gwm-uchaf, Dyfed G1 37
Felixkirk, N.Yorks. F3 67
Felixstowe, Suff. H5 43
Felkington, Northumb. H5 89
Fell Side, Cumb. D5 74
Felmersham, Beds. H3 41
Felmingham, Norf. H3 45
Felpham, W.Suss. G4 25
Felsham, Suff. E3 42
Felsted, Essex C6 42
Feltham, G.L. F4 31
Felthorpe, Norf. G4 45
Felton Butler, Salop. B5 56
Felton, Northumb. K6 79
Feltwell Anchor, Cambs. C6 44
Feltwell, Norf. D6 44
Fen Ditton, Cambs. B3 42
Fen Drayton, Cambs. A2 42

Fence, Lancs. F1 61
Fencote, N.Yorks. E3 66
Fendike Corner, Lincs. J6 63
Feniscowles, Lancs. E2 60
Feniton, Dev. J5 35
Fenny Bentley, Derby. J3 57
Fenny Compton, War. C3 40
Fenny Drayton, Leics. C5 46
Fenny Stratford, Bucks. G5 41
Fenton, Staffs. F3 57
Fenwick, Northumb. J3 79
Fenwick, S.Yorks. C1 62
Fenwick, Stra. H2 83
Feochaig, Kintyre B5 82
Feock, Corn. E4 18
Feolin Ferry, Jura C3 84
Feriniquarrie, Isle of Skye A5 106
Fern, Tay. G1 91
Ferndale, M.Glam. A4 38
Ferndown, Dor. G4 23
Ferness, High. J5 105
Fernham, Oxon. H2 33
Fernhurst, W.Suss. F2 25
Fernilee, Derby. H6 61
Ferrensby, N.Yorks. B4 64
Ferring, W.Suss. H4 25
Ferrybridge, W.Yorks. B1 62
Ferryden, Tay. J1 91
Ferryhill, Dur. C5 76
Ferryside, Dyfed F3 36
Fersfield, Norf. F1 43
Fersit, High. F5 99
Feshiebridge, High. A3 100
Fetcham, Surr. G5 31
Fetterangus, Gram. J5 103
Fettercairn, Gram. G6 101
Fewston, N.Yorks. D6 66
Ffairfach, Dyfed H2 37
Ffestiniog, Gwyn. E3 54
Fforest, Dyfed H3 37
Ffostrasol, Dyfed E5 52
Ffrith, Clwyd J5 59
Froncysyllte, Clwyd A3 56
Fidden, Isle of Mull C4 94
Fiddington, Glos. J1 39
Fiddington, Som. K2 35
Field Broughton, Cumb. F4 69
Field Dalling, Norf. F2 45
Field Head, Leics. D4 46
Field, Staffs. G4 57
Fifehead Magdalen, Dor. D2 22
Fifehead Neville, Dor. D3 22
Fifield, Oxon. B6 40
Figheldean, Wilts. G6 33
Filby, Norf. K4 45
Filey, N.Yorks. H2 65
Filkins, Oxon. H1 33
Filleigh, Dev. F3 35
Fillingham, Lincs. E4 62
Fillongley, War. E5 48
Filton, Avon C3 32
Fimber, Hum. G4 65
Finavon, Tay. G1 91
Fincham, Norf. C5 44
Finchampstead, Berks. D5 30
Fincharn, Stra. B6 92
Finchingfield, Essex C5 42
Finchley, G.L. H3 31
Findern, Derby. F2 49
Findhorn, Gram. A4 102
Findo Gask, Tay. C4 90
Findochty, Gram. D4 102
Findon Mains, High. F4 105
Findon, Gram. K4 101
Findon, W.Suss. H4 25
Finedon, Northants. G2 41
Fingest, Bucks. D3 30
Finghall, N.Yorks. A1 64
Fingland, D.& G. C4 80
Fingringhoe, Essex F6 43
Finiskaig, High. B4 98
Finmere, Oxon. E5 40
Finningham, Suff. F2 43
Finningley, S.Yorks. C3 62
Finsbay, Isle of Lewis C3 108
Finstock, Oxon. C6 40
Finstown, Ork. F5 112
Fintry, Cen. B1 86
Fintry, Gram. G5 103
Fionnphort, Isle of Mull C4 94
Fir Tree, Dur. B5 76
Firbank, Cumb. H3 69
Firbeck, S.Yorks. B3 62
Firgrove, Grt.M. G3 61
Firsby, Lincs. J6 63
Fishbourne, I.o.W. C5 24
Fishburn, Dur. D5 76
Fishcross, Cen. B6 90
Fisherford, Gram. G1 101
Fisherstreet, W.Suss. G2 25
Fisherton, High. G5 105
Fishguard, Dyfed C1 36
Fishlake, S.Yorks. C2 62
Fishpool, Grt.M. F4 61
Fishtoft, Lincs. A2 44
Fishtown of Usan, Tay. J1 91
Fiskavaig, Isle of Skye D1 96
Fiskerton, Lincs. F5 63
Fiskerton, Notts. D6 62
Fitling, Hum. J6 65
Fittleton, Wilts. G6 33
Fittleworth, W.Suss. G3 25
Fitton End, Cambs. A4 44
Fitz, Salop. C5 56
Fitzhead, Som. J3 35
Fitzwilliam, W.Yorks. A1 62
Five Acres, Glos. C1 32
Five Ashes, E.Suss. D4 26
Five Oak Green, Kent D2 26
Five Oaks, W.Suss. H2 25
Five Roads, Dyfed G3 37
Five Wents, Kent F2 27
Fivehead, Som. A2 22
Fivelanes, Corn. H1 19
Fladbury, H.& W. J6 51
Fladdabister, Shet. D4 112

Flagg, Derby. H1 57
Flamborough, Hum. J3 65
Flamstead, Herts. J6 41
Flanshaw, W.Yorks. K3 61
Flash, Staffs. G1 57
Flatt, The, Cumb. F2 75
Flawborough, Notts. F2 47
Flawith, N.Yorks. E3 64
Flax Bourton, Avon B4 32
Flaxby, N.Yorks. C4 64
Flaxley, Glos. G2 39
Flaxton, N.Yorks. E3 64
Fleckney, Leics. H5 49
Flecknoe, War. D2 40
Fleet Hargate, Lincs. A3 44
Fleet, Dor. C6 22
Fleet, Hants. D5 30
Fleet, Lincs. A3 44
Fleets Corner, Dor. F5 23
Fleetwood, Lancs. B1 60
Flempton, Suff. D2 42
Fletching, E.Suss. C4 26
Flexbury, Corn. B5 34
Flimby, Cumb. B5 74
Flimwell, E.Suss. E3 26
Flint Mountain, Clwyd J4 59
Flint, Clwyd J3 59
Flintham, Notts. F2 47
Flinton, Hum. J6 65
Flitcham, Norf. D3 44
Flitton, Beds. H5 41
Flitwick, Beds. H5 41
Flixborough, Hum. E1 62
Flixton, Grt.M. F5 61
Flixton, N.Yorks. H2 65
Flixton, Suff. H1 43
Flockton, W.Yorks. J3 61
Flodigarry, Isle of Skye C3 106
Floods Ferry, Cambs. A6 44
Flordon, Norf. G5 45
Flore, Northants. E3 40
Flotterton, Northumb. H6 79
Flouch Inn, S.Yorks. J4 61
Fobbing, Essex E3 28
Fochabers, Gram. C4 102
Fockerby, Hum. E1 62
Fodderletter, Gram. C2 100
Foel, Powys H6 55
Foggathorpe, Hum. E5 64
Fogo, Bord. F4 89
Foindle, High. C3 109
Folda, Tay. E1 90
Fole, Staffs. G4 57
Foleshill, War. F6 49
Folkestone, Kent J3 27
Folkingham, Lincs. J3 47
Folksworth, Cambs. J6 47
Folkton, N.Yorks. H2 65
Folla Rule, Gram. F6 103
Follifoot, N.Yorks. B4 64
Folly Gate, Dev. E5 34
Fonthill Bishop, Wilts. F1 23
Fonthill Gifford, Wilts. F1 23
Fontmell Magna, Dor. E3 22
Foolow, Derby. J6 61
Ford End, Essex C6 42
Ford, Dev. D3 34
Ford, Glos. K1 39
Ford, Northumb. H3 79
Ford, Salop. B6 56
Ford, Staffs. H2 57
Ford, Stra. H6 95
Ford, W.Suss. G4 25
Ford, Wilts. E4 32
Forden, Powys C1 50
Fordham, Cambs. C2 42
Fordham, Essex E5 42
Fordham, Norf. C5 44
Fordingbridge, Hants. G3 23
Fordon, Hum. H2 65
Fordon, N.Yorks. K4 67
Fordoun, Gram. H6 101
Fordwich, Kent J5 29
Fordyce, Gram. E4 102
Forest Gate, G.L. J3 31
Forest Hall, Cumb. H2 69
Forest Head, Cumb. F3 75
Forest Mill, Cen. E1 86
Forest Row, E.Suss. C3 26
Forest Town, Notts. B6 62
Forest-in-Teesdale, Dur. J6 75
Forestburn Gate, Northumb. J6 79
Forestside, W.Suss. E3 24
Forfar, Tay. G2 91
Forgandenny, Tay. D4 90
Formby, Mer. B4 60
Forncett End, Norf. G6 45
Forncett St. Mary, Norf. G6 45
Forncett St. Peter, Norf. G6 45
Forneth, Tay. D2 90
Fornham All Saints, Suff. E2 42
Fornham St. Martin, Suff. E2 42
Forres, Gram. K4 105
Forsbrook, Staffs. G3 57
Forsinard, High. D3 110
Fort Augustus, High. F3 99
Fort George, High. G4 105
Fort William, High. D6 98
Forteviot, Tay. C4 90
Forth, Stra. E4 86
Fortingall, Tay. J2 93
Forton, Lancs. G6 69
Forton, Salop. C5 56
Forton, Som. A3 22
Forton, Staffs. E5 56
Fortrie, Gram. F5 103
Fortrose, Gram. G4 105
Fortuneswell, Dor. D6 22
Forty Feet Bridge, Cambs. K6 47
Fortyhill, G.L. H2 31
Forward Green, Suff. G3 43

Fosdyke, Lincs. A3 44
Foss, Tay. J1 93
Foss-y-ffin, Dyfed F4 53
Fossebridge, Glos. G1 33
Foston, Derby. E2 48
Foston, Lincs. G2 47
Foston, N.Yorks. E3 64
Foston-on-the-Wolds, Hum. H4 65
Fotherby, Lincs. H3 63
Fotheringhay, Northants. H6 47
Foulden, Bord. H1 79
Foulden, Bord. H4 89
Foulden, Norf. D5 44
Foulness Island, Essex G2 29
Foulridge, Lancs. G1 61
Foulsham, Norf. F3 45
Fountainhall, Bord. D4 88
Four Ashes, Suff. F2 43
Four Crosses, Powys H6 55
Four Crosses, Staffs. C3 48
Four Elms, Kent C2 26
Four Lanes, Corn. C4 18
Four Marks, Hants. D1 24
Four Mile Bridge, Angl. A3 58
Four Oaks, E.Suss. F4 27
Four Oaks, W.Mid. E6 48
Fourlanes End, Ches. F2 57
Fourstones, Northumb. J3 75
Fovant, Wilts. F2 23
Fowey, Corn. G3 19
Fowlis Wester, Tay. B4 90
Fowlis, Tay. F3 91
Fowlmere, Cambs. A4 42
Fownhope, H.& W. F1 39
Fox Corner, Surr. E5 30
Fox Hill, Surr. E5 30
Fox St. Essex F5 43
Foxdale, I.o.M. C4 70
Foxearth, Essex E4 42
Foxendale, Lincs. H5 63
Foxfield, Cumb. E3 68
Foxham, Wilts. J5 39
Foxholes, N.Yorks. H3 65
Foxley, Norf. F3 45
Foxley, Wilts. E3 32
Foxt, Staffs. G3 57
Foxton, Cambs. A4 42
Foxton, Leics. F6 47
Foxup, N.Yorks. K4 69
Foxwist Green, Ches. D1 56
Foy, H.& W. F1 39
Foyers, High. G2 99
Fraddon, Corn. E3 18
Fradley, Staffs. D3 48
Fradswell, Staffs. G4 57
Fraisthorpe, Hum. J3 65
Framfield, E.Suss. C4 26
Framingham Earl, Norf. H5 45
Framlingham, Suff. H2 43
Frampton Cotterell, Avon C3 32
Frampton, Dor. C4 22
Frampton, Lincs. A2 44
Frampton-on-Severn, Glos. G3 39
Framsden, Suff. G3 43
Framwellgate Moor, Dur. C4 76
Frankby, Mer. B5 60
Frankton, War. C2 40
Frant, E.Suss. D3 26
Fraserburgh, Gram. J4 103
Frating, Essex G6 43
Fratton, Hants. D4 24
Freckenham, Suff. C2 42
Freckleton, Lancs. C2 60
Freeby, Leics. F4 47
Freefolk, Hants. A6 30
Freeland, Oxon. J1 33
Freethorpe Common, Norf. J5 45
Freiston, Lincs. A2 44
Fremington, Dev. D3 34
Fremington, N.Yorks. C4 32
Frenchay, Avon C4 32
Freshfield, Mer. B4 60
Freshford, Som. D5 32
Freshwater, I.o.W. B5 24
Fressingfield, Suff. H1 43
Freston, Suff. G4 43
Freswick, High. H1 111
Fretherne, Glos. G3 39
Frettenham, Norf. H4 45
Freuchie, Fife E5 90
Friday Bridge, Cambs. B5 44
Friday Street, Suff. J3 43
Fridaythorpe, Hum. F4 65
Friden, Derby. H2 57
Friern Barnet, G.L. H2 31
Friesthorpe, Lincs. F4 63
Frieston, Lincs. G1 47
Frilford, Berks. K2 33
Frimley Green, Surr. E5 30
Frimley, Surr. E5 30
Fring, Norf. D2 44
Fringford, Oxon. E5 40
Frinsted, Kent F5 29
Frinton, Essex H6 43
Friockheim, Tay. H2 91
Frisby on the Wreak, Leics. F4 47
Frisham, Berks. B4 30
Friskney, Lincs. B1 44
Friston, E.Suss. D6 26
Friston, Suff. J3 43
Frith Common, H.& W. G4 51
Fritham, Hants. A3 24
Frithelstock Stone, Dev. D4 34
Frithelstock, Dev. D4 34
Frithville, Lincs. H6 63
Frittenden, Kent F2 27
Fritton, Norf. H6 45
Fritwell, Oxon. D5 40
Frizington, Cumb. C1 68
Frocester, Glos. G3 39

Frodesley, Salop. E1 50
Frodingham, Hum. E2 62
Frodsham, Ches. D6 60
Froggatt, Derby. K6 61
Froghall, Staffs. G3 57
Frogmore, Dev. F6 21
Frolesworth, Leics. G5 49
Frome St. Quinton, Dor. C4 22
Frome, Som. D6 32
Fromes Hill, H. & W. G5 51
Fron, Powys J6 55
Fron-goch, Gwyn. G3 55
Froncysyllte, Clwyd J6 59
Frosterley, Dur. K5 75
Froxfield, Wilts. H4 33
Froyle, Hants. D6 30
Fulbeck, Lincs. E6 62
Fulbourn, Cambs. B3 42
Fulbrook, Oxon. H1 33
Fulford, N.Yorks. D4 64
Fulford, Staffs. G4 57
Fulham, G.L. H4 31
Fulking, W.Suss. A5 26
Full Sutton, Hum. E4 64
Fullers Moor, Ches. C2 56
Fulletby, Lincs. H5 63
Fulmer, Bucks. F3 31
Fulmodestone, Norf. F3 45
Fulnetby, Lincs. G4 63
Fulney, Lincs. K3 47
Fulstow, Lincs. H3 63
Fulwood, Lancs. D2 60
Funtington, W.Suss. E4 24
Funzie, Shet. E2 112
Furley, Dev. K5 35
Furnace End, War. E5 48
Furnace, Stra. C6 92
Furneux Pelham, Herts. A5 42
Furze Platt, Berks. E3 30
Fyfet, Som. K4 35
Fyfield, Essex D1 28
Fyfield, Oxon. A2 30
Fyfield, Wilts. G4 33
Fylingthorpe, N.Yorks. K2 67
Fyvie, Gram. G6 103
Gabwell, Dev. G3 21
Gaddesby, Leics. E4 46
Gaerllwyd, Gwent E4 38
Gaerwen, Angl. C3 58
Gaerwen, Gwyn. C1 54
Gagingwell, Oxon. C5 40
Gainford, Dur. D1 66
Gainsborough, Lincs. D3 62
Gairloch, High. F3 107
Gairlochy, High. E5 98
Gaitsgill, Cumb. E4 74
Galashiels, Bord. D3 78
Galby, Leics. F5 47
Galcar, W.Yorks. H3 61
Galgate, Lancs. G6 69
Galhampton, Som. C2 22
Gallanach, Stra. H4 95
Galleywood, Essex E2 28
Gallowfauld, Tay. G2 91
Galphay, N.Yorks. D4 66
Galston, Stra. H3 83
Galtrigill, Isle of Skye A5 106
Gamblesby, Cumb. G5 75
Gamlingay, Cambs. K3 41
Gamston, Notts. D4 62
Ganllwyd, Gwyn. E5 54
Gannochy, Tay. G6 101
Ganstead, Hum. J6 65
Ganton, N.Yorks. G2 65
Garbhallt, Stra. J6 95
Garboldisham, Norf. F1 43
Gardenstown, Gram. G4 103
Gardham, Hum. G5 65
Gare Hill, Wilts. D1 22
Garelochhead, Stra. J1 85
Garford, Oxon. A2 30
Garforth Bridge, W.Yorks. C6 64
Garforth, W.Yorks. C6 64
Gargrave, N.Yorks. B6 66
Gargunnock, Cen. C1 86
Garlieston, D. & G. E4 72
Garlogie, Gram. H3 101
Garmond, Gram. G5 103
Garmony, Isle of Mull F3 95
Garmouth, Gram. C4 102
Garn Dolbenmaen, Gwyn. D3 54
Garnant, Dyfed J2 37
Garnett Bridge, Cumb. G2 69
Garreg Bank, Powys K6 55
Garreg, Gwyn. D3 54
Garrigill, Cumb. H5 75
Garros, Isle of Skye C4 106
Garrow, Tay. B3 90
Garsdale Head, Cumb. J3 69
Garsden, Wilts. J4 39
Garshall Green, Staffs. G4 57
Garsington, Oxon. B2 30
Garstang, Lancs. C1 60
Garston, Herts. G2 31
Garston, Mer. C6 60
Garswood, Mer. D4 60
Gartbreck, Isle of Islay B4 84
Garth, Clwyd J6 59
Garth, Powys A5 50
Gartheli, Dyfed G5 53
Garthorpe, Hum. E1 62
Garthorpe, Leics. G4 47
Gartmore, Cen. G6 93
Garton, Hum. K6 65
Garton-on-the-Wolds, Hum. G6 65

Garvald, Loth. E3 88
Garvard, Isle of Colonsay B1 84
Garve, High. E4 104
Garveston, Norf. F5 45
Garvock, Stra. J3 85
Garway, H. & W. E2 38
Garynahine, Isle of Lewis C2 108
Gaskan, High. G6 97
Gastard, Wilts. E4 32
Gasthorpe, Norf. F1 43
Gatcombe, I.o.W. C5 24
Gate Helmsley, N.Yorks. E4 64
Gatebeck, Cumb. H3 69
Gateford, Notts. B4 62
Gateforth, N.Yorks. D6 64
Gatehouse of Fleet, D. & G. F3 73
Gatehouse, Northumb. H1 75
Gatelawbridge, D. & G. D6 80
Gateley, Norf. F3 45
Gatesheath, Ches. C2 56
Gateside, Fife E5 90
Gateside, Stra. K4 85
Gateside, Stra. F2 91
Gathurst, Grt.M. D4 60
Gatley, Grt.M. F5 61
Gattonside, Bord. E3 78
Gauldry, Fife E4 91
Gaultree, Norf. B5 44
Gautby, Lincs. G5 63
Gavington, Bord. F2 79
Gavinton, Bord. F4 89
Gawcott, Bucks. E5 40
Gawsworth, Ches. F1 57
Gawthwaite, Cumb. E3 68
Gaydon, War. C3 40
Gayhurst, Bucks. G4 41
Gayles, N.Yorks. C2 66
Gayton le Marsh, Lincs. J4 63
Gayton Thorpe, Norf. D4 44
Gayton, Mer. J3 59
Gayton, Norf. D4 44
Gayton, Northants. F3 41
Gayton, Staffs. G4 57
Gaywood, Norf. C4 44
Gazeley, Suff. D2 42
Geary, Isle of Skye B4 106
Geddington, Northants. G6 47
Gedintailor, Isle of Skye D6 106
Gedintailor, Isle of Skye E1 96
Gedling, Notts. E2 46
Gedney Broadgate, Lincs. A3 44
Gedney Drove End, Lincs. B3 44
Gedney Dyke, Lincs. A3 44
Gedney Hill, Lincs. A4 44
Gedney, Lincs. A3 44
Gee Cross, Grt. M. G5 61
Geldeston, Norf. J6 45
Gelligaer, M.Glam. B4 38
Gellilydan, Gwyn. E3 54
Gellioedd, Clwyd G3 55
Gellywen, Dyfed E2 36
Gelston, D. & G. G3 73
Gembling, Hum. H4 65
Gentleshaw, Staffs. D3 48
George Green, Bucks. F3 31
George Nympton, Dev. F3 35
Georgeham, Dev. D2 34
Georth, Ork. F4 112
Germansweek, Dev. D6 34
Germoe, Corn. C5 18
Gerrans, Corn. E5 18
Gerrards Cross, Bucks. F3 31
Geuffordd, Powys J5 55
Gidea Park, G.L. C3 28
Gidleigh, Dev. E2 20
Gifford, Loth. E3 88
Gilberdyke, Hum. F6 65
Gilcrux, Cumb. C5 74
Gildersome, W.Yorks. K2 61
Gildingwells, S.Yorks. B4 62
Gilfach Goch, M.Glam. A4 38
Gilfachrheda, Dyfed E5 52
Gilgarran, Cumb. J6 73
Gilgerran, Dyfed D6 52
Gillamoor, N.Yorks. H3 67
Gilling East, N.Yorks. G4 67
Gilling West, N.Yorks. D2 66
Gillingham, Dor. E2 22
Gillingham, Kent E4 28
Gillingham, Norf. J6 45
Gillow Heath, Staffs. F2 57
Gills Green, Kent E3 26
Gills, High. H1 111
Gilmerton, Loth. G3 87
Gilmerton, Tay. B4 90
Gilmorton, Leics. H5 49
Gilsland, Northumb. G3 75
Gilston, Loth. D4 88
Giltbrook, Notts. D2 46
Gilwern, Gwent C2 38
Gimingham, Norf. H2 45
Ginge, Oxon. K3 33
Girsby, N.Yorks. E2 66
Girthon, D. & G. F4 73
Girton, Cambs. A2 42
Girton, Notts. D5 62
Girvan, Stra. F6 83
Gisburn, Lancs. A6 66
Gisleham, Suff. K6 45
Gislingham, Suff. F2 43
Gissing, Norf. G1 43
Gittisham, Dev. J5 35
Glackossain, High. F6 105
Gladdish, Kent F2 27
Gladestry, Powys C5 50
Gladsmuir, Loth. D3 88
Glais, W.Glam. J3 37
Glaisdale, Hum. H2 67
Glame, Island of Raasay D6 106
Glamis, Tay. F2 91
Glan Conwy, Gwyn. F2 55
Glan-rhyd, Dyfed C6 52
Glan-y-don, Clwyd H3 59
Glan-yr-afon, Gwyn. G3 55

Glanaber Terrace, Gwyn. F3 55
Glanaman, Dyfed J2 37
Glandford, Norf. F2 45
Glandwr, Dyfed E1 36
Glandwr, Gwent C3 38
Glangrasco, Isle of Skye C5 106
Glangrwyne, Powys C2 38
Glanton, Northumb. J5 79
Glanvilles Wootton, Dor. D3 22
Glapthorn, Northants. H6 47
Glapton, Notts. D2 46
Glapwell, Derby. B5 62
Glasbury, Powys B6 50
Glascoed, Gwent D3 38
Glascote, Staffs. E4 48
Glascwm, Powys B5 50
Glasdrum, Stra. C2 92
Glasfryn, Clwyd F5 59
Glasgow, Stra. B3 86
Glasinfryn, Gwyn. D4 58
Glaslaw, Gram. J5 101
Glaspwll, Powys H1 53
Glass Houghton, W.Yorks. A1 62
Glassburn, High. F1 99
Glasserton D. & G. D5 72
Glassford, Stra. B2 80
Glasshouse Hill, Glos. G2 39
Glasshouses, N.Yorks. D5 66
Glasson, Cumb. D3 74
Glasson, Lancs. D1 60
Glassonby, Cumb. F5 75
Glasterlaw, Tay. H2 91
Glaston, Leics. G5 47
Glastonbury, Som. B1 22
Glatton, Cambs. J6 47
Glazebury, Ches. E5 60
Glazeley, Salop. G2 51
Gleadless, S.Yorks. A4 62
Gleaston, Cumb. E4 68
Glemsford, Suff. D4 42
Glen Auldyn, I.o.M. E3 70
Glen Ceinig, Clwyd A4 56
Glen Parva, Leics. E5 46
Glen Vine, I.o.M. D4 70
Glen, D. & G. F3 73
Glenastle, Isle of Islay B5 84
Glenbarr, Kintyre B3 82
Glenbeg, High. F1 95
Glenbervie, Gram. H5 101
Glenboig, Stra. C3 86
Glenborrodale, High. F1 95
Glenbranter, Stra. D6 92
Glenbreck, Bord. E4 80
Glenbuck, Stra. C3 80
Glencarse, Tay. E4 90
Glenceitlin, High. D2 92
Glencoe, High. K1 95
Glencoe, Stra. D1 92
Glencraig, Fife F1 87
Glencuie, Gram. E2 100
Glendevon, Tay. C5 90
Glenegedale, Isle of Islay B4 84
Glenelg, High. B2 98
Glenfarg, Tay. D5 90
Glenfield, Leics. G4 49
Glenfinnan, High. B5 98
Glengarnock, Stra. G2 83
Glenhoul, D. & G. F1 73
Glenkerry, Bord. B5 78
Glenkindie, Gram. F2 101
Glenlatterach, Gram. B5 102
Glenlee, D. & G. F2 73
Glenlivet, Gram. D1 100
Glenluce, D. & G. C3 72
Glenmavis, Stra. C3 86
Glenmaye, I.o.M. C4 70
Glenmoy, Tay. E6 100
Glenprosen Village, Tay. E6 100
Glenridding, Cumb. F1 69
Glenrothes, Fife E6 90
Glensaugh, Gram. G5 101
Glenshee, Tay. C3 90
Glensluain, Stra. D6 92
Glenstriven, Stra. H2 85
Glentham, Lincs. F3 63
Glentrool Village, D. & G. D2 72
Glentworth, Lincs. E4 62
Glespin, Stra. C4 80
Gletness, Shet. D3 112
Glewstone, H. & W. F2 39
Glinton, Cambs. J5 47
Glooston, Leics. J5 49
Glossop, Derby. H5 61
Gloucester, Glos. H2 39
Gloup, Shet. D1 112
Glovenfords, Bord. J6 87
Glusburn, N.Yorks. B6 66
Glympton, Oxon. C6 40
Glyn Ceinog, Clwyd J4 55
Glyn Neath, W.Glam. K3 37
Glynarthen, Dyfed D5 52
Glyncorrwg, W.Glam. K3 37
Glynde, E.Suss. C5 26
Glyndyfrdwy, Clwyd J3 55
Glyntaff, M.Glam. B4 38
Gnosall Heath, Staffs. B3 48
Gnosall, Staffs. B3 48
Goadby Marwood, Leics. F3 47
Goadby, Leics. F5 47
Goatacre, Wilts. J5 39
Goathland, N.Yorks. J2 67
Goathurst, Som. K2 35
Gobowen, Salop. B4 56
Godalming, Surr. E6 30
Goddards Green, Kent F3 27
Goddmanham, Hum. G5 65
Godmanchester, Cambs. K2 41
Godmanstone, Dor. C4 22
Godmersham, Kent H2 27
Godolphin Cross, Corn. C5 18
Godshill, Hants. H3 23
Godshill, I.o.W. C6 24
Godstone, Surr. B2 26
Goffs Oak, Herts. B2 28

Goginan, Dyfed G3 53
Golan, Gwyn. D3 54
Golant, Corn. G3 19
Golborne, Grt.M. D5 60
Gold Hill, Norf. B6 44
Goldcliff, Gwent A3 32
Golden Balls, Oxon. B2 30
Golden Cross, E.Suss. D5 26
Golden Grove, Dyfed H2 37
Golden Pot, Hants. C6 30
Golden Valley, Glos. H2 39
Goldenhill, Staffs. F2 57
Golders Green, G.L. H3 31
Goldhanger, Essex F1 29
Golding, Salop. C6 56
Goldington, Beds. J3 41
Goldsborough, N.Yorks. C4 64
Goldthorpe, S.Yorks. B2 62
Gollanfield, High. H5 105
Golspie, High. H1 105
Gomersal, W.Yorks. J2 61
Gomshall, Surr. F6 31
Gonalston, Notts. E1 46
Good Easter, Essex C6 42
Gooderstone, Norf. D5 44
Goodleigh, Dev. E2 34
Goodmayes, G.L. C3 28
Goodnestone, Dev. G4 21
Goodwick, Dyfed A6 52
Goole, Hum. D1 62
Goolefields, Hum. D1 62
Gooseham, Corn. B4 34
Goosnargh, Lancs. D1 60
Goostrey, Ches. E1 56
Gorcott Hill, H. & W. A2 40
Gordon, Bord. E2 78
Gordonbush, High. D6 110
Gordonstown, Gram. E5 102
Gore Court, Kent E3 26
Gore Pit, Essex E6 42
Gorebridge, Loth. C4 88
Gorefield, Cambs. A4 44
Goring Heath, Oxon. C3 30
Goring, Oxon. B3 30
Goring-by-Sea, W.Suss. H4 25
Gorleston on Sea, Norf. K5 45
Gorran Churchtown, Corn. F4 19
Gorran Haven, Corn. F4 19
Gorsedd, Clwyd H3 59
Gorseinon, W.Glam. H4 37
Gorslas, Dyfed H2 37
Gorsley, Glos. G1 39
Gorstan, High. D4 104
Gorsty Hill, Staffs. A3 46
Gortantaoid, Isle of Islay B3 84
Gorton, Grt.M. G5 61
Gosbeck, Suff. G3 43
Gosberton, Lincs. K3 47
Gosfield, Essex D5 42
Gosforth, Cumb. D2 68
Gosforth, T. & W. C3 76
Gosmore, Herts. J5 41
Gosport, Hants. D4 24
Goswick, Northumb. J2 79
Gotham, Notts. D3 46
Gotherington, Glos. J1 39
Goudhurst, Kent E3 26
Goulceby, Lincs. H4 63
Gourdon, Gram. J6 101
Gourock, Stra. J2 85
Govan, Stra. A3 86
Gowdall, Hum. C1 62
Gowerton, W.Glam. H4 37
Goxhill Haven, Hum. H6 65
Goxhill, Hum. G1 63
Graffham, W.Suss. F3 25
Grafham, Cambs. J2 41
Grafton Flyford, H. & W. J5 51
Grafton Regis, Northants. F4 41
Grafton Underwood, Northants. G1 41
Grafton, N.Yorks. C3 64
Graianrhyd, Clwyd A2 56
Graig, Clwyd H3 59
Graig-fechan, Clwyd H5 59
Grain, Kent F4 29
Grainsby, Lincs. H3 63
Grainthorpe, Lincs. J3 63
Grampound Road, Corn. E3 18
Grampound, Corn. E4 18
Granborough, Bucks. F5 41
Granby, Notts. F2 47
Grandborough, War. D2 40
Grandtully, Tay. B2 90
Grange of Lindores, Fife E5 90
Grange, Cumb. E1 68
Grange, Kent F4 29
Grange, Mer. A5 60
Grange, Mer. J2 59
Grange, N.Yorks. D1 64
Grange, Tay. E4 90
Grange-over-Sands, Cumb. F4 69
Grangemill, Derby. J2 57
Grangemouth, Cen. D2 86
Grangetown, Cleve. E6 76
Gransmoor, Hum. H4 65
Grantchester, Cambs. A3 42
Grantham, Lincs. G2 47
Grantley, N.Yorks. A3 64
Grantlodge, Gram. H2 101
Granton, Loth. B2 88
Grantown-on-Spey, High. B1 100
Grantshouse, Bord. G3 89
Grappenhall, Ches. E5 60
Grasby, Lincs. G2 63
Grasmere, Cumb. F2 69
Grasscroft, Grt.M. G4 61
Grassendale, Mer. K2 59
Grassholme, Dur. J6 75
Grassington, N.Yorks. B5 66
Grassmoor, Derby. A5 62
Grassthorpe, Notts. D5 62
Gratwich, Staffs. G4 57
Graveley, Cambs. K2 41
Graveley, Herts. K5 41

Graveney, Kent H5 29
Gravesend, Kent D4 28
Gravir, Isle of Lewis D2 108
Grayingham, Lincs. E3 62
Grayrigg, Cumb. H2 69
Grays, Essex D4 28
Grayshott, Hants. F1 25
Grayswood, Surr. F1 25
Greasbrough, S.Yorks. A3 62
Greasby, Mer. B5 60
Great Abington, Cambs. B4 42
Great Addington, Northants. H1 41
Great Alne, War. A3 40
Great Altcar, Lancs. B4 60
Great Amwell, Herts. A6 42
Great Asby, Cumb. J1 69
Great Ashfield, Suff. F2 43
Great Ayton, N.Yorks. G1 67
Great Baddow, Essex E1 28
Great Badminton, Avon E3 32
Great Bardfield, Essex C5 42
Great Barford, Beds. J3 41
Great Barr, W.Mid. D5 48
Great Barrington, Glos. B6 40
Great Barrow, Ches. C1 56
Great Barton, Suff. E2 42
Great Barugh, N.Yorks. H4 67
Great Bedwyn, Wilts. H5 33
Great Bentley, Essex G6 43
Great Bircham, Norf. D3 44
Great Bolas, Salop. D5 56
Great Bookham, Surr. G5 31
Great Bowden, Leics. J5 49
Great Bradley, Suff. C3 42
Great Brickhill, Bucks. G5 41
Great Bridgeford, Staffs. F4 57
Great Brington, Northants. E2 40
Great Bromley, Essex G5 43
Great Broughton, N.Yorks. G2 67
Great Budworth, Ches. E6 60
Great Burdon, Dur. E1 66
Great Burstead, Essex E2 28
Great Carlton, Lincs. J4 63
Great Casterton, Leics. H4 47
Great Chart, Kent G2 27
Great Chatwell, Staffs. B3 48
Great Chesterford, Essex B4 42
Great Chishill, Cambs. A4 42
Great Clacton, Essex G6 43
Great Coates, Hum. H2 63
Great Comberton, H. & W. J6 51
Great Corby, Cumb. F4 75
Great Cornard, Suff. E4 42
Great Coxwell, Oxon. H2 33
Great Cransley, Northants. G1 41
Great Creaton, Northants. F2 41
Great Cressingham, Norf. E5 44
Great Crosby, Mer. B4 60
Great Cubley, Derby. H4 57
Great Dalby, Leics. F4 47
Great Doddington, Northants. G2 41
Great Driffield, Hum. H4 65
Great Dunham, Norf. E4 44
Great Dunmow, Essex C6 42
Great Easton, Essex C5 42
Great Easton, Leics. K5 49
Great Eccleston, Lancs. C1 60
Great Edstone, N.Yorks. H3 67
Great Ellingham, Norf. F5 45
Great Everdon, Northants. E3 40
Great Eversden, Cambs. A3 42
Great Fen, Cambs. C1 42
Great Finborough, Suff. F3 43
Great Fransham, Norf. E4 44
Great Gaddesdon, Herts. F1 31
Great Gidding, Cambs. J6 47
Great Glen, Leics. E5 46
Great Gonerby, Lincs. G2 47
Great Green, Norf. H6 45
Great Habton, N.Yorks. H4 67
Great Hale, Lincs. J2 47
Great Harkesley, Essex F5 43
Great Harrowden, Northants. G2 41
Great Harwood, Lancs. E2 60
Great Haseley, Oxon. C2 30
Great Hatfield, Hum. J5 65
Great Haywood, Staffs. C2 48
Great Heath, W.Mid. C1 40
Great Hockham, Norf. E6 44
Great Holland, Essex H6 43
Great Hormead, Herts. A5 42
Great Horton, W.Yorks. A6 64
Great Horwood, Bucks. F5 41
Great Houghton, S.Yorks. A2 62
Great Hucklow, Derby. J6 61
Great Kelk, Hum. H4 65
Great Kingshill, Bucks. E2 30
Great Langton, N.Yorks. E2 66
Great Leighs, Essex D6 42
Great Limber, Lincs. G2 63
Great Linford, Bucks. G4 41
Great Livermere, Suff. E2 42
Great Lumley, Dur. C4 76
Great Lyth, Salop. C6 56
Great Malvern, H. & W. G6 51
Great Marton, Lancs. B2 60
Great Massingham, Norf. D3 44
Great Milton, Oxon. C2 30
Great Missenden, Bucks. E2 30
Great Mitton, Lancs. E1 60
Great Mongeham, Kent K2 27
Great Musgrave, Cumb. J1 69
Great Ness, Salop. B5 56
Great Oakley, Northants. K5 49
Great Oakley, Essex G5 43
Great Offley, Herts. J5 41
Great Ormside, Cumb. J1 69
Great Orton, Cumb. D4 74

173

Place	Ref
Haverthwaite, Cumb.	F3 69
Hawarden, Clwyd	B1 56
Hawes, N.Yorks.	A3 66
Hawick, Bord.	D5 78
Hawkchurch, Dev.	K1 21
Hawkesbury Upton, Avon	G4 39
Hawkesbury, Avon	D3 32
Hawkhurst, Kent	E3 26
Hawkinge, Kent	J3 27
Hawkley, Hants.	E2 24
Hawkridge, Som.	G3 35
Hawkshead, Cumb.	F2 69
Hawksland, Stra.	D5 86
Hawkswick, N.Yorks.	B5 66
Hawksworth, Notts.	F2 47
Hawksworth, W.Yorks.	J1 61
Hawkwell, Essex	F2 29
Hawley, Hants.	D5 30
Hawleys Corner, G.L.	C5 28
Hawling, Glos.	K2 39
Hawnby, N.Yorks.	G3 67
Haworth, W.Yorks.	H1 61
Hawsker, N.Yorks.	K2 67
Hawstead, Suff.	E3 42
Hawthorn Hill, Lincs.	H6 63
Hawthorn, Dur.	D4 76
Hawthorn, Wilts.	E4 32
Hawton, Notts.	D6 62
Haxby, N.Yorks.	D4 64
Haxey, Hum.	D3 62
Hay Green, Norf.	B4 44
Hay Street, Herts.	A5 42
Hay-on-Wye, Powys	C6 50
Haydock, Mer.	D5 60
Haydon Bridge, Northumb.	H3 75
Haydon Wick, Wilts.	G3 33
Haydon, Dor.	D3 22
Hayes, G.L.	F3 31
Hayfield, Derby.	H5 61
Hayle, Corn.	B4 18
Hayling Island, Hants.	E4 24
Haynes, Beds.	J4 41
Hayscastle Cross, Dyfed	B1 36
Hayscastle, Dyfed	B1 36
Hayton Vale, Dev.	F3 21
Hayton, Cumb.	F3 75
Hayton, Hum.	F5 65
Hayton, Notts.	D4 62
Haywards Heath, W.Suss.	B4 26
Hazel Grove, Grt.M.	G5 61
Hazeley, Hants.	D5 30
Hazelslade, Staffs.	C3 48
Hazelton Walls, Fife	F4 91
Hazelton, Glos.	K2 39
Hazelwood, Derby.	C2 46
Hazlemere, Bucks.	E2 30
Hazlerigg, T.&W.	C2 76
Heacham, Norf.	C2 44
Headcorn, Kent	F2 27
Headingley, W.Yorks.	B5 64
Headington. Oxon.	B1 30
Headley, Hants.	B5 30
Headley, Surr.	G5 31
Headon, Notts.	D4 62
Heage, Derby.	C1 46
Healaugh, N.Yorks.	C5 64
Heald Green, Grt.M.	F5 61
Heald Moor, Lancs.	G2 61
Healey, Lancs.	G3 61
Healey, N.Yorks.	D4 66
Healey, Northumb.	A3 76
Healing, Hum.	H2 63
Heanor, Derby.	C1 46
Heanton Punchardon, Dev.	D2 34
Heapham, Lincs.	E4 62
Hearthstane, Bord.	F4 81
Hearthstone, Bord.	A6 88
Heast, Isle of Skye	F2 97
Heath and Reach, Beds.	G5 41
Heath End, Avon	D3 32
Heath End, Hants.	B5 30
Heath Hayes, Staffs.	C3 48
Heath Hill, Salop.	E5 56
Heath, Derby.	A5 62
Heath, The, Norf.	H4 45
Heath, The, Suff.	G4 43
Heathcote, Derby.	H2 57
Heather, Leics.	C4 46
Heathfield, E.Suss.	D4 26
Heathfield, Som.	K3 35
Heathfield, Stra.	G1 83
Heatley, Ches.	E5 60
Heaton Moor, Grt.M.	F5 61
Heaton, Staffs.	G2 57
Heaton, W.Yorks.	A6 64
Heaviley, Grt.M.	G5 61
Hebburn, T.&W.	C3 76
Hebden Bridge, W.Yorks.	G2 61
Hebden Green, Ches.	D1 56
Hebden, N.Yorks.	B5 66
Hebron, Northumb.	B1 76
Heckfield Green, Suff.	G1 43
Heckfield, Hants.	C5 30
Heckington, Lincs.	J2 47
Heckmondwike, W.Yorks.	J3 61
Heddington, Wilts.	F4 33
Heddon-on-the-Wall, Northumb.	B3 76
Hedenham, Norf.	H6 45
Hedge End, Hants.	C3 24
Hedgerley, Bucks.	E3 30
Hedley on the Hill, Northumb.	A3 76
Hednesford, Staffs.	C3 48
Hedon, Hum.	J6 65
Heighington, Dur.	C6 76
Heighington, Lincs.	F5 63
Heights of Brae, High.	E4 104
Heights of Kinlochewe, High.	H4 107
Heiton, Bord.	F3 79
Hele, Dev.	E3 34
Helensburgh, Stra.	K2 85
Helhoughton, Norf.	E3 44
Helions Bumpstead, Essex	C4 42
Helland, Corn.	G2 19
Hellesdon, Norf.	G4 45
Hellifield, N.Yorks.	A6 66
Hellingley, E.Suss.	D5 26
Hellmoor Loch, Bord.	H4 81
Helmdon, Northants.	E4 40
Helmsdale, High.	E6 110
Helmshore, Lancs.	F3 61
Helmsley, N.Yorks.	G3 67
Helperby, N.Yorks.	C3 64
Helperthorpe, N.Yorks.	G3 65
Helpringham, Lincs.	J2 47
Helpston, Cambs.	J5 47
Helsby, Ches.	C6 60
Helston, Corn.	C5 18
Helton, Cumb.	F6 75
Helwith Bridge, N.Yorks.	A5 66
Hemel Hempstead, Herts.	F1 31
Hemingbrough, N.Yorks.	E6 64
Hemingby, Lincs.	H5 63
Hemingford Abbots, Cambs.	K2 41
Hemingford Grey, Cambs.	K2 41
Hemington, Leics.	D3 46
Hemington, Northants.	J6 47
Hemington, Som.	D6 32
Hemp Green, Suff.	J2 43
Hempnall, Norf.	H6 45
Hempstead, Essex	C4 42
Hempstead, Norf.	G2 45
Hempsted, Glos.	H2 39
Hemsby, Norf.	K4 45
Hemstall Ridware, Staffs.	D3 48
Hemswell, Lincs.	E3 62
Hemsworth, W.Yorks.	A2 62
Hemyock, Dev.	J4 35
Henbury, Avon	C4 32
Henbury, Ches.	G6 61
Hendon, G.L.	G3 31
Hendred, Oxon.	A3 30
Hendy, Dyfed	H3 37
Henfield, W.Suss.	A5 26
Hengoed, M.Glam.	B4 38
Hengoed, Salop.	A4 56
Hengrave, Suff.	D2 42
Henham, Essex	B5 42
Heniarth, Powys	B1 50
Henley, Som.	B1 22
Henley, Suff.	G3 43
Henley, W.Suss.	F2 25
Henley-in-Arden, War.	K4 51
Henley-on-Thames, Oxon.	D3 30
Henllan, Clwyd	G4 59
Henllan, Dyfed	E6 52
Henllys, Gwent	C4 38
Henlow, Beds.	J4 41
Hennock, Dev.	F3 21
Henrys Moat, Dyfed	D1 36
Hensall, N.Yorks.	D6 64
Henshaw, Northumb.	H3 75
Henstead, Suff.	K1 43
Henstridge Ash, Som.	D2 22
Henstridge, Som.	D2 22
Henton, Som.	B6 32
Henwick, H.&W.	H5 51
Heol-y-Cyw, M.Glam.	A5 38
Hepple, Northumb.	H6 79
Hepscott, Northumb.	C1 76
Hepton, Lancs.	F2 61
Heptonstall, W.Yorks.	G2 61
Hepworth, Suff.	F1 43
Hepworth, W.Yorks.	J4 61
Herbrandston, Dyfed	B3 36
Hereford, H.&W.	E6 50
Hergest, H.&W.	C5 50
Hermitage, Berks.	B4 30
Hermitage, Bord.	D6 78
Hermon, Angl.	B4 58
Hermon, Dyfed	E1 36
Hermon, Gwyn.	C1 54
Herne Bay, Kent	J4 29
Herne, Kent	J5 29
Hernhill, Kent	H5 29
Herodsfoot, Corn.	H3 19
Hernard, Hants.	C6 30
Herringfleet, Suff.	K5 45
Herringswell, Suff.	D2 42
Hersden, Kent	J5 29
Hersham, Corn.	B5 34
Hersham, Surr.	G5 31
Herstmonceux, E.Suss.	D5 26
Herston, Ork.	G6 112
Hertford, Herts.	B1 28
Hesket Newmarket, Cumb.	D5 74
Hesketh Bank, Lancs.	C2 60
Hesketh Lane, Lancs.	D1 60
Heskin Green, Lancs.	D3 60
Hesleden, Dur.	D5 76
Hesleyside, Northumb.	H1 75
Heslington, N.Yorks.	D4 64
Hessay, N.Yorks.	D4 64
Hessenford, Corn.	H3 19
Hessett, Suff.	E2 42
Hessle, Hum.	F1 63
Hest Bank, Lancs.	G5 69
Hestan Island, D.&G.	H4 73
Heston, G.L.	G4 31
Heswall, Mer.	J3 59
Hethe, Oxon.	E5 40
Hethersett, Norf.	G4 45
Hethersgill, Cumb.	F3 75
Hethpool, Northumb.	G4 79
Hetton, N.Yorks.	B5 66
Hetton-le-Hole, T.&W.	D4 76
Heugh, Northumb.	A2 76
Heugh-head, Gram.	E3 100
Heveningham, Suff.	H2 43
Hever, Kent	C2 26
Heversham, Cumb.	G3 69
Hevingham, Norf.	G4 45
Hewelsfield, Glos.	F3 39
Hewish, Avon	A5 32
Hewish, Som.	A3 22
Heworth, N.Yorks.	D4 64
Hexham, Northumb.	J3 75
Hextable, Kent	C4 28
Hexton, Herts.	J5 41
Hexworthy, Dev.	E3 20
Heybridge Basin, Essex	F1 29
Heybridge, Essex	F1 29
Heydon, Cambs.	A4 42
Heydon, Norf.	G3 45
Heydour, Lincs.	H2 47
Heylipol, Isle of Tiree	A2 94
Heysham, Lancs.	F5 69
Heyshot, W.Suss.	F3 25
Heythrop, Oxon.	C5 40
Heywood, Grt.M.	F4 61
Heywood, Wilts.	E6 32
Hibaldstow, Hum.	F2 63
Hickleton, S.Yorks.	B2 62
Hickling Green, Norf.	J3 45
Hickling Heath, Norf.	J3 45
Hickling, Norf.	J3 45
Hickling, Notts.	E3 46
Hickstead, W.Suss.	A4 26
Hidcote Boyce, Glos.	K6 51
High Ackworth, W.Yorks.	A1 62
High Bank Cross, Derby.	B4 46
High Bentham, N.Yorks.	J5 69
High Bickington, Dev.	E4 34
High Birkwith, N.Yorks.	A4 66
High Bray, Dev.	F2 35
High Buston, Northumb.	K5 79
High Catton, Hum.	E4 64
High Coniscliffe, Dur.	D1 66
High Cross Bank, Derby.	E3 48
High Cross, Herts.	A6 42
High Easter, Essex	D1 28
High Ellington, N.Yorks.	A2 64
High Ercall, Salop.	D5 56
High Garrett, Essex	D5 42
High Green, Norf.	G5 45
High Green, S.Yorks.	A3 62
High Halden, Kent	F3 27
High Halstow, Kent	E4 28
High Ham, Som.	B2 22
High Hesket, Cumb.	F4 75
High Holland, S.Yorks.	K4 61
High Hurstwood, E.Suss.	C4 26
High Hutton, N.Yorks.	E3 64
High Lane, H.&W.	F4 51
High Laver, Essex	C1 28
High Leigh, Ches.	E6 60
High Melton, S.Yorks.	B2 62
High Newton, Cumb.	F4 69
High Offley, Staffs.	E4 56
High Ongar, Essex	D2 28
High Onn, Staffs.	B3 48
High Roding, Essex	C6 42
High Spen, T.&W.	B3 76
High Street, Corn.	F3 19
High Street, Suff.	E4 42
High Toynton, Lincs.	H5 63
High Trewhitt, Northumb.	H5 79
High Wray, Cumb.	F2 69
High Wych, Herts.	B6 42
High Wycombe, Bucks.	E2 30
High-Cross Bank, Derby.	J5 57
Higham Ferrers, Northants.	H2 41
Higham Gobion, Beds.	J5 41
Higham on the Hill, Leics.	F5 49
Higham, Derby.	C1 46
Higham, Lancs.	F1 61
Higham, Suff.	D2 42
Highampton, Dev.	D5 34
Highbridge, Som.	A6 32
Highclere, Hants.	A5 30
Highcliffe, Hants.	A5 24
Higher Ashton, Dev.	F2 21
Higher Ballam, Lancs.	B2 60
Higher Penwortham, Lancs.	D2 60
Higher Town, Som.	H1 35
Higher Walton, Ches.	D6 60
Higher Walton, Lancs.	D2 60
Highfield, Dev.	F5 35
Highfield, Hum.	E5 64
Highgate, G.L.	H3 31
Highlane, Derby.	A4 62
Highleadon, Glos.	G2 39
Highley, Salop.	G3 51
Highmoor Cross, Oxon.	C3 30
Highstreet, Kent	H5 29
Hightoe, D.&G.	C2 74
Hightown, Ches.	F2 57
Hightown, Mer.	B4 60
Highway, Wilts.	K5 39
Highweek, Dev.	F3 21
Highworth, Wilts.	H2 33
Hilborough, Norf.	D5 44
Hildenborough, Kent	D2 26
Hildersham, Cambs.	B4 42
Hilderstone, Staffs.	G4 57
Hilderthorpe, Hum.	J3 65
Hill End, Dur.	A5 76
Hill End, Fife	C6 90
Hill of Fearn, High.	H3 105
Hill Ridware, Staffs.	D3 48
Hill Row, Cambs.	A1 42
Hill Top, Hants.	B4 24
Hill Top, W.Yorks.	A1 62
Hill, Avon	F4 39
Hill, The, Cumb.	E3 68
Hillam, N.Yorks.	D6 64
Hillbeck, Cumb.	A1 66
Hillberry, I.o.M.	D4 70
Hillborough, Kent	J4 29
Hillfarance, Som.	K3 35
Hillfield, Dor.	C4 22
Hillhead, Stra.	H4 83
Hilliards Cross, Streathay, Staffs.	H6 57
Hilliards Cross, Staffs.	D3 48
Hillingdon, G.L.	F3 31
Hillington, Norf.	D3 44
Hillmorton, War.	D2 40
Hillockhead, Gram.	E3 100
Hills Town, Derby.	B5 62
Hillside, Gram.	J4 101
Hillside, Shet.	D3 112
Hillside, Tay.	J1 91
Hillsley, Avon	D3 32
Hillswick, Shet.	D2 112
Hilltop, W.Yorks.	K3 61
Hilmarton, Wilts.	F4 33
Hilperton, Wilts.	E5 32
Hilsea, Hants.	D4 24
Hilston, Hum.	K6 65
Hilton of Cadboll, High.	H3 105
Hilton, Cambs.	K2 41
Hilton, Cleve.	F1 67
Hilton, Cumb.	H6 75
Hilton, Derby.	E2 48
Hilton, Dor.	D4 22
Hilton, Dur.	B6 76
Hilton, Gram.	H6 103
Hilton, Salop.	G2 51
Himbleton, H.&W.	J5 51
Himley, Staffs.	B5 48
Hincaster, Cumb.	G3 69
Hindeveston, Norf.	F3 45
Hinderclay, Suff.	F1 43
Hinderwell, N.Yorks.	J1 67
Hindhead, Surr.	F1 25
Hindley Green, Grt.M.	E4 60
Hindley, Grt.M.	E4 60
Hindlip, H.&W.	H5 51
Hindon, Wilts.	E1 22
Hindringham, Norf.	F2 45
Hingham, Norf.	F5 45
Hinkley, Leics.	G5 49
Hinstock, Salop.	E4 56
Hintlesham, Suff.	G4 43
Hinton Blewett, Avon	C5 32
Hinton St. George, Som.	B3 22
Hinton St. Mary, Dor.	D3 22
Hinton Waldrist, Oxon.	J2 33
Hinton, Avon	D4 32
Hinton, Hants.	A5 24
Hinton, Salop.	B6 56
Hinton-on-the-Green, H.&W.	J6 51
Hints, Staffs.	D4 48
Hinwick, Beds.	G2 41
Hinxhill, Kent	H2 27
Hinxton, Cambs.	B4 42
Hinxworth, Herts.	K4 41
Hipperholme, W.Yorks.	J2 61
Hirnant, Powys	H5 55
Hirst Courtney, N.Yorks.	C1 62
Histon, Cambs.	A2 42
Hitcham, Suff.	F3 43
Hitchin, Herts.	J5 41
Hittisleigh Cross, Dev	E1 20
Hive, Hum.	F6 65
Hixon, Staffs.	G5 57
Hoar Cross, Staffs.	D2 48
Hoarwithy, H.&W.	F1 39
Hoath, Kent	J5 29
Hobberley, Salop.	D1 50
Hobkirk, Bord.	E5 78
Hoby, Leics.	E4 46
Hockcliffe, Beds.	H5 41
Hockering, Norf.	F4 45
Hockerton, Notts.	D6 62
Hockley Heath, W.Mid.	D6 48
Hockley, Essex	F2 29
Hockwold Cum Wilton, Norf.	D6 44
Hockworthy, Dev.	J4 35
Hoddesdon, Herts.	J1 31
Hoddlesden, Lancs.	E3 60
Hodgeston, Dyfed	C3 36
Hodnet, Salop.	D4 56
Hodthorpe, Derby.	B4 62
Hoe, Norf.	F4 45
Hoeford, Hants.	D4 24
Hoggeston, Bucks.	F5 41
Hoghton, Lancs.	D2 60
Hognaston, Derby.	J3 57
Hogsthorpe, Lincs.	K5 63
Holbeach Drove, Lincs.	A4 44
Holbeach Hurn, Lincs.	A3 44
Holbeach St. Johns, Lincs.	A4 44
Holbeach St. Marks, Lincs.	A3 44
Holbeach St. Matthew, Lincs.	A3 44
Holbeach, Lincs.	A3 44
Holbeck, Notts.	B5 62
Holberrow Green, H.&W.	J4 51
Holbeton, Dev.	D5 20
Holbrook, Derby.	F1 49
Holbrook, Suff.	G4 43
Holburn, Northumb.	J3 79
Holcombe Rogus, Dev.	J4 35
Holcombe, Dev.	G3 21
Holcombe, Som.	D6 32
Holcot, Northants.	F2 41
Holden, Lancs.	A6 66
Holdenby, Northants.	F2 41
Holdgate, Salop.	F2 51
Holdingham, Lincs.	H1 47
Holford, Som.	J2 35
Holgate, N.Yorks.	D4 64
Holker, Cumb.	F4 69
Holkham, Norf.	E2 44
Hollacombe, Dev.	C5 34
Holland Fen, Lincs.	K1 47
Holland, Ork.	G4 112
Holland-on-Sea, Essex	G6 43
Hollandstoun, Ork.	H4 112
Hollesley, Suff.	J4 43
Hollin, Staffs.	G1 57
Hollinfare, Ches.	E5 60
Hollingbourne, Kent	F5 29
Hollington, Derby.	J3 57
Hollington, E.Suss.	F5 27
Hollington, Staffs.	H3 57
Hollingworth, Derby.	A5 62
Hollingworth, Grt.M.	G5 61
Hollins, Grt.M.	F4 61
Hollinsdough, Derby.	H1 57
Hollinwood, Grt.M.	C4 56
Hollocombe, Dev.	E4 34
Hollow Meadows, S.Yorks.	J5 61
Holloway, Derby.	C1 46
Holloway, G.L.	H3 31
Hollowell, Northants.	E2 40
Holly End, Norf.	B5 44
Hollybush, Gwent	B3 38
Hollybush, H.&W.	G6 51
Hollybush, Stra.	H5 83
Hollym, Hum.	J1 63
Hollywell, Dor.	C4 22
Holme Chapel, Lancs.	G2 61
Holme Hale, Norf.	E5 44
Holme Lacy, H.&W.	F6 51
Holme Next The Sea, Norf.	C2 44
Holme on the Wolds, Hum.	G5 65
Holme, Cambs.	J6 47
Holme, Cumb.	G4 69
Holme, Hum.	E2 62
Holme, Notts.	D6 62
Holme, W.Yorks.	H4 61
Holme-on-the-Wolds, Hum.	K6 67
Holme-upon-Spalding Moor, Hum.	F5 65
Holmer, H.&W.	E6 50
Holmes Chapel, Ches.	E1 56
Holmesfield, Derby.	A4 62
Holmeswood, Lancs.	C3 60
Holmewood, Derby.	A5 62
Holmfirth, W.Yorks.	J4 61
Holmpton, Hum.	J1 63
Holmrook, Cumb.	D2 68
Holmwood, Surr.	A2 26
Holne, Dev.	E3 20
Holnest, Dor.	C3 22
Holsworthy Beacon, Dev.	C5 34
Holsworthy, Dev.	C5 34
Holt End, H.&W.	K4 51
Holt Heath, H.&W.	H4 51
Holt, Clwyd	B2 56
Holt, Dor.	F4 23
Holt, Norf.	F2 45
Holt, Wilts.	E5 32
Holtby, N.Yorks.	E4 64
Holton le Clay, Lincs.	H2 63
Holton le Moor, Lincs.	F3 63
Holton St. Mary, Suff.	F4 43
Holton, Lincs.	G4 63
Holton, Oxon.	B1 30
Holton, Som.	D2 22
Holton, Suff.	J1 43
Holwell, Dor.	D3 22
Holwell, Leics.	E3 47
Holwell, Oxon.	H1 33
Holwick, Dur.	J6 75
Holy Island, Northumb.	J2 79
Holyhead, Angl.	A3 58
Holymoorside, Derby.	A5 62
Holyport, Berks.	E4 30
Holystone, Northumb.	H6 79
Holytown, Stra.	C4 86
Holywell Green, W.Yorks.	H3 61
Holywell Row, Suff.	D1 42
Holywell, Clwyd	J3 59
Holywell, Corn.	D3 18
Holywood, D.&G.	J2 73
Homer, Salop.	D6 56
Homersfield, Suff.	H1 43
Homington, Wilts.	G2 23
Honey Tye, Suff.	E5 42
Honeybourne, H.&W.	K6 51
Honiley, War.	B2 40
Honing, Norf.	H3 45
Honingham, Norf.	G4 45
Honington, Lincs.	H2 47
Honington, Suff.	E1 42
Honiton, Dev.	K5 35
Honley, W.Yorks.	J3 61
Hoo Common, Kent	E4 28
Hoo, Kent	F4 29
Hooe, E.Suss.	E5 26
Hook Green, Kent	D5 28
Hook Norton, Oxon.	C5 40
Hook, Cambs.	A6 44
Hook, Dyfed	C2 36
Hook, Hants.	C5 30
Hook, Wilts.	G3 33
Hooke, Dor.	B4 22
Hookgate, Staffs.	E4 56
Hoole, Ches.	C1 56
Hooley, Surr.	B5 28
Hooton Levitt, S.Yorks.	B3 62
Hooton Pagnell, S.Yorks.	B2 62
Hooton Roberts, S.Yorks.	B3 62
Hope Bagot, Salop.	F3 51
Hope Bowdler, Salop.	E2 50
Hope Mansell, H.&W.	F2 39
Hope under Dinmore, H.&W.	E5 50
Hope, Clwyd	B2 56
Hope, Derby.	J6 61
Hope, Dev.	E6 20
Hope, High.	E2 109
Hope, Powys	A6 56
Hope, Salop.	D1 50
Hope, Staffs.	H2 57
Hopeman, Gram.	B3 102
Hopton Castle, Salop.	D3 50
Hopton Wafers, Salop.	F3 51
Hopton, Derby.	J2 57
Hopton, Norf.	K5 45
Hopton, Salop.	D4 56
Hopton, Staffs.	G4 57
Hopton, Suff.	F1 43
Hopton-Cangeford, Salop.	E3 50
Hopwas, Staffs.	E4 48
Hopwood, H.&W.	J3 51
Horam, E.Suss.	D4 26
Horbling, Lincs.	J2 47
Horbury, W.Yorks.	K3 61
Horden, Dur.	D5 76
Hordle, Hants.	A5 24
Hordley, Salop.	B4 56
Horeb, Dyfed	E6 52
Horfield, Avon	C4 32
Horham, Suff.	H2 43
Horkstow, Hum.	F1 63

175

176

Llanfair Talhaiarn, Clwyd. G4 59
Llanfair Waterdine, Salop. C3 50
Llanfair, Gwyn. D4 54
Llanfair-Caereinion, Powys B1 50
Llanfair-Dyffryn-Clwyd, Clwyd J2 55
Llanfair-Nant-Gwyn, Dyfed C6 52
Llanfair-yn-Neubwll, Angl. B3 58
Llanfairfechan, Gwyn. E3 58
Llanfairpwllgwyngyli, Angl. C3 58
Llanfairynghornwy, Angl. B2 58
Llanfallteg, Dyfed D2 36
Llanfechain, Powys J5 55
Llanfechell, Angl. B2 58
LLanfendigaid, Dyfed F1 53
Llanferres, Clwyd J4 59
Llanfflewyn, Angl. B2 58
Llanfihangel Crucorney, Gwent D2 38
Llanfihangel Glyn Myfyr, Clwyd G3 55
Llanfihangel Nant Bran, Powys A6 50
Llanfihangel Rhydithon, Powys B4 50
Llanfihangel Tal-y-llyn Powys B1 38
Llanfihangel-ar-Arth, Dyfed F6 53
Llanfihangel-nant-Melan, Powys B5 50
Llanfihangel-y-Creuddyn, Dyfed G3 53
Llanfihangel-y-pennant, Gwyn. D3 54
Llanfihangel-y-traethau. Gwyn. D4 54
Llanfoist, Gwent C2 38
Llanfor, Gwyn. G4 55
Llanfrechfa, Gwent D4 38
Llanfrynach, Powys B1 38
Llanfwrog, Angl. B3 58
Llanfwrog, Clwyd H2 55
Llanfyllin, Powys J5 55
Llanfynydd, Clwyd J5 59
Llanfynydd, Dyfed H1 37
Llanfyrnach, Dyfed E1 36
Llangadfan, Powys H6 55
Llangadog, Dyfed J1 37
Llangadwaladr, Angl. B4 58
Llangadwaladr, Clwyd J4 55
Llangadwaladr, Gwyn. C1 54
Llangaffo, Angl. C4 58
Llangaffo, Gwyn. C1 54
Llangain, Dyfed F2 37
Llangammarch Wells, Powys J5 53
Llangan, S.Glam. A5 38
Llangarron, H.&W. E2 38
Llangasty Talyllyn, Powys B1 38
Llangathen, Dyfed H2 37
Llangattock Lingoed, Gwent D2 38
Llangattock, Powys C2 38
Llangedwyn, Clwyd J5 55
Llangefni, Angl. C3 58
Llangeinor, M.Glam. K4 37
Llangeitho, Dyfed G4 53
Llangeler, Dyfed E6 52
Llangendeirne, Dyfed G2 37
Llangennech, Dyfed H3 37
Llangennith, W.Glam. G4 37
Llangenny, Powys C2 38
Llangernyw, Clwyd F4 59
Llangian, Gwyn. B4 54
Llanglydwen, Dyfed E1 36
Llangoed, Angl. D3 58
Llangollen, Clwyd J3 55
Llangolman, Dyfed D1 36
Llangorse, Powys B1 38
Llangorwen, Dyfed G2 53
Llangoven, Gwent E3 38
Llangower, Gwyn. G4 55
Llangranog, Dyfed D5 52
Llangrove, H.&W. E2 38
Llangua, Gwyn. D1 38
Llangunllo, Powys C4 50
Llangurig, Powys J3 53
Llangwm, Clwyd G3 55
Llangwm, Dyfed C3 36
Llangwm, Gwent B2 32
Llangwnnadl, Gwyn. A4 54
Llangwyryfon, Dyfed G4 53
Llangybi, Dyfed G5 53
Llangybi, Gwent D4 38
Llangybi, Gwyn. C3 54
Llangynidr, Powys B2 38
Llangynin, Dyfed E2 36
Llangynog, Dyfed F2 37
Llangynog, Powys H4 55
Llanharan, M.Glam. A5 38
Llanharry, M.Glam. A5 38
Llanhennock, Gwent D4 38
Llanhilleth, Gwent C3 38
Llanidloes, Powys A2 50
Llanigon, Powys C6 50
Llaniliar, Dyfed G3 53
Llanishen, Gwent E3 38
Llanishen, S.Glam. C5 38
Llanllechid, Gwyn. D4 58
Llanllowell, Gwent D4 38
Llanllugan, Powys H6 55
Llanllyfni, Gwyn. C2 54
Llanllywel, Gwent A2 32
Llanmadoc, W.Glam. G4 37

Llanmaes, S.Glam. A6 38
Llanmartin, Gwent D4 38
Llanmerewig, Powys B2 50
Llannefydd, Clwyd G4 59
Llannon, Dyfed G3 37
Llannor, Gwyn. B4 54
Llanon, Dyfed F4 53
Llanpumsaint, Dyfed G1 37
Llanrhaeadr-ym-Mochnant, Clwyd J5 55
Llanrhidian, W.Glam. G4 37
Llanrhyddlad, Angl. B2 58
Llanrhystyd, Dyfed F4 53
Llanrothal, H.&W. E2 38
Llanrug, Gwyn. C4 58
Llanrwst, Gwyn. F2 55
Llansadwrn, Dyfed J1 37
Llansaint, Dyfed F3 36
Llansamlet, W.Glam. J4 37
Llansannan, Clwyd G4 59
Llansantffraed-in-Elvel, Powys B5 50
Llansantffraid Glan Conwy, Gwyn. F3 59
Llansantffraid, Dyfed F4 53
Llansantffraid-ym-Mechain, Powys J5 55
Llansawel, Dyfed G6 53
Llansay, Gwent E3 38
Llansilin, Clwyd J4 55
Llansoy, Gwent B2 32
Llanspyddid, Powys A1 38
Llanstephan, Dyfed F3 36
Llanstephen, Powys B6 50
Llanthony, Gwent C1 38
Llantilio Crossenny Gwent D2 38
Llantrisant, Gwent D4 38
Llantrisant, M.Glam. A5 38
Llantrithyd, S.Glam. B6 38
Llantwit Major, S.Glam. A6 38
Llantwit, M.Glam. B5 38
Llanuwchllyn, Gwyn. G4 55
Llanvaches, Gwent E4 38
Llanvair-Discoed, Gwent B2 32
Llanvapley, Gwent D2 38
Llanvetherine, Gwent D2 38
Llanveynoe, H.&W. D1 38
Llanvihangel Gobion, Gwent D3 38
Llanwarne, H.&W E1 38
Llanwddyn, Powys H5 55
Llanwern, Gwent A3 32
Llanwnda, Dyfed A6 52
Llanwnen, Dyfed F5 53
Llanwnog, Powys A2 50
Llanwrda, Dyfed J1 37
Llanwrin, Powys F6 55
Llanwrst, Gwyn. F4 59
Llanwrthwl, Powys A4 50
Llanwrtyd Wells, Powys J5 53
Llanyblodwel, Salop. A4 56
Llanybri, Dyfed F2 37
Llanycefn, Dyfed D2 36
Llanychaer Bridge, Dyfed B6 52
Llanychaer, Dyfed C1 36
Llanymawddwy, Gwyn. G5 55
Llanymynech, Powys A5 56
Llanynghenedl, Angl. B3 58
Llanynys, Clwyd H4 59
Llanyre, Powys A4 50
Llanystumdwy, Gwyn. C4 54
Llawhaden, Dyfed D2 36
Llawnt, Salop. A4 56
Llawr-y-dref, Gwyn. B4 54
Llawryglyn, Powys J2 53
Llay, Clwyd B2 56
Llechcynfarwy, Angl. B3 58
Llechfaen, Powys B1 38
Llechryd, Dyfed D6 52
Lledrod, Dyfed G4 53
Llidiardau, Gwyn. A4 54
Lithfaen, Gwyn. B3 54
Llong, Clwyd J4 59
Llowes, Powys C6 50
Llwydiarth, Powys H5 55
Llwyncelyn, Dyfed E4 52
Llwyndafydd, Dyfed E5 52
Llwynderw, Powys C1 50
Llwyndyrys, Gwyn. C3 54
Llwyngwril, Gwyn. D6 54
Llwynhendy, Dyfed G3 37
Llwynmawr, Clwyd J4 55
Llwynpia, M.Glam. A4 38
Llys-y-frân, Dyfed C1 36
Llysfaen, Clwyd F3 59
Llyswen, Powys B6 50
Llysworney, S.Glam. A5 38
Llywel, Powys K1 37
Loanhead, Loth. G3 87
Loans, Stra. G3 83
Loch Arthur, D.&G. H3 73
Loch Doon, D.&G. A6 80
Loch Dornal, D.&G. D2 72
Loch Dungeon, D.&G. E1 72
Loch Enoch, D.&G. E1 72
Loch Grannoch, D.&G. E2 72
Loch Ken, D&G. F2 73
Loch Kindar, D.&G. J3 73
Loch Maberry, D.&G. C2 72
Loch Macaterick, Stra. E1 72
Loch Mannoch, D.&G. F3 73
Loch Moan, D.&G. D1 72
Loch Neldricken, D.&G. E1 72
Loch Ochiltree, D.&G. D2 72
Loch of the Lowes, Bord. G4 81
Loch Ronald, D.&G. C3 72
Loch Ryan, D.&G. B3 72
Loch Skeen, D.&G. F5 81
Loch Skerrow, D.&G. F3 73
Loch Urr, D.&G. G1 73
Loch Valley, D.&G. E1 72
Loch Whinyeon, D.&G. F3 73
Lochailort, High. G5 97
Lochaline, High. F2 95
Lochans, D.&G. B3 72
Locharbriggs, D.&G. B2 74
Lochboisdale, S.Uist B5 108

Lochbuie, Isle of Mull F4 95
Lochcarron, High. G6 107
Lochdonhead, Isle of Mull G3 95
Locheamhead, Cen. H4 93
Lochee, Tay. F3 91
Lochend, High. G1 111
Locherben, D.&G. D6 80
Lochfoot, D.&G. H2 73
Lochgair, Stra. G1 85
Lochgarthside, High. G2 99
Lochgelly, Fife G1 87
Lchgilpead, Stra. F1 85
Lochgoilhead, Stra. E6 92
Lochinver, High. F1 73
Lochluichart, High. D4 104
Lochmaben, D.&G. B1 74
Lochmaddy, N.Uist B4 108
Lochore, Fife E6 90
Lochranza, Island of Arran G4 85
Lochrutton Loch, D.&G. H2 73
Lochside, Gram. J1 91
Lochside, High. D4 110
Lochskipport, S.Uist B5 108
Lochton, Gram. H4 101
Lochty, Fife G5 91
Lochwinnoch, Stra. G1 83
Lockwood, D.&G E6 80
Lockengate, Corn. F2 19
Lockerbie, D.&G. C1 74
Lockeridge, Wilts. G4 33
Lockerley, Hants. A2 24
Locking, Avon A5 32
Lockington, Hum. G5 65
Lockington, Leics. D3 46
Lockleywood, Salop. E4 56
Lockton, N.Yorks. J3 67
Loddington, Leics. J4 49
Loddiswell, Dev. E5 20
Loddon, Norf. J5 45
Lode, Cambs. B2 42
Loders, Dor. B4 22
Lodsworth, W.Suss. F2 25
Lofthouse, N.Yorks. C4 66
Lofthouse, W.Yorks. B6 64
Loftus, Cleve. H1 67
Logan Mains, D.&G. B5 72
Loggerheads, Staffs. E4 56
Loggie, High. B2 104
Logie Coldstone, Gram. F3 101
Logie Newton, Gram. F6 103
Login, Dyfed D2 36
Loglerait, Tay. C2 90
Lolworth, Cambs. A2 42
Lonbain, High. E5 106
Londesborough, Hum. F5 65
London Colney, Herts. G2 31
Londonderry, N.Yorks. E3 66
Londonthorpe, Lincs. H2 47
Long Ashton, Avon C4 32
Long Bennington, Lincs. G2 47
Long Bredy, Dor. C5 22
Long Buckby, Northants. E2 40
Long Burton, Dor. C3 22
Long Clawson, Leics. F3 47
Long Compton, Staffs. F5 57
Long Compton, War. B5 40
Long Crendon, Bucks. C1 30
Long Drax, N.Yorks. E6 64
Long Eaton, Derby. D2 46
Long Itchington, War. C2 40
Long Lawford, War. D1 40
Long Load, Som. B2 22
Long Marston, Bucks. G6 41
Long Marston, N.Yorks. C4 64
Long Marston, War. K5 51
Long Marton, Cumb. G6 75
Long Melford, Suff. E4 42
Long Newnton, Glos. E2 33
Long Preston, N.Yorks. A6 66
Long Riston, Hum. H5 65
Long Stanton All Saints, Cambs. A2 42
Long Stratton, Norf. G6 45
Long Sutton, Hants. D6 30
Long Sutton, Lincs. A3 44
Long Sutton, Som. B2 22
Long Whatton, Leics. D3 46
Long Wittenham, Oxon. B2 30
Longbank, Stra. K3 85
Longbenton, T.&W. C2 76
Longborough, Glos. A5 40
Longbridge, War. B2 40
Longcliffe, Derby. J2 57
Longcot, Oxon. H3 33
Longden, Salop. E1 50
Longdon on Tern, Salop. D5 56
Longdon, H.&W. H6 51
Longdon, Staffs. D3 48
Longdown, Dev. F2 21
Longfield, Kent D4 28
Longford, Derby. J4 57
Longford, G.L. F4 31
Longford, Salop. D4 56
Longforgan, Tay. F3 91
Longformacus, Bord. F4 89
Longframlington, Northumb. J6 79
Longham, Norf. E4 44
Longhirst, Northumb. C1 76
Longhope, Glos. G2 39
Longhorsley, Northumb. J6 79
Longhoughton, Northumb. K5 79
Longlane, Derby. J4 57
Longley Green, H.&W. G5 51
Longmanhill, Gram. G4 103
Longnewton, Bord. E4 78
Longnewton, Cleve. E1 66
Longney, Glos. D1 32
Longniddry, Loth. D2 88
Longnor, Staff. H1 57
Longparish, Hants. K6 33
Longridge, Lancs. D1 60
Longridge, Loth. E3 86
Longriggend, Stra. D3 86
Longsdon, Staffs. G2 57
Longside, Gram. J5 103
Longslow, Salop. D4 56
Longstock, Hants. B1 24

Longstone, Derby. J1 57
Longthorpe, Cambs. J5 47
Longton, Lancs. C2 60
Longton, Staffs. G3 57
Longtown, Cumb. E2 74
Longtown, H.&W. D1 38
Longville in the Dale, Salop. E2 50
Longwick, Bucks. D1 30
Longwitton, Northumb. A1 76
Longworth, Oxon. J2 33
Lonmore, Isle of Skye B5 106
Loose, Kent E2 26
Lootcherbrae, Gram. F5 103
Lopcombe Corner, Wilts. A1 24
Lopen, Som. B3 22
Loppington, Salop. C4 56
Lorbottle, Northumb. J5 79
Lorton, Cumb. C6 74
Loscoe, Derby. C1 46
Lossiemouth, Gram. C3 102
Lossit, Isle of Islay A4 84
Lostock Gralam, Ches. E6 60
Lostwithiel, Corn. G3 19
Lothbeg, High. E6 110
Lothersdale, N.Yorks. G1 61
Lothmore, High. E6 110
Lots Bridge, Norf. B5 44
Loudwater, Bucks. E3 30
Loughborough, Leics. D4 46
Loughor, W.Glam. H4 37
Loughton, Bucks. G4 41
Loughton, Essex C2 28
Loughton, Salop. F3 51
Lound, Notts. C4 62
Lound, Suff. K5 45
Lount, Leics. F3 49
Louth, Lincs. H4 63
Love Clough, Lancs. F2 61
Loversall, S.Yorks. B3 62
Loveston, Dyfed D3 36
Lovington, Som. C2 22
Low Bentham, N.Yorks. H5 69
Low Bradfield, S.Yorks. K5 61
Low Bradley, N.Yorks. B6 66
Low Braithwaite, Cumb. E5 74
Low Brunton, Northumb. J2 75
Low Burnham, Hum. D2 62
Low Catton, Hum. E4 64
Low Dinsdale, Dur. E1 66
Low Eggborough, N.Yorks. D6 64
Low Gate, Northumb. J3 75
Low Ham, Som. B2 22
Low Hesket, Cumb. E4 74
Low Hesleyhurst, Northumb. J6 79
Low Hutton, N.Yorks. F3 65
Low Marnham, Notts. D5 62
Low Mill, N.Yorks. H3 67
Low Moor, Lancs. E1 60
Low Redford, Dur. A6 76
Low Row, Cumb. F3 75
Low Street, Norf. J3 45
Low Thurlton, Norf. J5 45
Low Worsall, N.Yorks. E1 66
Lowca, Cumb. B6 74
Lowdham, Notts. E1 46
Lower Ashton, Dev. F2 21
Lower Beeding, W.Suss. A4 26
Lower Boddington, Northants. D3 40
Lower Bourne, Surr. D6 30
Lower Brailes, War. C4 40
Lower Cam, Glos. D3 39
Lower Chapel, Powys A6 50
Lower Cwmtwrch, Powys J3 37
Lower Darwen, Lancs. E2 60
Lower Diabaig, High. F4 107
Lower Dunsforth, N.Yorks. C3 64
Lower Frankton, Salop. B4 56
Lower Green, Kent D2 26
Lower Green, Norf. F2 45
Lower Halstow, Kent F4 29
Lower Hardres, Kent H2 27
Lower Heyford, Oxon. D5 40
Lower Hordley, Salop. B4 56
Lower Killeyan, Isle of Islay B5 84
Lower Kingswood, Surr. H5 31
Lower Largo, Fife F6 91
Lower Machen, Gwent C4 38
Lower Maes-coed, H.&W. D1 38
Lower Pean, Staffs. H2 51
Lower Peaver, Ches. E1 56
Lower Penn, Staffs. B5 48
Lower Peover, Ches. E6 60
Lower Quinton, War. A4 40
Lower Shuckburgh, War. D2 40
Lower Slaughter, Glos. A6 40
Lower Stoke, Kent F4 29
Lower Stow Bedon, Norf. F6 45
Lower Swell, Glos. A5 40
Lower Upham, Hants. C3 24
Lower Weare, Som. A6 32
Lowertown, Dev. C2 20
Lowesby, Leics. F5 47
Lowestoft End, Suff. K6 45
Lowestoft, Suff. K6 45
Loweswater, Cumb. C6 74
Lowfield Heath, W.Suss. A3 26
Lowgill, Lancs. H5 69
Lowick, Northants. H1 41
Lowick, Northumb. H5 89
Lowsonford, War. A2 40
Lowthorpe, Hum. H4 65
Lowton Common, Grt.M. E5 60
Lowton, Grt.M. D5 60
Lowton, Som. K4 35
Loxbeare, Dev. H4 35
Loxhore, Dev. E2 34
Loxley, S.Yorks. K5 61
Loxley, War. B3 40
Loxton, Avon A5 32
Loxwood, W.Suss. G2 25
Lubcroy, High. D1 104
Luccombe, Som. H2 35
Lucker, Northumb. J3 79
Luckington, Wilts. E3 32
Lucton, H.&W. E4 50

Ludborough, Lincs. H3 63
Ludchurch, Dyfed D3 36
Luddenden, W.Yorks. H2 61
Luddington, Hum. D1 62
Ludford Magna, Lincs. G3 63
Ludford Parva, Lincs. G3 63
Ludgershall, Bucks. E6 40
Ludgershall, Wilts. H6 33
Ludgvan, Corn. B5 18
Ludham, Norf. J4 45
Ludlow, Salop. E3 50
Ludwell, Wilts. E2 22
Ludworth, Dur. D5 76
Luffincott, Dev. B1 20
Lugar, Stra. J4 83
Lugton, Stra. H2 83
Lugwardine, H.&W. E6 50
Luib, Isle of Skye E1 96
Lulham, H.&W. D6 50
Lullington, Derby. E3 48
Lulsgate Bottom, Avon E6 38
Lumb, W.Yorks. H3 61
Lumphanan, Gram. G3 101
Lumsdaine, Bord. G3 89
Lumsden, Gram. F2 101
Lunanhead, Tay. G2 91
Luncarty, Tay. D3 90
Lund, Hum. G5 65
Lundie, High. D3 98
Lundie, Tay. E3 90
Lundwood, S.Yorks. A2 62
Lunna, Shet. D2 112
Lunsford, E.Suss. E5 26
Lunt, Mer. B4 60
Luntley, H.&W. D5 50
Luppitt, Dev. K5 35
Lupset, W.Yorks. K3 61
Lupton, Cumb. H4 69
Lurgashall, W.Suss. F2 25
Lusby, Lincs. J5 63
Luss, Stra. F6 93
Lusta, Isle of Skye B5 106
Lustleigh, Dev. F3 21
Luston, H.&W. E4 50
Luthermuir, Gram. G6 101
Luthrie, Fife F4 91
Luton, Beds. J6 41
Luton, Dev. G3 21
Lutterworth, Leics. H5 49
Lutton, Lincs. A3 44
Lutton, Northants. J6 47
Luxborough, Som. H2 35
Luxulyan, Corn. F3 19
Lybster, High. G4 111
Lydbury North, Salop. D2 50
Lydd-on-Sea, Kent H4 27
Lydden, Kent J2 27
Lyddington, Leics. G5 47
Lydeard St. Lawrence, Som. J3 35
Lydford, Dev. D2 20
Lydgate, W.Yorks. G2 61
Lydham, Salop. D2 50
Lydiard Green, Wilts. G3 33
Lydiard Millicent, Wilts. G3 33
Lydiate, Mer. C4 60
Lydlinch, Dor. D3 22
Lydney, Glos. F3 39
Lydstep, Dyfed D4 36
Lye Green, Bucks. E2 30
Lye Green, E.Suss. C3 26
Lye, W.Mid. C5 48
Lyme Regis, Dor. A5 22
Lyminge, Kent J3 27
Lymington, Hants. B5 24
Lyminster, W.Suss. G4 25
Lymm, Ches. E5 60
Lympne, Kent H3 27
Lympsham, Som. A5 32
Lympstone, Dev. G2 21
Lynch Green, Norf. G5 45
Lynchat, High. J3 99
Lyndhurst, Hants. A4 24
Lyndon, Leics. G5 47
Lyne of Skene, Gram. H3 101
Lyneal, Salop. C4 56
Lyneham, Oxon. B6 40
Lyneham, Wilts. F3 33
Lynemouth, Northumb. C1 76
Lyness, Ork. F5 112
Lyng, Norf. F4 45
Lyng, Som. A2 22
Lynmouth, Dev. F1 35
Lynsted, Kent G5 29
Lynton, Dev. F1 35
Lyonshall, H.&W. D5 50
Lytchett Matravers, Dor. F4 23
Lytchett Minster, Dor. F5 23
Lytham St. Annes, Lancs.
Lytham, Lancs. C2 60
Lythe, N.Yorks. J1 67
Maaruig, Isle of Lewis C2 108
Mabie, D.&G. J2 73
Mablebeck, Notts. D6 62
Mablethorpe, Lincs. K4 63
Macclesfield Forest, Ches. G1 57
Macclesfield, Ches. F1 57
Macduff, Gram. F4 103
Machrianloch, Kintyre B5 82
Machrihanish, Kintyre A4 82
Machynlleth, Powys H1 53
Mackworth, Derby. B2 46
Macmerry, Loth. D3 88
Maddington, Wilts. G6 33
Maddiston, Cen. E2 86
Madeley, Salop. E6 56
Madeley, Staffs. E3 56
Madingley, Cambs. A3 42
Madley, H.&W. D6 50
Madresfield, H.&W. H5 51
Madron, Corn. B5 18
Maenclochog, Dyfed D1 36
Maendy, S.Glam. A5 38
Maentwrog, Gwyn. E3 54
Maer, Staffs. E4 56
Maerdy, Clwyd H3 55

Maerdy, M.Glam. A4 38
Maes-y-cwmmer, M.Glam.
Maesbrook, Salop. B5 56
Maesbury Marsh, Salop. B5 56
Maeshafn, Clwyd J4 59
Maesmynis, Powys K5 53
Maesteg, M.Glam. K4 37
Maggieknockater, Gram. C5 102
Magham Down, E.Suss. D5 26
Maghull, Mer. C4 60
Magor, Gwent E4 38
Maiden Bradley, Wilts. E1 22
Maiden Law, Dur. B4 76
Maiden Newton, Dor. C4 22
Maidencombe, Dev. G4 21
Maidenhead, Berks. E3 30
Maidens, Stra. F5 83
Maidford, Northants. E3 40
Maids Moreton, Bucks. F5 41
Maidstone, Kent E5 28
Maidwell, Northants. F1 41
Maindee, Gwent A3 32
Mains of Ballindarg, Tay. F2 91
Mains of Dalvey, Gram. K6 105
Mains of Dalvey, High. C1 100
Mains of Drum, Gram. J4 101
Mains of Thornton, Gram. H6 101
Mains, High. E6 104
Mainstone, Salop. C2 50
Maisemore, Glos. H2 39
Malden, G.L. G4 31
Maldon, Essex F1 29
Malham, N.Yorks. K5 69
Mallaig, High. F4 97
Mallwyd, Gwyn. F6 55
Malmesbury, Wilts. F3 33
Malpas, Ches. C3 56
Malpas, Corn. E4 18
Malpas, Gwent D4 38
Maltby, Cleve. F1 67
Maltby, S.Yorks. B3 62
Malton, N.Yorks. F3 65
Malvern Link, H.&W. G5 51
Malvern Wells, H.&W. G6 51
Manaccan, Corn. D5 18
Manafon, Powys B1 50
Manaton, Dev. E3 20
Manby, Lincs. J4 63
Mancetter, War. F4 49
Manchester, Grt.M. F5 61
Mancot, Clwyd K1 55
Mandally, High. E4 98
Manea, Cambs. B6 44
Manfield, N.Yorks. D1 66
Mangotsfield, Avon C4 32
Mankinholes, W.Yorks. G2 61
Manley, Ches. C1 56
Manmoel, Gwent C3 38
Mannings Heath, W.Suss. A3 26
Manningtree, Essex G5 43
Manorbier, Dyfed D4 36
Manorowen, Dyfed C1 36
Mansell Lacy, H.&W. D6 50
Mansfield Woodhouse, Notts. B6 62
Mansfield, Notts. B6 62
Manston, Dor. E3 22
Manston, Kent K5 29
Manthorpe, Lincs. G2 47
Manton, Hum. E2 62
Manton, Leics. G5 47
Manton, Notts. C4 62
Manuden, Essex B5 42
Maperton, Som. D2 22
Maple Cross, Herts. F2 31
Mapleton, Derby. H3 57
Mapperley, Derby. C2 46
Mapperton, Dor. B4 22
Mappleton, Hum. J5 65
Mapplewell, S.Yorks. K4 61
Mappowder, Dor. D4 22
Marazion, Corn. B5 18
March, Cambs. A5 44
Marcham, Oxon. K2 33
Marchamley, Salop. D4 56
Marchington, Staffs. H4 57
Marchwiel, Ches. B3 56
Marchwiel, Clwyd K3 55
Marchwood, Hants. B3 24
Marden Beech, Kent E2 26
Marden, Kent E2 26
Marden, W.Suss. E3 24
Marden, Wilts. G5 33
Mardy, Gwent D2 38
Mare Green, Som. A2 22
Marefield, Leics. F5 47
Mareham le Fen, Lincs. H6 63
Mareham-on-the-Hill, Lincs. H5 63
Marehill, W.Suss. G3 25
Maresfield, E.Suss. C4 26
Marfleet, Hum. J6 65
Margam, W.Glam. J4 37
Margaretting, Essex E2 28
Margate, Kent K4 29
Margnaheglish, Island of Arran E3 82
Marham, Norf. C4 44
Marhamchurch, Corn. B5 34
Marholm, Cambs. J5 47
Marian-glas, Angl. C2 58
Mariansleigh, Dev. F3 35
Mark Cross, E.Suss. D3 26
Mark, Som. A6 32
Markbeech, Kent C2 26
Markby, Lincs. K4 63
Market Bosworth, Leics. F4 49
Market Clinton, Notts. D5 62
Market Deeping, Lincs. J4 47
Market Drayton, Salop. E4 56
Market Harborough, Leics. J5 49
Market Lavington, Wilts. F5 33
Market Overton, Leics. G4 47
Market Rasen, Lincs. G3 63
Market Stainton, Lincs. H4 63
Market Street, Norf. H3 45
Market Weighton, Hum. F5 65
Market Weston, Suff. F1 43
Markfield, Leics. D4 46
Markinch, Fife E6 90
Markington, N.Yorks. B3 64
Marks Tey, Essex E5 42
Marksbury, Avon C5 32
Markyate, Herts. H6 41
Marlborough, Dev. E6 20
Marlborough, Wilts. H4 33
Marldon, Dev. F4 21
Marlesford, Suff. H3 43
Marley Green, Ches. D3 56
Marlin, Lincs. H5 63
Marlingford, Norf. G4 45
Marloes, Dyfed B3 36
Marlow, Bucks. D3 30
Marlpit Hill, Kent C2 26
Marlpool, Derby. C2 46
Marnhull, Dor. D3 22
Marnoch, Gram. E5 102
Marple, Grt.M. G5 61
Marr, S.Yorks. B2 62
Marrick, N.Yorks. C2 66
Marros, Dyfed E3 36
Marsden, W.Yorks. H3 61
Marsett, N.Yorks. K3 69
Marsh Baldon, Oxon. B2 30
Marsh Chapel, Lincs. J3 63
Marsh Gibbon, Bucks. E6 40
Marsh Green, Kent C2 26
Marsh Green, Salop. D5 56
Marsh, Dev. K4 35
Marsham, Norf. G3 45
Marshaw, Lancs. H6 69
Marshfield, Avon D4 32
Marshfield, Gwent C5 38
Marshgate, Corn. A6 34
Marshlane, Derby. A4 62
Marshside, Mer. B3 60
Marske, N.Yorks. C2 66
Marske-by-the-Sea, Cleve. F6 77
Marston Doles, War. D3 40
Marston Green, W.Mid. A6 46
Marston Magna, Som. C2 22
Marston Meysey, Wilts. K4 39
Marston Montgomery, Derby. H4 57
Marston Moretaine, Beds. H4 41
Marston Stannett, H.&W. F5 51
Marston Trussell, Northants. F6 47
Marston Trussell, Northants. J5 49
Marston, Ches. D1 56
Marston, H.&W. D5 50
Marston, Lincs. G2 47
Marston, Oxon. B1 30
Marston, Staffs. F4 57
Marston, War. E5 48
Marston, Wilts. F5 33
Marsworth, Bucks. G6 41
Marthall, Ches. F6 61
Martham, Norf. J4 45
Martin, Hants. G2 23
Martin, Lincs. G6 63
Martindale, Cumb. E6 74
Martinhoe, Dev. F1 35
Martinscroft, Ches. E5 60
Martlesham, Suff. H4 43
Martley, H.&W. G4 51
Martock, Som. B2 22
Marton le Moor, N.Yorks. B3 64
Marton, Ches. F1 57
Marton, Cleve. F1 67
Marton, Hum. J5 65
Marton, Lincs. E4 62
Marton, N.Yorks. H4 67
Marton, Salop. C1 50
Marton, War. C2 40
Marwick, Ork. F4 112
Marwood, Dev. E2 34
Mary Tavy, Dev. D3 20
Marybank, High. E5 104
Maryculter, Gram. J4 101
Marygold, Bord. G4 89
Maryhill, Gram. G5 103
Marykirk, Gram. H6 101
Marylebone, Grt.M. D4 60
Marypark, Gram. B6 102
Maryport, Cumb. B5 74
Maryport, D.&G. B5 72
Marystow, Dev. C2 20
Marywell, Gram. G4 101
Marywell, Tay. H2 91
Masham, N.Yorks. D4 66
Mastin Moor, Derby. A5 62
Matching Green, Essex B6 42
Matfen, Northumb. A2 76
Matfield, Kent E2 26
Mathon, H.&W. G6 51
Matlaske, Norf. G2 45
Matlock Bath, Derby. J2 57
Matlock, Derby. J2 57
Matson, Glos. H2 39
Matterdale End, Cumb. E6 74
Mattersey Thorpe, Notts. C3 62
Mattersey, Notts. C3 62
Mattingley, Hants. C5 30
Mattishall, Norf. F4 45
Mauchline, Stra. K4 83
Maud, Gram. H5 103
Maugersbury, Glos. B5 40
Maughold, I.o.M. E3 70
Maulden, Beds. H4 41
Maulds Meaburn, Cumb. H1 69
Maunby, N.Yorks. E3 66
Maund Bryan, H.&W. F5 51
Mavis Enderby, Lincs. J5 63
Mawbray, Cumb. B4 74
Mawdesley, Lancs. C3 60
Mawnan, Corn. D5 18
Maxstoke, War. E5 48
Maxton, Bord. E3 78
Maxton, Kent K3 27
Maxwellheugh, Bord. F3 79
Maybole, Stra. G5 83
Mayfield, E.Suss. D4 26
Mayfield, Loth. H3 87
Mayfield, Staffs. H3 57
Mayford, Surr. F5 31
Mayland, Essex G2 29
Maypole Green, Norf. J6 45
Maypole, Gwent E2 38
Mead, Dev. F3 21
Meal Bank, Cumb. G2 69
Mealsgate, Cumb. C5 74
Mears Ashby, Northants. G2 41
Measham, Leics. C4 46
Meathop, Cumb. G4 69
Meavy, Dev. D4 20
Medbourne, Leics. K5 49
Medburn, Northumb. B2 76
Meddon, Dev. B4 34
Medmenham, Bucks. D3 30
Medomsley, Dur. B4 76
Medstead, Hants. D1 24
Meer End, W.Mid. B1 40
Meerbrook, Staffs. G2 57
Meers Bridge, Lincs. K4 63
Meesden, Herts. A5 42
Meeth, Dev. E5 34
Meggethead, Bord. F4 81
Meidrim, Dyfed E2 36
Meifod, Powys J6 55
Meigle, Tay. E2 90
Meikle Tarty, Gram. K1 101
Meikle Wartle, Gram. H1 101
Meikleour, Tay. D3 90
Meinciau, Dyfed G3 37
Meir, Staffs. G3 57
Melbourn, Cambs. A4 42
Melbourne, Derby. K5 57
Melbourne, Hum. E5 64
Melbury Bubb, Dor. C3 22
Melbury Osmond, Dor. C3 22
Melcombe Regis, Dor. D6 22
Meldon, Northumb. B1 76
Meldreth, Cambs. A4 42
Melfort, Stra. H5 95
Melgarve, High. G4 99
Meliden, Clwyd H3 59
Melin-y-coed, Gwyn. F4 59
Melin-y-ddol, Powys H6 55
Melin-y-grug, Powys H6 55
Melin-y-wig, Clwyd G5 59
Melin-y-wig, Clwyd H3 55
Melkinthorpe, Cumb. F6 75
Melkridge, Northumb. H3 75
Melksham, Wilts. E5 32
Melldalloch, Stra. G2 85
Melling, Lancs. H4 69
Melling, Mer. C4 60
Mellis, Suff. G1 43
Mellon Charles, High. F2 107
Mellon Udrigle, High. G1 107
Mellor Brook, Lancs. E2 60
Mellor, Grt.M. G5 61
Mellor, Lancs. E2 60
Mells, Som. D6 32
Melmerby, Cumb. G5 75
Melmerby, N.Yorks. E4 66
Melplash, Dor. B4 22
Melrose, Bord. E3 78
Melsonby, N.Yorks. D2 66
Meltham, W.Yorks. H4 61
Melton Constable, Norf. F3 45
Melton Mowbray, Leics. F4 47
Melton Ross, Hum. F2 63
Melton, Hum. G6 65
Melton, Suff. H3 43
Melvaig, High. E2 106
Melvich, High. D2 110
Membury, Dev. K1 21
Memsie, Gram. H4 103
Menai Bridge, Angl. D3 58
Menai Bridge, Gwyn. D1 54
Mendham, Norf. H1 43
Mendlesham, Suff. G2 43
Menheniot, Corn. H2 19
Menston, W.Yorks. J1 61
Menstrie, Cen. D1 86
Mentmore, Bucks. G6 41
Meole Brace, Salop. C6 56
Meonstoke, Hants. D3 24
Meopham Green, Kent D5 28
Meopham, Kent D5 28
Mepal, Cambs. A1 42
Meppershall, Beds. J5 41
Mere Brow, Lancs. C3 60
Mere, Ches. E6 60
Mere, Wilts. E1 22
Mereclough, Lancs. G2 61
Mereworth, Kent E1 26
Menden, W.Mid. B1 40
Merlins Bridge, Dyfed C2 36
Merrington, Salop. C5 56
Merriott, Som. B3 22
Merrivale, Dev. D3 20
Merrow, Surr. F6 31
Merrymeet, Corn. H2 19
Merstham, Surr. B2 26
Merthyr Cynog, Powys A6 50
Merthyr Mawr, M.Glam. K5 37
Merthyr Tydfil, M.Glam. B3 38
Merthyr Vale, M.Glam. B3 38
Merton, Dev. D4 34
Merton, G.L. H4 31
Merton, Norf. E5 44
Merton, Oxon. B6 40
Meshaw, Dev. F4 35
Messingham, Hum. E2 62
Metfield, Suff. H1 43
Metheringham, Lincs. F6 63
Methil, Fife F6 91
Methley, W.Yorks. C6 64
Methlick, Gram. J1 101
Methven, Tay. C4 90
Methwold Hythe, Norf. D6 44
Methwold, Norf. D6 44
Mettingham, Suff. J6 45
Mevagissey, Corn. F4 19
Mexborough, S.Yorks. B3 62
Meysey Hampton, Glos. K3 39
Miavaig, Isle of Lewis C2 108
Michaelchurch Escley, H.&W. D1 38
Michaelchurch on Arrow, Powys C5 50
Michaelstow, Corn. G1 19
Micheldever, Hants. C1 24
Michelmersh, Hants. B2 24
Mickfield, Suff. G2 43
Mickle Trafford, Ches. C1 56
Mickleby, N.Yorks. J1 67
Micklefield Green, Herts. F2 31
Mickleham, Surr. G6 31
Mickleover, Derby. B2 46
Mickleton, Glos. A4 40
Mickletown, W.Yorks. C6 64
Mickley Square, Northumb. K3 75
Mickley, N.Yorks. D4 66
Mid Ardlaw, Gram. H4 103
Mid Calder, Loth. F3 87
Mid Lavant, W.Suss. F3 25
Mid Sannox, Island of Arran D2 82
Mid Yell, Shet. D2 112
Midbea, Ork. G4 112
Middle Aston, Oxon. D5 40
Middle Barton, Oxon. C5 40
Middle Claydon, Bucks. F5 41
Middle Mill, Dyfed B1 36
Middle Rasen, Lincs. G3 63
Middle Wallop, Hants. A1 24
Middlebie, D.&G. C2 74
Middleham, N.Yorks. C3 66
Middlehill, Corn. H2 19
Middlesbrough, Cleve. F1 67
Middlesmoor, N.Yorks. C4 66
Middlestone Stoney, Oxon. D6 40
Middleton Cheney, Northants. D4 40
Middleton Green, Staffs. G4 57
Middleton in Teesdale, Dur. J6 75
Middleton Priors, Salop. F2 51
Middleton Scriven, Salop. F2 51
Middleton St. George, Dur. E1 66
Middleton Tyas, N.Yorks. D2 66
Middleton, Isle of Tiree A2 94
Middleton, Cumb. H3 69
Middleton, Derby. J2 57
Middleton, Grt.M. G4 61
Middleton, Lancs. G5 69
Middleton, Loth. C4 88
Middleton, N.Yorks. H3 67
Middleton, Norf. C4 44
Middleton, Northants. K5 49
Middleton, Northumb. A1 76
Middleton, Salop. B4 56
Middleton, Suff. J2 43
Middleton, Tay. D2 90
Middleton, W.Suss. G4 25
Middleton, W.Yorks. B6 64
Middleton, War. E4 48
Middleton-on-the-Wolds, Hum. G4 65
Middletown, Powys B6 56
Middlewich, Ches. E1 56
Middlezoy, Som. A1 22
Middridge, Dur. C6 76
Midfield, High. B2 110
Midge Hall, Lancs. D3 60
Midgeholme, Cumb. G3 75
Midgham, Berks. B4 30
Midgley, W.Yorks. H2 61
Midhopestones, S.Yorks. J4 61
Midhurst, W.Suss. F2 25
Midlem, Bord. D4 78
Midtown of Buchromb, Gram. C6 102
Midtown, High. F2 107
Midway, Derby. F3 49
Miefield, D.&G. F3 73
Migvie, Gram. F3 101
Milborne Port, Som. D3 22
Milborne, Dor. E4 22
Milbourne, Northumb. B2 76
Milburn, Cumb. G6 75
Milcombe, Oxon. C5 40
Mildenhall, Suff. D1 42
Mildenhall, Wilts. H4 33
Mile Elm, Wilts. F4 33
Mile End, Essex F5 43
Mile End, Glos. C1 32
Milebush, Kent E2 26
Mileham, Norf. E4 44
Miles Bush, War. A3 40
Milesmark, Fife A1 88
Milfield, Northumb. H3 79
Milford Haven, Dyfed B3 36
Milford, Derby. C2 46
Milford, Staffs. C2 48
Milford-on-Sea, Hants. A5 24
Mill Bank, W.Yorks. H3 61
Mill End, Bucks. D3 30
Mill End, Cambs. A1 42
Mill Green, Salop. E4 56
Mill Street, Norf. F4 45
Milland, W.Suss. F2 25
Millbrook, Beds. H4 41
Millbrook, Corn. J3 19
Millburn, Stra. H3 83
Millers Dale, Derby. H1 57
Milleur Point, D.&G. B2 72
Millhouse, S.Yorks. J4 61
Millhouse, Stra. G3 85
Millhouses, S.Yorks. A2 62
Millington, Hum. F4 65
Millmeece, Staffs. F4 57
Millom, Cumb. E4 68
Millpool, Corn. G2 19
Millport, Great Cumbrae Isle J4 85
Millthorpe, Lincs. J3 47
Millthrop, Cumb. H3 69
Milltimber, Gram. J3 101
Milltown of Auchindown, Gram. D6 102
Milltown of Campfield, Gram. G4 101
Milltown of Edinvillie, Gram. C6 102
Milltown, D.&G. D2 74
Milltown, Derby. K2 57
Milltown, Gram. E2 34
Milltown, Gram. E5 102
Milnathort, Tay. D5 90
Milngavie, Stra. A2 86
Milnrow, Grt.M. G3 61
Milnthorpe, Cumb. G4 69
Milnthorpe, W.Yorks. K3 61
Milovaig, Isle of Skye A5 106
Milson, Salop. F3 51
Milsted, Kent F5 29
Milston, Wilts. G6 33
Milton Abbas, Dor. E4 22
Milton Abbot, Dev. C3 20
Milton Bridge, Loth. B3 88
Milton Bridge, Loth. G3 87
Milton Bryan, Beds. H5 41
Milton Clevedon, Som. C1 22
Milton Coldwells, Gram. H6 103
Milton Damerel, Dev. C4 34
Milton End, Glos. G2 33
Milton Ernest, Beds. H3 41
Milton Green, Ches. C2 56
Milton Keynes, Bucks. G4 41
Milton Lilbourne, Wilts. H5 33
Milton Loch, D.&G. H2 73
Milton of Auchinhove, Gram. F3 101
Milton of Campsie, Stra. B2 86
Milton of Cushnie, Gram. F3 101
Milton of Potterton, Gram. K2 101
Milton of Tullich, Gram. E4 100
Milton Regis, Kent F5 29
Milton, Cambs. B2 42
Milton, Cen. A1 86
Milton, Cumb. F3 75
Milton, D.&G. C4 72
Milton, Derby. C3 46
Milton, Gram. E4 102
Milton, Hants. A5 24
Milton, High. G3 105
Milton, Northants. F3 41
Milton, Oxon. B2 30
Milton, Oxon. D5 40
Milton-on-Stour, Dor. E2 22
Milton-under-Wychwood, Oxon. B6 40
Miltoncombe, Dev. C4 20
Miltonduff, Gram. B4 102
Milverton, Som. J3 35
Milverton, War. B2 40
Milwich, Staffs. G4 57
Milwr, Clwyd J3 59
Minard, Stra. G1 85
Minchinhampton, Glos. H3 39
Mindrum, Northumb. G3 79
Minehead, Som. H1 35
Minera, Clwyd J5 59
Minety, Wilts. J4 39
Mingary, S.Uist B5 108
Miningsby, Lincs. H5 63
Minishant, Stra. G5 83
Minnes, Gram. K2 101
Minnigaff, D.&G. D3 72
Minnonie, Gram. G4 103
Minskip, N.Yorks. C3 64
Minstead, Hants. A3 24
Minster Lovell, Oxon. J1 33
Minster, Kent G4 29
Minsteracres, Northumb. K4 75
Minsterley, Salop. B6 56
Minsterworth, Glos. G2 39
Minterne Magna, Dor. C4 22
Minting, Lincs. G5 63
Mintlaw, Gram. J5 103
Minto, Bord. E4 78
Minwear, Dyfed C2 36
Mirfield, W.Yorks. J3 61
Miserden, Glos. J3 39
Miskin, M.Glam. B5 38
Misson, Notts. C3 62
Misterton, Leics. H5 49
Misterton, Northants. D1 40
Misterton, Notts. D3 62
Misterton, Som. B3 22
Mistley, Essex G5 43
Mitcham, G.L. H4 31
Mitchel Troy, Gwent E3 38
Mitcheldean, Glos. F2 39
Mitchell, Corn. E3 18
Mitton, Staffs. B3 48
Mixbury, Oxon. E5 40
Mobberley, Ches. F6 61
Mochare, Powys B2 50
Mochdre, Clwyd F3 59
Mochdre, Powys K2 53
Mochrum Loch, D.&G. C4 72
Mockerkin, Cumb. B6 74
Modbury, Dev. E5 20
Moddershall, Staffs. G4 57
Moelfre, Angl. C2 58
Moelfre, Clwyd A4 56
Moffat, D.&G. E5 80
Moggerhanger, Beds. J3 41
Moira, Leics. F3 49

Place	Ref
Molash, Kent	G2 27
Mold, Clwyd	J4 59
Molehill Green, Essex	B5 42
Molescroft, Hum.	H5 65
Molesey, Surr.	G4 31
Molesworth, Cambs.	J1 41
Molland, Dev.	G3 35
Mollington, Ches.	K4 59
Mollington, Oxon.	C4 40
Mollinsburn, Stra.	C3 86
Moneydie, Tay.	D3 90
Moniaive, D.& G.	G1 73
Monifieth, Tay.	G3 91
Monikie, Tay.	G3 91
Monk Bretton, S.Yorks.	A2 62
Monk Fryston, N.Yorks.	C6 64
Monk Sherborne, Hants.	C5 30
Monken Hadley, G.L.	H2 31
Monkhopton, Salop.	F2 51
Monkland, H.& W.	E5 50
Monkleigh, Dev.	D4 34
Monkokehampton, Dev.	E5 34
Monks Eleigh, Suff.	F4 43
Monks Heath, Ches.	F1 57
Monks Kirby, War.	D6 46
Monks Risborough, Bucks.	D1 30
Monkshill, Gram.	G6 103
Monksilver, Som.	J2 35
Monkswood, Gwent	D3 38
Monktan, Stra.	K6 85
Monkton Farleigh, Wilts.	H6 39
Monkton, Dev.	K5 35
Monkton, Kent	K5 29
Monkton, Stra.	G4 85
Monmouth, Gwent	E2 38
Monnington on Wye, H.& W.	D6 50
Monreith, D.& G.	D5 72
Montacute, Som.	B3 22
Montford, Salop.	B5 56
Montgarrie, Gram.	G2 101
Montgomery, Powys	C1 50
Montgreenan, Stra.	G2 83
Montrave, Fife	F5 91
Montrose, Tay.	J1 91
Monxton, Hants.	J6 33
Monyash, Derby.	H1 57
Monymusk, Gram.	H2 101
Monzie, Tay.	B4 90
Moonzie, Fife	F4 91
Moor Alderwasley, Derby.	A6 62
Moor Allerton, W.Yorks.	B5 64
Moor Monkton, N.Yorks.	D4 64
Moor Nook, Lancs.	E1 60
Moor Side, W.Yorks.	A6 64
Moor, The, Kent	E3 26
Moorby, Lincs.	H5 63
Moore, Ches.	D6 60
Moorends, S.Yorks.	C1 62
Moorgreen, Notts.	D1 46
Moorhouse, Cumb.	D3 74
Moorhouse, Notts.	D5 62
Moorlinch, Som.	A1 22
Moorsholm, Cleve.	H1 67
Moorside, Grt.M.	G4 61
Moorswater, Corn.	H2 19
Moortown, Lincs.	F3 63
Morar, High.	F4 97
Morborne, Cambs.	J6 47
Morchard Bishop, Dev.	F5 35
Morconbelake, Dor.	A4 22
Morcott, Leics.	G5 47
Morcott, Lincs.	K4 49
Morda, Salop.	A4 56
Morden, Dor.	E4 22
Morden, G.L.	A4 28
Mordiford, H.& W.	F6 51
Mordon, Dur.	C6 76
More, Salop.	D2 50
Morebath, Dev.	H3 35
Morebattle, Bord.	F4 79
Morecambe, Lancs.	G5 69
Morefield, High.	B1 104
Moreleigh, Dev.	F5 21
Morenish, Tay.	H3 93
Moresby Parks, Cumb.	B6 74
Moresby, Cumb.	B6 74
Moresby, Cumb.	J6 73
Morestead, Hants.	C2 24
Moreton Corbet, Salop.	D5 56
Moreton Morrell, War.	B3 40
Moreton on Lugg, H.& W.	E6 50
Moreton Pinkney, Northants.	E3 40
Moreton Say, Salop.	D4 56
Moreton Valence, Glos.	G3 39
Moreton, Dor.	E5 22
Moreton, Essex	D1 28
Moreton, Mer.	B5 60
Moreton, Oxon.	C1 30
Moreton-in-Marsh, Glos.	B5 40
Moretonhampstead, Dev.	E2 20
Morfa Bychan, Gwyn.	D4 54
Morfa Nefyn, Gwyn.	B3 54
Morland, Cumb.	G6 75
Morley Green, Ches.	F6 61
Morley St. Botolph, Norf.	F5 45
Morley, Derby.	C2 46
Morley, Dur.	B6 76
Morley, W.Yorks.	K2 61
Morning Thorpe, Norf.	H6 45
Morningside, Loth.	B3 88
Morpeth, Northumb.	B1 76
Morrey, Staffs.	D3 48
Morriston, W.Glam.	H4 37
Morston, Norf.	F2 45
Mortehoe, Dev.	D2 34
Morthen, S.Yorks.	B3 62
Mortimer West End, Hants.	C5 30
Mortimers Cross, H.& W.	D4 50
Morton Bagot, War.	K4 51
Morton, Avon	F4 39
Morton, Derby.	A6 62
Morton, Lincs.	D3 62
Morton, Lincs.	A4 56
Morton-on-Swale, N.Yorks.	E3 66
Morvah, Corn.	A5 18
Morval, Corn.	H3 19
Morville, Salop.	F2 51
Morwenstow, Corn.	B4 34
Mosbrough, S.Yorks.	A4 62
Moscow, Stra.	H3 83
Moseley, W.Mid.	A6 46
Moss Bank, Mer.	D4 60
Moss Side, Lancs.	C2 60
Moss, Clwyd	B2 56
Moss, S.Yorks.	C2 62
Mossbank, Shet.	D2 112
Mossburnford, Bord.	F5 79
Mossend, Stra.	C4 86
Mossley, Grt.M.	G4 61
Mosstodloch, Gram.	C4 102
Mosterton, Dor.	B4 22
Mostyn, Clwyd	H3 59
Motcombe, Dor.	E2 22
Mothecombe, Dev.	D5 20
Motherwell, Stra.	C4 86
Mottingham, G.L.	C4 28
Mottisfont, Hants.	B2 24
Mottistone, I.o.W.	B5 24
Mottram in Longdendale, Grt.M.	G5 61
Mottram St. Andrew, Ches.	G6 61
Mouldsworth, Ches.	C1 56
Moulin, Tay.	C1 90
Moulsecombe, E.Suss.	B5 26
Moulsford, Oxon.	B3 30
Moulsoe, Bucks.	G4 41
Moulton Chapel, Lincs.	K4 47
Moulton Eaugate, Lincs.	K4 47
Moulton Seas End, Lincs.	K3 47
Moulton St. Mary, Norf.	J5 45
Moulton St. Michael, Norf.	G6 45
Moulton, Ches.	D1 56
Moulton, Lincs.	K3 47
Moulton, N.Yorks.	D2 66
Moulton, Northants.	F2 41
Moulton, Suff.	C2 42
Mount Pleasant, Notts.	B5 62
Mount, Corn.	G2 19
Mountain Ash, M.Glam.	B3 38
Mountfield, E.Suss.	E4 26
Mountgerald, High.	F4 105
Mountnessing, Essex	D2 28
Mountsorrel, Leics.	E4 46
Mountstuart, Isle of Bute	H4 85
Mousehole, Corn.	B5 18
Mouswald, D.& G.	B2 74
Mow Cop, Staffs.	F2 57
Mowsley, Leics.	H5 49
Mowtie, Gram.	J4 101
Moy, High.	F5 99
Moylgrove, Dyfed	C6 52
Muasdale, Kintyre	E5 84
Much Birch, H.& W.	E1 38
Much Cowarne, H.& W.	F5 51
Much Dewchurch, H.& W.	E1 38
Much Hadham, Herts.	A6 42
Much Hoole, Lancs.	C3 60
Much Marcle, H.& W.	F1 39
Much Wenlock, Salop.	F1 51
Muchelney, Som.	B2 22
Muchrachd, High.	D6 104
Muckleton, Salop.	D5 56
Mucklestone, Staffs.	E4 56
Muckley Corner, Staffs.	A5 46
Muckton, Lincs.	J4 63
Mud Row, Kent	G4 29
Mudale, High.	E4 109
Mudeford, Dor.	H5 23
Mudford, Som.	C2 22
Mudgley, Som.	B6 32
Mugdock, Cen.	B2 86
Mugeary, Isle of Skye	C6 106
Muie, High.	G1 105
Muir of Fowlis, Gram.	G3 101
Muir of Ord, High.	F5 105
Muirden, Gram.	F5 103
Muirdrum, Tay.	H3 91
Muirhead, Fife	E5 90
Muirhead, Stra.	C3 86
Muirhead, Tay.	F3 91
Muirkirk, Stra.	B4 80
Muirshearlich, High.	D5 98
Muirtack, Gram.	J6 103
Muirton of Ballochy, Tay.	H1 91
Muirtown, Tay.	B5 90
Muker, N.Yorks.	B2 66
Mulbarton, Norf.	G5 45
Mulben, Gram.	C5 102
Mull of Galloway, D.& G.	B6 72
Mullion, Corn.	C6 18
Mumbles, The, W.Glam.	H4 37
Mumby, Lincs.	K5 63
Munderfield Row, H.& W.	F5 51
Mundesley, Norf.	H2 45
Mundford, Norf.	D6 44
Mundham, Norf.	H5 45
Mundon Hill, Essex	F2 29
Munerigie, High.	B3 98
Mungasdale, High.	G2 107
Mungrisdale, Cumb.	E6 74
Munsley, H.& W.	F6 51
Munslow, Salop.	E2 50
Murchington, Dev.	E2 20
Murcott, Oxon.	E6 40
Murkle, High.	F1 111
Murlaggan, High.	C4 98
Murrayfield, Loth.	G3 87
Murrow, Cambs.	A5 44
Mursley, Bucks.	F5 41
Murthill, Tay.	G1 91
Murthly, Tay.	D3 90
Murton, Cumb.	H6 75
Murton, Dur.	D4 76
Murton, N.Yorks.	E4 64
Musbury, Dev.	K1 21
Musselburgh, Loth.	C3 88
Muston, Leics.	G2 47
Muston, N.Yorks.	H2 65
Mutford, Suff.	K6 45
Muthill, Tay.	B4 90
Mybster, High.	F3 111
Myddfai, Dyfed	J1 37
Myddle, Salop.	C5 56
Mydroilyn, Dyfed	F5 53
Mynachlog-ddu, Dyfed	D1 36
Mynydd Llandegai, Gwyn.	D4 58
Mynydd-bach, Gwent	B2 32
Mynytho, Gwyn.	B4 54
Mytholm, W.Yorks.	G2 61
Mytholmroyd, W.Yorks.	H2 61
Myton, War.	B2 40
Myton-on-Swale, N.Yorks.	C3 64
Naast, High.	F2 107
Nab Wood, W.Yorks.	A5 64
Naburn, N.Yorks.	D5 64
Nacton, Suff.	H4 43
Nafferton, Hum.	H4 65
Nailbourne, Som.	K3 35
Nailsea, Avon	B4 32
Nailstone, Leics.	C5 46
Nailsworth, Glos.	H3 39
Nairn, High.	H4 105
Nancegollen, Corn.	C5 18
Nanhoran, Gwyn.	B4 54
Nannerch, Clwyd	H4 59
Nanpanton, Leics.	D4 46
Nanpean, Corn.	F3 19
Nanstallon, Corn.	F2 19
Nant Peris, Gwyn.	D2 54
Nant-ddû, Powys	A2 38
Nant-glâs, Powys	A4 50
Nantgaredig, Dyfed	G2 37
Nantgarw, M.Glam.	B5 38
Nantglyn, Clwyd	G4 59
Nantlle, Gwyn.	C5 58
Nantmawr, Salop.	A4 56
Nantmel, Powys	A4 50
Nantwich, Ches.	D2 56
Nantyffyllon, M.Glam.	K4 37
Nantyglo, Gwent	C3 38
Napton-on-the-Hill, War.	D2 40
Narberth, Dyfed	D2 36
Narborough, Leics.	G4 49
Narborough, Norf.	D4 44
Nasareth, Gwyn.	C3 54
Naseby, Northants.	E1 40
Nashs Green, Hants.	C6 30
Nash, Bucks.	F5 41
Nash, Gwent	A3 32
Nash, Salop.	F3 51
Nassington, Northants.	H5 47
Nateby, Cumb.	J2 69
Nateby, Lancs.	C1 60
National Exhibition Centre, W.Mid.	A6 46
Natland, Cumb.	G3 69
Naunton Beauchamp, H.& W.	J5 51
Naunton, Glos.	A5 40
Naunton, H.& W.	H6 51
Navenby, Lincs.	F6 63
Nayland, Suff.	F5 43
Naze Park, Essex	H6 43
Nazeing, Essex	C1 28
Near Cotton, Staffs.	H3 57
Neasham, Dur.	E1 66
Neath, W.Glam.	J4 37
Neatishead, Norf.	J4 45
Nebo, Gwyn.	C5 58
Necton, Norf.	E4 44
Nedd, High.	B4 109
Nedging Tye, Suff.	F3 43
Needham Market, Suff.	G3 43
Needham, Norf.	H1 43
Needingworth, Cambs.	A2 42
Needwood, Staffs.	A3 46
Neen Savage, Salop.	F3 51
Neen Sollars, Salop.	F3 51
Nefyn, Gwyn.	B3 54
Neilston, Stra.	H1 83
Neithrop, Oxon.	D4 40
Nelson Village, Northumb.	C2 76
Nelson, Lancs.	F1 61
Nelson, M.Glam.	B4 38
Nenthead, Cumb.	H4 75
Nenthorn, Bord.	F5 89
Nercwys, Clwyd	J4 59
Nereabolls, Isle of Islay	A4 84
Ness, Ches.	K3 59
Ness, Ork.	G5 112
Nesscliffe, Salop.	B5 56
Neston, Ches.	J3 59
Neston, Wilts.	H6 39
Nether Alderley, Ches.	F6 61
Nether Blainsle, Bord.	E5 88
Nether Broughton, Leics.	F3 47
Nether Burrow, Lancs.	H4 69
Nether Cerne, Dor.	D4 22
Nether Compton, Dor.	C3 22
Nether Cortes, Gram.	J4 103
Nether Crimond, Gram.	J2 101
Nether Edge, S.Yorks.	A4 62
Nether End, Derby.	J1 57
Nether Heyford, Northants.	E3 40
Nether Howcleugh, Stra.	E5 80
Nether Kellet, Lancs.	G5 69
Nether Kinmundy, Gram.	J5 103
Nether Langwith, Notts.	B5 62
Nether Padley, Derby.	K6 61
Nether Poppleton, N.Yorks.	D4 64
Nether Row, Cumb.	D5 74
Nether Silton, N.Yorks.	F3 67
Nether Stowey, Som.	K2 35
Nether Wallop, Hants.	A1 24
Nether Whitacre, War.	E5 48
Nether Worton, Oxon.	C5 40
Netheravon, Wilts.	G6 33
Netherbrae, Gram.	G4 103
Netherburn, Stra.	C2 80
Netherbury, Dor.	B4 22
Netherby, Cumb.	E2 74
Netherend, Glos.	F3 39
Netherfield, E.Suss.	E4 26
Netherhampton, Wilts.	G2 23
Netherlaw, D.& G.	G4 73
Netherley, Gram.	J4 101
Nethermill, D.& G.	B1 74
Netherplace, Stra.	A4 86
Netherseal, Derby.	E3 48
etherthird, Stra.	A4 80
Netherthird, Stra.	J4 83
Netherthong, W.Yorks.	J4 61
Netherton, Mer.	B4 60
Netherton, Northumb.	H5 79
Netherton, Salop.	D2 90
Netherton, Tay.	
Netherton, W.Yorks.	K3 61
Nethertown, Isle of Stroma	H1 111
Nethertown, Cumb.	C2 68
Netherwitton, Northumb.	B1 76
Nethy Bridge, High.	B2 100
Netley Marsh, Hants.	B3 24
Netley, Hants.	C3 24
Nettlebed, Oxon.	C3 30
Nettlebridge, Som.	C6 32
Nettlecombe, Som.	J2 35
Nettleham, Lincs.	F5 63
Nettlestead, Kent	E2 26
Nettleton, Lincs.	G3 63
Nettleton, Wilts.	H5 39
Nevendon, Essex	E3 28
Nevern, Dyfed	C6 52
New Abbey, D.& G.	J3 73
New Aberdour, Gram.	H4 103
New Addington, G.L.	B5 28
New Alresford, Hants.	D2 24
New Annesley, Notts.	B6 62
New Barnet, G.L.	H2 31
New Bewick, Northumb.	J4 79
New Bolingbroke, Lincs.	H6 63
New Bradwell, Bucks.	G4 41
New Brancepeth, Dur.	C5 76
New Brighton, Mer.	B5 60
New Brinsley, Notts.	B6 62
New Buckenham, Norf.	G6 45
New Byth, Gram.	G5 103
New Chapel, Surr.	B2 26
New Clipstone, Notts.	C6 62
New Costessey, Norf.	G4 45
New Cross, Dyfed	G3 53
New Cumnock, Stra.	B5 80
New Deer, Gram.	H5 103
New Duston, Northants.	F2 41
New Earswick, N.Yorks.	D4 64
New Edlington, S.Yorks.	B3 62
New End, H.& W.	J4 51
New Ferry, Mer.	B6 60
New Fletton, Cambs.	K5 47
New Galloway, D.& G.	F2 73
New Hartley, Northumb.	C2 76
New Hedges, Dyfed	D3 36
New Holkham, Norf.	E2 44
New Holland, Hum.	G1 63
New Houghton, Derby.	B5 62
New Hunstanton, Norf.	C2 44
New Hutton, Cumb.	H3 69
New Inn, Gwent	E3 38
New Lanark, Stra.	D2 80
New Lane, Lancs.	C3 60
New Leake, Lincs.	J6 63
New Leeds, Gram.	J5 103
New Longton, Lancs.	D2 60
New Luce, D.& G.	C3 72
New Mains, Stra.	C1 80
New Malden, G.L.	G4 31
New Marske, Cleve.	G1 67
New Marton, Stra.	B4 56
New Micklefield, W.Yorks.	C6 64
New Mill, Herts.	E1 30
New Mill, W.Yorks.	J4 61
New Mills, Corn.	E3 18
New Mills, Derby.	H6 61
New Mills, Gwent	E3 38
New Milton, Hants.	A5 24
New Moat, Dyfed	D1 36
New Oscott, W.Mid.	A6 46
New Pitsligo, Gram.	H5 103
New Quay, Dyfed	E4 52
New Radnor, Powys	C4 50
New Romney, Kent	H4 27
New Rossington, S.Yorks.	C3 62
New Sauchie, Cen.	D1 86
New Scone, Tay.	D4 90
New Silksworth, T.& W.	D4 76
New Stevenston, Stra.	C4 86
New Town, Loth.	D3 88
New Tredegar, M.Glam.	B3 38
New Whittington, Derby.	A5 62
New Wimpole, Cambs.	A3 42
New York, Lincs.	H6 63
Newark on Trent, Notts.	D6 62
Newark upon Trent, Notts.	F1 47
Newarthill, Stra.	C4 86
Newbiggin, Cumb.	F6 75
Newbiggin, Dur.	J6 75
Newbiggin, N.Yorks.	B3 66
Newbiggin-by-the-Sea, Northumb.	C1 76
Newbiggin-on-Lune, Cumb.	J2 69
Newbigging, Stra.	E2 80
Newbigging, Tay.	G3 91
Newbold on Avon, War.	D1 40
Newbold Pacey, War.	B3 40
Newbold Verdon, Leics.	G4 49
Newbold, Derby.	A5 62
Newbold-on-Stour, War.	B4 40
Newborough, Angl.	C4 58
Newborough, Cambs.	K5 47
Newborough, Gwyn.	C1 54
Newborough, Staffs.	D2 48
Newbourn, Suff.	H4 43
Newbridge on Wye, Powys	K5 53
Newbridge, Clwyd	K3 55
Newbridge, Corn.	J2 19
Newbridge, Gwent	C4 38
Newbridge-on-Usk, Gwent	D4 38
Newbridge-on-Wye, Powys	A5 50
Newbrough, Northumb.	J3 75
Newburgh, Fife	E4 90
Newburgh, Gram.	K2 101
Newburgh, Lancs.	C4 60
Newburn, T.& W.	B3 76
Newbury, Berks.	A4 30
Newby Bridge, Cumb.	F3 69
Newby East, Cumb.	F3 75
Newby Wiske, N.Yorks.	E3 66
Newby, Cumb.	F6 75
Newby, N.Yorks.	J5 69
Newcastle Emlyn, Dyfed	D6 52
Newcastle Upon Tyne, T.& W.	C3 76
Newcastle, Gwent	E2 38
Newcastle, Salop.	C3 50
Newcastle-under-Lyme, Staffs.	F3 57
Newcastleton, Bord.	F1 75
Newchapel, Dyfed	D6 52
Newchapel, Staffs.	F2 57
Newchurch in Pendle, Lancs.	F1 61
Newchurch, Dyfed	F1 37
Newchurch, I.o.W.	C5 24
Newchurch, Kent	H3 27
Newchurch, Powys	C5 50
Newdigate, Surr.	A2 26
Newell Green, Berks.	E4 30
Newended, Kent	F4 27
Newent, Glos.	G1 39
Newerne, Glos.	C2 32
Newfield, Dur.	B5 76
Newgale, Dyfed	B2 36
Newgate Street, Herts.	B1 28
Newhall, Ches.	D3 56
Newhall, Derby.	E3 48
Newhaven, E.Suss.	C6 26
Newhaw, Surr.	F5 31
Newhey, Grt.M.	G3 61
Newholm, N.Yorks.	J1 67
Newick, E.Suss.	C4 26
Newingreen, Kent	H3 27
Newington Bagpath, Glos.	E2 32
Newington, Kent	F5 29
Newington, Oxon.	C2 30
Newland, Glos.	F3 39
Newland, Hum.	H6 65
Newland, N.Yorks.	C1 62
Newlands of Geise, High.	F2 111
Newlands, Bord.	D6 78
Newlands, Gram.	C5 102
Newlyn East, Corn.	E3 18
Newmachar, Gram.	J2 101
Newmains, Stra.	D4 86
Newmarket, Suff.	C2 42
Newmill End, Beds.	J6 41
Newmill of Inshewan, Tay.	F1 91
Newmill, Bord.	D5 78
Newmill, Gram.	D5 102
Newmilns, Stra.	J3 83
Newnham Bridge, H.& W.	F4 51
Newnham, Glos.	G2 39
Newnham, Herts.	K4 41
Newnham, Kent	G5 29
Newnham, Northants.	E3 40
Newpnett Thrubwell, Avon	B5 32
Newport Pagnell, Bucks.	G4 41
Newport, Dev.	E3 34
Newport, Dyfed	B6 52
Newport, Essex	B5 42
Newport, Glos.	G4 39
Newport, Gwent	D4 38
Newport, Hum.	F5 111
Newport, Hum.	F6 65
Newport, I.o.W.	C5 24
Newport, Salop.	E5 56
Newport-on-Tay, Fife	F4 91
Newquay, Corn.	E2 18
Newsham, N.Yorks.	C1 66
Newsholme, Lancs.	A6 66
Newstead, Notts.	D1 46
Newthorpe, N.Yorks.	C6 64
Newton Abbot, Dev.	F3 21
Newton Arlosh, Cumb.	C4 74
Newton Aycliffe, Dur.	C6 76
Newton Bewley, Cleve.	E6 76
Newton Bromshold, Northants.	H2 41
Newton Ferrers, Dev.	D5 20
Newton Flotman, Norf.	H5 45
Newton Harcourt, Leics.	E5 46
Newton Longville, Bucks.	G5 41
Newton Mearns, Stra.	J1 83
Newton of Balconquhal, Tay.	D5 90
Newton Poppleford, Dev.	H2 21
Newton Regis, War.	E4 48
Newton Reigny, Cumb.	F5 75
Newton Solney, Derby.	E2 48
Newton St. Boswells, Bord.	J3 81
Newton St. Cyres, Dev.	G5 35
Newton St. Faith, Norf.	H4 45
Newton St. Loe, Avon	D5 32
Newton St. Petrock, Dev.	D4 34
Newton Stewart, D.& G.	D3 72
Newton Tony, Wilts.	A1 24
Newton Tracey, Dev.	D3 34
Newton Unthank, Leics.	G4 49
Newton upon Derwent, Hum.	E4 64
Newton, Bord.	E4 78
Newton, Cambs.	A3 42
Newton, Ches.	C2 56
Newton, Cleve.	G1 67
Newton, D.& G.	F6 81
Newton, Derby.	C1 46
Newton, Gram.	B4 102
Newton, High.	C4 109
Newton, Lancs.	H4 69
Newton, Lincs.	H4 47

Place	Ref
Painswick, Glos.	H3 39
Paisley, Stra.	H1 83
Pakefield, Suff.	K6 45
Pakenham, Suff.	E2 42
Pale, Gwyn.	G4 55
Paley Street, Berks.	E4 30
Palmers Green, G.L.	H2 31
Palmersbridge, Corn.	H1 19
Palnackie, D & G.	H3 73
Palnure, D & G.	E3 72
Palterton, Derby.	B5 62
Pamber End, Hants.	C5 30
Pamphill, Dor.	F4 23
Pampisford, Cambs.	B4 42
Pandy Tudur, Clwyd	F4 59
Pandy, Clwyd	J4 55
Pandy, Gwent	D2 38
Pandy, Powys	G6 55
Panfield, Essex	D5 42
Pangbourne, Berks.	C4 30
Pannal Ash, N.Yorks.	B4 64
Pannal, N.Yorks.	B4 64
Pant Mawr, Powys	J3 53
Pant Pastynog, Clwyd	H4 59
Pant, Salop.	K5 55
Pant-glas, Gwyn.	C3 54
Pant-y-dŵr, Powys	A3 50
Pant-y-ffrridd, Powys	J6 55
Pantglas Hall, Dyfed	H1 37
Pantglas, Powys	H1 53
Panton, Lincs.	G4 63
Pantperthog, Dyfed	H1 53
Pantperthog, Gwyn.	F6 55
Panxworth, Norf.	J4 45
Papple, Loth.	E3 88
Papplewick, Notts.	B6 62
Papworth Everard, Cambs.	K2 41
Par, Corn.	G3 19
Parbold, Lancs.	C3 60
Parbrook, Som.	C1 22
Parc-llyn, Dyfed	D5 52
Pardshaw, Cumb.	C6 74
Parham, Suff.	H3 43
Park Corner, Berks.	E3 30
Park Corner, Oxon.	C3 30
Park Gate, Hants.	C4 24
Park Street, Herts.	G2 31
Park, Gram.	H4 101
Park, Stra.	H3 95
Parkend, Glos.	F3 39
Parkeston, Essex	H5 43
Parkfield, Bucks.	D2 30
Parkgate, Ches.	J3 59
Parkgate, D & G.	B1 74
Parkgate, Surr.	A2 26
Parkham, Dev.	C3 34
Parkneuk, Gram.	H6 101
Parkstone, Dor.	F5 23
Parracombe, Dev.	F2 35
Parranuthnoe, Corn.	B5 18
Parrog, Dyfed	B6 52
Parson Cross, S.Yorks.	K5 61
Parson Drove, Cambs.	A5 44
Partick, Stra.	B3 86
Partington Moss, Grt.M.	E5 60
Parton, Cumb.	J6 73
Parton, D & G.	G2 73
Partridge Green, W.Suss.	H3 25
Parwich, Derby.	J2 57
Passingford Bridge, Essex	C2 28
Paston Street, Norf.	H2 45
Patcham, E.Suss.	B5 26
Patching, W.Suss.	H4 25
Patchway, Avon	C3 32
Pateley Bridge, N.Yorks.	D5 66
Path of Condie, Tay.	D5 90
Pathhead, Gram.	J1 91
Pathhead, Loth.	H3 87
Pathhead, Stra.	B5 80
Patna, Stra.	H5 83
Patrick Brompton, N.Yorks.	D3 66
Patrick, I.o.M.	C4 70
Patrington, Hum.	H1 63
Patterdale, Cumb.	F1 69
Pattingham, Staffs.	B4 48
Pattishall, Northants.	E3 40
Paul, Corn.	B5 18
Paulerspury, Northants.	F4 41
Paull, Hum.	G1 63
Paulton, Avon	C5 32
Pavenham, Beds.	H3 41
Paxford, Glos.	A4 40
Paxton, Bord.	H4 89
Payhembury, Dev.	J5 35
Paynsfield, W.Suss.	A4 26
Paythorne, Lancs.	A6 66
Peace Pottage, W.Suss.	A3 26
Peacehaven, E.Suss.	B6 26
Peachley, H.& W.	H5 51
Peak Dale, Derby.	H6 61
Peak Forest, Derby.	H6 61
Peakirk, Cambs.	J5 47
Peanmeanach, High.	G5 97
Pearsie, Tay.	F1 91
Peasedown St. John, Avon	D5 32
Peasemore, Berks.	A4 30
Peasenhall, Suff.	J2 43
Peasmarsh, E.Suss.	F4 27
Peaston, Loth.	D3 88
Peaston, Loth.	H3 87
Peat Inn, Fife	G5 91
Peathill, Gram.	H4 103
Peatling Magna, Leics.	E6 46
Peatling Parva, Leics.	H5 49
Pebmarsh, Essex	E5 42
Pebworth, H.& W.	A4 40
Pecket Well, W.Yorks.	H2 61
Peckforton, Ches.	C2 56
Peckleton, Leics.	G4 49
Peebles, Bord.	G3 81
Peel, I.o.M.	C3 70
Pegswood, Northumb.	C1 76
Peinchorran, Isle of Skye	E1 96
Peinlich, Isle of Skye	C4 106
Peldon, Essex	F6 43
Pelsall, W.Mid.	C4 48
Pelutho, Cumb.	C4 74
Pelynt, Corn.	H3 19
Pembrey, Dyfed	G3 37
Pembridge, H.& W.	D5 50
Pembroke Dock, Dyfed	C3 36
Pembroke, Dyfed	C3 36
Pembury, Kent	D3 26
Pen-bont Rhydybeddau, Dyfed	G3 53
Pen-ffordd, Dyfed	D2 36
Pen-llyn, Angl.	B3 58
Pen-rhos, Gwent	D2 38
Pen-sarn, Gwyn.	C3 54
Pen-twyn, Gwent	E3 38
Pen-y-Bont, Clwyd	J5 55
Pen-y-bryn, Gwyn.	E5 54
Pen-y-cae, Powys	K2 37
Pen-y-cae-Mawr, Gwent	D4 38
Pen-y-clawdd, Gwent	E3 38
Pen-y-coedcae, M.Glam.	B4 38
Penallt, Gwent	E3 38
Penally, Dyfed	D3 36
Penalt, Gwent	B1 32
Penant, Dyfed	F4 53
Penarth, S.Glam.	C6 38
Penbryn, Dyfed	D5 52
Pencader, Dyfed	G1 37
Pencaitland, Loth.	D3 88
Pencelli, Powys	B1 38
Penclawydd, W.Glam.	H4 37
Pencombe, H.& W.	F5 51
Pencraig, H.& W.	F2 39
Pencraig, Powys	H4 55
Pendeen, Corn.	A5 18
Penderyn, M.Glam.	A3 38
Pendine, Dyfed	E3 36
Pendlebury, Grt.M.	F4 61
Pendleton, Lancs.	F1 61
Pendock, H.& W.	G1 39
Pendoggett, Corn.	F1 19
Pendoylan, S.Glam.	B5 38
Penge, G.L.	B4 28
Penhow, Gwent	B3 32
Penicuik, Loth.	G4 87
Penifiler, Isle of Skye	C6 106
Peninver, Kintyre	B4 82
Penis'a'r Waun, Gwyn.	D4 58
Penistone, S.Yorks.	K4 61
Penketh, Ches.	D5 60
Penkridge, Staffs.	C3 48
Penley, Ches.	B3 56
Penley, Clwyd	K6 59
Penllyn, S.Glam.	A5 38
Penmachno, Gwyn.	F3 55
Penmaen, W.Glam.	G4 37
Penmaenmawr, Gwyn.	E3 58
Penmarfa, Gwyn.	D6 58
Penmark, S.Glam.	B6 38
Penmorfa, Gwyn.	D3 54
Penmynydd, Angl.	C3 58
Penmynydd, Gwyn.	D1 54
Penn, Bucks.	E2 30
Pennal, Dyfed	H1 53
Pennan, Gram.	G4 103
Pennant Melangell, Powys	H4 55
Pennant, Powys	J1 53
Pennington, Hants.	A5 24
Pennsylvania Village, Glos.	C2 32
Pennycross, Isle of Mull	E4 94
Pennygown, Isle of Mull	F2 95
Pennymoor, Dev.	G4 35
Penparc, Dyfed	D5 52
Penpercau, Dyfed	G3 53
Penperlleni, Gwent	D3 38
Penpont, D & G.	C6 80
Penpont, Powys	A1 38
Penrhiwllan, Dyfed	E6 52
Penrhiwpal, Dyfed	E6 52
Penrhos, Angl.	A3 58
Penrhos, Gwent	A1 32
Penrhos, Gwyn.	B4 54
Penrhyn Bay, Gwyn.	F3 59
Penrhyn Side, Gwyn.	F3 59
Penrhyncoch, Dyfed	G2 53
Penrhyndeudraeth, Gwyn.	D3 54
Penrith, Cumb.	F5 75
Penruddock, Cumb.	E6 74
Penryn, Corn.	D5 18
Pensarn, Clwyd	G3 59
Pensax, H.& W.	G4 51
Pensby, Mer.	J3 59
Penselwood, Som.	D2 22
Pensford, Avon	C5 32
Penshaw, T.& W.	C4 76
Penshurst, Kent	C2 26
Pentewan, Corn.	F4 19
Pentir, Gwyn.	D4 58
Pentireglaze, Corn.	E1 18
Pentney, Norf.	D4 44
Penton Mewsey, Hants.	J6 33
Pentraeth, Angl.	C3 58
Pentre Berw, Angl.	C3 58
Pentre Berw, Gwyn.	C1 54
Pentre Dolau-Honddu, Powys	A6 50
Pentre Gwenlais, Dyfed	H2 37
Pentre'r-halk, Clwyd	J3 59
Pentre'r-felin, Powys	K1 37
Pentre, Clwyd	H4 59
Pentre, Gwent	B1 32
Pentre, Powys	C4 50
Pentre, Salop.	B5 56
Pentre-bach, Powys	K1 37
Pentre-celyn, Clwyd	H5 59
Pentre-chwyth, W.Glam.	J4 37
Pentre-cwrt, Dyfed	E6 52
Pentre-dwr, W.Glam.	J4 37
Pentre-tafarn-y-fedw, Gwyn.	F4 59
Pentrebach, M.Glam.	B3 38
Pentrebeirdd, Powys	J5 55
Pentredwr, Clwyd	J3 55
Pentrefelin, Gwyn.	F3 59
Pentrich, Derby.	C1 46
Pentridge, Dor.	F3 23
Pentyrch, M.Glam.	B5 38
Penuwch, Dyfed	G4 53
Penybanc, Dyfed	H1 37
Penybont, Powys	B4 50
Penybontfawr, Powys	H5 55
Penycae, Clwyd	A3 56
Penyffordd, Clwyd	B2 56
Penygarnedd, Powys	H5 55
Penygroes, Dyfed	H2 37
Penygroes, Gwyn.	C2 54
Penysarn, Angl.	C2 58
Penywaun, M.Glam.	A3 38
Penzance, Corn.	B5 18
Peopleton, H.& W.	J5 51
Peover Heath, Ches.	E1 56
Peplow, Salop.	D5 56
Peniton, Som.	H2 35
Perranar-Worthal, Corn.	D4 18
Perranporth, Corn.	D3 18
Perranzabuloe, Corn.	D3 18
Perry Barr, W.Mid.	A6 46
Perry Crofts, Staffs.	E4 48
Perry, Cambs.	J2 41
Perry, W.Mid.	A6 46
Pershore, H.& W.	J6 51
Pertenhall, Beds.	J2 41
Perth, Tay.	D4 90
Perthy, Salop.	B4 56
Peterborough, Cambs.	K5 47
Peterburn, High.	E2 106
Peterchurch, H.& W.	D6 50
Peterculter, Gram.	J4 101
Peterhead, Gram.	K5 103
Peterlee, Dur.	D5 76
Peters Green, Herts.	J6 41
Peters Marland, Dev.	D4 34
Petersfield, Hants.	E2 24
Peterston-super-Ely, S.Glam.	B5 38
Peterstone Wentlooge, Gwent	C5 38
Peterstow, H.& W.	F1 39
Petertavy, Dev.	D3 20
Petham, Kent	H2 27
Petrockstow, Dev.	D4 34
Pett, E.Suss.	F5 27
Pettaugh, Suff.	G3 43
Pettinain, Stra.	D2 80
Pettistree, Suff.	H3 43
Petton, Dev.	H3 35
Petton, Salop.	C4 56
Pettymuick, Gram.	J2 101
Petworth, W.Suss.	G2 25
Pevensey Bay, E.Suss.	E5 26
Pevensey, E.Suss.	D5 26
Pewsey, Wilts.	G5 33
Philiphaugh, Bord.	H4 81
Philleigh, Corn.	E4 18
Phoenix Green, Hants.	D5 30
Pica, Cumb.	B6 74
Piccotts End, Herts.	F1 31
Pickering, N.Yorks.	J3 67
Picket Post, Hants.	H4 23
Pickhill, N.Yorks.	E3 66
Picklescott, Salop.	E1 50
Pickmere, Ches.	E6 60
Pickwell, Leics.	F4 47
Pickworth, Leics.	H4 47
Pickworth, Lincs.	H3 47
Picton, Ches.	C1 56
Picton, N.Yorks.	F2 67
Piddington, Bucks.	D2 30
Piddington, Oxon.	E6 40
Piddlehinton, Dor.	D4 22
Piddletrenthide, Dor.	D4 22
Pidley, Cambs.	A1 42
Piercebridge, Dur.	D1 66
Pierowall, Ork.	G4 112
Pigdon, Northumb.	B1 76
Pikehall, Derby.	J2 57
Pilgrims Hatch, Essex	D2 28
Pilham, Lincs.	E3 62
Pill, Avon	B4 32
Pillaton, Corn.	J2 19
Pillerton Priors, War.	B4 40
Pillgwenlly, Gwent	D4 38
Pilling, Lancs.	F6 69
Pillowell, Glos.	C1 32
Pilsdon, Dor.	A4 22
Pilsley, Derby.	J1 57
Pilton, Dev.	E2 34
Pilton, Leics.	G5 47
Pilton, Lincs.	K4 49
Pilton, Northants.	H1 41
Pimperne, Dor.	E3 22
Pinchbeck Bars, Lincs.	K3 47
Pinchbeck West, Lincs.	K3 47
Pinchbeck, Lincs.	K3 47
Pinehurst, Wilts.	G3 33
Pinfold, Lancs.	C3 60
Pinhoe, Dev.	G1 21
Pinley Green, War.	B2 40
Pinmore, Stra.	C1 72
Pinn, Dev.	H2 21
Pinner Green, G.L.	G3 31
Pinner, G.L.	G3 31
Pinvin, H.& W.	J5 51
Pinwherry, Stra.	C1 72
Pinxton, Derby.	D1 46
Pipe Gate, Salop.	E3 56
Pipehill, Staffs.	A5 46
Pipewell, Northants.	G6 47
Pirbright, Surr.	E5 30
Pirnmill, Island of Arran	C2 82
Pirton Cross, Herts.	J5 41
Pirton, Herts.	J5 41
Pishill, Oxon.	C3 30
Pistyll, Gwyn.	B3 54
Pitcairngreen, Tay.	D4 90
Pitcaple, Gram.	H2 101
Pitch Green, Bucks.	D2 30
Pitchcombe, Glos.	H3 39
Pitchcott, Bucks.	F6 41
Pitchford, Salop.	C6 56
Pitcombe, Som.	D1 22
Pitcox, Loth.	E2 88
Pitcur, Tay.	E3 90
Pitlochry, Tay.	C1 90
Pitmedden, Gram.	J1 101
Pitminster, Som.	K4 35
Pitney, Som.	B2 22
Pitscottie, Fife	F5 91
Pitsea, Essex	E3 28
Pitsford, Northants.	F2 41
Pittendreich, Gram.	B4 102
Pittentrail, High.	G1 105
Pittenweem, Fife	G6 91
Pitton, Wilts.	A2 24
Plains, Stra.	C3 86
Plaish, Salop.	E1 50
Plaistow, W.Suss.	G2 25
Plas Isaf, Clwyd	H3 55
Plas Llwyd, Clwyd	G3 59
Plas-yn-Cefn, Clwyd	G4 59
Platt, E.Suss.	D3 26
Platt, Kent	D5 28
Platts Common, S.Yorks.	A2 62
Platts Heath, Kent	F2 27
Plavden, E.Suss.	G4 27
Plaxtol, Kent	D2 26
Plealey, Salop.	C6 56
Plean, Cen.	D1 86
Pleasington, Lancs.	E2 60
Pleasley, Derby.	B5 62
Pleasleyhill, Notts.	B5 62
Pleshey, Essex	C6 42
Plockton, High.	B1 98
Ploxgreen, Salop.	D1 50
Pluckley, Kent	G2 27
Plumbland, Cumb.	C5 74
Plumley, Ches.	E1 56
Plumpton Green, E.Suss.	B4 26
Plumpton, Cumb.	F5 75
Plumpton, E.Suss.	B5 26
Plumpton, Lancs.	C2 60
Plumstead, G.L.	C4 28
Plumstead, Norf.	G2 45
Plumtree, Notts.	E3 46
Plungar, Leics.	F2 47
Plusha, Corn.	H1 19
Plusterwine, Glos.	C2 32
Plwmp, Dyfed	E5 52
Plymouth, Dev.	C5 20
Plympton, Dev.	D4 20
Plymstock, Dev.	D5 20
Plymtree, Dev.	J5 35
Pockley, N.Yorks.	G3 67
Pocklington, Hum.	F4 65
Pode Hole, Lincs.	K3 47
Podimore, Som.	C2 22
Podington, Beds.	H2 41
Podmore, Staffs.	E4 56
Pointon, Lincs.	J3 47
Polbain, High.	A6 109
Polbathick, Corn.	J3 19
Polbeth, Loth.	E4 86
Poldean, D & G.	F6 81
Pole of Itlow, The, Gram.	F4 103
Polebrook, Northants.	J6 47
Polegate, E.Suss.	D5 26
Polesworth, War.	E4 48
Polgooth, Corn.	F3 19
Polke, Dor.	C3 22
Polla, High.	D2 109
Pollington, Hum.	C1 62
Polloch, High.	G6 97
Polperro, Corn.	H3 19
Polruan, Corn.	G3 19
Polskeath, D & G.	B6 80
Polstead, Suff.	F4 43
Polt Shrigley, Ches.	G6 61
Poltalloch, Stra.	F1 85
Poltimore, Dev.	H5 35
Polwarth, Bord.	F4 89
Polyphant, Corn.	H1 19
Polzeath, Corn.	E1 18
Ponders End, G.L.	B2 28
Pondersh, Cambs.	K6 47
Ponsanooth, Corn.	D4 18
Ponsworthy, Dev.	E3 20
Pont Cyfyng, Gwyn.	E2 54
Pont Pen-y-benglog, Gwyn.	D4 58
Pont-faen, Powys	A1 38
Pont-henri, Dyfed	G3 37
Pont-Hir, Gwent	A2 32
Pont-Nedd Fechan, W.Glam.	K3 37
Pont-rhyd-y-fen, W.Glam.	J4 37
Pontardawe, W.Glam.	J3 37
Pontardulais, W.Glam.	H3 37
Pontarsais, Dyfed	G1 37
Pontefract, W.Yorks.	A1 62
Ponteland, Northumb.	B2 76
Ponterwyd, Dyfed	H3 53
Pontesbury, Salop.	D1 50
Pontfadog, Clwyd	J4 55
Pontfaen, Dyfed	C1 36
Ponthirwaun, Dyfed	D6 52
Pontllan-fraith, Gwent	C4 38
Pontlliw, W.Glam.	H3 37
Pontlottyn, M.Glam.	B3 38
Pontlyfni, Gwyn.	C2 54
Pontnewydd, Gwent	C4 38
Pontrhydfendigaid, Dyfed	H4 53
Pontrhydygroes, Dyfed	H3 53
Pontrilas, H.& W.	D1 38
Pontrobert, Powys	H6 55
Ponts Green, E.Suss.	E5 26
Pontshaen, Dyfed	E6 52
Pontshill, H.& W.	F2 39
Pontyates, Dyfed	G3 37
Pontyberem, Dyfed	G3 37
Pontyclun, M.Glam.	A5 38
Pontycymmer, M.Glam.	K4 37
Pontypool, Gwent	C3 38
Pontypridd, M.Glam.	B4 38
Pool Keynes, Glos.	J4 39
Pool o' Muckhart, Cen.	C6 90
Pool, Corn.	C4 18
Pool, W.Yorks.	D6 66
Poole, Dor.	F5 23
Poolewe, High.	F3 107
Pooley Bridge, Cumb.	F6 75
Pooley Street, Norf.	F1 43
Poolhill, Glos.	G1 39
Poolsbrook, Derby.	A5 62
Popeswood, Berks.	D4 30
Poplar, G.L.	B3 28
Porchester, Notts.	E2 46
Porchfield, I.o.W.	C5 24
Porkellis, Corn.	D5 18
Porlock Weir, Som.	G1 35
Porlock, Som.	G1 35
Port Appin, Stra.	B2 92
Port Ascaig, Isle of Islay	C3 84
Port Bannatyne, Isle of Bute	H3 85
Port Charlotte, Isle of Islay	A4 84
Port Clarence, Cleve.	E6 76
Port Dinorwic, Gwyn.	C4 58
Port e Vullen, I.o.M.	E3 70
Port Ellen, Isle of Islay	B5 84
Port Elphinstone, Gram.	H2 101
Port Erin, I.o.M.	C5 70
Port Eynon, W.Glam.	G5 37
Port Glasgow, Stra.	K2 85
Port Henderson, High.	E3 106
Port Isaac, Corn.	F1 19
Port Lamont, Stra.	H3 85
Port Logan, D & G.	B5 72
Port of Menteith, Cen.	H6 93
Port of Ness, Isle of Lewis	D1 108
Port Ramsay, Stra.	H2 95
Port St. Mary, I.o.M.	C5 70
Port Sunlight, Mer.	B6 60
Port Talbot, W.Glam.	J4 37
Port Wemyss, Isle of Islay	A4 84
Port William, D.& G.	D5 72
Portavadia, Stra.	G3 85
Portchester, Hants.	D4 24
Portencross, Stra.	F2 83
Portesham, Dor.	C5 22
Portfield Gate, Dyfed	C2 36
Portgate, Dev.	C2 20
Portgordon, Gram.	D4 102
Portgower, High.	E6 110
Porth Mellion, Corn.	C6 18
Porth, M.Glam.	A4 38
Porth-gain, Dyfed	B1 36
Porthallow, Corn.	D6 18
Porthcawl, M.Glam.	K5 37
Porthleven, Corn.	C5 18
Porthmadog, Gwyn.	D3 54
Porthmeor, Corn.	A4 18
Porthpean, Corn.	F3 19
Porthscatho, Corn.	E5 18
Porthtowan, Corn.	D4 18
Porthyrhyd, Dyfed	G2 37
Portincaple, Stra.	E6 92
Portinnishernich, Stra.	C5 92
Portishead, Avon	B4 32
Portknockie, Gram.	E4 102
Portlethen, Gram.	K4 101
Portloe, Corn.	E4 18
Portmahomack, High.	J2 105
Portmeinon, Gwyn.	D4 54
Portmore Loch, Bord.	B2 78
Portnacroish, Stra.	C2 92
Portnaguran, Isle of Lewis	D2 108
Portnahaven, Isle of Islay	A4 84
Portnalong, Isle of Skye	D1 96
Portnancon, High.	E2 109
Portobello, Loth.	G2 87
Portpatrick, D & G.	A4 72
Portreath, Corn.	C4 18
Portree, Isle of Skye	C6 106
Portrye, Great Cumbrae Isle	J4 85
Portsea, Hants.	D4 24
Portskerra, High.	D2 110
Portskewett, Gwent	B3 32
Portslade-by-Sea, E.Suss.	A5 26
Portsmouth, Hants.	D4 24
Portsoy, Gram.	E4 102
Portswood, Hants.	B3 24
Portuairk, High.	D6 96
Portway, War.	A2 40
Portyerrock, D & G.	E5 72
Poslingford, Suff.	D4 42
Postbridge, Dev.	E3 20
Postcombe, Oxon.	C2 30
Postwick, Norf.	H5 45
Potarch, Gram.	G4 101
Potter Heigham, Norf.	J4 45
Potter Street, Essex	C1 28
Potterhanworth, Lincs.	F5 63
Potterne, Wilts.	F5 33
Potters Bar, Herts.	H2 31
Pottershill, Avon	B5 32
Potterspury, Northants.	F4 41
Potto, N.Yorks.	F2 67
Potton Island, Essex	G3 29
Potton, Beds.	K3 41
Pottrow, Norf.	C3 44
Poughill, Corn.	B5 34
Poughill, Dev.	G5 35
Poulshot, Wilts.	F5 33
Poulton, Glos.	G2 33
Poulton-le-Fylde, Lancs.	B1 60
Pound Hill, W.Suss.	B3 26
Poundon, Bucks.	E5 40
Poundsgate, Dev.	E3 20
Poundstock, Corn.	B5 34
Povey Cross, Surr.	A2 26
Powburn, Northumb.	J4 79
Powderham, Dev.	G2 21
Powerstock, Dor.	B4 22

183

Rothwell, Lincs. G3 63
Rothwell, Northants. F1 41
Rothwell, W.Yorks. K2 61
Rottingdean, E.Suss. B6 26
Rough Close, Staffs. F3 57
Rough Hay, Staffs. E2 48
Rougham, Norf. D4 44
Roughburn, High. F5 99
Roughlee, Lancs. F1 61
Roughsike, Cumb. F2 75
Roughton, Lincs. H5 63
Roughton, Norf. H2 45
Roughton, Salop. G2 51
Round Bush, Herts. G2 31
Round Hill, Notts. D1 46
Roundhay, W.Yorks. B5 64
Roundway, Wilts. F5 33
Rounton, N.Yorks. F2 67
Rous Lench, H.& W. J5 51
Routh, Hum. H5 65
Row, Corn. G1 19
Row, The, Oxon. C6 40
Rowanburn, D.& G. E2 74
Rowde, Wilts. F5 33
Rowden Down, Wilts. E4 32
Rowhedge, Essex F6 43
Rowington, War. B2 40
Rowistone, H.& W. D1 38
Rowlands Castle, Hants. E3 24
Rowlands Gill, T.& W. B3 76
Rowledge, Surr. D6 30
Rowley Regis, W.Mid. C5 48
Rowley, Hum. G6 65
Rowley, Salop. D1 50
Rowney Green, H.& W. J3 51
Rowstock, Oxon. A3 30
Rowston, Lincs. G6 63
Rowton, Ches. C1 56
Rowton, Salop. D5 56
Roxburgh, Bord. F3 79
Roxby, Hum. E1 62
Roxby, N.Yorks. H1 67
Roxton, Beds. J3 41
Roxwell, Essex D1 28
Roybridge, High. E5 98
Roydon, Essex C1 28
Roydon, Norf. D3 44
Royston, Herts. A4 42
Royston, S.Yorks. K3 61
Royton, Grt.M. G4 61
Ruabon, Clwyd B3 56
Ruabon, Clwyd K3 55
Ruaig, Isle if Tiree B2 94
Ruan Lanthorne, Corn. E4 18
Ruan Minor, Corn. D6 18
Ruardean, Glos. F2 39
Rubery, H.& W. J3 51
Ruckcroft, Cumb. F4 75
Ruckinge, Kent G3 27
Ruckland, Lincs. J4 63
Ruckley, Salop. E1 50
Ruddington, Notts. E3 46
Rudgeway, Avon F4 39
Rudgwick, W.Suss. H1 25
Rudhall, H.& W. F1 39
Rudry, M.Glam. C4 38
Rudston, Hum. H3 65
Rudyard, Staffs. G2 57
Rufford, Lancs. C3 60
Rufforth, N.Yorks. D4 64
Rugby, War. D1 40
Rugeley, Staffs. D3 48
Ruilick, High. E5 104
Ruishton, Som. K3 35
Ruislip, G.L. F3 31
Rumburgh, Suff. J1 43
Rumney, S.Glam. C5 38
Runcorn, Ches. D6 60
Runcton Holme, Norf. C4 44
Runfold, Surr. E6 30
Runhall, Norf. F5 45
Runham, Norf. K4 45
Runswick, N.Yorks. J1 67
Runtaleave, Tay. D6 100
Runwell, Essex E2 28
Ruscombe, Berks. D4 30
Rushack, H.& W. H4 51
Rushall, H.& W. F6 51
Rushall, Norf. G1 43
Rushall, W.Mid. C4 48
Rushall, Wilts. G5 33
Rushbury, Salop. E2 50
Rushden, Northants. H2 41
Rushford, Dev. C3 20
Rushford, Suff. E1 42
Rushlake Green, E.Suss. D4 26
Rushmere, Suff. K1 43
Rusholme, Grt.M. F5 61
Rushton Spencer, Staffs. G2 57
Rushton, Ches. D1 56
Rushton, Northants. G1 41
Rushton, Salop. D6 56
Ruskie, Cen. H6 93
Ruskington, Lincs. F6 63
Rusland, Cumb. F3 69
Rusper, W.Suss. A3 26
Ruspidge, Glos. F2 39
Rustington, W.Suss. G4 25
Ruston Parva, Hum. H3 65
Rutherglen, Stra. B3 86
Ruthernbridge, Corn. F2 19
Ruthin, Clwyd H5 59
Ruthven, Gram. E5 102
Ruthven, High. H6 105
Ruthven, Tay. E2 90
Ruthwell, D.& G. C3 74
Ruxley Corner, G.L. C4 28
Ruyton-XI-Towns, Salop. B5 56
Ryal Fold, Lancs. E3 60
Ryal, Northumb. A2 76
Ryarsh, Kent E5 28
Ryde, I.o.W. D5 24
Rye Harbour, E.Suss. G4 27
Rye, E.Suss. G4 27

Ryhall, Leics. H4 47
Ryhill, Hum. H1 63
Ryhill, W.Yorks. A1 62
Ryhope, T.& W. D4 76
Ryland, Lincs. F4 63
Rylstone, N.Yorks. B5 66
Ryme Intrinseca, Dor. C3 22
Ryther, N.Yorks. D5 64
Ryton, Glos. G1 39
Ryton, Salop. A4 48
Ryton on Dunsmore, War. C1 40
Ryton, T.& W. B3 76
Sabden, Lancs. F1 61
Sacombe, Herts. A6 42
Sacriston, Dur. C4 76
Sadberge, Dur. E1 66
Saddell, Kintyre C3 82
Saddington, Leics. H5 49
Saddle Bow, Norf. C4 44
Sadgill, Cumb. G2 69
Saffron Walden, Essex B4 42
Saham Toney, Norf. E5 44
Saighton, Ches. C2 56
St. Abbs, Bord. H3 89
St. Agnes, Corn. D3 18
St. Albans, Herts. G1 31
St. Alburgh, Norf. H1 43
St. Allen, Corn. E3 18
St. Andrews, Fife G4 91
St. Annes, Lancs. B2 60
St. Anns Chapel, Corn. J2 19
St. Anns, D.& G. E6 80
St. Anthonys Hill, E.Suss. D6 26
St. Arvans, Gwent E4 38
St. Asaph (Llanelwy), Clwyd G3 59
St. Athan, S.Glam. A6 38
St. Austell, Corn. F3 19
St. Bees, Cumb. C1 68
St. Blazey, Corn. F3 19
St. Boswells, Bord. E3 78
St. Breock, Corn. F2 19
St. Breward, Corn. G1 19
St. Briavels, Glos. F3 39
St. Brides Major, M.Glam. K5 37
St. Brides Wentlooge, Gwent D5 38
St. Brides, Dyfed B3 36
St. Budeaux, Dev. C4 20
St. Buryan, Corn. A5 18
St. Catherines, Stra. D5 92
St. Clears, Dyfed E2 36
St. Cleer, Corn. H2 19
St. Clether, Corn. H1 19
St. Columb Major, Corn. E2 18
St. Columb Minor, Corn. E2 18
St. Columb Porth, Corn. E2 18
St. Combs, Gram. J4 103
St. Cross South Elmham, Suff. H1 43
St. Cyrus, Gram. H6 101
St. Davids, Dyfed A1 36
St. Davids, Tay. C4 90
St. Day, Corn. D4 18
St. Dennis, Corn. F3 19
St. Dogmaels, Dyfed C6 52
St. Dominick, Corn. J2 19
St. Endellion, Corn. F1 19
St. Enoder, Corn. E3 18
St. Erme, Corn. E3 18
St. Erth, Corn. B5 18
St. Ervan, Corn. E2 18
St. Eval, Corn. E2 18
St. Ewe, Corn. F4 19
St. Fagans, S.Glam. B5 38
St. Fergus, Gram. J5 103
St. Fillans, Tay. A4 90
St. Florence, Dyfed D3 36
St. Gennys, Corn. A5 34
St. George, Avon A5 32
St. Germans, Corn. J3 19
St. Giles in the Wood, Dev. E4 34
St. Giles on the Heath, Dev. B2 20
St. Harmon, Powys A3 50
St. Harmon, Powys K3 53
St. Helen Auckland, Dur. B6 76
St. Helena, Norf. G4 45
St. Helena, War. E4 48
St. Helens, I.o.W. D5 24
St. Helens, Mer. D5 60
St. Hilary, Corn. B5 18
St. Hilary, S.Glam. A6 38
St. Ishmaels, Dyfed B3 36
St. Issey, Corn. E2 18
St. Ive, Corn. H2 19
St. Ives, Cambs. A2 42
St. Ives, Corn. B4 18
St. James South Elmham, Suff. H1 43
St. John, Corn. J3 19
St. Johns Chapel, Dur. J5 75
St. Johns Fen End, Norf. B4 44
St. Johns Highway, Norf. B4 44
St. Johns Town of Dolry, D.& G. F2 73
St. Johns, I.o.M. C4 70
St. Judes, I.o.M. D2 70
St. Just, Corn. A5 18
St. Keverne, Corn. D6 18
St. Kew, Corn. F1 19
St. Keyne, Corn. H2 19
St. Lawrence, Essex G1 29
St. Lawrence, I.o.W. C6 24
St. Leonards, E.Suss. F5 27
St. Levan, Corn. A6 18
St. Mabyn, Corn. F2 19
St. Margaret South Elmham, Suff. H1 43
St. Margarets Hope, Ork. G5 112
St. Margarets, Herts. B1 28
St. Margarets-at-Cliffe, Kent K2 27

St. Marks, I.o.M. D4 70
St. Martins Green, Corn. D5 18
St. Martins, Salop. B4 56
St. Mary Bourne, Hants. K6 33
St. Mary Church, S.Glam. A6 38
St. Mary-in-the-Marsh, Kent H4 27
St. Marys Bay, Kent H4 27
St. Marys Hoo, Kent F4 29
St. Marys Loch, Bord. G4 81
St. Marys, Ork. G5 112
St. Mawes, Corn. E5 18
St. Mawgan, Corn. E2 18
St. Mellion, Corn. J2 19
St. Mellons, S.Glam. C5 38
St. Merryn, Corn. E1 18
St. Mewan, Corn. F3 19
St. Michael Caerhays, Corn. F4 19
St. Michael Penkevil, Corn. E4 18
St. Michael South Elmham, Suff. J1 43
St. Michaels on Wyre, Lancs. C1 60
St. Michaels, H.& W. F4 51
St. Michaels, Kent F3 27
St. Minver, Corn. F1 19
St. Monance, Fife G6 91
St. Neot, Corn. G2 19
St. Neots, Cambs. J3 41
St. Nicholas, Dyfed A6 52
St. Nicholas, S.Glam. B5 38
St. Nicholas-at-Wade, Kent J4 29
St. Ninians, Cen. C1 86
St. Osyth, Essex G6 43
St. Owens Cross, H.& W. E1 38
St. Pauls Walden, Herts. J6 41
St. Peters, Kent K4 29
St. Quivox, Stra. G4 83
St. Stephen, Corn. F3 19
St. Stephens, Herts. G1 31
St. Teath, Corn. F1 19
St. Thomass Bridge, Wilts. G1 23
St. Tudy, Corn. F1 19
St. Twynnells, Dyfed C4 36
St. Veep, Corn. G3 19
St Vigeans, Tay. H2 91
St. Wenn, Corn. F2 19
St. Weonards, H.& W. E1 38
Saintbury, Glos. K6 51
Salattyn, Salop. K4 55
Salcombe Regis, Dev. J2 21
Salcombe, Dev. E6 20
Salcott, Essex E6 42
Sale, Grt.M. F5 61
Saleby, Lincs. K4 63
Salehurst, E.Suss. E4 26
Salem, Dyfed H1 37
Salen, High. F6 97
Salen, Isle of Mull F2 95
Salesbury, Lancs. E2 60
Salford Priors, War. K5 51
Salford, Beds. G4 41
Salford, Grt.M. F5 61
Salford, Oxon. B5 40
Salfords, Surr. A2 26
Salhouse, Norf. H4 45
Saline, Fife C6 90
Salisbury, Wilts. G2 23
Sall, Norf. G3 45
Sallachy, High. B1 98
Salmonby, Lincs. H5 63
Salmonds Muir, Tay. H3 91
Salperton, Glos. K2 39
Salsburgh, Stra. D3 86
Salt, Staffs. G4 57
Saltaire, W.Yorks. A5 64
Saltash, Corn. J3 19
Saltburn, High. G3 105
Saltburn-by-the-Sea, Cleve. F6 77
Saltby, Leics. G3 47
Saltcoats, Stra. F2 83
Saltdean, E.Suss. B6 26
Salter, Lancs. H5 69
Salterforth, Lancs. G1 61
Sltergate, N.Yorks. F1 65
Saltergate, N.Yorks. J3 67
Salters Lode, Norf. C5 44
Salterswall, Ches D1 56
Saltfleet, Lincs. J3 63
Saltfleetby St. Clements, Lincs. K3 63
Saltfleetby St. Peter, Lincs. J3 63
Saltford, Avon D4 32
Salthouse, Norf. F2 45
Saltmarshe, Hum. D1 62
Saltney, Ches. B1 56
Salton, N.Yorks. E2 64
Saltwick, Northumb. B2 76
Saltwood, Kent J3 27
Salvington, W.Suss. H4 25
Salwarpe, H.& W. H4 51
Salway Ash, Dor. B4 22
Sambrook, Salop. E5 56
Samlesbury Bottoms, Lancs. E2 60
Samlesbury, Lancs. D2 60
Sampford Arundel, Som. J4 35
Sampford Brett, Som. J2 35
Sampford Courtenay, Dev. C5 34
Sampford Peverell, Dev. H4 35
Sampford Spinney, Dev. D3 20
Sanaigmore, Isle of Islay A3 84
Sancreed, Corn. A5 18
Sancton, Hum. G5 65
Sand Hutton, N.Yorks. E4 64
Sandaig, High. G3 97
Sandal Magna, W.Yorks. K3 61
Sandbach, Ches. E2 56

Sandbank, Stra. J2 85
Sandbanks, Dor. F5 23
Sandend, Gram. E4 102
Sanderstead, G.L. B5 28
Sandford St. Martin, Oxon. C5 40
Sandford, Avon B5 32
Sandford, Dev. G5 35
Sandford, Dor. F5 23
Sandford, Stra. B2 80
Sandford-on-Thames, Oxon. B2 30
Sandgarth, Ork. G5 112
Sandgate, Kent J3 27
Sandgreen, D.& G. F4 73
Sandhaven, Gram. H4 103
Sandhead, D.& G. B4 72
Sandhoe, Northumb. A3 76
Sandholme, Hum. F6 65
Sandhurst, Berks. D5 30
Sandhurst, Glos. H2 39
Sandhurst, Kent F4 27
Sandhutton, N.Yorks. E4 66
Sandiacre, Derby. D2 46
Sandilands, Lincs. K4 63
Sandiway, Ches. D1 56
Sandleheath, Hants. G3 23
Sandling, Kent E5 28
Sandon, Herts. A5 42
Sandon, Staffs. G4 57
Sandown, I.o.W. D5 24
Sandplace, Corn. H3 19
Sandridge, Herts. G1 31
Sandsend, N.Yorks. J1 67
Sandwich, Kent K5 29
Sandwick, Cumb. E6 74
Sandwick, S.Uist B5 108
Sandwith, Cumb. C1 68
Sandy Lane, Wilts. F4 33
Sandy, Beds. J3 41
Sandycroft, Clwyd K4 59
Scunthorpe, Hum. E2 62
Sanfon Downham, Norf. D6 44
Sangobeg, High. E1 109
Sanna, High. D6 96
Sanquhar, D.& G. C5 80
Santon Bridge, Cumb. D2 68
Sapcote, Leics. G5 49
Sapey Common, H.& W. G4 51
Sapiston, Suff. E1 42
Sapperton, Glos. J3 39
Sapperton, Lincs. H2 47
Saracens Head, Lincs. A3 44
Sarclet, High. H3 111
Sarisbury, Hants. C3 24
Sarn Meyllteyrn, Gwyn. A4 54
Sarn, M.Glam. K5 37
Sarn, Powys C2 50
Sarn-bach, Gwyn. B4 54
Sarnau, Dyfed D5 52
Sarnau, Gwyn. G3 55
Sarnau, Powys J5 55
Saron, Dyfed H2 37
Sarratt, Herts. F2 31
Sarre, Kent J5 29
Satley, Dur. B5 76
Satterthwaite, Cumb. F3 69
Sauchen, Gram. H3 101
Saughall, Ches. B1 56
Saughtree, Bord. E6 78
Saul, Glos. G3 39
Saundby, Notts. D4 62
Saundersfoot, Dyfed D3 36
Saunton, Dev. D2 34
Sausthorpe, Lincs. J5 63
Sawbridgeworth, Herts. B6 42
Sawdon, N.Yorks. G2 65
Sawley, Derby. D3 46
Sawley, Lancs. A6 66
Sawley, N.Yorks. D5 66
Sawston, Cambs. B3 42
Sawtry, Cambs. J1 41
Saxby All Saints, Hum. F1 63
Saxby, Leics. F4 63
Saxby, Lincs. F3 47
Saxby, Lincs. E5 62
Saxlingham Green, Norf. H5 45
Saxlingham Nethergate, Norf. H5 45
Saxlingham, Norf. F2 45
Saxmundham, Suff. J2 43
Saxon Street, Cambs. C3 42
Saxtead Green, Suff. H2 43
Saxthorpe, Norf. G3 45
Saxton, N.Yorks. C5 64
Scackleton, N.Yorks. G4 67
Scaftworth, Notts. C3 62
Scagglethorpe, N.Yorks. F3 65
Scalasaig, Isle of Colonsay D6 94
Scalby, Hum. F6 65
Scalby, N.Yorks. H1 65
Scaleby, Cumb. E3 74
Scales, Cumb. E4 68
Scalford, Leics. F3 47
Scaling, N.Yorks. H1 67
Scalloway, Shet. D3 112
Scamblesby, Lincs. H4 63
Scammonden, N.Yorks. J4 67
Scampton, Lincs. E4 62
Scar, Ork. G4 112
Scarborough, N.Yorks. K3 67
Scarcliffe, Derby. B5 62
Scarcroft, W.Yorks. B5 64
Scarfskerry, High. G1 111
Scargill, Dur. C1 66
Scarinish, Isle of Tiree A2 94
Scarisbrick, Lancs. C3 60
Scarning, Norf. E4 44
Scarrington, Notts. F2 47
Scarth Hill, Lancs. C4 60
Scartho, Hum. H2 63
Scawby, Hum. F2 63
Scawton, N.Yorks. D2 64
Scaynes Hill, W.Suss. B4 26
Scethrog, Powys B1 38
Scholar Green, Ches. F2 57
Scholes, W.Yorks. J4 61
Scissell, W.Yorks. K4 61

Scleddau, Dyfed C1 36
Sco Ruston, Norf. H3 45
Scofton, Notts. C4 62
Scole, Norf. G1 43
Sconser, Isle of Skye D6 106
Scoor, Isle of Mull D4 94
Scopwick, Lincs. F6 63
Scoraig, High. A1 104
Scorborough, Hum. H5 65
Scorrier, Corn. D4 18
Scorton, Lancs. G6 69
Scorton, N.Yorks. D2 66
Scotby, Cumb. E4 74
Scotch Corner, N.Yorks. D2 66
Scothern, Lincs. F4 63
Scotlandwell, Tay. E6 90
Scots Gap, Northumb. A1 76
Scotstown, High. G6 97
Scotter, Lincs. E3 62
Scottlethorpe, Lincs. H4 47
Scotton, Lincs. E3 62
Scotton, N.Yorks. B4 64
Scoulton, Norf. F5 45
Scourie, High. C3 109
Scousburgh, Shet. D4 112
Scrabster, High. F1 111
Scrane End, Lincs. A2 44
Scraptoft, Leics. E5 46
Scrayingham, N.Yorks. H5 67
Scredington, Lincs. J2 47
Scremby, Lincs. J5 63
Scremerston, Northumb. H2 79
Screveton, Notts. F2 47
Scriven, N.Yorks. B4 64
Scrooby, Notts. C3 62
Scropton, Derby. A3 46
Scruton, N.Yorks. E3 66
Sculcoates, Hum. H6 65
Scullington, W.Suss. H3 25
Sculthorpe, Norf. E3 44
Scunthorpe, Hum. E2 62
Sea Palling, Norf. J3 45
Sea, Som. A3 22
Seaborough, Dor. B4 22
Seacombe, Mer. B5 60
Seacroft, Lincs. K6 63
Seacroft, W.Yorks. B6 64
Seaford, E.Suss. C6 26
Seaforth, Mer. B5 60
Seagrave, Leics. E4 46
Seaham, Dur. D4 76
Seahouses, Northumb. K3 79
Seal, Kent D1 26
Seale, Surr. E6 30
Seamer, N.Yorks. H2 65
Seamer, N.Yorks. F2 65
Seamill, Stra. F2 83
Searby, Lincs. F2 63
Seascale, Cumb. D2 68
Seathwaite, Cumb. E2 68
Seaton Burn, T.& W. C2 76
Seaton Carew, Cleve. E6 76
Seaton Delaval, Northumb. C2 76
Seaton Ross, Hum. F5 65
Seaton Sluice, Northumb. C2 76
Seaton, Cumb. B6 74
Seaton, Dev. J2 21
Seaton, Hum. J5 65
Seaton, Leics. G5 47
Seaton, Northumb. C2 76
Seatown, Dor. B5 22
Seaview, I.o.W. D5 24
Seavington St. Michael, Som. A3 22
Sebergham, Cumb. E5 74
Seckington, War. B5 46
Sedbergh, Cumb. H3 69
Sedbury, Glos. F4 39
Sedbusk, N.Yorks. A3 66
Sedgeberrow, H.& W. J6 51
Sedgebrook, Lincs. G2 47
Sedgefield, Dur. D6 76
Sedgeford, Norf. D2 44
Sedgehill, Wilts. E2 22
Sedgewick, Cumb. G3 69
Sedgley, W.Mid. C5 48
Sedlescombe, E.Suss. E4 26
Seend, Wilts. F5 33
Seething, Norf. H5 45
Sefton, Mer. B4 60
Seghill, Northumb. C2 76
Seighford, Staffs. B2 48
Seisdon, Staffs. B5 48
Selborne, Hants. E2 24
Selby, N.Yorks. D6 64
Selham, W.Suss. F3 25
Selkirk, Bord. D4 78
Sellack, H.& W. F1 39
Sellafield, Cumb. C2 68
Sellindge, Kent H3 27
Selling, Kent H5 29
Sells Green, Wilts. F5 33
Selly Oak, W.Mid. J3 51
Selmeston, E.Suss. C5 26
Selsdon, G.L. B5 28
Selsey, W.Suss. F5 25
Selstead, Kent J2 27
Selston, Notts. D1 46
Selworthy, Som. H1 35
Semington, Wilts. E5 32
Semley, Wilts. E2 22
Send, Surr. F5 31
Senghenydd, M.Glam. B4 38
Sennen, Corn. A5 18
Sennybridge, Powys K1 37
Sessay, N.Yorks. F4 67
Settle, N.Yorks. A5 66
Settrington, N.Yorks. F3 65
Seven Kings, G.L. C3 28
Seven Sisters, W.Glam. K3 37
Sevenhampton, Wilts. H3 33
Sevenoaks Weald, Kent C2 26
Sevenoaks, Kent D5 28
Sevenoaks, Kent K5 31
Severn Beach, Avon B3 32
Severn Stoke, H.& W. H6 51
Sewerby, Hum. J3 65
Sewstern, Leics. G3 47
Shackerstone, Leics. K6 57

Shackleford, Surr. E6 30
Shader, Isle of Lewis D1 108
Shadingfield, Suff. J1 43
Shadoxhurst, Kent G3 27
Shadwell, W.Yorks. B5 64
Shaftesbury, Dor. E2 22
Shafton, S.Yorks. A2 62
Shafton-Two-Gates, S.Yorks. A2 62
Shakerstone, Leics. F4 49
Shalbourne, Wilts. J5 33
Shalcombe, I.o.W. B5 24
Shaldon, Dev. G3 21
Shalfleet, I.o.W. B5 24
Shalford, Essex D5 42
Shalford, Surr. F6 31
Shalstone, Bucks. E4 40
Shandon, Stra. J1 85
Shandwick, High. H3 105
Shangton, Leics. F5 47
Shanklin, I.o.W. D6 24
Shap, Cumb. H1 69
Shapwick, Som. A1 22
Shardlow, Derby. C3 46
Shareshill, Staffs. C4 48
Sharlston, W.Yorks. A1 62
Sharnbrook, Beds. H3 41
Sharnford, Leics. G5 49
Sharow, N.Yorks. E4 66
Sharperton, Northumb. H5 79
Sharpness, Glos. G3 39
Sharrington, Norf. F2 45
Shaugh Prior, Dev. D4 20
Shavington, Ches. E2 56
Shaw Mills, N.Yorks. B3 64
Shaw, Grt.M. G4 61
Shaw, Wilts. E5 32
Shawbury, Salop. D5 56
Shawell, Leics. H6 49
Shawell, Northants. D1 40
Shawford, Hants. C2 24
Shawforth, Lancs. G3 61
Shawhead, D.&G. H2 73
Shearsby, Leics. H5 49
Shebbear, Dev. D4 34
Shebden, Staffs. E5 56
Shebster, High. E2 110
Shedfield, Hants. C3 24
Shedwich, Kent G5 29
Sheen, Staffs. H2 57
Sheepscar, W.Yorks. B6 64
Sheepscombe, Glos. E1 32
Sheepstor, Dev. D4 20
Sheepwash, Dev. D5 34
Sheepway, Avon B4 32
Sheepy Magna, Leics. F4 49
Sheepy Parva, Leics. F4 49
Sheering, Essex C1 28
Sheerness, Kent G4 29
Sheet, Hants. E2 24
Sheffield Green, E.Suss. C4 26
Sheffield, S.Yorks. A4 62
Shefford, Beds. J4 41
Sheinton, Salop. D6 56
Shelderton, Salop. D3 50
Sheldon, Derby. H1 57
Sheldon, Dev. J4 35
Sheldon, W.Mid. D6 48
Sheldyke, Lincs. A2 44
Shelf, W.Yorks. J2 61
Shelfanger, Norf. G1 43
Shelfield, W.Mid. C4 48
Shelfield, War. A2 40
Shelford, Notts. E2 46
Shelley, W.Yorks. J3 61
Shellingford, Oxon. J2 33
Shelsley Beauchamp, H.&W. G4 51
Shelton Lock, Derby. C3 46
Shelton, Beds. H2 41
Shelton, Norf. H6 45
Shelton, Notts. F2 47
Shelve, Salop. D1 50
Shenfield, Essex D2 28
Shenington, Oxon. C4 40
Shenley Brook End, Bucks. G5 41
Shenley, Herts. G2 31
Shenstone, H.&W. H3 51
Shenstone, Staffs. D4 48
Shenton, Leics. F4 49
Shenval, Gram. D1 100
Shepeau Stow, Lincs. K4 47
Shepherdine, Avon C2 32
Shepherds Bush, G.L. G3 31
Shepherdswell, Kent J2 27
Shepley, W.Yorks. J4 61
Shepperdine, Avon F4 39
Shepperton, Surr. F4 31
Shepreth, Cambs. A4 42
Shepshed, Leics. G3 49
Shepton Beauchamp, Som. A3 22
Shepton Montague, Som. D2 22
Sherborne St. John, Hants. C5 30
Sherborne, Dor. C3 22
Sherborne, Glos. H1 33
Sherbourne, War. B2 40
Sherburn in Elmet, N.Yorks. C6 64
Sherburn, Dur. C5 76
Sherburn, N.Yorks. G2 65
Shere, Surr. F6 31
Shereford, Norf. E3 44
Sherfield English, Hants. A2 24
Sherfield-upon-Loddon, Hants. C5 30
Sherford, Dev. F5 21
Sheriff Hutton, N.Yorks. E3 64
Sheriffhales, Salop. E6 56
Sheringham, Norf. G2 45
Sherington, Bucks. G4 41
Shernborne, Norf. D3 44
Sherrington, Wilts. F1 23
Sherston, Wilts. E3 32
Shettleston, Stra. B3 86
Shevington, Grt.M. D4 60
Sheviock, Corn. J3 19

Shiel Bridge, High. C2 98
Shieldaig, High. F5 107
Shieldhill, Cen. D2 86
Shielfoot, High. F6 97
Shifford, Oxon. J2 33
Shifnal, Salop. G1 51
Shilbottle, Northumb. K5 79
Shildon, Dur. C6 76
Shillingford, Dev. H3 35
Shillingford, Oxon. B2 30
Shillingstone, Dor. E3 22
Shillington, Beds. J5 41
Shillmoor, Northumb. G5 79
Shilton, Oxon. H1 33
Shilton, War. F5 49
Shimpling, Norf. G1 43
Shimpling, Suff. E3 42
Shiney Row, Dur. C4 76
Shinfield, Berks. D4 30
Shinners Bridge, Dev. F4 21
Shinness, High. E5 109
Shipbourne, Kent D2 26
Shiphay, Dev. G4 21
Shiplake Row, Oxon. D4 30
Shiplake, Oxon. D4 30
Shipley, Salop. H2 51
Shipley, W.Yorks. J1 61
Shipmeadow, Suff. J6 45
Shipton Bellinger, Hants. H6 33
Shipton Gorge, Dor. B5 22
Shipton Moyne, Glos. H4 39
Shipton, Glos. J2 39
Shipton, N.Yorks. D4 64
Shipton, Salop. F2 51
Shipton-on-Cherwell, Oxon. D6 40
Shipton-on-Stour, War. B4 40
Shipton-under-Wychwood, Oxon. B6 40
Shiptonthorpe, Hum. F5 65
Shirburn, Oxon. C2 30
Shirdley Hill, Lancs. B3 60
Shire Oak, Staffs. A5 46
Shire Oak, W.Mid. H6 57
Shirebrook, Derby. B5 62
Shirecliffe, S.Yorks. A3 62
Shirehampton, Avon E5 38
Shiremoor, T.&W. C2 76
Shirenewton, Gwent E4 38
Shireoaks, Notts. B4 62
Shirland, Derby. C1 46
Shirley, Derby. J3 57
Shirley, Hants. B3 24
Shirley, W.Mid. D6 48
Shirwell, Dev. E2 34
Shobdon, H.&W. D4 50
Shobnall, Staffs. E2 48
Shobrooke, Dev. G5 35
Shocklach, Ches. C3 56
Shoeburyness, Essex G3 29
Shop, Corn. E2 18
Shoreditch, Som. K3 35
Shoreham, Kent C5 28
Shoreham-by-Sea, W.Suss. A5 26
Shorne, Kent E4 28
Shortacombe, Dev. D2 20
Shortgate, E.Suss. C5 26
Shorwell, I.o.W. C6 24
Shotesham, Norf. H5 45
Shotley Bridge, Dur. B4 76
Shotley Gate, Suff. H5 43
Shotley Street, Suff. H5 43
Shottenden, Kent H5 29
Shottermill, Surr. F2 25
Shottisham, Suff. H4 43
Shotton Colliery, Dur. D5 76
Shotton, Clwyd B1 56
Shotton, Northumb. G3 79
Shotts, Stra. D4 86
Shotwick, Ches. B1 56
Shouldham Thorpe, Norf. C5 44
Shouldham, Norf. C5 44
Shovers Green, E.Suss. D3 26
Shrewley, War. B2 40
Shrewsbury, Salop. C6 56
Shrewton, Wilts. G6 33
Shripney, W.Suss. F4 25
Shrivenham, Oxon. H3 33
Shropham, Norf. F6 45
Shrub End, Essex F6 43
Shudy Camps, Cambs. C4 42
Shurdington, Glos. J2 39
Shurlock Row, Berks. D4 30
Shustoke, War. E5 48
Shute, Dev. J1 21
Shutford, Oxon. C4 40
Shutlanger, Northants. F3 41
Shuttington, War. E4 48
Shuttlewood, Derby. B5 62
Sibbertoft, Northants. E6 46
Sibford Gower, Oxon. C4 40
Sible Hedingham, Essex D5 42
Sibsey, Lincs. J6 63
Sibson, Leics. F4 49
Sibthorpe, Notts. F2 47
Sicklesmere, Suff. E3 42
Sicklinghall, N.Yorks. B5 64
Sid, Dev. J2 21
Sidbury, Dev. J2 21
Sidbury, Salop. G2 51
Sidcup, G.L. C4 28
Siddington, Ches. F1 57
Siddington, Glos. F2 33
Sidestand, Norf. H2 45
Sidford, Dev. J2 21
Sidlesham, W.Suss. F4 25
Sidley, E.Suss. E5 26
Sidmouth, Dev. H2 21
Sigglesthorne, Hum. J5 65
Sileby, Leics. E4 46
Silecroft, Cumb. D4 68
Silian, Dyfed G5 53
Silk Willoughby, Lincs. H2 47
Silkstone, S.Yorks. K4 61
Silloth, Cumb. C4 74
Silpho, N.Yorks. G1 65
Silsden, W.Yorks. C6 66
Silsoe, Beds. J5 41
Silver End, Essex D6 42

Silver Hill, E.Suss. F5 27
Silver Street, Wilts. F3 33
Silverburn, Loth. G4 87
Silverdale, Lancs. G4 69
Silverdale, Staffs. F3 57
Silverford, Gram. G4 103
Silverstone, Northants. E4 40
Silverton, Dev. H5 35
Simonburn, Northumb. J2 75
Simonsbath, Som. F2 35
Simonstone, Lancs. F2 61
Simprim, Bord. G5 89
Simpson, Bucks. G4 41
Sinclairston, Stra. H4 83
Sinderby, N.Yorks. B2 64
Sinderhope, Northumb. J4 75
Singleton, Lancs. C1 60
Singleton, W.Suss. F3 25
Singlewell, Kent D4 28
Sinnahard, Gram. F3 101
Sinnington, N.Yorks. E2 64
Sinton Green, H.&W. H4 51
Sissinghurst, Kent F3 27
Siston, Avon G5 39
Sithney, Corn. C5 18
Sittingbourne, Kent G5 29
Six Ashes, Staffs. G2 51
Six Hills, Leics. E4 46
Six Mile Bottom, Cambs. B3 42
Sixhills, Lincs. G4 63
Sizewell, Suff. K2 43
Sizergh, Cumb. E2 64 [—]
Skail, High. C3 110
Skail, Ork. F5 112
Skaill, Ork. G5 112
Skares, Stra. J4 83
Skaw, Shet. E2 112
Skeeby, N.Yorks. D2 66
Skeffington, Leics. F5 47
Skeffling, Hum. J1 63
Skegby, Notts. B6 62
Skegness, Lincs. K6 63
Skelbo Street, High. H1 105
Skellingthorpe, Lincs. E5 62
Skellow, S.Yorks. B2 62
Skelmanthorpe, W.Yorks. J4 61
Skelmersdale, Lancs. C4 60
Skelmorlie, Stra. J3 85
Skelpick, High. C2 110
Skelton, Cleve. G1 67
Skelton, Cumb. E5 74
Skelton, Hum. D1 62
Skelton, N.Yorks. D4 64
Skelwith Bridge, Cumb. F2 69
Skendleby, Lincs. J5 63
Skenfrith, Gwent E2 38
Skerne, Hum. H4 65
Skerray, High. B2 110
Sketty, W.Glam. H4 37
Skewen, W.Glam. J4 37
Skewsby, N.Yorks. G4 67
Skiag Bridge, High. C5 109
Skidby, Hum. H6 65
Skigersta, Isle of Lewis D1 108
Skilgate, Som. H3 35
Skillington, Lincs. G3 47
Skinburness, Cumb. C4 74
Skinidin, Isle of Skye A5 106
Skinningrove, Cleve. H1 67
Skipness, Kintyre F4 85
Skipsea, Hum. J4 65
Skipton, N.Yorks. B6 66
Skipton-on-Swale, N.Yorks. E4 66
Skipwith, N.Yorks. E5 64
Skirbeck, Lincs. A2 44
Skirling, Bord. F5 87
Skirpenbeck, Hum. E4 64
Skirwith, Cumb. G5 75
Skirza, High. H1 111
Skulamus, Isle of Skye F2 97
Skye of Curr, High. B2 100
Slack, W.Yorks. G2 61
Slackhall, Derby. H6 61
Slackhead, Gram. D4 102
Slad, Glos. H3 39
Slade, Dev. D1 34
Slaggyford, Northumb. G4 75
Slaidburn, Lancs. J6 69
Slaithwaite, W.Yorks. H3 61
Slaley, Northumb. A3 76
Slamannan, Cen. D3 86
Slapton, Bucks. G6 41
Slapton, Dev. F5 21
Slapton, Northants. E4 40
Slaughterford, Wilts. E4 32
Slawston, Leics. F6 47
Sleaford, Hants. E1 24
Sleaford, Lincs. H2 47
Sleagill, Cumb. H1 69
Sleapford, Salop. D5 56
Sledmere, Hum. G3 65
Sleekburn, Northumb. C1 76
Sleightholme, Dur. B1 66
Sleights, N.Yorks. J2 67
Sliddery, Island of Arran D4 82
Sligachan Inn, Isle of Skye E1 96
Slimbridge, Glos. D2 32
Slindon, Staffs. F4 57
Slindon, W.Suss. G4 25
Slinfold, W.Suss. H2 25
Slingsby, N.Yorks. H4 67
Slioch, Gram. E6 102
Slip End, Beds. J6 41
Slippers Bottom, Norf. H4 45
Slipton, Northants. H1 41
Slochd, High. A2 100
Slockavullin, Stra. F1 85
Sloley, Norf. H3 45
Sloothby, Lincs. K5 63
Slough Green, W.Suss. B4 26
Slough, Berks. E3 30
Slyfield Green, Surr. F6 31
Smailholm, Bord. E3 78
Small Dole, W.Suss. A5 26
Small Hythe, Kent F3 27
Smallbridge, Grt.M. G3 61
Smallburgh, Norf. H3 45
Smallburn, Stra. B4 80

Smalley Common, Derby. C2 46
Smalley, Derby. C2 46
Smallfield, Surr. B2 26
Smallridge, Dev. K1 21
Smallworth, Norf. F1 43
Smarden, Kent F2 27
Smarts Hill, Kent C2 26
Smeeth, The, Norf. B4 44
Smeeton Westerby, Leics. J5 49
Smethwick, W.Mid. C5 48
Sminsary, High. F5 97
Smisby, Derby. F3 49
Smithfield, Cumb. E3 74
Smithies, S.Yorks. K4 61
Smithincott, Dev. J4 35
Smithton, High. G5 105
Smockington, Leics. G5 49
Snailwell, Cambs. C2 42
Snainton, N.Yorks. G2 65
Snaith, Hum. C1 62
Snape, N.Yorks. D3 66
Snape, Suff. J3 43
Snarestone, Leics. F3 49
Snargate, Kent G4 27
Snave, Kent G3 27
Sneaton, N.Yorks. J2 67
Sneatonthorpe, N.Yorks. J2 67
Snelland, Lincs. F4 63
Snelston, Derby. H3 57
Snettisham, Norf. C2 44
Snitter, Northumb. H6 79
Snitterby, Lincs. F3 63
Snitterfield, War. B3 40
Snodland, Kent E5 28
Snowdens Bridge, Lincs. J6 63
Snowshill, Glos. A5 40
Soberton, Hants. D3 24
Soham, Cambs. C2 42
Solas, N.Uist B4 108
Sollom, Lancs. C3 60
Solva, Dyfed B1 36
Somerby, Leics. F4 47
Somerby, Lincs. F2 63
Somercotes, Derby. C1 46
Somerford Keynes, Glos. F2 33
Somerleyton, Suff. K5 45
Somersal Herbert, Derby. H4 57
Somersby, Lincs. J5 63
Somersham, Cambs. A1 42
Somersham, Suff. G4 43
Somerton, Oxon. D5 40
Somerton, Som. B2 22
Sompting, W.Suss. H4 25
Sonning Common, Oxon. C3 30
Sonning, Berks. D4 30
Sookholme, Notts. B5 62
Sopley, Hants. G4 23
Sopworth, Wilts. H5 39
Sorbie, D.&G. E4 72
Sorisdale, Isle of Coll C6 96
Sorisdale, Isle of Coll C1 94
Sorn, Stra. J4 83
Sortat, High. G2 111
Sotby, Lincs. G4 63
Sots Hole, Lincs. G5 63
Sotterley, Suff. J1 43
Sotwell, Oxon. B3 30
Soudley, Glos. C1 32
Soudley, Salop. E4 56
Soughton, Clwyd J4 59
Soulbury, Bucks. G5 41
Soulby, Cumb. J1 69
Souldern, Oxon. D5 40
Souldrop, Beds. H2 41
Soundwell, Avon F5 39
Sourton, Dev. D2 20
South Acre, Norf. D4 44
South Alloa, Cen. D1 86
South Ambersham, W.Suss. F3 25
South Barrow, Som. C2 22
South Benfleet, Essex E3 28
South Brent, Dev. E4 20
South Brewham, Som. D1 22
South Cadbury, Som. C2 22
South Cairn, D.&G. A2 72
South Carlton, Lincs. E4 62
South Cave, Hum. G6 65
South Cerney, Glos. G2 33
South Charlton, Northumb. K4 79
South Chenton, Som. D2 22
South Cliffe, Hum. F6 65
South Clifton, Notts. D5 62
South Cockerington, Lincs. J3 63
South Corley, Hants. G3 23
South Cove, Suff. K1 43
South Creake, Norf. E2 44
South Croxton, Leics. E4 46
South Croydon, G.L. H5 31
South Dalton, Hum. G5 65
South Darenth, Kent D4 28
South Duffield, N.Yorks. E6 64
South Elkington, Lincs. H4 63
South Elmsall, W.Yorks. B2 62
South End, Hum. G1 63
South Ferriby, Hum. F1 63
South Hanningfield, Essex E2 28
South Harting, W.Suss. E3 24
South Hayling, Hants. E4 24
South Heighton, E.Suss. C6 26
South Heighton, Dur. D4 76
South Hiendley, W.Yorks. A2 62
South Hill, Corn. J2 19
South Hinksey, Oxon. B2 30
South Hole, Dev. B4 34
South Hornchurch, G.L. C3 28
South Huish, Dev. E6 20
South Hykeham, Lincs. E5 62
South Kelsey, Lincs. F3 63
South Killingholme, Hum. G1 63
South Kilvington, N.Yorks. C2 64

South Kilworth, Northants. E1 40
South Kilworth, Leics. H6 49
South Kirby, W.Yorks. A2 62
South Kyme, Lincs. J1 47
South Lancing, W.Suss. H4 25
South Leigh, Oxon. J1 33
South Leverton, Notts. D4 62
South Littleton, H.&W. A4 40
South Lopham, Norf. F1 43
South Luffenham, Leics. H5 47
South Milford, N.Yorks. C6 64
South Milton, Dev. E6 20
South Mimms, Herts. G2 31
South Molton, Dev. F3 35
South Moreton, Oxon. B3 30
South Muskham, Notts. D6 62
South Newbald, Hum. G6 65
South Newton, Wilts. G1 23
South Normanton, Derby. C1 46
South Ockendon, Essex D3 28
South Ormsby, Lincs. J5 63
South Otterington, N.Yorks. B1 64
South Owersby, Lincs. F3 63
South Park, Surr. H6 31
South Perrott, Dor. B3 22
South Petherton, Som. B3 22
South Petherwin, Corn. H1 19
South Pickenham, Norf. E5 44
South Pool, Dev. F6 21
South Port, Stra. C4 92
South Rauceby, Lincs. H2 47
South Raynham, Norf. E3 44
South Reston, Lincs. J4 63
South Runcton, Norf. C5 44
South Shields, T.&W. D3 76
South Shore, Lancs. B2 60
South Skirlaugh, Hum. J5 65
South Somercotes, Lincs. J3 63
South Stainley, N.Yorks. B3 64
South Stoke, Avon D5 32
South Stoke, Oxon. B3 30
South Stoke, W.Suss. G3 25
South Street, E.Suss. B4 26
South Street, Kent D5 28
South Tawton, Dev. E1 20
South Thoresby, Lincs. J4 63
South Tidworth, Hants. H6 33
South Walsham, Norf. J4 45
South Warnborough, Hants. C6 30
South Wheatley, Notts. D4 62
South Wick, Hants. D3 24
South Wigston, Leics. H4 49
South Willingham, Lincs. G4 63
South Wingfield, Derby. C1 46
South Witham, Lincs. G4 47
South Wooton, Norf. C3 44
South Wraxall, Wilts. E5 32
South Zeal, Dev. E2 20
Southall, G.L. G3 31
Southam, Glos. J1 39
Southam, War. C2 40
Southampton, Hants. B3 24
Southborne, Dor. G5 23
Southborough, G.L. C4 28
Southborough, Kent D2 26
Southburgh, Norf. F5 45
Southburn, Hum. G4 65
Southease, E.Suss. C5 26
Southend, Kintyre B5 82
Southend-on-Sea, Essex F3 29
Southerndown, M.Glam. K5 37
Southerness, D.&G. B4 74
Southery, Norf. C6 44
Southfleet, Kent D4 28
Southgate, G.L. H2 31
Southgate, Norf. C3 44
Southgate, W.Glam. H4 37
Southill, Beds. J4 41
Southleigh, Dev. J2 21
Southminster, Essex G2 29
Southoe, Cambs. J2 41
Southorpe, Cambs. J5 47
Southowram, W.Yorks. H2 61
Southport, Mer. B3 60
Southrepps, Norf. H2 45
Southrey, Lincs. G5 63
Southrop, Glos. H2 33
Southsea, Hants. D4 24
Southtown, Norf. K5 45
Southtown, Ork. G5 112
Southwaite, Cumb. E4 74
Southwater, W.Suss. H2 25
Southwell, Notts. C6 62
Southwick, Northants. H6 47
Southwick, W.Suss. A5 26
Southwick, Wilts. E5 32
Southwold, Suff. K1 43
Soutra Mains, Loth. D4 88
Sowerby Bridge, W.Yorks. H2 61
Sowerby, N.Yorks. F4 67
Sowerby, W.Yorks. H2 61
Sowley Green, Suff. D3 42
Sowton, Dev. G2 21
Spacey Houses, N.Yorks. B4 64
Spalding, Lincs. K3 47
Spaldington, Hum. F6 65
Spaldwick, Cambs. J2 41
Spalford, Notts. E5 62
Sparkford, Som. C2 22
Sparkhill, W.Mid. A6 46
Sparkwell, Dev. D4 20
Sparnam, Norf. F4 45
Sparrowpit, Derby. H6 61
Sparrows Green, E.Suss. D3 26
Sparsholt, Hants. B2 24
Sparsholt, Oxon. J3 33
Spaunton, N.Yorks. E1 64
Spaxton, Som. K2 35

185

Tittle Row, Berks. E3 30	Tournaig, High. F2 107	Trotton, W.Suss. F2 25	Ufton Nervet, Berks. C4 30	Upton, Hants. J5 33
Tittleshall, Norf. E4 44	Toux, Gram. E4 102	Troutbeck Bridge, Cumb. F2 69	Ufton, War. C2 40	Upton, Leics. F4 49
Tiverton, Ches. D2 56	Tow Law, Dur. B5 76	Troutbeck, Cumb. F2 69	Ugadale, Kintyre C4 82	Upton, Lincs. E4 62
Tiverton, Dev. H4 35	Towcester, Northants. F3 41	Trow Green, Glos. C1 32	Ugborough, Dev. E5 20	Upton, Mer. B5 60
Tivetshall St. Margaret, Norf. G1 43	Townednack, Corn. B4 18	Troway, Derby. A4 62	Uggeshall, Suff. J1 43	Upton, Norf. J4 45
Tivetshall St. Mary, Norf. G1 43	Towersey, Oxon. D1 30	Trowbridge, Wilts. E5 32	Ugley, Essex B5 42	Upton, Notts. D4 62
Tixall, Staffs. C2 48	Town End, Cambs. A6 44	Trowell, Notts. D2 46	Ugthorpe, N.Yorks. J1 67	Upton, Oxon. B3 30
Toab, Shet. D4 112	Town End, Cumb. G3 69	Trowse Newton, Norf. H5 45	Uig, Isle of Skye C4 106	Upton, Salop. A3 48
Tobermory, Isle of Mull E1 94	Town Yetholm, Bord. G4 79	Trull, Som. K3 35	Ulbster, High. H4 111	Upton, W.Yorks. B2 62
Toberonochy, Stra. G5 95	Townhead of Greenlaw, D.&G. G3 73	Trumpan, Isle of Skye A4 106	Ulceby Skitler, Hum. G1 63	Upware, Cambs. B2 42
Tockenham Wick, Wilts. J5 39	Townhead, D.&G. G4 73	Trumpet, H.&W. F6 51	Ulceby, Hum. G1 63	Upwell, Cambs. B5 44
Tockenham, Wilts. F3 33	Townhill, Fife A1 88	Trumps Green, Surr. F4 31	Ulceby, Lincs. J5 63	Upwey, Dor. C5 22
Tockholes, Lancs. E2 60	Townshend, Corn. C5 18	Trunch, Norf. H2 45	Ulcombe, Kent F2 27	Upwood, Cambs. K6 47
Tockington, Avon C3 32	Towthorpe, Hum. G3 65	Truro, Corn. E4 18	Uldale, Cumb. D5 74	Urchal, High. G5 105
Tockwith, N.Yorks. C4 64	Towthorpe, N.Yorks. D4 64	Trusham, Dev. F2 21	Uley, Glos. D2 32	Urchfont, Wilts. F5 33
Todber, Dor. E2 22	Towton, N.Yorks. C5 64	Trusley, Derby. B2 46	Ulgham, Northumb. C1 76	Urmston, Grt.M. F5 61
Toddington, Beds. H5 41	Towyn, Clwyd G3 59	Trusthorpe, Lincs. K4 63	Ullapool, High. H2 107	Urquhart, Gram. C4 102
Toddington, Glos. J1 39	Toynton All Saints, Lincs. J5 63	Trysull, Staffs. B5 48	Ullenhall, War. A2 40	Ushaw Moor, Dur. C5 76
Todenham, Glos. B5 40	Toynton St. Peter, Lincs. J6 63	Tuddenham, Suff. G4 43	Ulleskelf, N.Yorks. D5 64	Usk, Gwent D3 38
Todhills, Cumb. E3 74	Trabboch, Stra. H4 83	Tudeley, Kent D2 26	Ulpha, Cumb. E3 68	Usselby, Lincs. G3 63
Todmorden, W.Yorks. G2 61	Trafford Park, Grt.M. F5 61	Tudhoe, Dur. C5 76	Ulrome, Hum. J4 65	Utley, W.Yorks. H1 61
Todwick, S.Yorks. B4 62	Tranent, Loth. C3 88	Tudweiliog, Gwyn. A6 58	Ulsta, Shet. D2 112	Uton, Dev. G5 35
Toft next Newton, Lincs. F4 63	Tranwell, Northumb. B1 76	Tuffley, Glos. H2 39	Ulverston, Cumb. F4 69	Utterby, Lincs. H3 63
Toft, Cambs. A3 42	Trapp, Dyfed H2 37	Tugby, Leics. J4 49	Umberleigh Bridge, Dev. E3 34	Uttoxeter, Staffs. H4 57
Toft, Ches. F6 61	Traprain, Loth. E2 88	Tugford, Salop. F2 51	Unapool, High. C4 109	Uwchmynydd, Gwyn. A5 54
Toft, Lincs. J4 47	Traquair, Bord. C3 78	Tullibody, Cen. D1 86	Underbarrow, Cumb. G3 69	Uxbridge, G.L. F3 31
Toftrees, Norf. E3 44	Trawden, Lancs. G1 61	Tullich Muir, High. G3 105	Undercliffe, W.Yorks. J2 61	Uzmaston, Dyfed C2 36
Tofts Monks, Norf. J6 45	Trawsfynydd, Gwyn. E4 54	Tullich, Stra. D5 92	Underwood, Notts. D1 46	Valley, Angl. B3 58
Toftwood Common, Norf. F4 45	Tre'r-ddôl, Dyfed G2 53	Tullochgorm, Stra. J6 95	Undley, Suff. C1 42	Vange, Essex E3 28
Togston, Northumb. K6 79	Tre-cwm, Dyfed C1 36	Tulloes, Tay. G2 91	Undy, Gwent E4 38	Varteg, Gwent C3 38
Tokavaig, Isle of Skye F3 97	Tre-ddiog, Dyfed B1 36	Tullymurdoch, Tay. E2 90	Union Mills, I.o.M. D4 70	Vatten, Isle of Skye B6 106
Toll Bar, S.Yorks. B2 62	Tre-groes, Dyfed E6 52	Tullynessle, Gram. G2 101	Unstone, Derby. A4 62	Vaul, Isle if Tiree A2 94
Toll of Birness, Gram. J6 103	Treales, Lancs. C2 60	Tumble, Dyfed H2 37	Unthank, Cumb. E5 74	Vauld, The, H.&W. E5 50
Tolland, Som. J3 35	Trearddur Bay, Angl. A3 58	Tumby Woodside, Lincs. H6 63	Up Cerne, Dor. C4 22	Veensgarth, Shet. D3 112
Tollard Royal, Wilts. F3 23	Treborough, Som. H2 35	Tumby, Lincs. H6 63	Up Exe, Dev. H5 35	Velindre, Dyfed E6 52
Tollbar End, War. C1 40	Trebudannon, Corn. E2 18	Tummel Bridge, Tay. J1 93	Up Holland, Lancs. D4 60	Velindre, Powys C6 50
Toller Porcorum, Dor. C4 22	Trebyan, Corn. G2 19	Tunbridge Wells, Kent D3 26	Up Sydling, Dor. C4 22	Venn Ottery, Dev. H2 21
Tollerton, N.Yorks. D3 64	Trecastle, Powys K1 37	Tunstall, Hum. K6 65	Upavon, Wilts. G5 33	Vennington, Salop. B6 56
Tollerton, Notts. E2 46	Tredegar, Gwent B3 38	Tunstall, Kent F5 29	Upchurch, Kent F4 29	Ventnor, I.o.W. C6 24
Tollesbury, Essex F6 43	Tredington, War. B4 40	Tunstall, Lancs. H4 69	Upgate Street, Norf. H6 45	Vernham Dean, Hants. J5 33
Tolleshunt D'Arcy, Essex E6 42	Tredomen, Powys B1 38	Tunstall, N.Yorks. D3 66	Upgate, Norf. G4 45	Verwig, Dyfed C5 52
Tolpuddle, Dor. D4 22	Tredunnock, Gwent A2 32	Tunstall, Staffs. F2 57	Uphall, Loth. E3 86	Verwood, Dor. G3 23
Tomatin, High. K1 99	Treen, Corn. A6 18	Tunstall, Suff. J3 43	Upham, Hants. C3 24	Veryan, Corn. E4 18
Tombreck, High. J1 99	Trefdraeth, Angl. B4 58	Tunworth, Hants. C6 30	Uphill, Avon A5 32	Vickerstown, Cumb. E5 68
Tomchrasky, High. E3 98	Trefdraeth, Gwyn. C1 54	Tupton, Derby. A5 62	Uplawmoor, Stra. H1 83	Vidlin, Shet. D3 112
Tomich, High. G3 105	Trefeca, Powys B1 38	Tur Langton, Leics. J5 49	Upleadon, Glos. G1 39	Viewpark, Stra. C4 86
Tomintoul, Gram. C2 100	Trefeglwys, Powys K2 53	Turgis Green, Hants. C5 30	Uplowman, Dev. H4 35	Virginstow, Dev. B2 20
Tomnaven, Gram. E1 100	Trefenter, Dyfed G4 53	Turkdean, Glos. K2 39	Uplyme, Dev. K2 21	Vowchurch, H.&W. D6 50
Tomnavoulin, Gram. D2 100	Treffgarne, Dyfed C2 36	Turnberry, Stra. F5 83	Upminster, G.L. D3 28	Voy, Ork. F5 112
Tonbridge, Kent D2 26	Treffynnon, Dyfed B1 36	Turnditch, Derby. J3 57	Upottery, Dev. K5 35	Wacton, Norf. G6 45
Tong, Salop. B4 48	Trefil, Gwent B2 38	Turners Hill, W.Suss. B3 26	Upper Arley, H.&W. G3 51	Wadborough, H.&W. H5 51
Tong, W.Yorks. J2 61	Trefnant, Clwyd H4 59	Turnworth, Dor. E3 22	Upper Basildon, Berks. B4 30	Waddesdon, Bucks. F6 41
Tonge, Leics. C3 46	Trefonen, Salop. K4 55	Turriff, Gram. F5 103	Upper Benefield, Northants. H6 47	Waddingham, Lincs. F3 63
Tongham, Surr. E6 30	Trefor, Angl. B3 58	Turton Bottoms, Lancs. E3 60	Upper Beeding, W.Suss. A5 26	Waddington, Lancs. E1 60
Tongland, D.&G. G4 73	Trefriw, Gwyn. E4 58	Turvey, Beds. H3 41	Upper Boddington, Northants. D3 40	Waddington, Lincs. F5 63
Tongue, High. B2 110	Tregadillett, Corn. H1 19	Turville, Bucks. D3 30	Upper Borth, Dyfed G2 53	Waddon, G.L. B5 28
Tongwynlais, S.Glam. B5 38	Tregare, Gwent E3 38	Turweston, Bucks. E4 40	Upper Brailes, War. B4 40	Wadebridge, Corn. F2 19
Tonna, W.Glam. J4 37	Tregaron, Dyfed G4 53	Tushielaw Inn, Bord. G4 81	Upper Broughton, Notts. J2 49	Wadeford, Som. A3 22
Tonteg, M.Glam. B4 38	Tregarth, Gwyn. D4 58	Tutbury, Staffs. B3 46	Upper Chapel, Powys A6 50	Wadenhoe, Northants. H6 47
Tonwell, Herts. A6 42	Tregeinog, Clwyd J4 55	Tutbury, Staffs. J4 57	Upper Clynnog, Gwyn. C3 54	Wadesmill, Herts. A6 42
Tonypandy, M.Glam. A4 38	Tregele, Angl. B2 58	Tutnalls, Glos. C2 32	Upper Dean, Beds. H2 41	Wadhurst, E.Suss. D3 26
Tonyrefail, M.Glam. A4 38	Treglemais, Dyfed B1 36	Tutshill, Glos. B2 32	Upper Denby, W.Yorks. J4 61	Wadlow, Derby. J1 57
Topcliffe, N.Yorks. C2 64	Tregony, Corn. E4 18	Tuttington, Norf. H3 45	Upper Dicker, E.Suss. D5 26	Wadshelf, Derby. A5 62
Topcroft Street, Norf. H6 45	Tregynon, Powys B1 50	Tutwell, Corn. J1 19	Upper Elkstone, Staffs. H2 57	Wadworth, S.Yorks. B3 62
Topcroft, Norf. H6 45	Treharris, M.Glam. B4 38	Tuxford, Notts. D5 62	Upper End, Derby. H6 61	Waen Fach, Powys J5 55
Toppesfield, Essex D4 42	Treherbert, M.Glam. A4 38	Twatt, Ork. F5 112	Upper Ethie, High. G4 105	Wag, High. E5 110
Toppings, Grt.M. E3 60	Trelawnyd, Clwyd H3 59	Twechar, Stra. C2 86	Upper Hackney, Derby. J2 57	Wainfleet All Saints, Lincs. B1 44
Topsham, Dev. G2 21	Trelech a'r Betws, Dyfed F1 37	Tweedmouth, Northumb. H4 89	Upper Helmsley, N.Yorks. E4 64	Wainfleet Bank, Lincs. B1 44
Torbeg, Gram. E4 100	Trelech, Dyfed E1 36	Tweeds Well, Bord. E5 80	Upper Heyford, Northants. E3 40	Wainstalls, W.Yorks. H2 61
Torbeg, Island of Arran D3 82	Treleddyd Fawr, Dyfed A1 36	Tweedsmuir, Bord. E4 80	Upper Heyford, Oxon. D5 40	Waitby, Cumb. J1 69
Torboll, High. G1 105	Trelewis, M.Glam. B4 38	Twenty, Lincs. J4 47	Upper Hopton, W.Yorks. J3 61	Wakefield, W.Yorks. A1 62
Torcross, Dev. F6 21	Trelleck Grange, Gwent B2 32	Twickenham, G.L. G4 31	Upper Hulme, Staffs. G2 57	Wakerley, Northants. H5 47
Tore, High. F5 105	Trelleck, Gwent E3 38	Twigworth, Glos. H2 39	Upper Inglesham, Wilts. H2 33	Wakes Colne, Essex E5 42
Torksey, Lincs. E4 62	Trelogan, Clwyd H3 59	Twineham, W.Suss. A4 26	Upper Knockando, Gram. B6 102	Walberswick, Suff. K1 43
Torlundy, High. D5 98	Tremadog, Gwyn. D3 54	Twiss Green, Ches. E5 60	Upper Longdon, Staffs. D3 48	Walberton, W.Suss. G4 25
Tormarton, Avon D3 32	Tremaine, Corn. B6 34	Twitchen, Dev. G3 35	Upper Longwood, Salop. D6 56	Walcot Green, Norf. G1 43
Tormaton, Avon G5 39	Tremeirchion, Clwyd H3 59	Two Bridges, Dev. D3 20	Upper Lydbrook, Glos. F2 39	Walcot, Lincs. H2 47
Tormisdale, Isle of Islay A4 84	Trenance, Corn. E2 18	Two Dales, Derby. J2 57	Upper Maes-coed, H.&W. D6 50	Walcot, Salop. D6 56
Tormitchell, Stra. F6 83	Trench, Salop. E6 56	Twycross, Leics. C5 46	Upper Minety, Wilts. J4 39	Walcote, Leics. E6 46
Tormore, Island of Arran D3 82	Treneglos, Corn. B6 34	Twyford Common, H.&W. E6 50	Upper Moor, Derby. A5 62	Walcote, Northants. E1 40
Tornagrain, High. G5 105	Trent, Dor. C3 22	Twyford Gardens, Oxon. D4 40	Upper Norwood, G.L. H4 31	Walcott, Norf. J3 45
Tornaveen, Gram. G3 101	Trentham, Staffs. F3 57	Twyford, Berks. D4 30	Upper Poppleton, N.Yorks. D4 64	Walden Head, N.Yorks. B4 66
Torness, High. H1 99	Trentishoe, Dev. E1 34	Twyford, Bucks. E5 40	Upper Seagry, Wilts. J5 39	Walden Stubbs, N.Yorks. B1 62
Torpenhow, Cumb. C5 74	Treodyrhiw, M.Glam. B3 38	Twyford, Hants. C2 24	Upper Sheringham, Norf. G2 45	Walden, N.Yorks. B4 66
Torphichen, Loth. E3 86	Treoes, S.Glam. A5 38	Twyford, Leics. F4 47	Upper Slaughter, Glos. A6 40	Walderslade, Kent E5 28
Torphins, Gram. G3 101	Treorchy, M.Glam. A4 38	Twyford, Norf. F3 45	Upper Staploe, Beds. J3 41	Walderton, W.Suss. E3 24
Torpoint, Corn. J3 19	Trerule Foot, Corn. J3 19	Twynholm, D.&G. F4 73	Upper Stonnall, Staffs. A5 46	Waldingfield, Suff. H4 43
Torquay, Dev. G4 21	Tresarth, Dyfed D5 52	Twyning Green, Glos. H6 51	Upper Swell, Glos. A5 40	Waldron, E.Suss. D4 26
Torquhan, Bord. D5 88	Tresham, Avon E3 32	Twynllanan, Dyfed J1 37	Upper Tasburgh, Norf. G6 45	Wales, S.Yorks. B4 62
Torran, Isle of Skye D5 106	Tresinwen, Dyfed A6 52	Twywell, Northants. H1 41	Upper Tean, Staffs. G3 57	Walesby, Lincs. G3 63
Torrance, Stra. B2 86	Tresmeer, Corn. B6 34	Ty'n-y-groes, Gwyn. E4 58	Upper Tillyrie, Tay. D5 90	Walesby, Notts. C5 62
Torre, Dev. G4 21	Tresparrett Post, Corn. A6 34	Ty-hen, Gwyn. A4 54	Upper Town, Avon E6 38	Walford, H.&W. D3 50
Torridon, High. G5 107	Tressait, Tay. B1 90	Ty-Mawr, Clwyd F5 59	Upper Waltham, W.Suss. F3 25	Walford, Salop. C5 56
Torrin, Isle of Skye F2 97	Tresta, Shet. D3 112	Ty-nant, Clwyd G3 55	Upper Weedon, Northants. E3 40	Walgherton, Ches. E3 56
Torrisdale, High. C2 110	Treswell, Notts. D4 62	Ty-nant, Gwyn. G5 55	Upper Winchendon, Bucks. D1 30	Walgrave, Northants. F2 41
Torrish, High. E5 110	Tretio, Dyfed A1 36	Tyberton, H.&W. D6 50	Upper Witton, W.Mid. A6 46	Walk Mill, Lancs. F2 61
Torterston, Gram. J5 103	Tretower, Powys C2 38	Tycroes, Dyfed H3 37	Upper Wolvercote, Oxon. B1 30	Walkden, Grt.M. E4 60
Torthorwald, D.&G. B2 74	Treuddyn, Clwyd J5 59	Tycrwyn, Powys H5 55	Uppermill, Grt.M. G4 61	Walker Fold, Lancs. E1 60
Tortworth, Avon D2 32	Trevelmond, Corn. H2 19	Tydd Gate, Lincs. A4 44	Upperthong, W.Yorks. J4 61	Walker, T.&W. C3 76
Torvaig, Isle of Skye C5 106	Trevethin, Gwent C3 38	Tydd St. Giles, Cambs. A4 44	Uppertown, Isle of Stroma H1 111	Walkerburn, Bord. H3 81
Torver, Cumb. E3 68	Trevine, Dyfed B1 36	Tydd St. Mary, Lincs. A4 44	Uppertown, Derby. A5 62	Walkeringham, Notts. D3 62
Torworth, Notts. C4 62	Trevone, Corn. E1 18	Tyldesley, Grt.M. E4 60	Uppingham, Leics. G5 47	Walkerith, Lincs. D3 62
Toscaig, High. E6 106	Trevor, Gwyn. C3 54	Tyler Hill, Kent H1 27	Uppington, Salop. D6 56	Walkern, Herts. K5 41
Toseland, Cambs. K2 41	Trewithian, Corn. E4 18	Tylers Green, Essex C1 28	Upsall, N.Yorks. C1 64	Walkers Green, H.&W. E5 50
Tosside, N.Yorks. J6 69	Treyford, W.Suss. F3 25	Tylorstown, M.Glam. A4 38	Upstreet, Kent J5 29	Walkhampton, Dev. D3 20
Tostock, Suff. E2 42	Triabad, Powys J6 53	Tynehead, Loth. C4 88	Upton Bishop, H.&W. F1 39	Walkington, Hum. G5 65
Totaig, Isle of Skye A5 106	Tricketts Cross, Dor. G4 23	Tynemouth, T.&W. D2 76	Upton Cheyney, Avon D4 32	Walkley, S.Yorks. A3 62
Totegan, High. D1 110	Trimdon Colliery, Dur. D5 76	Tynewydd, W.Glam. K3 37	Upton Cressett, Salop. F2 51	Wall, Bord. H4 81
Totland, I.o.W. B5 24	Trimdon, Dur. D5 76	Tyninghame, Loth. E2 88	Upton Cross, Corn. H2 19	Wall, Corn. C4 18
Totley, S.Yorks. K6 61	Trimingham, Norf. H2 45	Tynron, D.&G. C2 92	Upton Grey, Hants. C6 30	Wall, Northumb. J2 75
Totnes, Dev. F4 21	Trimley Heath, Suff. H4 43	Tysoe, War. C4 40	Upton Hellions, Dev. G5 35	Wall, Staffs. D4 48
Toton, Notts. D2 46	Trimley, Suff. H4 43	Tytherington, Avon D3 32	Upton Magna, Salop. D6 56	Wallasea Island, Essex G2 29
Tottenham, G.L. B3 28	Trimpley, H.&W. G3 51	Tytherington, Ches. F1 57	Upton Noble, Som. D1 22	Wallasey, Mer. K2 59
Tottenhill, Norf. C4 44	Trimsaran, Dyfed G3 37	Tytherleigh, Dev. K1 21	Upton Pyne, Dev. H5 35	Wallingford, Oxon. B3 30
Totteridge, G.L. H2 31	Trinant, Gwent C3 38	Tywardreath, Corn. G3 19	Upton Scudamore, Wilts. E6 32	Wallington, G.L. H5 31
Totternhoe, Beds. H6 41	Tring, Herts. E1 30	Tywyn, Dyfed G1 53	Upton Snodsbury, H.&W. J5 51	Wallington, Herts. K5 41
Tottington, Grt.M. F3 61	Trinity, Tay. H1 91	Tywyn, Gwyn. E3 58	Upton St. Leonards, Glos. H2 39	Wallis, Dyfed C1 36
Totton, Hants. B3 24	Trislaig, High. D6 98	Ubley, Avon B5 32	Upton upon Severn, H.&W. H6 51	Wallsend, T.&W. C3 76
Touchenend, Berks. E4 30	Trispen, Corn. E3 18	Uckfield, E.Suss. C4 26	Upton, Cambs. J5 47	Wallyford, Loth. H3 87
	Tritlington, Northumb. B1 76	Uckington, Glos. H1 39	Upton, Ches. B1 56	Walmer Bridge, Lancs. C2 60
	Tritton, Norf. K5 45	Uddingston, Stra. C4 86	Upton, Dor. F5 23	Walmer, Kent K6 29
	Trochine, Tay. C3 90	Uddington, Stra. D3 80		Walmley, W.Mid. D5 48
	Troedyraur, Dyfed E6 52	Udimore, E.Suss. F4 27		Walpole Highway, Norf. B4 44
	Troon, Corn. C4 18	Udny, Gram. J1 101		Walpole St. Andrew, Norf. B4 44
	Troon, Stra. G3 83	Uffcott, Wilts. K5 39		Walpole St. Peter, Norf. B4 44
	Troston, Suff. E2 42	Uffculme, Dev. J4 35		Walsall Wood, W.Mid. D4 48
	Trottiscliffe, Kent D5 28	Uffington, Lincs. H5 47		Walsall, W.Mid. C4 48
		Uffington, Oxon. J3 33		Walsden, W.Yorks. G3 61
		Uffington, Salop. D6 56		
		Ufford, Cambs. J5 47		
		Ufford, Suff. H3 43		